W9-CEN-056

CHICAGO PUBLIC LIBRARY

R01629 89318

T H E R E V I S E D
NOMENCLATURE
FOR MUSEUM CATALOGING

THE REVISED
NOMENCLATURE
FOR MUSEUM CATALOGING

*A Revised and Expanded Version
of Robert G. Chenhall's System
for Classifying Man-Made Objects*

James R. Blackaby
Patricia Greeno
and The Nomenclature Committee

A A S L H P R E S S

Library of Congress Cataloging in Publication Data

Chenhall, Robert G., 1923—
 The revised nomenclature for museum cataloging : a
revised and expanded version of Robert G. Chenhall's system
for classifying man-made objects / [by] James R. Blackaby,
Patricia Greeno.
 p. cm.
 Bibliography : p.
 ISBN 0-910050-93-7 : $62.00
 1. Museum registration methods. I. Chenhall, Robert G.,
1923— Nomenclature for museum cataloging II. Blackaby,
James R., 1944— III. Greeno, Patricia, 1927— IV. Title.
AM139.C493 1988
O69.5′2—dc 19

**Copyright © 1988 by the American Association for State and Local
History.** All rights reserved. Printed in the United States of
America. Except for brief quotations used in critical articles or
reviews no part of this publication may be reproduced or trans-
mitted in any form by any means, electronic or mechanical, includ-
ing photocopying, recording, or any information or retrieval
system, without written permission of the copyright owner. For
information, write to the American Association for State and Local
History, 172 Second Avenue, North, Suite 102, Nashville, TN
37201.

RU1629 89318

CONTENTS

PREFACE

Nomenclature for Museum Cataloging was first published in 1978 and quickly became the standard cataloging tool for many historical organizations. When the first edition went out of print in mid-1984, many museums were still struggling to get their collections under control. Some had dog-eared copies of *Nomenclature* and needed new ones, while others were ready to order their very first copies. It became clear that there was a need for *Nomenclature*, that it was a standard reference, and that it could not be allowed to disappear from bookshelves.

It also became clear that reprinting the first edition would be unacceptable. Individuals who had been using *Nomenclature* had suggestions for revisions, and some had devised their own specialized rules for handling certain collections. Sufficient questions were raised that it became desirable to consider a new and revised edition of *Nomenclature*.

The *Nomenclature* system had first been devised at the Strong Museum under the guidance of Robert Chenhall. Although Chenhall was no longer at the Strong, or even directly involved in the museum field, the museum staff felt responsible for the system and spearheaded a "grassroots" movement to revise the book. A group of individuals experienced in the use of *Nomenclature* and interested in its revision was invited to meet in Rochester during the winter of 1985 and begin evolving a new edition of the work. These individuals were chosen from large and small museums throughout the country. A few were experienced with the computerization of *Nomenclature*, while others continued to work with manual systems. Even after the Rochester meeting, these representatives continued to make suggestions and recommendations.

Support for the revision has been overwhelming from both individuals and organizations. The American Association for State and Local History, first under the direction of Gerald George and now of Larry Tise, has actively supported the project. In August of 1985 *History News* published the article "What's in a Name?" which described the revision project and included a *Nomenclature* questionnaire. Many individuals not specifically involved in the revision helped by answering the questionnaire and by offering supplementary material to the project team. The National Museum Act granted the Strong Museum funds to help defray the Rochester meeting travel expenses and to hire two editors for the revised edition. In 1987 James Blackaby, from the Bucks County Historical Society in Doylestown, Pennsylvania, was engaged to revise the explanatory text, and Patricia Greeno of the Strong Museum agreed to edit the lists of object terms.

Although it is impossible to thank everyone who helped with this new edition, the following organizations and individuals directly participated in the project.

American Association for State and Local History
Candace Floyd
Betty Doak Elder

Gene Autry Western Heritage Museum
Mary Ellen Hennessey Nottage

Maine State Museum
Ron Kley

Mercer Museum of the Bucks County Historical Society
James R. Blackaby

Museum of Western Colorado
William L. Tennent

Canadian Parks Service
Rosemary Campbell

National Park Service - United States
Joan Bacharach
Kathleen Triggs

New Hanover County Museum of the Lower Cape Fear
Susan Applegate Krouse

New York State Museum
Ronald Burch

Smithsonian Institution
Mary Case

The Strong Museum
Judy Emerson
Patricia Greeno
Jan Guldbeck
Mary-Ellen Earl Perry
Deborah Smith
Patricia Tice
Susan Williams

The project team worked towards consensus, but consensus is difficult to reach, and at times the majority ruled. Some people may agree with the changes and additions; other people may disagree with some revisions and yet agree with others. In general, this new edition reflects the thoughts of the history museum field at large. The project team continues to believe in the need for refinement, and so "Yes, Virginia" there may very well be yet another revision of *Nomenclature*.

LYNNE F. POIRIER
Vice-President for Collections
The Strong Museum

T H E R E V I S E D
NOMENCLATURE
FOR MUSEUM CATALOGING

R01629 89318

CHAPTER I
LOOKING AT NOMENCLATURE

What is *Nomenclature*, and why should history museums of all sizes use it? *Nomenclature* is a structured and controlled list of terms organized in a classification system to provide the basis for indexing and cataloging collections. It addresses the problems that museums with varied collections face in managing their collection data. And it allows holders of collections to share meaningful data with one another.

Work on the *Nomenclature* system was begun in 1974 by Robert Chenhall, then of the Strong Museum, and a group of concerned professionals from history museums of all sizes. Their goal was to provide collections of material culture uniform preferred terms like those used for scientific collections. When it was first introduced, *Nomenclature* was a new and largely untested idea for history collections.

Nomenclature was developed in anticipation of sharing collection data. The first edition attempted to provide ways to solve problems that computerization presented. Institutions that had experimented with computers in the 1970s had already discovered that computers are much less imaginative than people. For the most part, computers do not deal easily with the variety of words we use to describe the artifacts in our collections. Because of regional variations and local preferences, the object that one might call a "goosewing ax" is called a "broadax" by others. Computers do not recognize this variety. Most computers do not even know that "shoe," "SHOE," and "shoes" are the same as far as people are concerned, let alone that "pumps" and "heels" are shoes too. Manual systems are, of course, much more forgiving, but *Nomenclature* facilitates subject index cards for collections, and its classifications serve a valuable function in organizing research vertical files. An article written about Albany plane makers, for example, can be filed under "Woodworking T&E" ("T&E" meaning "tools and equipment") instead of *A* for "Albany," *P* for "plane," or *C* for

cabinetmaking. *Nomenclature* categories provide a much needed standard for organizing information. Today, as museums begin to develop ways to share collection data, *Nomenclature* will prove a useful tool for manual and automated records systems.

Nomenclature and Naming Systems—An Overview

Nomenclature is a tool for cataloging museum collections. As such, it helps museums organize their records, retrieve documentary information, and connect interrelated data. It is not intended as a replacement for normal discourse. Normally, one would not go about speaking of a RACK, HAT or a BOTTLE, TOILET, nor would one talk about a pair of SHOE or a set of DISH.[1] For the purposes of keeping track of information in museum catalogs, however, it is useful to establish a limited set of acceptable terms to identify objects and to practice some simple conventions, such as inverting object terms so that nouns precede adjectives to force like objects to appear together alphabetically, or avoiding plural forms of object terms. In that respect, *Nomenclature* is like other scientific naming systems. That a botanist might refer to *Poa pratensis* to distinguish it from *Poa compressa* or *Poa annua* or to relate it to other members of the *Gramineae* family (which includes *Lolium* and *Festuca*) makes little practical difference to the teenager called upon to mow the lawn. The needs of the botanical community to communicate about types of bluegrass (*Poa*) and the parent to communicate about weekend yard work are differences museum catalogers must contend with also.

Scientific naming systems with their standardized binominal terms, such as *Poa pratensis*, are the models on which *Nomenclature* is based, and *Nomenclature* follows those systems in creating a hierarchy of relationships between the terms it standardizes. The lawn that needs to be mowed might be a mix-

ture of bluegrass, rye, and fescue. The botanist relates these three similar plants by identifying their genus and species as being part of a larger hierarchy. *Poa pratensis* (Kentucky bluegrass), *Lolium multiflorum* (common ryegrass), and *Festuca elatior* (meadow fescue) are all members of the *Gramineae* (grass) family, which is in the subclass *Monocotyledonae* (those plants with just one leaf on their seedlings) of the class *Angiospermae* (plants with flowers) of the division *Tracheophyta* (plants with vascular systems) of the kingdom called *Plantae* as distinguished from the kingdom called *Animalia*. Such hierarchical distinctions are convenient for relating similar things and for discovering what the scientific term for a plant might be. Each level in the hierarchy represents a division that relates like things. Generally, these divisions are clear and simple, and each division contains equally significant groups. The hierarchy divides a very complex body of material—all plants—into manageable groups of similar things.

Besides dividing populations into similar and related groups, taxonomic hierarchies create a place for everything. This process of division can be seen as filtering: each member of the population passes through an initial filter that channels it to an appropriate second filter, and the distributive process is repeated until the member finds its proper final group. For plants, one filter has to do with where seeds are: those with seeds in flowers are placed in one group; those with seeds on bracts are placed in another. The group with flowers is further filtered according to whether the seedlings have one leaf or more. By successively determining which filters an unidentified plant passes through, the researcher can find the proper term for a particular plant. *Nomenclature* establishes a similar hierarchy.

Of course, establishing such hierarchies is a matter of controversy and confusion, and it is important to bear in mind that the distinctions drawn are the ones that *seem* to offer the most clarity and utility. Scientific naming systems create hierarchies through the observation of physical characteristics of natural things—are the seeds contained in flowers or borne on bracts? Do seedlings have one leaf or more? The characteristic chosen—number of leaves for seedlings, for instance—is one of many possible characteristics that might be selected as a filter to divide all of the plants with seeds. It is selected because it creates a useful and simple division. Since history museums deal with man-made objects, human intention and physical appearance figure into the creation of the hierarchy; thus creating useful divisions that aid in identification is more difficult.

A hierarchy for man-made objects will necessarily be less perfect and less descriptive than taxonomic classifications. Nevertheless, as with scientific hierarchies, the filters that are employed on each level are describable, they create ever smaller populations, and they provide a place for everything to go.

The hierarchy used for *Nomenclature* is based on original function rather than on any other characteristic because the one thing that can be said of all man-made objects is that they were made for some particular purpose, and that purpose can be determined in nearly every case.

Nomenclature provides standard object terms for catalogers to use in indexing collections. Within a single institution, one cataloger might call an object a "rabbet plane," another might call it a "rabbeting plane," and a third might call it a "rebate plane." All three would be correct, of course, as would a cataloger who called the object a "boxing plane" or a "check plane." But catalogs that list similar objects under five or six different names are useful only if the people using them know all of the names that refer to similar objects or if those names are linked somehow. The solution offered by the *Nomenclature* system is similar to that offered in the natural sciences—to publish a structured list of preferred terms that can be used to provide unambiguous links between objects. The plant that is often called "wintergreen" is also known as "partridge-berry," "teaberry," "checker berry," and "Canada tea." By calling the plant *Gaultheria procumbens*, botanists are able to refer unambiguously to that plant regardless of its common name. History museums may attain the same kind of consistency by using *Nomenclature*.

It is important to bear in mind that *Nomenclature* is intended to be an aid to cataloging, not a replacement for everyday conversation or observation. Museums should keep track of the common names for objects—"rebate plane," "rabbeting plane," and so on—just as they should keep track of the common users of those tools—cooper, cabinet maker, and carpenter. The object term PLANE, RABBET, found in the classification "Woodworking T&E" should help link related terms and collection records without replacing them, just as a single Latin term links "teaberry" and "wintergreen."

The Structure of Nomenclature

Terms in *Nomenclature* are indexed in two ways—alphabetically and hierarchically according to artifact categories and classifications. The cataloger who is simply checking to see if a particular term is listed

might use the alphabetical listing. The hierarchical listing, like those employed in scientific taxonomies, helps the cataloger locate a term by leading him or her through a series of filters identifying a population of accepted terms. Establishing that an object is a tool and that it was originally intended for woodworking leads the cataloger to a selection of terms in the classification "Woodworking T&E" that most likely will include the correct term.

Like the filters employed in scientific hierarchies, the ones used in *Nomenclature* have been chosen from many possibilities because they are simple and clear and because they divide things into parallel and manageable groups. Also, as with scientific systems, the most significant level of the hierarchy is the one in which object terms are given. The next most significant level is the one immediately above that, the classifications. For objects, as for plants, varieties might be listed below the level of object terms. In *Nomenclature*, varietal terms are not used for purposes of indexing, and they are not included in the system. For general collections, object terms will be sufficiently precise to lead the researcher or user to a small population of artifacts. Each major category and classification is defined in detail in Chapter III, but an overview of the hierarchy gives a general idea of the filtering process.

Of the possible initial filters that *Nomenclature* might have used to divide all man-made objects—materials, country of origin, age, style, and so on—function was chosen as the most useful. Every man-made object has a discoverable original function, one way in which the object was originally intended to mediate between humans and their environment. There are three ways that objects mediate: they shelter us from the environment, they act on the environment, or they comment on the environment. These three divisions can be described as "Shelter," "Tools and Equipment," and "Communication." Everything that is man-made falls into one of those three divisions, though a fourth division for those things that we cannot identify might be noted in this initial filtering. These divisions are further divided into major categories.

The major categories are drawn from the divisions, again by filtering so as to provide a sensible place for everything. "Shelter" is divided into three related groups: shared shelters, furnishings, and personal shelters. These are given the names "Structures," "Furnishings," and "Personal Artifacts." "Tools and Equipment" is divided into four related groups: those created to be used with particular materials or resources; those created to observe phenomena or act on those observations; those created to facilitate thought; and those that distribute. These are given the names "Tools & Equipment for Materials," "Tools & Equipment for Science & Technology," "Tools & Equipment for Communication," and "Distribution & Transportation Artifacts." Objects, other than tools, that are concerned with communication are divided into things that communicate directly (Category 8, "Communication Artifacts") and things that communicate indirectly by providing rules and structures (Category 9, "Recreational Artifacts"). Each of these major categories is further filtered to create the classifications.

For some categories, the division into classifications is made easily into sensible groups. "Structures" are divided into whole structures and components of structures. The former is divided into "Buildings" and "Other Structures"; the latter into "Building Components" and "Site Features." All structures and their components fit into one of the four classifications. Not all major categories can be divided so easily, though. "Tools & Equipment for Materials," for instance, is further divided to accommodate kinds of materials—wood, metal, and glass, for example. "Tools & Equipment for Science & Technology" is further divided into a number of technologies—armament, medicine, and maintenance, among others. These divisions create such classifications as "Woodworking T&E," "Metalworking T&E," "Medical & Psychological T&E," and "Maintenance T&E." But not all materials are listed in "Tools & Equipment for Materials" (though the major ones are included), and certainly classifications for all technologies could never be included in "Tools & Equipment for Science & Technology" (though many major ones are listed). In order to include all members of a population in the filtering process from one level to the next, "Other T&E for Materials" and "Other T&E for Science & Technology," for instance, have been introduced as classifications. These classifications can be subdivided to include minor groupings such as "Wigmaking T&E" or "Cigar Making T&E." Within the classifications, object terms are listed.

Modifying Nomenclature

In some respects, *Nomenclature* is designed as an open-ended system. Object terms may be added to the system, and those major categories that require flexibility have been given classifications for "other" divisions. In most respects, however, *Nomenclature* is intended as a firmly structured system. The reason for this structure is to allow collections indexed

with *Nomenclature* to be readily compared or even to be joined in common data bases. This communication demands that institutions use similar object terms and similar structures for relating object terms.

The List of Terms

The structure of *Nomenclature* is modeled on scientific naming systems like the Linnaean system for naming plants and animals. For a number of reasons, *Nomenclature* does not work as smoothly as scientific naming systems. It uses familiar names for its preferred object terms, the things it classifies lack the family relationships that plants and animals have, and it is often difficult to distinguish the generic object terms that should be included (such as LATHE, FOOT) from the more specific, varietal object names that should not (such as "reciprocating foot lathe").

When Linnaeus devised his system for naming plants and animals, he had a tremendous advantage over those who developed *Nomenclature*—Latin. Because *Nomenclature* was developed using what botanists would call "common names" for things, users of *Nomenclature* have spent a great deal of time debating the appropriateness of preferred object terms. Of course, botanists debate the appropriateness of their classification system, but by agreeing upon the term *Gaultheria procumbens*, they can avoid such issues as whether to call "wintergreen," "teaberry" or to call "teaberry," "wintergreen." Because *Nomenclature* uses "common names" in its list of object terms and because the preferred terms have been chosen by the inexact methods of democracy, not all catalogers agree about the appropriateness of some terms.

Using Latin gave Linnaeus another great advantage that users of *Nomenclature* do not have—each individual in a family can have a simple, two-part name that reflects its position in the hierarchy—the genus followed by the species. Since modifiers follow nouns in Latin, the terms are delightfully similar and sortable. All of the kinds of evergreen shrubs of which wintergreen is just one example begin with the word *Gaultheria*. Common names are difficult to work with structurally. "Fretsaw," "Ripsaw," "Sawmill," "Miter-box Saw," and "Hand Saw" are all artifacts that should appear together in a list of similar things. Creating rules to make them appear together in an alphabetical list, however, is a difficult task. Another advantage to Linnaeus's naming system was that varieties could be indicated within the system simply by adding an additional word to the standard binomial term. *Rhododendron cinnabarinum*

var. blandfordiaeflorum and *Rhododendron cinnabarinum var. roylei* are linked to their binomial form by including it in a three-part name. Named hybrids such as "Royal Flush" and "Youthful Sin" still have to be linked to *Rhododendron cinnabarinum*, but even so, these variations can be clearly identified as such because their names include the standard binomial term. For objects, differentiating varieties is difficult. Some might define a "framed veneer saw" as a variety of "veneer saw," and some might differentiate between the two. Common names are only partial clues to identifying varieties. The problems that Linnaeus avoided by using binomial terms are problems with which users of *Nomenclature* have had to deal.

Nevertheless, treating common names as binomial terms by inverting their normal order in English and generally limiting those common names to a single noun and a single adjective have given *Nomenclature* some of the advantages that hierarchies for the natural sciences have. At least, the inversion of two-part common names to produce acceptable object terms has been an ideal to strive for.

Trying to use binomial terms for objects may be an ideal, but many things, such as PANTS or KEY, do not have binomial common names. Many things—especially tools—are hyphenated, such as LOOM, WATER-JET or CHART, VISUAL-ACUITY, so they are trinomial in a sense. Terms such as MITTEN, TARGET SHOOTER'S or FINDER, RADIO RANGE need to be expressed with three words in order to convey accurately a binomial idea. Inversion has its drawbacks also. In normal discourse, we would say "blacksmith's shovel" or "butter cutter," but in *Nomenclature* these are listed as SHOVEL, BLACKSMITH'S and CUTTER, BUTTER in order to place all shovels and all cutters together in the alphabetical list of object terms. For objects that are used in only one classification, this inversion is useful. All of the chairs show up together in the classification "Furniture" under CHAIR, — . For objects such as hooks, the inversion to HOOK, —- does not succeed in putting similar things together. Nor does inversion work for words created from an adjective and a noun such as HAYFORK or DRAWKNIFE.

Nomenclature is intended to provide index terms, not names for all objects. In the first edition of *Nomenclature*, some varietal terms were admitted. "Dredge boat, Chesapeake Bay" and "Seine boat, shad" were listed as approved terms. In the present edition, such specific varieties have been eliminated. Even for very specialized collections, the terms BOAT, DREDGE and BOAT, SEINE will be sufficiently specific for cataloging purposes. For the most part, trinomial terms have been omitted, and those

binomial terms that seemed only to indicate varieties of otherwise identified objects have been eliminated as well. Like naming systems for the natural sciences, _Nomenclature_ terms are generic, not specific.

The following conventions for object terms are used in this edition of _Nomenclature_:

1. A distinction is made between object _names_ and object _terms_. Object _names_ include all of the common names that things are called. Object _terms_ are the preferred words or phrases used by _Nomenclature_ to identify and link similar or identical objects no matter what their object names may be. The object _term_ PLANE, ROUGHING refers to objects _named_ "cow plane," "hunter plane," "scrub plane," "scuffing plane," "scurging plane," and "roughing plane." To preserve the richness of local use or tradition that is carried in an object's name, however, the name should be recorded as a part of the catalog information about an object along with its object term from _Nomenclature_. The user should remember that the terms in _Nomenclature_ are drawn from the names we give things, so many objects' terms and names will be the same.

Every effort has been made to choose the object term that reflects the most general acceptance. Nevertheless, the object terms that have been agreed upon for use in _Nomenclature_ may not be the ones that individuals prefer or find the most familiar. Recording names separately from object terms will allow an institution to retain local or common names for things and still have the benefit of an object term to use for indexing purposes.

2. Object terms with few exceptions are listed in their inverted forms with a single noun followed by a comma followed by a modifier.

3. Wherever possible, object terms have been presented in binomial forms—one noun modified by one adjective or by a single phrase. The attempt has been to exclude varieties from the list of object terms and to avoid the addition of a large number of superfluous terms. For most indexing purposes, binomial terms will succeed in bringing a small enough group of object records to the attention of a researcher to enable him or her to locate specific items.

The Structure of This Book

Chapter II provides an overview of how to use _Nomenclature_. It includes rules for using the system and provides explanations that will prove useful to

catalogers. Chapter III gives definitions for determining what the contents of each category and classification should be. It also includes bibliographic sources that will be useful for catalogers trying to identify objects.

The most used parts of the book are the lists of terms and their classifications, in Chapters IV and V. The first complete list is arranged hierarchically; the second, alphabetically. The object terms, the related terms, and the non-preferred terms are identical in both lists. Pages in Chapters IV and V are numbered separately, each chapter beginning with page 1. The numbers in the body of the alphabetical listing of preferred terms refer to the pages in Chapter IV, the hierarchical listing.

Nomenclature's Revision

The people who originally developed _Nomenclature_ anticipated that, as institutions worked with it, suggestions for improvements would be made by the users themselves. Since _Nomenclature_ was first published in 1978, many people have expressed ideas about it. Some encouraged sweeping changes in the system. Some pointed out inconsistencies or errors in the system. Some offered suggestions to make _Nomenclature_ easier to use. Some simply sought clarification. Many have offered additional object terms. The present edition responds to as many of the suggestions about the _Nomenclature_ system as possible without losing sight of the fact that it is a system that American and Canadian museums have used for some time and that any changes in a "standard" should be made with great deliberation. While many holders of collections of material culture are beginning to look towards computerization, most users of _Nomenclature_ rely on manual systems. Looking towards sharing information is appealing, but most museums would be content to establish functional collection management systems for themselves. All who have commented have agreed that _Nomenclature_ must be easily used by any cataloger using any kind of registration system, and it should be accessible to the researcher or the occasional user.

1. Throughout this book, accepted _Nomenclature_ terms are written in UPPERCASE letters to distinguish them from synonyms and common names for objects. Furthermore, the phrase "object term" is used to describe the accepted terms used in _Nomenclature_ as opposed to "object name," which is used to describe the everyday names that things are called.

CHAPTER II
USING NOMENCLATURE

Of the many kinds of data that might be recorded about an object, the *Nomenclature* system is concerned with only two: a formal, generic object term and a general classification for that object based on its use. These two attributes offer the most information with the least ambiguity for purposes of collection management. Of course, museums will record information about objects besides the object term and classification. Material, style, quantity, period, maker, and such additional modifiers as "part" or "set" are commonly recorded about objects. For history museums, however, such information is of secondary importance for collection management just as flower color, date of bloom, or fragrance are of secondary importance for plant taxonomy. Of course, for the gardener or the historian, color, date, use, provenance, and so on are the most interesting data fields. For purposes of collection management, however, identifying an object as a SPOON from the classification "Food Service T&E" is more important than knowing that it is part of a set, that it is made of silver, that it dates from the eighteenth century, or that it was used by Thomas Jefferson. The secondary data that gardeners and historians are interested in depends on primary data such as object term and classification.

Even within the narrow confines of object term and classification, *Nomenclature* does not attempt to make complex distinctions between individual objects or even between particular varieties of objects. A collection that has significant individual objects that need precise identifiers beyond a generic term will have to include appropriate fields to record such information. The object term PAINTING is not sufficient to distinguish an Edward Hicks *Peaceable Kingdom* from a Norman Rockwell *Arbor Day*, nor is PLANE, BLOCK adequate to distinguish a Stanley adjustable throat block plane from a Tru-Value utility plane. Data fields that carry information about individual objects such as title, artist,

maker, or medium will provide such distinctions. Similarly, the object term SHORTS is not sufficient to distinguish varieties of shorts. Bermuda shorts, hot pants, and gym shorts are all described by that generic term. Data fields carrying information that identifies varieties such as style, use, or the familiar object name will provide those distinctions. In spite of such limitations, *Nomenclature* is a valuable tool for making general distinctions about general collections—the kind of collections that most history museums have. Prescribed object terms will lead to less easily defined varietal distinctions and even to individual objects.

The effective use of *Nomenclature* depends on thoughtful and consistent use of the system. In the sections that follow, the kinds of data that *Nomenclature* does capture are described along with the rules and conventions that were used to prepare this edition. These are offered to clarify the ways that difficult terms should be handled, the ways that terms may be added to the list, and the general workings of the system.

Object Terms

The object terms assigned to artifacts in *Nomenclature* are based on *original intended function*. An object may be used in a variety of ways, so identifying it with a generic term determined by original intended function will create the least ambiguity for cataloging. A can opener may be used to pry open storm windows, to remove staples, to scrape gunk off of things, or to tighten screws. The convention of assigning object terms according to original intended function, however, requires it to be cataloged as an OPENER, CAN, not as a "pry," "staple remover," "scraper," or "screwdriver." For the sake of consistency, and because occasional use cannot always be inferred about objects, cataloging by origi-

nal function provides a reliable standard to record or retrieve collection data.

Information that is normally carried in secondary data fields such as material, style, period, quantity, and maker is not used in creating object terms. "Chippendale mirror," "Empire sofa," "American pattern ax," "oil painting," "silver spoon," "three drill bits," "miniature hammer," "Stanley plane," and "Barbie doll" are not acceptable object terms. Object terms are generic identifiers that indicate an artifact's original function without reference to secondary data. MIRROR; SOFA; AX, FELLING; PAINTING; TEASPOON; BIT, TWIST; HAMMER; PLANE, MOLDING; and DOLL are object terms. In a subject index, these generic terms enable the researcher to draw finer comparisons by establishing a generic population. All teaspoons, silver and otherwise, share the object term TEASPOON. From that population, secondary comparisons can be made easily: all silver teaspoons can be compared, all Tiffany teaspoons, or all early eighteenth-century teaspoons.

The confusion arising out of the quite natural desire to use words that will distinguish individuals or varieties from generic types is in large measure alleviated by carefully distinguishing object *terms* from object *names*. If the most important thing about a teaspoon is that it is the "Jefferson spoon," and if that is what a museum has always called it, "Jefferson spoon" can be entered as the object's *name*. Nevertheless, TEASPOON will be its object *term*— the accepted generic term used for indexing or comparison. The tendency to add new terms to *Nomenclature* so that everything in the collection has an approved term should be avoided. Part of the value of having an indexing system is that it will bring similar, but not necessarily identical, things together.

Classifications

Besides being brought together by virtue of sharing object terms, collection pieces are related in the classifications of the *Nomenclature* hierarchy. That hierarchy is intended to divide all man-made objects into logically similar groups. For the purposes of indexing and collection management, the classifications are most important after the object terms. Some classifications—"Games," for example— conform very closely to the words we might usually use to distinguish groups of similar things. Some of the classifications, however, do not. "Woodworking T&E," for instance, includes those tools used for marquetry, joinery, coopering, carpentry, barn-framing, coffin-making, wheelwrighting, and chair-making.

Just as an object's name is a valuable piece of information to be recorded apart from the object term, maintaining a data field for recording the particular activity in which the object was used is a valuable supplement to the hierarchical *Nomenclature* classification.

Because *Nomenclature* deals with man-made objects—objects that are created for particular purposes—and because part of what defines human creativity is our ability to adapt and borrow and solve problems with objects, artifacts are not as easily categorized as natural science specimens. The Latin term given to describe genus and species in natural science taxonomies is literally bound to a hierarchy. With *Nomenclature* there is no such formal arrangement. Object terms are associated with particular classifications because the objects are normally used for the activities that fall within that classification. SAW, CHAIN is an object that is usually used for woodcutting, so it is associated with "Forestry T&E." A chain saw might be used, however, by a sculptor or by a barn-framer, activities associated with "Woodworking T&E." Generally object terms are assigned to classifications in such a way as to reflect common usage. Some object terms may appear in more than one classification, however, especially common terms such as FORK or HOOK. Institutions have followed a number of strategies for dealing with the ambiguities that arise because of the placement of particular terms in particular classifications. Three major variations can be described:

1. Some institutions always record the classification that is associated with an object term in the published word list despite how the object was used. Even though a potter might have used a rolling pin to roll out clay, that rolling pin will be cataloged as "Food Preparation T&E." Of course, the institution may choose to add the term PIN, ROLLING to "Glass, Plastics, Clayworking T&E" by formally recording the addition.

2. Some institutions always record the classification that is associated with an object term in the published word list despite how the object was used, but they also use a data field to record or "trace" actual use. In the example above, PIN, ROLLING would be cataloged as "Food Preparation T&E," but if it was used by a ceramist for clay, "Glass, Plastics, Clayworking T&E" would be listed as a tracer. These tracers can be used to identify all artifacts in a collection associated with "Glass, Plastics, Clayworking T&E."

3. Some institutions allow the association of any accepted object term with any accepted classification. In the above example, PIN, ROLLING, an acceptable object term, would be classified as "Glass, Plastics, Clayworking T&E," an acceptable classification. No formal notation of the linkage of term and classification is required.

Each of these methods has its advantages and disadvantages, and each has the authority of the rules offered in the first edition of *Nomenclature*. The first method is preferred in the first edition, but tracer fields are suggested as a way of handling difficult object terms or usage. The third is mentioned, and it is the method suggested for cataloging toys: an acceptable object term is linked with the classification "Toy" to indicate that the object is a toy rather than an entirely functional item. A HIGHCHAIR classified as "Furniture" would indicate a full-sized chair; classified as "Toy," it would indicate a miniature.

Whichever method of relating object terms to classifications an institution chooses, it is important to use the method consistently and to be sure that *Nomenclature* facilitates information retrieval from the recordkeeping system. Assigning one person the task of recording and disseminating information about new terms and determining which of the conventions noted here are to be followed is a wise course of action for an institution.

Users of *Nomenclature* will encounter some difficulties. Despite continuing efforts to add to the list, not all objects have object terms. Some objects are placed ambiguously in the system. Some objects in museum collections are parts of things or sets of things. Some things are difficult to classify without referring to their varietal names. Some things have been modified from their original purposes. All of these problems need to be addressed in a consistent fashion. The following suggestions and options will be helpful.

Adding Object Terms to Nomenclature

The most important thing to remember about the word list is that it contains generic object terms used for indexing purposes. It is not a list of synonyms. Object terms should not be added to the word list indiscriminately. The strength of the object terms lies in their ability to facilitate location and relation of information about all similar or functionally related artifacts despite the variety of *names* used to describe those artifacts. The word list provides the single preferred term for an object. This preferred term may

or may not be identical to a locally used name or a locally used term, and it may be spelled differently than it is commonly spelled in all localities. The list of preferred terms is drawn from the experience of those institutions that have submitted them for consideration, and the authority for spelling is *Webster's Third International Dictionary*. Information about locally preferred names for objects should be noted as a part of the cataloging process in a separate data field, but for the purposes of indexing, the preferred object term should be used. Synonyms and alternate spellings are not included in the word list except as notes.

The lexicon is intended as a tool for identifying and associating functionally related objects. It is not an authority for all names of things. As a rule, object terms are binomial; a single noun is modified by a single modifier. This rule allows the same object term to refer to objects with fundamental similarities, just as genus and species do, without attempting to provide more specific terms to distinguish less fundamental variations. There are many variants that might be offered for the term AX, FELLING: "Maine pattern felling ax," "long-bitted felling ax," "English felling ax," "wedge-type felling ax," and so on. Adding each of these varietal terms to the lexicon would inhibit the system's ability to relate like objects by using generic terms. A binomial term is usually specific enough to lead the researcher to a limited number of related objects. *There is no merit in adding more complex terms just so there will be a preferred object term for everything in a collection.*

When terms are added to the list, they should employ the same conventions as the other terms. They should specify a useful generic distinction, and they should be limited to binomial forms—a single noun modified by a single adjective. Secondary data such as material, size, quantity, maker, style, and period should not be used in creating new object terms. Added terms should be entered in both the alphabetical and the hierarchical lists.

Adding Classifications to Nomenclature

The classification system should not need modification. The classifications and categories are intended to provide a logical place to categorize all man-made artifacts. Except for adding useful subclassifications, such as "Wigmaking T&E" to the "Other" classifications associated with the "Tools & Equipment" categories, no new classifications should be needed. Museums with significant natural history collections will use the standard taxonomies appropriate to those collections in parallel with

Nomenclature. Collections with small numbers of such specimens may want to devise a simple "animal, vegetable, mineral" distinction that can be used in conjunction with *Nomenclature*.

Recording Object Terms and Classifications

When an artifact is cataloged, its object term and classification should be recorded. All objects in a collection should be given object terms, just as all objects should be given accession numbers. For most objects, locating the correct term in either the alphabetical index or the hierarchical listing will be easy. For some, however, trying to establish the proper term can be difficult. If an object term cannot be identified for a particular artifact, several things can be done short of adding a new term to the list.

Objects difficult to identify. One problem that catalogers face in working with historical collections is that not all objects can be properly identified. A number of options are available for recording the information that is known about such objects. By combining unmodified nouns, the term "PROBLEMATIC," the classification names, and the classification "Function Unknown," any unidentified object can be recorded in the *Nomenclature* system.

For an unidentified kind of hammer used for metalworking, use:

 HAMMER and "Metalworking T&E"

For an unidentified kind of hammer that cannot be associated with a particular activity, use:

 HAMMER and "Function Unknown"

For an unidentified tool used for metalworking, use:

 PROBLEMATIC and "Metalworking T&E"

For an unidentified tool that cannot be associated with a particular activity, use:

 PROBLEMATIC and "Function Unknown"

Following these conventions allows similar things to be listed together in meaningful ways until further research can be done and an appropriate term found.

Objects difficult to classify. Some objects cannot be easily linked to a single classification in the categorical division of the lexicon because they were made to serve many general purposes. Swiss army knives and fence mending tools, for example, have multiple purposes. Some objects cannot be readily classified because they were intended to serve dual functions: thermometers advertising soft drinks and clothing—such as a blacksmith's apron—worn during the performance of particular work have such duality. Objects that were intended to be used for one purpose but that were used for another can also be confusing. Cowboy boots made into lamps fall into this category. There are a variety of ways to deal with these problems, but institutions should attempt to address these situations in a consistent fashion.

One way museums have handled such ambiguous cases has been to note in the cataloging records a data field to trace additional information. The primary classification for the blacksmith's apron would be "Clothing"; its trace field would be "Metalworking T&E."

When it is impractical to add a second data field in a catalog system, the principal objective should be to list the object in such a way that it can be found later by others. Where there is a clear choice, an object should be listed according to the primary purpose for which it was originally created. A Swiss army knife is primarily a pocket knife ("Personal Gear"), not a fish scaler ("Fishing & Trapping T&E"), tweezers ("Medical & Psychological T&E"), or a toothpick ("Toilet Article"). Therefore it would be classified as "Personal Gear." The soft drink thermometer may be primarily an advertisement, not a meteorological tool, so it would be classified as "Advertising Medium." If that thermometer were primarily a meteorological tool it would be classified as "Meteorological T&E." Each institution should devise a rule governing primary function and follow it consistently.

Objects that have been intentionally transformed from serving one function to another should be classified according to their most recent function. A pair of cowboy boots made into a lamp should be given the object term LAMP, ELECTRIC and classified as "Lighting Device." Again, institutions that have a data field for tracing other information might want to note BOOT or "Clothing—Footwear" for purposes of cross referencing.

Additional Modifiers—Parts and Sets

There are several situations that arise in museum cataloging that compromise the aim of *Nomenclature* to provide a relatively concise list of object terms. Object parts, containers, and models, if given unique object terms, would substantially increase the length of the list of terms. More importantly, since the purpose of *Nomenclature* is to facilitate indexing, terms added to describe parts of objects or containers for things are apt to confuse alphabetical ordering and

to separate objects that should be listed together. The following paragraphs outline concerns that museums have raised about such situations, and three alternate ways of handling them are suggested at the end of this section.

Parts, accessories, and fragments. Some objects are normally collected as parts—most of the things listed in "Building Components," the "Accessory" classifications of the "Transportation & Distribution" category, and some individual objects such as lamp shades. These are given object terms in the word list. Some objects such as sherds and remnants are collected as fragments. These are given object terms in the word list. Accessories such as those accompanying vacuum cleaners or sewing machines are not normally listed as separate objects in *Nomenclature*, nor are most parts and fragments. The value of object terms is their ability to facilitate indexing. On this account, the fact that a museum specimen is just a part or fragment of something else should not affect the object term. Just as the leaf or branch or flower of a *Rhododendron cinnabarinum* is referred to without special notice that it is a part of the plant, so a hammer handle or a pot fragment or the upholstery accessory for a vacuum cleaner should be indexed using the object term that refers to the whole.

Sets, pairs, and assemblages. Some objects are generally only available in sets—SET, BLEEDING and KIT, TOILET are examples. Other objects are really assemblages of various things to perform a particular task. A GRINDER, TOOL may be an assemblage of a power source, an arbor, a grindstone, a buffing wheel, or a metal frame. Generally, the term "set" should be avoided as a part of an object term. Instead, the individual objects in the set should be separately cataloged. Generally, the component parts of assemblages are not separately recorded with particular object terms. Instead, they are cataloged with the object term that identifies the whole. Nevertheless, it is useful to note in cataloging that something is part of a set or that it is an assemblage.

Cases and product packages. Some kinds of objects are apt to increase the number of object terms significantly. Since almost anything can have a case or a specialized product package, terms like CASE and BOX and BOTTLE are apt to have many modifiers. Indeed, many modifiers are offered along with those terms listed in the word list as accepted terms.

CASE, VIOLIN; CASE, BINOCULARS; BOX, SPICE; and JAR, CONFECTIONARY have all been listed as object terms. Clearly, "case, magnifying glass," "box, detergent," "box, powdered bleach," and "jar, olive" might also be put forward as possible additions to the word list. Some institutions have chosen to avoid such proliferation by establishing ways to relate these kinds of artifacts to their modifiers (the thing encased rather than the case itself) or to allow the addition of modifiers without the necessity of adding each new term to the word list. Associating CASE with SAXOPHONE may be more helpful than adding a new kind of case to the word list. Acknowledging that JAR can be modified by a wide range of modifiers that describe what is in the jar, so that all such modifiers are ignored for the purposes of indexing or establishing authorities, simplifies dealing with product packages. Some institutions have limited the use of terms that describe product packages to generic descriptors that can be further modified in additional data fields (for example, JAR, FOOD-STORAGE could be elsewhere noted as being used for olives).

Patterns and molds. Since many objects are produced with patterns or molds, some institutions have chosen to avoid the proliferation of terms that might be the result of trying to distinguish a handle mold from a spout mold from a lid mold used for making ceramics by treating the part that is made with the mold as an addditional modifier. These molds would all be given the more general object term MOLD, PIECE.

Models and samples. Virtually any object can be produced as a model, and many materials can be collected as samples. These need to be associated with their proper object terms and classifications, but they should be distinguished from whole items.

All of these situations—parts, sets, cases, models, and so on—present a common problem. A particular object that has a quite legitimate object name needs to be related to another object term. Each is similar because it involves the use of an additional modifier such as "part" or "set" or "model." Museums have employed a number of strategies for dealing with these problems. Three are presented here.

1. Additional modifiers can be dealt with by simply adding them to the end of an acceptable object term. This was the method that was generally advocated in the first edition of *Nomenclature*.

2. Additional modifiers can be separated from object terms with a punctuation mark.

3. Additional modifiers can be added as new data fields.

Entries using each of these methods would be cataloged as shown in the chart below.

Toys

Toys are very often simply small or representational versions of things normally used in human activity. They should be given object terms that identify them correctly, but they should be classified as "Toy" rather than as whatever classification the object term is usually associated with.

> For a child's highchair, use: HIGHCHAIR and "Furniture"
> For a toy highchair, use: HIGHCHAIR and "Toy"
> For a chain saw, use: SAW, CHAIN and "Forestry T&E"
> For a toy chain saw, use: SAW, CHAIN and "Toy"

Souvenirs

Almost anything can be created or collected as a souvenir. For the purposes of cataloging, those things that were _created_ to serve as souvenirs or mementos should be given an appropriate object name, but they should be classified as "Documentary Artifacts" because their purpose was primarily to record an event. Those objects that were _collected_ as mementos, but were not originally created to be mementos, should be given terms and classifications that reflect their original purpose.

For a towel produced as a souvenir of the bicentennial, use:
> TOWEL and "Documentary Artifact"

For a towel used in the White House and taken as a souvenir, use:
> TOWEL and "Toilet Article"

Supplies

Supplies and consumables collected by museums should be given object terms and associated with the classification with which they are used. Cleaning powder should be classified as "Maintenance T&E," ceramic glaze as "Glass, Plastics, Clayworking T&E," flax as "Textileworking T&E," and dried apples as "Food Processing T&E."

Upper and Lower Case

Preferred terms for objects are given in the lexicon in uppercase letters, TONGS, LAUNDRY or

Method 1 Object term with a space	_Method 2_ Object term with punctuation	_Method 3_ Object term with additional data field
LAMP BASE	LAMP-BASE	LAMP [Part-Base]
MILL, FOOD LID	MILL, FOOD-LID	MILL, FOOD [Part-Lid]
KNIFE FRAGMENT	KNIFE-FRAGMENT	KNIFE [Fragment]
SAW, HAND FRAGMENT	SAW, HAND-FRAGMENT	SAW, HAND [Fragment]
CLEANER, VACUUM NOZZLE	CLEANER, VACUUM-NOZZLE	CLEANER, VACUUM [Acces. - Nozzle]
GLOVE PAIR	GLOVE-PAIR	GLOVE [Pair]
COMB	COMB	COMB [From a set]
MILL, CIDER	MILL, CIDER	MILL, CIDER [Assemblage]
SAXOPHONE CASE	SAXOPHONE-CASE	SAXOPHONE [Case]
VIOLIN	VIOLIN	VIOLIN [With case]
GAUGE, DEPTH CASE	GAUGE, DEPTH-CASE	GAUGE, DEPTH [Case]
BELL MODEL	BELL-MODEL	BELL [Model]
PAD, CARPET SAMPLE	PAD, CARPET-SAMPLE	PAD, CARPET [Sample]
CAN OLIVE OIL	CAN-OLIVE OIL	CAN [Olive Oil]
JAR, FOODSTUFF OLIVE	JAR, FOODSTUFF-OLIVE	JAR, FOODSTUFF [Olive]
MOLD, PIECE SPOUT	MOLD, PIECE-SPOUT	MOLD PIECE [Spout]

For the last three examples above, the object terms "CAN, OLIVE OIL" "JAR, OLIVE" and "MOLD, SPOUT" may be added to the list instead of using one of the three methods suggested.

MACHINE, BORING. When non-preferred words are listed in the lexicon, they are given in upper and lower case letters, and they are always accompanied by reference to the preferred terms, such as "Cabin *use* HOUSE." Non-preferred terms are listed for situations where there might be ambiguity, where common errors of word sequence or spelling occur, or wherever catalogers are likely to need assistance. Examples of non-preferred terms include:

Sprayer, Knapsack *use* SPRAYER, HAND
Spoon, Tea *use* TEASPOON
Handgun *use* more specific term, e.g. PISTOL, REVOLVER

Singular, Plural, and Collective Terms

Plural forms of object terms are not used for cataloging. Object terms are normally given in the lexicon in singular form. Exceptions to this rule are made for object terms that do not sensibly occur in singular form, such as TONGS, PLIERS, SCISSORS, and TWEEZERS. Terms for objects that occur in pairs are entered in their singular form, such as SHOE or GLOVE, whether a pair is referred to or not.

Word Sequence

Object terms in *Nomenclature* are entered in their inverted forms. The noun of an object term is placed first, followed by a comma, followed by a modifying word or phrase. The few exceptions to this rule are for such object terms as CHEST OF DRAWERS, NIDDY NODDY, and CAMERA OBSCURA, which would make no sense if inverted.

Abbreviations and Conventions

Two abbreviations are used to shorten classification names:

T&E for "Tools and Equipment"
LTE for "Land Transportation Equipment"

Three conventions are followed to provide additional information in the word list:

note indicates particular usage or explains how a term is to be subdivided and further modified. Examples of *notes* include:

SET, LUNCHEON *note* use for a matching set of place mats, coasters, centerpiece, etc., or for a relatively small tablecloth and matching napkins.

PLANTER, WALKING *note* use for an animal-drawn planter behind which the operator walks.

rt is used to indicate a related term. Related terms identify similar, but not quite identical, objects, or they refer to objects that might be confused with one another. Both object terms identified as being related are preferred object terms. Examples of *related term* entries include:

PLANE, GUTTERING *rt* ADZ, GUTTERING
SETTEE *rt* SOFA

use is used along with a non-preferred term to indicate what the preferred term should be. Examples of *use* entries include:

Bateau, V-bottomed *use* SKIPJACK
Chair, Deck *use* CHAIR, FOLDING

Nomenclature is intended to facilitate communication about historical collections. Individual institutions will develop methods to make the system work better for them, and in time, groups of institutions sharing information will develop standards for exchanging information about data fields outside the scope of *Nomenclature*—to describe styles, periods, materials, and other, more detailed information. The conventions suggested in this chapter are intended to make recording, recovering, and sharing collection data easier and more consistent. Institutions will add to these conventions depending on their record-keeping systems and their needs. Bearing in mind that *Nomenclature* provides only the most general information about collections—object terms and classifications—should help the user. The system, like any generic system, necessarily overlooks the texture of the world reflected by objects and the language we use to describe them. *Nomenclature* should be used as a tool to get back to or on to that texture. It should never be seen as a replacement or as a hindrance to those things that lead history museums to collect objects in the first place.

CHAPTER III
NOMENCLATURE CLASSIFICATIONS DEFINED

The definitions on the following pages indicate the scope of the categories and classifications used for *Nomenclature*. They will be a useful guide to those who are adding terms to the word list. The original edition of *Nomenclature* included a list of references. This edition has added substantially to the bibliographical support of the object terms. Each classification includes a list of books that are particularly useful due to their descriptive and pictorial glossaries. These glossaries may not use the *Nomenclature* terms; indeed, some may provide good bases for arguing that particular object terms should be changed or dropped. Nevertheless, judicious use of the bibliographic materials should help to identify many of the terms in the lexicon and many things in collections.

There are a few general works that are valuable resources:

Webster's Third New International Dictionary of the English Language, Unabridged. *Webster's* is the authority for all spellings in *Nomenclature*. It is valuable for its many descriptions of items noted in the lexicon and its illustrations.

Encyclopaedia Britannica. A valuable resource, no matter what edition is available.

Sears Roebuck Catalogs, Montgomery Ward Catalogs, and other general catalogs can be used in original editions, reprinted editions, and modern editions.

Knight's American Mechanical Dictionary, Appleton's Cyclopaedia of Applied Mechanics, and other technological encyclopedias. Valuable sources for early power tools as well as many specialized nineteenth-century American tools and machines.

Category 1: Structures

Definition: Artifacts originally created to define space for human activities or to be used as components of space defining artifacts.

Building

Definition: An artifact originally created primarily to provide or define a space with a controllable climate—usually through enclosure—for human activities. This classification may include permanent structures, such as garages or office buildings, or portable structures, such as tents. This classification includes most man-made structures. Houses, barns, warehouses, train stations, and jails are all primarily intended to provide spaces that can be kept warm or cool and dry. Architectural samples integral to buildings, such as wall sections or roof sections, should be cataloged in this classification as parts of buildings. Separable, distinct, and interchangeable components, such as doorknobs or window sashes, should be classified as "Building Components."

Blumenson, John J.G. *Identifying American Architecture: A Pictorial Guide to Styles and Terms, 1600-1945.* Nashville: American Association for State and Local History, 1977.

Fleming, John; Honour, Hugh; and Pevsner, Nikolaus. *The Penguin Dictionary of Architecture.* New York: Penguin, 1982.

Harris, John and Lever, Jill. *Illustrated Glossary of Architecture, 850-1830.* London: Faber and Faber, 1966.

Whiffen, Marcus. *American Architecture since 1780: Guide to the Styles.* Cambridge, Mass.: MIT Press, 1969.

Building Component

Definition: An artifact originally created as a separate, distinct, and generally interchangeable structural or decorative part of a building (though such artifacts—hinges, for example—can be used on artifacts besides buildings such as gates or tables). Though building components are distinct objects, they function as parts of larger structures rather than independent units. This classification includes such

things as mantels and window frames. Excluded from this classification are parts of buildings or other structures that lack distinctiveness or interchangeability, such as roofs, chimneys, or joists. Also excluded from this classification are parts of buildings that are not integral parts of the structure, such as furnishings, lighting devices, and plumbing fixtures, all of which are listed in the Furnishings category.

Alth, Max. *All About Locks and Locksmithing*. New York: Hawthorne Books, 1972.

Binstead, Harry E. *The Fully Illustrated Book of Decorative Details from Major Architectural Styles*. 1894. Reprint. Alberquerque, N.M.: The Foundation for Classical Reprints, 1984.

Condit, Carl W. *American Building: Materials and Techniques from the First Colonial Settlements to the Present*. Chicago: University of Chicago Press, 1982.

D'Allemagne, Henry Rene. *Decorative Antique Ironwork: A Pictorial Treasury*. New York: Dover Publications, 1968.

Moss, Roger. *Century of Color: Exterior Decoration for American Buildings, 1820-1920*. Watkins Glen, N.Y.: American Life Foundation, 1981.

Parker, John H. *A Concise Glossary of Terms Used in Grecian, Roman, Italian and Gothic Architecture*. 1896. Reprint. Dover, N.H.: Longwood Publishing Group, 1980.

Pegler, Martin. *The Dictionary of Interior Design*. Rev. ed. New York: Fairchild, 1983.

Russel and Erwin Manufacturing Co. *Illustrated Catalogue of American Hardware of the Russel and Erwin Manufacturing Co.* 1869. Reprint. Ottawa: Association of Preservation Technology, 1980.

Stein, J. Stewart. *Construction Glossary: An Encyclopedic Reference Manual*. New York: Wiley, 1980.

Site Feature

Definition: An artifact originally created as a distinct element that is associated with a site, a building, or other structure. Rather than functioning simply as a part of a larger structure, a site feature is an independent entity that complements other structures. This classificaton includes such things as birdbaths, flagpoles, gates, and fences.

Favretti, Rudy J., and Favretti, Joy Putman. *Landscapes and Gardens for Historic Buildings: A Handbook for Reproducing and Creating Authentic Landscape Settings*. Nashville: American Association for State and Local History, 1978.

Sloane, Eric. *Our Vanishing Landscape*. New York: Ballantine Books, 1974.

Other Structure

Definition: An artifact originally created primarily to modify the environment or landscape or to define a space for some reason besides climate control. This classification includes dams, mines, and bridges. Structures such as sports complexes that are primarily intended to provide controlled access and convenient seating should be placed in this classification. Some other structures may have climate controlled spaces, such as the space under a dome in a stadium or the generating room of a hydroelectric dam, but these spaces serve a secondary role to the function of the structures.

Halsted, Byron David, ed. *Barns, Sheds, and Outbuildings*. 1881. Reprint. Brattleboro, Vt.: Stephen Greene Press, 1977.

Maddex, Diane, ed. *Built in the U.S.A.: American Buildings from Airports to Zoos*. Washington, D.C.: Preservation Press, 1985.

Pevsner, Nikolaus. *A History of Building Types*. Princeton, N.J.: Princeton University Press, 1979.

Sloane, Eric. *An Age of Barns*. New York: Ballantine (Published by arrangement with Funk and Wagnalls), 1967.

——— . *American Barns and Covered Bridges*. New York: Funk and Wagnalls, 1954.

——— . *Our Vanishing Landscape*. New York: Ballantine, 1974.

Category 2: Building Furnishings

Definition: Artifacts originally created to facilitate human activity and to provide for physical needs of people generally by offering comfort, convenience, or protection. Clothing is excluded from this classification as it addresses only the needs of a specific individual. Furnishings are not artifacts used as active agents in other processes such as artifacts used as tools or equipment; they passively enable human activity.

Bedding

Definition: An artifact originally created to be used on a bed or in association with sleeping.

Pegler, Martin M. *The Dictionary of Interior Design*. Rev. ed. New York: Fairchild, 1983.

Schwartz, Marvin D. *Chairs, Tables, Sofas and Beds*. New York: Alfred A. Knopf, 1982.

Warren, William L. *Bed Rugs, 1722-1833*. Hartford, Conn.: Wadsworth Atheneum, 1972.

Floor Covering

Definition: An artifact originally created as portable or temporary covering for the floor of a building. This classification includes rugs and carpeting but not permanently attached tile or linoleum, which are included in the "Building Component" classification.

Landreau, Anthony N. *America Underfoot: A History of Floor Coverings from Colonial Times to the Present*. Washington, D.C.: Smithsonian Institution Press, 1976.

Little, Nina Fletcher. *Floor Coverings in New England Before 1850*. Sturbridge, Mass.: Old Sturbridge Village, 1967.

Von Rosenstiel, Helene. *American Rugs and Carpets from the Seventeenth Century to Modern Times*. New York: William Morrow & Co., 1978.

Furniture

Definition: An artifact originally created to answer the physical requirements and comforts of people in their living and work spaces. This classification includes outdoor furniture, desks, tables, beds, and chairs, but it excludes appliances or tools such as washing machines or ladders.

Butler, Joseph T. *Field Guide to American Antique Furniture*. New York: H. Holt, 1986.

Fairbanks, Jonathan L., and Bidwell, Elizabeth. *American Furniture, 1620 to the Present*. New York: Richard Marek Publishers, 1981.

Ketchum, William C. *Chests, Cupboards, Desks and Other Pieces*. The Knopf Collectors' Guides to American Furniture. New York: Alfred A. Knopf, 1982.

Pegler, Martin. *The Dictionary of Interior Design*. Rev. ed. New York: Fairchild, 1983.

Schwartz, Marvin D. *Chairs, Tables, Sofas and Beds*. New York: Alfred A. Knopf, 1982.

Household Accessory

Definition: An artifact originally created to be placed in or around a building for the convenience of people to enhance, complement, or facilitate the maintenance of their environment. This classification includes small furnishings such as soap dishes and spittoons, special household containers such as vases and wastebaskets, and objects that protect furniture such as antimacassars and table covers. The

classification does not include artifacts intended primarily to communicate—they are classified as "Art" in Communication Artifacts—nor does it include devices used in a productive housekeeping activity such as cooking or maintenance.

Art Journal. *Illustrated Catalogue of the International Exhibition, 1862*. London and New York: Virtue & Co., 1863.

Mace (L. H.) & Company. *L. H. Mace & Co., 1883: Woodenware, Meat Safes, Toys, Refrigerators, Children's Carriages, and House Furnishing Goods; Illustrated Catalog and Historical Introduction*. Princeton, N.J.: Pyne Press, 1971.

Montgomery Ward and Co. *Catalogue and Buyers' Guide, No. 57, Spring and Summer, 1895*. Reprint. New York: Dover Publications, 1969.

Pegler, Martin. *The Dictionary of Interior Design*. Rev. ed. New York: Fairchild, 1983.

Lighting Device

Definition: An artifact originally created to provide illumination. This classification includes lighting accessories such as candlesnuffers or wick trimmers; general purpose portable lighting devices such as kerosene lanterns; and specialized fixtures such as streetlamps and theater lighting devices.

Darbee, Herbert C. "A Glossary of Old Lamps and Lighting Devices." American Association for State and Local History Technical Leaflet 30, *History News* 20:8 (August 1965).

Hayward, Arthur H. *Colonial Lighting*. New York: Dover Publications, 1962.

Hough, Walter. *Collection of Heating and Lighting Utensils in the United States National Museum*. Talcottville, Conn.: Rushlight Club, 1981.

Rushlight Club. *Early Lighting: A Pictorial Guide*. Talcottville, Conn.: Rushlight Club, 1979.

Plumbing Fixture

Definition: An artifact originally created to be attached as an integral component to water and sewer lines, often within a building. Portable objects that serve comparable purposes are listed as "Household Accessories." Pipes and pipe fittings are "Building Components," not "Plumbing Fixtures."

Montgomery Ward and Co. *Catalogue and Buyers' Guide, No. 57, Spring and Summer, 1895*. Reprint. New York: Dover Publications, 1969.

Reynolds, Reginald. *Cleanliness and Godliness: or, the*

Further Metamorphosis: A Discussion of the Problems of Sanitation Raised by Sir John Harrington New York: Harcourt, Brace, & Jovanovich, 1976.

Temperature Control Device

Definition: An artifact originally created to enable people to control the temperature of their immediate environment according to their needs. This classification does not include devices to control temperature for purposes other than human comfort, as is the case with bake ovens and kilns, nor does it include relatively permanent structural parts of a building, such as fireplaces or flues.

Kauffman, Henry J. *The American Fireplace: Chimneys, Mantelpieces, Fireplaces & Accessories.* Nashville: Thomas Nelson, Inc., 1972.

Kauffman, Henry J., and Bowers, Quentin H. *Early American Andirons and Other Fireplace Accessories.* Nashville: Thomas Nelson, Inc., 1974.

Montgomery Ward and Co. *Catalogue and Buyers' Guide, No. 57, Spring and Summer, 1895.* New York: Dover Publications, 1969.

Wright, Lawrence. *Home Fires Burning: The History of Domestic Heating and Cooking.* Boston: Routledge & Kegan Paul, 1964.

Window or Door Covering

Definition: An artifact originally created to cover or adorn a window, door, or doorway. This classification does not include relatively permanent structural parts of buildings that are "Building Components," such as doors or window sashes.

Brightman, Anna. *Window Treatments for Historic Houses, 1700-1850.* Washington, D.C.: National Trust for Historic Preservation, 1968.

Montgomery Ward and Co. *Catalogue and Buyers' Guide, No. 57, Spring and Summer, 1895.* New York: Dover Publications, 1969.

Pegler, Martin. *The Dictionary of Interior Design.* Rev. ed. New York: Fairchild, 1983.

Category 3: Personal Artifacts

Definition: Artifacts originally created to serve the personal needs of an individual as clothing, adornment, body protection, or an aid for grooming.

Adornment

Definition: An artifact originally created to be worn on the human body or on clothing for ornamentation rather than for protection or simply as a body covering. Adornment lacks the communicative aspect of objects listed in the "Personal Symbol" classification, and it is more decorative than those listed in the "Personal Gear" classification.

Buck, Anne. *Victorian Costume and Costume Accessories.* 2nd ed. Carleton, Bedford: Ruth Bean, 1984.

Gregorietti, Guido. *Jewelry Through the Ages.* New York: American Heritage, 1969.

Mason, Anita. *An Illustrated Dictionary of Jewelry.* New York: Harper & Row, 1974.

Montgomery Ward and Co. *Catalogue and Buyers' Guide, No. 57, Spring and Summer, 1895.* New York: Dover Publications, 1969.

Scarisbrick, Diana. *Jewelry.* New York: Drama Book Publishers, 1984.

Von Boehn, Max. *Ornaments: Lace, Fans, Gloves, Walking Sticks, Parasols, Jewelry, and Trinkets.* New York: B. Blom, 1970.

Clothing

Definition: An artifact originally created as a covering for the human body. This classification includes underwear, outerwear, headwear, footwear, and also accessories such as belts or cuff links.

Carman, W. Y. *A Dictionary of Military Uniform.* New York: Charles Scribners Sons, 1977.

Fairholt, F. W. *Costume in England: A History of Dress to the End of the 18th Century.* Detroit: Singing Tree Press, 1968.

Gorsline, Douglas W. *What People Wore: A Visual History of Dress from Ancient Times to Twentieth Century America.* New York: Bonanza Books, 1974.

Kohler, Karl. *History of Costume.* New York: Dover Publications, 1963.

Lord & Taylor. *Clothing and Furnishings: . . . 1881, Illustrated Catalog and Historical Introduction.* Princeton, N.J.: Pyne Press, 1971.

Picken, Mary Brooks. *The Fashion Dictionary: Fabric, Sewing, and Apparel as Expressed in the Language of Fashion.* New York: Funk & Wagnalls, 1978.

Ross, David, and Chartaud, R. *Cataloging Military Uniforms.* St. John, New Brunswick: New Brunswick Museum, 1977.

Tarrant, Naomi. *Collecting Costume: Care and Display of Clothes and Accessories.* London: Boston, Allen and Unwin, 1983.

Wilcox, Ruth T. *The Dictionary of Costume.* New York: Macmillan, 1986.

Clothing—Footwear
Definition: Clothing and other protective items that

are worn on the feet for protection or cover.

Swann, June. *Shoes*. New York: Drama Book Publishers, 1982.

Wright, Thomas. *The Romance of the Shoe: Being a History of Shoemaking in All Ages, and Especially in England and Scotland*. Detroit: Singing Tree Press, 1968.

Clothing—Headwear
Definition: Clothing that protects or covers the head.

Clark, Fiona. *Hats*. New York: Drama Book Publishers, 1982.

Wilcox, R. Turner. *The Mode in Hats and Headdress*. New York: Charles Scribners Sons, 1959.

Clothing—Outerwear
Definition: Clothing that is worn on the body over undergarments or as an exterior layer of dress.

Davenport, Millia. *The Book of Costume*. 1948. Reprint. New York: Crown Publishers, 1979.

Dolan, Maryanne. *Vintage Clothing, 1880-1960: Identification and Value Guide*. Florence, Ala.: Books Americana, 1984.

Clothing—Underwear
Definition: Clothing that is worn beneath outerwear to protect or cover the body. Underwear is the layer of clothing that is closest to the skin.

Cunnington, C. Willett, and Cunnington, Phillis. *The History of Underclothes*. London: Boston: Faber and Faber, 1981.

Waugh, Norah. *Corsets and Crinolines*. London: B.T. Batsford, 1987.

Clothing—Accessory
Definition: An artifact created originally to be used in association with clothing, such as a belt or a cuff link. Accessories include artifacts that are worn, such as ascots, as well as those that are used for minor care of clothing, such as shoe polish applicators.

Alexander, Helene. *Fans*. London: B.T. Batsford, 1984.

Colle, Doriece. *Collars, Stocks, Cravats: A History and Costume Dating Guide to Civilian Men's Neckpieces, 1655-1900*. Emmaus, Pa.: Rodale Press, 1972.

Cumming, Valerie. *Gloves*. London: B.T. Batsford, 1982.

Foster, Vanda. *Bags and Purses*. The Costume Accessories Series. London: B.T. Batsford, 1982.

Montgomery Ward and Co. *Catalogue and Buyers' Guide, No. 57, Spring and Summer, 1895*. New York: Dover Publications, 1969.

Von Boehn, Max. *Ornaments: Lace, Fans, Gloves, Walking Sticks, Parasols, Jewelry, and Trinkets*. New York: B. Blom, 1970.

Personal Gear
Definition: An artifact originally created to be used by an individual as a personal carrying device such as a wallet or a knapsack; as a protective apparatus such as an umbrella or goggles; as a personal or physical aid such as a cane or eyeglasses; or as personal smoking equipment and supplies such as a pipe.

D'Allemagne, Henry Rene. *Decorative Antique Ironwork: A Pictorial Treasury*. New York: Dover Publications, 1968.

Dunhill, Alfred. *The Pipe Book*. London: A&C Black, Ltd., 1924.

Neumann, George C., and Kravic, Frank J. *Collector's Illustrated Encyclopedia of the American Revolution*. Harrisburg, Pa.: Stackpole Books, 1975.

Von Boehn, Max. *Ornaments: Lace, Fans, Gloves, Walking Sticks, Parasols, Jewelry, and Trinkets*. New York: B. Blom, 1970.

Toilet Article
Definition: An artifact originally created to be used for personal care, hygiene, or grooming.

Montgomery Ward and Co. *Catalogue and Buyers' Guide, No. 57, Spring and Summer, 1895*. New York: Dover Publications, 1969.

Pinto, Edward. *Treen and Other Wooden Bygones: An Encyclopedia and Social History*. 1969. Reprint. Bell and Hyman, 1979.

Category 4: Tools & Equipment for Materials

Definition: Tools, equipment, and supplies originally created to manage, oversee, capture, harvest, or collect resources and to transform or modify particular materials, both raw and processed. These artifacts are normally created in response to problems inherent in the materials themselves. Wood requires certain kinds of cutting devices, fish require certain lures, food requires certain serving utensils.

McNerny, Kathryn. *Antique Tools: Our American Heritage*. Paducah, Ky.: Collector Books, 1979.
——*Primitives: Our American Heritage*. Paducah, Ky.: Collector Books, 1979.
Miller, Robert W. *Pictorial Guide to Early American Tools and Implements*. Des Moines, Iowa: Wallace-Homestead, 1980.

Agricultural T&E

Definition: Tools, equipment, and supplies originally created for farming or gardening. This classification includes implements used in planting, tending, harvesting, and storing crops and in processing food for animals but not food for humans (see "Food Processing T&E"). This classification does not include tools and equipment used in caring for animals (see "Animal Husbandry T&E"), working with forest products (see "Forestry T&E"), or in preparing fibers for textiles from agricultural products (see "Textileworking T&E").

Ardrey, Robert L. *American Agricultural Implements*. 1894. Reprint. New York: Arno Press, 1972.
Blandford, Percy W. *Country Craft Tools*. London: David & Charles, 1974.
Considine, Douglas M., and Considine, Glenn D. *Foods and Food Production Encyclopedia*. New York: Van Nostrand Reinhold, 1982.
Fussell, George Edwin. *The Farmer's Tools: The History of British Farm Implements, Tools, and Machinery, AD 1500-1900*. London: Bloomsbury Books, 1985.
Partridge, Michael. *Farm Tools through the Ages*. Boston: New York Graphic Society, 1973.
Schapsmeier, Frederick H. and Edward L. *Encyclopedia of American Agricultural History*. Westport, Conn.: Greenwood Press, 1975.
Smith, Joseph. *Explanation or Key to the Various Manufactories of Sheffield*. 1816. Reprint. South Burlington, Vt.: The Early American Industries Association, 1975.
Vince, John. *Old Farms: An Illustrated Guide*. New York: Bramhall House, 1986.
Winburne, John N., ed. *A Dictionary of Agricultural and Allied Terminology*. East Lansing, Mich.: Michigan State University Press, 1962.

Animal Husbandry T&E

Definition: Tools, equipment, and supplies originally created for the care, breeding, and study of animals. This classification includes instruments used in the practice of veterinary medicine, in the psychologi-cal study of animals, and in the care of animals, such as the tools a farrier uses to shoe animals. This classification excludes equipment used in processing animal products for human use (see "Food Processing T&E" or "Leather, Horn, Shellworking T&E"). Also excluded are the tools of trades related to animal husbandry that are not used directly with animals, such as a farrier's metal-working tools.

Ardrey, Robert L. *American Agricultural Implements*. 1894. Reprint. New York: Arno Press, 1972.
Moseman (C. M.) and Brother. *Moseman's Illustrated Guide for Purchasers of Horse Furnishing Goods: Novelties and Stable Appointments, Imported and Domestic*. 1892. Reprint. 5th ed. New York: Arco, 1976.
Richardson, M. T., ed. *Practical Blacksmithing*. 1889-91. Reprint. New York: Weathervane Books, 1977.
Schapsmeier, Frederick H. and Edward L. *Encyclopedia of American Agricultural History*. Westport, Conn.: Greenwood Press, 1975.
Timmons, R., & Sons. *Tools for the Trades and Crafts: An Eighteenth Century Pattern Book, R. Timmons & Sons, Birmingham*. Fitzwilliam, N.H.: K. Roberts Publishing Co., 1976.
United States Patent Office. *Rural America a Century Ago*. Ed. by S. H. Rosenberg. 1892. Reprint. St. Joseph, Mich.: American Society of Agricultural Engineers, 1976.

Fishing & Trapping T&E

Definition: Tools, equipment, and supplies originally created for capturing aquatic and terrestrial animals by any means other than weaponry.

Bateman, James A. *Animal Traps and Trapping*. Harrisburg, Pa.: Stackpole Books, 1971.
Blair, Carvel Hall and Ansel, Willits Dyer. *A Guide to Fishing Boats and Their Gear*. Cambridge, Md.: Cornell Maritime Press, 1968.
Gerstell, Richard. *The Steel Trap in North America*. Harrisburg, Pa.: Stackpole Books, 1985.
Pinto, Edward. *Treen and Other Wooden Bygones: An Encyclopedia and Social History*. 1969. Reprint. London: Bell and Hyman, 1979.
Russell, Carl P. *Firearms, Traps, and Tools of the Mountain Men*. New York: Alfred A. Knopf, 1967.

Food T&E

Food Processing T&E

Definition: Tools, equipment, and supplies originally created for the processing, storage, and preparation of food or beverages for human consumption. This classification does not include tools for gathering, production, or management of food materials.

Celehar, Jane H. *Kitchens and Gadgets: 1920-1950*. Des Moines, Iowa: Wallace-Homestead Book Co., 1982.

Corbeil, Jean-Claude, ed. *The Facts on File Visual Dictionary*. New York: Facts on File, 1986.

Evan-Thomas, Owen. *Domestic Utensils of Wood, 16th to 19th Century*. London: Author, 1932.

Franklin, Linda. *300 Years of Kitchen Collectibles*. 2nd ed. Florence, Ala.: Books Americana, Inc., 1984.

Gould, Mary Earle. *Early American Woodenware and Other Kitchen Utensils*. Rutland, Vt.: Charles E. Tuttle Co., 1962.

Lantz, Louise K. *Old American Kitchenware, 1725-1925*. Camden, N.J.: Thomas Nelson, Inc., 1970.

Mace (L. H.) & Company. *L. H. Mace & Co., 1883: Woodenware, Meat Safes, Toys, Refrigerators, Children's Carriages, and House Furnishing Goods; Illustrated Catalog and Historical Introduction*. Princeton, N.J.: Pyne Press, 1971.

Norwak, Mary. *Kitchen Antiques*. New York: Praeger Publishers, 1975.

Food Service T&E

Definition: Tools, equipment, and supplies originally created for the service, presentation, or consumption of food or beverages by humans.

Daniel, Dorothy. *Cut and Engraved Glass, 1771-1905*. New York: M. Barrows, 1950.

Ketchum, William C. *Pottery and Porcelain*. New York: Alfred A. Knopf, 1983.

Lee, Ruth Webb. *Ruth Webb Lee's Handbook of Early American Pressed Glass Patterns*. Framingham, Mass.: R.W. Lee, 1936.

Meriden Britannia Company. *The Meriden Britannia Silver-Plate Treasury: The Complete Catalog of 1886-7 with 3,200 illustrations*. New York: Dover Publications, 1982.

Montgomery Ward and Co. *Catalogue and Buyers' Guide, No. 57, Spring and Summer, 1895*. New York: Dover Publications, 1969.

Spillman, Jane Shadel. *Glass Bottles, Lamps and Other Objects*. New York: Alfred A. Knopf, 1983.

———. *Glass Tableware, Bowls, and Vases*. New York: Alfred A. Knopf, 1982.

Forestry T&E

Definition: Tools, equipment, and supplies originally created for cutting, handling, or processing timber or for harvesting forest crops such as bark, sap, gum, resin, or rubber. This classification does not include equipment for cartage, which is classified under "Transportation Artifacts," or for manufacturing products from wood, which is classified under "Woodworking T&E" or "Papermaking T&E."

Arbor, Marilyn. *Tools and Trades of America's Past: The Mercer Collection*. Doylestown, Pa.: The Bucks County Historical Society, 1981.

Salaman, R. A. *Dictionary of Tools Used in the Woodworking and Allied Trades c. 1700-1970*. 1975. Reprint. New York: Macmillan, 1986.

Timmons, R., & Sons. *Tools for the Trades and Crafts: An Eighteenth Century Pattern Book, R. Timmons & Sons, Birmingham*. Fitzwilliam, N.H.: K. Roberts Publishing Co., 1976.

Glass, Plastics & Clayworking T&E

Definition: Tools, equipment, and supplies originally created for fabricating objects from homogenous, complex compounds, such as glass, clay, rubber, synthetic resins, plastics, or waxes. This classification also includes the tools, equipment, and supplies used for producing such homogenous, complex compounds. These compounds differ from other materials because they generally require elaborate processing at some point during their use. As compounds, they differ from other processed materials such as leather because they are not discrete units; they differ from aggregate materials such as masonry because of their homogeneity and their need for elaborate processing.

Berlye, M. K. *Encyclopedia of Working With Glass*. New York: Everest House, 1983.

Bivins, J., Jr. *Moravian Potters in North Carolina*. Winston-Salem: Published for Old Salem, Inc., by the University of North Carolina Press, Chapel Hill, 1972.

Diagram Group. *Handtools of Arts and Crafts: the Encyclopedia of the Fine, Decorative, and Applied Arts*. New York: St. Martin's Press, 1981.

Fournier, Robert. *Illustrated Dictionary of Practical Pottery*. New York: Van Nostrand Reinhold, 1977.

Hamilton, David. *The Thames and Hudson Manual of Pottery and Ceramics*. London: Thames and Hudson, Ltd., 1982.

Kulasiewicz, Frank. *Glassblowing*. New York: Watson-Guptill, 1974.

Littleton, Harvey K. *Glassblowing: A Search for Form.* 1971. Reprint. New York: Van Nostrand Reinhold, 1980.

Savage, George, and Newman, Harold. *An Illustrated Dictionary of Ceramics: Defining 3,054 Terms Relating to Wares, Materials, Processes, Styles, Patterns and Shapes From Antiquity to the Present Day.* New York: Van Nostrand Reinhold, 1974.

Leather, Horn, & Shellworking T&E

Definition: Tools, equipment, and supplies originally created for processing materials that are animal in origin. This classification includes tools and equipment for processing furs or hides, for preparing leather, for fabricating leather products, for working shell, horn, bone, and ivory, and tools for making things from quills or feathers. This classification also includes artifacts for processing materials that are the products of insects and bacteria.

Diagram Group. *Handtools of Arts and Crafts: The Encyclopedia of the Fine, Decorative, and Applied Arts.* New York: St. Martin's Press, 1981.

Salaman, R. A. *Dictionary of Leather-Working Tools, c.1700-1950, and the Tools of Allied Trades.* New York: Macmillan, 1986.

Timmons, R., & Sons. *Tools for the Trades and Crafts: An Eighteenth Century Pattern Book, R. Timmons & Sons, Birmingham.* Fitzwilliam, N.H.: K. Roberts Publishing Co., 1976.

Masonry & Stoneworking T&E

Definition: Tools, equipment, and supplies originally created for working with natural stone or with aggregate materials such as concrete, mortar, brick, or plaster. These aggregate materials can be of natural or manufactured origin. They differ from materials related to "Glass, Plastics, Clayworking T&E" because they lack the homogeneity and the need for complex processing of those materials.

Diagram Group. *Handtools of Arts and Crafts: The Encyclopedia of the Fine, Decorative, and Applied Arts.* New York: St. Martin's Press, 1981.

Jenkins, J. Geraint. *Traditional Country Craftsmen.* Rev. ed. London and Boston: Routledge and Kegan Paul, 1978.

McKee, Harley J. *Introduction to Early American Masonry, Stone, Brick, Mortar and Plaster.* Washington, D.C.: The National Trust for Historic Preservation, 1973.

Timmons, R., & Sons. *Tools for the Trades and Crafts:*

An Eighteenth Century Pattern Book, R. Timmons & Sons, Birmingham. Fitzwilliam, N.H.: K. Roberts Publishing Co., 1976.

Metalworking T&E

Definition: Tools, equipment, and supplies originally created for casting, forging, machining, or fabricating metals or metal products. This classification does not include tools, equipment, and supplies used in mining or preliminary processing of ores (listed under "Mining & Mineral Harvesting T&E").

Diagram Group. *Handtools of Arts and Crafts: The Encyclopedia of the Fine, Decorative, and Applied Arts.* New York: St. Martin's Press, 1981.

Dover Stamping Company. *Dover Stamping Co., 1869: Tinware, Tin Toys, Tinned Iron Wares, Tinners Material, Enameled Stove Hollow Ware, Tinners' Tools and Machines.* Princeton, N.J.: Pyne Press, 1971.

Feirer, John L. *General Metals.* 6th ed. New York: McGraw-Hill, 1986.

Holmstrom, John Gustaf, and Holford, Henry. *American Blacksmithing and Twentieth Century Toolsmith and Steelworker.* 1977. Reprint. New York: Greenwich House, 1982.

Richardson, M. T., ed. *Practical Blacksmithing.* 1889-91. Reprint. New York: Weathervane Books, 1978.

Rolt, L. T. C. *A Short History of Machine Tools.* Cambridge, Mass.: MIT Press, 1965.

Scott, Peter. *The Thames and Hudson Manual of Metalworking.* London: Thames and Hudson, 1978.

Smith, H. R. Bradley. *Blacksmiths' and Farriers' Tools at Shelburne Museum: A History of Their Development From Forge to Factory.* Shelburne, Vt.: Shelburne Museum, 1966.

Smith, Joseph. *Explanation or Key to the Various Manufactories of Sheffield.* 1816. Reprint. South Burlington, Vt.: The Early American Industries Association, 1975.

Steeds, W. *A History of Machine Tools, 1700-1910.* Oxford: Clarendon Press, 1969.

Timmons, R., & Sons. *Tools for the Trades and Crafts: An Eighteenth Century Pattern Book, R. Timmons & Sons, Birmingham.* Fitzwilliam, N.H.: K. Roberts Publishing Co., 1976.

Woodbury, Robert S. *Studies in the History of Machine Tools.* Cambridge, Mass.: MIT Press, 1972.

Wyke, John. *A Catalog of Tools for Watch and Clock Makers.* Charlottesville: Published for the Henry Francis du Pont Winterthur Museum by the University Press of Virginia, 1978.

Mining & Mineral Harvesting T&E

Definition: Tools, equipment, and supplies originally created for extracting materials in solid, liquid, or gaseous state from the natural environment. This classification includes equipment used for underground and surface mines, quarries, oil and water wells, for prospecting, and for supplemental processing operations such as breaking, milling, washing, cleaning, or grading. It also includes tools used for ice harvesting and salt harvesting.

Corbeil, Jean-Claude, ed. *The Facts on File Visual Dictionary.* New York: Facts on File, 1986.

Hall, Henry. *The Ice Industry of the United States.* 1880. Reprint. Albany, N.Y.: The Early American Industries Association, 1974.

Thrush, Paul W. *Dictionary of Mining, Minerals and Related Terms.* Washington, D.C.: U.S. Bureau of Mines, 1968. For sale by the Superintendent of Documents, U.S. Government Printing Office.

Painting T&E

Definition: Tools, equipment, and supplies originally created for working with materials that mask large surfaces by depositing a residual film such as a paint film, or by using adhesives to attach a thin covering such as wallpaper or gold leaf to a surface. This classification includes tools, equipment, and supplies used in decorative, artistic, and protective applications. Excluded from this classification are tools and equipment that are used with thicker coatings, such as wood veneers or plastic laminates, and tools and equipment used for metal plating. Also excluded are tools and equipment associated with printing processes, such as ink knives and silk screens.

The Coach Painter. 1880. Reprint. Stony Brook, N.Y.: The Museums at Stony Brook, 1981.

Diagram Group. *Handtools of Arts and Crafts: The Encyclopedia of the fine, Decorative, and Applied Arts.* New York: St. Martin's Press, 1981.

Greysmith, Brenda. *Wallpaper.* New York: Macmillan, 1976.

Mayer, Ralph. *A Dictionary of Art Terms and Techniques.* New York: Barnes and Noble, 1981.

Taubes, Frederic. *Painter's Dictionary of Materials and Methods.* New York: Watson-Guptill, 1979.

Papermaking T&E

Definition: Tools, equipment, and supplies originally created for the manufacture of materials formed from the residue of suspensions or in the fabrication of products made of such materials. Paper—whether made from wood pulp, textile fibers, or plastic fibers—is the principle product that falls in this classification. Particles mixed with liquids form suspensions. Though felt is made of materials that are matted like paper, tools for felting are listed with "Textileworking T&E" because felt is not formed from a suspension.

Blum, Andre. *On the Origin of Paper.* New York: R. R. Bowker, 1934.

Butler, Frank O. *The Story of Paper-Making: An Account of Paper-Making From Its Earliest Known Record Down to the Present Time.* Chicago: J. W. Butler Paper Co., 1901.

Diagram Group. *Handtools of Arts and Crafts: The Encyclopedia of the Fine, Decorative, and Applied Arts.* New York: St. Martin's Press, 1981.

Hunter, Dard. *Papermaking: The History and Technique of an Ancient Craft.* 1947. Reprint. New York: Dover Publications, 1978.

Papermaking: Art and Craft: An Account Derived from the Exhibition Presented in the Library of Congress, Washington, D.C., and Opened on April 21, 1968. Washington, D.C.: Library of Congress, 1968.

Textileworking T&E

Definition: Tools, equipment, and supplies originally created for the preparation of materials made from fibers and the preparation of woven fabrics. Also included in this category are tools, equipment, and supplies used for manufacturing objects from fibers or cloth. This classification includes tools specific to the preparation of fibers, such as hatchels and cotton gins, but excludes tools, such as sheep shears and cotton balers, that are related to sources of fibers.

American Fabrics and Fashions Magazine, Editors of. *Encyclopedia of Textiles.* Englewood Cliffs, N.J.: Prentice-Hall, 1980.

Baines, Patricia. *Spinning Wheels: Spinners and Spinning.* New York: Charles Scribners Sons, 1977.

Broudy, Eric. *The Book of Looms: A History of the Handloom from Ancient Times to the Present.* New York: Van Nostrand Reinhold, 1979.

Burnham, Dorothy K. *Warp and Weft: A Textile Terminology.* Toronto: Royal Ontario Museum, 1980.

Diagram Group. *Handtools of Arts and Crafts: The Encyclopedia of the Fine, Decorative, and Applied Arts.* New York: St. Martin's Press, 1981.

Groves, Sylvia. *The History of Needlework Tools and Accessories.* New York: Arco Publishing Co., 1973.

Houart, Victor. *Sewing Accessories: An Illustrated History.* London: Souvenir Press, 1984.

McClellan, Mary Elizabeth. *Felt, Silk and Straw Handmade Hats—Tools and Processes.* Doylestown, Pa.: The Bucks County Historical Society, 1977.

Rogers, Gay Ann. *An Illustrated History of Needlework Tools.* London: John Murray, 1983.

Whiting, Gertrude. *Tools and Toys of Stitchery.* New York: Columbia University Press, 1928.

Woodworking T&E

Definition: Tools, equipment, and supplies originally created for the fabrication of objects from wood. This classification includes artifacts used with and to create physically modified wood by-products such as plywood, chipboard, and masonite. This classification excludes tools and equipment for making objects out of chemically modified wood by-products such as paper, rayon, and rubber.

Hummel, Charles F. *With Hammer in Hand: The Dominy Craftsman of East Hampton, N.Y.* Charlottesville: University Press of Virginia, 1968.

Jenkins, J. Geraint. *Traditional Country Craftsmen.* London: Boston: Routledge and Kegan Paul, 1978.

Kebabian, Paul B., and Witney, Dudley. *American Woodworking Tools.* Boston: New York Graphic Society, 1978.

Salaman, R. A. *Dictionary of Tools Used in the Woodworking and Allied Trades C. 1700-1970.* Reprint. New York: Macmillan, 1986.

Smith, Joseph. *Explanation or Key to the Various Manufactories of Sheffield.* 1816. Reprint. South Burlington, Vt.: The Early American Industries Asssociation, 1975.

Timmons, R., & Sons. *Tools for the Trades and Crafts: An Eighteenth Century Pattern Book, R. Timmons & Sons, Birmingham.* Fitzwilliam, N.H.: K. Roberts Publishing Co., 1976.

Wildung, Frank H. *Woodworking Tools at Shelburne Museum.* Shelburne, Vt.: Shelburne Museum, 1957.

Other T&E for Materials

Basket, Broom, Brush-Making T&E
Definition: Tools, equipment, and supplies for fabricating objects out of fibrous materials that are generally coarser than those used for textiles. This sub-classification includes tools used for basketmaking, broom-making, brush-making, and thatching.

Jenkins, J. Geraint. *Traditional Country Craftsmen.* London: Boston: Routledge and Kegan Paul, 1978.

Salaman, R. A. *Dictionary of Tools Used in the Woodworking and Allied Trades C. 1700-1970.* Reprint. New York: Macmillan, 1986.

Staniforth, Arthur. *Straw and Straw Craftsmen.* Aylesbury, England: Shire Publications, 1981.

Cigar-Making T&E
Definition: Tools, equipment, and supplies for fabricating nonfood products for human consumption out of tobacco and related vegetable products. This sub-classification includes tools for handling harvested tobacco and manufacturing tobacco products. Smoking accessories and supplies are listed under "Personal Gear."

Brooks, Jerome, E. *The Mighty Leaf: Tobacco Through the Centuries.* Boston: Little and Brown, 1952.

Lapidary T&E
Definition: Tools, equipment, and supplies for fabricating objects out of crystalline materials—primarily precious and semi-precious stones. This sub-classification includes jeweler's gem-cutting tools, but it excludes tools used in the manufacture of jewelry that are for working other materials such as metal, wood, or plastic.

Diagram Group. *Handtools of Arts and Crafts: The Encyclopedia of the Fine, Decorative, and Applied Arts.* New York: St. Martin's Press, 1981.

Long, Frank W. *Creative Lapidary: Materials, Tools, Techniques, Design.* New York: Van Nostrand Reinhold, 1976.

Wigmaking T&E
Definition: Tools, equipment, and supplies used in the fabrication of wigs and hair pieces from fibers. This sub-classification includes tools for preparing and arranging fibers, for sewing wigs, and special tools for finishing wigs. Excluded are tools that might be generally used for grooming, such as combs and brushes, unless they are specifically designed for wigmaking.

Bothan, Mary, and Sharrad, L. *Manual of Wigmaking.* 1972. Reprint. London: W. Heinemann, 1982.

The Wigmaker in Eighteenth Century Williamsburg: An Account of His Barbering, Hairdreffing and Perukemaking Services, and Some Remarks on Wigs of Various Styles. Williamsburg, Va.: Colonial Williamsburg, 1971.

Category 5: Tools & Equipment for Science & Technology

Definition: Tools, equipment, and supplies used for the observation of natural phenomena or to apply knowledge gained from such observation. Tools in this category tend to be made to enlarge or record our understanding of the world or to help express such understanding. The classifications in this category are related by virtue of the fact that they contain artifacts created to employ a particular body of knowledge. "Astronomical T&E" is a classification that lists those tools used to examine distant phenomena. "Timekeeping T&E" is a classification that lists those things that people have developed to measure time. "Maintenance T&E" is a classification that lists those tools developed in response to a body of knowledge about how to take care of things. These classifications are based, then, on knowledge rather than materials.

Acoustical T&E

Definition: Tools, equipment, and supplies originally created for the study of sound and its effect upon hearing. Artifacts listed under "Acoustical T&E" differ from those under "Sound Communication Equipment" in that the function of the former is to study sound, not to transmit or receive it. They differ from some related items in "Medical and Psychological T&E" in that the function of items in "Acoustical T&E" is to examine the nature and the effects of sound, not to diagnose or treat medical situations.

Applied Technical Dictionary: Acoustics. Collet.
Van Cleve, John V., ed. *Gallaudet Encyclopedia of Deaf People and Deafness.* New York: McGraw-Hill, 1987.

Armament T&E

Definition: Tools, equipment, and supplies originally created to be used for hunting, target-shooting, warfare, or self-protection. This classification includes firearms, artillery, bladed weapons, and striking weapons. It does not include objects designed for transporting troops or supplies. For convenience, it is divided into several sub-classifications based on forms of weapons.

Bannerman, Francis, & Son. *Bannerman Catalogue of Military Goods, 1927.* Northfield, Ill.: DBI Books, 1980.
Diagram Group. *Weapons: An International Encyclopedia from 5000 BC to 2000 AD.* New York: St. Martin's Press, 1980.
Hart, Harold H. *Weapons and Armor: A Pictorial Archive of Woodcuts & Engravings with over 1,400 Copyright-free Illustrations for Artists and Designers.* 1978. Reprint. New York: Dover Publications, 1982.
Quick, John. *Dictionary of Weapons and Military Terms.* New York: McGraw-Hill, 1973.
Stone, George Cameron. *A Glossary of the Construction, Decoration and Use of Arms and Armor in All Countries and in All Times, Together with Closely Related Subjects.* New York: Jack Brussel Publisher, 1961.
Tarassuk, Leonid, and Blair, Claude. *The Complete Encyclopedia of Arms and Weapons: The Most Comprehensive Reference Work Ever Published on Arms and Armor.* New York: Bonanza Books, 1986.

Armament T&E—Firearm

Definition: This sub-classification includes all projectile-firing weapons than can be easily deployed by one person. It excludes ammunition, firearm accessories, and crew-served heavy armament.

Blackmore, Howard L. *Guns and Rifles of the World.* London: B.T. Batsford, 1968.
Flayderman, Norm, ed. *Flayderman's Guide to Antique American Firearms—and Their Values.* Northfield, Ill.: DBI Books, Inc., 1987.
Gluckman, Arcadi. *Identifying Old U. S. Muskets, Rifles and Carbines.* Harrisburg, Pa.: Stackpole Books, 1965.

Armament T&E—Edged

Definition: This sub-classification includes all armament that is intended to cut or pierce by cutting. It includes edged weapons such as bayonets that are accessories to firearms and tools such as crossbows that launch edged weapons.

Strung, Norman. *An Encyclopedia of Knives.* Philadelphia: Lippincott, 1976.

Armament T&E—Bludgeon

Definition: This sub-classification includes all armament that is designed to batter or crush by weight or momentum. It also includes arms such as slingshots that propel missiles that are neither explosive nor penetrating.

Armament T&E—Artillery

Definition: This sub-classification includes all heavy weapons that employ combustion or explosion to fire a projectile. Artillery may be portable, and it may be employed by only one person, but typically it is

fired by a crew from a more or less stationary position.

Armament T&E—Ammunition
Definition: This sub-classification includes all ammunition for armament whether intended for particular weapons, such as BB's or cartridges, or intended to be deployed alone, such as missiles, or bombs.

Barnes, Frank C. *Cartridges of the World*. Northbrook Ill.: DBI Books, 1985.
Logan, Herschel C. *Cartridges: A Pictorial Digest of Small Arms Ammunition*. Harrisburg, Pa.: Stackpole Books, 1959.

Armament T&E—Body Armor
Definition: This sub-classification includes clothing worn as defensive armament. It includes the formal parts of a "suit of armor" and protective devices used in combat.

Blair, Claude. *European Armour: Circa 1066 to Circa 1700*. Woodstock, N.Y.: Beekman Publishing, 1979.

Armament T&E—Accessory
Definition: This sub-classification includes all accessories used for hunting, target-shooting, warfare or self-protection.

Astronomical T&E
Definition: Tools, equipment, and supplies originally created to observe, measure, and document objects and events outside of the earth's atmosphere. Artifacts listed under "Astronomical T&E" differ from those under "Optical T&E" in that the former are not intended to address particular problems associated with vision. They differ from those under "Surveying and Navigational T&E" in that they are concerned with observation rather than with practical uses for such observation.

Calvert, Henry Reginald. *Astronomy: Globes, Orreries and Other Models*. London: Her Majesty's Stationery Office, 1971.
Ridpath, Ian, ed. *The Illustrated Encyclopedia of Astronomy and Space*. New York: Thomas Y. Crowell, 1979.
Struve, Otto, and Zebergs, Velta. *Astronomy of the 20th Century*. New York: Macmillan, 1962.

Biological T&E
Definition: Tools, equipment, and supplies originally created to observe, measure, and document phys-iological or anatomical aspects of organisms for purposes other than diagnosis or treatment. Tools for diagnosis and treatment of people are classified under "Medical and Psychological T&E"; those for animals are under "Animal Husbandry T&E."

Fisher Scientific Catalogs. Springfield, N.J.: Fisher Scientific, published annually.
McGraw-Hill Encyclopedia of Electrical and Electronic Engineering. New York: McGraw-Hill, 1985.
Thomas Scientific Catalog. Springfield, N.J.: Thomas Scientific, published annually.

Chemical T&E
Definition: Tools, equipment, and supplies originally created for the study or manufacture of substances based upon their molecular composition, structure, and properties. The study of atomic and subatomic particles is classified under "Nuclear Physics T&E"; the study of the interaction of physical objects, under "Mechanical T&E."

Child, Ernest. *The Tools of the Chemist: Their Ancestry and American Evolution*. New York: Van Nostrand Reinhold, 1940.
Fisher Scientific Catalogs. Springfield, N.J.: Fisher Scientific, published annually.
Greenaway, Frank. *Chemistry*. London: Her Majesty's Stationery Office, 1966.
McGraw-Hill Encyclopedia of Chemistry. New York: McGraw-Hill, 1983.

Construction T&E
Definition: Tools, equipment, and supplies originally created for moving earth and building structures. This classification includes paving machines and equipment that modifies by demolition, such as wrecking balls and jack hammers. It also includes tools such as pile drivers used for the construction of highways and structural facilities. This classification does not include specialized tools listed in other classifications and used in the construction industries, such as hammers or cement mixers.

Brooks, Hugh. *Encyclopedia of Building and Construction Terms*. Englewood Cliffs, N.J.: Prentice-Hall, 1983.
Bucksch, Herbert. *Dictionary of Civil Engineering and Construction Machinery and Equipment*. New York: French & European Publications, 1976.
CIT Agency. *Construction Industry Thesaurus*. London: Property Services Agency, (12 Marsham St., S.W. 1), 1976.

Corbeil, Jean-Claude, ed. *The Facts on File Visual Dictionary*. New York: Facts on File, 1986.

Fitchen, John. *Building Construction Before Mechanization*. Cambridge, Mass.: MIT Press, 1986.

Electrical & Magnetic T&E

Definition: Tools, equipment, and supplies originally created to observe, measure, and document electrical and magnetic phenomena. This classification also includes tools, equipment, and components used in the manufacture, installation, and repair of electrical and electronic devices, such as electrician's pliers or oscilloscopes. This classification does not include electrical or electronic devices created to serve other specific purposes, such as sound communication or data processing, nor does it include electrical motors or generators (see "Energy Production T&E").

Benjamin, Park. *A History of Electricity*. New York: Arno Press, 1975.

Corbeil, Jean-Claude, ed. *The Facts on File Visual Dictionary*. New York: Facts on File, 1986.

McGraw-Hill Encyclopedia of Electrical and Electronic Engineering. New York: McGraw-Hill, 1985.

Meyer, Herbert W. *A History of Electricity and Magnetism*. Norwalk, Conn.: Burndy Library, 1972.

Sharlin, Harold. *Making of the Electrical Age: From the Telegraph to Automation*. 1963. Reprint. New York: Abelard-Schuman, 1964.

Wheatland, David. *The Apparatus of Science at Harvard, 1765-1800*. Cambridge, Mass.: Harvard University Press, 1968.

Energy Production T&E

Definition: Tools, equipment, and supplies originally created to generate, convert, or distribute energy or power.

Baker, T. Lindsay. *A Field Guide to American Windmills*. Norman, Okla.: University of Oklahoma Press, 1985.

Dibner, Bern. *Early Electrical Machines: The Experiments and Apparatus of Two Enquiring Centuries (1600 to 1800) that Led to the Triumphs of the Electrical Age*. Norwalk, Conn.: Burndy Library, 1957.

Reynolds, John. *Windmills and Watermills*. New York: Praeger Publishers, 1970.

Geological T&E

Definition: Tools, equipment, and supplies originally created to observe, measure, and document geological phenomena. This classification includes geologists' picks and seismic measuring devices, but it excludes tools used for harvesting or mining rock or mineral materials.

McGraw-Hill Encyclopedia of Earth Sciences. New York: McGraw-Hill, 1984.

Maintenance T&E

Definition: Tools, equipment, and supplies originally created for cleaning or laundering activities, whether carried on in a home or a public building, whether performed occasionally or as a business. This classification includes specialized tools used for the restoration and conservation of objects.

American Institute of Maintenance. *Selection and Care of Cleaning Equipment*. Glendale, Calif.: American Institute of Maintenance, 1982.

Lifshey, Earl. *The Housewares Story*. Chicago: National Housewares Manufacturing Association, 1973.

Montgomery Ward and Co. *Catalogue and Buyers' Guide, No. 57, Spring and Summer, 1895*. New York: Dover Publications, 1969.

Pinto, Edward. *Treen and Other Wooden Bygones: An Encyclopedia and Social History*. 1969. Reprint. London: Bell and Hyman, 1979.

Sambrook, Pamela. *Laundry Bygones*. Aylesbury, England: Shire Publications, 1983.

Mechanical T&E

Definition: Tools, equipment, and supplies originally created for the study, measurement, or utilization of the static and dynamic properties of solids, liquids, and gasses. This classification includes general-purpose mechanical devices, such as wedges and hoists, and specialized devices, such as tensiometers and pressure gauges, used to measure mechanical properties.

Bucksch, H. *Dictionary of Mechanisms*. New York: French & European Publications, 1976.

Fraf, Rudolph F., et. al. *How It Works: Illustrated Everyday Devices and Mechanisms*. New York: Van Nostrand Reinhold, 1979.

Hiscox, Gardner D. *Curious Mechanical Movements*. 1904. Reprint. Bradley, Ill.: Lindsay Publications, 1986.

Medical & Psychological T&E

Definition: Tools, equipment, and supplies originally created for the examination, testing, diagnosis, and treatment of humans. This classification includes dental tools, objects used for testing sight and hearing, and objects used for psychological testing or

treatment. It does not include objects used to study physical phenomena (see "Optical T&E," "Acoustical T&E," "Biological T&E," and "Chemical T&E") or tools for veterinary medicine (see "Animal Husbandry T&E").

Bennion, Elizabeth. *Antique Medical Instruments*. London: Sotheby Parke Bernet, and Berkley: University of California, 1979.

Dammann, Gordon. *Encyclopedia of Civil War Medical Instruments and Equipment*. Missoula, Mont.: Pictorial Histories Publishing Co., 1983.

Davis, Audrey B. *Medicine and Its Technology: An Introduction to the History of Medical Instruments*. Westport, Conn.: Greenwood, 1981.

Pike, Benjamin. *Pike's Illustrated Catalogue of Scientific and Medical Instruments*. 1856. Reprint. San Francisco: The Antiquarian Scientist, 1984.

Richardson, Lillian, and Richardson, Charles. *The Pill Rollers: Apothecary Antiques and Drug Store Collectibles*. Fort Washington, Md.: Old Fort Press, 1976.

Wilbur, C. Keith. *Revolutionary Medicine: 1700-1800*. Chester, Conn.: The Globe Pequot Press, 1980.

——— . *Antique Medical Instruments*. West Chester, Pa.: Schiffer Publishing, 1987.

Merchandising T&E

Definition: Tools, equipment, and supplies originally created to facilitate or enable the exchange of goods or services. This classification includes those artifacts used to present goods, such as counters, as well as specific product packages. General product packages that are primarily intended for transporting goods rather than for marketing them are listed in the classification "Containers" in the " Distribution & Transportation Artifacts" category.

Graham, Irvin. *Encyclopedia of Advertising*. New York: Fairchild, 1969.

Meteorological T&E

Definition: Tools, equipment, and supplies originally created to observe, measure, and document atmospheric phenomena.

Huschke, Ralph E., ed. *Glossary of Meteorology*. Boston: American Meteorological Society, 1959.

Middleton, W. E. Knowles. *The History of the Barometer*. Baltimore: Johns Hopkins Press, 1964.

——— . *Invention of the Meteorological Instruments*. Baltimore: Johns Hopkins Press, 1969.

Nuclear Physics T&E

Definition: Tools, equipment, and supplies originally created to study atomic structure and elementary particles as well as the physical properties of the universe.

Corbeil, Jean-Claude, ed. *The Facts on File Visual Dictionary*. New York: Facts on File, 1986.

Lyman, James D. *Nuclear Terms: A Brief Glossary*. Oak Ridge, Tenn.: U.S. Atomic Energy Commission, 1964.

McGraw-Hill Encyclopedia of Physics. New York: McGraw-Hill, 1983.

Optical T&E

Definition: Tools, equipment, and supplies originally created to observe, measure, and record light. This classification includes commonly used equipment, such as binoculars and microscopes. It excludes specialized artifacts created for other scientific observation, such as visual-acuity charts and telescopes that are used particularly for astronomy.

Bennett, Alva Herschel. *Glossary of Terms Frequently Used in Optics and Spectroscopy*. New York: American Institute of Physics, 1962.

Clay, Reginald Stanley, and Court, Thomas H. *The History of the Microscope*. London: C. Griffin, 1932.

Montgomery Ward and Co. *Catalogue and Buyers' Guide, No. 57, Spring and Summer, 1895*. Reprint. New York: Dover Publications, 1969.

Richter, Gunter. *Dictionary of Optics, Photography, and Photogrammetry*. New York: Elsevier Publishing Co., 1966.

Regulative & Protective T&E

Definition: Tools, equipment, and supplies originally created for controlling the behavior of people, providing security or protection for property, and carrying out nonceremonial activities of a governmental organization (including fire protection, police protection, and voting).

Dewar, Michael. *Internal Security Weapons and Equipment of the World*. England: Ian Allan, 1981.

Ditzel, Paul. *Fire Engines, Firefighters: The Men, Equipment, and Machines, from Colonial Days to the Present*. New York: Crown Publishers, 1976.

Garvan, Anthony N. B., and Wojtowicz, Carol A. *Catalogue of The Green Tree Collection*. Philadelphia, Pa.: The Mutual Assurance Company, 1977.

McCosker, M. J. *The Historical Collection of the Insur-*

ance Ccompany of North America. Philadelphia, Pa.: INA, 1967.

Surveying & Navigational T&E

Definition: Tools, equipment, and supplies originally created to determine the position of an observer relative to known reference points or to indicate the form and extent of a region, such as land surface. This classification includes instruments for taking linear and angular measurements. It excludes devices for making calculations (see "Data Processing T&E") or for recording data graphically (see "Drafting T&E"). This classification differs from "Astronomical T&E" in that the objects in this classification are used for applied purposes, not for scientific study.

Bedini, Silvio. *Thinkers and Tinkers: Early American Men of Science.* New York: Charles Scribners Sons, 1975.

Kemp, Peter, ed. *The Oxford Companion to Ships and the Sea.* London: Oxford University Press, 1976.

Kiely, Edmond R. *Surveying Instruments: Their History.* 1947. Reprint. Columbus, Ohio: CARBEN Survey, 1979.

Pike, Benjamin. *Pike's Illustrated Catalogue of Scientific and Medical Instruments.* 1856. Reprint. San Francisco: The Antiquarian Scientist, 1984.

Uzes, Francois D. *Illustrated Price Guide to Antique Surveying Instruments and Books.* Cardova, Calif.: Landmark Enterprises, 1980.

Wheatland, David. *The Apparatus of Science at Harvard, 1765-1800.* Cambridge, Mass.: Harvard University Press, 1968.

Thermal T&E

Definition: Tools, equipment, and supplies originally created to observe, measure, and document heat and its effects. Specialized artifacts created to serve specific purposes, such as a meteorological thermometer, are excluded from this classification.

McGraw-Hill Encyclopedia of Physics. New York: McGraw-Hill, 1983.

Timekeeping T&E

Definition: Tools, equipment, and supplies originally created for recording and measuring time. This classification does not include timekeeping artifacts created for specialized purposes, such as chronometers.

Bailey, Chris H. *Two Hundred Years of American Clocks*

and Watches. Englewood Cliffs, N.J.: Prentice-Hall, 1975.

Britten, Frederick James. *Britten's Old Clocks and Watches and Their Makers.* New York: Dutton, 1973.

DeCarle, Donald. *Watch and Clock Encyclopedia.* New York: Bonanza Books, 1975.

Harris, H. G. *Handbook of Watch and Clock Repairs.* New York: Barnes and Noble, 1972.

Weights & Measures T&E

Definition: Tools, equipment, and supplies originally created to observe, record, and measure mass (weight) or physical dimensions such as length, area, and volume. This classification includes general-purpose measuring devices such as precision balances or folding rules. It excludes artifacts created to measure time and to measure particular scientific data. Also excluded are specialized measuring devices and gauges such as sextants or carpenter's squares.

Eaches, Albert R. "Scales and Weighing Devices: An Aid to Identification," American Association for State and Local History Technical Leaflet 59, *History News* 27:3 (March 1972).

Kisch, Bruno. *Scales and Weights, A Historical Outline.* 1966. Reprint. New Haven, Conn.: Yale University Press, 1977.

Zupko, Ronald Edward. *A Dictionary of English Weights and Measures: From Anglo-Saxon Times to the 19th Century.* Madison: University of Wisconsin Press, 1968.

————. *Italian Weights and Measures from the Middle Ages to the Nineteenth Century.* Philadelphia, Pa.: American Philosophical Society, 1981.

Other T&E for Science & Technology

Category 6: Tools & Equipment for Communication

Definition: Tools, equipment, and supplies used to enable communication. This category includes those classifications for literal and abstract communication—"Printing T&E" and "Musical T&E." This category does not include things produced as communication, such as works of art and documents. These are the artifacts created by the tools of this category, and they are listed in category 8, "Communication Artifacts."

Data Processing T&E
Definition: Tools, equipment, and supplies originally created for processing data by manual, mechanical, or electronic means. This classification includes numerical and wordprocessing devices such as abacuses and digital computers; process-control devices such as analog computers; and learning devices such as teaching machines.

Bates, William. *The Computer Cookbook.* Garden City, N.Y.: Doubleday, 1984.
Data Communication Buyers' Guide. New York: McGraw-Hill, 1979.
Sippl, Charles, J. *Dictionary of Data Communications.* New York: Wiley, 1985.

Drafting T&E
Definition: Tools, equipment, and supplies originally created to be used for precision drawing, such as T-squares or drafting tables. This classification includes instruments used to record surveying and navigational observations. It does not include general purpose writing or lettering tools.

Dickinson, Henry W. "A Brief History of Draughtsmen's Instruments." *Transactions of the Newcomen Society* 27 (1949-51): 73-84.
French, Thomas E., and Vierck, Charles J. *Engineering Drawing and Graphic Technology.* New York: McGraw-Hill, 1972.
Wheatland, David. *The Apparatus of Science at Harvard, 1765-1800.* Cambridge, Mass.: Harvard University Press, 1968.

Musical T&E
Definition: Tools, equipment, and supplies originally created to produce musical sounds. This classification includes devices actively employed in musical performance. It excludes equipment that simply transmits sound as well as acoustical tools and equipment for studying sound.

Baines, Anthony. *European and American Musical Instruments.* London: B.T. Batsford, 1966.
Bonanni, Filippo. *Antique Musical Instruments and Their Players.* 1723. Reprint. New York: Dover Publications, 1964.
Bowers, Q. David. *Encyclopedia of Automatic Musical Instruments.* Vestal, N.Y.: Vestal Press, 1972.
Diagram Group. *Musical Instruments of the World.* New York: Facts on File, 1976.
Ord-Hume, Arthur W. J. G. *Clockwork Music: An Illustrated History of Mechanical Musical Instruments.* New York: Crown Publishers, 1973.

Photographic T&E
Definition: Tools, equipment, and supplies originally created to capture a permanent visual image by optical and chemical means, such as a camera, a film-processing tank, or an enlarger.

Auer, Michel. *The Illustrated History of the Camera from 1839 to the Present.* Boston: New York Graphic Society, 1975.
Booth, Larry, and Weinstein, Robert A. *Collection, Use, and Care of Historical Photographs.* Nashville: American Association for State and Local History, 1977.
Gernsheim, Helmut, and Gernsheim, Alison. *The History of Photography.* New York: McGraw-Hill, 1969.
Montgomery Ward and Co. *Catalogue and Buyers' Guide, No. 57, Spring and Summer, 1895.* Reprint. New York: Dover Publications, 1969.
Richter, Gunter. *Dictionary of Optics, Photography, and Photogrammetry.* New York: Elsevier Publishing Co., 1966.

Printing T&E
Definition: Tools, equipment, and supplies originally created to reproduce written, photographic, or artistic material. This classification includes specialized tools such as handpresses, engraver's blocks, and photocopiers that are used for bookbinding, engraving, etching, lithography, and silk-screening.

Blum, Andre. *The Origins of Printing and Engraving.* New York: Charles Scribners Sons, 1940.
Diagram Group. *Handtools of Arts and Crafts: The Encyclopedia of the Fine, Decorative, and Applied Arts.* New York: St. Martin's Press, 1981.
Johnson, Arthur W. *The Thames and Hudson Manual of Bookbinding.* London: Thames and Hudson, Ltd., 1978.
Moran, James. *Printing Presses: History and Development from the 15th Century to Modern Times.* Berkeley: University of California Press, 1973.
Roberts, Matt T., and Etherington, Don. *Bookbinding and the Conservation of Books: A Dictionary of Descriptive Terminology.* Washington, D.C.: Library of Congress, 1982.

Sound Communication T&E
Definition: Tools, equipment, and supplies originally

created to amplify or store music, spoken words, or other sounds that are meaningful for human communication.

Corbeil, Jean-Claude, ed. *The Facts on File Visual Dictionary*. New York: Facts on File, 1986.

Ord-Hume, Arthur W. J. G. *Clockwork Music: An Illustrated History of Mechanical Musical Instruments*. New York: Crown Publishers, 1973.

Telecommunication T&E

Definition: Tools, equipment, and supplies originally created to facilitate communicating at a distance, usually by means of electronic equipment. This classification includes the telephone, telegraph, radio, and television.

Bones, R. *Concise Encyclopaedic Dictionary of Telecommunications*. New York: Elsevier Science Publishing, 1970.

Corbeil, Jean-Claude, ed. *The Facts on File Visual Dictionary*. New York: Facts on File, 1986.

Manly, Harold Phillips. *Drake's Cyclopedia of Radio and Electronics*. Chicago: F.J. Drake & Co., 1942.

Meyer, Herbert W. *A History of Electricity and Magnetism*. Norwalk, Conn.: Burndy Library, 1972.

Sharlin, Harold. *Making of the Electrical Age: From the Telegraph to Automation*. 1963. Reprint. New York: Abelard-Schuman, 1964.

Visual Communication T&E

Definition: Tools, equipment, and supplies originally created to be used as a visual sign or signaling device or as a means of viewing photographic or other visual images.

Corbeil, Jean-Claude, ed. *The Facts on File Visual Dictionary*. New York: Facts on File, 1986.

Written Communication T&E

Definition: Tools, equipment, and supplies originally created to facilitate communication between people by means of written documents. This classification includes tools and supplies used for writing, such as pens, ink, and paper. Excluded from this classification are artifacts produced by writing, such as letters, and artifacts that are written upon but that were created for another purpose, such as postcards. These particular exclusions are both "Documentary Artifacts."

Diagram, Group. *Handtools of Arts and Crafts: The Encyclopedia of the Fine, Decorative, and Applied Arts*. New York: St. Martin's Press, 1981.

Ormond, Leonee. *Writing*. London: Her Majesty's Stationery's Office, 1981.

Whalley, Joyce Irene. *Writing Implements and Accessories: From the Roman Stylus to the Typewriter*. Devon, England: David & Charles, 1975.

Other T&E for Communication

Category 7: Distribution & Transportation Artifacts

Definition: Artifacts originally created to transport or distribute animate and inanimate things. This category also includes artifacts originally created to facilitate such transportation or as an adjunct to such transportation. This category includes propelled vehicles such as automobiles and wheelbarrows as well as containers that facilitate distribution. Because transportation equipment is complex and parts are often collected independently, sub-classifications for accessories are offered for some classifications.

Container

Definition: Artifacts originally created for packing, shipping, or holding goods and commodities. Containers created for particular products and used for marketing and merchandising products are listed with "Merchandising T&E."

Ketchum, William C., Jr. *A Treasury of American Bottles*. New York: Bobbs-Merrill, 1975.

McKearin, Helen, and Wilson, Kenneth. *American Bottles and Flasks and Their Ancestry*. New York: Crown Publishers, 1978.

Munsey, Cecil. *The Illustrated Guide to Collecting Bottles*. New York: Hawthorne, 1970.

Switzer, Ronald R. *The Bertrand Bottles: Study of 19th Century Glass and Ceramic Containers*. Washington, D.C.: National Park Service, 1974.

Aerospace Transportation

Aerospace Transportation—Equipment
Definition: An artifact originally created to transport people or goods above the surface of the earth.

Baughman, Harold E. *Aviation Dictionary and Reference Guide*. 2nd ed. Glendale, Calif.: Aero Publishers, 1942.

Marks, Robert W., ed. *The New Dictionary and Handbook of Aerospace*. New York: Praeger, 1969.

Nayler, J. N. *Concise Encyclopaedic Dictionary of Astronautics*. New York: Elsevier Science Publishing, 1964.

Zweng, Charles A., ed. *The Zweng Aviation Dictionary*. N. Hollywood, Calif: Pan American Navigation Service, 1944.

Aerospace Transportation—Accessory
Definition: An artifact originally created as an accessory to be used in conjunction with the transportation of people or goods above the surface of the earth.

Land Transportation
Land Transportation—Animal Powered
Definition: An artifact, powered by animal energy, originally created to transport people or goods on land without restriction to a fixed route determined by a track or other guidance device.

Berkebile, Don H. *Carriage Terminology: An Historical Dictionary*. Washington, D.C.: Smithsonian Institution Press, 1978.

Harter, Jim, ed. *Transportation: A Pictorial Archive From 19th Century Sources*. New York: Dover Publications, 1983.

Ingram, Arthur. *Horse Drawn Vehicles Since 1760*. England: Blandford Press, 1977.

Montgomery Ward and Co. *Catalogue and Buyers' Guide, No. 57, Spring and Summer, 1895*. New York: Dover Publications, 1969.

Rand McNally and Co., ed. *The Rand McNally Encyclopedia of Transportation*. Chicago: Rand McNally, 1976.

Spivey, Towana, ed. *A Historical Guide to Wagon Hardware and Blacksmith Supplies*. Lawton, Okla.: Museum of the Great Plains, 1979.

Tuma, Ing J. *The Pictorial Encyclopedia of Transport*. New York: Hamlyn, 1979.

Wheeling, Kenneth E. *Horse-Drawn Vehicles at the Shelburne Museum*. Shelburne, Vt.: Shelburne Museum, 1974.

Land Transportation—Human Powered
Definition: An artifact, powered by human energy alone, originally created to transport people or goods on land without restriction to a fixed route determined by a track or other guidance device.

Calif, Ruth. *The World of Wheels: An Illustrated History of the Bicycle and Its Relatives*. East Brunswick, N.J.: Cornwall Books, 1981.

Montgomery Ward and Co. *Catalogue and Buyers' Guide, No. 57, Spring and Summer, 1895*. New York: Dover Publications, 1969.

Murphy, Jim. *Two Hundred Years of Bicycles*. New York: Harper & Row, 1983.

Oliver, Smith H. *Catalog of the Cycle Collection of the Division of Engineering, United States National Museum*. Washington, D.C.: Smithsonian Institution Press, 1953.

Oliver, Smith H., and Berkebile, Donald H. *Wheels and Wheeling: The Smithsonian Cycle Collection*. Washington, D.C.: Smithsonian Institution Press, 1974.

Land Transportation—Motorized
Definition: An artifact, powered by some kind of self-acting mechanism such as a motor, originally created to transport people or goods on land without restriction to a fixed route determined by a track or other guidance device.

Burness, Tad. *American Truck Spotter's Guide, 1920-1970*. Osceola, Wis.: Motorbooks International, 1978.

Corbeil, Jean-Claude, ed. *The Facts on File Visual Dictionary*. New York: Facts on File, 1986.

Miller, Dennis. *The Illustrated Encyclopedia of Trucks and Buses*. New York: W.H. Smith, 1982.

Norbeck, Jack. *Encyclopedia of American Steam Traction on Engines*. Sarasota, Fla.: Crestline, 1976.

Oliver, Smith H., and Berkebile, Donald H. *The Smithsonian Collection of Automobiles and Motorcycles*. Washington, D.C.: Smithsonian Institution Press, 1968.

Page, Victor Wilfred. *Handbook of Early Motorcycles: Construction, Operation, Service*. Arcadia, Calif.: Post Motor Books, 1971.

Rand McNally and Co., ed. *The Rand McNally Encyclopedia of Transportation*. Chicago: Rand McNally, 1976.

Wendell, Charles H. *Encyclopedia of American Farm Tractors*. Sarasota, Fla.: Crestline, 1979.

Land Transportation—Accessory
Definition: An artifact originally created as an accessory used in the transportation of people or goods on land without restriction to a fixed route determined by a track or other guidance device.

Montgomery Ward and Co. *Catalogue and Buyers' Guide, No. 57, Spring and Summer, 1895*. New York: Dover Publications, 1969.

Moseman (C. M.) and Brother. *Moseman's Illustrated Guide for Purchasers of Horse Furnishing Goods: Novelties and Stable Appointments, Imported and*

Domestic. 1892. Reprint. New York: Arco, 1976.

Rail Transportation
Rail Transportation—Equipment
Definition: An artifact originally created to transport people or goods on or along a fixed route determined by a track or some similar device.

Adams, Ramon F. *The Language of the Railroader*. Norman: University of Oklahoma Press, 1977.
Association of American Railroads. *Car and Locomotive Cyclopedia of American Practice*. 3rd. ed. New York: Simmons-Boardman, 1974.
Bruce, Alfred W. *The Steam Locomotive in America*. New York: Bonanza Books, 1952.
Forney, Matthias N. *The Railroad Car Builder's Pictorial Dictionary*. 1889. Reprint. New York: Dover Publications, 1974.

Rail Transportation—Accessory
Definition: An artifact originally created as an accessory to the transportation of people or goods on or along a fixed route determined by a track or some similar device.

Water Transportation
Water Transportation—Equipment
Definition: An artifact originally created to transport people or goods on or under water.

Blair, Carvel Hall, and Ansel, Willits Dyer. *A Guide to Fishing Boats and Their Gear*. Cambridge, Md.: Cornell Maritime Press, 1968.
Jane's Fighting Ships, annual editions.
Kemp, Peter, ed. *The Oxford Companion to Ships and the Sea*. London: Oxford University Press, 1976.
Svensson, Sam, ed. *The Lore of Sail*. New York: Facts on File, 1982.

Water Transportation—Accessory
Definition: An artifact originally created as an accessory for the transportation of people or goods on or under water.

Category 8: Communication Artifacts

Definition: Artifacts originally created as expressions of human thought. Communication artifacts comment on, interpret, or enhance people's environments. Communication artifacts can function symbolically or literally. This category excludes the tools and equipment that are used to create communication artifacts.

Advertising Medium
Definition: An artifact originally created to call public attention to a product, service, or event and to elicit a specific response in regard to products, services, or events. Generally, the intended response is to urge people to acquire, use, or participate in the product, service, or event that is being advertised.

Barry, Kit. *The Advertising Trade Card*. Brattleboro, Vt.: privately printed, 1981.
Graham, Irvin. *Encyclopedia of Advertising*. New York: Fairchild, 1969.

Art
Definition: An artifact originally created for the expression and communication of ideas, values, or attitudes through images, symbols, and abstractions. It often reflects aesthetic pleasure or demonstrates creative skills and dexterity. Art can be uniquely created, or it can be produced in a medium that allows many duplicates to be made.

Allen, Edward M. *Harper's Dictionary of the Graphic Arts*. New York: Harper & Row, 1963.
Burnham, Harold, and Burnham, Dorothy. *"Keep Me Warm One Night": Early Handweaving in Eastern Canada*. Toronto: University of Toronto Press, 1972.
Buschsbaum, Ann. *Practical Guide to Print Collecting*. New York: Van Nostrand Reinhold, 1975.
Christensen, Erwin C. *Early American Wood Carving*. New York: Dover Publications, 1973.
Haggar, Reginald. *A Dictionary of Art Terms: Painting, Sculpture, Architecture, Engraving, etc*. New York: Hawthorn, 1962.
Marzio, Peter. *The Democratic Art, Chromolithography, 1840-1900*. Boston: David R. Godine, 1979.
Osborne, Harold, ed. *The Oxford Companion to Art*. Oxford: Clarendon Press, 1970.
Ring, Betty. *Needlework: An Historical Survey*. Pittstown, N.J.: Main Street Press, 1984.
Safford, Carleton L., and Bishop, Richard. *America's Quilts and Coverlets*. New York: Bonanza Books, 1980.
Swan, Susan Burrows. *A Winterthur Guide to American Needlework*. New York: Crown Publishers, 1976.

Ceremonial Artifact
Definition: Artifacts originally created for carrying on governmental, fraternal, religious, or other organized and sanctioned societal activities. These artifacts are intended to evoke, symbolize, or express certain

aspects of the traditions or heritage of a community or group of people. Usually, they are associated with rituals or ceremonies. This classification includes: (1) any religious artifact, such as communion cups and altar pieces (note, though, that personal devotional objects such as religious medals and talismans are classified under "Personal Symbol"); (2) any object used in a ceremony concerned with major personal events or crises, such as birth, puberty, sickness, or death, or concerned with community events or crises, such as harvest festivals or the need for rain; and (3) any object used in the ceremonial activities of a fraternity, lodge, club, governmental, or military organization, such as the pennant of a Girl Scout troop.

Duval, Francis Y., and Rigby, Ivan. *Early American Gravestone Art in Photographs*. New York: Dover Publications, 1978.

Miles, Charles. *Indian and Eskimo Artifacts of North America*. New York: Bonanza Books, 1963.

Talocci, Mauro. *Guide to the Flags of the World*. New York: William Morrow and Co., 1982.

Van Duren, Peter. *Orders of Knighthood, Awards and the Holy See*. Buckinghamshire, England: Van Duren Publishers, 1984.

Documentary Artifact

Definition: An artifact originally created to comunicate information to people. Unlike "Advertising Media," "Documentary Artifacts" are not generally intended to elicit a specific response in regards to products, services, or events. Instead, they present a point of view, an image, or a set of ideas, often with the aim of enlightening or swaying the attitude of people. This classification includes documents and also artifacts displaying commemorative information on materials other than paper, such as commemorative coins and souvenir plates.

Allen, Alistair, and Hoverstadt, Joan. *The History of Printed Scraps*. London: New Cavendish Books, 1983.

Duckett, Kenneth W. *Modern Manuscripts: A Practical Manual for Their Management, Care, and Use*. Nashville: American Association for State and Local History, 1975.

Hornung, Clarence P., and Johnson, Fridolf. *200 Years of American Graphic Art*. New York: Braziller, 1976.

Marzio, Peter. *The Democratic Art, Chromolithography, 1840-1900*. Boston: David R. Godine, 1979.

Reilly, James M. *Care and Identification of 19th Century Photographic Prints*. Rochester, N.Y.: Kodak, 1986.

Roberts, Matt T., and Etherington, Don. *Bookbinding and the Conservation of Books: A Dictionary of Descriptive Terminology*. Washington, D.C.: Library of Congress, 1982.

Exchange Medium

Definition: An artifact originally created to be used as a medium of exchange, such as coins, currency, or shell money, or as a means of obtaining specific services, such as a postage stamp or a transportation token.

Hobson, Burton, and Reinfeld, Fred. *Illustrated Encyclopedia of World Coins*. Garden City, N.Y.: Doubleday, 1970.

Schilke, Oscar G., and Soloman, Raphael E. *America's Foreign Coins*. New York: Coin and Currency Institute, 1964.

Williams, L. N., and Williams, M. *Fundamentals of Philately*. State College, Pa.: American Philatelic Society, 1971.

Personal Symbol

Definition: An artifact originally created to communicate a particular personal belief, achievement, status, or membership. This classification includes articles of adornment or clothing worn primarily for their symbolism, such as a fraternal ring, an academic gown, or a crown. "Personal Symbols" differ from "Ceremonial Artifacts" in that they express individual ideas, not the ideas of a group.

Campbell, Burt L. *Marine Badges and Insignia of the World*. London: Blandford Press, 1983.

Carman, W. Y. *A Dictionary of Military Uniform*. New York: Charles Scribners Sons, 1977.

Emerson, William K. *Chevrons: Illustrated History and Catalog of U. S. Army Insignia*. Washington, D.C.: Smithsonian Institution Press, 1983.

Gregor, Arthur S. *Amulets, Talismans and Fetishes*. New York: Charles Scribners Sons, 1975.

Loubat, Joseph F. *Medallic History of the U.S.A.* 1878. Reprint. New Milford, Conn.: Flayderman, 1967.

Marcus, Mordecai. *Talismans*. Lafayette, Ind.: Sparrow Press, 1981.

Palliser, Fanny M. *Historic Devices, Badges, and War Cries*. 1870. Reprint. Detroit, Mich.: Gale Research Co., 1971.

Potter, Carole A. *Knock on Wood: An Encyclopedia of Talismans, Charms, Superstitions, and Symbols*. New York: Beaufort Books, 1983.

Sullivan, Edmund B. *American Political Campaign Badges and Medalets, 1789-1892*. Lawrence, Mass.: Quarterman, 1981.

Van Duren, Peter. *Orders of Knighthood, Awards and the Holy See*. Buckinghamshire, England: Van Duren Publishers, 1984.

Werlich, Robert. *Orders and Decorations of All Nations*. Washington, D.C.: Quaker Press, 1974.

Category 9: Recreational Artifacts

Definition: Artifacts originally created to be used as toys or to carry on the activities of sports, games, gambling, or public entertainment.

Game

Definition: An artifact originally created for a competitive activity based upon chance, problem-solving, or calculation, rather than physical effort, and conducted according to stated rules. This category also includes all forms of gambling devices.

Peck and Snyder. *Sporting Goods, 1886 Illustrated Catalog*. Princeton, N.J.: Pyne Press, n.d.

Stella, Jacques. *Games and Pastimes of Childhood*. New York: Dover Publications, 1969.

Public Entertainment Device

Definition: An artifact originally created for the production of non-competitive spectator entertainment.

Heffner, Hubert C. *Modern Theater Practice: A Handbook for Play Production*. Englewood Cliffs, N.J.: Prentice-Hall, 1973.

Recreational Device

Definition: An artifact originally created for a participatory, usually non-competitive, recreational activity other than an athletic game or exercise. This classification includes equipment for entertainment, such as a carrousel, a pinball machine, a swing, or a slide, whether such equipment is publicly or privately owned and whether or not a charge is associated with its use.

Green, Harvey. *Fit for America*. New York: Viking Press, 1986.

National Workshop on Equipment and Supplies for Athletics, Physical Education, and Recreation (1959: Michigan State University). *Equipment and Supplies for Athletics, Physical Education, and Recreation, by Participants in National Conference*. Chicago: Athletic Institute, 1960.

Weaver, Robert B. *Amusements and Sports in American Life*. 1939. Reprint. Westport, Conn.: Greenwood Press, 1968.

Sports Equipment

Definition: An artifact originally created for a physical activity that is often competitive. This classification includes equipment used in all forms of athletic games and exercises, including individual and team sports.

Cuddon, J. A. *The International Dictionary of Sports and Games*. New York: Schocken, 1979.

Ditchfield, Peter H. *Old English Sports, Pastimes and Customs*. 1891. Reprint. Boston: Charles River Books, 1977.

Green, Harvey. *Fit for America*. New York: Viking Press, 1986.

Murphy, Jim. *Two Hundred Years of Bicycles*. New York: Harper & Row, 1983.

Peek, Hedley, and Aflalo, F. G. *Encyclopedia of Sport*. 1897. Reprint. Detroit, Mich.: Gale Research Co., 1976.

Toy

Definition: An artifact originally created as a plaything. Toys often represent functional objects, such as toy hammers and toy ships, or living things, such as baby dolls and stuffed animals. Toys also include objects developed primarily for play, such as balls, tops, and kites.

Ayres, William S. *The Warner Collector's Guide to American Toys*. New York: Warner Books, 1981.

Coleman, Dorothy, et al. *The Collector's Encyclopedia of Dolls*. New York: Crown Publishers, 1968.

King, Constance Eileen. *The Encyclopedia of Toys*. Secaucus, N.J.: Chartwell, 1984.

McClintock, Inez, and McClintock, Marshall. *Toys in America*. Washington, D.C.: Public Affairs Press, 1961.

McClinton, Katherine M. *Antiques of American Childhood*. New York: C. N. Potter (distributed by Crown Publishers), 1970.

Schroeder, Joseph J., comp. *The Wonderful World of Toys, Games and Dolls, 1860-1930*. Reprint. Northfield, Ill.: Digest Books, 1971.

Category 10: Unclassifiable Artifacts

Definition: Artifacts originally created to serve a purpose that cannot be identified at the time the object is cataloged.

Artifact Remnant

Definition: A segment or incomplete part of an artifact originally created to fulfill a purpose that cannot be determined or inferred from the fragment.

Function Unknown

Definition: An artifact originally created to serve an unknown purpose.

Multiple Use Artifact

Definition: An artifact originally created to serve a variety of purposes that extend beyond the range of one classification. Tools that have multiple attachments that enable them to serve a range of functions fall into this classification along with hybrid tools that are made of several disparate parts that are used together to perform a particular function such as mending fences.

HIERARCHICAL LIST WITH PAGE NUMBERS REFERRING TO CHAPTER IV.

- -

CATEGORY 1: STRUCTURES

BUILDING

 A-FRAME
 AIRPORT
 note use for the complex of landing field and associated buildings
 APARTMENT
 AQUARIUM
 ARCADE
 ARCHWAY
 ARMORY
 BALCONY
 BARN
 BARN, HOPCURING
 BARN, TOBACCO
 Belfry ... use TOWER, BELL
 Belvedere ... use GAZEBO
 BLOCKHOUSE
 Building, Ceremonial ... use more specific term, e.g.: CHURCH;
 MEETINGHOUSE; TEMPLE
 Building, Civic ... use more specific term, e.g.: FIREHOUSE; STATION,
 POLICE; COURTHOUSE
 Building, Commercial ... use more specific term, e.g.: RESTAURANT; SHOP,
 BARBER; STORE, DRUG
 Building, Cultural ... use more specific term, e.g.: MUSEUM; THEATER
 Building, Defense ... use more specific term, e.g.: ARMORY; BLOCKHOUSE;
 FORT
 Building, Educational ... use more specific term, e.g.: SCHOOL; LIBRARY;
 MUSEUM
 Building, Farm ... use more specific term, e.g.: BARN; COOP, CHICKEN
 Building, Health ... use more specific term, e.g.: HOSPITAL
 Building, Industrial ... use PLANT, INDUSTRIAL
 BUILDING, OFFICE
 BUILDING, RECREATIONAL
 Building, Residential ... use HOUSE or another more specific term, e.g.:
 HOGAN; WICKIUP
 BUILDING, STORAGE
 Building, Transportation ... use more specific term, e.g.: DEPOT;
 TERMINAL
 BUTTRESS
 Cabin ... use HOUSE
 CASTLE
 Chalet ... use HOUSE
 CHURCH
 COOP, CHICKEN
 CORNCRIB

- -

BUILDING (cont.)

```
     Cottage ... use HOUSE
   COURTHOUSE
    Crib, Corn ... use CORNCRIB
   CRIB, TOOL
   DEPOT ... rt TERMINAL
   DEPOT, RAILROAD
   DORMER
   DUPLEX
    Factory ... use PLANT, INDUSTRIAL
   FIREHOUSE
   FIREPLACE
   FORT
   GARAGE
   GATEHOUSE
   GAZEBO
   GREENHOUSE
   HALL, TOWN
   HOGAN
   HOSPITAL
   HOTEL
   HOUSE
   HOUSE, CHARNEL ... rt MAUSOLEUM
   HOUSE, FRUIT-DRYING
   HOUSE, HOG
   HOUSE, POWDER
    House, Toll ... use TOLLHOUSE
   ICEHOUSE
   INN
   JAIL
   JOINT, MORTISE
   JOIST, FLOOR
   KENNEL
   KIVA
   LEAN-TO
   LIBRARY
   LIGHTHOUSE
   LODGE
   MAUSOLEUM ... rt HOUSE, CHARNEL
   MEETINGHOUSE
   MILL
   MONUMENT ... rt SHRINE
   MUSEUM
   OFFICE, POST
   OUTHOUSE
    Pagoda ... use TEMPLE
   PARLOR, MILKING
   PAVILLION
   PERGOLA
```

- -

BUILDING (cont.)

 PLANETARIUM
 PLANT, INDUSTRIAL
 PORCH
 PORTICO
 Privy ... use OUTHOUSE
 PUEBLO
 PUMPHOUSE
 RESTAURANT
 ROUNDHOUSE
 SALOON
 SCHOOL
 SHAFTHOUSE
 SHED
 SHED, CATTLE
 SHED, SHEEP
 SHELL, BAND
 SHOP
 note usually modified to indicate service or product provided
 SHRINE ... rt MONUMENT
 SILO
 SMOKEHOUSE
 SNOWSHED
 SPRINGHOUSE
 STABLE
 STABLE, LIVERY
 STAIRCASE
 STALL
 STANCHION
 Station ... use DEPOT
 STATION, POLICE
 STATION, SPACE
 STONE, BUILDING
 STORE
 note usually modified to indicate service or product provided
 Store, Retail ... use more specific term, e.g.: STORE, GROCERY
 SYNAGOGUE
 TAVERN
 TEMPLE
 TENT
 TEPEE
 TERMINAL ... rt DEPOT
 THEATER
 TOLLHOUSE
 TOWER
 TOWER, BELL
 TOWER, CONTROL
 TURRET

- -

BUILDING (cont.)

 Warehouse ... use BUILDING, STORAGE
 WICKIUP
 WIGWAM
 WOODSHED

BUILDING COMPONENT

 ANTEFIX
 ASSEMBLY, LATCH
 BALUSTER
 BAR
 BARGEBOARD
 BOARD
 BOLT
 BOLT, DRAW
 BRACKET
 BRACKET, FLOWERPOT
 BRACKET, LAMP
 BRACKET, PEDIMENT
 Bracket, Plant ... use BRACKET, FLOWERPOT
 Bracket, Shelf ... use BRACKET
 Bracket, Wall ... use BRACKET
 BRICK
 BULKHEAD
 BUMPER
 CABINET, MEDICINE
 CAP, WINDOW
 CASE, RADIATOR
 CHIMES, DOOR
 Chimney ... use more specific term, e.g.: FLUE
 Chimneypiece ... use OVERMANTEL
 COLUMN
 CORNERSTONE
 CORNICE
 COUNTERWEIGHT
 COVER, FLUE
 COVERPLATE
 CUPOLA
 DAMPER, VENTILATOR
 DOOR
 DOOR, ACCORDION
 DOOR, SCREEN
 DOORBELL
 DOORCAP
 DOORCASE
 DOORFRAME

- -

BUILDING COMPONENT (cont.)

 DOORKNOB
 DOORPLATE
 DOWNSPOUT
 DUMBWAITER
 ELEVATOR
 ENFRAMEMENT, DOOR
 note use for entire structure including case and frame and possibly
 other parts such as the door, fanlight, sidelight etc.
 ENFRAMEMENT, FIREPLACE
 ENTABLATURE
 ESCAPE, FIRE
 ESCUTCHEON
 FANLIGHT ... rt SASH, WINDOW
 FINIAL
 FIREPOLE
 FITTING, PIPE
 FLUE
 FRAME, WINDOW
 GARGOYLE
 GRATE, REGISTER
 GRILL
 GRILL, VENTILATOR
 GRILL, WINDOW
 HASP
 HINGE
 HOOK, CEILING
 KNOCKER
 LACTORIUM
 Latch ... use ASSEMBLY, LATCH
 LATH
 LINTEL
 LOCK, DOOR
 LOCK, WINDOW
 LOG
 MANTEL
 Mantelshelf ... use MANTEL
 MOSAIC
 NEWEL
 ORNAMENT, CEILING
 OVERMANTEL
 PANTILE
 PEDESTAL
 PEDIMENT
 PILASTER
 PILLAR
 PIPE
 PIPE, WATER
 PLAQUE, DATE

- -

BUILDING COMPONENT (cont.)

 Plate, Doorknob ... use ESCUTCHEON
PLATE, STRIKE
POT, CHIMNEY
PULPIT
PUSHPLATE, DOOR
RAIL, BAR
ROD, LIGHTNING
ROD, STAIR
ROSETTE
SASH, WINDOW ... rt FANLIGHT; SIDELIGHT; SKYLIGHT
SCREEN, WINDOW
 Scutcheon ... use ESCUTCHEON
SEAT, WINDOW
SHELF
SHINGLE
SHUTTER
SIDELIGHT ... rt SASH, WINDOW
SILL
SILL, WINDOW
SKYLIGHT
SLOT, MAIL
 Smokestack ... use FLUE
SPIKE
SPIRE
SPOUT, DRAIN
STAGE
STAND, TICKET
STONE, DATE
STOOP
TIEBACK
TILE
TILE, DRAIN
TILE, FIREPLACE
TILE, ROOF
VALVE, PIPE
VENTILATOR
VENTILATOR, WINDOW
WALLPAPER
 Weight, Counter ... use COUNTERWEIGHT
 Window, Stained glass ... use WINDOWPANE, LEADED
WINDOWPANE
WINDOWPANE, LEADED

- -

SITE FEATURE

 BIRDBATH
 BIRDHOUSE
 BRICK, PAVING
 CELLAR, ROOT
 CISTERN
 DOGHOUSE
 FEEDER, BIRD
 FENCE
 FIREPIT
 FLAGPOLE
 FOUNTAIN, WATER
 GATE
 GATEWAY
 GUARDRAIL
 LAMPPOST
 OVEN, BEEHIVE
 PADDOCK
 PEDESTAL, GARDEN
 PLANTER, GARDEN
 PLATFORM
 POST, FENCE
 POST, HITCHING
 SWEEP, WELL
 TOLLGATE
 TRELLIS
 URN, GARDEN
 WHEEL, WELL

OTHER STRUCTURE

 AMPHITHEATER
 AQUEDUCT
 ARCH
 AVIARY
 BILLBOARD
 Bleacher ... use GRANDSTAND
 BOOTH, TELEPHONE
 BRIDGE ... rt TRESTLE
 BRIDGE, COVERED
 CAGE, ANIMAL
 CONDUIT
 COVER, DRAIN
 COVER, MANHOLE
 DAM
 DOCK
 EARTHWORK

- -

OTHER STRUCTURE (cont.)

 ELEVATOR, GRAIN
 Fireplug ... use HYDRANT
 FLOODGATE
 FLUME ... rt SLUICE
 GRANDSTAND
 HYDRANT
 LOCK
 MINE
 MOUND
 PALISADE
 PENSTOCK
 PIER
 POLE
 POLE, UTILITY
 POOL
 POOL, SWIMMING
 QUARRY
 Race ... use FLUME
 RESERVOIR
 SHELTER, BOMB
 SLUICE ... rt FLUME
 SPILLWAY
 STADIUM
 STILE
 TAILRACE
 TOWER
 TOWER, OBSERVATION
 TOWER, TRANSMITTING
 TOWER, WATER
 TRESTLE ... rt BRIDGE
 TUNNEL, RAILROAD
 WHARF

- -

CATEGORY 2: FURNISHINGS

BEDDING

 Afghan ... use BLANKET
 BAG, SLEEPING
 BEDSPREAD
 BEDSPRINGS
 note refers to a construction of springs and supports for a mattress
 BLANKET
 BLANKET/SHEET
 BOLSTER
 CANOPY
 CLOTH, GROUND
 COMFORTER
 Counterpane ... use BEDSPREAD
 COVER, BOLSTER
 COVER, MATTRESS
 COVER, PILLOW
 Coverlet ... use BEDSPREAD
 Flounce, Bed ... use RUFFLE, DUST
 HAMMOCK
 HEADREST
 MAT, SLEEPING
 MATTRESS
 MATTRESS, AIR
 NET, MOSQUITO
 PILLOW
 PILLOWCASE
 QUILT
 RUFFLE, DUST
 SHAM, BOLSTER
 SHAM, PILLOW
 SHEET
 Sheet/Blanket ... use BLANKET/SHEET
 Slip, Pillow ... use PILLOWCASE
 Springs, Box ... use BEDSPRINGS
 Throw, Bed ... use BEDSPREAD
 Tick ... use COVER, MATTRESS

FLOOR COVERING

 CARPET
 COVER, STAIR
 DOORMAT

- -

FLOOR COVERING (cont.)

 Drugget ... use RUG
 FLOORCLOTH
 Linen, Stair ... use COVER, STAIR
 MAT
 PAD, CARPET
 RUG
 RUG, LINOLEUM
 Rug, Scatter ... use RUG, THROW
 RUG, THROW
 RUNNER
 TREAD, STAIR

FURNITURE

 Armchair ... use more specific term, e.g.: CHAIR, EASY; -,DINING
 Armoire ... use WARDROBE
 BACKREST
 BARSTOOL
 BASSINET
 BED
 BED, BUNK
 BED, CANOPY
 BED, FIELD
 BED, FOLDING
 BED, FOUR-POSTER
 BED, HALF-TESTER
 Bed, Murphy ... use BED, FOLDING
 Bed, Plantation ... use BED, CANOPY
 BED, SLEIGH
 BED, SOFA
 BED, TRUNDLE
 BED, WATER
 BENCH
 BENCH, BUCKET
 BENCH, CIRCULAR
 BENCH, GARDEN
 Bench, Hooded ... use SETTLE
 Bench, Mammy ... use CRADLE/ROCKER
 BENCH, PARK
 BENCH, PICNIC
 BENCH, WINDOW
 BOARD, HUNT ... rt SIDEBOARD
 BOOKCASE
 Breakfront ... use more specific term, e.g.: BOOKCASE; CABINET, CHINA
 Buffet ... use SIDEBOARD

- -

FURNITURE (cont.)

 Bureau ... use CHEST OF DRAWERS
 CABINET ... rt CUPBOARD
 CABINET, CHINA
 CABINET, COIN
 CABINET, CORNER
 Cabinet, Curio ... use CABINET, DISPLAY
 CABINET, DISPLAY
 CABINET, FILING
 CABINET, GUN
 CABINET, KITCHEN
 CABINET, LIQUOR
 CABINET, MUSIC
 CABINET, PARLOR
 CABINET, PHONOGRAPH
 CABINET, RADIO
 CABINET, RECORD
 Cabinet, Sewing ... use TABLE, SEWING
 CANDLESTAND
 CANTERBURY ... rt RACK, MAGAZINE
 CART, TEA ... rt TABLE, TEA
 CASE, DRESSING ... rt TABLE, DRESSING
 CELLARETTE
 CHAIR
 CHAIR, ALTAR
 Chair, Arm ... use more specific term, e.g.: CHAIR, EASY; -,DINING
 CHAIR, BALLROOM
 CHAIR, BARBER'S
 CHAIR, BEACH
 CHAIR, BED
 Chair, Bent-wire ... use CHAIR, SODA FOUNTAIN
 CHAIR, CAPTAIN'S
 CHAIR, CORNER
 Chair, Deck ... use CHAIR, FOLDING
 CHAIR, DESK
 CHAIR, DINING
 CHAIR, EASY
 CHAIR, FIREPLACE
 CHAIR, FOLDING
 CHAIR, GARDEN
 Chair, Gondola ... use CHAIR, DINING
 CHAIR, GREAT
 CHAIR, HALL
 Chair, High ... use HIGHCHAIR
 CHAIR, INVALID
 Chair, Morris ... use CHAIR, RECLINING
 CHAIR, MUSIC
 CHAIR, PORTER'S
 CHAIR, POTTY

- -

FURNITURE (cont.)

 CHAIR, RECLINING
 CHAIR, ROCKING
 Chair, Side ... use more specific term, e.g.: CHAIR, HALL; -,DINING
 CHAIR, SLIPPER
 CHAIR, SODA FOUNTAIN
 CHAIR, STENOGRAPHER'S
 CHAIR, STEP
 Chair, Swivel ... use more specific term, e.g.: CHAIR, STENOGRAPHER'S
 CHAIR, TABLET-ARM
 CHAIR, TREATMENT
 CHAIR, WING
 CHAIR/TABLE ... rt TABLE, SETTLE
 Chaise longue ... use LOUNGE
 CHEST
 CHEST, APOTHECARY
 CHEST, BLANKET
 CHEST, CAMPAIGN
 Chest, High ... use CHEST OF DRAWERS
 Chest, Hope ... use CHEST, BLANKET
 CHEST, SEWING
 CHEST OF DRAWERS ... rt CHIFFOROBE; CHEST ON FRAME
 Chest on chest ... use CHEST OF DRAWERS
 CHEST ON FRAME ... rt CHEST OF DRAWERS
 Chiffonier ... use CHEST OF DRAWERS
 CHIFFOROBE ... rt CHEST OF DRAWERS; WARDROBE
 COATRACK ... rt RACK, HAT
 COAT-TREE ... rt HALLSTAND
 COMMODE
 COUCH
 Couch, Fainting ... use COUCH
 CRADLE
 CRADLE/ROCKER
 Credenza ... use SIDEBOARD
 CRIB
 CUPBOARD ... rt CABINET
 CUPBOARD, CORNER
 CUPBOARD, HANGING
 CUPBOARD, PRESS
 Davenport ... use SOFA
 DAYBED
 DESK
 DESK, CAMPAIGN
 DESK, DROP-FRONT ... rt SECRETARY
 DESK, QUARTER-CYLINDER
 DESK, ROLLTOP
 DESK, SCHOOL
 DESK, SLANT-TOP
 DESK, TAMBOUR

- -

FURNITURE (cont.)

 Divan ... use SOFA or SETTEE or SEAT, LOVE
 Dresser ... use CHEST OF DRAWERS
 EASEL
 ETAGERE ... rt WHATNOT
 FENDER
 Fireguard ... use FENDER
 FOOTSTOOL ... rt OTTOMAN; HASSOCK
 Glass, Dressing ... use MIRROR, CHEVAL
 Glass, Looking ... use MIRROR, CHEVAL
 GLIDER
 HALLSTAND ... rt COAT-TREE
 Hall-tree ... use COAT-TREE
 HASSOCK ... rt OTTOMAN; FOOTSTOOL
 Highboy ... use CHEST OF DRAWERS
 HIGHCHAIR
 Hutch ... use more specific term, e.g.: CABINET, CORNER; CABINET, CHINA
 Kas ... use WARDROBE
 Klismos ... use CHAIR, DINING
 LECTURN
 LOUNGE
 Lowboy ... use CHEST OF DRAWERS
 Meridienne ... use LOUNGE
 MIRROR
 MIRROR, CHEVAL
 MIRROR, DRESSER
 Mirror, Girandole ... use MIRROR, WALL
 Mirror, Mantel ... use MIRROR, WALL
 Mirror, Tabernacle ... use MIRROR, WALL
 MIRROR, WALL
 Nightstand ... use TABLE, NIGHT
 OTTOMAN ... rt HASSOCK; FOOTSTOOL
 PEDESTAL
 PEW
 PLAYPEN
 PODIUM
 Press, Linen ... use CUPBOARD, PRESS
 PRIE-DIEU
 RACK
 RACK, BOOT
 RACK, GUN
 RACK, HAT ... rt COATRACK
 RACK, LUGGAGE
 RACK, MAGAZINE ... rt CANTERBURY
 RACK, PLANT
 RACK, TOWEL
 Recamier ... use LOUNGE
 SAFE
 SCREEN

- -

FURNITURE (cont.)

```
    SCREEN, POLE
    SEAT, GARDEN
    SEAT, LOVE ... rt SOFA, CONVERSATIONAL
    SECRETARY ... rt DESK, DROP-FRONT
     Server ... use TABLE, SERVING
    SETTEE
      note use for a sofa that is all wood with an open or upholstered back
      rt    SOFA
    SETTLE
     Shrank ... use WARDROBE
    SIDEBOARD ... rt BOARD, HUNT
    SOFA ... rt SETTEE
    SOFA, CONVERSATIONAL
      note use for a sofa seating two persons facing in opposite directions
      rt    SEAT, LOVE
     Stand, Basket ... use TABLE, KNITTING
     Stand, Candle ... use CANDLESTAND
    STAND, PLANT
    STAND, SHAVING
    STEPS, BED
    STEPS, LIBRARY
    STOOL
     Stool, Bar ... use BARSTOOL
     Stool, Camp ... use STOOL, FOLDING
    STOOL, FOLDING
    STOOL, GOUT
    STOOL, KITCHEN
    STOOL, MILKING
    STOOL, STEP
    SUITE, BEDROOM
    SUITE, DINING
    SUITE, GARDEN
    SUITE, HALL
    SUITE, LIBRARY
     Suite, Living Room ... use SUITE, PARLOR
    SUITE, NURSERY
    SUITE, PARLOR
    TABLE
     Table, Banquet ... use TABLE, DINING
    TABLE, BREAKFAST
    TABLE, CALLING CARD
    TABLE, CARD
     Table, Chair ... use CHAIR/TABLE
    TABLE, CHART
    TABLE, COFFEE
    TABLE, DINING
    TABLE, DRESSING ... rt CASE, DRESSING
```

- -

FURNITURE (cont.)

 Table, Drop-leaf ... use more specific term, e.g.: TABLE, DINING
 TABLE, GAME
 TABLE, GARDEN
 TABLE, KITCHEN
 TABLE, KNITTING
 TABLE, LIBRARY
 TABLE, NESTING
 TABLE, NIGHT
 TABLE, PICNIC
 TABLE, PIER
 TABLE, RENT
 TABLE, SERVING
 TABLE, SETTLE ... rt CHAIR/TABLE
 TABLE, SEWING
 Table, Side ... use more specific term, e.g.: TABLE, NIGHT
 TABLE, SOFA
 Table, Stacking ... use TABLE, NESTING
 TABLE, TEA ... rt CART, TEA
 TABLE, VESTING
 Table, Work ... use more specific term, e.g.: TABLE, SEWING
 TABLE, WRITING
 TABORET
 Teapoy ... use TABLE, TEA
 Tepoy ... use TABLE, TEA
 Tete-a-tete ... use SOFA, CONVERSATIONAL
 Torchere ... use CANDLESTAND
 VALET
 Vanity ... use TABLE, DRESSING
 Vitrine ... use CABINET, DISPLAY
 Wagon, Tea ... use CART, TEA
 WARDROBE ... rt CHIFFOROBE
 WASHSTAND
 WHATNOT ... rt ETAGERE

HOUSEHOLD ACCESSORY

 Afghan ... use THROW
 ANTIMACASSAR
 AQUARIUM
 ARMOR, PARLOR
 ASHTRAY
 AVIARY
 BASKET, HANGING
 BEDKEY
 BELLPULL
 BIRDCAGE

- -

HOUSEHOLD ACCESSORY (cont.)

 BOOKEND
 Bookstand ... use STAND, BOOK
 BOOTJACK
 BOTTLE, HOT-WATER
 BOWL
 BOWL, BULB
 Bowl, Fish ... use FISHBOWL
 BOWL, FLOWER
 BOX, BIBLE
 BOX, CIGARETTE
 BOX, JEWELRY
 BOX, LETTER
 BOX, PIPE
 Box, Strong ... use STRONGBOX
 BOX, TRINKET
 BOX, WALL
 BRACKET
 BURNER, INCENSE
 CABINET, TRINKET
 CACHEPOT
 CADDY, DRAWER
 CAP, BOTTLE
 CASE, DISPLAY
 CASTER
 CATCHER, FLY
 CATCHER, WATER
 CHEST, MEDICINE
 CHEST, SILVER
 Cloth, Mantel ... use LAMBREQUIN
 COATHANGER
 Cork ... use STOPPER, BOTTLE
 COVER, ASH
 COVER, CHAIR SEAT
 COVER, CUSHION
 COVER, DESK
 Cover, Dust ... use SLIPCOVER
 COVER, LAMP
 Cover, Piano ... use THROW
 Cover, Table ... use THROW, TABLE
 CUP, CASTER
 CURTAIN, SHOWER
 CUSHION
 Cuspidor ... use SPITTOON
 DISH, COMB
 DISH, RING
 DOILY
 Dome, Display ... use JAR, BELL
 DOORSTOP

- -

HOUSEHOLD ACCESSORY (cont.)

 EASEL, PICTURE
 FISHBOWL
 FLOWERPOT
 FLOWERPOT, HANGING
 FLYPAPER
 FLYTRAP
 FLYWISK
 FRAME, PICTURE
 FROG
 HALF-FIGURE
 Hanger, Clothes ... use COATHANGER
 HANGER, PICTURE
 HOLDER, BOTTLE
 HOLDER, MATCH
 HOLDER, PIPE
 HOLDER, SCARF
 HOLDER, SPILL
 HOLDER, TISSUE
 HOLDER, TREE
 HOLDER, UMBRELLA
 HOLDER, WATCH
 HOOK
 HOOK, COAT
 HOOK, CURTAIN
 HOOK, PICTURE
 HUMIDOR
 HYDRIA ... rt JAR, WATER
 INCENSE
 JAR, BELL
 JAR, POTPOURRI
 JAR, SLOP
 JAR, SNUFF
 Jar, Tobacco ... use HUMIDOR
 JAR, WATCH
 JAR, WATER ... rt HYDRIA
 JARDINIERE ... rt PLANTER
 KEY
 LADDER
 Ladder, Step ... use STEPLADDER
 LAMBREQUIN
 LANTERN, PAPER
 MAT, TABLE
 MOUSETRAP
 MUG
 NAIL, PICTURE
 PADLOCK
 Paper, Fly ... use FLYPAPER
 PILLOW, THROW

- -

HOUSEHOLD ACCESSORY (cont.)

 PLANTER ... rt JARDINIERE
 PLUG, DRAIN
 POCKET, WALL
 Pot, Flower ... use FLOWERPOT
 POT, PASTE
 RACK
 RACK, BOOK
 RACK, BROOM
 RACK, MUSIC
 RACK, NEWSPAPER
 RACK, PIPE
 RACK, PLATE
 RACK, RECORD
 RACK, SPOON
 RACK, TOWEL
 Rack, Umbrella ... use HOLDER, UMBRELLA
 RATTRAP
 RECEIVER, CARD
 RING, CURTAIN
 note refers to shower curtain
 ROLLER, TOWEL
 RUNNER, TABLE
 SAFE, MATCH
 SAUCER, FLOWERPOT
 SCARF, BUREAU
 Scarf, Dresser ... use SCARF, BUREAU
 SCARF, PIANO
 SCARF, TABLE
 Scarf, Washstand ... use SCARF, BUREAU
 SCRAPER, BOOT
 SCREEN, TABLE
 SLIPCOVER
 SPITTOON
 STAND, BOOK
 Stand, Christmas tree ... use HOLDER, TREE
 STAND, FLOWER
 STAND, MUCILAGE
 STAND, SMOKER'S
 Stand, Umbrella ... use HOLDER, UMBRELLA
 STAND, WATCH
 STEPLADDER
 STOPPER, BOTTLE
 STRONGBOX
 SUPPORT, STOVE
 SWATTER, FLY
 THROW
 THROW, CHAIR
 THROW, SOFA

- -

HOUSEHOLD ACCESSORY (cont.)

 THROW, TABLE
 Tidy ... use ANTIMACASSAR
 TOWEL, SHOW
 Trap, Fly ... use FLYTRAP
 Trap, Mouse ... use MOUSETRAP
 Trap, Rat ... use RATTRAP
 TRAP, ROACH
 TRAY
 Tray, Calling card ... use RECEIVER, CARD
 TRELLIS, PLANT
 TRINKET
 URN
 Valance, Shelf ... use LAMBREQUIN
 VASE
 VASE, BUD
 VASE, FLOWER
 VASE, WALL
 VEILLEUSE
 VITRINE
 WARMER, BED
 WARMER, FOOT
 WASTEBASKET
 Wrench, Rope bed ... use BEDKEY

LIGHTING DEVICE

 Basket, Fire ... use CRESSET
 BEACON, LIGHTHOUSE
 Board, Control ... use CONSOLE, LIGHTING
 BOBECHE
 Borderlight ... use STRIPLIGHT
 BOX, CANDLE
 BULB, LIGHT
 CANDELABRUM ... rt CANDLESTICK; SCONCE
 CANDLE
 CANDLELIGHTER
 CANDLESNUFFER
 CANDLESTICK ... rt CANDELABRUM; SCONCE
 CANDLESTICK, MINER'S
 CHANDELIER
 note may be modified according to fuel
 CONSOLE, LIGHTING
 CRESSET
 DIMMER
 EXTINGUISHER, CANDLE
 FILLER, LAMP

- -

LIGHTING DEVICE (cont.)

 FIXTURE, CEILING
 FIXTURE, WALL
 FLASHLIGHT
 FLOODLIGHT
 FOOTLIGHT
 Gasolier ... use CHANDELIER with an appropriate modifier
 GIRANDOLE
 Holder, Candle ... use CANDELABRUM or CANDLESTICK or SCONCE
 HOLDER, LAMP
 HOLDER, RUSHLIGHT ... rt HOLDER, TAPER
 HOLDER, SPLINT
 HOLDER, TAPER ... rt HOLDER, RUSHLIGHT
 HOLDER, TORCH
 Jack, Wax ... use HOLDER, TAPER
 LAMP
 note usually modified according to fuel
 LAMP, ALCOHOL
 Lamp, Argand ... use LAMP, OIL
 Lamp, Astral ... use LAMP, OIL
 LAMP, BATTERY OPERATED
 Lamp, Betty ... use LAMP, SEMILIQUID
 LAMP, BURNING-FLUID
 LAMP, CAMPHENE
 LAMP, CANDLE
 LAMP, CARBIDE
 Lamp, Carcel ... use LAMP, OIL
 Lamp, Crusie ... use LAMP, SEMILIQUID
 LAMP, ELECTRIC
 Lamp, Fairy ... use LAMP, CANDLE
 LAMP, GAS
 LAMP, GASOLINE
 Lamp, Hitchcock ... use LAMP, OIL
 LAMP, KEROSINE
 Lamp, Mantel ... use more specific term, e.g.: LAMP, KEROSINE; -,OIL
 Lamp, Moderator ... use LAMP, OIL
 LAMP, OIL
 note use for a lamp designed to burn whale-, seal-, colza- or rosin oil
 Lamp, Rumford ... use LAMP, OIL
 LAMP, SEMILIQUID
 note use for any lamp designed to burn lard, tallow, grease
 Lamp, Solid-fuel ... use more specific term, e.g.: CANDLE; RUSHLIGHT;
 SPLINT
 Lamp, Wanzer ... use LAMP, OIL
 LANTERN
 note usually modified according to fuel; e.g., LANTERN, KEROSINE
 LANTERN, CANDLE
 LANTERN, GASOLINE
 LANTERN, KEROSINE

- -

LIGHTING DEVICE (cont.)

 RUSHLIGHT
 SAFE, CANDLE
 SCONCE ... rt CANDELABRUM; CANDLESTICK
 SEARCHLIGHT
 SHADE, SMOKE
 Snuffer, Candle ... use CANDLESNUFFER
 SPLINT
 SPOTLIGHT
 Stand, Lamp ... use HOLDER, LAMP
 STREETLAMP
 STRIPLIGHT
 TAPER
 TORCH
 TRIMMER, WICK
 WICK

PLUMBING FIXTURE

 Bath, Hip ... use BATH, SITZ
 BATH, SITZ
 BATHTUB
 BIDET
 CONDITIONER, WATER
 Disposal, Garbage ... use DISPOSER
 DISPOSER
 FAUCET
 FOOTBATH
 FOUNTAIN
 FOUNTAIN, DRINKING
 HEATER, WATER
 Lavatory ... use more specific term, e.g.: TOILET; SINK
 PUMP
 PUMP, SUMP
 PUMP, WATER
 SHOWER
 SINK
 STALL, SHOWER
 TOILET
 TUB, LAUNDRY

- -

TEMPERATURE CONTROL DEVICE

 ANDIRON
 BELLOWS
 BLOCK, FIREMAKING
 BOARD, STOVE
 Book, Match ... use MATCHBOOK
 BOW, FIRE
 Box, Match ... use MATCHBOX
 Box, Wood ... use WOODBIN
 BRACKET, FIRESET
 BROOM, FIREPLACE
 CARRIER, LOG
 CLEANER, FURNACE
 CONDITIONER, AIR
 DEHUMIDIFIER
 DRILL, FIREMAKING
 FAN, ELECTRIC
 FIREBACK
 FIREBOARD
 Firedog ... use ANDIRON
 FIRESET
 FLINT
 FURNACE
 GRATE, FIREPLACE
 GRATE, STOVE
 Guard, Spark ... use SCREEN, FIRE
 HEATER
 HEATER, ELECTRIC
 HEATER, LAMP
 HEATER, OIL
 HEATER, WATER
 HOD, COAL
 Holder, Fireplace Tool ... use STAND, FIRESET
 HOOD, STOVE
 HUMIDIFIER
 MATCH
 MATCHBOOK
 MATCHBOX
 PICK, COAL
 Pistol, Tinder ... use TINDERPISTOL
 POKER
 RADIATOR
 SCRAPER, ASH
 SCRAPER, STOVE
 SCREEN, FIRE
 SCUTTLE, COAL
 SHAKER, GRATE
 SHOVEL, COAL
 SHOVEL, FIREPLACE

- -

TEMPERATURE CONTROL DEVICE (cont.)

 SHOVEL, STOVE
 STAND, FIRESET
 STEEL
 STOVE
 note usually modified according to fuel used
 STOVEPIPE
 TANK, OIL
 TINDERBOX
 TINDERPISTOL
 TONGS, FIREPLACE
 Tools, Fireplace ... use FIRESET
 WOODBIN

WINDOW OR DOOR COVERING

 AWNING
 BLIND, VENETIAN
 BRACKET, ROD
 Canopy ... use AWNING
 CURTAIN
 CURTAIN, DOOR
 CURTAIN, FURNITURE
 CURTAIN, WINDOW
 Drape ... use DRAPERY
 DRAPERY
 Festoon ... use SWAG
 Holdback ... use LOOP, CURTAIN
 LOOP, CURTAIN
 Portiere ... use CURTAIN, DOOR
 RING, CURTAIN
 ROD, CURTAIN
 SHADE
 SHADE, SPRING-PULL
 SHUTTER
 SWAG
 VALANCE
 WEIGHT, CURTAIN

- -

CATEGORY 3: PERSONAL ARTIFACTS

ADORNMENT

 ANKLET
 ARMLET
 Bangle ... use BRACELET
 Barrette ... use ORNAMENT, HAIR
 BEAD
 BODKIN
 Boutonniere ... use PIN, LAPEL
 BOW
 BOW, SHOE
 BRACELET
 BRELOQUE
 BROOCH ... rt PIN
 Cameo ... use more specific term, e.g.: BROOCH
 CASE, JEWELRY
 note use for a case fitted for specific jewelry
 CASE, WIG
 CHARM
 Charm, Watch ... use FOB
 CHATELAINE
 Choker ... use NECKLACE
 COMB
 Conceit ... use PENDANT
 CORSAGE
 Earplug ... use SPOOL, EAR
 EARRING
 FERRONIERE
 FOB
 FOB, KEY
 FRONTLET
 GORGET
 HAIRPIECE ... rt WIG
 Kanzashi ... use ORNAMENT, HAIR
 Kogai ... use ORNAMENT, HAIR
 LABRET
 LAVALIERE
 LOCKET
 NECKLACE
 ORNAMENT, HAIR
 PENDANT
 Periwig ... use WIG
 Peruke ... use WIG
 PIN ... rt BROOCH

- -

ADORNMENT (cont.)

 Pin, Baby ... use PIN, SCATTER
PIN, LAPEL
PIN, SCATTER
PLUG, NOSE
PLUME
RIBBON
RING
RING, NOSE
 Sautoir ... use PENDANT
SET, JEWELRY
SPOOL, EAR
STAND, WIG
TIARA
 Toupee ... use HAIRPIECE
WIG ... rt HAIRPIECE

CLOTHING

CLOTHING -- FOOTWEAR

BOOT
BOOT, COWBOY
BOOT, HIP
BOOT, RIDING
BOOT, SKI
BOOTEE
 Booties ... use BOOTEE
BOTTE SAUVAGE
CHOPINE
CLEAT, SHOE
CLOG
CRAKOW
ESPADRILLE
GAITER
GALOSH
GETA
HUARACHE
JACKBOOT
 Klomp ... use SABOT
 Lace, Boot ... use SHOELACE
LOAFER
MOCCASIN
MUKLUK

- -

CLOTHING -- FOOTWEAR (cont.)

 Mule ... use SLIPPER
 Nylon ... use STOCKING
 Overshoe ... use BOOT or GALOSH or RUBBER
 PAC
 Patten ... use CLOG
 Poulaine ... use CRAKOW
 PUMP
 RUBBER
 SABOT
 SANDAL
 Scuff ... use SLIPPER
 SHOE
 SHOE, DECK
 SHOE, TENNIS
 SHOE, TOE
 SHOE, TRACK
 SHOELACE
 SLIPPER
 SLIPPER, BALLET
 SLIPPER, BATHING
 Sneaker ... use SHOE with suitable modifier, e.g.: SHOE, TENNIS
 SOCK
 SPAT
 STOCKING
 TABI
 THONG

CLOTHING -- HEADWEAR

 Amice ... use HOOD
 BALMORAL
 Bandana ... use KERCHIEF
 BARBETTE
 BEANIE ... rt SKULLCAP
 BERET ... rt TAM-O-SHANTER
 BIGGIN
 BIRETTA
 BOATER
 BONNET
 BONNET, INDOOR
 Bowler ... use DERBY
 BUSBY
 Calot ... use BEANIE
 CAP
 CAP, BATHING
 CAP, BOUDOIR

- -

CLOTHING -- HEADWEAR (cont.)

 Cap, Day ... use BONNET, INDOOR
 CAP, DUST
 Cap, Flat ... use FLATCAP
 CAP, FORAGE
 CAP, GARRISON
 CAP, GOB
 CAP, MINER'S
 CAP, NURSE'S
 Cap, Officer's ... use CAP, SERVICE
 Cap, Overseas ... use CAP, GARRISON
 CAP, SAILOR
 CAP, SERVICE
 CAP, WATCH
 CAUL ... rt HAIRNET
 CLOCHE
 CORNET
 COVER, BONNET
 CUSHION, HELMET
 DERBY
 Dustcap ... use CAP, DUST
 EARMUFFS
 EYESHADE
 FEDORA
 FEZ
 FLATCAP
 Gibus ... use HAT, TOP
 GLENGARRY
 HAIRNET ... rt CAUL
 HAT
 HAT, COCKED
 HAT, COWBOY ... rt SOMBRERO
 Hat, Derby ... use DERBY
 HAT, HARD
 Hat, Homberg ... use HOMBERG
 HAT, PANAMA
 HAT, PICTURE
 Hat, Safety ... use more specific term, e.g.: HAT, HARD
 HAT, TOP
 HATBAND
 HAVELOCK
 HEADBAND
 Headkerchief ... use KERCHIEF
 HELMET
 HELMET, CRASH
 HELMET, DIVER'S
 HELMET, PITH
 HENNIN
 HOMBERG

- -

CLOTHING -- HEADWEAR (cont.)

 HOOD
 Kepi ... use CAP, FORAGE
 KERCHIEF
 LAPPET
 Mantilla ... use SCARF
 MONTERA
 NET, PROTECTIVE
 NIGHTCAP
 ORLE
 PILLBOX
 PLUME, HAT
 SCARF
 SHAKO
 SKULLCAP ... rt BEANIE
 Snood ... use HAIRNET
 SOMBRERO ... rt HAT, COWBOY
 SUNBONNET
 SWEATBAND
 TAJ
 TAM-O-SHANTER ... rt BERET
 THOLIA
 Topee ... use HELMET, PITH
 TOQUE
 TRICORN
 TUQUE
 TURBAN
 VEIL
 Visor ... use EYESHADE
 WIMPLE
 WREATH, WEDDING
 Yarmulke ... use SKULLCAP
 Yashmak ... use VEIL

CLOTHING -- OUTERWEAR

 ABA ... rt TOGA; CAFTAN
 ALB
 APRON
 APRON, BLACKSMITH'S
 APRON, ELASTRATOR
 Barrowcoat ... use BUNTING
 BATHROBE
 BLOUSE
 BODICE
 BOLERO
 BOMBACHAS

HIERARCHICAL LIST WITH PAGE NUMBERS REFERRING TO CHAPTER IV.

Eliminated
- Art Objects (now w/ Comm. Artifacts)
- Societal Artifacts (" ")
- Packages & Containers (now w/ Dist. & Trans)

(old term)

T&E sub-divided differently (left margin handwritten)

- -

CLOTHING -- OUTERWEAR (cont.)

 Breechcloth ... use LOINCLOTH
 BREECHES
 Breeches, Jodhpur ... use BREECHES, RIDING
 BREECHES, RIDING
 BREECHES, TRUNK
 BUNTING
 BURKA
 BURNOUS ... rt CLOAK
 CAFTAN ... rt ABA; TOGA
 CAPE
 CAPOTE
 Carrick ... use GREATCOAT
 CASSOCK
 CHALWAR
 CHAPERON
 CHAPS
 CHASUBLE
 Chemise ... use DRESS
 Chemisette ... use BLOUSE
 Choli ... use BLOUSE
 CLOAK ... rt BURNOUS
 COAT
 COAT, CUTAWAY
 COAT, EVENING
 COAT, FROCK
 COAT, LABORATORY
 Coat, Morning ... use COAT, CUTAWAY
 COAT, SPORTS
 COATEE
 CODPIECE
 Cope ... use CLOAK
 COSTUME
 COSTUME, DANCE
 COSTUME, SEASONAL
 COSTUME, THEATER
 COTTA
 COVERALLS
 CULOTTES
 DALMATIC
 Dashiki ... use BLOUSE
 DIRNDL
 Doublet ... use JERKIN
 DRESS ... rt GOWN
 Dress, Folk ... use more specific term
 Duster ... use HOUSECOAT
 ENSEMBLE
 GOWN ... rt DRESS
 GOWN, BAPTISMAL

- -

CLOTHING -- OUTERWEAR (cont.)

GOWN, DRESSING
GOWN, EVENING
 Gown, Night ... use NIGHTGOWN
GOWN, WEDDING
GREATCOAT
 Guimpe ... use BLOUSE
HABIT, MONK'S
HABIT, NUN'S
HABIT, RIDING
HALTER
HOUSECOAT
JACKET
JACKET, BED
JACKET, BUSH
 Jacket, Combing ... use JACKET, BED
 Jacket, Dinner ... use TUXEDO
JACKET, MESS
JACKET, PEA
JACKET, SMOKING
JERKIN
 Jodphur ... use BREECHES, RIDING
JUMPER
KILT
KIMONO
KNICKERS
LAYETTE
 Lederhosen ... use SHORTS
LEGGING
LOINCLOTH
MACKINAW
MANIPLE
 Mantelet ... use CAPE
 Mantle ... use CAPE
MUU-MUU
 Negligee ... use GOWN, DRESSING
NIGHTGOWN
 Nightshirt ... use NIGHTGOWN
OILSKIN ... rt RAINCOAT; SLICKER
OVERCOAT
OVERDRESS
OVERSKIRT
PAJAMAS
 Paltock ... use TUNIC
PANNIER
 Pantaloons ... use PANTS
PANTS
PANTSUIT
PARKA

- -

CLOTHING -- OUTERWEAR (cont.)

 Peignoir ... use GOWN, DRESSING
 Pelerine ... use CAPE
PINAFORE
PONCHO
PUTTEE
 Pyjamas ... use PAJAMAS
RAINCOAT ... rt SLICKER; OILSKIN
 Robe ... use BATHROBE or GOWN, DRESSSING
ROMPER
SACK,
 Sacque ... use SACK
SARI
SARONG
 Serape ... use PONCHO
SHAWL
SHIRT
SHIRT, DRESS
SHIRT, POLO
 Shirt, T ... use T-SHIRT
SHORTS
SKIRT
SKIRT, HOOP
SKIRT, HULA
 Slacks ... use PANTS
SLICKER ... rt RAINCOAT; OILSKIN
SMOCK
STOLE
SUIT
SUIT, BATHING
SUIT, DIVER'S
SUIT, EXPOSURE
SUIT, FLIER'S
SUIT, JUMP
 Suit, Pants ... use PANTSUIT
SUIT, SPACE
SUNSUIT
SURPLICE
SWEATER
TABARD
TIGHTS
TOGA ... rt ABA; CAFTAN
 Topcoat ... use OVERCOAT
TRAIN
 Trousers ... use PANTS
T-SHIRT
TUNIC
 Tutu ... use COSTUME, DANCE
TUXEDO

- -

CLOTHING -- OUTERWEAR (cont.)

UNIFORM
VEST
WAIST
WAISTCOAT
 Wrapper ... use GOWN, DRESSING

CLOTHING -- UNDERWEAR

BELT, GARTER
BINDER
BLOOMERS
BODYSTOCKING
BRASSIERE
BRIEFS
BUSTLE
CAMISOLE
CHEMISE
COMBINATION ... rt SUIT, UNION
CORSET
 Cover, Corset ... use CAMISOLE
 Crinoline ... use PETTICOAT
DIAPER
DRAWERS
FARTHINGALE
GIRDLE
IMPROVER, BUST
 Leotard ... use BODYSTOCKING
PANNIER
PANTALETTES
PANTALOONS
PANTIES
PANTYHOSE
PETTICOAT
SHIFT
SHORTS
SLIP
 Slip, Half ... use PETTICOAT
STAY
SUIT, UNION ... rt COMBINATION
SUPPORTER
 Teddy ... use COMBINATION
UNDERSHIRT
UNDERSKIRT
 Undervest ... use UNDERSHIRT
 Vest ... use UNDERSHIRT

- -

CLOTHING -- ACCESSORY

 AGAL
 APPLICATOR, SHOE-POLISH
 ASCOT
 BANDOLIER
 BELT
 BELT, SAM BROWNE
 Bertha ... use COLLAR
 BIB
 BOA
 BOW
 BOX, BOOTBLACKING ... rt KIT, SHOESHINE
 BRUSH
 BRUSH, CLOTHES
 BRUSH, HAT
 BRUSH, SHOE
 BRUSH, SUEDE
 BUCKLE
 BUCKLE, BELT
 BUCKLE, KNEE
 BUCKLE, SHOE
 BUFFER, SHOE
 BUTTON
 BUTTONHOOK
 Canion ... use GARTER
 CLASP
 Clip, Shirt ... use CLASP
 CLIP, TIE
 COLLAR ... rt RUCHE; RUFF
 Collarbone ... use STAY, COLLAR
 CRAVAT
 CUFF
 Cummerbund ... use SASH
 DICKEY
 DISPENSER, SHOE-POWDER
 FICHU
 GARTER
 GLOVE
 HATPIN
 Holder, Cuff ... use CLASP
 HOLDER, HATPIN
 HOOK, BOOT
 Hook, Button ... use BUTTONHOOK
 INSOLE
 JABOT
 KIT, SHOESHINE ... rt BOX, BOOTBLACKING
 LIFTER, SKIRT
 LINK, CUFF

- -

CLOTHING -- ACCESSORY (cont.)

 Manchette ... use SLEEVE
MITT
MITTEN
MONOGRAM
MUFF
MUFFLER ... rt SCARF, NECK
NECKERCHIEF ... rt SCARF, NECK
NECKTIE
 Obi ... use SASH
ORNAMENT, SHOE
 Oversleeve ... use SLEEVE
 Pin, Collar ... use CLASP
PLATE, HEEL
RUCHE ... rt COLLAR
RUFF ... rt COLLAR
SACHET
SASH
SCARF
SCARF, NECK ... rt MUFFLER; NECKERCHIEF
SET, COLLAR & CUFF
SET, COLLAR & MUFF
SET, COLLAR & SLEEVE
SHOEHORN
SLEEVE
SLIDE, SCARF
SPREADER, COLLAR
STAY, COLLAR
STICKPIN
 Stock ... use CRAVAT
STRETCHER, GLOVE
 Stretcher, Shoe ... use TREE, SHOE
STRETCHER, SOCK
STUD
SUSPENDERS
TACK, TIE
TIE, BOW
 Tie, Neck ... use NECKTIE
TIE, STRING
 Tiepin ... use STICKPIN
TREE, SHOE
UNDERSLEEVE
WAX, SHOE
WEIGHTBELT
WRISTLET

- -

PERSONAL GEAR

 AID, HEARING
 BACKPACK ... rt KNAPSACK
 Bag, Beaded ... use PURSE
 BAG, DITTY
 BAG, DOCTOR'S
 BAG, DUFFLE
 BAG, GARMENT
 Bag, Hand ... use PURSE
 Bag, Kit ... use BAG, DUFFLE
 Bag, Musette ... use HAVERSACK
 BAG, PAJAMA
 BAG, SCHOOL
 Bag, Tobacco ... use POUCH, TOBACCO
 BANDBOX
 BASKET
 BASKET, BURDEN
 BASKET, PACK
 BASKET, TRINKET
 Bead, Toggle ... use NETSUKE
 BELT, MONEY
 BOTTLE, SMELLING
 BOTTLE, SNUFF
 Box, Band ... use BANDBOX
 Box, Bride's ... use BANDBOX
 BOX, COLLAR
 BOX, GLOVE
 BOX, HANDKERCHIEF
 Box, Pill ... use PILLBOX
 Box, Snuff ... use SNUFFBOX
 BOX, TOBACCO
 BRIEFCASE
 CANE
 CANTEEN
 Carpetbag ... use SUITCASE
 CARRIER, LUGGAGE/SHAWL
 Case, Attache ... use BRIEFCASE
 CASE, CARD
 CASE, CIGAR
 CASE, CIGARETTE
 CASE, COUPON
 CASE, DENTURES
 CASE, EYEGLASSES
 CASE, KEY
 Case, Match ... use SAFE, MATCH
 CASE, MEDICINE
 CASE, PHOTOGRAPH
 CASE, PIPE
 CASE, SLIPPER

- -

PERSONAL GEAR (cont.)

 CASE, STAMP
 CASE, STUD
 CASE, TRAVELING
 CHAIN, EYEGLASSES ... rt CHAIN, LORGNETTE
 CHAIN, KEY
 CHAIN, LORGNETTE ... rt CHAIN, EYEGLASSES
 CHAIN, WATCH
 CHEST, LIQUOR
 CHEST, SEA
 CIGAR
 CLEANER, EYEGLASSES
 CLEANER, PIPE
 CLIP, KEY
 CLIP, MONEY
 COOLER, HAND
 COVER, CHECKBOOK
 COVER, PARASOL
 COVER, SHOE
 CRUTCH
 CUSHION, AIR
 CUTTER, CIGAR
 DENTURES
 DISPENSER, TOKEN
 EARPHONE
 EARPLUG
 ETUI
 EYEGLASSES
 FAN
 FLASK, POCKET
 FOOTLOCKER
 Glasses, Eye ... use EYEGLASSES
 GLASSES, OPERA
 GOGGLES
 GOGGLES, DRIVING
 GOGGLES, WELDER'S
 GUARD, FINGERNAIL
 GUARD, KEY
 Handbag ... use PURSE
 HANDKERCHIEF
 HATBOX
 HAVERSACK
 HEADRING
 HOLDER, CIGAR
 HOLDER, CIGARETTE
 HOLDER, COIN
 HOLDER, NOSEGAY
 HOLDER, SHOE
 HOOKAH

- -

PERSONAL GEAR (cont.)

 Inro ... use CASE, MEDICINE
 Jackknife ... use KNIFE, POCKET
 KNAPSACK ... rt BACKPACK
 KNIFE
 KNIFE, PIPE
 KNIFE, POCKET
 KNIFE, SHEATH
 LAMP, OPIUM
 LANYARD
 Leg, Artificial ... use PROSTHESIS
 LENS, CONTACT
 LIGHTER
 LORGNETTE
 MONOCLE
 NETSUKE
 OJIME
 PACIFIER
 PARASOL
 Penknife ... use KNIFE, POCKET
 PILLBOX
 PIN, WATCH
 Pince-nez ... use EYEGLASSES
 PIPE
 PIPE, OPIUM
 PLUG, NOSE
 POCKET
 Pocketbook ... use PURSE
 Portmanteau ... use SUITCASE
 POUCH
 POUCH, TOBACCO
 PROSTHESIS
 PURSE
 PURSE, CHANGE
 Reticule ... use PURSE
 RING, KEY
 RING, TEETHING
 SAFE, MATCH
 SATCHEL
 SET, SCRIBE
 SNUFFBOX
 SPOON, COCAINE
 STAND, HAT
 STAND, PIPE
 STICK, SHOOTING
 STICK, SWAGGER
 Stick, Walking ... use CANE
 SUITCASE
 SUNGLASSES

- -

PERSONAL GEAR (cont.)

 Teeth, False ... use DENTURES
 TOBACCO
 TOBACCO, CHEWING
 TONGS, PIPE
 TRUMPET, EAR
 TRUNK
 Tus ... use CANTEEN
 UMBRELLA
 Valise ... use SUITCASE
 Vinaigrette ... use BOTTLE, SMELLING
 WALKER
 WALLET
 WARMER, HAND
 WHEELCHAIR
 Yatate ... use SET, SCRIBE

TOILET ARTICLE

 ATOMIZER
 Bag, Cosmetic ... use KIT, TOILET
 BASIN
 BEDPAN ... rt URINAL
 BLADE, RAZOR
 Bottle, Barber's ... use BOTTLE, TOILET
 Bottle, Cologne ... use BOTTLE, TOILET
 Bottle, Perfume ... use BOTTLE, TOILET
 BOTTLE, TOILET
 BOX, HAIRPIN
 Box, Powder ... use BOX, PUFF
 BOX, PUFF
 BOX, SHAVING
 BRUSH, NAIL
 BRUSH, SCALP
 BRUSH, SHAVING
 BUFFER
 CASE, HAIRPIN
 CASE, MANICURE
 CASE, RAZOR
 CASE, SHAVING BRUSH
 CASE, SOAP
 CASE, TOILET BOTTLE
 CASE, TOOTHBRUSH
 CLIP, HAIR
 CLIPPERS, HAIR
 CLIPPERS, NAIL
 COMB

- -

TOILET ARTICLE (cont.)

 COMB, MUSTACHE
 COMB, PUFF
 COMB, SIDE
 COMB, TUCK
 Combinette ... use POT, CHAMBER
 COMPACT
 CURLER
 DART, HAIR ... rt HAIRPIN
 DISH, SOAP
 DRYER, HAIR
 EYECUP
 EYEDROPPER
 FILE, NAIL
 Flask, Urinal ... use URINAL
 HAIRBRUSH
 HAIRPIN ... rt DART, HAIR
 HOLDER, SHAVING PAPER
 HOLDER, TOOTHBRUSH
 IRON, CURLING
 Iron, Pinching ... use IRON, STRAIGHTENING
 IRON, STRAIGHTENING
 JAR, COSMETIC
 Kit, Dop ... use KIT, TOILET
 KIT, SHAVING
 KIT, TOILET
 KNIFE, CORN
 KNIFE, CUTICLE
 MAT, BATH
 MIRROR, HAND
 MUG, SHAVING
 PAN, DOUCHE
 PENCIL, EYEBROW
 PENCIL, STYPTIC
 PIN, BOBBY
 PITCHER
 POMANDER
 POT, CHAMBER
 Potty ... use POT, CHAMBER or COMMODE
 PUFF, POWDER
 PURSE, COSMETIC
 Purse, Hairpin ... use CASE, HAIRPIN
 RAZOR
 RAZOR, ELECTRIC
 RECEIVER, HAIR
 RECEIVER, HAIRPIN
 SCISSORS
 SCISSORS, MANICURE
 SCRAPER, TONGUE

- -

TOILET ARTICLE (cont.)

 SCRATCHER, BACK
 SET, COMB & HAIRBRUSH
 SET, DRESSER
 Set, Ewer & Basin ... use SET, TOILET
 SET, MANICURE
 SET, SHAVING
 SET, TOILET
 Set, Washstand ... use SET, TOILET
 SHAKER, POWDER
 SHAKER, SOAP
 SHEARS, THINNING
 SOAP
 SPOON, EAR WAX
 STAND, CURLING IRON
 STAND, MIRROR
 STICK, CUTICLE
 Strap, Razor ... use STROP
 STRIGIL
 STROP
 TISSUE
 Tong, Curling ... use IRON, CURLING
 TOOTHBRUSH
 TOOTHPICK
 TOWEL, BATH
 TOWEL, BEACH
 TOWEL, FACE
 TOWEL, FINGERTIP
 TOWEL, HAND
 TRAY, DRESSER
 TWEEZERS
 URINAL
 note a vessel for use by a bedfast patient
 rt BEDPAN
 Washbasin ... use BASIN
 WASHCLOTH

- -

CATEGORY 4: TOOLS & EQUIPMENT FOR MATERIALS

AGRICULTURAL T&E

 Avarrancator ... use PRUNER, TREE
 BAG, FRUIT PICKING
 BALER, COTTON
 BALER, HAY
 Bar, Planting ... use DIBBLE
 BARROW, APPLE
 Basket, Berry ... use BASKET, GATHERING
 BASKET, COTTON
 Basket, Egg-gathering ... use BASKET, GATHERING
 Basket, Fruit-picking ... use BASKET, GATHERING
 BASKET, GATHERING ... rt BOWL, GATHERING
 Basket, Potato ... use BASKET, GATHERING
 BASKET, WINNOWING
 BEARDER, BARLEY
 BELT, BINDER
 BILLHOOK ... rt HOOK, PRUNING
 BINDER, CORN
 BINDER, GRAIN
 Binder, Row ... use BINDER, CORN
 Binder, Twine ... use BINDER, GRAIN
 Binder, Wire ... use BINDER, GRAIN
 BLOWER, ENSILAGE
 Blower, Forage ... use BLOWER, ENSILAGE
 Blower, Impeller ... use BLOWER, ENSILAGE
 Blower, Silage ... use BLOWER, ENSILAGE
 Blower, Silo ... use BLOWER, ENSILAGE
 Board, Dibble ... use DIBBLE
 Board, Spotting ... use DIBBLE
 Boat, Stone ... use STONEBOAT
 BOILER, FEED
 BOWL, GATHERING ... rt BASKET, GATHERING
 BOX, FIELD
 BOX, GRAIN
 Broadcaster ... use SEEDER, CENTRIFUGAL or SEEDER, HAND CENTRIFUGAL or
 SEEDER, SEEDBOX or SEEDER, HAND SEEDBOX
 CAN, WATERING
 CARD, PICKER'S
 Cart, Tractor grain ... use TRAILER, FARM
 CHISEL, GRAFTING
 CHISEL, PRUNING
 Chopper, Ensilage ... use CUTTER, ENSILAGE
 CHOPPER, FEED ... rt CUTTER, ENSILAGE

- -

AGRICULTURAL T&E (cont.)

 Chopper, Fodder ... use CHOPPER, FEED
 Chopper, Hay ... use CHOPPER, FEED
 Chopper, Silage ... use CUTTER, ENSILAGE
 Chopper, Stalk ... use CHOPPER, FEED
 Chopper, Stover ... use CHOPPER, FEED
 CHUTE, GRAIN
 CLEANER, COTTONSEED
 CLEANER, DRAIN
 Cleaner, Grain ... use MILL, FANNING
 CLEVIS
 CLIPPERS, FLOWER
 COMBINE
 Combine, Corn-head ... use COMBINE
 Combine, Corn picker/sheller ... use COMBINE
 COMBINE, GREEN PEA
 COMBINE, PEANUT
 Combine, Pull-type ... use COMBINE
 Combine, Self-propelled ... use COMBINE
 Combine, Side-hill ... use COMBINE
 CONDITIONER, HAY ... rt MOWER/CONDITIONER
 COOKER, FEED
 CORNHUSKER, HAND
 Cradle, Barley ... use SCYTHE, CRADLE
 Cradle, Grain ... use SCYTHE, CRADLE
 CROOK, HAY
 Crook, Throw ... use TIER, CORN SHOCK
 Crusher, Corn-and-cob ... use GRINDER, FEED
 CUBER, HAY
 Cultipacker ... use ROLLER, LAND
 CULTIVATOR
 note use for a cultivator on which the operator rides
 Cultivator, Chisel ... use CULTIVATOR, FIELD
 CULTIVATOR, FIELD
 note a machine used for field preparation rather than cultivation
 CULTIVATOR, GARDEN
 note use for any cultivator pushed by hand
 CULTIVATOR, HAND
 note use for a hand tool employed in garden cultivation
 CULTIVATOR, ROTARY
 note a machine used for weed control or shallow mulching
 CULTIVATOR, ROW-CROP
 Cultivator, Straddle-row ... use CULTIVATOR
 CULTIVATOR, WALKING
 note use for an animal-drawn cultivator behind which the operator walks
 Cultivator, Wheel-hoe ... use CULTIVATOR, GARDEN
 CUTTER, ENSILAGE ... rt CHOPPER, FEED
 Cutter, Feed ... use CHOPPER, FEED

- -

AGRICULTURAL T&E (cont.)

```
    Cutter, Flail ... use SHREDDER, FLAIL
    Cutter, Fodder ... use CHOPPER, FEED
CUTTER, POTATO SEED
CUTTER, ROOT
    Cutter, Silage ... use CUTTER, ENSILAGE
CUTTER, STALK
    Cutter, Stover ... use CHOPPER, FEED
    Cutter, Thistle-and-dock ... use SPUD, WEEDING
CUTTER, TOBACCO
    Cutter, Vegetable ... use CUTTER, ROOT
CUTTER, WEED
    Cutter and blower, Ensilage ... use BLOWER, ENSILAGE
    Cutters, Wire-band ... use SHEARS, BAND-CUTTER
DERRICK, GRAIN-STACKING
DIBBLE
    Dibble, Planting spud ... use DIBBLE
DIGGER, POTATO
    Digger, Thistle ... use SPUD, WEEDING
DISTRIBUTOR, FERTILIZER
    Drag, Hay ... use RAKE, HAY-BUNCHING
    Drag, Plank ... use DRAG, SMOOTHING
DRAG, SMOOTHING
    Drill, Barrow ... use DRILL, SEED
    Drill, Disk ... use DRILL, SEED
    Drill, Fertilizer ... use DRILL, SEED
    Drill, Garden ... use DRILL, SEED
    Drill, Grain ... use DRILL, SEED
    Drill, Hand ... use DRILL, SEED
    Drill, Hoe ... use DRILL, SEED
    Drill, Press ... use DRILL, SEED
DRILL, SEED
    Drill, Shoe ... use DRILL, SEED
    Drill, Walking ... use DRILL, SEED
    Drill, Wheelbarrow ... use DRILL, SEED
DRYER, CROP
    Dryer, Grain ... use DRYER, CROP
DUSTER, DRY-POWDER
    Duster, Hand ... use DUSTER, DRY-POWDER
    Duster, Potato ... use DUSTER, DRY-POWDER
    Duster, Saddle-gun ... use DUSTER, DRY-POWDER
    Duster, Tobacco ... use DUSTER, DRY-POWDER
    Edger, Lawn ... use EDGER, TURF
EDGER, TURF
ELEVATOR, AUGER
ELEVATOR, BALE
    Envelope, Seed ... use PACKET, SEED
    Fan, Dutch ... use MILL, FANNING
```

- -

AGRICULTURAL T&E (cont.)

 Fan, Winnowing ... use BASKET, WINNOWING or MILL, FANNING
 FEEDER, ROOT
 FERTILIZER
 Filler, Silo ... use BLOWER, ENSILAGE
 FLAIL
 Flail, Threshing ... use FLAIL
 Flamethrower ... use WEEDER, FLAME
 FORK
 FORK, ALFALFA
 FORK, BAILING-PRESS
 FORK, BARLEY
 FORK, BEET
 FORK, CABBAGE-HARVESTING
 Fork, Chaff ... use FORK, HEADER
 FORK, COTTONSEED
 Fork, Digging ... use FORK, SPADING
 FORK, ENSILAGE
 Fork, Garden ... use FORK, SPADING
 Fork, Grain ... use FORK, HEADER
 Fork, Grapple ... use FORK, HAY-LIFTING
 Fork, Harpoon ... use FORK, HAY-LIFTING
 Fork, Hay ... use HAYFORK
 FORK, HAY-LIFTING
 FORK, HEADER
 Fork, Horse hay ... use FORK, HAY-LIFTING
 Fork, Lock-lever ... use FORK, HAY-LIFTING
 FORK, MANURE
 Fork, Pitch ... use HAYFORK or FORK, MANURE
 FORK, POTATO-DIGGING
 Fork, Silage ... use FORK, ENSILAGE
 FORK, SPADING
 Fork, Straw ... use FORK, BARLEY
 FORK, VEGETABLE SCOOP
 FORK, WEEDING
 Furnace, Agricultural ... use BOILER, FEED
 Gaff, Hay ... use CROOK, HAY
 Gatherer, Fruit ... use PICKER, FRUIT
 GAUGE, FRUIT
 GERMINATOR
 GRINDER, FEED
 GRINDER, SOIL
 GRINDER/MIXER, FEED
 Gun, Dusting ... use DUSTER, DRY-POWDER
 Gun, Insect powder ... use DUSTER, DRY-POWDER
 HARROW, ACME
 HARROW, DISK
 Harrow, Drag ... use HARROW, SPIKE-TOOTH

- -

AGRICULTURAL T&E (cont.)

 Harrow, Spading ... use HOE, ROTARY
 HARROW, SPIKE-TOOTH
 HARROW, SPRING-TOOTH
 HARROW, TINE-TOOTH
 HARVESTER, BEAN
 HARVESTER, CORN
 HARVESTER, FORAGE
 HARVESTER, ONION
 HARVESTER, POTATO
 HARVESTER, SUGAR-BEET
 HARVESTER, SUGARCANE
 HARVESTER, TOMATO
 Harvester/thresher ... use COMBINE
 HAYFORK
 HAY-LOADER
 HAY-LOADER, BALE
 HEADER, GRAIN
 HOE
 HOE, BEET-THINNING
 Hoe, Bog ... use HOE, GRUB
 Hoe, Broad ... use HOE, GARDEN
 Hoe, Bunching ... use HOE, BEET-THINNING
 HOE, CELERY
 HOE, CORN
 HOE, COTTON
 Hoe, Cultivator ... use HOE, WEEDING
 Hoe, Dutch ... use HOE, SCUFFLE
 HOE, GARDEN
 HOE, GRAPE
 Hoe, Grass ... use HOE, MEADOW
 HOE, GRUB
 HOE, HOP
 Hoe, Horse ... use CULTIVATOR, ROW-CROP
 HOE, MATTOCK
 HOE, MEADOW
 Hoe, Narrow ... use HOE, GRUB
 HOE, NURSERY
 Hoe, Plantation ... use HOE, COTTON
 Hoe, Planter ... use HOE, COTTON
 HOE, ROTARY
 HOE, SCUFFLE
 Hoe, Shuffle ... use HOE, SCUFFLE
 HOE, SUGAR BEET
 HOE, TOBACCO
 HOE, TURNIP
 HOE, WARREN
 HOE, WEEDING

- -

AGRICULTURAL T&E (cont.)

 Hoe, Wheel ... use CULTIVATOR, GARDEN
 Hook, Bagging ... use HOOK, REAPING
 Hook, Bill ... use BILLHOOK
 Hook, Bramble ... use HOOK, BRUSH
 HOOK, BRUSH
 Hook, Bush ... use HOOK, BRUSH
 HOOK, CORN ... rt KNIFE, CORN
 HOOK, DRILL
 Hook, Fagging ... use HOOK, REAPING
 Hook, Garden ... use HOOK, NURSERY
 HOOK, GRASS
 Hook, Grub ... use HOOK, POTATO
 Hook, Hay ... use CROOK, HAY
 HOOK, HEDGE
 Hook, Husking ... use CORNHUSKER, HAND
 HOOK, MANURE
 HOOK, NURSERY
 HOOK, POTATO
 HOOK, PRUNING ... rt BILLHOOK
 HOOK, REAPING ... rt SICKLE
 Hook, Shrubbery ... use HOOK, NURSERY
 Hook, Vine ... use HOOK, NURSERY
 HOSE, IRRIGATION
 Hummeler ... use BEARDER, BARLEY
 Husker, Corn ... use CORNHUSKER, HAND or HUSKER/SHREDDER, CORN
 HUSKER/SHREDDER, CORN
 INJECTOR, FERTILIZER
 IRON, GRAFTING
 JAR, SEED
 KIT, SOIL-TESTING
 KNIFE, BAND-CUTTER
 KNIFE, BEET-TOPPING
 Knife, Budding ... use KNIFE, GRAFTING
 KNIFE, CORN ... rt HOOK, CORN
 KNIFE, GRAFTING
 KNIFE, GRAIN-HEADING
 KNIFE, HAY ... rt SPADE, HAY
 Knife, Potato ... use CUTTER, POTATO SEED
 KNIFE, PRUNING
 KNIFE, SUGARCANE ... rt MACHETE
 KNIFE, TOBACCO
 LADDER, FRUIT-PICKING
 LEVELER, LAND
 LIFTER, SOD
 Lifter, Stump ... use PULLER, STUMP
 Linter, Cottonseed ... use CLEANER, COTTONSEED
 LOADER, CORN-SHOCK

- -

AGRICULTURAL T&E (cont.)

 Loader, Hay ... use HAY-LOADER
 MACHETE ... rt KNIFE, SUGARCANE
 MACHINE, DIBBLING
 Machine, Husking ... use HUSKER/SHREDDER, CORN
 Machine, Mowing ... use MOWER
 MACHINE, THRESHING
 MACHINE, TRANSPLANTING
 Machine, Winnowing ... use MILL, FANNING
 MALLET, GRAFTING
 MATTOCK
 MIDDLEBUSTER
 Mill, Attrition ... use GRINDER, FEED
 Mill, Fan ... use MILL, FANNING
 MILL, FANNING
 Mill, Feed ... use GRINDER, FEED
 Mill, Hammer ... use GRINDER, FEED
 Mill, Winnowing ... use MILL, FANNING
 MIXER, FEED
 MOWER
 MOWER, GANG-REEL
 MOWER, HORSE-DRAWN
 MOWER, LAWN
 Mower, Semimounted ... use MOWER
 Mower, Tractor-drawn ... use MOWER or MOWER, GANG-REEL
 Mower, Tractor-mounted ... use MOWER
 MOWER/CONDITIONER ... rt CONDITIONER, HAY
 MULCHER
 Packer, Surface ... use ROLLER, LAND
 PACKET, SEED
 Peg, Husking ... use CORNHUSKER, HAND
 PICKER, CORN
 PICKER, COTTON
 PICKER, FRUIT
 PICKER/HUSKER, CORN
 PICKER/SHELLER, CORN
 Pin, Husking ... use CORNHUSKER, HAND
 PIPE, IRRIGATION
 Pitchfork ... use HAYFORK or FORK, MANURE
 PLANTER
 note use for a horse- or machine-drawn planter
 Planter, Bed ... use PLANTER or PLANTER, WALKING
 Planter, Drill ... use PLANTER or PLANTER, WALKING or PLANTER, GARDEN
 PLANTER, GARDEN
 note use for a planter pushed by hand
 PLANTER, HAND
 note use for a planter carried by hand
 Planter, Lister ... use PLANTER or PLANTER, WALKING
 PLANTER, POTATO

- -

AGRICULTURAL T&E (cont.)

 Planter, Precision ... use PLANTER
 Planter, Riding ... use PLANTER
 PLANTER, WALKING
 note use for an animal-drawn planter behind which the operator walks
 Planter, Walking-stick ... use PLANTER, HAND
 Planter, Wheel ... use PLANTER, GARDEN
 PLOW, BOG-CUTTER
 PLOW, BREAKING
 Plow, Chisel ... use PLOW, SUBSOIL
 PLOW, DISK
 PLOW, GANG
 PLOW, GARDEN
 Plow, Lister ... use MIDDLEBUSTER
 Plow, Middlebuster ... use MIDDLEBUSTER
 PLOW, MOLDBOARD
 Plow, One-way wheatland ... use PLOW, DISK
 Plow, Peat ... use PLOW, BOG-CUTTER
 PLOW, SHOVEL
 PLOW, STUBBLE
 PLOW, SUBSOIL
 POT, SMUDGE
 Press, Hay-baling ... use BALER, HAY
 PRUNER, TREE
 PULLER, STUMP
 Pulverizer, Surface ... use ROLLER, LAND
 RAKE
 Rake, Buck ... use RAKE, HAY-BUNCHING
 Rake, Bull ... use RAKE, HAND HAY
 RAKE, CLOVER
 RAKE, COMMON HAY
 RAKE, CRANBERRY
 RAKE, DUMP HAY
 Rake, Flip-flop ... use RAKE, REVOLVING HAY
 Rake, Floral ... use RAKE, GARDEN
 RAKE, GARDEN
 Rake, Grain ... use RAKE, HAND HAY
 RAKE, GRAIN-BINDER'S
 RAKE, HAND HAY
 RAKE, HAY-BUNCHING
 RAKE, LAWN
 Rake, Man ... use RAKE, HAND HAY
 RAKE, ONION
 RAKE, REAPER-PLATFORM
 Rake, Reel-type hay ... use RAKE, SIDE-DELIVERY HAY
 RAKE, REVOLVING HAY
 RAKE, SIDE-DELIVERY HAY
 Rake, Spring-tooth hay ... use RAKE, DUMP HAY

- -

AGRICULTURAL T&E (cont.)

 Rake, Sweep ... use RAKE, HAY-BUNCHING
 REAPER
 Reaper, Hand-rake ... use REAPER
 Reaper, Self-rake ... use REAPER
 Reaper/mower ... use REAPER
 RIDDLE, GRAIN
 Riddle, Winnowing ... use RIDDLE, GRAIN
 Roller, Corrugated ... use ROLLER, LAND
 ROLLER, GARDEN
 ROLLER, LAND
 Roller, Lawn ... use ROLLER, GARDEN
 SAW, PRUNING
 SCABBARD, MACHETE
 SCISSORS, VINE
 SCOOP, FEED
 Scoop, Grain ... use SHOVEL, GRAIN
 Scoop, Potato ... use FORK, VEGETABLE SCOOP
 Scoop, Winnowing ... use BASKET, WINNOWING
 SCRAPER, COTTON
 SCYTHE
 Scythe, Brush ... use SCYTHE
 SCYTHE, CRADLE
 SCYTHE, FLEMISH
 Scythe, Grass ... use SCYTHE
 Scythe, Hainault ... use SCYTHE, FLEMISH
 Scythe, Weed ... use SCYTHE
 SEALER, TREE
 Seeder, Broadcast ... use SEEDER, CENTRIFUGAL; SEEDER, HAND CENTRIFUGAL;
 SEEDER SEEDBOX; or SEEDER, HAND SEEDBOX
 SEEDER, CENTRIFUGAL
 note use for an animal- or machine-powered centrifugal seeder
 Seeder, Endgate ... use SEEDER, CENTRIFUGAL
 SEEDER, HAND CENTRIFUGAL
 note use for a hand-powered centrifugal seeder
 SEEDER, HAND SEEDBOX
 note use for a hand-carried or -pushed seedbox seeder
 Seeder, Rotary ... use SEEDER, CENTRIFUGAL or SEEDER, HAND CENTRIFUGAL
 SEEDER, SEEDBOX
 note use for an animal- or machine-powered seedbox seeder
 Seeder, Wheelbarrow ... use SEEDER, HAND SEEDBOX
 Separator ... use THRESHER/SEPARATOR
 SETTER, SEEDLING
 SHAKER, TREE
 SHEARS, BAND-CUTTER
 Shears, Garden ... use SHEARS, HEDGE
 SHEARS, GRASS
 SHEARS, HEDGE
 SHEARS, LAWN

- -

AGRICULTURAL T&E (cont.)

 Shears, Pruning ... use PRUNER, TREE
 SHELLER, BEAN
 SHELLER, CORN
 SHOCKER, CORN
 SHOVEL, GRAIN
 Shovel, Potato ... use FORK, VEGETABLE SCOOP
 SHREDDER, FLAIL
 Shredder, Stalk ... use CUTTER, STALK
 SICKLE ... rt HOOK, REAPING
 Sickle, Grass ... use HOOK, GRASS
 Sieve, Grain ... use RIDDLE, GRAIN
 Sieve, Winnowing ... use RIDDLE, GRAIN
 Sith ... use SCYTHE, FLEMISH
 SLICER, EAR-CORN
 Sling, Grain ... use SLING, HAY
 SLING, HAY
 Snapper, Corn ... use PICKER, CORN
 Sower, Broadcast ... use SEEDER, CENTRIFUGAL or SEEDER, SEEDBOX
 Sower, Seedbox ... use SEEDER, SEEDBOX
 SPADE, DITCHING
 SPADE, DRAIN-TILE
 SPADE, GARDEN
 SPADE, HAY ... rt KNIFE, HAY
 SPADE, PEAT
 Spade, Turf ... use LIFTER, SOD
 Sprayer, Bucket ... use SPRAYER, HAND
 Sprayer, Flame ... use WEEDER, FLAME
 SPRAYER, HAND
 Sprayer, Knapsack ... use SPRAYER, HAND
 SPRAYER, POWER
 Sprayer, Wheelbarrow ... use SPRAYER, HAND
 Spreader, Garden manure ... use SPREADER, WHEELBARROW
 SPREADER, MANURE
 note use for an animal- or machine-drawn spreader
 SPREADER, WHEELBARROW
 · note use for a hand-pushed spreader
 SPRINKLER, IRRIGATION
 Sprinkler, Knapsack ... use SPRAYER, HAND
 Sprinkler, Lawn ... use SPRINKLER, IRRIGATION
 Spud, Dandelion ... use SPUD, WEEDING
 SPUD, WEEDING
 Stacker, Cable ... use STACKER, HAY
 Stacker, Derrick ... use STACKER, HAY
 STACKER, HAY
 Stacker, Overshot ... use STACKER, HAY
 Stacker, Swinging ... use STACKER, HAY
 Stacker, Tripod ... use STACKER, HAY

- -

AGRICULTURAL T&E (cont.)

 Stick, Planting ... use DIBBLE
 STILT, PRUNING
 STONEBOAT
 STRIPPER, COTTON
 STRIPPER, GRAIN
 Subsoiler ... use PLOW, SUBSOIL
 TEDDER
 THINNER, FRUIT
 Thresher, Groundhog ... use MACHINE, THRESHING
 Thresher, Peanut ... use MACHINE, THRESHING
 Thresher, Portable ... use THRESHER/SEPARATOR
 Thresher, Simple ... use MACHINE, THRESHING
 Thresher, Stationary ... use THRESHER/SEPARATOR
 THRESHER/SEPARATOR
 Tier, Corn ... use TIER, CORN-SHOCK
 Tier, Corn-fodder ... use TIER, CORN-SHOCK
 TIER, CORN-SHOCK
 TILLER, GARDEN ROTARY
 TILLER, ROTARY
 TRACTOR, FARM
 TRACTOR, GARDEN
 TRAILER, FARM
 Trailer, Tractor-drawn ... use TRAILER, FARM
 TRANSPLANTER, HAND
 TRAY, WINNOWING
 TROWEL, GARDEN
 Trowel, Nursery ... use TROWEL, GARDEN
 VINER, PEA
 Wagon, Tractor-drawn ... use TRAILER, FARM
 WEEDER
 WEEDER, FLAME
 WEEDER, ROD
 WEEDER, SPRING-TOOTH
 Whip, Brush ... use CUTTER, WEED
 WINDROWER
 Winnower ... use BASKET, WINNOWING or MILL, FANNING

ANIMAL HUSBANDRY T&E

 ADAPTER, ENEMA
 Adjuster, Hoof ... use LEVELER, HOOF
 AID, PILL ... rt FORCEPS, PILL
 ALPENHORN
 APIARY
 BARREL, SYRINGE
 BEEHIVE

- -

ANIMAL HUSBANDRY T&E (cont.)

 Bell, Cow ... use COWBELL
 BELL, HORSE
 BIT
 BLANKET
 BLOCK, CLINCHING
 BOOT, LAWN
 BOWL, PET
 BOX, BEE
 BOX, FEED
 BOX, SHOEING
 BRANDER, FREEZING
 BRANDER, HORN
 BROODER, POULTRY
 BRUSH, ANIMAL
 BUFFER, HOOF
 BUNK, FEED
 Butteris ... use TRIMMER, HOOF
 CAGE, ANIMAL
 CAGE, BIRD
 CAGE, INSECT
 CARRIER, FEED
 CARRIER, LITTER
 CATCHER, HOG
 CATCHER, POULTRY
 CHAIN, CURB
 CHAIN, OBSTETRICAL
 CHARGER, FENCE
 CHEST, VETERINARY
 CHISEL, HOOF
 Clinch ... use BLOCK, CLINCHING
 Clincher ... use TONGS, CLINCHING
 Clip, Cow ... use HOLDER, COW-TAIL
 CLIPPER, ANIMAL
 COLLAR, BARK-TRAINING
 COLLAR, BELL
 COLLAR, CHOKE
 COLLAR, FLEA
 COLLAR, PET
 COMB, ANIMAL
 Comb, Curry ... use CURRYCOMB
 COOP, POULTRY-SHIPPING
 COWBELL
 CRATE, HOG-BREEDING
 CROOK, SHEPHERD'S
 CURRYCOMB
 CUTTER, MOLAR
 Cutter, Nail ... use NIPPERS, NAIL
 CUTTER, SNOUT

- -

ANIMAL HUSBANDRY T&E (cont.)

 DEBEAKER
 DEHORNER
 DETECTOR, HEATMOUNT
 DISH, PET
 DISPENSER, POWDER
 DOCKER
 DRENCHER
 DRIVER, CALK
 EMASCULATOR
 EXTRACTOR, CALK
 EXTRACTOR, FETAL
 FECALYZER
 FEEDBAG
 FEEDER, ESOPHAGEAL
 FEEDER, LIVESTOCK
 FEEDER, POULTRY
 FLOAT, DENTAL
 FORCEPS, PILL ... rt AID, PILL
 Fountain, Poultry ... use WATERER, POULTRY
 Fountain, Stock ... use WATERER, LIVESTOCK
 FRAME, OX-SHOEING
 GAG, CANINE
 GROOVER, HOOF
 Gum, Bee ... use BEEHIVE
 GUN, BALLING
 Gun, Dose ... use DRENCHER
 GUN, MARKING
 GUN, TATTOO
 HALTER
 HAMMER, DRIVING
 HAMMER, FITTING
 Hammer, Shoeing ... use HAMMER, DRIVING
 HARNESS, CASTING
 HATCHER, POULTRY
 HOBBLE
 HOLDER, COW-TAIL
 HOLDER, HOG
 HOOD, SWEAT
 HOOK, CARCASS
 HOOK, OX
 HORSESHOE
 INCUBATOR, POULTRY
 IRON, BRANDING
 IRON, CAUTERIZING
 KICK-STOP
 KIT, INSEMINATION
 KNIFE, CASTRATING

- -

ANIMAL HUSBANDRY T&E (cont.)

 Knife, Dehorning ... use DEHORNER
 Knife, Farrier's ... use more specific term, e.g.: KNIFE, HOOF; KNIFE,
 TOE
 KNIFE, HOOF
 Knife, Shoeing ... use KNIFE, HOOF
 KNIFE, SOLE
 KNIFE, TEAT
 KNIFE, TOE
 LARIAT
 Leader, Cattle ... use LEADER, LIVESTOCK
 LEADER, LIVESTOCK
 LEASH
 LEVELER, HOOF
 LIFT, COW
 MULESHOE
 MUZZLE
 NAIL, HORSESHOE
 NEEDLEPIN, INOCULATING
 NET, ANIMAL
 NET, FLY
 Nippers, Hoof ... use PARER, HOOF
 NIPPERS, NAIL
 note use for tool to cut the toe nails of small animals
 NIPPLE, NURSING
 Nosebag ... use FEEDBAG
 NOTCHER, EAR
 OXSHOE
 PAD, HORSESHOE
 PARER, HOOF
 PATTERN, EAR
 PICK, HOOF
 PIN, BANDAGE
 PIN, PROLAPSE
 PINCERS, FARRIER'S
 PIPETTE, INTRAUTERINE
 Pistol, Paint-pellet ... use GUN, MARKING
 POKE
 Prod, Cattle ... use PROD, STOCK
 PROD, STOCK
 PROTRACTOR, HOOF
 PULLER, CALF
 Pullers, Shoe ... use PINCERS, FARRIER'S
 Punch, Ear ... use NOTCHER, EAR
 PUNCH, EAR TAG
 PUNCH, POULTRY
 RACK, HORSE-SHOEING
 RASP, HOOF

- -

ANIMAL HUSBANDRY T&E (cont.)

 Rasp, Tooth ... use FLOAT, DENTAL
 RING, ANIMAL-NOSE
 RING, RECTAL
 RINGER, ANIMAL-NOSE
 Saw, Dehorning ... use DEHORNER
 SCALE, LIVESTOCK
 SCRAPER, SWEAT
 SET, TATTOO
 SHEARS, DENTAL
 SHEARS, FETLOCK
 SHEARS, HORSE
 Shears, Mule ... use SHEARS, HORSE
 SHEARS, SHEEP
 Skep, Bee ... use BEEHIVE
 SLAPPER, LIVESTOCK
 SLITTER, TEAT
 SMOKER, BEE
 SPECULUM, ANIMAL
 Spreader, Shoe ... use TONGS, SHOE-SPREADING
 STAND, SHOEING
 STICK, SHOW
 SWITCH, FLY
 SWIVEL
 note for Lariat
 SYRINGE, DOSE
 TACKLE, BREAKING
 TAG, ANIMAL
 Tamer, Hog ... use CUTTER, SNOUT
 TESTER, HOOF
 THERMOMETER, INCUBATOR
 TIE, CATTLE
 TONGS, CLINCHING
 Tongs, Farrier's ... use more specific term, e.g.: TONGS, CLINCHING;
 TONGS, SHOE-SPREADING
 TONGS, SHOE-SPREADING
 TRIMMER, EAR
 TRIMMER, HOOF
 Trough, Feed ... use FEEDER, LIVESTOCK
 Trough, Poultry water ... use WATERER, POULTRY
 Trough, Watering ... use WATERER, LIVESTOCK
 TUBE, ENEMA
 TUBE, MILK
 TUBE, TRACHEOTOMY
 TWISTER, NOSE
 Twitch, Nose ... use TWISTER, NOSE
 WATERER, LIVESTOCK
 WATERER, POULTRY
 WEANER, CALF

- -

ANIMAL HUSBANDRY T&E (cont.)

 WEIGHT, HORN
 WEIGHT, TOE

FISHING & TRAPPING T&E

 ANCHOR, NET
 BAG, WHALER'S
 BOARD, MEASURING
 BOX, TACKLE
 BRIDLE, NET
 BUOY, NET
 CREEL
 DIPPER, WHALE-OIL
 DREDGE
 EELPOT
 FISHHOOK
 FLOAT
 FORK, BLUBBER
 GAFF, FISH
 GAFF, SEALING
 GIG
 HARPOON
 HOE, CLAMMING
 HOOK, BLUBBER
 HURDY-GURDY
 IRON, LILY
 JIG
 KNIFE, BOARDING
 KNIFE, MINCING
 LONGLINE
 LURE
 NET
 NET, BLANKET
 NET, BOTTOM-SET
 NET, BRAIL
 NET, CASTING
 NET, CRAB
 NET, DIP
 NET, DRIFT
 NET, FYKE
 NET, GILL
 Net, Hoop ... use NET, CRAB
 NET, POUND ... rt TRAP, FISH
 NET, PURSE
 NET, REEF

- -

FISHING & TRAPPING T&E (cont.)

 Net, Scoop ... use NET, DIP
 NET, SEINE
 NET, THROW
 NET, TRAWL
 POT, CRAB
 Pot, Eel ... use EELPOT
 POT, FISH ... rt TRAP, FISH
 POT, LOBSTER
 POT, TRY
 RAKE, HERRING
 RAKE, SHELLFISH
 REEL, FISHING
 ROD, FISHING
 SCOOP, TURTLE
 Seine ... use NET, SEINE or NET, PURSE
 SINKER ... rt WEIGHT, NET
 SKIMMER, WHALE-OIL
 SNARE
 SPADE, BLUBBER
 SPADE, BONE
 TONGS, CLAM
 TONGS, OYSTER
 TOOL, FLENSING
 TRAP
 TRAP, BEAR
 TRAP, BEAVER
 TRAP, FISH ... rt NET, POUND; POT, FISH
 Trap, Lobster ... use POT, LOBSTER
 Trawl ... use LONGLINE or NET, TRAWL
 WEIGHT, NET ... rt SINKER
 WEIR
 WHEEL, FISH

FOOD T&E

 FOOD PROCESSING T&E
 note the first word of the object term for a food-storage container
 should be the type of container. Modifiers may be used to
 indicate the contents. Institution rules vary as to the
 specificity (BAKING POWDER) or generality (FOOD-STORAGE) of the
 modifier.

 ACIDIMETER
 AERATOR, MILK

- -

FOOD PROCESSING T&E (cont.)

AGITATOR, FLOUR-BLEACHING
ALEUROMETER
AUGER, FRUIT
AUGER, SUGAR
AUTOCLAVE, CANNING
 Ax, Killing ... use AX, SLAUGHTERING
AX, SLAUGHTERING
BAG, PASTRY
 Ball, Tea ... use INFUSER, TEA
BAR, MEAT-HANGING
 Basket, Cheese ... use STRAINER, WHEY
BASKET, COOKING
BASKET, DOUGH-RISING
BASKET, MORTAR
BASKET, RING
BASKET, STORAGE
 Beanpot ... use POT, CROCK
BEATER
BEATER, SEED
 Beetle ... use MASHER
BIN, FOOD-STORAGE
 Bird, Pie ... use FUNNEL, PIE
BLENDER
 Blender, Bread ... use MIXER, DOUGH
BLENDER, FLOUR
BLENDER, PASTRY
BLOCK, CHOPPING
 Board, Bread ... use BOARD, CUTTING
BOARD, CUTTING
BOILER, DOUBLE
 Bolter, Cloth ... use BOLTER, SIEVE
BOLTER, SIEVE
BOWL, BUTTER-WORKING
BOWL, CHOPPING
BOWL, MIXING
BOWL, SKIMMING
BOX, BREAD
BOX, CHEESE
BOX, CHOPPING
 Box, Dough ... use TROUGH, DOUGH
BOX, FOOD-STORAGE
BOX, SALT
BOX, SPICE
BRAZIER
 Breadboard ... use BOARD, CUTTING
BROILER
BRUSH, FOOD
BUCKET, BUTTER

- -

FOOD PROCESSING T&E (cont.)

BURNER, SPIRIT
BUTYROMETER
 Cabinet, Creamery ... use SEPARATOR, CREAM
CABINET, FOOD-STORAGE
CABINET, SPICE
CADDY
 Caddy, Tea ... use CADDY
CALDRON
 Caldron, Scalding ... use SCALDER, HOG
CAN, FOOD-STORAGE
CAN, MILK
CANDLER, EGG
CANISTER, FOOD-STORAGE
CAPPER, BOTTLE ... rt MACHINE, BOTTLING
CARRIER, CHEESE
CARRIER, EGG
CASK, BREAD
CASK, WATER
CASSEROLE
 Cauldron ... use CALDRON
CHISEL, ICE
CHOPPER, FOOD
CHURN
CHURN, BUTTER
 Churn, Sylabub ... use WHIP, CREAM
CLEANER, BAG
CLEAVER
CODDLER
COLANDER
CONDENSER, MILK
CONDITIONER, GRAIN
 Conditioner, Wheat ... use CONDITIONER, GRAIN
 Cooker, Electric ... use a more specific term, i.e. OVEN, ELECTRIC
COOKER, PRESSURE
 Cooler, Brine ... use COOLER, DAIRY
COOLER, DAIRY
COOLER, LARD
 Cooler, Milk ... use COOLER, DAIRY
 Cooler, Tubular ... use COOLER, DAIRY
 Cooler, Unit ... use COOLER, DAIRY
CORER, FRUIT
CORKER, BOTTLE
CORKSCREW
COVER, FOOD
COVER, ROLLING PIN
 Crimper, Pie ... use WHEEL, JAGGING
CROCK

- -

FOOD PROCESSING T&E (cont.)

 Crown, Dutch ... use HOOK, MEAT
 CRUSHER, ICE
 CRUSHER, SEED
 Cup, Custard ... use RAMEKIN
 CUP, MEASURING
 CURLER, BUTTER
 CUTTER, BISCUIT
 CUTTER, BONE
 CUTTER, BUTTER
 CUTTER, CABBAGE
 CUTTER, CIDER CHEESE
 CUTTER, COOKIE
 Cutter, Curd ... use KNIFE, CURD
 CUTTER, DOUGHNUT
 Cutter, Green bone ... use CUTTER, BONE
 Cutter, Kraut ... use CUTTER, CABBAGE
 CUTTER, NOODLE
 Cutter, Slaw ... use CUTTER, CABBAGE
 CUTTER, SUGAR
 DASHER
 DIPPER
 DISH, BAKING
 DISH, CHAFING
 DISH, SOUFFLE
 DOWEL
 DREDGER
 DRYER, FRUIT
 Dryer, Milk ... use EVAPORATOR, MILK
 DUSTER, BRAN
 EGGBEATER ... rt WHIP, CREAM
 ELECTRIFIER, FLOUR-BLEACHING
 Emulsior, Milk ... use HOMOGENIZER, MILK
 EVAPORATOR, MILK
 EVAPORATOR, SUGAR
 EXTRACTOR, HONEY
 EXTRACTOR, JUICE
 FEEDER, BLENDING
 FEEDER, FLOUR-BLEACHING
 FEEDER, ROLL
 FILLER, BOTTLE
 FIRKIN
 FORK
 FORK, CURD
 FORK, TOASTING
 FREEZER
 Freezer, Brine ... use FREEZER, ICE-CREAM
 Freezer, Direct-expansion ... use FREEZER, ICE-CREAM
 FREEZER, ICE-CREAM

- -

FOOD PROCESSING T&E (cont.)

 Fret, Meat ... use MAUL, MEAT
 FRYER, DEEP-FAT
 FUNNEL
 FUNNEL, PIE
 GALACTOMETER
 GAMBREL
 Glass, Jelly ... use JAR, PRESERVING
 GLASS, MEASURING
 GLUCOMETER
 Grader, Bean ... use SORTER, BEAN
 GRADER, EGG
 GRADER, FRUIT
 GRATER
 GRATER, SPICE
 GRIDDLE
 GRIDIRON
 GRILL
 GRINDER ... rt MILL
 GRINDER, BONE
 GRINDER, BRAN
 Grinder, Coffee ... use MILL, COFFEE
 GRINDER, MEAT
 Grinder, Middlings ... use MILL, MIDDLINGS
 Grinder, Spice ... use MILL, SPICE
 Hammer, Killing ... use HAMMER, SLAUGHTERING
 Hammer, Meat ... use MAUL, MEAT
 HAMMER, SLAUGHTERING
 Hammer, Steak ... use MAUL, MEAT
 HAND, SCOTCH
 Hands, Butter ... use WORKER, BUTTER
 HATCHET, CANDY
 HEATER, MILK
 Heater, Wheat ... use CONDITIONER, GRAIN
 Hibachi ... use GRILL
 HOIST, DRESSING
 HOLDER, BAG
 Holder, Grain bag ... use HOLDER, BAG
 HOMOGENIZER, MILK
 HOOK, MEAT
 HULLER, NUT
 Huller, Pea ... use HULLER, SEED
 HULLER, SEED
 ICEBOX
 INCUBATOR, YOGURT
 INFUSER, TEA
 IRON, ROSETTE
 IRON, WAFER
 IRON, WAFFLE

- -

FOOD PROCESSING T&E (cont.)

 Jack, Bell ... use JACK, BOTTLE
 JACK, BOTTLE
 Jack, Clock ... use JACK, ROASTING
 JACK, ROASTING
 JAR, COOKIE
 JAR, FOOD-STORAGE
 JAR, PRESERVING
 Jigger, Pastry ... use WHEEL, JAGGING
 JUG
 JUG, MILK
 JUG, SYRUP
 JUG, WHISKEY
 Juicer ... use REAMER, JUICE
 KEG
 KETTLE
 KETTLE, LARD-RENDERING
 Kettle, Lard-settling ... use TANK, LARD-SETTLING
 KETTLE, PRESERVING
 Kettle, Tea ... use TEAKETTLE
 Killer, Poultry ... use KNIFE, POULTRY-KILLING
 KNIFE, BONING
 KNIFE, BREAD
 KNIFE, BUTCHER
 KNIFE, CHEESE
 KNIFE, CHEF'S
 KNIFE, CHOPPING
 KNIFE, CURD
 KNIFE, GRAPEFRUIT
 KNIFE, HAM
 KNIFE, ORANGE
 KNIFE, OYSTER
 KNIFE, PARING
 KNIFE, POULTRY-KILLING
 KNIFE, SKINNING
 Knife, Slaughtering ... use KNIFE, STICKING
 KNIFE, STICKING
 KNIFEBOARD
 LACTOBUTYROMETER
 LACTOMETER
 LADLE
 LIFTER, JAR
 LIFTER, PIE
 LIFTER, POT
 LIFTER, STOVE
 MACHINE, BAG-CLOSING
 Machine, Bag-sewing ... use MACHINE, BAG-CLOSING
 MACHINE, BAG-TYING

- -

FOOD PROCESSING T&E (cont.)

 MACHINE, BOTTLING ... rt CAPPER, BOTTLE
 MACHINE, BRUSH
 MACHINE, CAN-CAPPING
 Machine, Cartoning ... use MACHINE, PACKAGING
 MACHINE, MILKING
 MACHINE, PACKAGING
 MACHINE, PACKING
 Machine, Wrapping ... use MACHINE, PACKAGING
 MAGNET, SPOUT
 Maker, Bread ... use MIXER, DOUGH
 MAKER, COFFEE
 note use for any coffee-brewing utensil
 MANO
 MASHER
 MASHER, KRAUT
 MASHER, POTATO
 MAUL, MEAT
 Meat-ax ... use CLEAVER
 METATE
 MILL ... rt GRINDER
 MILL, APPLE
 Mill, Bone-grinding ... use CUTTER, BONE
 MILL, BUHR
 MILL, COFFEE
 Mill, Colloid milk ... use HOMOGENIZER, MILK
 MILL, CURD
 MILL, FLOUR
 MILL, HAMMER
 MILL, MIDDLINGS
 MILL, NUT
 MILL, ROLLER
 MILL, SPICE
 Mill, Stone ... use MILL, BUHR
 MIXER, DOUGH
 MIXER, ELECTRIC
 MIXER, ICE-CREAM
 MIXER, MAYONNAISE
 Mold, Border ... use MOLD, RING
 MOLD, BUTTER
 MOLD, CAKE
 MOLD, CANDY
 MOLD, CHEESE
 Mold, Chocolate ... use MOLD, CANDY
 MOLD, COOKIE
 MOLD, GELATIN
 MOLD, ICE-CREAM
 MOLD, JELLY
 MOLD, PUDDING

- -

FOOD PROCESSING T&E (cont.)

MOLD, RING
 Mold, Springerle ... use MOLD, COOKIE
MORTAR
 Mortar, Samp ... use MORTAR, STAMP
MORTAR, STAMP
MORTAR & PESTLE
 Nippers, Sugar ... use CUTTER, SUGAR
NUTCRACKER
OENOMETER
 Olla ... use JAR, FOOD-STORAGE
OPENER, BOTTLE
OPENER, CAN
OPENER, JAR
 Oven, Dutch ... use PAN, ROASTING
OVEN, ELECTRIC
OVEN, MICROWAVE
OVEN, REFLECTOR
OVEN, WARMING
PACKER, BARREL
 Packer, Bran ... use PACKER, BARREL
PACKER, BUTTER
 Packer, Feed ... use PACKER, BARREL
 Packer, Flour ... use PACKER, BARREL
PAD, STOVE
PADDLE
PADDLE, APPLE BUTTER
 Paddle, Butter ... use SPADE, BUTTER-WORKING
PAIL, MILKING
 Pan ... use SAUCEPAN
PAN, BAKING
PAN, BREAD
PAN, BREADSTICK
PAN, CAKE
 Pan, Cornstick ... use PAN, BREADSTICK
PAN, CREPE
PAN, FRYING ... rt SPIDER
 Pan, Gem ... use PAN, MUFFIN
PAN, JELLY ROLL
PAN, MILK
PAN, MUFFIN
PAN, OMELET
PAN, PIE
 Pan, Popover ... use PAN, MUFFIN
PAN, PUDDING
PAN, ROASTING
 Pan, Roll ... use PAN, MUFFIN
PAN, SPRING-FORM
PAN, STEW

- -

FOOD PROCESSING T&E (cont.)

PAN, TUBE
PASTEURIZER, MILK
PEEL
PEELER, FRUIT
PEELER, VEGETABLE
 Pepperbox ... use SHAKER, PEPPER
 Percolator ... use MAKER, COFFEE
PESTLE
PICK, ICE
 Piggin, Milking ... use PAIL, MILKING
PIN, ROLLING
PIOSCOPE
PITCHER, BATTER
PITCHER, DRY
PITCHER,MEASURING
PITTER, FRUIT
PLANSIFTER
PLATE, HOT
 Plate, Pie ... use PAN, PIE
POACHER
 Poleax ... use AX, SLAUGHTERING
POPPER, CORN
 Pot ... use SAUCEPAN
 Pot, Bean ... use POT, CROCK
POT, CROCK
 Pot, Pepper ... use SHAKER, PEPPER
POT, STOCK
POTHOLDER
 Pounder, Meat ... use MAUL, MEAT
PRESS, BUTTER
PRESS, CHEESE
PRESS, FRUIT
PRESS, LARD
PRESS, TANKAGE
 Printer, Butter ... use PRESS, BUTTER
PUMP, MILK
PURIFIER, MIDDLINGS
QUERN
RACK, BOTTLE
RACK, CANNING
RACK, COOLING
RACK, MEAT
RACK, SAUCEPAN
RACK, SPICE
RACK, UTENSIL
RACK, WINE
RAKE, CURD
RAKE, POMACE

- -
 FOOD PROCESSING T&E (cont.)

 RAMEKIN
 REAMER, JUICE
 REFRIGERATOR
 Refrigerator, Dairy ... use COOLER, DAIRY
 REST, SPOON
 RETORT, CANNING
 RICER
 ROASTER, COFFEE
 ROLL, LARD
 ROTISSERIE
 Safe, Food ... use CABINET, FOOD-STORAGE
 Safe, Pie ... use CABINET, FOOD-STORAGE
 SALTSHAKER
 SAMPLER, MILK
 SAUCEPAN
 SAW, CHEESE
 SAW, MEAT
 SCALDER, HOG
 SCALE, BUTTER
 SCALE, GRAIN
 Scale, Hopper ... use SCALE, GRAIN
 SCALE, MILK
 SCALER, FISH
 Scissors, Pineapple ... use SNIPS, PINEAPPLE
 Scissors, Poultry ... use SHEARS, POULTRY
 SCOOP
 SCOOP, BUTTER
 SCOOP, CRANBERRY
 SCOOP, CURD
 SCOOP, ICE-CREAM
 SCOOP, MARROW
 SCOURER, GRAIN
 Scourer, Wheat ... use SCOURER, GRAIN
 SCRAPER, CASING
 SCRAPER, CORN
 SCRAPER, DOUGH
 SCRAPER, HOG
 Screen, Food ... use COVER, FOOD
 Screen, Revolving ... use SCREEN, ROLLING
 SCREEN, ROLLING
 SEAL, JAR LID
 SEPARATOR, CREAM
 SEPARATOR, DISK
 SEPARATOR, EGG
 SEPARATOR, GRADING
 SEPARATOR, MILLING
 SEPARATOR, RECEIVING

- -

FOOD PROCESSING T&E (cont.)

 Separator, Warehouse ... use SEPARATOR, RECEIVING
 SHAKER
 SHAKER, BEVERAGE
 SHAKER, FLOUR
 SHAKER, PEPPER
 Shaker, Salt ... use SALTSHAKER
 SHAKER, SALT & PEPPER
 SHAVE, ICE
 SHEARS, POULTRY
 SHEET, COOKIE
 SIEVE ... rt SIFTER
 SIFTER ... rt SIEVE
 SIFTER, FLOUR
 SINK, DRY
 Sizer, Potato ... use SORTER, POTATO
 SKEWER
 SKEWER, BUTCHERING
 Skillet ... use SPIDER or PAN, FRYING
 SKIMMER
 SKIMMER, CREAM
 SLICER, CHEESE
 SLICER, FRUIT
 SLICER, MEAT
 SLICER, VEGETABLE
 Smokejack ... use JACK, BOTTLE
 SMUTTER
 SNIPS, PINEAPPLE
 SORTER, BEAN
 Sorter, Pea ... use SORTER, BEAN
 SORTER, POTATO
 SPADE, BUTTER-WORKING
 SPATULA
 SPIDER ... rt PAN, FRYING
 SPIGOT
 Spit ... use ROTISSERIE
 SPOON
 SPOON, BASTING
 SPOON, MEASURING
 SQUEEZER, CURD
 SQUEEZER, FRUIT
 STAND, CAKE
 STEAMER
 Steamer, Wheat ... use CONDITIONER, GRAIN
 STEEL, CARVING
 STERILIZER, BOTTLE
 STICK, MIXING
 STILL
 STILL, SOLAR

- -

FOOD PROCESSING T&E (cont.)

STIRRER
STIRRER, APPLE BUTTER
STIRRER, CURD
STIRRER, LARD
STIRRER, MILK
STIRRER, SCRAPPLE
 Stomper, Kraut ... use MASHER, KRAUT
STOPPER
STOVE
STOVE, ALCOHOL
STOVE, ELECTRIC
STOVE, GAS
STOVE, WOOD
STRAINER
 Strainer, Cream ... use STRAINER, MILK
STRAINER, GRAVY
STRAINER, MILK
STRAINER, WHEY
STUFFER, SAUSAGE
TABLE, KNEADING
TABLE, MEAT-CUTTING
TABLE, STEAM
TAMPER
 Tamper, Kraut ... use MASHER, KRAUT
TANK, COOLING
TANK, PROCESSING
TANK, STORAGE
TEAKETTLE
 Tenderer, Meat ... use MAUL, MEAT
TESTER, ACIDITY
TESTER, CHEESE
TESTER, MILK
TESTER, OVERRUN
TESTER, SEDIMENT
THERMOMETER
THERMOMETER, CANDY
THERMOMETER, MEAT
THERMOMETER, MILK
TIMER, KITCHEN
 Tin, Kitchen ... use OVEN, REFLECTOR
TOASTER
TONGS
TOPPER, EGG
TRAMMEL
TRAY, CHOPPING
TRAY, DRYING
TRAY, ICE CUBE

- -

FOOD PROCESSING T&E (cont.)

 Trier, Butter ... use TRIER, CHEESE
TRIER, CHEESE
TROUGH, DOUGH
TROUGH, MEAT-SALTING
 Trough, Scalding ... use SCALDER, HOG
 Truck, Bag-holder ... use HOLDER, BAG
TUB, BUTTER
TUBE, MILK
 Tube, Teat ... use TUBE, MILK
TURNER, CAKE
VAT, CHEESE
VAT, COOLING
 Vat, Cream ... use VAT, CHEESE
VAT, PROCESSING
VAT, STORAGE
WARMER, BOTTLE
WARMER, BRANDY
WARMER, PLATE
WASHER, EGG
WASHER, GRAIN
WASHER, MILK-BOTTLE
WASHER, MILK-CAN
 Washer, Wheat ... use WASHER, GRAIN
WHEEL, JAGGING
WHIP, CREAM ... rt EGGBEATER
 Whip, Egg ... use WHISK
WHISK
 Windlass, Slaughtering ... use HOIST, DRESSING
WOK
WORKER, BUTTER
ZYMOSISMETER

FOOD SERVICE T&E

BASIN
BASKET
BASKET, BREAD
BASKET, CAKE
BASKET, FRUIT
BASKET, LUNCH
BASKET, PICNIC
BEAKER
 Boat, Feeding ... use FEEDER, INVALID
 Boat, Gravy ... use SAUCEBOAT
 Boat, Pap ... use FEEDER, INVALID
 Bonbonniere ... use DISH, BONBON
BOTTLE

- -

FOOD SERVICE T&E (cont.)

 BOTTLE, CONDIMENT
 BOTTLE, NURSING
 Bottle, Thermos ... use BOTTLE, VACUUM
 BOTTLE, VACUUM
 BOWL
 BOWL, BERRY
 BOWL, BOUILLON
 BOWL, BRIDE'S
 BOWL, CEREAL
 BOWL, DESSERT
 BOWL, FINGER
 BOWL, FRUIT
 BOWL, JELLY
 BOWL, NUT
 BOWL, PUNCH
 BOWL, SALAD
 BOWL, SERVING
 Bowl, Slop ... use BOWL, WASTE
 BOWL, SOUP
 BOWL, SUGAR
 BOWL, TEA
 BOWL, WASTE
 Box, Flatware ... use TRAY, FLATWARE
 Box, Knife ... use TRAY, FLATWARE
 Box, Knife and Fork ... use TRAY, FLATWARE
 BOX, LUNCH ... rt PAIL, DINNER
 Box, Picnic ... use HAMPER, PICNIC
 BOX, SARDINE
 Box, Spoon ... use TRAY, FLATWARE
 BUCKET, ICE
 CANTIR
 CARAFE ... rt DECANTER
 CASE, CHOPSTICK
 CASE, FLATWARE
 Case, Knife ... use CASE, FLATWARE
 CASE, NAPKIN
 Case, Spoon ... use CASE, FLATWARE
 CASTER
 CHARGER
 CHOPSTICK
 Cloth, Bread Basket ... use NAPKIN, BREAD BASKET
 COASTER
 COASTER, WINE
 COFFEEPOT
 COMPOTE
 COOLER, BEER
 COOLER, WATER
 COOLER, WINE

- -

FOOD SERVICE T&E (cont.)

```
COZY
 Creamer ... use PITCHER, CREAM
CRUET
CUP
 Cup, Candy ... use CUP, FAVOR
CUP, CANTEEN
CUP, CAUDLE
CUP, CHOCOLATE
CUP, COFFEE
CUP, COLLAPSIBLE
CUP, DEMITASSE
CUP, FAVOR
CUP, INVALID
CUP, MUSTACHE
 Cup, Mustard ... use POT, MUSTARD
CUP, NURSING ... rt BOTTLE, NURSING
 Cup, Nut ... use CUP, FAVOR
CUP, PUNCH
CUP, SAKI
CUP, SOUP
 Cup, Tea ... use TEACUP
CUP, TRAVELING
CUP & SAUCER
DECANTER ... rt CARAFE
DECANTER, BAR
DISH
DISH, BERRY
DISH, BONBON
DISH, BONE
DISH, BUTTER
DISH, CANDY
DISH, CELERY
DISH, CHEESE
 Dish, Condiment ... use DISH, RELISH
DISH, DESSERT
DISH, HONEY
DISH, JELLY
DISH, NUT
 Dish, Olive ... use DISH, RELISH
 Dish, Pickle ... use DISH, RELISH
DISH, PUDDING
DISH, RELISH
DISH, SALT
DISH, SAUCE
DISH, SERVING
DISH, SHERBERT
DISH, TEA BAG
DISH, VEGETABLE
```

- -

FOOD SERVICE T&E (cont.)

DISH, WASTE
DISPENSER, BEVERAGE
 Dome, Cheese ... use DOME, FOOD
DOME, FOOD
EGGCUP
EPERGNE
 Ewer ... use PITCHER
FEEDER, INVALID
 Feeder, Sick ... use FEEDER, INVALID
 Feeder, Soup ... use FEEDER, INVALID
FLAGON
 Flask ... use DECANTER
FORK
FORK, BERRY
FORK, CARVING
FORK, COLD-MEAT
FORK, DESSERT
FORK, DINNER
FORK, FISH
FORK, FISH-SERVING
FORK, LEMON
FORK, LUNCHEON
FORK, OYSTER
FORK, PICKLE
FORK, SALAD
FORK, SARDINE
 Fork, Table ... use FORK, DINNER
FOUNTAIN, DRINKING
FOUNTAIN, SODA
GLASS
 Glass, Ale ... use GLASS, MALT-BEVERAGE
 Glass, Beer ... use GLASS, MALT-BEVERAGE
GLASS, CHAMPAGNE
GLASS, COCKTAIL
GLASS, CORDIAL
GLASS, DESSERT
 Glass, Flip ... use BEAKER
 Glass, Flute ... use GLASS, CHAMPAGNE
 Glass, Goblet ... use GOBLET
 Glass, Hock ... use GLASS, WINE
GLASS, JUICE
GLASS, LEMONADE
 Glass, Liqueur ... use GLASS, CORDIAL
GLASS, MALT-BEVERAGE ... rt STEIN; TANKARD
 Glass, Sherry ... use GLASS, WINE
GLASS, SHOT ... rt JIGGER
GLASS, SODA FOUNTAIN
GLASS, SWEETMEAT

- -

FOOD SERVICE T&E (cont.)

 GLASS, TRICK
 GLASS, WATER
 GLASS, WINE
 GOBLET
 HAMMER, SUGAR
 HAMPER, PICNIC
 HOLDER, CASSEROLE
 HOLDER, NAPKIN
 HOLDER, PLACECARD
 Holder, Spoon ... use SPOONER
 HOLDER, TOOTHPICK
 HORN, DRINKING
 JAR, CONDIMENT
 JAR, GINGER
 JAR, HONEY
 Jar, Mustard ... use POT, MUSTARD
 JAR, PICKLE
 JIGGER ... rt GLASS, SHOT
 Jug ... use PITCHER
 KIT, MESS
 KNIFE
 KNIFE, BREAD
 KNIFE, BUTTER
 KNIFE, CAKE
 KNIFE, CARVING
 KNIFE, DESSERT
 KNIFE, DINNER
 KNIFE, FISH
 KNIFE, FRUIT
 KNIFE, ICE-CREAM
 KNIFE, LUNCHEON
 KNIFE, STEAK
 Knife, Table ... use KNIFE, DINNER
 LADLE
 LADLE, PUNCH
 LADLE, SAUCE
 LADLE, SOUP
 LIFTER, TODDY
 LINER, PLATTER
 MAT, PLACE
 MILL, PEPPER
 Muffineer ... use SHAKER, SUGAR
 MUG
 NAPKIN
 NAPKIN, BREAD BASKET
 NAPPY
 NUTCRACKER
 NUTPICK

- -

FOOD SERVICE T&E (cont.)

PAD, HOT
PAD, TABLE
PAIL, DINNER ... rt BOX, LUNCH
 Passglas ... use BEAKER
PITCHER
PITCHER, BEER
PITCHER, CREAM
PITCHER, HOT WATER
PITCHER, ICE WATER
PITCHER, MILK
PITCHER, SYRUP
PITCHER, WATER
PLATE
PLATE, BUTTER
PLATE, CAKE
PLATE, CUP
PLATE, DESSERT
PLATE, DINNER
PLATE, FRUIT
PLATE, LUNCHEON
PLATE, OYSTER
PLATE, PLACE
PLATE, SALAD
PLATE, SAUCEBOAT
PLATE, SERVING
PLATE, SOUP
PLATE, TEA
PLATE, VEGETABLE
PLATEAU
PLATTER
 Pokal ... use GOBLET
PORRINGER
PORRO
POT, CHOCOLATE
 Pot, Coffee ... use COFFEEPOT
POT, HOT-WATER
POT, MUSTARD
POT, POSSET
 Pot, Tea ... use TEAPOT
PYRAMID, DESSERT
RACK, BOTTLE
RACK, TOAST
REST, KNIFE
 Rhyton ... use HORN, DRINKING
RING, NAPKIN
 Roemer ... use GOBLET
 Roller, Linen ... use CASE, NAPKIN

- -

FOOD SERVICE T&E (cont.)

 Rummer ... use GOBLET
SALTCELLAR
SALTSHAKER
SALVER
 Salver, Cake ... use STAND, CAKE
 Samovar ... use URN, COFFEE
SAUCEBOAT
SAUCER
SAUCER, BERRY
SAUCER, DEMITASSE
SCOOP, CHEESE
SCOOP, NUT
SERVER, CAKE
SERVER, CHEESE
SERVER, ICE-CREAM
SERVER, LEMON
SERVER, PIE
SERVER, SALAD
SERVER, TOMATO
SERVICE, DESSERT
SERVICE, TEA
 Serviette ... use NAPKIN
SET, BEVERAGE
 note use for a set comprising a pitcher and matching glasses
 Set, Bridge ... use SET, LUNCHEON
SET, CARVING
SET, CONDIMENT
 note use for a set comprising a mustard jar, saltshaker, pepperbox, etc
 Set, Dish ... use SET, TABLEWARE
SET, FLATWARE
 Set, Lemonade ... use SET, BEVERAGE
SET, LUNCHEON
 note use for a matching set of place mats, coasters, centerpiece, etc.,
 or for a relatively small tablecloth and matching napkins
 rt SET, TABLECLOTH
 Set, Pitcher & Cordial ... use SET, BEVERAGE
SET, SALT & PEPPER
SET, SPOON & SALT
SET, TABLECLOTH
 note use for a matching set of napkins and tablecloth
 rt SET, LUNCHEON
SET, TABLEWARE
 note use for any matched set of cups, saucers, plates, etc.
 Set, Tea ... use SERVICE, TEA
 Set, Water ... use SET, BEVERAGE
SHAKER, SUGAR
SHEARS, GRAPE

- -

FOOD SERVICE T&E (cont.)

 Shell, Sugar ... use SPOON, SUGAR
 SNIFTER
 SNIPS, PINEAPPLE
 SPOON
 SPOON, BABY
 SPOON, BAR
 SPOON, BERRY
 SPOON, BONBON
 SPOON, BOUILLON
 SPOON, CLARET
 SPOON, CREAM
 SPOON, DEMITASSE
 SPOON, DESSERT
 SPOON, FRUIT
 SPOON, GRAPEFRUIT
 Spoon, Ice-cream ... use SPOON, DESSERT
 SPOON, ICED-TEA
 SPOON, LEMONADE SIPPER
 SPOON, MUSTARD
 SPOON, OLIVE
 SPOON, ORANGE
 SPOON, SALT
 SPOON, SERVING
 SPOON, SHERBET
 SPOON, SODA
 SPOON, SOUP
 SPOON, SUGAR
 Spoon, Table ... use TABLESPOON
 Spoon, Tea ... use TEASPOON
 SPOONER
 STAND, CAKE
 STAND, CASK
 STAND, CRUET
 STEIN ... rt GLASS, MALT-BEVERAGE; TANKARD
 STICK, SWIZZLE
 Stick, Toddy ... use STICK, SWIZZLE
 SUGAR & CREAMER
 TABLECLOTH
 TABLESPOON
 TANKARD ... rt GLASS, MALT-BEVERAGE; STEIN
 TANTALUS
 TAP, BEER
 TAZZA
 TEACUP
 TEAPOT
 TEASPOON
 TILTER, POT
 TONGS, ASPARAGUS

- -

FOOD SERVICE T&E (cont.)

 TONGS, ICE
 TONGS, SANDWICH
 TONGS, SUGAR
 TRAY, BED
 TRAY, BREAD
 TRAY, BUTTER
 Tray, Cutlery ... use TRAY, FLATWARE
 TRAY, FLATWARE
 TRAY, RELISH
 TRAY, SAUCEBOAT
 TRAY, SERVING
 Trencher ... use PLATTER
 TRIVET
 TUMBLER
 TUREEN
 TUREEN, SAUCE
 TYG
 URN, COFFEE
 URN, TEA
 VASE, CELERY
 Waster ... use DISH, WASTE

FORESTRY T&E

 ADZ, MARKING
 AUGER, RAFT
 AX, BARKING
 AX, FELLING
 AX, MARKING
 AX, SPLIT
 AX, TURPENTINE
 BAR, TOMMY
 BRIER
 BUCKET, SAP
 Bucket, Sugar ... use BUCKET, SAP
 BUCKSAW
 CALIPERS, TIMBER
 CHAIN, BRAKE
 CHAIN, LOG
 CHISEL, BARKING
 DENDROMETER
 DIPPER, TURPENTINE
 Dog, Hewing ... use DOG, LOG
 DOG, LOG
 Dog, Post ... use DOG, LOG
 DOG, RAFT

- -

FORESTRY T&E (cont.)

 DOG, RING
 DOG, SPAN
 Dog, Timber ... use DOG, LOG
 DOLLY, TIMBER
 Drug ... use DOLLY, TIMBER
 HACK, TURPENTINE
 HAMMER, MARKING
 HOOK, CANT
 HOOK, GRAPPLING
 HOOK, RAFT
 HOOK, SWAMP
 IRON, BARKING
 Knife, Race ... use SCRIBE, TIMBER
 MILL, BARK
 PARBUCKLE
 PEAVY
 PICKAROON
 PIKE, JAM
 PIKE, POLE
 RING, SNUB
 RULE, LOG
 Saw, Buck ... use BUCKSAW
 SAW, CHAIN
 SAW, TWO-HANDED CROSSCUT
 Saw, Woodcutter's ... use BUCKSAW
 SCALE, TIMBER
 SCRAPER, TREE
 SCRAPER, TURPENTINE
 SCRIBE, TIMBER
 Shackle, Drag ... use DOG, SPAN
 SHACKLE, RAFT
 SLED, LOG
 Spile ... use SPOUT, SAP
 SPOUT, SAP
 SPUD, BARKING
 TONGS, SKIDDING
 WANAGAN
 WEDGE
 WHEELS, LOG

GLASS, PLASTICS, CLAYWORKING T&E

 ARMATURE
 Battledore ... use PADDLE
 BENCH, GLASSMAKER'S
 BLOCK, FORMING

- -

GLASS, PLASTICS, CLAYWORKING T&E (cont.)

 BLOCK, GLASSBLOWER'S
 Blowiron ... use BLOWPIPE
 BLOWPIPE
 BLUNGER
 BOARD, CUT-DOWN
 BOARD, TOOL
 BOSS
 BOX, CHEST
 Brick, Kiln ... use FIREBRICK
 BRUSH, GLAZING
 BUCKET, WATER
 CALENDER ... rt MACHINE, COATING
 CALIPERS
 CAME
 CARRIAGE, POT-SETTING
 CART, BATCH
 CHAIR, BALL-HOLDER'S
 Chair, Gaffer's ... use BENCH, GLASSMAKER'S
 CLAMP
 COGGLE
 COMPASS, POTTER'S
 CONE
 CRIMPER
 Crucible ... use POT
 CUP, SLIP-TRAILING
 CUTTER, GLASS
 CUTTER, TOGGLE
 DRILL, FLEXIBLE-SHAFT
 DUMMY
 EXTRUDER
 FILE
 FIREBRICK
 FLANGE
 FLASK, SNAP
 FOOTSTICKS
 FORK, CARRYING-IN
 FURNACE, GLASS
 FURNITURE, KILN
 GLAZE
 Grozer ... use PLIERS, GLASS
 GUN, SPRAY
 HANGER
 HEATER, CALROD
 HEATER, STRIP
 HOOK
 IRON, GATHERING
 JACK
 KIDNEY

- -

GLASS, PLASTICS, CLAYWORKING T&E (cont.)

KILN
KILN, MOLD
KILN, POT
KNIFE, CHEST
KNIFE, FETTLING
KNIFE, STOPPING
LADLE
LADLE, WAX
LATHE
LAWN
MACHINE, COATING ... rt CALENDER
MACHINE, ENGRAVING
MACHINE, FILAMENT-WINDING
MACHINE, FOAM
MACHINE, FOAM-CUTTING
MACHINE, FORMING
MACHINE, METERING
MACHINE, MOLDING
MACHINE, PREFORM
MACHINE, PUMPING
MACHINE, STAMPING
MARVER
MASK, CUP
MASK, LIP
MASK, PLUG
MILL, GLAZE
MILL, PUG
MOLD, CANDLE
MOLD, DOLL
MOLD, DOLL HEAD
MOLD, GLASS
MOLD, PIECE
MOLD, PLATE
MOLD, TOY
OPENER, FID-LEAD
OVEN, CURING
PADDLE
PAN, BLOCKING
PAN, DRIP
PIG
PINCERS
PLATE, CUT-OFF
 Plate, Kettle ... use PLATE, CUT-OFF
PLIERS, GLASS
POINT, GLAZIER'S
PONTIL
POT
PRESS, MOLD

- -

GLASS, PLASTICS, CLAYWORKING T&E (cont.)

 PRESS, VACUUM
 Pucellas ... use JACK
 Punty ... use PONTIL
 RACK, BLOWPIPE
 RAKE
 REAMER
 REEL, CANDLE-DIPPING
 ROD, TUNGSTEN
 ROLLER, IMPREGNATING
 ROLLER, POTTER'S
 SAGGER
 SCRAPER
 SCROLLER
 SHEARS
 SHOVEL, CARRYING-IN
 SLAB, GRAPHITE
 SNAPDRAGON
 SPATULA
 STICK, CLAPPER
 STICK, STEAM
 STILT
 STYLUS
 SYRINGE
 TAMPER
 TEST, OVEN
 TONGS, DIPPING
 TONGS, RAKU
 TOOL, FINISHING
 TOOL, FLARING
 TOOL, FOAM-CUTTING
 TOOL, FORMING
 TOOL, INCISING
 TOOL, LOOP
 Tool, Modeling ... use more specific term, e.g.: TOOL, LOOP; TOOL, RIB
 TOOL, NEEDLE
 TOOL, POT-SETTING
 TOOL, RIB
 TOOL, TURNING
 TRACER
 Trailer, Slip ... use CUP, SLIP-TRAILING
 TRAY, CUT-OFF
 Tub, Ball-holder's ... use TUB, IRON-COOLING
 TUB, IRON-COOLING
 TWEEZERS
 V-BLOCK
 WHEEL, BANDING
 WHEEL, BENCH
 WHEEL, CUTTING

- -

GLASS, PLASTICS, CLAYWORKING T&E (cont.)

 WHEEL, GRINDING ... rt WHEEL, LAPPING
 WHEEL, KICK
 WHEEL, LAPPING ... rt WHEEL, GRINDING
 WHEEL, POLISHING
 Wheel, Potter's ... use more specific term, e.g.: WHEEL, BENCH; WHEEL,
 KICK
 WHEEL, TABLESTAND

LEATHER, HORN, SHELLWORKING T&E

 ANVIL
 AWL
 Awl, Closing ... use AWL, SEWING
 AWL, COLLAR
 AWL, DRAWING
 AWL, PEG
 AWL, SADDLER'S
 AWL, SCRATCH
 AWL, SEWING
 AWL, STABBING
 BAR, HORNWORKER'S
 BEAM, CURRIER'S
 BEAM, TANNER'S
 BENCH, COBBLER'S
 BENCH, HARNESS MAKER'S
 BENCH, HORNWORKER'S
 BEVELER, EDGE
 BEVELER, SAFETY
 BLANK, HORN
 BLANK, TORTOISE
 BLOCK, PRINTING
 BOARD, GRAINING
 Board, Raising ... use BOARD, GRAINING
 BOUNCER
 Break, Peg ... use RASP, SHOEMAKER'S
 BRISTLE, SEWING
 BRUSH, POLISH
 BURNISHER
 CAGE, DRYING
 CANE, BEATING
 CARD
 CASE, PUNCH
 CHANNELER
 CHISEL, THONGING
 CLAMP
 CLAMP, BOOT

- -

LEATHER, HORN, SHELLWORKING T&E (cont.)

 CLAMP, HORNWORKER'S
 CLAMP, LAST
 CLAMP, SADDLER'S
 CLAMP, STRETCHING
 Clicker ... use MACHINE, DIE-CUTTING
 COMPASS
 Cot ... use FINGERSTALL
 CREASER, EDGE
 CREASER, SCREW
 CREASER, SINGLE
 CRIMPER
 CUTTER, CLINCH
 CUTTER, EDGE
 CUTTER, REVOLVING-WHEEL
 CUTTER, WASHER
 DIE, HORNWORKER'S
 DISH, NAIL
 DIVIDER, STITCH
 DRAWKNIFE, HORNWORKER'S
 DRUM, SAWDUST
 Ease, Stript ... use GAUGE, DRAW
 Ends, Wax ... use BRISTLE, SEWING
 FASTENER, BUTTON
 FEATHER, TIPPING
 FID
 FILE
 FILE, HORNWORKER'S
 FINGERSTALL
 FRAME, TOGGLING
 GAUGE
 GAUGE, DRAW ... rt GAUGE, PLOUGH
 GAUGE, PLOUGH ... rt GAUGE, DRAW
 GLAZER
 GOUGE
 GOUGE, ADJUSTABLE
 GOUGE, CHANNEL
 GOUGE, V
 GRAIL, HORNWORKER'S ... rt FILE
 GROOVER, STITCHING
 HAFT, SEWING
 HAMMER, COBBLER'S
 HAMMER, HEEL
 HAMMER, SADDLER'S
 HAMMER, SHOEMAKER'S
 HAMMER, TURN-SHOE
 HOOK, LAST
 HORN, BUFFALO
 HORSE, HORNWORKER'S

- -

LEATHER, HORN, SHELLWORKING T&E (cont.)

 Iron, Glazing ... use SLICKER
 IRON, PINKING
 IRON, SEAT
 IRON, SHOEMAKER'S
 JACK, GLAZING
 JACK, LAST
 KETTLE, HORNWORKER'S
 KICKER
 KNIFE, BEAMING
 KNIFE, DRAW
 KNIFE, FLESHING
 KNIFE, HEAD
 KNIFE, SKIVING
 KNIFE, STRETCHING
 KNIFE, STROUP
 KNIFE, UNHAIRING
 LAST
 LAST, BOOT
 LAST, SHOE
 MACHINE, BEAMING
 MACHINE, BEATING
 MACHINE, BRUSHING
 MACHINE, BUFFING
 MACHINE, CARDING
 MACHINE, DE-BURRING
 MACHINE, DEHAIRING
 MACHINE, DIE-CUTTING
 MACHINE, DRYING
 MACHINE, FLESHING
 MACHINE, HORNWORKER'S
 MACHINE, IRONING
 MACHINE, PULLING
 MACHINE, RIVETING
 MACHINE, SEWING
 MACHINE, SHEARING
 MACHINE, SHOEMAKING
 MACHINE, SKIVING
 MACHINE, SPLITTING
 MACHINE, STRETCHING
 MACHINE, TWINNING
 MALLET
 MANDREL, HORNWORKER'S
 MAUL, RAWHIDE
 NEEDLE
 NEEDLE, GLOVER'S
 NEEDLE, HARNESS
 NEEDLE, LACING
 NIPPERS

- -

LEATHER, HORN, SHELLWORKING T&E (cont.)

 PALM
 PATTERN, SOLE
 PELT
 PEN, PYROGRAPHY
 PINCERS, LASTING
 PLIERS, LACING
 PLIERS, PAD SCREW
 POINT, PYROGRAPHY
 Pommel ... use BOARD, GRAINING
 PONY, LACING
 PRESS, BLINDER
 PRESS, HORNWORKER'S
 PRICKER, WHEEL
 PUNCH, ARCH
 Punch, Belt ... use PUNCH, REVOLVING or PUNCH, SADDLER'S
 PUNCH, BUTTON-HOLE
 PUNCH, DRIVE
 PUNCH, EYELET
 PUNCH, HAND
 PUNCH, HOLE
 PUNCH, LINE
 PUNCH, OBLONG
 PUNCH, PIERCING
 PUNCH, REVOLVING
 PUNCH, SADDLER'S
 PUNCH, SCALLOPING
 PUNCH, STRAP-END
 QUARNET, HORNWORKER'S
 RASP, SHOEMAKER'S
 REAMER, HORNWORKER'S
 RIVET
 ROD, STUFFING
 ROUNDER
 SCRAPER
 SET, LAST & JACK
 SETTER
 SETTER, GROMMET
 SETTER, RIVET
 SHAVE, EDGE
 SHAVE, HEEL
 SHEARS, LEATHER
 Skife ... use BEVELER, SAFETY
 SLICKER
 SMOOTHER
 SPOKESHAVE
 STAND, AWL
 STEEL, FINGER
 STEEL, TURNING

- -
LEATHER, HORN, SHELLWORKING T&E (cont.)

 STENCIL
 STICK, SIZE
 STRETCHER, PELT
 STRETCHER, SHOE
 TONGS, HORNWORKER'S
 TOPPER, HORNWORKER'S
 TRAY, PEG
 TRIMMER, EDGE
 TRIMMER, WELT
 TURNER, SEAM
 VAT
 VAT, BLEACHING
 VAT, DYEING
 VAT, PICKLING
 VISE, HARNESSMAKER'S
 WHEEL, EMBOSSING
 WHEEL, FINISHING
 WHEEL, LEATHERWORKING
 WHEEL, POLISHING/SANDING
 WHEEL, PRICKING
 WRINGER

MASONRY & STONEWORKING T&E

 ANVIL, SLATER'S
 AX, BRICK
 AX, MASON'S
 Ax, Stone ... use AX, MASON'S
 AX, TOOTH
 BILLET
 BIT
 BLOCK, POLISHING
 BURIN ... rt GRAVER
 BUSHHAMMER
 CAVIL
 CHISEL
 CHISEL, BRICK
 CHISEL, CUTTING
 CHISEL, OCTAGONAL
 CHISEL, PITCHING
 CHISEL, PLUGGING
 CHISEL, SPLITTING
 CHISEL, STRAIGHT
 CHISEL, TOOTH
 Darby ... use FLOAT, LONG
 DRILL

- -

MASONRY & STONEWORKING T&E (cont.)

 DRILL, OCTAGONAL
 DRILL, ROUND
 FEATHER
 FLOAT
 FLOAT, LONG
 GRAVER ... rt BURIN
 HAMMER, AX
 Hammer, Bush ... use BUSHHAMMER
 HAMMER, CRANDALL
 HAMMER, FACE
 HAMMER, KNAPPING
 HAMMER, MASON'S
 HAMMER, PATENT
 HAMMER, SLATER'S
 Handsaw ... use SAW, MASON'S
 HAWK
 HOD
 JOINTER
 Jumper ... use DRILL
 KILN, BRICK
 KILN, LIME
 KNIFE, SLATE-TRIMMING
 LEVEL, MASON'S
 LEWIS
 MACHINE, BRICK
 MACHINE, CONCRETE-FINISHING
 MALLET, MASON'S
 MALLET, STONECARVER'S
 MARKER, MASON'S
 MIXER, CEMENT
 MOLD, BRICK
 NIPPERS, TILE
 PICK
 PICK, FLINTING
 PICK, MASON'S
 PICK, MILL
 PIN, LINE
 PLUG
 POINT
 POKER, KILN
 RAKER
 RIPPER, SLATER'S
 RULE, JOINTING
 SAW, BRICK
 SAW, MASON'S
 Saw, Stone ... use SAW, MASON'S
 SCREED
 SPOON, MUD

- -

MASONRY & STONEWORKING T&E (cont.)

 SQUARE, MASON'S
 TROUGH, MIXING
 TROWEL
 TROWEL, GROUTING
 TROWEL, POINTING
 TROWEL, SMOOTHING
 TUBE, GROUTING
 ZAX

METALWORKING T&E

 ANVIL
 ANVIL, CONCAVE
 ANVIL, FILECUTTER'S
 ANVIL, NAILMAKER'S
 ANVIL, SCYTHE-SHARPENING
 ARRASTRA
 AWL
 BARREL, AMALGAMATING
 BEAKIRON
 BELLOWS, BLACKSMITH'S ... rt BLOWER, BLACKSMITH'S
 BENDER, FLANGE
 BENDER, TIRE
 Bickern ... use BEAKIRON
 BIT, CUTTING
 BIT, FLAT
 BIT, STRAIGHT-FLUTED
 BIT, TWIST
 BLOWER, BLACKSMITH'S ... rt BELLOWS, BLACKSMITH'S
 Blowtorch ... use TORCH modified according to fuel
 BOLT, EYE
 BOSS, FILECUTTER'S
 BOX, CHARGING
 BOX, DRILL BIT
 BRAKE ... rt MACHINE, FOLDING
 BRAZIER
 BROACH
 BRUSH, FILE
 BURNISHER
 CAR, SLAG
 CENTERDRILL
 CHISEL, CAPE
 CHISEL, DIAMOND-POINT
 Chisel, Filecutter's ... use CHISEL, HOT
 CHISEL, FLAT
 CHISEL, HALF-ROUND NOSE

- -

METALWORKING T&E (cont.)

 CHISEL, HOT ... rt CREASER, HOT
 CHUCK, BOW DRILL
 CHUCK, DRILL
 CHUCK, LATHE
 CHUCK, TAP
 CLAMP, MOTION INDICATOR
 Clipper, Bolt ... use CUTTER, BOLT
 CLOTH, EMERY
 CONCENTRATOR
 CONCENTRATOR, CYCLONE
 CONCENTRATOR, ELECTROMAGNETIC
 CONCENTRATOR, FLOTATION
 CONCENTRATOR, JIG
 CONCENTRATOR, SHAKING-TABLE
 CONVERTER
 Copper, Soldering ... use IRON, SOLDERING
 COUNTERBORE
 COUNTERSINK
 CREASER, HOT ... rt CHISEL, HOT
 Crimper ... use MACHINE, CRIMPING
 CUP, GRINDER
 CUP, OIL
 CUPEL
 CUSHION, LEAD
 CUTTER, BAR
 CUTTER, BOLT
 CUTTER, CLINCH
 Cutter, Gear ... use MACHINE, GEAR-CUTTING
 Cutter, Nail ... use NIPPERS, NAIL
 CUTTER, PIPE
 CUTTER, WASHER
 CUTTER, WIRE
 DIE
 DIE, SCREW
 DIE, TOE-CALK WELDING
 DIE, WIREDRAWING
 Dingelstuck ... use ANVIL, SCYTHE-SHARPENING or STONE, SCYTHE-SHARPENING
 DOG, LATHE
 Dog, Tiring ... use TONGS, TIRE-PULLING
 DOLLY
 DRESSER, GRINDING WHEEL
 DRIFT
 note use for a cutting tool; do not use for PIN, DRIFT or PUNCH, DRIFT
 DRILL, BOW
 DRILL, ELECTRIC
 DRILL, HAND
 ENGINE, BLOWING
 EXTENDER, HANDLE

- -

METALWORKING T&E (cont.)

 EXTRUDER
 FILE
 FILE, FLAT
 FILE, HALF ROUND
 FILE, NEEDLE
 File, Rat Tail ... use FILE, ROUND
 FILE, ROUND
 FILE, SAW
 FILE, SQUARE
 FILE, TRIANGULAR
 FLANGE
 FLATTER ... rt HAMMER, SET
 FORGE N
 FORGE, BLACKSMITH'S
 Forge, Drop ... use HAMMER, DROP
 FORK, BENDING
 FULLER
 FULLER, BOTTOM
 FULLER, TOP
 FURNACE, ANNEALING
 FURNACE, BLAST
 FURNACE, HEARTH
 FURNACE, MUFFLE
 FURNACE, REVERBERATORY
 Gage ... use GAUGE
 GAUGE
 GAUGE, CENTER
 GAUGE, DRILL
 GAUGE, SCREW-PITCH
 GAUGE, THREAD
 Gauge, Tiring ... use TRAVELER
 GAUGE, WIRE
 GRAPHOTYPE
 GRINDER ... rt GRINDSTONE
 GRINDER, CYLINDRICAL
 GRINDER, MOWER-KNIFE
 GRINDER, PLANER KNIFE
 GRINDER, SURFACE
 GRINDER, TOOL
 GRINDER, VALVE
 GRINDSTONE ... rt GRINDER
 GROOVER, HAND
 HACKSAW
 HAMMER
 HAMMER, BALL-PEEN
 HAMMER, BLAST
 Hammer, Board ... use HAMMER, DROP

- -

METALWORKING T&E (cont.)

 Hammer, Chipping ... use more specific term, e.g.: HAMMER, BALL-PEEN;
 HAMMER, STRAIGHT-PEEN
HAMMER, CROSS-PEEN
HAMMER, DROP
HAMMER, FILE-CUTTING
HAMMER, FOOT-POWERED
HAMMER, FORGING
HAMMER, HELVE
HAMMER, IRONING
HAMMER, PLANISHING
HAMMER, PLOW
 Hammer, Power ... use more specific term, e.g.: HAMMER, HELVE or
 TRIP-HAMMER
HAMMER, RAISING
HAMMER, RIVETING
 Hammer, Rounding ... use HAMMER, TURNING
HAMMER, SET ... rt FLATTER
HAMMER, SETTING ... rt HAMMER, SWAGE
HAMMER, SHARPENING
 Hammer, Shoe-turning ... use HAMMER, TURNING
 Hammer, Sledge ... use SLEDGE
HAMMER, STEAM
HAMMER, STRAIGHT-PEEN
 Hammer, Striking ... use SLEDGE
HAMMER, SWAGE ... rt HAMMER, SETTING
 Hammer, Tilt ... use HAMMER, HELVE
 Hammer, Trip ... use TRIP-HAMMER
HAMMER, TURNING
HAMMER, WELDING
HARDY
HARDY, SIDE-CUTTING
HARDY, STRAIGHT
HEATER, BRANDING-IRON
HOLDER, DIE
HOLDER, SCYTHE-SHARPENER
HOLDER, TIRE-BOLT
 Hone ... use WHETSTONE
 Horn, Mower's ... use HOLDER, SCYTHE-SHARPENER
HORSE, ANVIL
IMPACTOR
INDEX, MILLER
INGOT
 Iron, Bick ... use BEAKIRON
IRON, SNARLING
IRON, SOLDERING
JIG
 Keeve ... use CONCENTRATOR

- -
METALWORKING T&E (cont.)

```
     Key, Cotter ... use PIN, COTTER
   LADLE, CINDER
   LADLE, HOT-METAL
   LADLE, SLAG
    Lamp, Jewelers ... use TORCH, ALCOHOL
   LATHE
   LATHE, ENGINE
     note use for a lathe with a slide rest and a power feed on the carriage
   LATHE, FOOT
     note use for a lathe operated by a treadle
   LATHE, HAND
     note use for a lathe in which the lathe tool is hand-held
   LATHE, TURRET
     note use for a multi-tooled lathe
    Levando ... use CONCENTRATOR
   LINER, CYLINDER
   LINK, BACKING
   MACHINE, BEADING
   MACHINE, BOLT-CLIPPER
   MACHINE, BOLT-HEADING
   MACHINE, BORING
   MACHINE, BRADING
   MACHINE, BREECHING
   MACHINE, BROACHING
   MACHINE, BUFFING
   MACHINE, BURRING
   MACHINE, CHARGING
   MACHINE, CONE
   MACHINE, CREASING
   MACHINE, CRIMPING
   MACHINE, DIE-CUTTING
   MACHINE, DOUBLE-SEAMING
   MACHINE, FOLDING ... rt BRAKE
   MACHINE, FORMING
   MACHINE, GEAR-CUTTING
   MACHINE, GROOVING
   MACHINE, MILLING
   MACHINE, NAIL-CUTTING
   MACHINE, POLISHING
   MACHINE, RIFLING
   MACHINE, RIVET-MAKING
   MACHINE, SCREW-CUTTING
   MACHINE, SETTING-DOWN
   MACHINE, SHEARING
   MACHINE, SINTERING
   MACHINE, SOLDERING
   MACHINE, STRAIGHTENING
   MACHINE, TAPPING
```

- -

METALWORKING T&E (cont.)

 MACHINE, TIRE-BENDING
 MACHINE, TURNING
 MACHINE, WIRING
 MANDREL
 MASK, WELDER'S
 MAUL, SPIKE
 MILL, RAIL
 MILL, ROLLING
 MILL, SAMPLING
 MILL, SLITTING
 MILL, STAMPING
 MILL, TUBE
 MILL, WIRE
 MOLD, CASTING
 NIPPERS, NAIL
 NIPPERS, PULLING
 NIPPERS, SHEET
 NUT
 OILCAN
 Oilstone ... use WHETSTONE
 OVEN, COKE
 PAN, AMALGAMATING
 PATTERN, CASTING
 PATTERN, TRACING
 PIN, COTTER
 PIN, DRIFT
 PINCERS, WIRE
 PIPE, COUPLING
 PLANER ... rt SHAPER
 PLANER, DRIFT
 Plate, Amalgam ... use TABLE, AMALGAMATING
 PLATE, BENCH
 PLATE, JAMB
 PLATE, SCREW
 Plate, Wiredrawing ... use DIE, WIREDRAWING
 POKER
 PRESS, DRILL
 PRESS, PUNCH
 PRESS, STAMPING
 PRITCHEL
 PUNCH, BACKING-OUT
 Punch, Bob ... use COUNTERSINK
 PUNCH, CENTER
 PUNCH, DRIFT
 PUNCH, DRIVE CALK
 PUNCH, FORE
 PUNCH, HOLLOW
 PUNCH, OBLONG

- -

METALWORKING T&E (cont.)

 PUNCH, OVAL
 Punch, Pin ... use PUNCH, BACKING-OUT
 PUNCH, PRICK
 PUNCH, ROUND
 PUNCH, SQUARE
 RABBLE
 RAKE, BLACKSMITH'S
 RATCHET
 REAMER
 RETORT, AMALGAM
 RING, CLINCH
 RING, FORGE
 RING, TONG
 RIVET
 RIVET, TONG
 ROASTER
 ROLLER
 SAW
 Saw, Hack ... use HACKSAW
 SCRAPER
 SCRAPER, FLAT
 SCRAPER, HALF-ROUND
 SCRAPER, HOOK
 SCRAPER, THREE-CORNERED
 SCREEN
 SCREW
 SCREW, MACHINE
 SCREW, RIGGERS
 SCREW, SHEET METAL
 Separator
 note see Mining T&E for separators for metals
 SET, TAP & DIE
 SHAPER ... rt PLANER
 Sharpener, Knife ... use STEEL or WHETSTONE
 Sharpener, Scissors ... use STEEL or WHETSTONE
 Sharpener, Scythe ... use ANVIL, SCYTHE-SHARPENING or STONE,
 SCYTHE-SHARPENING
 Sharpener, Sickle-bar ... use GRINDER, MOWER-KNIFE
 SHEARS, BENCH
 SHEARS, CIRCLE
 SHEARS, LEVER
 SHEARS, SQUARING
 SHOVEL, BLACKSMITH'S
 Shrinker, Tire ... use UPSETTER, TIRE
 SKIMMER
 SLEDGE ... rt HAMMER
 SLEDGE, CROSS-PEEN
 SLEDGE, DOUBLE-FACE

- -

METALWORKING T&E (cont.)

 SLEDGE, SHOE-TURNING
 SLEDGE, STRAIGHT-PEEN
 Sledgehammer ... use SLEDGE
 SNIPS, SHEET METALWORKER'S
 SOCKET
 SPOON, BLACKSMITH'S
 SPRINKLER, BLACKSMITH'S
 STAKE
 STAKE, BLOWHORN
 STAKE, CANDLEMOLD
 STAKE, CREASING
 STAKE, DOUBLE-CREASING
 STAKE, HATCHET
 STAKE, HOLLOW-MANDREL
 STAKE, NEEDLE CASE
 STAKE, PLANISHING
 STAKE, SQUARE
 STAMP
 STAND, BLACKSMITH'S
 STEEL ... rt WHETSTONE
 STENCIL
 STONE, SCYTHE-SHARPENING
 Strickle ... use STONE, SCYTHE-SHARPENING
 SWAGE
 SWAGE, ANVIL
 SWAGE, BOLT-HEADING
 SWAGE, BOTTOM
 SWAGE, CREASING
 SWAGE, FORMING
 SWAGE, HALF-ROUND TOP
 SWAGE, HATCHET
 SWAGE, MANDREL
 SWAGE, NECKING
 SWAGE, NUT
 SWAGE, SPRING
 SWAGE, TOP
 SWAGE, V-SHAPED
 Swedge ... use SWAGE
 Table, Air ... use CONCENTRATOR
 TABLE, AMALGAMATING
 TABLE, WELDING
 TAP
 TAP, BOTTOM
 TAP, PLUG
 TAP, TAPER
 TEMPLATE
 Tongs, Anvil ... use TONGS, PICKUP
 TONGS, BENDING

- -

METALWORKING T&E (cont.)

 TONGS, BOLT ... rt TONGS, HOLLOW-BIT; TONGS, ROUND-LIP
 TONGS, BOX ... rt TONGS, DOUBLE BOX
 TONGS, BRAZING
 TONGS, CHAIN
 TONGS, CLIP
 TONGS, CROOK-BIT ... rt TONGS, SIDE
 TONGS, DOUBLE BOX ... rt TONGS, BOX
 TONGS, DRAWING
 Tongs, Eye ... use TONGS, HAMMER
 TONGS, FLAT
 TONGS, GAD
 TONGS, HALF-ROUND
 TONGS, HAMMER
 TONGS, HOLLOW-BIT ... rt TONGS, BOLT; TONGS, ROUND-LIP
 TONGS, HOOP
 TONGS, LINK
 TONGS, NAIL
 TONGS, PICKUP
 TONGS, PINCER
 TONGS, PLOW
 Tongs, Right-angle bit ... use TONGS, SIDE
 TONGS, ROOFING
 TONGS, ROUND-LIP ... rt TONGS, BOLT; TONGS, HOLLOW-BIT
 TONGS, SHOE
 TONGS, SIDE ... rt TONGS, CROOK-BIT
 TONGS, SLIDING
 Tongs, Straight-lip ... use TONGS, FLAT
 TONGS, SWIVEL JAW
 TONGS, TIRE
 TONGS, TIRE-PULLING
 Tongs, V-lip ... use TONGS, HOLLOW-BIT
 TOOL, ANGLE-BENDING
 TOOL, BORING
 TOOL, HEADING
 TOOL, KNURLING
 TORCH
 TORCH, ACETYLENE
 TORCH, ALCOHOL
 TORCH, GASOLINE
 TORCH, KEROSENE
 TORCH, OXYACETYLENE
 TORCH, OXYHYDROGEN
 TRAVELER
 TRIP-HAMMER
 TUB, SLACK
 TWISTER, WIRE
 UPSETTER, TIRE
 VISE

- -

METALWORKING T&E (cont.)

 VISE, BENCH
 VISE, BLACKSMITH'S
 VISE, LEG
 VISE, MACHINE
 Welder, Arc ... use WELDER, ELECTRIC
 WELDER, ELECTRIC
 Welder, Gas ... use TORCH modified according to fuel
 Wheel, Tire-measuring ... use TRAVELER
 WHETSTONE ... rt STEEL
 WINDER, SPRING
 WRENCH
 Wrench, Adjustable-end ... use WRENCH, CRESCENT
 WRENCH, ALLEN
 WRENCH, ALLIGATOR
 WRENCH, AXLE CAP
 WRENCH, BOX
 WRENCH, BOX-END
 WRENCH, CARRIAGE NUT
 WRENCH, CLOSED END
 WRENCH, COMBINATION
 WRENCH, CRESCENT
 WRENCH, KEY
 WRENCH, LUG
 WRENCH, MONKEY
 WRENCH, OPEN-END
 WRENCH, PIPE
 WRENCH, SOCKET
 WRENCH, T
 WRENCH, TAP
 WRENCH, WAGON
 WREST, SAW

MINING & MINERAL HARVESTING T&E

 ADZ, ICE
 AMIGO
 APPARATUS, ASSAY
 APPARATUS, BREATHING
 Auger ... use DRILL, ROTARY
 AX, ICE
 BAG, ORE
 BAG, TAMPING
 BAILER
 BALANCE, ASSAY-
 BALANCE, BOB
 BALANCE, WATER

- -

MINING & MINERAL HARVESTING T&E (cont.)

 BAR, BORING
 BAR, CLAYING
 BAR, MINER'S
 BAR, QUARRY
 BAR, RIGGING
 BAR, STRETCHER
 BAR, TAMPING
 BAR, WAGON-PINCH
 BASKET, ORE
 BIN, ORE
 BIT
 BIT, CORE
 Blaster ... use DETONATOR
 BOGIE
 BOILER
 BOLT, LEWIS
 BOLT, RAG
 BOLT, ROOF
 BOX, DIP
 BOX, SLUICE
 BOX, STUFFING
 Bucket, Sinking ... use KIBBLE
 CADGER
 CAGE
 CAGE, MAN
 CAN, SAFETY CARBIDE
 Canary ... use DETECTOR, GAS
 CAP, BLASTING
 CAP, TIMBER
 CAR, AMBULANCE
 CAR, MAN
 CAR, MINE
 Car, Ore ... use CAR, MINE
 CARRIAGE, TUNNEL
 CASING
 CELL, FLOTATION
 CHANGKOL
 CHANNELER
 CHISEL, ICE
 CLASSIFIER
 CONCENTRATOR
 note may be modified as are METALWORKING concentrators
 CRIB, CRIBBING
 CRIMPER, BLASTING CAP
 Crossbar ... use CAP, TIMBER
 CRUSHER, BALL
 Crusher, Chilean ... use CRUSHER, ROLLER
 CRUSHER, GYRATORY

- -

MINING & MINERAL HARVESTING T&E (cont.)

 CRUSHER, HAMMER
 CRUSHER, JAW
 CRUSHER, ORE
 CRUSHER, ROLLER
 CRUSHER, STAMP
 CUTTER, CHANNEL BAR
 CUTTER, COAL
 CUTTER, ICE
 DART, SPRING
 DERRICK
 Detector, Firedamp ... use DETECTOR, GAS
 DETECTOR, GAS
 DETONATOR
 DIAL, MINER'S
 DREDGE
 DREDGE, BUCKETLINE
 DREDGE, SUCTION
 DRILL
 Drill, Calyx ... use DRILL, SHOT
 DRILL, CHURN
 DRILL, CORE
 DRILL, DIAMOND
 Drill, Drifter ... use DRILL, PERCUSSIVE
 DRILL, GANG
 DRILL, JETTING
 DRILL, PERCUSSIVE
 Drill, Pole ... use DRILL, CHURN
 DRILL, ROTARY
 DRILL, SHOT
 DRILL, SINKER
 DRILL, STOPPER
 DRILL, TURBO
 Drill, Well ... use more specific term, e.g.: DRILL, CHURN; -,ROTARY
 DULANG
 E-machine ... use MACHINE, BLOWING
 ENGINE, MAN
 Exploder ... use DETONATOR
 FAN, VENTILATION
 FISHPLATE
 FORK, SLUICE
 FUSE, DETONATING
 GAD ... rt MOIL
 GADDER
 GALVANOMETER, BLASTING
 GEOPHONE
 Giant, Hydraulic ... use MONITOR, HYDRAULIC
 Gin ... use HOIST, MINE
 GIRT

- -

MINING & MINERAL HARVESTING T&E (cont.)

 GOVERNOR
 GRAPNEL
 GRIZZLY
 Hammer, Air ... use DRILL, PERCUSSIVE
 HAMMER, HAND
 HANDSTEEL ... rt DRILL
 HOIST, MINE
 HOIST, QUARRY
 HOOK, GRAB
 HOOK, ICE
 HOOKAH
 Hoppit ... use KIBBLE
 HORN, MINER'S
 HURDY-GURDY
 Igniter ... use DETONATOR
 INDICATOR, DRIFT
 INJECTOR, CEMENT
 IRON, BUCKING
 ITA
 Jack, Single ... use HAMMER, HAND
 Jackhammer ... use DRILL, PERCUSSIVE
 Jackleg ... use LEG, AIR
 JUMBO
 KELLEY
 KIBBLE
 KUA
 LAGGING
 LEG, AIR
 LIFT, DRAWING
 LINE, SPINNING
 LOADER
 LOCOMOTIVE, MINE
 LOG
 LOG, NEUTRON
 MACHINE, BLOWING
 MACHINE, CUTTING
 Machine, Grout ... use INJECTOR, CEMENT
 MACHINE, LOADING
 Machine, Mucking ... use LOADER
 MACHINE, PRESSING
 MACHINE, QUARRYING ... rt DRILL, GANG; CUTTER, CHANNEL BAR;
 CUTTER,JET-PIERCING
 MILL, FLINT
 Mill, Quartz ... use MILL, STAMP
 MILL, STAMP
 Mill, Steel ... use MILL, FLINT
 MILLBRACE
 MINER, CONTINUOUS

- -

MINING & MINERAL HARVESTING T&E (cont.)

 Miner, Mechanical ... use MINER, CONTINUOUS
 MOIL ... rt GAD
 MONITOR, HYDRAULIC
 Motor ... use LOCOMOTIVE, MINE
 NEEDLE, DIPPING
 PAN, MINER'S
 PHANAROGRISONMETER
 PHOTOCLINOMETER
 PICK
 PICK, DOUBLE-POINTED
 PICK, DRIFTING
 Pick, Holing ... use PICK, UNDERCUTTING
 PICK, POLL
 PICK, UNDERCUTTING
 PICKER
 PLATE, SNATCH
 POLE, GIN
 POLE, SPRING
 PRICKER
 PUMP
 PUMP, CENTRIFUGAL
 PUMP, DOUBLE-ACTION
 PUMP, SUBMERSIBLE
 RIFFLES
 Rocker ... use SEPARATOR
 ROD, DIVINING
 ROD, SUCKER
 Roll, Cornish ... use CRUSHER, ROLLER
 SAMPLER, SIDEWALL
 SAW, ICE
 SCRAPER, HOE
 SCREEN, TROMMEL
 SEPARATOR
 SEPARATOR, CRADLE
 SEPARATOR, ELECTROMAGNETIC
 SEPARATOR, ELECTROSTATIC
 SEPARATOR, FRAME
 SEPARATOR, JIGGING-MACHINE
 SEPARATOR, WASHER
 SHAFTSET
 SHEAVE, WINDING
 SHIELD
 SKIP
 SLUSHER
 SNORE
 SPADE, GRAFTING
 SPLITTER, SAMPLE
 SPOON

- -

MINING & MINERAL HARVESTING T&E (cont.)

 SPUD
 STEMMER, TAMPING-BAR
 STRAKE, BLANKET
 STULL
 SUPPORTS, POWERED
 TIE, SLEEPERS
 TILLER
 TIMBER
 Tom, Long ... use SEPARATOR
 TONGS, ICE
 TOOL, FISHING
 TORPEDO
 TRAM
 TRAY, ORE
 TRIPOD
 UNDERCURRENT
 Vanner ... use SEPARATOR
 VAT, CYANIDATION
 WASHER
 WASHER, DRY
 WEDGE, DEFLECTION
 Whipstock ... use WEDGE, DEFLECTION
 Widowmaker ... use DRILL
 WORM, SPIRAL

PAINTING T&E

 AIRBRUSH
 BOX, ARTIST'S
 BRUSH, LETTERING
 BRUSH, PAINT
 BRUSH, STENCILLING
 BRUSH, WALLPAPER
 COMB, GRAINING
 CRAYON
 CUP, PALETTE
 CUSHION, GILDER'S
 CUTTER, EDGE
 CUTTER, MAT
 EASEL
 FIGURE, LAY
 Grainer ... use COMB, GRAINING
 GUN, SPRAY
 KEG, PAINT
 KNIFE, MAT
 KNIFE, PAINTING

- -

PAINTING T&E (cont.)

 KNIFE, PALETTE
 KNIFE, PUTTY
 KNIFE, WALLPAPER
 Mahlstick ... use MAULSTICK
 MAULSTICK
 MILL, BALL
 MILL, ROLLER
 Model, Artist's ... use FIGURE, LAY
 MULLER
 PAD, SKETCH
 PAINT
 PALETTE
 PEN, LETTERING
 PENCIL, COLORING
 PESTLE, PAINT
 PIGMENT, PAINT
 PLIERS, STRETCHING
 ROLLER
 ROLLER, GRAINING
 SAUCER, NEST
 SCRAPER, WALL
 SPATULA
 STONE, PAINT
 STUMP
 STYLOGRAPH
 TIP, GILDER'S

PAPERMAKING T&E

 BEATER, HOLLANDER
 BEATER, JORDAN
 BLENDER, STOCK
 BOX, SUCTION
 CALENDER
 CELL, BLEACHING
 CHIPPER
 CUTTER
 DECKLE
 DIGESTER
 DRYER
 FINISHER
 FINISHER, FLINT-GLAZING
 FINISHER, PEBBLING
 GLARIMETER
 Grinder ... use CHIPPER

- -

PAPERMAKING T&E (cont.)

 Guillotine ... use CUTTER
 MACHINE, BAG-FORMING
 MACHINE, COATING
 Machine, Cylinder ... use MACHINE, PAPER
 Machine, Fourdrinier ... use MACHINE, PAPER
 MACHINE, PACKING
 MACHINE, PAPER
 Machine, Paper-making ... use MACHINE, PAPER
 MACHINE, SCORING
 MACHINE, WASHING
 Machine, Yankee ... use MACHINE, PAPER
 MARKER, REAM
 MOLD, PAPERMAKING
 OPACIMETER
 PRESS, SMOOTHING
 PULPER
 REWINDER
 ROLL, DANDY
 RUNNER, EDGE
 SAVE-ALL
 SKID
 SLITTER
 Stamper ... use PULPER
 SUPERCALENDER
 TESTER, MULLEN
 TESTER, SCHOPPER
 TRIMMER
 TRIMMER, BRACKET
 TRIP-HAMMER
 VAT

TEXTILEWORKING T&E

 AWL ... rt FID
 Bag, Emery ... use CUSHION, EMERY
 BAG, NEEDLEWORK
 BALLER
 BAR, WARPING
 BASKET, NEEDLEWORK
 BATTEN
 BEAMER
 BEETLE
 BENCH, RIGGER'S
 BENCH, SAILMAKER'S
 BENCH, WEAVER'S
 BENCH-HOOK, RIGGER'S

- -

TEXTILEWORKING T&E (cont.)

 BILLY, SLUBBING
 BINDING
 Bird, Sewing ... use CLAMP, SEWING
 BLENDER, FEEDER
 BLENDER, SANDWICH
 BLOCK, HAT
 BLOCK, QUILT
 note use for materials intended for the finished quilt
 BOARD, SCUTCHING
 BOBBIN
 BOBBIN, LACE
 BODKIN ... rt FID
 BOLT, CLOTH
 BOWL, SCOURING
 BOX, GILL
 BOX, NEEDLEWORK
 BOX, PIN
 BOX, STUFFER
 Braid ... use TRIM
 BRAIDER
 BREAKER, BALE
 BREAKER, BUTTON
 BREAKER, FLAX
 BROCHE
 CALENDER, EMBOSSING
 CARD, HAND
 CARD, JACQUARD
 CASE, BODKIN
 CASE, CROCHET HOOK
 CASE, KNITTING NEEDLE
 CASE, NEEDLE
 CASE, NEEDLEWORK
 CASE, PIN
 CASE, SCISSORS
 CASE, SPOOL
 CASE, THIMBLE
 CASE, THREAD
 CHALK, TAILOR'S
 CLAMP, QUILTING-FRAME
 CLAMP, RIGGER'S
 CLAMP, SEWING
 CLAMP, WINDING
 COMB
 COMB, HAND
 CONDENSER
 CONDENSER, COTTON
 CONDENSER, GOULDING
 CONDENSER, RUB-APRON

- -

TEXTILEWORKING T&E (cont.)

 CONDENSER, RUB-ROLL
 CONDENSER, TAPE
 CONVERTER, PACIFIC
 COUNTER, THREAD
 CREEL
 CROSS, TEASLE
 CUSHION, EMERY
 CUSHION, LACEMAKER'S
 Darner ... use EGG, DARNING
 DISTAFF
 DRESSER
 DRYER
 DRYER, LOOP
 DRYER, REEL
 DUSTER
 EGG, DARNING
 FADEOMETER
 FID ... rt AWL; BODKIN
 FINGER, WOOL
 FORM, DRESS
 FRAME, DRAWING
 FRAME, EMBROIDERY
 FRAME, QUILTING
 FRAME, RING
 FRAME, ROVING
 FRAME, SLUBBING
 FRAME, SPINNING
 Frame, Teasel ... use NAPPER
 FRAME, TENTER
 FRAME, THROSTLE
 FRAME, TWISTING
 FRAME, WARPING
 Fringe ... use TRIM
 GAUGE, KNITTING NEEDLE
 GAUGE, NET
 GIG, NAPPING
 Gig, Teasel ... use GIG, NAPPING
 GIN, COTTON
 GRINDER, CARD
 GUIDE, SEAM
 Hackle ... use HATCHEL
 HAM, TAILOR'S
 HATCHEL
 Heckle ... use HATCHEL
 Hetchel ... use HATCHEL
 HOLDER, FLAX
 HOLDER, NEEDLE
 HOLDER, SPOOL

- -

TEXTILEWORKING T&E (cont.)

 HOLDER, TAPE
 HOLDER, THIMBLE
 HOLDER, THREAD
 HOOK, CROCHET
 HOOK, RUG
 HOOK, TAMBOUR
 HOOP, EMBROIDERY
 Housewife ... use KIT, NEEDLEWORK
 JACK, SPINNING
 JENNY, SPINNING
 KETTLE, DYEING
 KIT, NEEDLEWORK
 Kit, Sewing ... use KIT, NEEDLEWORK
 KNIFE, SAILMAKER'S
 KNIFE, SCUTCHING
 Knife, Swingling ... use KNIFE, SCUTCHING
 KNOTTER
 Leader, Ribbon ... use BODKIN
 LOOM
 LOOM, BACKSTRAP
 LOOM, BEAD
 LOOM, BELT
 LOOM, BROAD
 note use for any loom designed to weave a fabric 54" or more in width
 LOOM, CAM
 LOOM, CARPET
 LOOM, COUNTER-BALANCE
 LOOM, COUNTER-MARCH
 LOOM, DOBBY
 Loom, Doup ... use LOOM, LENO
 LOOM, DRAW
 LOOM, HAND
 LOOM, JACK
 LOOM, JACQUARD
 LOOM, LACE
 LOOM, LENO
 LOOM, NEEDLE POINT
 LOOM, PILE FABRIC
 LOOM, RAPIER
 LOOM, RIGID HEDDLE
 LOOM, SHUTTLELESS
 LOOM, SWIVEL
 LOOM, TABLET
 LOOM, TAPE
 LOOM, WARP WEIGHTED
 LOOM, WATER-JET
 LUCET
 MACHINE, BACKFILLING

- -

TEXTILEWORKING T&E (cont.)

 MACHINE, BATT-MAKING
 MACHINE, BLEACHING
 MACHINE, BONDING
 MACHINE, BRUSHING
 MACHINE, BULKING
 MACHINE, BURLING
 MACHINE, CARD CLOTHING
 MACHINE, CARDING
 MACHINE, CARD-PUNCHING
 MACHINE, CHINCHILLA
 MACHINE, COATING
 MACHINE, CRABBING
 MACHINE, CRIMPING
 MACHINE, CROCHETING
 MACHINE, DECATING
 MACHINE, DRAWING-IN
 MACHINE, DYEING
 MACHINE, EMBROIDERY
 MACHINE, FELTING
 Machine, Finishing ... use more specific term, e.g.: MACHINE, DECATING;
 CALENDER, EMBOSSING
 MACHINE, FLOAT-CUTTING
 MACHINE, FLOCKING
 MACHINE, FOLDING
 MACHINE, FULLING
 MACHINE, GARNETT
 MACHINE, GIGGING
 MACHINE, HEAT-SETTING
 MACHINE, KNIT/SEW
 MACHINE, KNITTING
 MACHINE, LOOPING
 MACHINE, MERCERIZING
 MACHINE, PACKAGE-CHANGING
 note see also SPOOLER; WINDER; REEL
 MACHINE, PAD
 MACHINE, PERLOCK
 MACHINE, PINKING
 MACHINE, PLEATING
 MACHINE, QUILTING
 MACHINE, ROPE-MAKING
 MACHINE, SEWING
 MACHINE, SHEARING
 MACHINE, SHRINKING
 MACHINE, SIMPLEX
 MACHINE, SUEDING
 MACHINE, TEXTURING
 MACHINE, THROWING
 MACHINE, TUFTING

- -

TEXTILEWORKING T&E (cont.)

 MACHINE, TYING-IN
 MACHINE, WASTE
 MALLET, SERVING
 MARKER, HEM
 MARLINESPIKE
 MILL, FULLING
 MOLD, HAT
 NAPPER
 NEEDLE, DARNING
 NEEDLE, KNITTING
 NEEDLE, NETMAKING
 NEEDLE, SAILMAKER'S
 NEEDLE, SEWING
 NEEDLE, UPHOLSTERER'S
 NIDDY NODDY
 Opener-picker ... use PICKER
 PALM, SAILMAKER'S
 PATTERN
 PATTERN, NEEDLEWORK
 PATTERN, QUILT
 PICKER
 Pillow, Bobbin lace ... use CUSHION, LACEMAKER'S
 PIN, SAFETY
 PIN, STRAIGHT
 PINCUSHION
 PRESS, CLOTH
 PRESS, HOT-HEAD
 PROVER, LINEN
 PUNCH, GROMMET
 PUNCH, SAILMAKER'S
 QUILLER
 RACK, NEEDLEWORK
 RACK, SAFETY PIN
 RACK, SPOOL
 REED
 REEL
 REEL, CLOCK ... rt WINDER
 REEL, WARPING
 Reel, Yarn ... use REEL
 REMOVER, BURR
 RIPPER, STITCH
 SCISSORS ... rt SHEARS
 Scutcher, Flax ... use KNIFE, SCUTCHING
 SHARPENER, NEEDLE
 SHEARS ... rt SCISSORS
 SHEARS, DRESSMAKER'S
 SHEARS, FULLER'S
 SHEARS, PINKING

- -

TEXTILEWORKING T&E (cont.)

SHUTTLE
SHUTTLE, NETTING
SHUTTLE, TATTING
SKEINER
SLASHER
SLUBBER
SNAPSETTER
SPINDLE
SPINDLE, ROPEMAKING
SPINNERET
SPOOL
SPOOLER
 Stapler, Break-stretch ... use MACHINE, PERLOCK
 Stapler, Diagonal-cutting ... use CONVERTER, PACIFIC
 Stapler, Turbo ... use MACHINE, PERLOCK
STILETTO
STITCH-HEAVER, RIGGER'S
STRAIGHTENER, CLOTH
STRETCHER, CLOTH
STRETCHER, HAT
SWIFT
 Swingle, Flax ... use KNIFE, SCUTCHING
 Tambour ... use HOOP, EMBROIDERY
TEMPLE
TESTER
TESTER, BURST
TESTER, CRIMP
TESTER, FINENESS
TESTER, FIRE-RESISTANCE
TESTER, NEP
TESTER, SCORCH
TESTER, SHRINKAGE
TESTER, SLIVER
TESTER, TEAR
TESTER, TWIST
TESTER, WASHFASTNESS
THIMBLE
THREAD
THREADER
TINTOMETER
TRAIN, SCOURING
TRAY, PIN
TRIM
TWISTER
VAT
 Wheel, Godet ... use WHEEL, STRETCHING
WHEEL, HAND
WHEEL, QUILLING

- -

TEXTILEWORKING T&E (cont.)

 WHEEL, SPINNING
 WHEEL, STRETCHING
 WHEEL, TOW
 WHEEL, TRACING
 WINDER ... rt REEL, CLOCK
 WINDER, BOBBIN
 WINDER, CONE
 WINDER, SPOOL
 Workbasket ... use BASKET, NEEDLEWORK
 YARN
 ZIPPER

WOODWORKING T&E

 ADZ
 ADZ, BUNGING
 ADZ, CARPENTER'S
 ADZ, CLEAVING
 ADZ, COOPER'S
 Adz, Dubbing ... use ADZ, LIPPED
 ADZ, GUTTERING ... rt PLANE, GUTTERING
 Adz, Hammer ... use ADZ, RAILROAD
 ADZ, HOLLOWING
 ADZ, LIPPED
 Adz, Platelayer's ... use ADZ, RAILROAD
 ADZ, RAILROAD
 ADZ, SHIPWRIGHT'S
 Adz, Spout ... use ADZ, GUTTERING
 ADZ, TRUSSING ... rt HAMMER, COOPER'S
 ADZ, WHEELWRIGHT'S
 AUGER
 Auger, Burn ... use IRON, WHEELWRIGHT'S BURNING
 Auger, Center-bit ... use AUGER, SPIRAL
 Auger, Cooper's bong-borer ... use AUGER, TAPER
 Auger, Expanding ... use AUGER, SPIRAL
 AUGER, HOLLOW
 Auger, Hollow Bit ... use AUGER, HOLLOW
 Auger, Nose ... use AUGER, SHELL
 Auger, Pipe ... use AUGER, TAPER or AUGER, SHELL or AUGER, SNAIL
 Auger, Pod ... use AUGER, SHELL or AUGER, SNAIL
 Auger, Pump ... use AUGER, TAPER or AUGER, SHELL or AUGER, SNAIL
 Auger, Screw ... use AUGER, SPIRAL
 AUGER, SHELL
 AUGER, SNAIL
 AUGER, SPIRAL

- -

WOODWORKING T&E (cont.)

 Auger, Tap ... use AUGER, TAPER
 AUGER, TAPER
 Auger, Twist ... use AUGER, SPIRAL
 AWL
 Awl, Brad ... use BRADAWL
 Awl, Flooring ... use BRADAWL
 AWL, MARKING ... rt KNIFE, MARKING; SCRIBER
 Awl, Scratch ... use AWL, MARKING
 Awl, Scribe ... use AWL, MARKING
 AWL, SQUARE
 AX
 Ax, Broad ... use BROADAX
 AX, COOPER'S
 AX, CRATEMAKER'S
 Ax, Goosewing ... use BROADAX
 Ax, Hewing ... use BROADAX
 AX, MAST & SPAR
 AX, MORTISING
 AX, SHIPWRIGHT'S
 AX, SIDE
 BEETLE ... rt MALLET; MAUL, POST
 BELLOWS, COOPER'S
 BENCH, BOX MAKING
 BENCH, CARPENTER'S
 Bench, Saw-sharpening ... use HORSE, SAW-SHARPENING
 BENCH, WHEELWRIGHT'S
 BIT
 BIT, ANNULAR ... rt SAW, CROWN
 BIT, CENTER
 BIT, COUNTERSINK
 BIT, GIMLET
 BIT, NOSE
 BIT, SHELL
 BIT, SPOON
 BIT, STRAIGHT-FLUTED
 BIT, TAPER
 BIT, TWIST
 Bitstock ... use BRACE
 BLOCK, BEVEL
 BLOCK, FRAMING
 BLOCK, MITER
 Block, Miter-shooting ... use JACK, MITER
 BLOCK, SHAVING ... rt HORSE, SHAVING
 BOARD, SHOOTING
 BOLT
 BORER, CORK
 BOX, MITER
 BOX, MOLDING

- -

WOODWORKING T&E (cont.)

 BOX, SHIPWRIGHT'S CAULKING
 BOX, SHIPWRIGHT'S OIL
 BOX, TOOL
 Box, Turning ... use BOX, MOLDING
 BRACE
 BRACE, ENGINEER'S RATCHET
 BRACE, EXTENSION
 BRACE, SPOFFORD
 BRACE, WIMBLE
 BRAD
 BRADAWL
 Brake, Cleaving ... use HORSE, FROE
 BREASTPLATE
 BROACH ... rt REAMER
 BROADAX
 BRUSH, SEAM
 BUNGSTART
 Celt ... use AX or ADZ
 CHALK, LUMBER
 CHISEL
 CHISEL, BENT
 CHISEL, BOATBUILDER'S
 Chisel, Broad ... use SLICK
 Chisel, Bruzz ... use CHISEL, CORNER
 Chisel, Cant ... use CHISEL, FIRMER
 CHISEL, CARVING
 CHISEL, CORNER
 CHISEL, FIRMER
 Chisel, Forming ... use CHISEL, FIRMER
 Chisel, Framing ... use CHISEL, FIRMER
 CHISEL, GOOSENECK
 CHISEL, MORTISE
 CHISEL, PARING
 CHISEL, PARTING
 CHISEL, RIPPING ... rt WEDGE
 CHISEL, SKEW
 Chisel, Slice ... use SLICK
 CHISEL, SOCKET
 CHISEL, TURNING
 CHUCK
 CLAMP
 CLAMP, C
 CLAMP, COLLAR & SCREW
 CLAMP, CORNER
 CLAMP, FLOORING
 CLAMP, FURNITURE
 Clamp, G ... use CLAMP, C
 CLAMP, JOINER'S

- -

WOODWORKING T&E (cont.)

```
    CLAMP, SAW
    CLAMP, SCREW
     Claw, Tack ... use PULLER, TACK
    CLOTH, EMERY
    CLUB, FROE
     Commander ... use BEETLE
    COMPASS
    CRADLE, HUB
     Cradle, Rounding ... use BLOCK, BEVEL
     Cramp ... use CLAMP
    CRAYON, LUMBER
    CRESSET
    CROWBAR
    CROZE ... rt PLANE
     Cudgel ... use CLUB, FROE
     Cutter, Dowel ... use CUTTER, PEG
    CUTTER, PEG
    CUTTER, SHINGLE
     Dip ... use ROD, GAUGE
    DIVIDERS
    DOG
    DOG, HOOPING
    DOG, JOINER'S
    DOG, SPOKE
    DOWEL ... rt TREENAIL; PEG
    DOWNSHAVE, COOPER'S
    DRAWKNIFE ... rt DRAWSHAVE; JIGGER; SCORPER, CLOSED; SCORPER, OPEN;
                    SPOKESHAVE
    DRAWKNIFE, BACKING
    DRAWKNIFE, BARKING
    DRAWKNIFE, CARPENTER'S
    DRAWKNIFE, CHAMFERING
    DRAWKNIFE, COOPER'S
    DRAWKNIFE, HANDLEMAKERS
    DRAWKNIFE, HEADING
    DRAWKNIFE, HOLLOWING
    DRAWKNIFE, WHEELWRIGHT'S
    DRAWSHAVE ... rt DRAWKNIFE; SPOKESHAVE
    DRIFT
    DRILL
    DRILL, BOW
    DRILL, PUMP
    DRILL, PUSH
    DRIVER, HOOP
    FILE
    FINGERSTALL, SHIPWRIGHT'S
    FLOAT ... rt RASP; FILE
```

- -

WOODWORKING T&E (cont.)

 Flogger, Bung ... use BUNGSTART
FRAME, WHEEL
FRETSAW ... rt SAW, COPING
FROE
FROE, COOPER'S
FROE, KNIFE
FROE, LATHMAKER'S
 Frow ... use FROE
GAUGE
GAUGE, BEVEL
GAUGE, BORING
 Gauge, Butt ... use GAUGE, MARKING
GAUGE, COMBINATION
GAUGE, CUTTING
GAUGE, DOVETAIL
 Gauge, Grasshopper ... use GAUGE, MONKEY
 Gauge, Handrail ... use GAUGE, MONKEY
GAUGE, MARKING
GAUGE, MONKEY
 Gauge, Mortise ... use GAUGE, MARKING
 Gauge, Panel ... use GAUGE, MARKING
 Gauge, Patternmaker's ... use GAUGE, MONKEY
GAUGE, RABBET
 Gauge, Slitting ... use GAUGE, CUTTING
GAUGE, STAVE
 Gauge, Thumb ... use GAUGE, MARKING
GAUGE, TURNER'S
GAUGE, WHEELWRIGHT'S
GIMLET
GLUEPOT
GOUGE ... rt CHISEL
GOUGE, CARVING
GOUGE, FIRMER
GOUGE, PARING
GOUGE, TURNING
GOUGE, WHEELWRIGHT'S
HAMMER
HAMMER, CLAW
HAMMER, CLENCH
HAMMER, COOPER'S ... rt ADZ, TRUSSING
 Hammer, Flooring ... use HAMMER, CLENCH
HAMMER, FRAMING
HAMMER, JOINER'S
HAMMER, PATTERNMAKER'S
 Hammer, Roofing ... use HAMMER, CLENCH
 Hammer, Ship's maul ... use HAMMER, TOP MAUL
HAMMER, TACK
HAMMER, TOP MAUL

- -

WOODWORKING T&E (cont.)

```
        HAMMER, TRIMMER'S
        HAMMER, VENEER
         Handsaw ... use more specific term, e.g.: SAW, CROSSCUT; RIPSAW
        HATCHET ... rt AX
        HATCHET, CLAW
        HATCHET, HEWING
        HATCHET, LATHING
        HATCHET, SHINGLING
        HOLDFAST
        HOOK, BENCH
        HORSE, FROE ... rt HORSE, SHAVING
         Horse, Saw ... use SAWHORSE
        HORSE, SAW-SHARPENING
        HORSE, SHAVING ... rt BLOCK, SHAVING; HORSE, FROE
         Horse, Shingling ... use HORSE, FROE
        IRON, CAULKING
        IRON, CHINCING
        IRON, COOPER'S BURNING
        IRON, CREASING
        IRON, FLAGGING
        IRON, HORSING
         Iron, Knocking-up ... use JUMPER
        IRON, MARKING
        IRON, RAISING ... rt JUMPER
        IRON, SHIPWRIGHT'S CAULKING
        IRON, SHIPWRIGHT'S MEAKING
        IRON, WHEELWRIGHT'S BURNING
        JACK, MITER
        JIGGER ... rt DRAWKNIFE
        JIGSAW
        JOINTER
        JOINTER-PLANER
        JUMPER ... rt IRON, RAISING
         Knife, Bench ... use KNIFE, BLOCK
        KNIFE, BLOCK
        KNIFE, CARVING
         Knife, Chamfer ... use DRAWKNIFE, CHAMFERING
        KNIFE, FINGER
         Knife, Froe ... use FROE, KNIFE
        KNIFE, HOOP-NOTCHING ... rt ADZ, COOPER'S NOTCHING
         Knife, Lathmaker's ... use FROE, KNIFE
        KNIFE, MARKING ... rt AWL, MARKING
        KNIFE, SHAVING
        LADLE, SHIPWRIGHT'S CAULKING
        LATHE
        LATHE, BORING
        LATHE, DUPLICATING
        LATHE, SPOKE
```

- -

WOODWORKING T&E (cont.)

```
    LEVEL
    LEVEL, PLUMB
     Level, Spirit ... use LEVEL
    LINE, CHALK ... rt REEL, CHALK
    MACHINE, BEDDING
    MACHINE, BORING
    MACHINE, DOVE-TAILING
    MACHINE, MORTISING
    MACHINE, PROFILING
    MACHINE, SHAVING
    MACHINE, SPOTTING
    MACHINE, TENONING
    MACHINE, TONGUE & GROOVE
    MACHINE, TREENAILING
    MACHINE, TRIMMING
    MACHINE, WHEEL-MAKING
    MAKER, CHEESE-BOX
    MALLET ... rt BEETLE; MAUL, POST
    MALLET, CARPENTER'S
    MALLET, CARVER'S
    MALLET, CAULKING
    MALLET, SHIPWRIGHT'S
    MAUL
    MAUL, POST ... rt BEETLE; MALLET
    MORTISER
    MOULDER
    NAIL
    NUT
    PATTERN ... rt TEMPLATE
    PEG ... rt TREENAIL; DOWEL
     Pin ... use DOWEL or PEG
    PIN, DRAW BORE
    PINCERS
    PLANE
    PLANE, ASTRAGAL
     Plane, Badger ... use PLANE, RABBET
    PLANE, BANDING
     Plane, Beading ... use PLANE, ASTRAGAL
     Plane, Bead Molding ... use PLANE, ASTRAGAL
    PLANE, BLOCK
    PLANE, BULLNOSE
     Plane, Center-Bead ... use PLANE, CENTERBOARD
    PLANE, CENTERBOARD
     Plane, Chisel ... use PLANE, EDGE
     Plane, Chiv ... use PLANE, HOWELL
     Plane, Cluster-Bead ... use PLANE, MOLDING
    PLANE, COACH
    PLANE, COMBINATION
```

- -

WOODWORKING T&E (cont.)

 PLANE, COMPASS
 PLANE, COOPER'S STOUP
 PLANE, CORNICE
 Plane, Crown ... use PLANE, CORNICE
 Plane, Croze ... use CROZE
 PLANE, DADO ... rt PLANE, GROOVING
 PLANE, DRAWER
 PLANE, EDGE
 PLANE, FILLISTER
 PLANE, FLOOR
 Plane, Fore ... use PLANE, JACK
 PLANE, GROOVING ... rt PLANE, PLOW; PLANE, DADO
 PLANE, GUTTERING ... rt ADZ, GUTTERING
 Plane, Handrail ... use PLANE, STAIRBUILDER'S
 PLANE, HOLLOW ... rt PLANE, ROUND
 PLANE, HOWELL
 PLANE, JACK
 PLANE, JOINTER ... rt PLANE, TRYING
 Plane, Leveling ... use PLANE, SUN
 PLANE, MITER
 PLANE, MODELING
 PLANE, MOLDING
 Plane, Old woman's tooth ... use PLANE, ROUTER
 PLANE, PANEL
 Plane, Panel-fielding ... use PLANE, RAISING
 PLANE, PLOW ... rt PLANE, GROOVING
 Plane, Pull ... use PLANE, JOINTER
 PLANE, RABBET
 PLANE, RAISING
 Plane, Rebate ... use PLANE, RABBET
 PLANE, ROUGHING
 PLANE, ROUND ... rt PLANE, HOLLOW
 PLANE, ROUNDER
 PLANE, ROUTER ... rt ROUTER
 PLANE, SASH
 Plane, Scaleboard ... use PLANE, SPLINT
 PLANE, SCOOPMAKER
 PLANE, SHOULDER
 PLANE, SIDE RABBET
 Plane, Skew ... use PLANE, RABBET
 PLANE, SMOOTHING
 PLANE, SPLINT
 PLANE, SPOKE
 PLANE, STAIRBUILDER'S
 PLANE, SUN
 PLANE, TONGUE-AND-GROOVE
 PLANE, TONGUING
 PLANE, TOOTHING

- -

WOODWORKING T&E (cont.)

 Plane, Topping ... use PLANE, SUN
 PLANE, TRYING ... rt PLANE, JOINTER
 PLANE, VIOLINMAKER'S
 Plane, Witchet ... use PLANE, ROUNDER
 PLANER
 Plate, Dowel ... use CUTTER, PEG
 PLATE, GLUE
 POUCH, NAIL
 PRESS, CORK
 PRESS, VENEER
 PROP, SAWYER'S ... rt SAWBUCK; SAWHORSE; TACKLE, SAWING
 PULLER, NAIL
 PULLER, STAPLE
 PULLER, TACK
 PUNCH, CARVER'S
 PUNCH, COOPER'S
 PUNCH, HANDRAIL
 PUNCH, MARKING
 PUNCH, NAIL
 Punch, Rivet ... use PUNCH, STARTING
 PUNCH, SHINGLE
 PUNCH, STARTING
 PUNCH, VENEER
 PUNCH, WOOD
 RASP ... rt FILE; FLOAT
 REAMER ... rt AUGER; BIT; BROACH
 REEL, CHALK ... rt LINE, CHALK
 Riffler ... use FILE or RASP
 RIPSAW
 ROD, GAUGE
 ROUNDER
 ROUTER ... rt PLANE, ROUTER
 RULE, CALIPER
 RULE, PATTERNMAKER'S
 RULE, PROTRACTOR
 SANDER
 SANDER, BELT
 SANDER, DISK
 SANDPAPER
 SAW
 SAW, ANGLE
 SAW, BACK
 SAW, BAND
 SAW, BEAD
 SAW, BENCH
 Saw, Board ... use SAW, PIT
 SAW, BOW

- -

WOODWORKING T&E (cont.)

 Saw, Bracket ... use FRETSAW
 Saw, Buhl ... use FRETSAW
 SAW, CARCASS
 Saw, Chairmaker's ... use SAW, FELLOE
 Saw, Circular ... use SAW, BENCH or SAW, RADIAL-ARM or SAW,
 ELECTRIC-PORTABLE
 SAW, COMPASS ... rt SAW, KEYHOLE
 SAW, COPING ... rt FRETSAW
 SAW, CROSSCUT
 SAW, CROWN ... rt BIT, ANNULAR
 SAW, DOVETAIL
 SAW, ELECTRIC-PORTABLE
 SAW, FELLOE
 SAW, FRAME
 SAW, FRAMED VENEER ... rt SAW, VENEER
 Saw, Fret ... use FRETSAW
 Saw, Fretwork ... use FRETSAW
 SAW, HAND
 SAW, HEADING
 Saw, Jig ... use JIGSAW
 SAW, KEYHOLE ... rt SAW, COMPASS
 Saw, Lock ... use SAW, KEYHOLE
 Saw, Long ... use SAW, CROSSCUT
 SAW, MITER-BOX
 SAW, PATTERNMAKER'S
 SAW, PIT
 SAW, RABBET ... rt PLANE, RABBET
 SAW, RADIAL-ARM
 Saw, Rip ... use RIPSAW
 SAW, SABRE
 Saw, Scroll ... use FRETSAW
 Saw, Skill ... use SAW, ELECTRIC PORTABLE
 SAW, STAIRBUILDER'S
 SAW, TENON
 Saw, Thwart ... use SAW, CROSSCUT
 SAW, VELLUM
 SAW, VENEER
 SAWBUCK ... rt PROP, SAWYER'S; SAWHORSE; TACKLE, SAWING
 SAWHORSE ... rt SAWBUCK; PROP, SAWYER'S; TACKLE, SAWING
 SAWMILL, BAND
 SAWMILL, CIRCULAR
 SAWMILL, GANG
 SAWMILL, GATE-TYPE
 SAWMILL, MULEY
 SAWMILL, UP-AND-DOWN
 SAW-SET ... rt WREST, SAW
 SCORPER, CLOSED ... rt DRAWKNIFE

- -

WOODWORKING T&E (cont.)

 SCORPER, OPEN ... rt DRAWKNIFE
 SCRAPER
 SCREW
 SCRIBER ... rt AWL, MARKING
 SHAPER
 Shave ... use DRAWSHAVE or SPOKESHAVE
 Shave, Round ... use SCORPER, CLOSED or SCORPER, OPEN
 SHEATH, AXE
 SLICK ... rt CHISEL
 SPIKE
 SPOKESHAVE ... rt DRAWKNIFE; DRAWSHAVE
 SQUARE
 SQUARE, BEVEL
 SQUARE, CARPENTER'S
 SQUARE, DRILL POINT
 SQUARE, MITER
 SQUARE, SET
 SQUARE, SLIDING
 SQUARE, TRY
 STAND, SHAFT
 STAPLE
 STAVE
 Stock, Drill ... use DRILL
 STOP, BENCH
 TACKLE, SAWING ... rt PROP, SAWYER'S; SAWBUCK; SAWHORSE
 TAP, SCREW
 TEMPLATE ... rt PATTERN
 TOPPER, BARREL
 TREENAIL ... rt PEG; DOWEL
 Trunnel ... use TREENAIL
 TWIBIL
 VISE
 WASHER
 WEDGE ... rt CHISEL, RIPPING
 WREST,SAW ... rt SAW-SET

OTHER T&E FOR MATERIALS

 BASKET, BROOM, BRUSH MAKING T&E

 BEATER
 BODKIN
 BRAKE
 CLAMP

- -

BASKET, BROOM, BRUSH MAKING T&E (cont.)

 CLEAVER
 COMB
 CUTTER
 GUARD, HAND
 HATCHEL
 KNIFE, PICKING
 KNIFE, WILLOW
 LAPBOARD
 MACHINE, BROOM
 MOLD
 NEEDLE
 Peeler, Willow ... use BRAKE
 SHAVE, BASKET
 SHAVE, UPRIGHT
 SHEARS
 STRIPPER
 VISE

CIGAR MAKING T&E

 CLAMP, CIGAR
 MOLD, CIGAR
 ROLLER, CIGARETTE
 ROLLER, TOBACCO

LAPIDARY T&E

 CADRAN, GEMOLOGIST'S

WIGMAKING T&E

 HATCHEL

- -

CATEGORY 5: TOOLS & EQUIPMENT FOR SCIENCE & TECHNOLOGY

ACOUSTICAL T&E

 Acoumeter ... use AUDIOMETER
 Acousimeter ... use AUDIOMETER
 AMPLIFIER, AUDIO ... rt FUNNEL-HORN; RESONATOR
 ANALYZER, SOUND
 ANALYZER/SYNTHESIZER, CLANG
 Apparatus, Auditory ... use more specific term, e.g.: GENERATOR, SOUND;
 AMPLIFIER, AUDIO; ANALYZER, SOUND;
 APPARATUS, DIFFERENCE TONE
 AUDIOMETER
 AUDIO-OSCILLATOR
 CAGE, SOUND
 CONE, TUNING
 FORK, TUNING
 FUNNEL-HORN ... rt AMPLIFIER, AUDIO
 GENERATOR, SOUND
 HAMMER, SOUND
 HARMONOMETER
 HELMET, SOUND
 KYMOSCOPE
 LAMELLA
 LOGOGRAPH
 MASKER
 MEASURER, SOUND
 note use for a sound generator with scales
 OPEIDOSCOPE
 ORGAN, LABORATORY
 PENDULUM, SOUND
 PERIMETER, SOUND
 PHONELESCOPE
 PHONODEIK
 PHONOMETER
 PHONO-PROJECTOSCOPE
 PHONORGANON
 PHONOSCOPE
 PHOTOPHONE
 PSEUDOPHONE
 RADIOPHONE
 RECEIVER, SOUND
 RECORDER, SOUND
 REPRODUCER, SOUND
 RESONATOR ... rt AMPLIFIER, AUDIO
 SONOMETER
 SPECTROGRAM, SOUND

- -

ACOUSTICAL T&E (cont.)

 SPECTROGRAPH, SOUND
 STIMULATOR, SOUND
 STROBILION
 note use for an instrument that records vibrational patterns
 TONOMETER
 TONOSCOPE
 TOPOPHONE
 TRANSMITTER, SOUND
 TUBE, QUINCKE'S
 VARIATOR, STERN
 VIBROSCOPE
 WHEEL, SAVART
 WHISTLE, GALTON

ARMAMENT T&E

 ARMAMENT -- FIREARM

 Arquebus ... use HARQUEBUS
 BLUNDERBUSS
 CANNON, HAND
 CARBINE ... rt PETRONEL
 DERRINGER ... rt PISTOL
 FLAMETHROWER
 FOWLER
 FUSIL ... rt MUSKET
 GUARD, TRIGGER
 GUN, BB
 Gun, Bird ... use more specific term, e.g.: SHOTGUN
 GUN, BOMB
 Gun, Burp ... use GUN, SUBMACHINE
 GUN, CANE
 Gun, Capture ... use GUN, TRANQUILIZER
 GUN, COMBINATION
 GUN, DART
 GUN, FOLDING
 Gun, Game ... use more specific term, e.g.: RIFLE; SHOTGUN
 Gun, Grease ... use GUN, SUBMACHINE
 GUN, HARPOON
 GUN, MACHINE
 GUN, SUBMACHINE
 GUN, TRANQUILIZER
 Gun, Whaling ... use GUN, HARPOON

- -

ARMAMENT -- FIREARM (cont.)

 Handgun ... use more specific term, e.g.: PISTOL; REVOLVER
 HARQUEBUS
 LAUNCHER, GRENADE
 MUSKET ... rt HARQUEBUS; FUSIL
 MUSKETOON
 PEPPERBOX
 PETRONEL ... rt CARBINE
 PISTOL ... rt REVOLVER; DERRINGER
 PISTOL, AUTOMATIC
 PISTOL, BLANK
 PISTOL, DUELLING
 Pistol, Machine ... use GUN, SUBMACHINE
 PISTOL, POCKET
 PISTOL, SEMI-AUTOMATIC
 PISTOL, TARGET
 PISTOL/AX
 PISTOL/CARBINE
 PISTOL/CUTLASS
 PISTOL/KNIFE
 PISTOL/SWORD
 REVOLVER ... rt PISTOL
 RIFLE
 RIFLE, HALF-STOCK
 Rifle, Kentucky ... use RIFLE, LONG
 RIFLE, LONG
 RIFLE, MILITARY
 RIFLE, OVER-AND-UNDER
 Rifle, Pennsylvania ... use RIFLE, LONG
 RIFLE, PLAINS
 RIFLE, REPEATING
 RIFLE, SEA-COAST
 RIFLE, TARGET
 RIFLE/AX
 RIFLE/MUSKET
 RIFLE/SHOTGUN
 SHOTGUN
 SHOTGUN, DOUBLE-BARREL
 SHOTGUN, MULTI-BARREL
 SHOTGUN, REPEATING
 SHOTGUN, SINGLE-BARREL
 SHOTGUN, SKEET
 SHOTGUN, TRAP
 Weapon, Automatic ... use GUN, MACHINE or GUN, SUBMACHINE

- -

ARMAMENT -- EDGED

ANGON
ARROW
ARROWHEAD ... rt POINT, PROJECTILE
 Ax, Battle ... use BATTLE-AX
AX, BELT
AX, BOARDING
BACKSWORD
BARB, LANCE
BARDICHE
BASELARD
BATTLE-AX
BAYONET, KNIFE
BAYONET, PLUG
BAYONET, SOCKET
BAYONET, SWORD
BAYONET, TRIANGULAR
BILL
BLOWGUN
BOLO
BOW
BROADSWORD
CLAYMORE
CROSSBOW
CUTLASS
DAGGER ... rt PONIARD; STILETTO
DART
DIRK
 Gig ... use SPEAR
 Glaive ... use BROADSWORD
GRAIN
HALBERD
HARPOON
 Hook, Bill ... use BILL
KNIFE
KNIFE, BOWIE
KNIFE, SHEATH
KNIFE, SWITCHBLADE
KNIFE, THROWING
KNIFE, TRENCH
KRIS
LANCE
LANCE, WHALE
 Misericord ... use DAGGER
PARTISAN
PIKE
PIKE, AWL
PIKE, BOARDING
POINT, PROJECTILE

- -

ARMAMENT -- EDGED (cont.)

POLEAX
PONIARD ... rt DAGGER; STILETTO
RAPIER
SABER
SABER, SHORT
 Shiv ... use KNIFE
SPEAR
SPEAR, EEL
SPEAR, FISH
SPEAR, SQUID
SPONTOON
STILETTO ... rt DAGGER; PONIARD
SWORD
SWORD, ARTILLERY
SWORD, HANGER
SWORD, HUNTING
TOMAHAWK

ARMAMENT -- BLUDGEON

BLACKJACK
BOLA
BOOMERANG
CLUB
HAMMER, WAR
KNUCKLES, BRASS
MACE
POGAMOGGAN
SHILLELAGH
SLINGSHOT

ARMAMENT -- ARTILLERY

ARTILLERY, BREECH-LOADING
 note use more specific term if known
ARTILLERY, MUZZLE-LOADING ... rt CARRONADE; FALCONET
BALLISTA
BAZOOKA
CANNON
CANNON, PETRONEL
CANNON, SERPENTINE
CARRONADE
CATAPULT
CULVERIN
DEMI-CANNON
DEMI-CULVERIN

- -

ARMAMENT -- ARTILLERY (cont.)

DESTROYER, TANK
FALCON
FALCONET
GUN, ANTIAIRCRAFT
GUN, ANTITANK
GUN, FIELD
GUN, GARRISON
GUN, GATLING
GUN, RAILWAY
GUN, RECOILESS
GUN, SEA-COAST
GUN, SEIGE
GUN, SELF-PROPELLED
GUN, SWIVEL
GUN/HOWITZER
HOWITZER
MANGONEL
MINION
MORTAR
PERRIER
RAM, BATTERING
RIFLE, FIELD
ROBINET
SAKER
TREBUCKET

ARMAMENT -- AMMUNITION

Ball, Minie ... use BULLET, MINIE
BALL, MUSKET
Bb ... use CAP, BB
BOMB, AIR-TO-AIR
BOMB, AIR-TO-SURFACE
BOMB, AIR-TO-UNDERWATER
Bomb, Antiaircraft ... use BOMB, AIR-TO-AIR
BULLET
BULLET, ARMOR-PIERCING
BULLET, CONTROLLED-EXPANSION
BULLET, EXPANDING
BULLET, INCENDIARY
BULLET, MINIE
BULLET, TRACER
CANNONBALL
CAP, BB
CARCASS
Cartridge, Blank ... use CARTRIDGE, DUMMY
CARTRIDGE, CASELESS

- -

ARMAMENT -- AMMUNITION (cont.)

 CARTRIDGE, CENTER-FIRE
 CARTRIDGE, DUMMY
 CARTRIDGE, RIM-FIRE
 CHARGE, DEPTH
 FUZE
 GRAPESHOT
 GRENADE, ANTIPERSONNEL
 GRENADE, ANTITANK
 GRENADE, INCENDIARY
 Minieball ... use BULLET, MINIE
 MISSILE
 MISSILE, AIR-TO-AIR
 MISSILE, AIR-TO-SURFACE
 MISSILE, AIR-TO-UNDERWATER
 MISSILE, AIR-TO-WATER
 Missile, Antiaircraft ... use MISSILE, SURFACE-TO-AIR
 Missile, Antimissile ... use MISSILE, SURFACE-TO-AIR or MISSILE,
 AIR-TO-AIR
 Missile, Ballistic ... use more specific term, e.g.: MISSILE, AIR-TO-AIR
 MISSILE, SURFACE-TO-AIR
 MISSILE, SURFACE-TO-SURFACE
 MISSILE, UNDERWATER-TO-SURFACE
 PETARD
 PRIMER
 Rocket ... use MISSILE
 SHELL, ARTILLERY
 SHELL, SHOTGUN
 SHOT, BAR
 SHOT, CASE
 SHOT, CHAIN
 TORPEDO
 TORPEDO, AERIAL

ARMAMENT -- BODY ARMOR

 ARMOR
 note use only for entire suit of armor
 BACKPLATE
 BASCINETE
 BREASTPLATE
 BURGONET
 Collar ... use GORGET
 COVER, HELMET
 GAUNTLET
 GORGET
 HAT, KETTLE
 HAUBERK

- -

ARMAMENT -- BODY ARMOR (cont.)

 HEAUME ... rt HELMET
 HELM
 HELMET ... rt HEAUME
 LEG-HARNESS
 LINER, HELMET
 MAIL
 MORION
 PAULDRON
 PLATE
 SABOTON
 SALLET
 SPAUDLER
 VAMBRACE
 VEST, BULLETPROOF
 VEST, FLAK
 ZISCHAGGE

ARMAMENT -- ACCESSORY

 ADAPTER, BARREL
 ADAPTER, GRIP
 AUGER, FUZE
 BAG, HUNTING
 BAG, POWDER
 BALDRIC
 BANDOLIER
 BAR, ELEVATING
 BASTILLE
 BELT, ACCESSORY
 BELT, AMMUNITION
 BELT, CARTRIDGE
 BELT, CARTRIDGE-BOX
 BELT, LINK
 BELT, SWORD
 BENCH, SPOTTING
 BIPOD
 Bird, Clay ... use TARGET, SKEET
 BOX, AMMUNITION
 BOX, CAP
 BOX, CARTRIDGE
 BOX, PATCH
 BOX, PERCUSSION CAP
 BRAKE, MUZZLE
 BUCKET
 BUCKET, GREASE
 BUCKET, TAR
 BUCKLER

- -

ARMAMENT -- ACCESSORY (cont.)

BUFFER, RECOIL
CALIPERS, GUNNER'S
CALIPERS, SHELL
CALL, GAME
CALTROP
CAP, MUSKET
CAP, MUZZLE
CAP, PERCUSSION
CAP, SNAP
CASE, ARTILLERY SHELL
CASE, CARTRIDGE
CASE, GUN
CASE, POWDER BOX
CAT
CHARGER, NIPPLE
CHEST, AMMUNITION
CHEVAL-DE-FRISE
CLIP, CARTRIDGE
COVER, VENT
CRADLE, CANNON
CRIMPER
CUTTER, CAKE
CUTTER, FUZE
CUTTER, SPRUE
CUTTER, WAD
DECAPPER/RECAPPER
DECOY
DETECTOR, MINE
DIE, LOADING
DISK, SIGHT
DISPENSER, CAP
EXTENSION, SIGHT
EXTRACTOR, FUZE
FLAG, WIND
FLASK, POWDER
FLASK, PRIMING
FLASK, SHOT
FLINT
FORK, HOT-SHOT
GAUGE, ARTILLERY
GAUGE, BULLET
GAUGE, CANNONBALL
GAUGE, POWDER
GAUGE, VENT
GAUGE, WIND
GIMLET, FUZE
GIMLET, GUNNER'S
GLOVE, TARGET SHOOTER'S

- -

ARMAMENT -- ACCESSORY (cont.)

 GOUGE, FUZE
 GRATE, HOT SHOT
 GUARD, ARM
 GUARD, SWORD
 GUARD, WRIST
 GYROJET
 HANDSPIKE
 HAVERSACK, GUNNER'S
 HOLDER, CARTRIDGE
 HOLDER, CLIP
 HOLDER, SHELL
 HOLSTER
 HOOK, SHELL
 HOOP, EXTRACTOR
 HORN, POWDER
 JACKET, TARGET SHOOTER'S
 JAG
 KEEPER, SLING
 KEG, POWDER
 Key, Nipple ... use WRENCH, NIPPLE
 KIT, GUN-CLEANING
 LANYARD
 LEVEL, GUNNER'S
 LINSTOCK
 LOADER, AMMUNITION BELT
 LOCK, CANNON
 LOCKER, ARMS
 LUBRICATOR-SIZER
 MACHINE, ROCKET-DRIVING
 MAGAZINE
 MALLET, FUZE
 MEASURE, POWDER
 MITTEN, TARGET SHOOTER'S
 MOLD, BALL
 MOLD, BULLET
 MOLD, FUZE
 MOLD, PORTFIRE
 MOLD, ROCKET
 MOLD, WAD
 MOUNT, SIGHT
 MUZZLE, FALSE
 PANTS, BAZOOKA
 PENDULUM, BALLISTIC
 PIN, PRIMING
 PINCERS, GUNNER'S
 POST, AIMING
 POUCH, CAP
 POUCH, CARTRIDGE

- -

ARMAMENT -- ACCESSORY (cont.)

 POUCH, GUNNER'S
 POUCH, PRIMER
 POUCH, SHOT
 PRESS, CARTRIDGE-CASE
 PRESS, PRIMING
 PRICKER
 PRIMER, NIPPLE
 PROTECTOR, THROAT
 PULLER, BULLET
 PUNCH, VENT
 QUADRANT, GUNNER'S
 QUIVER
 QUOIN
 RACK, ARMS
 RACK, BOMB
 RAKE, HOT-SHOT
 REAMER, CHAMBER
 REAMER, FUZE-PLUG
 RELEASE, BOMB
 REMOVER, CASE
 REMOVER, DENT
 REST, MACHINE
 ROD, CLEANING
 ROD, KNOCKOUT
 RULE, TRUNNION
 SAFETY, GRIP
 SAW, FUZE
 SCABBARD
 SCABBARD, BAYONET
 SCABBARD, CARBINE
 SCABBARD, DAGGER
 SCABBARD, SWORD
 Scope, Rangefinder ... use SIGHT, TELESCOPE
 Scope, Sniper's ... use SIGHT, TELESCOPE
 Scope, Target ... use SIGHT, TELESCOPE
 SCRAPER, BAND
 SCRAPER, BARREL
 SCRAPER, MORTAR
 SCRAPER, SHELL
 SEARCHER, VENT
 SEATER, BULLET
 SETTER, FUZE
 SHEARS, PORTFIRE
 SHEATH
 SHIELD
 SHOE, TRIGGER
 SIGHT
 SIGHT, GLOBE

- -

ARMAMENT -- ACCESSORY (cont.)

 SIGHT, MICROMETER
 SIGHT, MILITARY
 SIGHT, TANG
 SIGHT, TELESCOPE
 SIGHT, VERNIER
 SIGHT, WINDGAUGE
 SILENCER
 SLED, ARTILLERY
 SLEEVE, GUNNER'S
 SLING
 SPIKE, CANNON
 STABILIZER
 STARTER, BULLET
 STOCK, PORTFIRE
 SUPPRESSOR, FLASH
 TAP, FUZE
 TARGET
 TARGET, ARCHERY
 TARGET, SKEET
 TELESCOPE, SPOTTING
 TESTER, POWDER
 TESTUDO
 Tetrahedron ... use CALTROP
 THUMBSTALL
 TINDERBOX
 TINDERBOX, POCKET
 TONGS, LOADING
 TONGS, ROCKET
 TOOL, TONG
 TRAP
 TRAP, BULLET
 Trap, Cartridge ... use TRAP, BULLET
 TRAP, HAND
 TRAY, BALL
 TRIPOD
 TRUNNION
 TUBE, PERCUSSION
 TURRET, MACHINE GUN
 VISE, BREECHING
 VISE, HAMMER SPRING
 VISE, LOCK-SPRING
 Weight, Barrel ... use STABILIZER
 WIRE, PRIMING
 WORM
 WRENCH, BREECHING
 WRENCH, COCK
 WRENCH, COCK-AND-HAMMER
 WRENCH, FRONT-SIGHT

- -

ARMAMENT -- ACCESSORY (cont.)

 WRENCH, FUZE
 WRENCH, GUN-CARRIAGE
 WRENCH, MUZZLE
 WRENCH, NIPPLE
 WRENCH, PIN

ASTRONOMICAL T&E

 AETHRIOSCOPE
 ASTRODICTICUM
 ASTROLABE
 Astrolage ... use ASTROLABE
 ASTROMETER
 ASTROPATROTOMETER
 ASTROSCOPE
 CAMERA, SCHMIDT ... rt TELESCOPE, REFLECTING
 CHROMATOSCOPE
 CIRCLE, MERIDIAN
 CLOCK, ASTRONOMICAL
 CLOCK, SIDEREAL
 CORONOGRAPH
 Cosmolabe ... use ASTROLABE
 COSMOSPHERE
 CYANOMETER
 DIPLEIDOSCOPE
 ECLIPSAREON
 GEODESCOPE
 HELIOMETER
 HELIOSCOPE
 INSTRUMENT, AZIMUTH
 INTERFEROMETER, RADIO
 MAGNETOGRAPH
 METEOROSCOPE
 MIRROR
 ORRERY
 PHOTOHELIOGRAPH
 PHOTOMETER, PHOTOELECTRIC
 PLANETARIUM
 PLANISPHERE
 PRISM, OBJECTIVE
 PYRHELIOMETER
 QUADRANT, ASTRONOMICAL
 SELENOTROPE
 SIDEROSTAT
 SPECTROHELIOGRAPH

- -

ASTRONOMICAL T&E (cont.)

 Speculum ... use MIRROR
 SPHERE, ARMILLARY
 SPHEROSCOPE
 TELENGISCOPE
 TELEPOLARISCOPE
 TELESCOPE
 TELESCOPE, ACHROMATIC ... rt TELESCOPE, GALILEAN; TELESCOPE, REFRACTING
 TELESCOPE, CASSEGRAIN ... rt TELESCOPE, REFLECTING
 TELESCOPE, EQUATORIAL
 TELESCOPE, GALILEAN
 TELESCOPE, ORBITING
 TELESCOPE, RADIO
 TELESCOPE, REFLECTING ... rt TELESCOPE, CASSEGRAIN
 TELESCOPE, REFRACTING ... rt TELESCOPE, ACHROMATIC; TELESCOPE, GALILEAN
 Telescope, Schmidt ... use CAMERA, SCHMIDT
 TELESCOPE, SOLAR
 TELESPECTROSCOPE

BIOLOGICAL T&E

 AEROSCOPE
 Aesthesiometer ... use ESTHESIOMETER
 APPARATUS, AMMONIA-ABSORPTION
 APPARATUS, COUNTING
 APPARATUS, CULTURE
 APPARATUS, KAHN-TEST
 APPARATUS, SHAKING
 APPARATUS, STAINING
 APPARATUS, VAN SLYKE
 AUXANOMETER
 BACTERIOSCOPE
 BATH, DEHYDRATING
 BATH, EMBEDDING
 BLOWPIPE
 BOX, GERMINATION
 CENTRIFUGE, HUMAN
 CHAMBER, HELIOTROPIC
 CHROMATROPE
 CLINOSTAT
 COAGULOMETER
 CONCHOMETER
 CONFORMATEUR
 CRANIOMETER
 CUTTER, MICROSCOPIC SECTION
 DISH, CULTURE
 DISH, PETRI

- -

BIOLOGICAL T&E (cont.)

 ESTHESIOMETER
 FILTER, SEITZ
 FILTER, SERUM
 FLASK, CULTURE
 FORCEPS, DISSECTING
 GRANOMETER
 HEMACYTOMETER
 HEMAGLOBINOMETER
 INCUBATOR
 KIT, DISSECTING
 LYSIMETER
 MICROTOME
 MOUNT, SPECIMEN
 NEEDLE, DISSECTING
 OSMOSCOPE
 PAPER, FILTER
 PENCIL, SKIN-MARKING
 PHOTOSYNTHOMETER
 POSTUROMETER
 POTOMETER
 RESPIROMETER
 SCISSORS, DISSECTING
 SET, DISSECTING
 SLIDE, MICROSCOPE
 STETHOGONIOMETER
 TASEOMETER
 TUBE, CULTURE
 VASCULUM

CHEMICAL T&E

 ACETOMETER
 ACTINOGRAPH
 ACTINOMETER
 ALCOHOLOMETER
 Alembic ... use APPARATUS, DISTILLING
 ALKALIMETER
 AMMONIAMETER
 ANTHROCOMETER
 APOPHOROMETER, CHEMICAL
 APPARATUS, ADENY'S
 APPARATUS, CATALYTIC
 APPARATUS, CEMENT VICAT
 APPARATUS, DISTILLING ... rt FLASK, DISTILLING; RECEIVER; RETORT
 APPARATUS, FLOAT-TEST
 APPARATUS, HOT EXTRACTION

- -

CHEMICAL T&E (cont.)

 AQUAMETER
 ARGENTOMETER
 ATMOLYSER
 AZOTOMETER
 BASIN, FLUSHING
 BASIN, RINSING
 BATH, WATER
 BEAKER
 BEAKER, BERZELIUS
 BEAKER, GRIFFEN
 BEAKER, PHILLIPS
 BLANCHIMETER
 BOARD, LEVELING
 BOTTLE, ASPIRATOR
 BOTTLE, CENTRIFUGE
 BOTTLE, GAS-WASHING
 BOTTLE, REAGENT
 BRUSH, BURETTE
 BRUSH, PIPETTE
 BULB, ABSORPTION
 BULB, CONNECTING
 BURETTE
 BURETTE, GEISSLER
 BURETTE, MOHR
 BURETTE, STOPCOCK
 BURETTE, TITRATION
 BURNER, ARGAND
 BURNER, BUNSEN
 CALCIMETER
 CARBOLIMETER
 CARBONOMETER
 CARBUROMETER
 CATHETOMETER
 CENTRIFUGE, CHEMICAL
 CENTRIFUGE, CLINICAL
 CHLOROMETER
 CHYOMETER
 CLAMP
 CLAMP, HOSECOCK
 CLAMP, STOPCOCK
 CLAMP, SUSPENSION
 Colorimeter ... use COMPARATOR
 COMPARATOR
 COMPARATOR, HIGH-PHOSPHATE SLIDE
 COMPARATOR, HYDROGENATION
 COMPARATOR, NESSLER TUBE
 CONE, IMHOFF
 CRUCIBLE

- -

CHEMICAL T&E (cont.)

 DASYMETER
 DESSICATOR
 DIFFUSIOMETER
 DILATOMETER
 DISH, DISSOLVING
 DISH, EVAPORATING
 DISH, PETRI
 DOSIMETER
 ELACOMETER
 EXTRACTOR
 FLASK
 FLASK, BOILING
 FLASK, CULTURE
 FLASK, DISTILLING
 FLASK, ERLENMEYER
 FLASK, FILTERING
 FRAME, HEATING
 FUNNEL
 FURNACE, CEMENT-TEST
 GAUGE, AMMONIA
 GLASS, WATCH
 GRADUATE
 HALOMETER
 HOLDER, RETORT
 HYDROPHORE
 HYDROSCOPE
 INDICATOR, VOLUME-CHANGE
 INDICATOR, WATER-STABILITY
 LAMP, SPIRIT
 LOGOMETER
 MANOMETER
 MELANOSCOPE
 Micromanometer ... use MANOMETER
 MORTAR
 MORTAR & PESTLE
 NATROMETER
 NEEDLE, GILLMORE
 NITROMETER
 OSMOMETER
 PAPER, LITMUS
 PENETROMETER
 PERCOLATOR
 PESTLE
 PHOSPHOROSCOPE
 PIPE, DRAUGHT
 note use for funnel collecting gases over experiment table
 PIPETTE
 PIPETTE, ABSORPTION

- -

CHEMICAL T&E (cont.)

 PIPETTE, VOLUMETRIC
 RACK, TEST TUBE
 RECEIVER ... rt APPARATUS, DISTILLING
 Reducer, Tubing ... use TUBING, ADAPTER
 RETORT ... rt APPARATUS, DISTILLING
 RING, BURNER
 SACCHARIMETER
 SALIMETER
 Salinometer ... use SALIMETER
 SAMPLER, EFFLUENT
 SET, WATER ANALYSIS
 note use for complete unit; reagents, flasks, tongs, etc
 SHAKER, PIPETTE
 SHAKER, WATER BATH
 SIPHON
 SPIDER, BURNER
 SPINTHARISCOPE
 STIRRER
 STOPCOCK
 SUPPORT, IMHOFF CONE
 TABLE, FLOW
 TESTER, FINENESS
 TESTER, SOUNDNESS
 TITHONOMETER
 TITRATOR
 TITROMETER
 TONGS
 TONGS, BEAKER
 TONGS, FLASK
 TONGS, MERCURY
 TRIPOD
 TROUGH, PNEUMATIC
 TUBE
 TUBE, BAROMETER
 TUBE, CENTRIFUGE
 TUBE, COMBUSTION
 TUBE, CULTURE
 TUBE, TEST
 TUBING, ADAPTER
 Tubing, Reducer ... use TUBING, ADAPTER
 VAPORIMETER
 WASHER, GLASSWARE

- -

CONSTRUCTION T&E

 BACKHOE
 BACKHOE/FRONT-END LOADER
 Ball, Headache ... use BALL, WRECKING
 BALL, WRECKING
 Blade ... use GRADER
 BOB, PLUMB
 BUCKET, CLAMSHELL
 BUCKET, DRAGLINE
 BULLDOZER
 Compacter ... use ROLLER or TAMPER
 Dozer ... use BULLDOZER
 DRILL
 note see also MINING T&E
 DRILL, PERCUSSIVE
 DRIVER, PILE
 Excavator ... use more specific term, e.g.: BACKHOE; MACHINE, TRENCHING
 GRADER
 HAMMER, STONE
 Jackhammer ... use DRILL, PERCUSSIVE
 LOADER, FRONT-END
 Machine, Ditching ... use MACHINE, TRENCHING
 MACHINE, GUNNITE
 MACHINE, TIERING
 MACHINE, TRENCHING
 PLANT, BATCH
 RAKE, GRADING
 RAMMER, PAVER'S
 ROLLER
 SAW, CONCRETE
 SCARIFIER
 SCRAPER
 SHOVEL, POWER
 SPREADER, ASPHALT
 Steamroller ... use ROLLER
 STRETCHER, FENCE-WIRE
 STRINGER, FENCE-WIRE
 TAMPER
 TRACTOR

ELECTRICAL & MAGNETIC T&E

 ACTUATOR
 AMMETER
 AMPLIFIER
 AMPLIFIER, CARRIER
 AMPLIFIER, DC

- -

ELECTRICAL & MAGNETIC T&E (cont.)

 AMPLIFIER, RADIO-FREQUENCY
 BATTERY, DRY-CELL
 BATTERY, WET-CELL
 BOARD, CIRCUIT
 BOX, CONTROL
 BOX, JUNCTION
 BOX, RESISTANCE
 BREAKER, CIRCUIT
 BRIDGE, WHEATSTONE
 CAPACITOR
 CAPACITOR, ELECTROLYTIC
 CAPACITOR, VARIABLE
 Condenser ... use CAPACITOR
 DECLINOMETER
 ELECTRODE
 ELECTROMETER
 FLUXMETER
 Fuse ... use BREAKER, CIRCUIT
 GALVANOMETER
 GALVANOSCOPE
 INDIGOMETER
 INDUCTOMETER
 INSULATOR
 JAR, BATTERY
 MAGNET
 MAGNETRON
 MODULATOR
 MODULATOR, SINGLE SIDE-BAND
 OSCILLATOR
 OSCILLOGRAPH
 OSCILLOSCOPE
 PLATYMETER
 PLIERS, ELECTRICIAN'S
 PLIERS, NEEDLENOSE
 PLUG, RECEPTACLE
 PLUG, SOCKET
 POTENTIOMETER
 RADIOMETER
 RECEPTACLE
 REGULATOR, VOLTAGE
 RELAY
 RESISTOR
 RHEOMETER
 RHEOSCOPE
 RHEOSTAT
 RHEOTOME
 SHIELD, MAGNETIC
 SIDEROSCOPE

- -

ELECTRICAL & MAGNETIC T&E (cont.)

 SOCKET, TUBE
 Solenoid ... use SWITCH, SOLENOID
 STRIPPER, WIRE
 SWITCH
 SWITCH, SOLENOID
 SWITCH, TIME
 TESTER, CIRCUIT
 TESTER, MAGNETO & COIL
 TESTER, TUBE
 THERMOAMMETER
 TRANSFORMER
 TRANSFORMER, IMPEDENCE
 TRANSISTOR
 TUBE, ELECTRON
 TUBE, VACUUM
 VOLTMETER
 WIRE

ENERGY PRODUCTION T&E

 BATTERY, SOLAR
 BOILER, STEAM
 COMPRESSOR
 COMPRESSOR, BLOWING-ENGINE
 COMPRESSOR, DUPLEX AIR
 COMPRESSOR, ROTARY
 COMPRESSOR, SULLIVAN ANGLE
 COMPRESSOR, TURBO
 CONVERTER, AC-DC
 CUP, GREASE
 Dynamo ... use GENERATOR
 ENGINE
 Engine, Compression-ignition ... use ENGINE, DIESEL
 ENGINE, DIESEL
 ENGINE, GAS
 ENGINE, GASOLINE ... rt ENGINE, LIQUID-FUEL
 ENGINE, HOT-AIR
 ENGINE, LIQUID-FUEL ... rt ENGINE, GASOLINE
 ENGINE, OIL-TRACTION
 ENGINE, RAMJET
 ENGINE, STEAM
 ENGINE, STEAM-GAS
 ENGINE, STEAM-TRACTION
 EXCITER
 FITTING, OIL
 FURNACE, SOLAR

- -

ENERGY PRODUCTION T&E (cont.)

 GAUGE, VACUUM
 GENERATOR
 note may be modified according to power source
 GENERATOR, GASOLINE
 GENERATOR, STEAM
 GENERATOR, WATER
 GOVERNOR
 HANGER, SHAFT
 HOUSING, CLUTCH
 IDLER
 INSULATOR
 JACKSHAFT
 LINESHAFT
 MOTOR, ELECTRIC
 PANEL, SOLAR
 POWER-PLANT, NUCLEAR
 REFLECTOR, SOLAR
 SHIELD, SOLAR
 SWEEP, ANIMAL-POWERED
 SWEEP, HUMAN-POWERED
 TABLE, ANIMAL-POWERED
 TRANSFORMER
 TREAD, ANIMAL-POWERED
 TREAD, HUMAN-POWERED
 Treadmill ... use TREAD, ANIMAL-POWERED or TREAD, HUMAN-POWERED
 TURBINE, HYDRAULIC
 TURBINE, IMPULSE
 TURBINE, INTERNAL-COMBUSTION
 TURBINE, STEAM
 Turbine, Tub ... use WATERWHEEL, TUB
 VALVE, STEAM
 WATERWHEEL, BREAST
 WATERWHEEL, OVERSHOT
 WATERWHEEL, TUB
 WATERWHEEL, UNDERSHOT
 WEIGHT, SAFETY BLOW-OFF
 WEIGHT, WINDMILL
 Wheel, Pelton ... use TURBINE, IMPULSE
 WINDMILL
 WIRE

GEOLOGICAL T&E

 PICK, PALEONTOLOGIST'S

- -

MAINTENANCE T&E

```
     AGITATOR, LAUNDRY
     ASHPAN
     BAG, LAUNDRY
     BASKET, LAUNDRY
     BEATER, RUG
     BENCH, LAUNDRY
     BOARD, IRONING
      Board, Sleeve ... use BOARD, IRONING
     BOILER, LAUNDRY
      Boiler, Steam Wash ... use BOILER, LAUNDRY
      Boiler, Wash ... use BOILER, LAUNDRY
      Bottlebrush ... use BRUSH, BOTTLE
     BROOM
     BROOM, ELECTRIC
     BROOM, PUSH
     BROOM, WHISK
     BRUSH, BOTTLE
     BRUSH, DUSTING
     BRUSH, SCRUB
     BRUSH, TOILET
     BRUSH, WINDOW
      Bucket ... use PAIL
     BUTLER, SILENT
     CAN, KEROSINE
     CAN, TRASH
      Cleaner, Pot ... use SCRUBBER
     CLEANER, VACUUM
      Cleaner, Wire Dish ... use SCRUBBER
     CLOTH, CLEANING
      Cloth, Dish ... use DISHCLOTH
     CLOTHESLINE
     CLOTHESPIN
     CRUMBER
     DISH, SOAP
     DISHCLOTH
     DISHPAN
     DISHWASHER
     DOLLY, WASH
     DRAINER, DISH
     DRYER
      Dustcloth ... use CLOTH, CLEANING
     DUSTER
      Duster, Cloth ... use CLOTH, CLEANING
     DUSTPAN
     FLATIRON
     FORK, LAUNDRY
     GRATER, SOAP
     HAMPER
```

- -

MAINTENANCE T&E (cont.)

 HOLDER, CLOTHESPIN
 HOLDER, WHISK BROOM
 IRON
 Iron, Flat ... use FLATIRON
 IRON, FLUTING
 Iron, Goffering ... use IRON, FLUTING
 Iron, Polishing ... use SADIRON
 KNOCKER, SNOW
 MACHINE, WASHING
 MANGLE
 MOP
 PAIL
 PAIL & WRINGER
 PAPER, SHELF
 PLUNGER
 POLISHER, FLOOR
 PRESS, LINEN
 RACK, DRYING
 REST, IRON
 SADIRON
 SAVER, SOAP
 SCRAPER, BOOT
 SCRUBBER
 SIFTER, ASH
 SOAP
 SPRINKLER
 STOVE, LAUNDRY
 STRAINER, SINK
 STRETCHER, CARPET
 STRETCHER, CURTAIN
 SWEEPER, CARPET
 TABLE, IRONING
 TACKER, CARPET
 TONGS, LAUNDRY
 TOWEL, DISH
 TRIVET
 Tub ... use WASHTUB
 Tub, Wash ... use WASHTUB
 WASHBOARD
 WASH-POUNDER
 WASHTUB
 WRINGER, CLOTHES
 WRINGER, MOP

- -

MECHANICAL T&E

 ACCELEROMETER
 BATOREOMETER
 BATTERY, GRAVITY
 BRAKE, BAND
 CAN, OIL
 COME-ALONG ... rt JACK, PULLING
 CONVEYOR
 CONVEYOR, BELT
 CONVEYOR, BUCKET
 CRANE
 DENSIMETER
 Derrick ... use CRANE
 DUCTILEMETER
 DYNAMOMETER
 Engine, Winding ... use WINDLASS
 FLYWHEEL
 GAUGE, STEAM PRESSURE
 GAUGE, WATER
 GRAVIMETER
 GYROSCOPE
 Gyrostat ... use GYROSCOPE
 HOIST
 note use for any lifting machine which operates with ropes and pulleys
 HYDRODYNAMOMETER
 HYDROMETER
 JACK, HOISTING
 JACK, LIFTING
 JACK, PULLING ... rt COME-ALONG
 JAR, VACUUM
 KINEGRAPH
 LEVER
 LIFT, HYDRAULIC
 LITRAMETER
 LUBRICATOR, PRESSURE
 MACHINE, FALL
 METER, WATER
 Oleometer ... use HYDROMETER
 OPERAMETER
 PENDULUM
 PIEZOMETER
 PLANE, INCLINED
 POLYTROPE
 Psychrometer ... use HYDROMETER
 PULLEY
 PYCNOMETER
 RAILWAY, CENTRIFUGAL
 RAM, HYDRAULIC
 SCLEROMETER

- -

MECHANICAL T&E (cont.)

 SCREW, ARCHIMEDIAN
 SLIDE, FRICTION
 SPRING, INDICATOR
 SPRING, PRESSURE
 SPRING, SPIRAL
 STEREOMETER
 STROBOSCOPE
 TABLE, OSCILLATING
 TACHOMETER
 Tackle ... use HOIST
 TENSIMETER
 TENSIOMETER
 TONOMETER
 TOP, INERTIA
 TRIBOMETER
 TUNNEL, WIND
 TURBIDIMETER
 TURNBUCKLE
 VELOCIMETER
 Viscometer ... use VISCOSIMETER
 VISCOSIMETER
 VOLUMINOMETER
 WEDGE
 Winch ... use HOIST or WINDLASS
 WINDLASS ... rt HOIST

MEDICAL & PSYCHOLOGICAL T&E

 ACUTOMETER
 ALBUMINOMETER
 AMALGAMATOR
 AMBLYOSCOPE
 AMPUL
 ANAGLYPH
 ANOMOLOSCOPE
 ANTIRRHEOSCOPE
 ANVIL, DENTAL
 APPARATUS, AFTER-IMAGE
 APPARATUS, METABOLISM
 APPARATUS, MULTIPLE-IMAGE
 APPARATUS, UREA
 APPLIANCE, ORTHODONTIC
 ARTICULATOR, DENTAL
 ASPIRATOR
 ASTROMETEOROSCOPE
 ATOMIZER

- -

MEDICAL & PSYCHOLOGICAL T&E (cont.)

 AUDIPHONE
 AURISCOPE
 AUTOCLAVE
 AXOMETER
 BAG, ICE
 BAG, MEDICINE
 BAND, DENTAL
 BANDAGE
 BASIN
 BELLOWS, DENTIST'S
 BESIDOMETER
 BINDER, OBSTETRICAL
 BIOMETER
 BIOSCOPE
 BISTOURY
 BOTTLE, MEDICINE
 BOTTLE, SERUM ... rt BOTTLE, VACCINE
 BOTTLE, SPECIMEN
 BOTTLE, VACCINE ... rt BOTTLE, SERUM
 BOUGIE ... rt CATHETER
 BOWL, BLEEDING
 BOWL, DENTAL MIXING
 BOX, FLEES'
 BUR, DENTAL
 BURNISHER, DENTAL
 CABINET, AUTOCLAVE
 CAMPIMETER
 CANNULA
 CARDIOGRAPH
 CARRIER, AMALGAM
 CARRIER, GOLD-FOIL
 CARVER, DENTAL
 CASE, DENTAL
 CASE, INSTRUMENT
 CASE, LANCET
 CASE, THERMOMETER
 CATHETER
 CEPHALOMETER
 CHAIR, DENTIST'S
 CHAIR, EXAMINING
 CHAMBER, COUNTING
 CHART, VISUAL-ACUITY
 CHEILVANGROSCOPE
 CHEST, MEDICINE
 CHISEL, DENTAL
 CHISEL, SURGICAL
 CLAMP
 CLAMP, DENTAL

- -

MEDICAL & PSYCHOLOGICAL T&E (cont.)

 CLAMP, RECTAL
 CLIMATOMETER
 COMPOUND, IMPRESSION
 COMPRESSOR/DEHYDRATOR, DENTAL
 CONE, ABRASIVE DENTAL
 CONE, ADJUSTING
 CORSET, SURGICAL
 COTTON, DRESSING
 COUNTER, BLOOD
 CUIRASS
 CUP, AMALGAM
 CUP, BLEEDING
 Cup, Cupping ... use CUP, BLEEDING
 CUP, DENTAL WASTE
 Cup, Expectorating ... use SPITTOON, INVALID
 CUP, IMPRESSION
 CURETTE
 CURETTE, ADENOID
 CURETTE, ALVEOLAR
 CURETTE, BONE
 CURETTE, PERIODONTAL
 Cystoscope ... use URETHROSCOPE
 DEHYDRATOR, DENTAL
 DENTIMETER
 DEPRESSOR, TONGUE
 DIE, DENTURE
 DILATOR
 DILATOR, CERVICAL
 DILATOR, UTERINE
 DISK, ABRASIVE DENTAL
 DISPENSER, DENTAL
 DRILL, DENTAL
 ECHOSCOPE
 ELEVATOR
 ELEVATOR, DENTAL
 ELEVATOR, MALAR
 ELEVATOR, PERIOSTEAL
 ELEVATOR, ROOT
 ENDOSCOPE
 ENGINE, DENTAL
 EQUINOCTIAL
 EVACUATOR, DENTAL
 EXCAVATOR, DENTAL
 EXPLORER, DENTAL ... rt PROBE, DENTAL
 EXTRACTOR, ROOT
 EXTRACTOR, TOOTH
 EYEDROPPER
 FACIOMETER

- -

MEDICAL & PSYCHOLOGICAL T&E (cont.)

 FILE, DENTAL
 FLASK, DENTURE CURING
 FLUOROSCOPE
 FORCEPS
 FORCEPS, CATCH
 FORCEPS, DENTAL
 FORCEPS, OBSTETRICAL
 FORCEPS, TREPHINING
 FORMER, BITE RIM
 GALLIPOT
 GAUGE, CROWN
 Glass, Cupping ... use CUP, BLEEDING
 GLOBULIMETER
 GONIOMETER
 GONIOSCOPE
 Haemacytometer ... use HEMOCYTOMETER
 Haematometer ... use HEMOCYTOMETER
 Haemoscope ... use HEMOSCOPE
 HAMMER, DENTAL
 HANDLE, DENTAL
 HAND-PIECE, DENTAL
 HATCHET, DENTAL
 HEMOCYTOMETER
 HEMOSCOPE
 HEMOSTAT
 HOE, PERIODONTAL
 HOLDER, AMPUL
 HOLDER, BROACH
 HOLDER, DENTAL FILM
 HOLDER, RUBBER DAM
 HOOK, TENDON
 Indiscope ... use OPHTHALMOSCOPE
 INHALATOR
 INHALER
 IRRIGATOR
 JAR, SPECIMEN
 JAR, SYRINGE
 KERATOME
 KERATOMETER
 Key, tooth ... use EXTRACTOR, TOOTH
 KIT, CUPPING
 KIT, DENTAL FILLING
 KIT, FIRST AID
 KIT, MEDICINE
 KIT, SURGICAL
 KIT, THERMO-CAUTERY
 KNIFE, AMPUTATING
 LANCET

- -

MEDICAL & PSYCHOLOGICAL T&E (cont.)

 LANCET, BLOOD
 LANCET, VACCINE
 LARYNGOSCOPE
 LATHE, DENTAL
 LENCOSCOPE
 LENS, STENOPAIC
 LIGATURE
 LITHOTRITE
 LUNG, IRON
 MACHINE, ELECTROTHERAPY
 MACHINE, METAL-CASTING
 MACHINE, OXYGEN
 MACHINE, PILL
 MAKER, DIMPLE
 MALLET, DENTAL
 MALLET, ORAL SURGERY
 MANDREL, DENTAL
 MANOPTOSCOPE
 MASK, ANESTHESIA
 MASK, OXYGEN
 MASK, SURGICAL
 Meatoscope ... use SPECULUM
 METROSCOPE
 MILL, GOLD-ROLLING
 MIRROR, EYE-OBSERVATION
 MIRROR, ORAL-EXAMINING
 MIXER, DENTAL-CASTING
 MODEL, ANATOMICAL
 MOLD, DENTAL-CASTING
 MOLD, SUPPOSITORY
 MORTAR
 MOUTHPIECE, SALIVA-EJECTOR
 MYDYNAMOMETER
 MYOGRAPH
 NEBULIZER, GLASEPTIC
 NEEDLE, BLOOD-COLLECTING
 NEEDLE, HYPODERMIC
 NEEDLE, INOCULATING
 NEEDLE, LIGATING
 NEEDLE, SPINAL
 NEEDLE, SUTURING
 ONCOMETER
 OPHTHALMOMETER
 OPHTHALMOSCOPE
 Opsiometer ... use OPTOMETER
 OPTOMETER
 ORTHOSCOPE
 OSTEOPHONE

- -

MEDICAL & PSYCHOLOGICAL T&E (cont.)

 OTACOUSTIC
 OTOSCOPE
 PACEMAKER
 PATCH, EYE
 PELVIMETER
 PERFORATOR
 PERIMETER
 PERSPECTOSCOPE
 PESSARY
 PESTLE
 PHENAKISTOSCOPE
 PHRENOGRAPH
 PLASTER, COUGH
 Plastograph ... use ANAGLYPH
 PLETHYSMOGRAPH
 Pliers, Band Soldering ... use TWEEZERS, SOLDERING
 PLIERS, CONTOURING
 PLIERS, DRESSING
 Pneometer ... use SPIROMETER
 POINT, CAUTERY
 POINT, DENTAL
 POLISHER, DENTAL
 POLISHER, PORTE
 POLYGRAPH
 Porte, Screw ... use EXTRACTOR, ROOT
 PROBANG
 PROBE
 PROBE, DENTAL ... rt EXPLORER, DENTAL
 PROBE, UTERINE
 PSEUDOSCOPE, LENTICULAR ... rt STEREOSCOPE
 PUMP, BREAST
 PUNCH, RUBBER DAM
 PUPILOMETER
 RESPIRATOR
 RESUSCITATOR
 RETAINER, MATRIX
 RETINOSCOPE
 RETRACTORS
 RHINOSCOPE
 ROLLER, GOLD-FINISHING
 SAW, DENTAL
 SAW, SURGICAL
 SCALER, DENTAL
 SCALPEL
 SCALPEL, DENTAL
 SCARIFICATOR
 SCISSORS, BANDAGE
 SCISSORS, DENTAL

- -

MEDICAL & PSYCHOLOGICAL T&E (cont.)

 SCISSORS, SURGICAL
 SCRAPER, DENTAL
 SCRAPER, TONGUE
 SEPARATOR, TEETH
 SET, ARCHWIRE SPLINT
 SET, BLEEDING
 SET, BLOOD COLLECTING
 SET, DISSECTING
 SET, INOCULATING
 SET, IV
 SET, LENS
 Set, Surgical instrument ... use KIT, SURGICAL
 SOUND
 SPATULA
 SPATULA, DENTAL
 SPATULA, SURGICAL
 SPECULUM
 SPHYGMOMANOMETER
 SPIROGRAPH
 SPIROMETER
 SPITTOON, INVALID
 SPLINT
 SPLINT, JAW
 SPLINT, THOMAS
 SPONGE, SURGICAL
 SPOON, MEDICAL
 SPOUT, EAR
 SPREADER, JAW
 STALAGMOMETER
 STEREOGRAM
 STEREOGRAPH
 STEREOSCOPE ... rt PSEUDOSCOPE, LENTICULAR
 STEREOSCOPE/PSEUDOSCOPE
 Sterilizer ... use AUTOCLAVE
 STETHOMETER
 STETHOSCOPE
 STOMATOSCOPE
 STRABISMOMETER
 SUPPORTER, MOUTH
 SURVEYOR, DENTURE ROD
 SUTURE
 SWAGE, DENTAL
 SYRINGE
 TABLE, DENTAL INSTRUMENT
 TABLE, EXAMINATION
 TABLE, OPERATING
 TAPE, ADHESIVE
 TAPE, UMBILICAL

- -

MEDICAL & PSYCHOLOGICAL T&E (cont.)

 TEMPLATE, DENTAL
 TENACULUM
 TEST, COLOR-PERCEPTION
 TESTER, COLOR-SENSE
 TETANOMETER
 THAUMATROPE
 THERMOMETER
 TIMER, PILL
 TIN, IMPRESSION
 TONGS, DENTAL
 TONOMETER
 TONSILLOTOME
 TOURNIQUET
 TRANSILLUMINATOR
 TRAY, DENTAL ACCESSORY
 TRAY, IMPRESSION
 TREPHINE
 TRIMMER, GINGIVAL
 TROCAR
 TROPOSTEREOSCOPE
 TRUSS
 TUBE, BLOOD-COLLECTING
 TUBE, STOMACH
 TWEEZERS
 TWEEZERS, SOLDERING
 UNIT, DENTURE-CURING
 UNIT, PROPHYLAXIS
 UREOMETER
 URETHROSCOPE
 URETHROTOME
 URICOMETER
 URINOMETER
 URINO-PYCNOMETER
 VAPORIZER
 VIAL
 VIBRATOR, DENTAL
 VISIOMETER
 WAX, DENTAL
 WEIGHT, RUBBER DAM

- -

MERCHANDISING T&E
note the first word of the object term for a product package should be
 the type of container. Modifiers may be used to indicate the
 product originally packaged. Institution rules vary as to the
 specificity (COCOA; SHAVING CREAM) or generality (FOODSTUFF;
 GROOMING AID) of the modifier.

 BAG
 BAG, DEPOSIT
 BARREL
 BIN,STORAGE
 BOTTLE ... rt DEMIJOHN
 BOTTLE, APOTHECARY
 BOX
 BOX, MONEY
 CABINET, DISPLAY
 CAN
 CARBOY
 CARDBOARD
 CARTON
 CASE
 CASE, DISPLAY
 CASE, SALES-SAMPLE
 CASK
 COUNTER
 CROCK
 CUTTER, TOBACCO
 DEMIJOHN ... rt BOTTLE
 ENVELOPE
 Flask ... use BOTTLE
 HOLDER, SIGN
 HOLDER, STRING
 JAR
 JAR, CONFECTIONARY
 JUG
 KEG
 KIT, SALES-SAMPLE
 MACHINE, VENDING
 MANIKIN
 MONEYCHANGER
 PACK
 PACKET
 PAPER, WRAPPING ... rt WRAP, GIFT (CEREMONIAL ARTIFACT)
 RACK, DISPLAY
 REGISTER, CASH
 Sack ... use BAG
 SALES-SAMPLE
 STAND, DISPLAY
 TABLE, DISPLAY

- -

MERCHANDISING T&E (cont.)

 Till ... use BOX, MONEY
 TIN
 TONGS, SHELF
 TRAY
 TUB
 TUBE
 TURNSTILE
 VIAL
 WRAPPER

METEOROLOGICAL T&E

 AEROMETER
 ANEMOGRAPH
 ANEMOMETER
 ANEMOSCOPE
 ANEROIDOGRAPH
 BALLOON, WEATHER
 BAROGRAPH
 BAROMETER
 BAROMETER, ANEROID
 BAROMETER, MERCURY
 BAROSTAT
 CEILOMETER
 CHAMBER, CLOUD
 DIAPHANOMETER
 DROSOMETER
 GAUGE, PRECIPITATION
 HYGROGRAPH
 HYGROMETER
 Hygrophant ... use HYGROMETER
 KONISCOPE
 METEOROGRAPH
 METEOROMETER
 METER, AIR
 MIRROR, CLOUD
 NEPHOSCOPE
 OMBROMETER
 OZONOMETER
 PAGOSCOPE
 PLUVIOGRAPH
 PLUVIOMETER
 POISE, AIR
 RADIOSONDE
 RECORDER, SUNSHINE
 SEISMOGRAPH

- -

METEOROLOGICAL T&E (cont.)

 SEISMOPHONE
 SET, RAWIN
 Sympiesometer ... use BAROMETER
 TASIMETER
 THERMOMETER
 TROMOMETER
 UDOMETER
 WEATHERVANE

NUCLEAR PHYSICS T&E

 ACCELERATOR ... rt BETATRON; PROTONSYNCHROTRON
 ACCELERATOR, LINEAR
 Atom smasher ... use ACCELERATOR
 BETATRON ... rt ACCELERATOR; PROTONSYNCHROTRON
 CHAMBER, BUBBLE
 CHAMBER, CLOUD
 CHAMBER, VACUUM
 COCKCROFT WALTON
 COLLIMATOR
 CONDENSER, ROTATING
 COUNTER, GEIGER
 CYCLOTRON
 CYCLOTRON, AVF
 DAMPER, VIBRATION
 DEFLECTOR
 DESICCATOR, BALANCE
 Donut ... use CHAMBER, VACUUM
 ELIMINATOR, STATIC
 GENERATOR, ELECTROSTATIC
 Hilac ... use ACCELERATOR, LINEAR
 ISOCHRONOUS
 KLYSTRON
 Linac ... use ACCELERATOR, LINEAR
 MACHINE, TANDEM
 MAGNET, BENDING
 MAGNET, QUADRUPOLE
 MAGNET, SEXTUPOLE
 PROTONSYNCHROTRON ... rt ACCELERATOR; BETATRON
 SEPARATOR, BEAM
 SPECTROGRAPH, MASS
 SPECTROMETER, MASS
 SYNCHROCYCLOTRON
 SYNCHROTRON
 SYNCHROTRON, ALTERNATING-GRADIENT
 SYNCHROTRON, CONSTANT-GRADIENT

- -

NUCLEAR PHYSICS T&E (cont.)

 SYNCHROTRON, ZERO-GRADIENT
 Van De Graaff ... use GENERATOR, ELECTROSTATIC

OPTICAL T&E

 ABSORPTIONMETER
 Altiscope ... use PERISCOPE
 Anastigmat ... use LENS, ANASTIGMATIC
 ANORTHOSCOPE
 APERTOMETER
 BINOCULARS
 CASE, BINOCULARS
 CATOPTER
 CHROMASCOPE
 CHROMATOMETER
 COLLIMATOR
 COLORIMETER
 CONDENSER
 COVER, TELESCOPE
 DICHROSCOPE
 DYNACTINOMETER
 DYNAMETER
 EIKONOMETER
 Engiscope ... use MICROSCOPE
 FOCOMETER
 GLASS, MAGNIFYING
 GLASS, REDUCING
 GLASSES, FIELD ... rt BINOCULARS
 GONIOPHOTOMETER
 HOLOPHOTE
 INTERFEROMETER
 LENS
 LENS, ANASTIGMATIC
 LENS, WATER
 Lucimeter ... use PHOTOMETER
 METROCHROME
 MICROSCOPE
 MICROSCOPE, BINOCULAR
 MICROSCOPE, ELECTRON
 MICROSPECTROSCOPE
 OTHEOSCOPE
 PERISCOPE
 PHONEIDOSCOPE
 PHOTODROME
 PHOTOMETER
 PHOTOMETER, POLARIZING

- -

OPTICAL T&E (cont.)

 POLARIMETER ... rt POLARISCOPE
 POLARISCOPE ... rt POLARIMETER
 PSEUDOSCOPE
 REFRACTOMETER
 SCOTOSCOPE
 SLIDE
 SPECTROGRAPH
 SPECTROMETER
 SPECTROPHOTOMETER
 SPECTROSCOPE
 STAUROSCOPE
 TACHISTOSCOPE
 TEINOSCOPE
 TELESCOPE
 Vivascope ... use TELESCOPE
 ZOOPRAXINOSCOPE

REGULATIVE & PROTECTIVE T&E

 ALARM, BURGLAR
 ALARM, FIRE
 ALARM, SMOKE
 AX, FIRE
 Bag, Sand ... use SANDBAG
 BALL & CHAIN
 Bell, Fire ... use ALARM, FIRE
 BELT, CHASTITY
 BELT, SAFETY
 BOCKS BRILLE
 BOOTH, VOTING
 BOX, BALLOT
 BOX, FIRE-ALARM
 Box, Voting ... use BOX, BALLOT
 BUCKET, FIRE
 CANGUE
 CAP, DUNCE
 CARRIER, GAS MASK
 Cat-o-nine-tails ... use WHIP
 CHAIN, RESTRAINING
 CHAIR, ELECTRIC
 Club, Billy ... use NIGHTSTICK
 CRADLE-WITH-SPIKES
 DAUGHTER, SCAVENGER'S
 DOCK, PRISONER'S
 EXTINGUISHER, FIRE
 GAG

- -

REGULATIVE & PROTECTIVE T&E (cont.)

 GALLOWS
 GRENADE, TEAR GAS
 GUILLOTINE
 HANDCUFFS
 HEADBAND, TIGHTENING
 HOLDER, FIRE EXTINGUISHER
 HOOD, GALLOWS
 HOSE, FIRE
 IRON, BRANDING
 Iron, Leg ... use SHACKLE, LEG
 KEY, HANDCUFFS
 KEY, JAIL
 MACHINE, VOTING
 Manacle ... use SHACKLE
 MASK, GAS
 METER, PARKING
 NIGHTSTICK
 NOOSE, HANGMAN'S
 PADDLE
 PADLOCK
 PILLORY
 SANDBAG
 SHACKLE
 SHACKLE, LEG
 Siren, Fire ... use ALARM, FIRE
 STOCKS
 STOOL, DUCKING
 STRAITJACKET
 SYSTEM, FIRE-ALARM
 THUMBSCREW
 WHEEL, JURY
 WHIP
 WRENCH, FIRE PLUG

SURVEYING & NAVIGATIONAL T&E

 ALIDADE
 ALTIMETER
 Ambulator ... use WHEEL, SURVEYOR'S
 ANTENNA, RADAR
 APOMECOMETER
 ASTROLABE, MARINER'S
 BACKSTAFF
 BATHOMETER
 BOARD, NAVIGATOR'S
 BUOY, NAVIGATIONAL

- -

SURVEYING & NAVIGATIONAL T&E (cont.)

 CAIRN
 CARD, COMPASS
 CASE, OCTANT
 CASE, SEXTANT
 CATHETOMETER
 CHAIN, ENGINEER'S
 CHAIN, SURVEYOR'S
 CHOROGRAPH
 CHRONOMETER
 CIRCLE, AZIMUTH
 CIRCLE, REFLECTING
 CIRCLE, REPEATING
 CIRCUMFERENTOR ... rt GRAPHOMETER; QUADRANT; OCTANT
 CLINOGRAPH
 CLINOMETER
 COMPASS
 COMPASS, BOREHOLE
 COMPASS, CARLSON
 COMPASS, DIP
 COMPASS, DRYCARD
 COMPASS, RADIO
 COMPASS, SURVEYOR'S
 COMPENSATOR
 CORRECTOR, COURSE
 CROSS-STAFF ... rt GROMA
 DEFLECTOR
 DRIFTSIGHT
 ECHOMETER
 Fathometer ... use FINDER, DEPTH
 FINDER, DEPTH
 FINDER, DIRECTION
 FINDER, DISTANCE
 FINDER, RADIO DIRECTION
 FINDER, RADIO RANGE
 FINDER, RANGE
 FINDER, STAR
 GAUGE, DEPTH
 GIMBAL, COMPASS
 Goniometer ... use FINDER, DIRECTION
 GRADIOMETER
 GRAPHOMETER ... rt CIRCUMFERENTOR; QUADRANT
 GROMA ... rt CROSS-STAFF; SQUARE, OPTICAL
 GYRO-COMPASS ... rt COMPASS
 Heliostat ... use HELIOTROPE
 HELIOTROPE
 Hodometer ... use WHEEL, SURVEYOR'S
 HORIZON, ARTIFICIAL
 INCLINOMETER

- -

SURVEYING & NAVIGATIONAL T&E (cont.)

 INDICATOR, AIRSPEED
 INDICATOR, BANK
 INDICATOR, CLIMB
 INDICATOR, DRIFT
 INDICATOR, POSITION
 INDICATOR, RATE-OF-CLIMB
 INDICATOR, TURN
 Indicator, Vertical-speed ... use INDICATOR, RATE-OF-CLIMB
 LEAD, SOUNDING
 LEVEL, SURVEYOR'S
 MACHINE, SOUNDING
 MAGNETOMETER
 Mark, Bench ... use more specific term, e.g.: CAIRN; STAKE; MARKER,
 CONCRETE
 MARKER, CONCRETE
 METER, ANGLE
 METER, YAW
 Nocturnal ... use ASTROLABE, MARINER'S
 OCTANT ... rt CIRCUMFERENTOR; SEXTANT
 Odometer ... use WHEEL, SURVEYOR'S
 Omnimeter ... use THEODOLITE
 OPISOMETER
 ORIENTATOR
 OROGRAPH
 OSCILLOMETER
 PALINURUS
 PANTOMETER
 Pelorus ... use CARD, COMPASS
 Perambulator ... use WHEEL, SURVEYOR'S
 PLANIMETER
 PLATOMETER
 POINTER, STATION
 POLE, PICKET
 QUADRANT ... rt CIRCUMFERENTOR; GRAPHOMETER
 RECEIVER
 RECEIVER, BEACON
 RECEIVER, LONG-WAVE BEACON
 RECEIVER/DISPLAY, LORAN
 RECEIVER/DISPLAY, RADAR
 RECORDER, SCEPTRE
 REEL, LOG
 Rod ... use ROD, STADIA
 ROD, BONING
 ROD, STADIA
 RULER, PARALLEL
 SCALE, NAVIGATIONAL
 SEMICIRCLE
 SEMICIRCUMFERENTOR

- -

SURVEYING & NAVIGATIONAL T&E (cont.)

 SETTER, COURSE
 SEXTANT
 SHADE, HORIZON GLASS
 SHADE, INDEX
 SONDOGRAPH
 SPHEROGRAPH
 SPOOL, COMPASS
 SPOOL, WIRE
 SQUARE, OPTICAL ... rt GROMA
 STADIMETER
 STAFF, STATION
 STAKE
 TABLE, PLANE
 Tachymeter ... use THEODOLITE or ALIDADE or TRANSIT
 TELESCOPE
 TELESCOPE, QUADRANT
 TELESCOPE, SEXTANT
 THEODOLITE ... rt TRANSIT
 TRANSIT ... rt THEODOLITE
 Trechometer ... use WHEEL, SURVEYOR'S
 TRIPOD
 TRUMPET, HAILING
 TUBE, SOUNDING
 TWEEZERS, STEAM INDICATOR
 Unit, Radar ... use RECEIVER/DISPLAY, RADAR
 Unit, Sonar ... use BATHOMETER or ECHOMETER
 VERTIMETER
 Waywiser ... use WHEEL, SURVEYOR'S
 WHEEL, SURVEYOR'S
 ZENOMETER

THERMAL T&E

 BAG, BUOYANCY
 BOLOMETER
 CALORIMETER
 CHRONOTHERMOMETER
 CRYOMETER
 CRYOPHORUS
 EBULLIOSCOPE
 EVAPORIMETER
 GALVANOTHERMOMETER
 GEOTHERMOMETER
 Hydropyrometer ... use PYROMETER
 HYPSOMETER

- -

THERMAL T&E (cont.)

 PYROMETER ... rt THERMOMETER
 Telethermometer ... use PYROMETER
 THERMOCOUPLE
 THERMOGRAPH
 THERMOHYDROMETER
 THERMOMETER ... rt PYROMETERR
 THERMOMETOGRAPH
 THERMOMULTIPLIER
 THERMOSCOPE
 THERMOSTAT

TIMEKEEPING T&E

 CASE, WATCH
 CHRONOGRAPH
 Chronometer, Solar ... use SUNDIAL
 CHRONOSCOPE
 Clepsydra ... use CLOCK, WATER
 CLOCK
 CLOCK, ALARM
 CLOCK, CARRIAGE
 CLOCK, CASE
 Clock, Grandfather ... use CLOCK, TALL CASE
 Clock, Grandmother ... use CLOCK, CASE
 CLOCK, SHIP'S
 CLOCK, TALL CASE
 CLOCK, TIME RECORDING
 CLOCK, TRAVEL
 CLOCK, TURRET
 CLOCK, WALL
 CLOCK, WATER
 GARNITURE, CLOCK
 HOROMETER
 HOURGLASS
 KEY, CLOCK
 KEY, WATCH
 METRONOME
 STOPWATCH
 SUNDIAL
 WATCH, PENDANT
 WATCH, POCKET
 WRISTWATCH

- -

WEIGHTS & MEASURES T&E

 BALANCE
 BALANCE, ANALYTICAL
 BALANCE, BERANGER
 BALANCE, DEMONSTRATION
 BALANCE, GRAM-CHAIN
 BALANCE, ROBERVAL
 BALANCE, SPECIFIC-GRAVITY
 BALANCE, TORSION
 CALIPERS
 CALIPERS, DOUBLE
 CALIPERS, INSIDE
 CALIPERS, OUTSIDE
 COMPARATOR
 ERIOMETER
 EXTENSOMETER
 GAUGE
 GAUGE, RAILWAY
 GAUGE, RING
 GAUGE, WATER
 GNOMON
 GONIOMETER
 GRADUATE
 MEASURE, DRY
 MEASURE, LIQUID
 MEASURE, SPRING
 MEASURE, TAPE ... rt RULE, RETRACTABLE
 METERSTICK
 MICROMETER
 PACHYMETER
 PANYOCHROMETER
 ROD, WANTAGE
 RULE, FOLDING
 RULE, RETRACTABLE ... rt MEASURE, TAPE
 RULER
 Scale, Apothecary ... use SCALE, BALANCE
 SCALE, BALANCE
 SCALE, BATHROOM
 SCALE, COMPUTING
 SCALE, CYLINDER
 Scale, Drum ... use SCALE, CYLINDER
 SCALE, LEVER
 SCALE, PLATFORM
 SCALE, POSTAL
 SCALE, SPRING
 SCALE, TRIANGULAR
 SCALE, TRUCK
 SCOOP, SCALE

- -

WEIGHTS & MEASURES T&E (cont.)

 Tape, Steel ... use MEASURE, TAPE or RULE, RETRACTABLE
 WAVEMETER
 WEIGHT, BALANCE
 YARDSTICK

OTHER T&E FOR SCIENCE & TECHNOLOGY

- -

CATEGORY 6: TOOLS & EQUIPMENT FOR COMMUNICATION

DATA PROCESSING T&E

 ABACUS
 ANALYZER
 ANALYZER, DIFFERENTIAL
 ANALYZER, HARMONIC
 ANALYZER, NETWORK
 ANGLEOMETER
 AUTOMATON
 Board, Plug ... use PATCH
 Bones, Napiers' ... use ROD, CALCULATING
 BURSTER
 CABLE
 CALCULATOR, DESK
 CALCULATOR, POCKET
 CARD, EDGE-NOTCH
 CARD, PUNCH
 CHAD
 Charactron ... use UNIT, VISUAL DISPLAY
 COLLATOR
 COMPARATOR
 COMPUTER, ANALOG ... rt ANALYZER
 COMPUTER, DIGITAL
 note use for the main unit comprising CPU, I/O processor, and storage
 COMPUTER, HYBRID
 note use for a computer which combines analog and digital features
 Computer, Micro ... use MICROCOMPUTER
 Computer, Mini ... use MINICOMPUTER
 Computer, Satellite ... use more specific term for external processing
 unit, e.g: MINICOMPUTER
 CONSOLE
 Controller, Card ... use PROCESSOR, CARD
 CONVERTER
 CONVERTER, ANALOG-TO-DIGITAL
 CONVERTER, CARD-TO-TAPE
 CONVERTER, DIGITAL-TO-ANALOG
 COUPLER
 CPU
 note use for computer central processing unit
 Dataplotter ... use PLOTTER
 DECODER
 DEVICE, TEST-SCORING
 DISK, MAGNETIC
 DRUM, MAGNETIC
 ENCODER

- -

DATA PROCESSING T&E (cont.)

 Equipment, Peripheral ... use more specific term, e.g.: READER, CHARACTER
GRADUATOR
HOLOMETER
INTEGRATOR ... rt PLANIMETER
KEYBOARD
 Keypunch ... use PUNCH, KEYBOARD
 Machine, Accounting ... use MACHINE, BOOKKEEPING
MACHINE, ADDING
MACHINE, BOOKKEEPING
 Machine, Data-processing ... use more specific term, e.g.: COMPUTER,
 ANALOG
MACHINE, PINBOARD
 Machine, Posting ... use MACHINE, BOOKKEEPING
MACHINE, TABULATING
MACHINE, TEACHING
MACHINE, TICKER-TAPE
MICROCOMPUTER
MINICOMPUTER
MOUSE
MULTIPLEXOR ... rt VARIOPLEX
ORTHOSCANNER ... rt READER, CHARACTER
PATCH
 Pen, Light ... use STYLUS, LIGHT
PERFORATOR
 Phone, Data ... use COUPLER
PINBOARD
PLANIMETER ... rt INTEGRATOR
PLOTTER
PRINTER
PRINTER, KEYBOARD
PRINTER, LINE
PRINTER, MATRIX
PRINTER, ON-THE-FLY
PRINTER, SERIAL
PROCESSOR, CARD
PUNCH
 Punch, Card ... use PUNCH, KEYBOARD
PUNCH, GANG
PUNCH, KEYBOARD
PUNCH, SPOT
PUNCH, SUMMARY
PUNCHBOARD
READER, CARD
READER, CHARACTER ... rt ORTHOSCANNER
READER, TAPE
RECORDER, FILM
REPRODUCER, CARD
REPRODUCER, TAPE

- -

DATA PROCESSING T&E (cont.)

 ROD, CALCULATING
 RULE, SLIDE
 SCALE
 Scanner, Optical ... use READER, CHARACTER
 SIMULATOR
 SORTER, CARD
 SPHEROMETER
 STYLUS, LIGHT
 TAPE, MAGNETIC
 TAPE, PAPER
 TAPE, TICKER
 TELEPRINTER
 TERMINAL
 TERMINAL, CRT
 TERMINAL, MAGNETIC-TAPE
 TERMINAL, TYPEWRITER
 Test-scoring Device ... use DEVICE, TEST-SCORING
 TYPEWRITER
 TYPEWRITER, CONSOLE
 TYPEWRITER, MAGNETIC-CARD
 TYPEWRITER, MAGNETIC-TAPE
 UNIT, ASSEMBLY
 UNIT, AUDIO-RESPONSE
 UNIT, CARD SENSING/PUNCHING
 Unit, Central processing ... use CPU
 UNIT, DISK
 UNIT, PERIPHERAL CONTROL
 UNIT, TAPE
 UNIT, VISUAL DISPLAY
 VARIOPLEX ... rt MULTIPLEXOR
 VERIFIER

DRAFTING T&E

 ARCOGRAPH
 BOARD, DRAWING
 BOW, SPRING
 CAMPYLOMETER
 CENTROLINEAD
 CHARTOMETER
 COMPASS, BEAM
 COMPASS, BOW
 COMPASS, PENCIL
 COMPASS, PROPORTIONAL
 COMPASS, WING

- -

DRAFTING T&E (cont.)

 CONOGRAPH ... rt ELLIPSOGRAPH
 CURVE
 CURVE, BROOK'S
 CYCLOIDOGRAPH
 CYCLOMETER
 CYMOGRAPH
 DIVIDERS
 DIVIDERS, CHART
 ECCENTROLINEAD
 Eidograph ... use PANTOGRAPH
 ELLIPSOGRAPH ... rt CONOGRAPH
 Elliptograph ... use ELLIPSOGRAPH
 ENGINE, DIVIDING
 ENGINE, RULING
 HELICOGRAPH
 HYALOGRAPH
 ISOGRAPH
 MACHINE, DRAFTING
 MICROGRAPH
 MODEL, GEOMETRIC
 ODONTOGRAPH
 PANTOGRAPH
 PEN, RULING
 PERSPECTOGRAPH
 Plagiograph ... use PANTOGRAPH
 Planigraph ... use PANTOGRAPH
 Points, Trammel ... use COMPASS, BEAM
 PROBE
 PROTRACTOR
 RHUMBOSCOPE
 ROTAMETER
 RULE, PARALLEL
 SCALE, ARCHITECT'S
 SECTOGRAPH
 SECTOR
 SET, DRAFTING
 SPIROGRAPH
 STYLUS
 TABLE, DRAFTING
 TEMPLATE, DRAFTING
 TRACER, CURVE
 TRIANGLE
 T-SQUARE

- -

MUSICAL T&E

 ACCORDION
 ANVIL
 AUTOHARP
 BAGPIPE
 BALALAIKA
 BANJO
 BARYTON ... rt VIOL, BASS
 BASS, DOUBLE
 BASSOON
 BASSOON, DOUBLE
 BASSOON, RUSSIAN
 BATON
 BELL
 BENCH, PIANO
 Bombardon ... use TUBA
 BOW, VIOLIN
 BRUSH, BORE
 BRUSH, WIRE
 BUCCIN
 BUGLE
 BUGLE, KEY
 BUGLE, VALVE
 CALLIOPE
 CASE, CLARINET
 CASE, FIFE
 CASE, GUITAR
 CASE, REED
 CASE, VIOLIN
 CASTANETS
 CELESTA
 CHAINS
 CHALUMEAU
 CHIMES
 CIMBALOM
 CITTERN
 CLARINET
 CLAVES
 CLAVICHORD
 CLAVICOR
 CLIP, MUSIC
 CONCERTINA
 Cor, Tenor ... use MELLOPHONE
 Cor anglais ... use HORN, ENGLISH
 CORNET
 CORNET, VALVE
 Cornopean ... use CORNET
 COWBELL
 CRUMHORN

- -

MUSICAL T&E (cont.)

 CRWTH
 CURTAL
 CYMBAL
 DRUM
 DRUM, BASS
 DRUM, BONGO
 DRUM, SIDE
 DRUM, SNARE
 DRUM, TENOR
 DRUMSTICK
 DULCIAN
 DULCIMER
 EUPHONIUM
 FIFE
 FLAGEOLET
 FLAGEOLET, DOUBLE
 FLAGEOLET, TRIPLE
 Flugelhorn ... use BUGLE, VALVE
 FLUTE
 GLOCKENSPIEL
 GONG
 GUITAR
 HARMONICA
 HARMONICA, GLASS
 Harmonium ... use ORGAN, REED
 HARP
 HARP, JEW'S
 HARPSICHORD
 Hautboy ... use OBOE
 HORN
 HORN, ALTO
 HORN, BARITONE
 HORN, BASS
 HORN, BASSET
 HORN, COACH
 HORN, ENGLISH
 HORN, FRENCH
 HORN, HUNTING
 HORN, POST
 HORN, TENOR
 HURDY-GURDY
 HUSLA
 INVENTIONSHORN
 JINGLES
 KAZOO
 Kettledrum ... use TIMPANUM
 KIT ... rt VIOLIN

- -

MUSICAL T&E (cont.)

 LIRA ... rt VIOLA
 LUTE ... rt THEOROBO
 LYRE
 LYRE-GUITAR
 MANDOCELLO
 MANDOLIN ... rt MANDORE
 MANDORE ... rt MANDOLIN
 MARACAS
 MARIMBA
 MELLOPHONE
 Melodeon ... use ORGAN, REED
 MOUTHPIECE
 OBOE
 OBOE D'AMORE
 OCARINA
 OCTAVIN
 OPHICLEIDE
 ORCHESTRION
 ORGAN, ELECTRONIC
 ORGAN, PIPE
 ORGAN, REED
 ORGANETTE
 PANPIPE
 PIANO
 PIANO, BABY GRAND
 PIANO, BARREL
 PIANO, GRAND
 PIANO, PLAYER
 Piano, Reproducing ... use PIANO, PLAYER
 PIANO, SQUARE
 PIANO, UPRIGHT
 PICCOLO
 Pipe ... use BAGPIPE or FIFE or PANPIPE
 PIPE, PITCH
 PIPE, TABOR
 RACKET
 RATCHET
 RATTLE
 REBEC ... rt VIOLIN
 RECORDER
 REST, CHIN
 RHYTHMOMETER
 ROSIN
 Sackbut ... use TROMBONE
 SARRUSOPHONE
 SAW, MUSICAL
 SAXHORN
 SAXOPHONE

- -

MUSICAL T&E (cont.)

 SERPENT
 SHAWM
 SITAR
 SOLOPHONE
 Sousaphone ... use TUBA
 SPINET
 STAND, MUSIC
 STOOL, PIANO
 STRING, INSTRUMENT
 SWITCH
 SYNTHESIZER
 TABOR
 TAMBOURINE
 Tam-tam ... use TOM-TOM or GONG
 TAROGATO
 TECHNICON
 TENOROON
 THEOROBO ... rt LUTE
 THEREMIN
 TIMPANUM
 TOM-TOM
 TRIANGLE
 TROMBONE
 TROMBONE, VALVE
 TRUMPET
 TRUMPET, CURVED
 TRUMPET, KEY
 TRUMPET, NATURAL
 TRUMPET, SLIDE
 TRUMPET, VALVE
 TRUMPET MARINE
 TUBA
 TUBA, WAGNER
 UKULELE
 VIBRAPHONE
 VIOL
 VIOL, BASS ... rt BARYTON
 VIOL, CITHER
 VIOL, LYRA
 VIOLA ... rt LIRA
 VIOLA D'AMORE
 VIOLIN ... rt KIT; REBEC
 VIOLONCELLO
 VIRGINAL
 WHIP
 WHISTLE
 WOODBLOCK
 XYLOPHONE

- -

MUSICAL T&E (cont.)

 ZITHER

PHOTOGRAPHIC T&E

 ATTACHMENT, FLASH
 ATTACHMENT, LENS
 CAMERA
 CAMERA, BOX
 CAMERA, FOLDING
 CAMERA, MOTION-PICTURE
 CAMERA, RANGEFINDER
 CAMERA, SINGLE LENS REFLEX
 CAMERA, STEREO
 CAMERA, VIEW
 CAMERA OBSCURA
 CAP, LENS
 CASE, CAMERA
 CLIP, PRINT
 DENSITOMETER
 DEVELOPER
 DRYER, FILM
 DRYER, PRINT
 EASEL
 ENLARGER
 FILM
 FILTER
 FRAME, CONTACT-PRINTING
 GAFFER
 HEADREST
 HOLDER, CUT-FILM
 HOLDER, DENTAL FILM
 Holder, Plate ... use PLATEHOLDER
 HOLDER, ROLL-FILM
 IRON, TACKING
 KNIFE, FILM
 LENS
 Light, Strobe ... use ATTACHMENT, FLASH
 METER, LIGHT
 PAPER, PHOTOGRAPHIC
 PLATE, DRY
 PLATE, FERROTYPE
 PLATEHOLDER
 POWDER, DEVELOPING
 PRESS, DRY-MOUNTING
 PRINTER, CONTACT
 RELEASE, CABLE

- -

PHOTOGRAPHIC T&E (cont.)

 ROD, STIRRING
 ROLLER, PRINT
 SAFELIGHT
 SHUTTER
 SPLICER, FILM
 TANK, FILM-PROCESSING
 THERMOMETER
 TIMER, DARKROOM
 TISSUE, DRY-MOUNTING
 TRAY, PRINT-PROCESSING
 TRIMMER, PHOTOGRAPH
 TRIPOD
 WASHER, FILM
 WASHER, PRINT

PRINTING T&E

 BLANKET, OFFSET
 BLOCK, ENGRAVER'S
 BLOCK, FABRIC
 BLOCK, LINOLEUM
 BLOCK, PRINTING
 BLOCK, WALLPAPER
 BLOCK, WOOD ... rt PLATE, ENGRAVING
 BOARD, BINDING
 BODKIN
 BRAYER
 Burin ... use GRAVER
 BURNISHER
 CASE, PARCHMENT
 CASE, TYPE
 CHASE
 CHECKWRITER
 CRAYON, LITHOGRAPHIC
 CUTTER, BOARD
 Cutter, Lead ... use CUTTER, SLUG
 CUTTER, PAPER
 CUTTER, SLUG
 DABBER
 DIE, BINDER
 DUPLICATOR ... rt MIMEOGRAPH
 ECHOPPE
 FILLET
 FOLDER, BONE
 FRAME, SEWING
 FRISKET

- -

PRINTING T&E (cont.)

 GAUGE, COMPOSING STICK
 GAUGE, LINE
 GAUGE, PLATE
 GAUGE, SAW
 GAUGE, TYPE HIGH
 GOFFER
 GRAVER
 HAMMER, BACKING
 HANDPRESS
 HECTOGRAPH
 INKBALL
 INKSTONE
 IRON, KNOCKING-DOWN
 KEY, SEWING
 KNIFE, ETCHING
 KNIFE, FOLDING
 KNIFE, PAPER
 KNIFE, SHEETER
 KNIFE, SKIVING
 KNIFE, TAB-CUTTER
 KNIFE, TRIMMER
 LETTERPRESS
 LEVIGATOR
 LITHO-PRESS
 MACE-HEAD
 MACHINE, ADDRESSING
 MACHINE, BACKSTRIPPING
 MACHINE, BANDING
 MACHINE, BATCHER/JOGGER
 MACHINE, BINDING
 MACHINE, BOOK-SEWING
 MACHINE, BOOK-SMASHING
 MACHINE, BOOK-TRIMMING
 MACHINE, CASEMAKING
 MACHINE, CASING-IN
 MACHINE, COLLATING
 Machine, Composing ... use TYPESETTER
 MACHINE, FOLDING
 MACHINE, GLUING
 MACHINE, MITERING
 MACHINE, NUMBERING
 MACHINE, OFFSET-PLATE PROCESSING
 Machine, Photocomposing ... use PHOTOTYPESETTER
 MACHINE, ROLLING
 MACHINE, ROUND-BACKING
 MACHINE, ROUND-CORNERING
 MACHINE, RULING
 MACHINE, STOCK-COMPRESSING

- -

PRINTING T&E (cont.)

 MACHINE, TAB-CUTTING
 MACHINE, TIPPING
 MACHINE, TYPE-CASTING
 MALLET
 Mimeograph ... use DUPLICATOR
 NEEDLE, ETCHING
 NEEDLE, LOOPER
 NIPPERS, BAND
 PALLET
 PEEL
 PERFORATOR
 PHOTOCOPIER
 PHOTOTYPESETTER
 PLANER
 PLATE, ENGRAVING ... rt BLOCK, WOOD
 PLATE, LITHOGRAPH
 PLATE, OFFSET
 PLATE, STEREOTYPE
 PLIERS, LINOTYPE
 PLOUGH
 POINT, LITHOGRAPHIC
 POT, GLUE
 Press, Arming ... use PRESS, BLOCKING
 PRESS, BLOCKING
 PRESS, BOOK
 PRESS, CUTTING
 PRESS, CYLINDER
 PRESS, EMBOSSING
 PRESS, ETCHING
 Press, Fly ... use PRESS, EMBOSSING
 Press, Hand ... use HANDPRESS
 Press, Job ... use more specific term, e.g.: LETTERPRESS
 Press, Letter ... use LETTERPRESS
 PRESS, LYING
 PRESS, NEWSPAPER
 PRESS, NIPPING
 PRESS, OFFSET
 PRESS, PLATEN
 PRESS, STANDING
 Printer, Electrostatic ... use PHOTOCOPIER
 Printer, Xerographic ... use PHOTOCOPIER
 QUOIN
 ROCKER
 ROULETTE
 RULE, COMPOSING
 RULE, LINE
 RULE, MAKE-UP
 SCRAPER

- -

PRINTING T&E (cont.)

 Screen, Silk ... use STENCIL
 SHEARS, BENCH
 SHEET, PLATE-BACKING
 SLUG
 SQUEEGEE
 STAMP, BAG
 STAMP, EMBROIDERY
 STENCIL
 STICK, COMPOSING
 Stick, Job ... use STICK, COMPOSING
 STICK, SHOOTING
 STONE, IMPOSING
 STONE, LITHOGRAPH
 STOVE, FINISHING
 SURFACER, SLUG
 TABLE, BINDERY
 TABLE, ETCHING
 TABLE, IMPOSING
 TABLE, LAYOUT/STRIPPING
 TABLE, LIGHT
 TOOL, TINT
 TUBE, INK
 TYPE
 TYPESETTER
 TYPESETTER, COMPUTER
 TYPESETTER, KEYBOARD
 Typesetter, Linotype ... use TYPESETTER, KEYBOARD
 Typesetter, Monotype ... use TYPESETTER, KEYBOARD
 Typesetter, Photo ... use PHOTOTYPESETTER
 Woodcut ... use BLOCK, WOOD

SOUND COMMUNICATION T&E

 ALBUM, RECORD
 AMPLIFIER, AUDIO
 BELL
 BELL, ANIMAL
 BELL, CHURCH
 BELL, SCHOOL
 BELL, SERVICE
 BOX, MUSIC
 BULLHORN
 BUZZER
 CARTRIDGE, TAPE
 CHIME
 CONTROL, ANTENNA

- -

SOUND COMMUNICATION T&E (cont.)

 CYLINDER, DICTATING
 CYLINDER, MUSIC-BOX
 CYLINDER, PHONOGRAPH
 DISC, MUSIC-BOX
 EARPHONE
 FOGHORN
 GONG
 HORN, DINNER ... rt BELL, SERVICE
 INTERCOM
 JUKEBOX ... rt NICKELODEON
 MACHINE, DICTATING
 MALLET, GONG
 MEGAPHONE
 MICROPHONE
 NEEDLE, PHONOGRAPH
 NICKELODEON ... rt JUKEBOX
 PHONOGRAPH
 PIPE, BOATSWAIN'S
 Pipe, Bosun's ... use PIPE, BOATSWAIN'S
 Player, Record ... use PHONOGRAPH
 Projector, Sound ... use BULLHORN or AMPLIFIER, AUDIO
 RATTLE, GAS
 RECORD, PHONOGRAPH
 RECORDER, TAPE
 ROLL, PLAYER PIANO
 SHAVER, DICTATING MACHINE
 SIMULATOR, SOUND-EFFECTS
 SIREN
 SPEAKER
 TAPE
 TRUMPET, HAILING
 TRUMPET, SPEAKING
 TUBE, SPEAKING
 TURNTABLE
 WHISTLE

TELECOMMUNICATION T&E

 AMPLIFIER
 ANTENNA
 ANTENNA, RADIO
 ANTENNA, TELEVISION
 CABLE, SUBMARINE
 CABLE, TELEPHONE
 CAMERA, TELEVISION
 HEADSET, RADIO

- -

TELECOMMUNICATION T&E (cont.)

 KEY, TELEGRAPH
 RADIO
 note use for instruments used for the reception of audio messages only
 Radio, Cb ... use TRANSCEIVER
 RADIOPHONE
 Radiotelephone ... use RADIOPHONE
 SWITCHBOARD
 TELEPHONE
 TICKER, STOCK
 TRANSCEIVER
 note use for any instrument that permits transmission and reception
 of audio messages
 TRANSMITTER
 TRANSMITTER, RADIO
 TRANSMITTER, TELEVISION

VISUAL COMMUNICATION T&E

 CASE, PROJECTOR
 EYEGLASSES, 3-D
 FLAG, CODE
 FLAG, SEMAPHORE
 FLAG, SIGNAL
 FLARE, DISTRESS
 GRAPHOSCOPE
 Guidepost ... use SIGN, TRAFFIC
 GUIDON
 GUN, FLARE
 HELIOGRAPH
 KINETOSCOPE
 LAMP, ALDIS
 LAMP, RAILROAD
 LANTERN, BATTLE
 Lantern, Magic ... use PROJECTOR, LANTERN-SLIDE
 LANTERN, RAILROAD
 LIGHT, SIGNAL
 Light, Traffic ... use SIGNAL, TRAFFIC
 LOCKER, FLAG
 MEGALITHOSCOPE
 Megascope ... use PROJECTOR, LANTERN-SLIDE
 PISTOL, SIGNAL
 Pistol, Very ... use PISTOL, SIGNAL
 POINTER
 POLEMOSCOPE
 POT, SMUDGE
 PROJECTOR, FILM STRIP

- -

VISUAL COMMUNICATION T&E (cont.)

 PROJECTOR, LANTERN-SLIDE
 PROJECTOR, MOTION-PICTURE
 PROJECTOR, OPAQUE
 PROJECTOR, SLIDE
 READER, MICROFICHE
 READER, MICROFILM
 ROCKET, SIGNAL
 SCREEN
 SEMAPHORE, RAILROAD ... rt SIGNAL, RAILROAD
 SIGN
 SIGN, INSTRUCTIONAL
 SIGN, TRAFFIC ... rt SIGNAL, TRAFFIC
 SIGNAL, RAILROAD ... rt SEMAPHORE, RAILROAD
 SIGNAL, TRAFFIC ... rt SIGN, TRAFFIC
 Stereopticon ... use PROJECTOR, LANTERN-SLIDE
 STEREOSCOPE
 STEREOVIEWER
 note use only for a "modern" stereoviewer

WRITTEN COMMUNICATION T&E

 BINDER, RING
 Blackboard ... use CHALKBOARD
 BLOTTER
 BOOKMARK
 BOX, FILE
 BOX, POUNCE
 BOX, SIGNET
 BOX, STAMP
 Box, Writing ... use DESK, PORTABLE
 Card, Business reply ... use POSTCARD
 CARD, INDEX
 note unused. If used, may be DOCUMENTARY ARTIFACT
 CASE, PEN
 CASE, PENCIL
 CASE, PENCIL LEAD
 CASE, TYPEWRITER
 CASE, WRITING
 CHALK
 CHALKBOARD
 Clip, Bill ... use CLIP, PAPER
 CLIP, PAPER
 CLIPBOARD
 CRAYON, MARKING
 CUTTER, PAPER
 CUTTER, QUILL

- -

WRITTEN COMMUNICATION T&E (cont.)

 Desk, Lap ... use DESK, PORTABLE
 DESK, PORTABLE
 ENVELOPE
 note unused. If used, may be DOCUMENTARY ARTIFACT
 ERASER
 FILE, PORTABLE
 FOLDER, FILE
 HOLDER, BRUSH
 HOLDER, DESK-BLOTTER
 HOLDER, PAPER CLIP
 HOLDER, PEN
 HOLDER, PENCIL
 HOLDER, STAMP
 INK
 INKPAD
 INKSTAND
 INKWELL
 KNIFE, PAPER
 LABEL, ADDRESS
 note blank. If non-blank, may be DOCUMENTARY ARTIFACT
 LAPBOARD
 LINER, INKWELL
 MACHINE, MAILING
 MAILBAG
 MAILBOX
 MAKER, LABEL
 METER, POSTAGE
 MOISTENER
 NOTEBOOK
 note unused. If used, may be DOCUMENTARY ARTIFACT
 Opener, Letter ... use KNIFE, PAPER
 PAD
 PAD, LEGAL
 PAD, WRITING
 PAPER
 PAPER, LETTERHEAD
 Paper, Music ... use PAPER, STAFF
 PAPER, STAFF
 note use for paper ruled to accommodate the writing of music
 PAPER, TYPING
 PAPER, WRITING
 PAPERWEIGHT
 PEN
 PEN, BALL-POINT
 PEN, FELT-TIP
 PEN, FOUNTAIN
 PEN, QUILL
 PENCIL

- -

WRITTEN COMMUNICATION T&E (cont.)

 PENCIL, MECHANICAL
 PENCIL, SLATE
 Pen Nib ... use PEN
 PORTFOLIO
 POSTCARD
 note unused. If used, may be DOCUMENTARY ARTIFACT
 POWDER, INK
 PROTECTOR, CHECK
 PUNCH, PAPER
 PUSHPIN
 RACK, LETTER
 RIBBON, TYPEWRITER
 Sandbox ... use BOX, POUNCE
 SET, DESK
 SHARPENER, PENCIL
 SIGNET
 Slate ... use CHALKBOARD
 SOLANDER
 Spike, Bill ... use SPINDLE
 SPINDLE
 STAMP
 STAMP, DATE
 STAMP, MARKING
 STAMP, NOTARY
 STAPLER
 Stationery ... use PAPER or PAPER, type-modifier
 STENCIL
 Tack, Bulletin Board ... use PUSHPIN
 TRAY, DESK
 TRAY, PEN
 TYPEWRITER
 TYPEWRITER, ELECTRIC
 TYPEWRITER, MANUAL
 WAX, SEALING
 WIPER, PEN

OTHER T&E FOR COMMUNICATION

- -

CATEGORY 7: DISTRIBUTION & TRANSPORTATION ARTIFACTS

CONTAINER
note more specialized container forms are classified according to their
 function: e.g., FOOD PROCESSING T&E, FOOD SERVICE T&E; containers
 associated with specific kinds of objects are classified with
 those objects: e.g., CASE, VIOLIN in MUSICAL T&E; BOX, PIN in
 TEXTILEWORKING T&E.

 BAG
 BALE
 BASKET
 BOTTLE
 BOX
 BOX, PACKING
 BOX, STORAGE
 BUCKET
 CAN
 CASE
 CRATE, SHIPPING
 CROCK
 JAR
 JUG
 KEG
 Phial ... use VIAL
 POUCH
 TUB
 TUBE
 VIAL

AEROSPACE TRANSPORTATION

 AEROSPACE TRANSPORTATION -- EQUIPMENT

 Aircraft ... use more specific term, e.g.: AIRPLANE; AIRSHIP; BALLOON
 AIRPLANE
 AIRSHIP
 AIRSHIP, BLIMP
 AIRSHIP, NONRIGID
 AIRSHIP, PRESSURE-RIGID
 AIRSHIP, RIGID
 AIRSHIP, SEMIRIGID

- -

AEROSPACE TRANSPORTATION -- EQUIPMENT (cont.)

 Amphibian ... use AIRPLANE
 AUTOGYRO
 BALLOON
 BALLOON, BARRAGE
 BALLOON, CAPTIVE
 BALLOON, FREE
 BELT, ROCKET
 BIOSATELLITE ... rt SATELLITE
 Blimp ... use AIRSHIP
 Boat, Flying ... use AIRPLANE
 Dirigible ... use AIRSHIP
 Drone ... use AIRPLANE
 GLIDER
 HELICOPTER
 KITE
 note use for a heavier-than-air aircraft propelled by a towline
 LIFT, CHAIR
 OBSERVATORY, ORBITING SOLAR ... rt SATELLITE
 ORNITHOPTER
 Sailplane ... use GLIDER
 SATELLITE ... rt BIOSATELLITE; OBSERVATORY, ORBITING SOLAR
 SATELLITE, COMMUNICATIONS
 SATELLITE, DATASPHERE
 SATELLITE, METEOROLOGICAL
 Seaplane ... use AIRPLANE
 SPACECRAFT
 SPACECRAFT, MANNED COMMAND-MODULE
 SPACECRAFT, MANNED LUNAR-MODULE
 SPACECRAFT, MANNED ORBITAL-WORKSHOP
 Spacecraft, Unmanned ... use SPACEPROBE
 SPACEPROBE

AEROSPACE TRANSPORTATION -- ACCESSORY

 AIRFRAME
 ALTIMETER
 COMPASS
 CONE, NOSE
 ENGINE
 ENGINE, RADIAL
 ENGINE, RECIPROCATING
 ENGINE, TURBOJET
 ENGINE, TURBOPROP
 Gear, Flight ... use more specific term elsewhere in lexicon; see also
 CLOTHING
 GYRO-COMPASS
 INDICATOR

- -

 AEROSPACE TRANSPORTATION -- ACCESSORY (cont.)

 Instrument, Flight ... use a term from SURVEYING & NAVIGATIONAL or
 TELECOMMUNICATION T&E
 LIGHT, AIRCRAFT
 LINE
 LINE, CONTROL
 LINE, MAIN MOORING
 LINE, MAST YAW
 MODULE, AIRLOCK
 PARACHUTE
 PARACHUTE, CARGO
 PARACHUTE, DROGUE
 PARACHUTE, PERSONNEL
 PROPELLER
 PROPELLER, ADJUSTABLE-PITCH
 PROPELLER, FIXED-PITCH
 RECORDER, FLIGHT
 SHACKLE, BOMB
 SHIELD, HEAT
 SIMULATOR, AIR-FLIGHT
 SIMULATOR, SPACE-FLIGHT
 SLED, ROCKET
 SOCK, WIND
 TACHOMETER
 WIRE
 WIRE, ANTIDRAG
 WIRE, ANTIFLUTTER
 WIRE, FAIRING
 WIRE, STAGGER

LAND TRANSPORTATION

 LAND TRANSPORTATION -- ANIMAL-POWERED

 AMBULANCE
 APPARATUS, FIRE ... rt WAGON, HOOK & LADDER
 Bandwagon, Circus ... use WAGON, CIRCUS PARADE
 BAROUCHE ... rt BROUGHAM; CALECHE; CARRIAGE; PHAETON
 BOBSLED
 Booby ... use SLEIGH
 Brake ... use BREAK, SKELETON or BREAK, WAGONETTE
 BREAK, SKELETON
 BREAK, WAGONETTE
 BROUGHAM ... rt BAROUCHE; CALECHE; CARRIAGE; PHAETON
 BUCKBOARD

- -

LAND TRANSPORTATION -- ANIMAL-POWERED (cont.)

 BUGGY
 BUGGY, MOUNTAIN
 CAB
 CAB, HANSOM
 CABRIOLET ... rt CHAISE; VICTORIA
 CAISSON
 CALECHE ... rt BAROUCHE; CHAISE
 CARRIAGE ... rt BAROUCHE; BROUGHAM; CALECHE; PHAETON
 CARRIAGE, CANNON
 Carriole ... use SLEIGH
 CART
 Cart, Breaking ... use BREAK, SKELETON
 CART, DOG
 CART, GOVERNESS
 CART, IRISH JAUNTING
 CART, LIFE-SAVING BEACH
 CART, LUMBER
 CART, MAIL
 Cart, Ox ... use OXCART
 CHAISE ... rt CABRIOLET; CALECHE
 CHAISE, POST
 CHARIOT
 COACH
 COACH, BERLIN
 COACH, CONCORD
 COACH, ROAD ... rt STAGECOACH; DRAG, PARK
 Coach, Stage ... use STAGECOACH
 COACH, STATE
 Coach-and-four ... use more specific term, e.g.: BREAK, WAGONETTE;
 COACH, ROAD
 CURRICLE
 CUTTER
 CUTTER, ALBANY
 CUTTER, COUNTRY
 CUTTER, PORTLAND
 Diligence ... use STAGECOACH
 DOGSLED
 DRAG, PARK ... rt COACH, ROAD
 DRAY
 DROSHSKY
 Four-in-hand ... use BREAK, WAGONETTE
 GIG
 Hack ... use CAB or CAB, HANSOM
 HEARSE
 HOWDAH
 LANDAU
 LANDAULET

- -

 LAND TRANSPORTATION -- ANIMAL-POWERED (cont.)

 LITTER ... rt TRAVOIS
 OMNIBUS
 OXCART
 PHAETON ... rt BAROUCHE; BROUGHAM; CALECHE; CARRIAGE
 PLOW, SNOW
 Pod ... use SLEIGH
 PUMPER, HAND
 PUMPER, STEAM
 Pung ... use SLEIGH
 REEL, HOSE ... rt WAGON, HOSE
 ROCKAWAY
 ROLLER, SNOW
 RUNABOUT
 SCHOONER, PRAIRIE ... rt WAGON, CONESTOGA
 Shay ... use CHAISE
 Sled ... use SLEIGH
 SLEDGE
 SLEIGH
 SLEIGH, RUNABOUT
 SLEIGH, SURREY
 SOCIABLE
 STAGECOACH ... rt COACH, ROAD
 STANHOPE
 SULKY
 SURREY
 Tally-ho ... use COACH, ROAD
 TILBURY
 TRAP
 TRAVOIS ... rt LITTER
 Trolley, Trackless ... use OMNIBUS
 VAN, GYPSY
 VICTORIA ... rt CABRIOLET
 VIS-A-VIS
 WAGON
 WAGON, BATTERY
 WAGON, CHEMICAL
 WAGON, CIRCUS PARADE
 WAGON, CONESTOGA ... rt PRAIRIE SCHOONER
 WAGON, DELIVERY
 WAGON, FARM
 WAGON, HOOK & LADDER ... rt APPARATUS, FIRE
 WAGON, HOSE ... rt REEL, HOSE
 WAGON, HOUNDBAND
 WAGON, LOG
 WAGON, MARKET
 WAGON, MORTAR
 WAGON, MOUNTAIN

- -

LAND TRANSPORTATION -- ANIMAL-POWERED (cont.)

 Wagon, Paddy ... use WAGON, POLICE PATROL
 WAGON, PEDDLER'S
 WAGON, POLICE PATROL
 WAGON, THOROUGHBRACE
 WAGON, TRAY
 WHISKY

LAND TRANSPORTATION -- HUMAN-POWERED

 BARROW
 BICYCLE
 BICYCLE, ORDINARY
 BICYCLE, SAFETY
 Bicycle, Side-by-side ... use SOCIABLE
 BICYCLE, TANDEM
 Boneshaker ... use VELOCIPEDE
 CARRIAGE, BABY
 CART, FIREHOSE
 Chair, Sedan ... use SEDAN
 Chair, Spa ... use CHAIR, TOURING
 CHAIR, TOURING
 CRADLE, BASKET
 CRADLE, BOARD
 CRADLE, SLAT
 Dandyhorse ... use DRAISINE
 DOLLY
 DRAISINE
 Farthing, Penny ... use BICYCLE, ORDINARY
 HANDCART
 Highwheeler ... use BICYCLE, ORDINARY
 Hobbyhorse ... use DRAISINE
 LITTER
 Mail, Irish ... use QUADRICYCLE
 Ordinary ... use BICYCLE, ORDINARY
 PALANQUIN
 Perambulator ... use CARRIAGE, BABY
 POLE, SKI
 PUMPER, HAND
 PUMPER, STEAM
 Pushcart ... use BARROW
 QUADRICYCLE
 RICKSHAW
 SEDAN
 SLEDGE
 SNOWSHOE
 SOCIABLE
 STRETCHER

- -

 LAND TRANSPORTATION -- HUMAN-POWERED (cont.)

 STROLLER
 TRICYCLE
 Tricycle, Side-by-side ... use SOCIABLE
 TRICYCLE, TANDEM
 TRICYCLE, TWO-TRACK
 UNICYCLE
 VELOCIPEDE
 WHEELBARROW
 YOKE

 LAND TRANSPORTATION -- MOTORIZED

 AMBULANCE ... rt TRUCK, CRASH
 APPARATUS, FIRE ... rt TRUCK, PUMPER; TRUCK, PUMPER-LADDER
 AUTOMOBILE
 BICYCLE, GASOLINE
 BICYCLE, STEAM
 BUS
 CAMPER
 Car ... use AUTOMOBILE
 CAR, ARMORED
 CAR, GONDOLA
 CAR, RACING
 CARRIER, AMMUNITION
 CARRIER, PERSONNEL
 Crane, Gooseneck ... use PLATFORM, ELEVATING
 DOLLY
 FORKLIFT
 HEARSE
 JEEP
 Motorbike ... use BICYCLE, GASOLINE
 MOTORCYCLE
 Pickup ... use TRUCK, PICKUP
 PLATFORM, ELEVATING
 Platform, Telescoping ... use PLATFORM, ELEVATING
 PLOW, SNOW
 Quadruple ... use more specific term, e.g.: TRUCK, PUMPER/LADDER
 ROADSTER
 SCOOTER, MOTOR
 SEMITRAILER ... rt TRAILER
 SIDECAR, MOTORCYCLE
 Snorkel ... use PLATFORM, ELEVATING
 SNOWMOBILE
 SWEEPER, STREET
 TANK
 TELPHER
 TOWER, WATER

- -

LAND TRANSPORTATION -- MOTORIZED (cont.)

TRACTOR, ARTILLERY
TRACTOR, TRUCK
TRAILER ... rt SEMITRAILER
TRAILER, BOAT
TRAILER, HOUSE
TRICYCLE, GASOLINE
TRICYCLE, STEAM
 Triple ... use more specific term, e.g.: TRUCK, PUMPER/LADDER
TRUCK
TRUCK, AERIAL LADDER
TRUCK, CRASH ... rt AMBULANCE
 Truck, Delivery ... use specific body type: e.g., TRUCK, DUMP; -,PANEL;
 -,TANK
TRUCK, DUMP
TRUCK, FLATBED
TRUCK, HOOK & LADDER
 Truck, Ladder ... use TRUCK, HOOK & LADDER
TRUCK, LIGHTING
TRUCK, LUMBER
TRUCK, MAIL
TRUCK, MILK
TRUCK, ORDNANCE WORKSHOP
TRUCK, PANEL
TRUCK, PICKUP
TRUCK, PUMPER ... rt APPARATUS, FIRE
TRUCK, PUMPER/AERIAL LADDER
TRUCK, PUMPER/LADDER ... rt APPARATUS, FIRE
TRUCK, SMOKE EJECTOR
TRUCK, STAKE
TRUCK, TANK
TRUCK, TOW
TRUCK, TROOP
VAN
VEHICLE, LUNAR
 Velocipede ... use BICYCLE, STEAM

LAND TRANSPORTATION -- ACCESSORY

APRON, CARRIAGE
ARMOR, HORSE
BAG, BICYCLE
BAG, WATER
 Band, Belly ... use BELLYBAND
BELL, BICYCLE
BELL, SLEIGH
BELLYBAND
BIT

- -

LAND TRANSPORTATION -- ACCESSORY (cont.)

 BLANKET, CARRIAGE
 BLANKET, SADDLE
 BLINDER
 BOOT, HORSE ANKLE
 Bow, Horse ... use YOKE, ANIMAL
 BOX, TACK
 BRIDLE
 BRIDLE, SINGLE
 BRIDLE, TEAM
 CAPARISON
 CARRIER, LUGGAGE
 CHAIN, BICYCLE
 CHAIN, TIRE
 CLAMP, C
 CLEVIS
 COLLAR, BREAST
 COLLAR, HORSE
 CROP, RIDING
 CRUPPER
 DOUBLETREE
 GAUGE, TIRE PRESSURE
 GIRTH
 GUN, GREASE
 HALTER
 HAME
 HAME, COVERED
 HAME, PLATED
 HARDWARE, HARNESS
 HARNESS
 HARNESS, BUGGY
 HARNESS, DOG
 HARNESS, DONKEY
 HARNESS, EXPRESS
 HARNESS, FARM
 Harness, Heavy truck ... use HARNESS, EXPRESS
 HARNESS, PONY
 HARNESS, RUNABOUT
 Harness, Team ... use HARNESS, FARM
 HARNESS, TRACK
 HOLDER, WHIP
 HORN
 JACK
 JACK, STAGECOACH
 JACK, WAGON
 KEY, IGNITION
 KIT, BICYCLE TOOL
 KIT, TOOL
 KNEECAP, HORSE

- -

LAND TRANSPORTATION -- ACCESSORY (cont.)

LAMP, BICYCLE
LAMP, CARRIAGE
LARIAT
MOCHILA
ORNAMENT, BRIDLE
 Oxbow ... use YOKE, ANIMAL
PAD, BUCKLE
PAD, COLLAR
PAD, SADDLE
PANNIER
PLATE, LICENSE
PUMP, TIRE
QUIRT ... rt WHIP
REINS, CHECK
REINS, DRIVING
 Robe, Buffalo ... use ROBE, LAP
ROBE, LAP
 Rosette, Bridle ... use ORNAMENT, BRIDLE
RUNNER, GAG
RUNNER, SLEIGH
SADDLE
SADDLE, PACK
SADDLE, RACING
SADDLE, RIDING
SADDLE, STOCK
SADDLEBAG
SEAT, FOLDING
SIDESADDLE
SINGLETREE
SPREADER, TIRE
SPUR
STIRRUP
 Surcingle ... use GIRTH
TARPOT
TAXIMETER
TIGHTENER, CHAIN
TIRE
TREE, SADDLE
TRIPLETREE
TUMPLINE
VASE, AUTOMOBILE
WHEEL
WHIP ... rt QUIRT
WHIP, BUGGY
WHIP, COACH
WHIP, RIDING
WRENCH, LUG
WRENCH, WAGON

- -

LAND TRANSPORTATION -- ACCESSORY (cont.)

YOKE, ANIMAL
YOKE, NECK

RAIL TRANSPORTATION

RAIL TRANSPORTATION -- EQUIPMENT

BOXCAR
CABOOSE
CAR, BAGGAGE
CAR, BUSINESS
 note use for a car created for use by an executive or official
CAR, CABLE
 Car, Chair ... use COACH
 Car, Chair-lounge ... use COACH
CAR, COAL
 Car, Commuter ... use COACH or CAR, SELF-PROPELLED
CAR, DYNAMOMETER SERVICE
 Car, Express ... use CAR, BAGGAGE
CAR, HOPPER
CAR, INSTRUCTIONAL SERVICE
CAR, LOUNGE
CAR, MONORAIL
CAR, PASSENGER
CAR, PIGGYBACK
 Car, Pullman ... use CAR, SLEEPING
CAR, REFRIGERATOR
CAR, SELF-PROPELLED
CAR, SERVICE
CAR, SLEEPING
CAR, SLEEPING/LOUNGE
CAR, SNOWPLOW SERVICE
CAR, STOCK
CAR, SUBWAY
CAR, TANK
CAR, VELOCIPEDE ... rt HANDCAR
COACH
 Engine ... use LOCOMOTIVE
FLATCAR
HANDCAR ... rt CAR, VELOCIPEDE
LOCOMOTIVE
LOCOMOTIVE, DIESEL-ELECTRIC
LOCOMOTIVE, DIESEL-HYDRAULIC
LOCOMOTIVE, ELECTRIC

- -

RAIL TRANSPORTATION -- EQUIPMENT (cont.)

 LOCOMOTIVE, GASOLINE
 LOCOMOTIVE, GASOLINE-ELECTRIC
 LOCOMOTIVE, STEAM
 LOCOMOTIVE, TURBINE
 STREETCAR
 STREETCAR, ELECTRIC
 STREETCAR, HORSE-DRAWN
 TENDER
 TRAIN
 note use only when cataloging a complete unit of locomotive(s) and cars
 TRAIN, FREIGHT
 TRAIN, PASSENGER
 Tram ... use STREETCAR
 Trolley ... use STREETCAR, ELECTRIC
 Van ... use CABOOSE

RAIL TRANSPORTATION -- ACCESSORY

 CAR-COUPLER
 CRANE, MAIL
 CROSSTIE
 HOOK, PULLMAN PORTER'S
 IRON, SWITCH
 SPIKE
 TRACK SECTION

WATER TRANSPORTATION

WATER TRANSPORTATION -- EQUIPMENT

 BARGE
 BARGE, TRAINING
 BATEAU ... rt DORY, BANKS
 Bateau, V-bottomed ... use SKIPJACK
 BATHYSCAPH
 BATTLESHIP
 Boat, Albemarle Sound ... use BOAT, SEINE
 BOAT, BEACH
 BOAT, BULL ... rt CORACLE
 BOAT, BUOY
 BOAT, CANAL
 BOAT, DREDGE
 BOAT, HAMPTON

- -

WATER TRANSPORTATION -- EQUIPMENT (cont.)

 BOAT, INFLATABLE
 BOAT, LOBSTER
 BOAT, PADDLE
 BOAT, PATROL
 BOAT, PILOT
 BOAT, RANGELY
 BOAT, SEINE
 BOAT, STRIKER
 BOAT, TONGING
 BOX, SNEAK
 BUGEYE
 CANOE
 CANOE, DECKED
 CANOE, DUGOUT
 CANOE, OUTRIGGER
 CANOE, SAILING
 CARRIER, AIRCRAFT
 CATAMARAN ... rt SAILBOAT
 CATBOAT, EASTERN
 CHASER, SUBMARINE
 CORACLE ... rt BOAT, BULL
 CORVETTE
 CRAFT, LANDING
 CRUISER, GUIDED MISSILE
 CRUISER, HEAVY
 CRUISER, LIGHT
 CUTTER
 DESTROYER
 DHOW
 DINGHY ... rt TENDER, YACHT; ROWBOAT
 DINGHY, BAHAMA
 DINGHY, SAILING ... rt SAILBOAT
 DORY ... rt ROWBOAT
 DORY, BANKS
 DORY, CHAMBERLAIN
 DORY, SWAMPSCOTT
 Dreadnought ... use BATTLESHIP
 DREDGE
 DRY-DOCK, FLOATING
 DUCKER, DELAWARE ... rt SKIFF, GUNNING
 FELUCCA
 FERRY
 FIREBOAT
 FISHERMAN
 FRIGATE
 GALLEY
 GARVEY
 GONDOLA

- -

WATER TRANSPORTATION -- EQUIPMENT (cont.)

 GUIDEBOAT, ADIRONDACK
 GUNBOAT, PATROL
 HOVERCRAFT
 HYDROFOIL
 HYDROPLANE ... rt RUNABOUT
 ICEBOAT
 ICEBREAKER
 JUNK
 KAYAK ... rt UMIAK
 LAUNCH, GASOLINE ... rt RUNABOUT
 LAUNCH, NAPTHA
 LAUNCH, STEAM
 LIFEBOAT, RESCUE ... rt SURFBOAT; LIFECAR
 LIFEBOAT, SHIP'S
 LIFECAR ... rt LIFEBOAT, RESCUE; SURFBOAT
 LIGHTSHIP
 LONGBOAT
 MAN-OF-WAR
 note use only for a full-rigged ship of the line
 MINELAYER
 MINESWEEPER
 Oomiak ... use UMIAK
 PACKET
 PEAPOD
 PINK
 Pirogue ... use CANOE, DUGOUT
 PONTOON
 PRAM ... rt SAILBOAT
 PRAM, SAILING
 PRIVATEER
 note use for any privately-armed vessel
 PUNT
 RAFT
 ROWBOAT ... rt DORY; SKIFF; DINGHY
 RUNABOUT ... rt HYDROPLANE; LAUNCH, GASOLINE
 SAILBOAT ... rt PRAM; DINGHY, SAILING; CATAMARAN
 SAILBOAT, COMET
 SAILBOAT, PENGUIN
 SAMPAN
 SANDBAGGER, HUDSON RIVER
 SCOW
 Scull ... use SHELL, SINGLE SCULL
 SEED, MELON ... rt SKIFF, GUNNING
 SHARPIE
 SHARPIE, NEW HAVEN
 SHELL
 SHELL, EIGHT-OARED
 SHELL, FOUR-OARED

- -

 WATER TRANSPORTATION -- EQUIPMENT (cont.)

 SHELL, PAIR-OARED
 SHELL, PRACTICE WHERRY
 SHELL, SINGLE SCULL
 SHIP
 note for sailing ships, use only with modifier indicating rigging,
 e.g.: SHIP, CLIPPER
 SHIP, LANDING
 Skeeter ... use ICEBOAT
 SKIFF ... rt ROWBOAT
 SKIFF, CHESAPEAKE BAY
 Skiff, Crab ... use SKIFF, CHESAPEAKE BAY
 SKIFF, FLATIRON
 SKIFF, GUNNING ... rt DUCKER, DELAWARE; SEED, MELON
 Skiff, Oyster ... use SKIFF, CHESAPEAKE BAY
 SKIFF, SEABRIGHT
 SKIFF, ST. LAWRENCE RIVER
 SKIFF, YANKEE
 SKIPJACK
 SLOOP, FRIENDSHIP
 SLOOP, NOANK
 Speedboat ... use RUNABOUT
 SUBMARINE
 SUBMARINE, ATTACK
 SUBMARINE, BALLISTIC MISSILE
 SUBMARINE, COMMERCIAL
 SUBMARINE, RESEARCH ... rt VESSEL, RESEARCH
 SURFBOAT ... rt LIFEBOAT, RESCUE; LIFECAR
 TENDER, BUOY
 TENDER, SUBMARINE
 TENDER, YACHT ... rt DINGHY; ROWBOAT
 TRANSPORT
 Trawler ... use FISHERMAN
 TRIMARAN
 TUG-TOWBOAT
 UMIAK ... rt KAYAK
 VESSEL, CARGO
 VESSEL, EXCURSION
 VESSEL, PASSENGER
 VESSEL, PETROLEUM-SERVICE
 note use for offshore station tender
 VESSEL, REFRIGERATOR
 VESSEL, RESEARCH ... rt SUBMARINE, RESEARCH
 VESSEL, SURVEY
 WHALEBOAT
 WHALER
 WHALER, TANCOOK
 WHERRY, SALMON
 WHITEHALL

- -

WATER TRANSPORTATION -- EQUIPMENT (cont.)

 YACHT
 YAWL-BOAT

WATER TRANSPORTATION -- ACCESSORY

 ANCHOR ... rt KILLICK
 BAILER
 BATHYSPHERE
 BEADS, PARREL
 BEAKHEAD
 BEARING, PUMP AXLE
 BELL, SHIP'S
 BOARD, BUNK
 BOARD, GANGWAY
 BOARD, NAME
 BOARD, QUARTER
 BOARD, TRAIL
 BOLLARD
 BOX, SHIP'S LOG
 BUCKET, DECK
 Bumper ... use FENDER
 BUNG
 BUOY, BREECHES
 BUOY, MOORING
 CABLE
 CAPSTAN ... rt WINDLASS
 CARVING, CATHEAD
 CARVING, PADDLEBOX
 CARVING, STERN
 CARVING, TAFFRAIL
 CASE, CHART
 CASK, HARNESS
 CHAIN, ANCHOR
 CHAIR, BOATSWAIN'S
 CHEST, CHART
 CHEST, MEDICINE
 CHOCK
 CLAMP, BEAM
 CLEAT
 CRADLE, BOAT
 CRUTCH, BOOM
 DAVIT, ANCHOR
 DAVIT, BOAT
 DEADEYE
 EUPHROE
 FAIRLEAD
 FENDER

- -

WATER TRANSPORTATION -- ACCESSORY (cont.)

FIGUREHEAD
FLOAT, LIFE
GAFF
GANGPLANK
GUN, LINE-THROWING
GUN, LYLE
HANDSPIKE
HEAVER
HOLDER, SHIP'S BELL
HOLYSTONE
HOOK, BOAT
HORSE, SHEET
JACKET, LIFE
JIB
KILLICK ... rt ANCHOR
LADDER, JACOB'S
LADDER, SHIP'S
LAMP, BINNACLE
LEAD, SOUNDING
LIGHT, ANCHOR
LIGHT, CHANNEL
LIGHT, MASTHEAD
LIGHT, NAVIGATION
LIGHT, RUNNING
LIGHT, STERN
LOG
MAINSAIL
MARLINESPIKE
MOTOR, OUTBOARD
OAR ... rt SWEEP
OAR, SCULLING ... rt YULOH
OAR, STEERING
OARLOCK
ORNAMENT, MASTHEAD
ORNAMENT, PILOT-HOUSE
ORNAMENT, YACHT
PADDLE
PADDLE, CANOE
PADDLE, DOUBLE-BLADED
PIN, BELAYING
PIN, TRUSS
 Pole ... use QUANT
PROPELLER
PUMP, BILGE
QUANT
RACK, BUCKET
RACK, HOSE
RACK, LIFE RING

- -

WATER TRANSPORTATION -- ACCESSORY (cont.)

 RACK, SIGNAL FLAG
 RAIL, FIFE
 REGISTER, TAFFRAIL LOG
 RING, LIFE
 RODE, ANCHOR ... rt ROPE
 ROPE ... rt SHEET; RODE, ANCHOR
 Rowlock ... use OARLOCK
 RUDDER
 SAIL
 SHEATH, MARLINESPIKE
 SHEET ... rt ROPE
 SPANKER
 SPINNAKER
 SPOOL
 STAND, WHEEL
 STONE, BALLAST
 STOOL, CAULKER'S
 SWEEP ... rt OAR
 TABLE, MESS
 TELEGRAPH, ENGINE ROOM
 TELLTALE
 TILLER
 WEIGHT, HEAVING LINE
 WHEEL, STEERING
 WHISTLE, STEAM
 WINDLASS ... rt CAPSTAN
 WINDLASS, HAND
 YULOH ... rt OAR, SCULLING

- -

CATEGORY 8: COMMUNICATION ARTIFACTS

ADVERTISING MEDIUM
note the first word of the object name should be the type of the
 advertisement; modifiers may be used to indicate the subject or
 theme of the advertisement, e.g.: BANNER, CIRCUS; POSTER, THEATER

 AD, MAGAZINE
 AD, NEWSPAPER
 BALLOON, POLITICAL
 BANNER
 BOARD, SANDWICH
 BOOKLET
 Broadside ... use POSTER or HANDBILL
 BUTTON
 CARD, CIGARETTE
 CARD, POLITICAL
 CARD, SHOW
 CARD, TRADE
 CATALOG
 CATALOG, TRADE
 Circular ... use HANDBILL
 COUPON
 Flier ... use HANDBILL or CATALOG
 HANDBILL ... rt POSTER
 HANDBILL, POLITICAL
 HANDBILL, TRADE
 Leaflet ... use HANDBILL
 MARQUEE
 Model, Product
 note methods of dealing with this vary; consult your institution's rule
 NOVELTY
 PIECE, DISPLAY
 PIN
 Placard ... use POSTER
 POSTER
 POSTER, POLITICAL
 POSTER, THEATER
 PREMIUM
 note may be modified to indicate its original product package
 PREMIUM, CIGARETTE
 SIGN, TRADE
 STICKER
 STICKER, BUMPER

- -

ADVERTISING MEDIUM (cont.)

 SYMBOL, TRADE
 note use for an object which by custom is considered a visual symbol
 of a product or service, e.g.: a barber pole, a cigar store figure
 TOKEN

ART

 ASSEMBLAGE
 Bell, Wind ... use WIND-BELL
 BOUQUET, FLORAL
 BOX, SHADOW
 BRIC-A-BRAC
 BUST
 CARVING
 CASTING
 Chime, Wind ... use WIND-BELL
 COLLAGE
 Cutting, Scissor ... use PICTURE, CUT-PAPER
 DRAWING
 ENGRAVING
 FAIRING
 FIGURINE
 FIGURINE, ANIMAL
 FIGURINE, BIRD
 FIGURINE, GROUP
 FLOWER, ARTIFICIAL
 FRAME, PICTURE
 FRUIT, ARTIFICIAL
 HANGING
 note use for macrame, needlework, weaving and other craft objects not
 otherwise named, e.g.: SAMPLER; TAPESTRY
 HOLDER, SPHERE
 Knick-knack ... use BRIC-A-BRAC
 KNOT, ORNAMENTAL
 Light, Christmas Tree ... use ORNAMENT, CHRISTMAS TREE
 LUSTER
 MOBILE
 MONTAGE
 Okimono ... use FIGURINE
 ORNAMENT, CHRISTMAS TREE
 ORNAMENT, GARDEN
 PAINTING
 PICTURE
 PICTURE, CUT-PAPER
 Picture, Embroidery ... use PICTURE, NEEDLEWORK
 PICTURE, FLORA

- -

ART (cont.)

 PICTURE, FRETWORK
 PICTURE, HAIR
 PICTURE, NEEDLEWORK
 PICTURE, SCRIMSHAW
 Picture, Seed ... use PICTURE, FLORA
 PICTURE, SHELL
 PICTURE, WOVEN
 PRINT
 PRINT, PHOTOGRAPHIC
 SAMPLER
 SCRAP
 SCULPTURE
 SHIP-IN-A-BOTTLE
 SILHOUETTE
 Sketch ... use DRAWING
 SPHERE
 STATUE
 STATUE, GARDEN
 Statuette ... use FIGURINE
 Stevengraph ... use PICTURE, WOVEN
 TAPESTRY
 Valentine, Sailor's ... use PICTURE, SHELL
 WHIMSEY
 WHIRLIGIG
 WIND-BELL
 WREATH
 Wreath, Hair ... use PICTURE, HAIR

CEREMONIAL ARTIFACT

 Almorratxa ... use ASPERGILLUM
 ALTAR
 ALTARPIECE
 AMPULLA
 ASPERGILLUM
 BAG, TRICK OR TREAT
 BALDACHIN
 BANNER
 BASKET
 BASKET, EASTER
 BELL, ALTAR
 BLOCK, GAVEL
 Board, Sounding ... use BLOCK, GAVEL
 Boat, Incense ... use NAVETTE
 BOTTLE, HOLY WATER
 BOUQUET, WEDDING

- -

CEREMONIAL ARTIFACT (cont.)

 BOWL, BAPTISMAL
 BOWL, LIBATION ... rt PHIALE
 BOWL, MARRIAGE
 Box, Offering ... use PLATE, OFFERING
 BULL-ROARER
 BUNDLE, MEDICINE
 BURSE
 CALUMET
 CARD, ALTAR
 CARD, PRAYER
 CASE, MUMMY ... rt COFFIN; SARCOPHAGUS
 Casket ... use COFFIN
 CATAFALQUE
 CENSER ... rt THURIBLE
 CHALICE
 CIBORIUM
 Cloth, Altar ... use FRONTAL
 COFFIN ... rt SARCOPHAGUS; CASE, MUMMY
 CORPORAL
 CRECHE
 Cross ... use PLAQUE, RELIGIOUS
 Crucifix ... use STATUE, RELIGIOUS
 CUP, BAPTISMAL
 CUP, BRIDE'S
 CUP, COMMUNION
 Diptych ... use ALTARPIECE
 DISK, PI
 DOLMEN
 EFFIGY
 FIGURE, RELIGIOUS
 FLABELLUM
 FLAG
 FONT, BAPTISMAL
 FONT, HOLY WATER
 FRONTAL
 FRONTLET
 GONG
 GRAGER
 Gravestone ... use TOMBSTONE
 Headstone ... use TOMBSTONE
 HOLDER, FLAG
 HYMNAL
 JAR, CANOPIC
 Jar, Mortuary ... use URN
 KACHINA
 LAMP, MOSQUE
 LAVABO
 MASK

- -

CEREMONIAL ARTIFACT (cont.)

 Megalith ... use DOLMEN or MENHIR
 MENHIR
 MENORAH
 MEZUZAH
 MISSAL
 MONSTRANCE
 MONUMENT
 NAVETTE
 Obelisk ... use MONUMENT
 Ornament, Package ... use WRAP, GIFT
 PALL
 PATEN
 PENNANT
 PHIALE ... rt BOWL, LIBATION
 Pipe, Peace ... use CALUMET
 PITCHER, COMMUNION
 PLAQUE
 PLAQUE, RELIGIOUS
 PLATE, COFFIN
 Plate, Collection ... use PLATE, OFFERING
 PLATE, OFFERING
 POLE, TOTEM
 PURIFICATOR
 PYX
 RATTLE
 RELIC, RELIGIOUS
 RELIQUARY ... rt SHRINE
 RIBBON, GIFT WRAP
 RUG, PRAYER
 SARCOPHAGUS ... rt COFFIN; CASE, MUMMY
 SET, COMMUNION
 SHAWABTI
 SHOFAR
 SHRINE ... rt RELIQUARY
 SHRINE, RELIGIOUS
 SHROUD
 Sprinkler, Holy water ... use ASPERGILLUM
 STANDARD
 STATIONS OF THE CROSS
 STATUE, RELIGIOUS
 STICK, PRAYER
 STOCKING, CHRISTMAS
 TABERNACLE
 THURIBLE ... rt CENSER
 TIKI
 TOMBSTONE
 TORAH, SEPHER
 TOTEM

- -

CEREMONIAL ARTIFACT (cont.)

 TRAY, CEREMONIAL
 Triptych ... use ALTARPIECE
 URN
 VASE, CEREMONIAL
 VASE, TEMPLE
 VEIL, CHALICE
 VEIL, TABERNACLE
 Vessel, Shari ... use RELIQUARY
 WHEEL, PRAYER
 WRAP, GIFT ... rt PAPER, WRAPPING (MERCHANDISING T&E)
 WREATH

DOCUMENTARY ARTIFACT
note a collection may be named in accordance with an archivist's
 "title" entry, using a collective noun such as PAPERS, RECORDS,
 LETTERS, DIARIES, MANUSCRIPTS, CORRESPONDENCE, etc.; a single
 item should be named using a term from the following list or any
 other acceptable object name; some objects listed under this
 classification would be classified as WRITTEN COMMUNICATION
 EQUIPMENT prior to their use in transmitting written information,
 e.g.: a postcard

 Address ... use SPEECH
 ALBUM
 ALBUM, AUTOGRAPH
 ALBUM, CARD
 ALBUM, PHOTOGRAPH
 ALBUM, POSTCARD
 AMBROTYPE
 ANNOUNCEMENT
 ANNOUNCEMENT, AWARD
 ANNOUNCEMENT, BIRTH
 ANNOUNCEMENT, FUNERAL
 ANNOUNCEMENT, GRADUATION
 ANNOUNCEMENT, MEETING
 ANNOUNCEMENT, WEDDING
 APPLICATION, LICENSE
 APPLICATION, REGISTRATION
 BALLOT
 BANKBOOK
 Bible ... use BOOK
 BILL
 BILL-OF-SALE
 BLUEPRINT
 BOND
 BOOK

- -

DOCUMENTARY ARTIFACT (cont.)

```
    BOOK, ACCOUNT
    BOOK, ADDRESS
    BOOK, COMIC
    BOOK, INSTRUCTION
    BOOKLET
    BOOKLET, INSTRUCTION
    BOOKMARK
    BOOKPLATE
    BOX, DOCUMENT
     Brochure ... use BOOKLET
    CALENDAR
    CAPSULE, TIME
    CARD, ADMITTANCE
    CARD, AUTOGRAPH
    CARD, BASEBALL
    CARD, CALLING
    CARD, COMMEMORATIVE
    CARD, DRAFT
    CARD, FLASH
    CARD, GREETING
    CARD, IDENTIFICATION
    CARD, INSPIRATIONAL
    CARD, MEMBERSHIP
    CARD, MOURNING
     Card, Post ... use POSTCARD
    CARD, REPORT
    CARD, SOUVENIR
     Card, Stereoscope ... use STEREOGRAPH
    CARD, UNION
    CARTE-DE-VISITE
    CARTOON
    CASE, COMMEMORATIVE MEDAL
    CASE, DAGUERREOTYPE
    CATALOG
    CERTIFICATE, ACHIEVEMENT
    CERTIFICATE, ATTENDANCE
     Certificate, Award ... use CERTIFICATE, ACHIEVEMENT
    CERTIFICATE, BAPTISMAL
    CERTIFICATE, BIRTH
    CERTIFICATE, CITIZENSHIP
    CERTIFICATE, COMMEMORATIVE
     Certificate, Commendation ... use CERTIFICATE, ACHIEVEMENT
    CERTIFICATE, CONFIRMATION
    CERTIFICATE, DEATH
    CERTIFICATE, DISCHARGE
    CERTIFICATE, MARRIAGE
    CERTIFICATE, MEMBERSHIP
```

- -

DOCUMENTARY ARTIFACT (cont.)

 Certificate, Merit ... use REWARD OF MERIT
 CERTIFICATE, REGISTRATION
 CERTIFICATE, STOCK
 Certificate, Testimonial ... use CERTIFICATE, ACHIEVEMENT
 CHART, FLOW
 CHART, NAVIGATIONAL
 CHART, SEATING
 CHECK, BANK
 COIN, COMMEMORATIVE
 COMMISSION
 CONTRACT
 DAGUERREOTYPE
 DAYBOOK
 DECAL
 DECLARATION, CUSTOMS
 DEED
 DIARY
 DIORAMA ... rt ROOM, MINIATURE
 DIORAMA, AUTOMATA
 DIPLOMA
 DIRECTORY, TELEPHONE
 DRAWING, ARCHITECTURAL
 Drawing, Engineer's ... use DRAWING, TECHNICAL
 DRAWING, TECHNICAL
 Dust jacket, Book ... use JACKET, BOOK
 ENVELOPE
 Ephemera ... use more specific term, e.g.: PROGRAM; INVITATION; LETTER
 EXERCISE, SCHOOL
 FILM
 Flyer ... use HANDBILL
 FOLIO
 FORM, ORDER
 GLOBE
 HANDBILL
 INVENTORY
 INVITATION
 INVOICE
 JACKET, BOOK
 JOURNAL
 KEY, COMMEMORATIVE
 LABEL
 LAYOUT
 Leaflet ... use HANDBILL
 Lecture ... use SPEECH
 LEDGER
 LETTER-
 LICENSE
 LICENSE, ANIMAL

- -

DOCUMENTARY ARTIFACT (cont.)

 License, Fishing ... use LICENSE, SPORTING
 License, Hunting ... use LICENSE, SPORTING
 LICENSE, OCCUPATIONAL
 LICENSE, SPORTING
 LICENSE, TRANSPORTATION
 note use for a license issued to operators or officers of
 transportation devices
 LOG
 LOG, SHIP'S
 MAGAZINE
 Magazine, Comic ... use BOOK, COMIC
 Magazine Section ... use SUPPLEMENT, NEWSPAPER
 Manual ... use BOOK or BOOKLET
 MANUSCRIPT
 MAP
 MEDAL, COMMEMORATIVE
 Medallion ... use MEDAL, COMMEMORATIVE
 MEMORANDUM
 MENU
 MICROFICHE
 MICROFILM
 MODEL, ARCHITECT'S
 MODEL, TOPOGRAPHIC
 MONOGRAPH
 MORTGAGE
 MUSIC, SHEET
 NAMEPLATE
 NEGATIVE, FILM
 NEGATIVE, GLASS-PLATE
 NEWSLETTER
 NEWSPAPER
 NOTEBOOK
 NOTECARD
 Notice ... use ANNOUNCEMENT
 ORDERS, MILITARY
 Pamphlet ... use BOOKLET
 PARDON
 PASS
 PASSPORT
 PATENT
 PEDIGREE
 PENNANT
 PERMIT
 PETITION
 Photograph ... use more specific term; e.g., PRINT, PHOTOGRAPHIC;
 TINTYPE; DAGUERREOTYPE; CARTE-DE-VISITE; PHOTOGRAPH,
 CABINET
 PHOTOGRAPH, CABINET

- -

DOCUMENTARY ARTIFACT (cont.)

 PLACECARD
 PLATE, COMMEMORATIVE
 Plate, Name ... use NAMEPLATE
 Playbill ... use PROGRAM, THEATER
 POEM
 POSTCARD
 Print, Blueline ... use BLUEPRINT
 PRINT, PHOTOGRAPHIC
 PRINT, SOLAR
 PROGRAM
 PROGRAM, DANCE
 PROGRAM, THEATER
 PROOF, PRINTING
 PROSPECTUS
 RADIOGRAM
 RECEIPT
 RECIPE
 RELEASE, NEWS
 Release, Press ... use RELEASE, NEWS
 REWARD OF MERIT
 RIBBON, COMMEMORATIVE
 ROLL, MUSTER
 ROOM, MINIATURE ... rt DIORAMA
 ROSTER
 SCORECARD
 SCRAPBOOK
 SCRIPT
 Sheet, Order ... use FORM, ORDER
 Slide ... use TRANSPARENCY, LANTERN-SLIDE or TRANSPARENCY, SLIDE
 Slide, Lantern ... use TRANSPARENCY, LANTERN-SLIDE
 SLIPCASE, BOOK
 Snapshot ... use PRINT, PHOTOGRAPHIC
 SPEECH
 STATEMENT, BANK
 STEREOGRAPH
 note use for the pictorial object viewed in a stereoscope
 STEREOVIEW
 note use for the pictorial object viewed in a modern stereoviewer
 STICKER
 STICKER, BUMPER
 SUMMONS
 SUPPLEMENT, NEWSPAPER
 Tag, Dog ... use TAG, IDENTIFICATION
 TAG, GIFT
 TAG, IDENTIFICATION
 TAG, MERCHANDISE
 TELEGRAM
 TIMETABLE

- -

DOCUMENTARY ARTIFACT (cont.)

 TINTYPE
 TOKEN, COMMEMORATIVE
 TRANSCRIPT
 TRANSPARENCY, LANTERN-SLIDE
 TRANSPARENCY, ROLL-FILM
 TRANSPARENCY, SLIDE
 TRUNK, DOCUMENT
 WAY-BILL
 WORKSHEET, ENGINE CALCULATIONS
 YEARBOOK

EXCHANGE MEDIUM

 BAG, MONEY
 BOOK, COUPON
 BOOK, RATION
 CARD, CREDIT
 CARD, STORE
 note a card exchanged for goods at a time of limited available currency
 rt TOKEN, STORE
 CERTIFICATE, GIFT
 COIN
 COUPON
 CURRENCY
 note use for paper money not coins
 Money, Paper ... use CURRENCY
 ORDER, MONEY
 PASS
 Scrip ... use CURRENCY
 STAMP, POSTAGE
 STAMP, RATION
 STAMP, TAX
 STAMP, TRADING
 TICKET
 TOKEN
 TOKEN, RATION
 TOKEN, STORE ... rt CARD, STORE
 TOKEN, TAX
 TOKEN, TRANSPORTATION
 TRAY, MONEY

- -

PERSONAL SYMBOL

 Aiguillette ... use LOOP, SHOULDER
AMULET
APRON
ARMBAND
ARMBAND, MOURNING
ARMBAND, POLITICAL
ARMILLA
 Atef ... use PSCHENT
BADGE ... rt PIN; PATCH
BADGE, POLICE
BANDOLIER
BEADS, ROSARY
BUTTON, CAMPAIGN
 note use for non-political statements
BUTTON, FRATERNAL
BUTTON, MILITARY
BUTTON, POLICE
BUTTON, POLITICAL
CASE, EPAULET
CHEVRON
 Coat of arms ... use more specific term, e.g.: RING, PLAQUE, SHIELD
 Costume, Academic ... use GOWN, ACADEMIC
CROSIER
 Cross ... use PENDANT, RELIGIOUS
CROWN
 Crucifix ... use PENDANT, RELIGIOUS or PLAQUE, RELIGIOUS
CUP, LOVING ... rt TROPHY
DAGGER, PRESENTATION
DECAL
DIADEM
 Emblem ... use more specific term, e.g.: PIN; PATCH; MEDAL
EPAULET
GORGET
GOWN, ACADEMIC
GUN, PRESENTATION
HAT, ECCLESIASTIC
HAT, FRATERNAL
HEAD, TROPHY
HEADDRESS
HOOD, ACADEMIC
KNOT, SHOULDER
KNOT, SWORD
LOOP, SHOULDER
MACE
MEDAL, POLITICAL
 Medallion ... use MEDAL
 Menat ... use AMULET

- -

PERSONAL SYMBOL (cont.)

 Merit badge ... use PATCH, MERIT-BADGE
 MITER
 MORTARBOARD
 MUG, FRATERNAL
 ORB
 PADDLE, FRATERNAL
 PATCH
 PATCH, FRATERNAL
 PATCH, MERIT-BADGE
 PATCH, MILITARY
 PENDANT
 PENDANT,FRATERNAL
 PENDANT, RELIGIOUS
 PIN
 PIN, CAMPAIGN
 note use for non-political statements
 PIN, FRATERNAL
 PIN, INSPIRATIONAL
 PIN, OCCUPATIONAL
 PIN, POLITICAL
 PIN, SORORITAL
 PLAQUE
 PLAQUE, RELIGIOUS
 PLUME
 PSCHENT
 RIBBON, FRATERNAL
 RIBBON, POLITICAL
 RIBBON, PRIZE
 RING
 RING, CLASS
 RING, FRATERNAL
 RING, SIGNET ... rt SEAL
 ROCHET
 Sash ... use BANDOLIER
 Scapular ... use PENDANT, RELIGIOUS
 SCEPTER
 SEAL ... rt RING, SIGNET
 STRAP, SHOULDER
 STUD, FRATERNAL
 Sword, Court ... use SWORD, PRESENTATION
 SWORD, PRESENTATION
 TALISMAN
 TALLITH
 TROPHY ... rt CUP, LOVING
 TROWEL, FRATERNAL
 WIG, BARRISTER'S

- -

CATEGORY 9: RECREATIONAL ARTIFACTS

GAME

 BACKGAMMON
 BAG, MARBLE
 BAGATELLE
 BINGO rt
 LOTTO
 BOARD, CRIBBAGE
 BOARD, GAME
 note use for a board suitable for many games or if specific game cannot
 be identified
 BOX, CARD
 Box, Dealing ... use SHOE
 CAROM
 CHECKERS
 CHECKERBOARD
 CHECKERS, CHINESE
 CHESS
 CHIP, POKER
 COUNTER, GAME
 CRIBBAGE
 CROKINOLE
 CUP, DICE
 CUP, WAGER
 DARTS
 DECK, CARD
 note use for standard playing cards such as bridge or pinochle decks
 DICE
 DIE
 DOMINOES
 GAME
 note use for non-mechanical games not played on boards. Non-proprietary
 game names may be entered individually, e.g.: CRIBBAGE; DOMINOES
 GAME, BOARD
 note use for a titled game played on a board. Non-proprietory names may
 be entered individually, e.g.: CHECKERS; CHESS
 GAME, CARD ... use for such games as Old Maid; Authors; Uno
 GAME, MECHANICAL
 JACKS
 JACKSTRAWS
 LOTTO ... rt BINGO
 MACHINE, SLOT
 MAH-JONGG
 MARBLE
 NABAHON

- -
GAME (cont.)

 NINEPINS
 PACHISI
 PADDLE, CROUPIER'S
 Pick up sticks ... use JACKSTRAWS
 PIECE, GAME
 note use for a piece suitable for multiple games or if specific game is
 unidentified
 RACK, POKER CHIP
 SET, GAME
 note use for a set of games or if specific game is unidentified
 SET, OUIJA
 SHOE
 Spillikins ... use JACKSTRAWS
 Squails ... use TIDDLYWINKS
 TIDDLYWINKS
 TIVOLI
 TRAY, GAMBLING
 WHEEL, ROULETTE
 WHIST

PUBLIC ENTERTAINMENT DEVICE

 BALL, MIRROR
 CURTAIN, STAGE
 DROP, FLAT
 DROP, ROLL
 DROP, SCRIM
 DUMMY, VENTRILOQUIST
 Equipment, Magician's ... use PROPERTIES, MAGICIAN'S
 Flat ... use DROP, FLAT
 MARIONETTE ... rt PUPPET, HAND
 MASK
 PIN, JUGGLING
 POLE, BALANCING
 PROPERTIES
 note use for an object that provides a realistic effect in a production
 PROPERTIES, MAGICIAN'S
 Props ... use PROPERTIES
 PUPPET, HAND ... rt MARIONETTE
 PUPPET, SHADOW
 RIGGING, AERIAL
 SCIOPTICON
 STAGE, PUPPET
 STAND, ANIMAL
 Trapeze ... use RIGGING, AERIAL

- -

PUBLIC ENTERTAINMENT DEVICE (cont.)

 Vizard ... use MASK
 Wire, High ... use RIGGING, AERIAL

RECREATIONAL DEVICE

 ANIMAL, CARROUSEL
 Bars, Monkey ... use LADDER, HORIZONTAL
 BOARD, WALKING
 Buck-a-bout ... use SEESAW, COILED-SPRING
 CARROUSEL
 CLIMBER
 COASTER, ROLLER
 Equipment, Playground ... use more specific term, e.g.: CLIMBER; SEESAW
 GALLERY, SHOOTING
 GATE, SWINGING
 GEE-JOGGLE
 GLIDER
 Gym, Jungle ... use CLIMBER
 LADDER, HORIZONTAL
 LADDER, ROPE
 MACHINE, ARCADE
 note use for any machine not identified by another general term: e.g.,
 MACHINE, PINBALL
 MACHINE, PEEP-SHOW ... rt MUTASCOPE
 MACHINE, PINBALL
 Mate, Saddle ... use RIDER, COILED-SPRING
 Merry-go-round ... use CARROUSEL
 MUTASCOPE ... rt MACHINE, PEEP-SHOW
 NET, CLIMBING
 POLE, SLIDING
 POOL, WADING
 Pull-a-way ... use WHIRL
 RIDE, AMUSEMENT
 RIDER, COILED-SPRING
 SANDBOX
 SEESAW
 SEESAW, COILED-SPRING
 SLIDE
 Springdom, Animal ... use RIDER, COILED-SPRING
 SWING
 SWING, CIRCLE
 TARGET, GALLERY
 Teeter-totter ... use SEESAW
 TRAPEZE
 TUNNEL
 WHEEL, FERRIS

- -

RECREATIONAL DEVICE (cont.)

 WHIRL

SPORTS EQUIPMENT

 ALPENSTOCK
 Aqualung ... use TANK, SCUBA
 AQUAPLANE
 BACKBOARD, BASKETBALL
 BAG
 BAG, GOLF
 BAG, PUNCHING
 BALL, BILLIARD
 BALL, BOWLING
 BALL, CROQUET
 BALL, KICK
 BALL, MEDICINE
 BALL, SOCCER
 BALL, TENNIS
 BANDERILLA
 BAR, HORIZONTAL
 BAR, STALL
 BARBELL
 BARS, PARALLEL
 BASEBALL
 BASKET, JAI ALAI
 BASKETBALL
 BAT, BASEBALL
 BAT, CRICKET
 Battledore ... use RACKET, BADMINTON
 BEAM, BALANCE
 BLOCK, STARTING
 BOBSLED
 BRIDGE, BILLIARD
 BROOM, CURLING
 CABER
 Candlepin ... use PIN, BOWLING
 CART, GOLF
 CLUB, GOLF
 CLUB, INDIAN
 CROP, RIDING
 CUE, BILLIARD
 CUE, SHUFFLEBOARD
 DEVELOPER, WRIST
 DISCUS
 DISK, SHUFFLEBOARD

- -

SPORTS EQUIPMENT (cont.)

 Duckpin ... use PIN, BOWLING
 DUMBBELL
 DUMMY, BLOCKING
 DUMMY, TACKLING
 EPEE ... rt SABER, FENCING
 Equipment, Exercise ... use more specific term, e.g.: DUMBELL; BARBELL;
 MACHINE, ROWING

 ESTOQUE
 FIN, SWIM
 FOIL ... rt SABER, FENCING
 FOOTBALL
 FRISBEE
 GLOVE, BOXING
 GLOVE, FENCING
 GLOVE, FIELDER'S
 GLOVE, GOALIE'S
 GLOVE, GOLF
 GUARD, SHIN
 GUARD, SKATE
 HAMMER
 HANDBALL
 HELMET, FOOTBALL
 HELMET, LACROSSE
 HOOP, BASKETBALL
 HORSE, SIDE
 HORSE, VAULTING
 HORSESHOE
 HURDLE
 JAVELIN
 KNIFE & SHEATH
 LUGE
 MACHINE, ROWING
 MALLET, CROQUET
 MASK, CATCHER'S
 MASK, GOALIE'S
 MITT, CATCHER'S
 MULETA
 Paddle, Ping pong ... use PADDLE, TABLE TENNIS
 PADDLE, TABLE TENNIS
 PADDLE, TENNIS
 PADS, HIP
 PADS, SHOULDER
 Passometer ... use PEDOMETER
 PEDOMETER
 PIN, BOWLING
 PITON
 PLASTRON
 POLE, VAULTIŃG

- -

SPORTS EQUIPMENT (cont.)

 PROTECTOR, BODY
 PUCK, HOCKEY
 QUOITS
 RACK, CUE
 RACKET, BADMINTON
 RACKET, SQUASH
 RACKET, TENNIS
 REGULATOR, SCUBA
 REJON
 RING, DECK TENNIS
 RING, PRIZE
 ROPE, CLIMBING
 ROPE, SWINGING
 SABRE, FENCING ... rt EPEE; FOIL
 SET, CROQUET
 SET, GOLF
 SET, SHUFFLEBOARD
 SET, TABLE CROQUET
 SET, TABLE TENNIS
 SHOTPUT
 SHUTTLECOCK
 SKATE, ICE
 SKATE, ROLLER
 SKATEBOARD
 SKI, SNOW
 SKI, WATER
 SLED
 SNORKEL
 SOFTBALL
 SPEEDBALL
 STICK, HOCKEY
 STICK, LACROSSE
 STICK, POLO
 Stick, Skiddle ... use PIN, BOWLING
 STONE, CURLING
 SURFBOARD
 TABLE, BILLIARD
 TABLE, POOL
 TABLE, TABLE TENNIS
 TABS, FINGER
 Tank, Diver's ... use TANK, SCUBA
 TANK, SCUBA
 Tenpin ... use PIN, BOWLING
 TETHERBALL
 TOBOGGAN
 TRAMPOLINE
 VOLLEYBALL
 WICKET, CROQUET

- -

SPORTS EQUIPMENT (cont.)

 WINGS, WATER

TOY

 ANIMAL
 ANIMAL, MECHANICAL
 ANIMAL, STUFFED
 ARK, NOAH'S
 Automaton ... use a more specific term; e.g., DOLL, MECHANICAL; ANIMAL,
 MECHANICAL
 BALL
 BANK, MECHANICAL
 BANK, SEMI-MECHANICAL
 BANK, STILL
 BEAD, SLIDING
 BEAD, STRINGING
 BEANBAG
 Bilboquet ... use CUP & BALL
 BLOCK
 BLOCK, ALPHABET
 BLOCK, PARQUETRY
 BLOCK, PICTURE
 BLOCK, TELESCOPIC
 BOOK
 Box, Surprise ... use JACK-IN-THE-BOX
 CAR, PEDAL
 CARD, SEWING
 CARRIAGE, DOLL
 Cart, Doll ... use CARRIAGE, DOLL
 CHEST, DOLL
 CIRCUS
 CLOTHES, DOLL
 Cracker ... use NOISEMAKER
 CRADLE, DOLL
 CUP & BALL
 DIABOLO ... rt TOP
 DOLL ... rt MARIONETTE; PUPPET, HAND
 DOLL, MECHANICAL
 DOLL, PAPER
 DOLLHOUSE
 Eidoscope ... use KALEIDOSCOPE
 ENGINE, MODEL
 EXPLODER, CAP
 FIGURE
 FIGURE, MECHANICAL
 FLIPPER-FLOPPER

- -

TOY (cont.)

 GARDEN, FLOWER
 GARDEN, VEGETABLE
 GUN, DART
 HEAD, DOLL
 HOBBYHORSE
 HOOP
 Hoop, Hula ... use HOOP
 HORSE, ROCKING
 Horse, Stick ... use HOBBYHORSE
 House, Doll ... use DOLLHOUSE
 JACK, JUMPING
 JACK-IN-THE-BOX
 KALEIDOSCOPE
 KIDDIE-CAR
 KIT, MODEL
 KITE
 Ladder, Jacob's ... use FLIPPER-FLOPPER
 LANTERN, MAGIC
 MAIL, IRISH
 MARIONETTE ... rt DOLL; PUPPET, HAND
 MAROTTE
 MOTOR, ELECTRIC
 MYRIOPTICON
 Myrioscope ... use KALEIDOSCOPE
 NOISEMAKER
 PACIFIER
 PANORAMA
 PAPER, CONSTRUCTION
 PAPER, ORIGAMI
 PEEP-SHOW
 PEG-BOARD
 Perambulator, Doll ... use CARRIAGE, DOLL
 Phantoscope ... use KALEIDOSCOPE
 PINWHEEL
 PIPE, BUBBLE
 PIPE, WHISTLE
 PISTOL, CAP
 PISTOL, FIRE CRACKER
 PISTOL, WATER
 Polygonoscope ... use KALEIDOSCOPE
 POPGUN
 Pram, Doll ... use CARRIAGE, DOLL
 PRAXINOSCOPE
 Projector, Lantern-slide ... use LANTERN, MAGIC
 PUPPET, HAND ... rt DOLL; MARIONETTE
 PUZZLE
 Puzzle, Chinese ... use BLOCK, PARQUETRY
 RATTLE

- -

TOY (cont.)

 RATTLE, BABY
 RATTLE, COMBINATION
 ROLLY-DOLL
 ROMPER
 ROPE, JUMP
 Rope, Skipping ... use ROPE, JUMP
 SCOOTER
 SERPENT, HIDDEN
 SET, CONSTRUCTION
 Set, Erector ... use SET, CONSTRUCTION
 SLINKY
 Soldier ... use FIGURE
 SQUEAKER
 STAND, DOLL
 STICK, POGO
 STILT
 STROBOSCOPE
 Stroller, Doll ... use CARRIAGE, DOLL
 THAUMATROPE
 TOP ... rt DIABOLO
 TOP, BOWSTRING
 TOP, GYROSCOPE
 TOP, MAGNETIC
 TOP, PEG
 TOP, WHIP
 TOY, BELL
 Toy, Optic ... use more specific term, e.g.: KALEIDOSCOPE; THAUMATROPE;
 ZOETROPE
 Toy, Paper ... use more specific term
 Toy, Penny ... use more specific term
 TOY, POUNDING
 TOY, PULL
 Toy, Push ... use TOY, TRUNDLE
 Toy, Rocking ... use TUMBLER
 TOY, SAND
 TOY, SCISSOR
 Toy, Spring ... use more specific term
 Toy, Stuffed ... use more specific term
 TOY, TRUNDLE
 Toy, Tumbling ... use TUMBLER
 TOY, WASHING
 Toys, Tinker ... use SET, CONSTRUCTION
 TRAIN
 note use for a complete set. See also RAIL TRANSPORTATION
 TRANSPARENCY, MAGIC LANTERN
 TRICYCLE
 TUMBLER
 VILLAGE

- -

TOY (cont.)

 WAGON
 Wheel of life ... use ZOETROPE
 WHIRLIGIG
 YO-YO
 ZOETROPE
 ZOO

- -

CATEGORY 10: UNCLASSIFIABLE ARTIFACTS

ARTIFACT REMNANT

 BASKET FRAGMENT
 BONE, WORKED
 CLOTH FRAGMENT ... rt LACE FRAGMENT
 GLASS FRAGMENT
 LACE FRAGMENT
 LEATHER FRAGMENT
 METAL FRAGMENT
 QUID
 SHERD
 STONE, WORKED
 TRIM
 WHEEL
 WOOD, WORKED

FUNCTION UNKNOWN

MULTIPLE USE ARTIFACTS

 AUGER, POST-HOLE ... rt DIGGER, POST-HOLE
 BAND, RUBBER
 Bar, Pry ... use CROWBAR
 Bar, Wrecking ... use CROWBAR
 BOX, TOOL
 BRACE
 BRUSH
 CHAIN
 CHEST, TOOL
 CHOCK
 CLAMP
 CLEVIS
 CROWBAR
 DIGGER, POST-HOLE ... rt AUGER, POST-HOLE
 DISPENSER, TAPE
 DRILL
 FUNNEL
 Glasspaper ... use SANDPAPER
 GRAPPLE
 GRIPPER

- -

MULTIPLE USE ARTIFACTS (cont.)

 GUN, CALKING
 HAMMER
 HAMMERSTONE
 HOOK
 JACK, FENCE
 KIT, TOOL
 KNIFE, UTILITY
 Knife, X-acto ... use KNIFE, UTILITY
 PICK
 PINCHBAR
 PLIERS
 PLIERS, COMBINATION
 PUMP, BARREL
 PUNCH
 RACK, TOOL
 REEL
 ROPE
 SANDPAPER
 SAW
 SCISSORS
 SCOOP
 SCREWDRIVER
 SHOVEL
 SPIGOT
 STAPLER
 STRAP
 STRING
 SYRINGE
 TACK
 TARPAULIN
 TOOL, COMBINATION
 TRIPOD
 TWEEZERS
 TWINE
 VISE
 WASHER
 WHEEL
 WORKBENCH

- -

ABA. CLOTHING -- OUTERWEAR. 28
 rt TOGA; CAFTAN
ABACUS DATA PROCESSING T&E. 168
ABSORPTIONMETER. OPTICAL T&E. 159
ACCELERATOR. NUCLEAR PHYSICS T&E. 158
 rt BETATRON; PROTONSYNCHROTRON
ACCELERATOR, LINEAR. NUCLEAR PHYSICS T&E. 158
ACCELEROMETER. MECHANICAL T&E 147
ACCORDION. MUSICAL T&E. 172
ACETOMETER CHEMICAL T&E 137
ACIDIMETER FOOD PROCESSING T&E. 57
 Acoumeter ACOUSTICAL T&E
 use AUDIOMETER
 Acousimeter ACOUSTICAL T&E
 use AUDIOMETER
ACTINOGRAPH. CHEMICAL T&E 137
ACTINOMETER. CHEMICAL T&E 137
ACTUATOR ELECTRICAL & MAGNETIC T&E. 141
ACUTOMETER MEDICAL & PSYCHOLOGICAL T&E. . . . 148
AD, MAGAZINE ADVERTISING MEDIUM 204
AD, NEWSPAPER. ADVERTISING MEDIUM 204
ADAPTER, BARREL. ARMAMENT -- ACCESSORY. 130
ADAPTER, ENEMA ANIMAL HUSBANDRY T&E 51
ADAPTER, GRIP. ARMAMENT -- ACCESSORY. 130
 Address DOCUMENTARY ARTIFACT
 use SPEECH
 Adjuster, Hoof. ANIMAL HUSBANDRY T&E
 use LEVELER, HOOF
ADZ. WOODWORKING T&E. 111
ADZ, BUNGING WOODWORKING T&E. 111
ADZ, CARPENTER'S WOODWORKING T&E. 111
ADZ, CLEAVING. WOODWORKING T&E. 111
ADZ, COOPER'S. WOODWORKING T&E. 111
 Adz, Dubbing. WOODWORKING T&E
 use ADZ, LIPPED
ADZ, GUTTERING WOODWORKING T&E. 111
 rt PLANE, GUTTERING
 Adz, Hammer WOODWORKING T&E
 use ADZ, RAILROAD
ADZ, HOLLOWING WOODWORKING T&E. 111
ADZ, ICE MINING & MINERAL HARVESTING T&E. . 97
ADZ, LIPPED. WOODWORKING T&E. 111
ADZ, MARKING FORESTRY T&E 77
 Adz, Platelayer's WOODWORKING T&E
 use ADZ, RAILROAD
ADZ, RAILROAD. WOODWORKING T&E. 111
ADZ, SHIPWRIGHT'S. WOODWORKING T&E. 111
 Adz, Spout. WOODWORKING T&E
 use ADZ, GUTTERING
ADZ, TRUSSING. WOODWORKING T&E. 111
 rt HAMMER, COOPER'S

- -

```
ADZ, WHEELWRIGHT'S . . . . . . . . . . WOODWORKING T&E. . . . . . . . . 111
AERATOR, MILK. . . . . . . . . . . . . FOOD PROCESSING T&E. . . . . . .  57
AEROMETER. . . . . . . . . . . . . . . METEOROLOGICAL T&E . . . . . . . 157
AEROSCOPE. . . . . . . . . . . . . . . BIOLOGICAL T&E . . . . . . . . . 136
  Aesthesiometer. . . . . . . . . . . . BIOLOGICAL T&E
    use  ESTHESIOMETER
AETHRIOSCOPE . . . . . . . . . . . . . ASTRONOMICAL T&E . . . . . . . . 135
  Afghan. . . . . . . . . . . . . . . . HOUSEHOLD ACCESSORY
    use  THROW
  Afghan. . . . . . . . . . . . . . . . BEDDING
    use  BLANKET
A-FRAME. . . . . . . . . . . . . . . . BUILDING . . . . . . . . . . . . .  1
AGAL . . . . . . . . . . . . . . . . . CLOTHING -- ACCESSORY. . . . . .  33
AGITATOR, FLOUR-BLEACHING. . . . . . . FOOD PROCESSING T&E. . . . . . .  58
AGITATOR, LAUNDRY. . . . . . . . . . . MAINTENANCE T&E. . . . . . . . . 145
AID, HEARING . . . . . . . . . . . . . PERSONAL GEAR. . . . . . . . . .  35
AID, PILL. . . . . . . . . . . . . . . ANIMAL HUSBANDRY T&E . . . . . .  51
    rt  FORCEPS, PILL
  Aiguillette . . . . . . . . . . . . . PERSONAL SYMBOL
    use  LOOP, SHOULDER
AIRBRUSH . . . . . . . . . . . . . . . PAINTING T&E . . . . . . . . . . 102
  Aircraft. . . . . . . . . . . . . . . AEROSPACE -- EQUIPMENT
    use  more specific term, e.g.: AIRPLANE; AIRSHIP; BALLOON
AIRFRAME . . . . . . . . . . . . . . . AEROSPACE -- ACCESSORY . . . . . 187
AIRPLANE . . . . . . . . . . . . . . . AEROSPACE -- EQUIPMENT . . . . . 186
AIRPORT. . . . . . . . . . . . . . . . BUILDING . . . . . . . . . . . . .  1
    note use for the complex of landing field and associated buildings
AIRSHIP. . . . . . . . . . . . . . . . AEROSPACE -- EQUIPMENT . . . . . 186
AIRSHIP, BLIMP . . . . . . . . . . . . AEROSPACE -- EQUIPMENT . . . . . 186
AIRSHIP, NONRIGID. . . . . . . . . . . AEROSPACE -- EQUIPMENT . . . . . 186
AIRSHIP, PRESSURE-RIGID. . . . . . . . AEROSPACE -- EQUIPMENT . . . . . 186
AIRSHIP, RIGID . . . . . . . . . . . . AEROSPACE -- EQUIPMENT . . . . . 186
AIRSHIP, SEMIRIGID . . . . . . . . . . AEROSPACE -- EQUIPMENT . . . . . 186
ALARM, BURGLAR . . . . . . . . . . . . REGULATIVE & PROTECTIVE T&E. . . 160
ALARM, FIRE. . . . . . . . . . . . . . REGULATIVE & PROTECTIVE T&E. . . 160
ALARM, SMOKE . . . . . . . . . . . . . REGULATIVE & PROTECTIVE T&E. . . 160
ALB. . . . . . . . . . . . . . . . . . CLOTHING -- OUTERWEAR. . . . . .  28
ALBUM. . . . . . . . . . . . . . . . . DOCUMENTARY ARTIFACT . . . . . . 209
ALBUM, AUTOGRAPH . . . . . . . . . . . DOCUMENTARY ARTIFACT . . . . . . 209
ALBUM, CARD. . . . . . . . . . . . . . DOCUMENTARY ARTIFACT . . . . . . 209
ALBUM, PHOTOGRAPH. . . . . . . . . . . DOCUMENTARY ARTIFACT . . . . . . 209
ALBUM, POSTCARD. . . . . . . . . . . . DOCUMENTARY ARTIFACT . . . . . . 209
ALBUM, RECORD. . . . . . . . . . . . . SOUND COMMUNICATION T&E. . . . . 180
ALBUMINOMETER. . . . . . . . . . . . . MEDICAL & PSYCHOLOGICAL T&E. . . 148
ALCOHOLOMETER. . . . . . . . . . . . . CHEMICAL T&E . . . . . . . . . . 137
  Alembic . . . . . . . . . . . . . . . CHEMICAL T&E
    use  APPARATUS, DISTILLING
ALEUROMETER. . . . . . . . . . . . . . FOOD PROCESSING T&E. . . . . . .  58
ALIDADE. . . . . . . . . . . . . . . . SURVEYING & NAVIGATIONAL T&E . . 161
ALKALIMETER. . . . . . . . . . . . . . CHEMICAL T&E . . . . . . . . . . 137
```

- -

```
Almorratxa. . . . . . . . . . . . . . . CEREMONIAL ARTIFACT
  use ASPERGILLUM
ALPENHORN. . . . . . . . . . . . . . . ANIMAL HUSBANDRY T&E . . . . . . .    51
ALPENSTOCK . . . . . . . . . . . . . . SPORTS EQUIPMENT . . . . . . . . .   220
ALTAR. . . . . . . . . . . . . . . . . CEREMONIAL ARTIFACT. . . . . . .     206
ALTARPIECE . . . . . . . . . . . . . . CEREMONIAL ARTIFACT. . . . . . .     206
ALTIMETER. . . . . . . . . . . . . . . AEROSPACE -- ACCESSORY . . . . .     187
ALTIMETER. . . . . . . . . . . . . . . SURVEYING & NAVIGATIONAL T&E . . .   161
  Altiscope . . . . . . . . . . . . . . OPTICAL T&E
  use PERISCOPE
AMALGAMATOR. . . . . . . . . . . . . . MEDICAL & PSYCHOLOGICAL T&E. . . .   148
AMBLYOSCOPE. . . . . . . . . . . . . . MEDICAL & PSYCHOLOGICAL T&E. . . .   148
AMBROTYPE. . . . . . . . . . . . . . . DOCUMENTARY ARTIFACT . . . . . . .   209
AMBULANCE. . . . . . . . . . . . . . . LTE -- ANIMAL-POWERED. . . . . .     188
AMBULANCE. . . . . . . . . . . . . . . LTE -- MOTORIZED . . . . . . . . .   192
  rt  TRUCK, CRASH
  Ambulator . . . . . . . . . . . . . . SURVEYING & NAVIGATIONAL T&E
  use WHEEL, SURVEYOR'S
  Amice . . . . . . . . . . . . . . . . CLOTHING -- HEADWEAR
  use HOOD
AMIGO. . . . . . . . . . . . . . . . . MINING & MINERAL HARVESTING T&E. .    97
AMMETER. . . . . . . . . . . . . . . . ELECTRICAL & MAGNETIC T&E. . . . .   141
AMMONIAMETER . . . . . . . . . . . . . CHEMICAL T&E . . . . . . . . . . .   137
  Amphibian . . . . . . . . . . . . . . AEROSPACE -- EQUIPMENT
  use AIRPLANE
AMPHITHEATER . . . . . . . . . . . . . OTHER STRUCTURE. . . . . . . . . .     7
AMPLIFIER. . . . . . . . . . . . . . . TELECOMMUNICATION T&E. . . . . . .   181
AMPLIFIER. . . . . . . . . . . . . . . ELECTRICAL & MAGNETIC T&E. . . . .   141
AMPLIFIER, AUDIO . . . . . . . . . . . ACOUSTICAL T&E . . . . . . . . . .   123
  rt  FUNNEL-HORN; RESONATOR
AMPLIFIER, AUDIO . . . . . . . . . . . SOUND COMMUNICATION T&E. . . . . .   180
AMPLIFIER, CARRIER . . . . . . . . . . ELECTRICAL & MAGNETIC T&E. . . . .   141
AMPLIFIER, DC. . . . . . . . . . . . . ELECTRICAL & MAGNETIC T&E. . . . .   141
AMPLIFIER, RADIO-FREQUENCY . . . . . . ELECTRICAL & MAGNETIC T&E. . . . .   142
AMPUL. . . . . . . . . . . . . . . . . MEDICAL & PSYCHOLOGICAL T&E. . . .   148
AMPULLA. . . . . . . . . . . . . . . . CEREMONIAL ARTIFACT. . . . . . .     206
AMULET . . . . . . . . . . . . . . . . PERSONAL SYMBOL. . . . . . . . . .   215
ANAGLYPH . . . . . . . . . . . . . . . MEDICAL & PSYCHOLOGICAL T&E. . . .   148
ANALYZER . . . . . . . . . . . . . . . DATA PROCESSING T&E. . . . . . . .   168
ANALYZER, DIFFERENTIAL . . . . . . . . DATA PROCESSING T&E. . . . . . . .   168
ANALYZER, HARMONIC . . . . . . . . . . DATA PROCESSING T&E. . . . . . . .   168
ANALYZER, NETWORK. . . . . . . . . . . DATA PROCESSING T&E. . . . . . . .   168
ANALYZER, SOUND. . . . . . . . . . . . ACOUSTICAL T&E . . . . . . . . . .   123
ANALYZER/SYNTHESIZER, CLANG. . . . . . ACOUSTICAL T&E . . . . . . . . . .   123
  Anastigmat. . . . . . . . . . . . . . OPTICAL T&E
  use LENS, ANASTIGMATIC
ANCHOR . . . . . . . . . . . . . . . . WATER TRANSPORTATION -- ACCESSORY.  201
  rt  KILLICK
ANCHOR, NET. . . . . . . . . . . . . . FISHING & TRAPPING T&E . . . . . .    56
ANDIRON. . . . . . . . . . . . . . . . TEMPERATURE CONTROL DEVICE . . . .    22
```

- -

- -

```
APPARATUS, CATALYTIC . . . . . . . . . CHEMICAL T&E . . . . . . . . . . .  137
APPARATUS, CEMENT VICAT. . . . . . . . CHEMICAL T&E . . . . . . . . . . .  137
APPARATUS, COUNTING. . . . . . . . . . BIOLOGICAL T&E . . . . . . . . . .  136
APPARATUS, CULTURE . . . . . . . . . . BIOLOGICAL T&E . . . . . . . . . .  136
APPARATUS, DIFFERENCE TONE . . . . . . ACOUSTICAL T&E . . . . . . . . . .  123
APPARATUS, DISTILLING. . . . . . . . . CHEMICAL T&E . . . . . . . . . . .  137
     rt   FLASK, DISTILLING; RECEIVER; RETORT
APPARATUS, FIRE. . . . . . . . . . . . LTE -- ANIMAL-POWERED. . . . . . .  188
     rt   WAGON, HOOK & LADDER
APPARATUS, FIRE. . . . . . . . . . . . LTE -- MOTORIZED . . . . . . . . .  192
     rt   TRUCK, PUMPER; TRUCK, PUMPER-LADDER
APPARATUS, FLOAT-TEST. . . . . . . . . CHEMICAL T&E . . . . . . . . . . .  137
APPARATUS, HOT EXTRACTION. . . . . . . CHEMICAL T&E . . . . . . . . . . .  137
APPARATUS, KAHN-TEST . . . . . . . . . BIOLOGICAL T&E . . . . . . . . . .  136
APPARATUS, METABOLISM. . . . . . . . . MEDICAL & PSYCHOLOGICAL T&E. . . .  148
APPARATUS, MULTIPLE-IMAGE. . . . . . . MEDICAL & PSYCHOLOGICAL T&E. . . .  148
APPARATUS, SHAKING . . . . . . . . . . BIOLOGICAL T&E . . . . . . . . . .  136
APPARATUS, STAINING. . . . . . . . . . BIOLOGICAL T&E . . . . . . . . . .  136
APPARATUS, UREA. . . . . . . . . . . . MEDICAL & PSYCHOLOGICAL T&E. . . .  148
APPARATUS, VAN SLYKE . . . . . . . . . BIOLOGICAL T&E . . . . . . . . . .  136
APPLIANCE, ORTHODONTIC . . . . . . . . MEDICAL & PSYCHOLOGICAL T&E. . . .  148
APPLICATION, LICENSE . . . . . . . . . DOCUMENTARY ARTIFACT . . . . . . .  209
APPLICATION, REGISTRATION. . . . . . . DOCUMENTARY ARTIFACT . . . . . . .  209
APPLICATOR, SHOE-POLISH. . . . . . . . CLOTHING -- ACCESSORY. . . . . . .   33
APRON. . . . . . . . . . . . . . . . . CLOTHING -- OUTERWEAR. . . . . . .   28
APRON. . . . . . . . . . . . . . . . . PERSONAL SYMBOL. . . . . . . . . .  215
APRON, BLACKSMITH'S. . . . . . . . . . CLOTHING -- OUTERWEAR. . . . . . .   28
APRON, CARRIAGE. . . . . . . . . . . . LTE -- ACCESSORY . . . . . . . . .  193
APRON, ELASTRATOR. . . . . . . . . . . CLOTHING -- OUTERWEAR. . . . . . .   28
   Aqualung. . . . . . . . . . . . . . SPORTS EQUIPMENT
   use  TANK, SCUBA
AQUAMETER. . . . . . . . . . . . . . . CHEMICAL T&E . . . . . . . . . . .  138
AQUAPLANE. . . . . . . . . . . . . . . SPORTS EQUIPMENT . . . . . . . . .  220
AQUARIUM . . . . . . . . . . . . . . . BUILDING . . . . . . . . . . . . .    1
AQUARIUM . . . . . . . . . . . . . . . HOUSEHOLD ACCESSORY. . . . . . . .   15
AQUEDUCT . . . . . . . . . . . . . . . OTHER STRUCTURE. . . . . . . . . .    7
ARCADE . . . . . . . . . . . . . . . . BUILDING . . . . . . . . . . . . .    1
ARCH . . . . . . . . . . . . . . . . . OTHER STRUCTURE. . . . . . . . . .    7
ARCHWAY. . . . . . . . . . . . . . . . BUILDING . . . . . . . . . . . . .    1
ARCOGRAPH. . . . . . . . . . . . . . . DRAFTING T&E . . . . . . . . . . .  170
ARGENTOMETER . . . . . . . . . . . . . CHEMICAL T&E . . . . . . . . . . .  138
ARK, NOAH'S. . . . . . . . . . . . . . TOY. . . . . . . . . . . . . . . .  223
ARMATURE . . . . . . . . . . . . . . . GLASS, PLASTICS, CLAYWORKING T&E .   78
ARMBAND. . . . . . . . . . . . . . . . PERSONAL SYMBOL. . . . . . . . . .  215
ARMBAND, MOURNING. . . . . . . . . . . PERSONAL SYMBOL. . . . . . . . . .  215
ARMBAND, POLITICAL . . . . . . . . . . PERSONAL SYMBOL. . . . . . . . . .  215
   Armchair. . . . . . . . . . . . . . FURNITURE
   use  more specific term, e.g.: CHAIR, EASY; -,DINING
ARMILLA. . . . . . . . . . . . . . . . PERSONAL SYMBOL. . . . . . . . . .  215
ARMLET . . . . . . . . . . . . . . . . ADORNMENT. . . . . . . . . . . . .   24
```

- -

Armoire FURNITURE
 use WARDROBE
ARMOR. ARMAMENT -- BODY ARMOR 129
 note use only for entire suit of armor
ARMOR, HORSE LTE -- ACCESSORY 193
ARMOR, PARLOR. HOUSEHOLD ACCESSORY. 15
ARMORY BUILDING 1
 Arquebus. ARMAMENT -- FIREARM
 use HARQUEBUS
ARRASTRA METALWORKING T&E 88
ARROW. ARMAMENT -- EDGED. 126
ARROWHEAD. ARMAMENT -- EDGED. 126
 rt POINT, PROJECTILE
ARTICULATOR, DENTAL. MEDICAL & PSYCHOLOGICAL T&E. . . . 148
ARTILLERY, BREECH-LOADING. ARMAMENT -- ARTILLERY. 127
 note use more specific term if known
ARTILLERY, MUZZLE-LOADING. ARMAMENT -- ARTILLERY. 127
 rt CARRONADE; FALCONET
ASCOT. CLOTHING -- ACCESSORY. 33
ASHPAN MAINTENANCE T&E. 145
ASHTRAY. HOUSEHOLD ACCESSORY. 15
ASPERGILLUM. CEREMONIAL ARTIFACT. 206
ASPIRATOR. MEDICAL & PSYCHOLOGICAL T&E. . . . 148
ASSEMBLAGE ART. 205
ASSEMBLY, LATCH. BUILDING COMPONENT 4
ASTRODICTICUM. ASTRONOMICAL T&E 135
ASTROLABE. ASTRONOMICAL T&E 135
ASTROLABE, MARINER'S SURVEYING & NAVIGATIONAL T&E . . . 161
 Astrolage ASTRONOMICAL T&E
 use ASTROLABE
ASTROMETEOROSCOPE. MEDICAL & PSYCHOLOGICAL T&E. . . . 148
ASTROMETER ASTRONOMICAL T&E 135
ASTROPATROTOMETER. ASTRONOMICAL T&E 135
ASTROSCOPE ASTRONOMICAL T&E 135
 Atef. PERSONAL SYMBOL
 use PSCHENT
ATMOLYSER. CHEMICAL T&E 138
ATOMIZER TOILET ARTICLE 38
ATOMIZER MEDICAL & PSYCHOLOGICAL T&E. . . . 148
 Atom smasher. NUCLEAR PHYSICS T&E
 use ACCELERATOR
ATTACHMENT, FLASH. PHOTOGRAPHIC T&E 176
ATTACHMENT, LENS PHOTOGRAPHIC T&E 176
AUDIOMETER ACOUSTICAL T&E 123
AUDIO-OSCILLATOR ACOUSTICAL T&E 123
AUDIPHONE. MEDICAL & PSYCHOLOGICAL T&E. . . . 149
 Auger MINING & MINERAL HARVESTING T&E
 use DRILL, ROTARY
AUGER. WOODWORKING T&E. 111
 Auger, Burn WOODWORKING T&E
 use IRON, WHEELWRIGHT'S BURNING

- -

Auger, Center-bit WOODWORKING T&E
 use AUGER, SPIRAL
Auger, Cooper's bong-borer. WOODWORKING T&E
 use AUGER, TAPER
Auger, Expanding. WOODWORKING T&E
 use AUGER, SPIRAL
AUGER, FRUIT FOOD PROCESSING T&E. 58
AUGER, FUZE. ARMAMENT -- ACCESSORY. 130
AUGER, HOLLOW. WOODWORKING T&E. 111
Auger, Hollow Bit WOODWORKING T&E
 use AUGER, HOLLOW
Auger, Nose WOODWORKING T&E
 use AUGER, SHELL
Auger, Pipe WOODWORKING T&E
 use AUGER, TAPER or AUGER, SHELL or AUGER, SNAIL
Auger, Pod. WOODWORKING T&E
 use AUGER, SHELL or AUGER, SNAIL
AUGER, POST-HOLE MULTIPLE USE ARTIFACT. 227
 rt DIGGER, POST-HOLE
Auger, Pump WOODWORKING T&E
 use AUGER, TAPER or AUGER, SHELL or AUGER, SNAIL
AUGER, RAFT. FORESTRY T&E 77
Auger, Screw. WOODWORKING T&E
 use AUGER, SPIRAL
AUGER, SHELL WOODWORKING T&E. 111
AUGER, SNAIL WOODWORKING T&E. 111
AUGER, SPIRAL. WOODWORKING T&E. 111
AUGER, SUGAR FOOD PROCESSING T&E. 58
Auger, Tap. WOODWORKING T&E
 use AUGER, TAPER
AUGER, TAPER WOODWORKING T&E. 112
Auger, Twist. WOODWORKING T&E
 use AUGER, SPIRAL
AURISCOPE. MEDICAL & PSYCHOLOGICAL T&E. . . . 149
AUTOCLAVE. MEDICAL & PSYCHOLOGICAL T&E. . . . 149
AUTOCLAVE, CANNING FOOD PROCESSING T&E. 58
AUTOGYRO AEROSPACE -- EQUIPMENT 187
AUTOHARP MUSICAL T&E. 172
AUTOMATON. DATA PROCESSING T&E. 168
Automaton TOY
 use a more specific term; e.g., DOLL, MECHANICAL; ANIMAL, MECHANICAL
AUTOMOBILE LTE -- MOTORIZED 192
AUXANOMETER. BIOLOGICAL T&E 136
Avarrancator. AGRICULTURAL T&E
 use PRUNER, TREE
AVIARY HOUSEHOLD ACCESSORY. 15
AVIARY OTHER STRUCTURE. 7
AWL. TEXTILEWORKING T&E 104
 rt FID
AWL. METALWORKING T&E 88

- -

- -

AX, SPLIT. FORESTRY T&E 77
Ax, Stone MASONRY & STONEWORKING T&E
 use AX, MASON'S
AX, TOOTH. MASONRY & STONEWORKING T&E 86
AX, TURPENTINE FORESTRY T&E 77
AXOMETER MEDICAL & PSYCHOLOGICAL T&E. . . . 149
AZOTOMETER CHEMICAL T&E 138
BACKBOARD, BASKETBALL. SPORTS EQUIPMENT 220
BACKGAMMON GAME 217
BACKHOE. CONSTRUCTION T&E 141
BACKHOE/FRONT-END LOADER CONSTRUCTION T&E 141
BACKPACK PERSONAL GEAR. 35
 rt KNAPSACK
BACKPLATE. ARMAMENT -- BODY ARMOR 129
BACKREST FURNITURE. 10
BACKSTAFF. SURVEYING & NAVIGATIONAL T&E . . . 161
BACKSWORD. ARMAMENT -- EDGED. 126
BACTERIOSCOPE. BIOLOGICAL T&E 136
BADGE. PERSONAL SYMBOL. 215
 rt PIN; PATCH
BADGE, POLICE. PERSONAL SYMBOL. 215
BAG. MERCHANDISING T&E. 156
BAG. CONTAINER. 186
BAG. SPORTS EQUIPMENT 220
Bag, Beaded PERSONAL GEAR
 use PURSE
BAG, BICYCLE LTE -- ACCESSORY 193
BAG, BUOYANCY. THERMAL T&E. 164
Bag, Cosmetic TOILET ARTICLE
 use KIT, TOILET
BAG, DEPOSIT MERCHANDISING T&E. 156
BAG, DITTY PERSONAL GEAR. 35
BAG, DOCTOR'S. PERSONAL GEAR. 35
BAG, DUFFLE. PERSONAL GEAR. 35
Bag, Emery. TEXTILEWORKING T&E
 use CUSHION, EMERY
BAG, FRUIT PICKING AGRICULTURAL T&E 41
BAG, GARMENT PERSONAL GEAR. 35
BAG, GOLF. SPORTS EQUIPMENT 220
Bag, Hand PERSONAL GEAR
 use PURSE
BAG, HUNTING ARMAMENT -- ACCESSORY. 130
BAG, ICE MEDICAL & PSYCHOLOGICAL T&E. . . . 149
Bag, Kit. PERSONAL GEAR
 use BAG, DUFFLE
BAG, LAUNDRY MAINTENANCE T&E. 145
BAG, MARBLE. GAME 217
BAG, MEDICINE. MEDICAL & PSYCHOLOGICAL T&E. . . . 149
BAG, MONEY EXCHANGE MEDIUM. 214
Bag, Musette. PERSONAL GEAR
 use HAVERSACK

- -

```
BAG, NEEDLEWORK. . . . . . . . . . . . . TEXTILEWORKING T&E . . . . . . . .  104
BAG, ORE . . . . . . . . . . . . . . . . MINING & MINERAL HARVESTING T&E. .   97
BAG, PAJAMA. . . . . . . . . . . . . . . PERSONAL GEAR. . . . . . . . . . .   35
BAG, PASTRY. . . . . . . . . . . . . . . FOOD PROCESSING T&E. . . . . . . .   58
BAG, POWDER. . . . . . . . . . . . . . . ARMAMENT -- ACCESSORY. . . . . . .  130
BAG, PUNCHING. . . . . . . . . . . . . . SPORTS EQUIPMENT . . . . . . . . .  220
   Bag, Sand . . . . . . . . . . . . . . REGULATIVE & PROTECTIVE T&E
      use SANDBAG
BAG, SCHOOL. . . . . . . . . . . . . . . PERSONAL GEAR. . . . . . . . . . .   35
BAG, SLEEPING. . . . . . . . . . . . . . BEDDING. . . . . . . . . . . . . .    9
BAG, TAMPING . . . . . . . . . . . . . . MINING & MINERAL HARVESTING T&E. .   97
   Bag, Tobacco. . . . . . . . . . . . . PERSONAL GEAR
      use POUCH, TOBACCO
BAG, TRICK OR TREAT. . . . . . . . . . . CEREMONIAL ARTIFACT. . . . . . . .  206
BAG, WATER . . . . . . . . . . . . . . . LTE -- ACCESSORY . . . . . . . . .  193
BAG, WHALER'S. . . . . . . . . . . . . . FISHING & TRAPPING T&E . . . . . .   56
BAGATELLE. . . . . . . . . . . . . . . . GAME . . . . . . . . . . . . . . .  217
BAGPIPE. . . . . . . . . . . . . . . . . MUSICAL T&E. . . . . . . . . . . .  172
BAILER . . . . . . . . . . . . . . . . . MINING & MINERAL HARVESTING T&E. .   97
BAILER . . . . . . . . . . . . . . . . . WATER TRANSPORTATION -- ACCESSORY.  201
BALALAIKA. . . . . . . . . . . . . . . . MUSICAL T&E. . . . . . . . . . . .  172
BALANCE. . . . . . . . . . . . . . . . . WEIGHTS & MEASURES T&E . . . . . .  166
BALANCE, ANALYTICAL. . . . . . . . . . . WEIGHTS & MEASURES T&E . . . . . .  166
BALANCE, ASSAY . . . . . . . . . . . . . MINING & MINERAL HARVESTING T&E. .   97
BALANCE, BERANGER. . . . . . . . . . . . WEIGHTS & MEASURES T&E . . . . . .  166
BALANCE, BOB . . . . . . . . . . . . . . MINING & MINERAL HARVESTING T&E. .   97
BALANCE, DEMONSTRATION . . . . . . . . . WEIGHTS & MEASURES T&E . . . . . .  166
BALANCE, GRAM-CHAIN. . . . . . . . . . . WEIGHTS & MEASURES T&E . . . . . .  166
BALANCE, ROBERVAL. . . . . . . . . . . . WEIGHTS & MEASURES T&E . . . . . .  166
BALANCE, SPECIFIC-GRAVITY. . . . . . . . WEIGHTS & MEASURES T&E . . . . . .  166
BALANCE, TORSION . . . . . . . . . . . . WEIGHTS & MEASURES T&E . . . . . .  166
BALANCE, WATER . . . . . . . . . . . . . MINING & MINERAL HARVESTING T&E. .   97
BALCONY. . . . . . . . . . . . . . . . . BUILDING . . . . . . . . . . . . .    1
BALDACHIN. . . . . . . . . . . . . . . . CEREMONIAL ARTIFACT. . . . . . . .  206
BALDRIC. . . . . . . . . . . . . . . . . ARMAMENT -- ACCESSORY. . . . . . .  130
BALE . . . . . . . . . . . . . . . . . . CONTAINER. . . . . . . . . . . . .  186
BALER, COTTON. . . . . . . . . . . . . . AGRICULTURAL T&E . . . . . . . . .   41
BALER, HAY . . . . . . . . . . . . . . . AGRICULTURAL T&E . . . . . . . . .   41
BALL . . . . . . . . . . . . . . . . . . TOY. . . . . . . . . . . . . . . .  223
BALL, BILLIARD . . . . . . . . . . . . . SPORTS EQUIPMENT . . . . . . . . .  220
BALL, BOWLING. . . . . . . . . . . . . . SPORTS EQUIPMENT . . . . . . . . .  220
BALL, CROQUET. . . . . . . . . . . . . . SPORTS EQUIPMENT . . . . . . . . .  220
   Ball, Headache. . . . . . . . . . . . CONSTRUCTION T&E
      use BALL, WRECKING
BALL, KICK . . . . . . . . . . . . . . . SPORTS EQUIPMENT . . . . . . . . .  220
BALL, MEDICINE . . . . . . . . . . . . . SPORTS EQUIPMENT . . . . . . . . .  220
   Ball, Minie . . . . . . . . . . . . . ARMAMENT -- AMMUNITION
      use BULLET, MINIE
BALL, MIRROR . . . . . . . . . . . . . . PUBLIC ENTERTAINMENT DEVICE. . . .  218
BALL, MUSKET . . . . . . . . . . . . . . ARMAMENT -- AMMUNITION . . . . . .  128
```

- -

```
BALL, SOCKER . . . . . . . . . . . . . SPORTS EQUIPMENT . . . . . . . . . 220
 Ball, Tea . . . . . . . . . . . . . . FOOD PROCESSING T&E
  use  INFUSER, TEA
BALL, TENNIS . . . . . . . . . . . . . SPORTS EQUIPMENT . . . . . . . . . 220
BALL, WRECKING . . . . . . . . . . . . CONSTRUCTION T&E . . . . . . . . . 141
BALL & CHAIN . . . . . . . . . . . . . REGULATIVE & PROTECTIVE T&E. . . . 160
BALLER . . . . . . . . . . . . . . . . TEXTILEWORKING T&E . . . . . . . . 104
BALLISTA . . . . . . . . . . . . . . . ARMAMENT -- ARTILLERY. . . . . . . 127
BALLOON. . . . . . . . . . . . . . . . AEROSPACE -- EQUIPMENT . . . . . . 187
BALLOON, BARRAGE . . . . . . . . . . . AEROSPACE -- EQUIPMENT . . . . . . 187
BALLOON, CAPTIVE . . . . . . . . . . . AEROSPACE -- EQUIPMENT . . . . . . 187
BALLOON, FREE. . . . . . . . . . . . . AEROSPACE -- EQUIPMENT . . . . . . 187
BALLOON, POLITICAL . . . . . . . . . . ADVERTISING MEDIUM . . . . . . . . 204
BALLOON, WEATHER . . . . . . . . . . . METEOROLOGICAL T&E . . . . . . . . 157
BALLOT . . . . . . . . . . . . . . . . DOCUMENTARY ARTIFACT . . . . . . . 209
BALMORAL . . . . . . . . . . . . . . . CLOTHING -- HEADWEAR . . . . . . .  26
BALUSTER . . . . . . . . . . . . . . . BUILDING COMPONENT . . . . . . . .   4
 Band, Belly . . . . . . . . . . . . . LTE -- ACCESSORY
  use  BELLYBAND
BAND, DENTAL . . . . . . . . . . . . . MEDICAL & PSYCHOLOGICAL T&E. . . . 149
BAND, RUBBER . . . . . . . . . . . . . MULTIPLE USE ARTIFACT. . . . . . . 227
BANDAGE. . . . . . . . . . . . . . . . MEDICAL & PSYCHOLOGICAL T&E. . . . 149
 Bandana . . . . . . . . . . . . . . . CLOTHING -- HEADWEAR
  use  KERCHIEF
BANDBOX. . . . . . . . . . . . . . . . PERSONAL GEAR. . . . . . . . . . .  35
BANDERILLA . . . . . . . . . . . . . . SPORTS EQUIPMENT . . . . . . . . . 220
BANDOLIER. . . . . . . . . . . . . . . CLOTHING -- ACCESSORY. . . . . . .  33
BANDOLIER. . . . . . . . . . . . . . . ARMAMENT -- ACCESSORY. . . . . . . 130
BANDOLIER. . . . . . . . . . . . . . . PERSONAL SYMBOL. . . . . . . . . . 215
 Bandwagon, Circus . . . . . . . . . . LTE -- ANIMAL-POWERED
  use  WAGON, CIRCUS PARADE
 Bangle. . . . . . . . . . . . . . . . ADORNMENT
  use  BRACELET
BANJO. . . . . . . . . . . . . . . . . MUSICAL T&E. . . . . . . . . . . . 172
BANK, MECHANICAL . . . . . . . . . . . TOY. . . . . . . . . . . . . . . . 223
BANK, SEMI-MECHANICAL. . . . . . . . . TOY. . . . . . . . . . . . . . . . 223
BANK, STILL. . . . . . . . . . . . . . TOY. . . . . . . . . . . . . . . . 223
BANKBOOK . . . . . . . . . . . . . . . DOCUMENTARY ARTIFACT . . . . . . . 209
BANNER . . . . . . . . . . . . . . . . ADVERTISING MEDIUM . . . . . . . . 204
BANNER . . . . . . . . . . . . . . . . CEREMONIAL ARTIFACT. . . . . . . . 206
BAR. . . . . . . . . . . . . . . . . . BUILDING COMPONENT . . . . . . . .   4
BAR, BORING. . . . . . . . . . . . . . MINING & MINERAL HARVESTING T&E. .  98
BAR, CLAYING . . . . . . . . . . . . . MINING & MINERAL HARVESTING T&E. .  98
BAR, ELEVATING . . . . . . . . . . . . ARMAMENT -- ACCESSORY. . . . . . . 130
BAR, HORIZONTAL. . . . . . . . . . . . SPORTS EQUIPMENT . . . . . . . . . 220
BAR, HORNWORKER'S. . . . . . . . . . . LEATHER, HORN, SHELLWORKING T&E. .  82
BAR, MEAT-HANGING. . . . . . . . . . . FOOD PROCESSING T&E. . . . . . . .  58
BAR, MINER'S . . . . . . . . . . . . . MINING & MINERAL HARVESTING T&E. .  98
 Bar, Planting . . . . . . . . . . . . AGRICULTURAL T&E
  use  DIBBLE
```

- -

```
Bar, Pry. . . . . . . . . . . . . . . . MULTIPLE USE ARTIFACT
   use  CROWBAR
BAR, QUARRY. . . . . . . . . . . . . . . MINING & MINERAL HARVESTING T&E. .   98
BAR, RIGGING . . . . . . . . . . . . . . MINING & MINERAL HARVESTING T&E. .   98
BAR, STALL . . . . . . . . . . . . . . . SPORTS EQUIPMENT . . . . . . . .    220
BAR, STRETCHER . . . . . . . . . . . . . MINING & MINERAL HARVESTING T&E. .   98
BAR, TAMPING . . . . . . . . . . . . . . MINING & MINERAL HARVESTING T&E. .   98
BAR, TOMMY . . . . . . . . . . . . . . . FORESTRY T&E . . . . . . . . . .     77
BAR, WAGON-PINCH . . . . . . . . . . . . MINING & MINERAL HARVESTING T&E. .   98
BAR, WARPING . . . . . . . . . . . . . . TEXTILEWORKING T&E . . . . . . .    104
Bar, Wrecking . . . . . . . . . . . . . MULTIPLE USE ARTIFACT
   use  CROWBAR
BARB, LANCE. . . . . . . . . . . . . . . ARMAMENT -- EDGED. . . . . . . .    126
BARBELL. . . . . . . . . . . . . . . . . SPORTS EQUIPMENT . . . . . . . .    220
BARBETTE . . . . . . . . . . . . . . . . CLOTHING -- HEADWEAR . . . . . .     26
BARDICHE . . . . . . . . . . . . . . . . ARMAMENT -- EDGED. . . . . . . .    126
BARGE. . . . . . . . . . . . . . . . . . WATER TRANSPORTATION -- EQUIPMENT. 197
BARGE, TRAINING. . . . . . . . . . . . . WATER TRANSPORTATION -- EQUIPMENT. 197
BARGEBOARD . . . . . . . . . . . . . . . BUILDING COMPONENT . . . . . . .      4
BARN . . . . . . . . . . . . . . . . . . BUILDING . . . . . . . . . . . .      1
BARN, HOPCURING. . . . . . . . . . . . . BUILDING . . . . . . . . . . . .      1
BARN, TOBACCO. . . . . . . . . . . . . . BUILDING . . . . . . . . . . . .      1
BAROGRAPH. . . . . . . . . . . . . . . . METEOROLOGICAL T&E . . . . . . .    157
BAROMETER. . . . . . . . . . . . . . . . METEOROLOGICAL T&E . . . . . . .    157
BAROMETER, ANEROID . . . . . . . . . . . METEOROLOGICAL T&E . . . . . . .    157
BAROMETER, MERCURY . . . . . . . . . . . METEOROLOGICAL T&E . . . . . . .    157
BAROSTAT . . . . . . . . . . . . . . . . METEOROLOGICAL T&E . . . . . . .    157
BAROUCHE . . . . . . . . . . . . . . . . LTE -- ANIMAL-POWERED. . . . . .    188
   rt   BROUGHAM; CALECHE; CARRIAGE; PHAETON
BARREL . . . . . . . . . . . . . . . . . MERCHANDISING T&E. . . . . . . .    156
BARREL, AMALGAMATING . . . . . . . . . . METALWORKING T&E . . . . . . . .     88
BARREL, SYRINGE. . . . . . . . . . . . . ANIMAL HUSBANDRY T&E . . . . . .     51
Barrette. . . . . . . . . . . . . . . . ADORNMENT
   use  ORNAMENT, HAIR
BARROW . . . . . . . . . . . . . . . . . LTE -- HUMAN-POWERED . . . . . .    191
BARROW, APPLE. . . . . . . . . . . . . . AGRICULTURAL T&E . . . . . . . .     41
Barrowcoat. . . . . . . . . . . . . . . CLOTHING -- OUTERWEAR
   use  BUNTING
Bars, Monkey. . . . . . . . . . . . . . RECREATIONAL DEVICE
   use  LADDER, HORIZONTAL
BARS, PARALLEL . . . . . . . . . . . . . SPORTS EQUIPMENT . . . . . . . .    220
BARSTOOL . . . . . . . . . . . . . . . . FURNITURE. . . . . . . . . . . .     10
BARYTON. . . . . . . . . . . . . . . . . MUSICAL T&E. . . . . . . . . . .    172
   rt   VIOL, BASS
BASCINETE. . . . . . . . . . . . . . . . ARMAMENT -- BODY ARMOR . . . . .    129
BASEBALL . . . . . . . . . . . . . . . . SPORTS EQUIPMENT . . . . . . . .    220
BASELARD . . . . . . . . . . . . . . . . ARMAMENT -- EDGED. . . . . . . .    126
BASIN. . . . . . . . . . . . . . . . . . TOILET ARTICLE . . . . . . . . .     38
BASIN. . . . . . . . . . . . . . . . . . FOOD SERVICE T&E . . . . . . . .     69
BASIN. . . . . . . . . . . . . . . . . . MEDICAL & PSYCHOLOGICAL T&E. . .    149
```

- -

```
BASIN, FLUSHING. . . . . . . . . . . . CHEMICAL T&E . . . . . . . . . . . 138
BASIN, RINSING . . . . . . . . . . . . CHEMICAL T&E . . . . . . . . . . . 138
BASKET . . . . . . . . . . . . . . . . PERSONAL GEAR. . . . . . . . . . .  35
BASKET . . . . . . . . . . . . . . . . FOOD SERVICE T&E . . . . . . . . .  69
BASKET . . . . . . . . . . . . . . . . CEREMONIAL ARTIFACT. . . . . . . . 206
BASKET . . . . . . . . . . . . . . . . CONTAINER. . . . . . . . . . . . . 186
 Basket, Berry . . . . . . . . . . . . AGRICULTURAL T&E
  use  BASKET, GATHERING
BASKET, BREAD. . . . . . . . . . . . . FOOD SERVICE T&E . . . . . . . . .  69
BASKET, BURDEN . . . . . . . . . . . . PERSONAL GEAR. . . . . . . . . . .  35
BASKET, CAKE . . . . . . . . . . . . . FOOD SERVICE T&E . . . . . . . . .  69
 Basket, Cheese. . . . . . . . . . . . FOOD PROCESSING T&E
  use  STRAINER, WHEY
BASKET, COOKING. . . . . . . . . . . . FOOD PROCESSING T&E. . . . . . . .  58
BASKET, COTTON . . . . . . . . . . . . AGRICULTURAL T&E . . . . . . . . .  41
BASKET, DOUGH-RISING . . . . . . . . . FOOD PROCESSING T&E. . . . . . . .  58
BASKET, EASTER . . . . . . . . . . . . CEREMONIAL ARTIFACT. . . . . . . . 206
 Basket, Egg-gathering . . . . . . . . AGRICULTURAL T&E
  use  BASKET, GATHERING
 Basket, Fire. . . . . . . . . . . . . LIGHTING DEVICE
  use  CRESSET
BASKET, FRUIT. . . . . . . . . . . . . FOOD SERVICE T&E . . . . . . . . .  69
 Basket, Fruit-picking . . . . . . . . AGRICULTURAL T&E
  use  BASKET, GATHERING
BASKET, GATHERING. . . . . . . . . . . AGRICULTURAL T&E . . . . . . . . .  41
  rt   BOWL, GATHERING
BASKET, HANGING. . . . . . . . . . . . HOUSEHOLD ACCESSORY. . . . . . . .  15
BASKET, JAI ALAI . . . . . . . . . . . SPORTS EQUIPMENT . . . . . . . . . 220
BASKET, LAUNDRY. . . . . . . . . . . . MAINTENANCE T&E. . . . . . . . . . 145
BASKET, LUNCH. . . . . . . . . . . . . FOOD SERVICE T&E . . . . . . . . .  69
BASKET, MORTAR . . . . . . . . . . . . FOOD PROCESSING T&E. . . . . . . .  58
BASKET, NEEDLEWORK . . . . . . . . . . TEXTILEWORKING T&E . . . . . . . . 104
BASKET, ORE. . . . . . . . . . . . . . MINING & MINERAL HARVESTING T&E. .  98
BASKET, PACK . . . . . . . . . . . . . PERSONAL GEAR. . . . . . . . . . .  35
BASKET, PICNIC . . . . . . . . . . . . FOOD SERVICE T&E . . . . . . . . .  69
 Basket, Potato. . . . . . . . . . . . AGRICULTURAL T&E
  use  BASKET, GATHERING
BASKET, RING . . . . . . . . . . . . . FOOD PROCESSING T&E. . . . . . . .  58
BASKET, STORAGE. . . . . . . . . . . . FOOD PROCESSING T&E. . . . . . . .  58
BASKET, TRINKET. . . . . . . . . . . . PERSONAL GEAR. . . . . . . . . . .  35
BASKET, WINNOWING. . . . . . . . . . . AGRICULTURAL T&E . . . . . . . . .  41
BASKETBALL . . . . . . . . . . . . . . SPORTS EQUIPMENT . . . . . . . . . 220
BASKET FRAGMENT. . . . . . . . . . . . ARTIFACT REMNANT . . . . . . . . . 227
BASS, DOUBLE . . . . . . . . . . . . . MUSICAL T&E. . . . . . . . . . . . 172
BASSINET . . . . . . . . . . . . . . . FURNITURE. . . . . . . . . . . . .  10
BASSOON. . . . . . . . . . . . . . . . MUSICAL T&E. . . . . . . . . . . . 172
BASSOON, DOUBLE. . . . . . . . . . . . MUSICAL T&E. . . . . . . . . . . . 172
BASSOON, RUSSIAN . . . . . . . . . . . MUSICAL T&E. . . . . . . . . . . . 172
BASTILLE . . . . . . . . . . . . . . . ARMAMENT -- ACCESSORY. . . . . . . 130
BAT, BASEBALL. . . . . . . . . . . . . SPORTS EQUIPMENT . . . . . . . . . 220
```

- -

- -

```
BEAKHEAD . . . . . . . . . . . . . . . WATER TRANSPORTATION -- ACCESSORY.  201
BEAKIRON . . . . . . . . . . . . . . . METALWORKING T&E . . . . . . . .   88
BEAM, BALANCE. . . . . . . . . . . . . SPORTS EQUIPMENT . . . . . . . .  220
BEAM, CURRIER'S. . . . . . . . . . . . LEATHER, HORN, SHELLWORKING T&E. .  82
BEAM, TANNER'S . . . . . . . . . . . . LEATHER, HORN, SHELLWORKING T&E. .  82
BEAMER . . . . . . . . . . . . . . . . TEXTILEWORKING T&E . . . . . . .  104
BEANBAG. . . . . . . . . . . . . . . . TOY. . . . . . . . . . . . . . .  223
BEANIE . . . . . . . . . . . . . . . . CLOTHING -- HEADWEAR . . . . . .   26
   rt  SKULLCAP
 Beanpot . . . . . . . . . . . . . . . FOOD PROCESSING T&E
  use  POT, CROCK
BEARDER, BARLEY. . . . . . . . . . . . AGRICULTURAL T&E . . . . . . . .   41
BEARING, PUMP AXLE . . . . . . . . . . WATER TRANSPORTATION -- ACCESSORY.  201
BEATER . . . . . . . . . . . . . . . . BASKET, BROOM, BRUSH MAKING T&E. .  121
BEATER . . . . . . . . . . . . . . . . FOOD PROCESSING T&E. . . . . . .   58
BEATER, HOLLANDER. . . . . . . . . . . PAPERMAKING T&E. . . . . . . . .  103
BEATER, JORDAN . . . . . . . . . . . . PAPERMAKING T&E. . . . . . . . .  103
BEATER, RUG. . . . . . . . . . . . . . MAINTENANCE T&E. . . . . . . . .  145
BEATER, SEED . . . . . . . . . . . . . FOOD PROCESSING T&E. . . . . . .   58
BED. . . . . . . . . . . . . . . . . . FURNITURE. . . . . . . . . . . .   10
BED, BUNK. . . . . . . . . . . . . . . FURNITURE. . . . . . . . . . . .   10
BED, CANOPY. . . . . . . . . . . . . . FURNITURE. . . . . . . . . . . .   10
BED, FIELD . . . . . . . . . . . . . . FURNITURE. . . . . . . . . . . .   10
BED, FOLDING . . . . . . . . . . . . . FURNITURE. . . . . . . . . . . .   10
BED, FOUR-POSTER . . . . . . . . . . . FURNITURE. . . . . . . . . . . .   10
BED, HALF-TESTER . . . . . . . . . . . FURNITURE. . . . . . . . . . . .   10
 Bed, Murphy . . . . . . . . . . . . . FURNITURE
  use  BED, FOLDING
 Bed, Plantation . . . . . . . . . . . FURNITURE
  use  BED, CANOPY
BED, SLEIGH. . . . . . . . . . . . . . FURNITURE. . . . . . . . . . . .   10
BED, SOFA. . . . . . . . . . . . . . . FURNITURE. . . . . . . . . . . .   10
BED, TRUNDLE . . . . . . . . . . . . . FURNITURE. . . . . . . . . . . .   10
BED, WATER . . . . . . . . . . . . . . FURNITURE. . . . . . . . . . . .   10
BEDKEY . . . . . . . . . . . . . . . . HOUSEHOLD ACCESSORY. . . . . . .   15
BEDPAN . . . . . . . . . . . . . . . . TOILET ARTICLE . . . . . . . . .   38
   rt  URINAL
BEDSPREAD. . . . . . . . . . . . . . . BEDDING. . . . . . . . . . . . .    9
BEDSPRINGS . . . . . . . . . . . . . . BEDDING. . . . . . . . . . . . .    9
  note refers to a construction of springs and supports for a mattress
BEEHIVE. . . . . . . . . . . . . . . . ANIMAL HUSBANDRY T&E . . . . . .   51
BEETLE . . . . . . . . . . . . . . . . TEXTILEWORKING T&E . . . . . . .  104
BEETLE . . . . . . . . . . . . . . . . WOODWORKING T&E. . . . . . . . .  112
   rt  MALLET; MAUL, POST
 Beetle. . . . . . . . . . . . . . . . FOOD PROCESSING T&E
  use  MASHER
 Belfry. . . . . . . . . . . . . . . . BUILDING
  use  TOWER, BELL
BELL . . . . . . . . . . . . . . . . . SOUND COMMUNICATION T&E. . . . .  180
BELL . . . . . . . . . . . . . . . . . MUSICAL T&E. . . . . . . . . . .  172
```

- -

BELL, ALTAR. CEREMONIAL ARTIFACT. 206
BELL, ANIMAL SOUND COMMUNICATION T&E. 180
BELL, BICYCLE. LTE -- ACCESSORY 193
BELL, CHURCH SOUND COMMUNICATION T&E. 180
 Bell, Cow ANIMAL HUSBANDRY T&E
 use COWBELL
 Bell, Fire. REGULATIVE & PROTECTIVE T&E
 use ALARM, FIRE
BELL, HORSE. ANIMAL HUSBANDRY T&E 52
BELL, SCHOOL SOUND COMMUNICATION T&E. 180
BELL, SERVICE. SOUND COMMUNICATION T&E. 180
BELL, SHIP'S WATER TRANSPORTATION -- ACCESSORY. 201
BELL, SLEIGH LTE -- ACCESSORY`: 193
 Bell, Wind. ART
 use WIND-BELL
BELLOWS. TEMPERATURE CONTROL DEVICE 22
BELLOWS, BLACKSMITH'S. METALWORKING T&E 88
 rt BLOWER, BLACKSMITH'S
BELLOWS, COOPER'S. WOODWORKING T&E. 112
BELLOWS, DENTIST'S MEDICAL & PSYCHOLOGICAL T&E. . . . 149
BELLPULL HOUSEHOLD ACCESSORY. 15
BELLYBAND. LTE -- ACCESSORY 193
BELT CLOTHING -- ACCESSORY. 33
BELT, ACCESSORY. ARMAMENT -- ACCESSORY. 130
BELT, AMMUNITION ARMAMENT -- ACCESSORY. 130
BELT, BINDER AGRICULTURAL T&E 41
BELT, CARTRIDGE. ARMAMENT -- ACCESSORY. 130
BELT, CARTRIDGE-BOX. ARMAMENT -- ACCESSORY. 130
BELT, CHASTITY REGULATIVE & PROTECTIVE T&E. . . . 160
BELT, GARTER CLOTHING -- UNDERWEAR. 32
BELT, LINK ARMAMENT -- ACCESSORY. 130
BELT, MONEY. PERSONAL GEAR. 35
BELT, ROCKET AEROSPACE -- EQUIPMENT 187
BELT, SAFETY REGULATIVE & PROTECTIVE T&E. . . . 160
BELT, SAM BROWNE CLOTHING -- ACCESSORY. 33
BELT, SWORD. ARMAMENT -- ACCESSORY. 130
 Belvedere BUILDING
 use GAZEBO
BENCH. FURNITURE. 10
BENCH, BOX MAKING. WOODWORKING T&E. 112
BENCH, BUCKET. FURNITURE. 10
BENCH, CARPENTER'S WOODWORKING T&E. 112
BENCH, CIRCULAR. FURNITURE. 10
BENCH, COBBLER'S LEATHER, HORN, SHELLWORKING T&E. . 82
BENCH, GARDEN. FURNITURE. 10
BENCH, GLASSMAKER'S. GLASS, PLASTICS, CLAYWORKING T&E . 78
BENCH, HARNESS MAKER'S LEATHER, HORN, SHELLWORKING T&E. . 82
 Bench, Hooded FURNITURE
 use SETTLE
BENCH, HORNWORKER'S. LEATHER, HORN, SHELLWORKING T&E. . 82

- -

BENCH, LAUNDRY MAINTENANCE T&E. 145
 Bench, Mammy. FURNITURE
 use CRADLE/ROCKER
BENCH, PARK. FURNITURE. 10
BENCH, PIANO MUSICAL T&E. 172
BENCH, PICNIC. FURNITURE. 10
BENCH, RIGGER'S. TEXTILEWORKING T&E 104
BENCH, SAILMAKER'S TEXTILEWORKING T&E 104
 Bench, Saw-sharpening WOODWORKING T&E
 use HORSE, SAW-SHARPENING
BENCH, SPOTTING. ARMAMENT -- ACCESSORY. 130
BENCH, WEAVER'S. TEXTILEWORKING T&E 104
BENCH, WHEELWRIGHT'S WOODWORKING T&E. 112
BENCH, WINDOW. FURNITURE. 10
BENCH-HOOK, RIGGER'S TEXTILEWORKING T&E 104
BENDER, FLANGE METALWORKING T&E 88
BENDER, TIRE METALWORKING T&E 88
BERET. CLOTHING -- HEADWEAR 26
 rt TAM-O-SHANTER
 Bertha. CLOTHING -- ACCESSORY
 use COLLAR
BESIDOMETER. MEDICAL & PSYCHOLOGICAL T&E. . . . 149
BETATRON NUCLEAR PHYSICS T&E. 158
 rt ACCELERATOR; PROTONSYNCHROTRON
BEVELER, EDGE. LEATHER, HORN, SHELLWORKING T&E. . 82
BEVELER, SAFETY. LEATHER, HORN, SHELLWORKING T&E. . 82
BIB. CLOTHING -- ACCESSORY. 33
 Bible DOCUMENTARY ARTIFACT
 use BOOK
 Bickern METALWORKING T&E
 use BEAKIRON
BICYCLE. LTE -- HUMAN-POWERED 191
BICYCLE, GASOLINE. LTE -- MOTORIZED 192
BICYCLE, ORDINARY. LTE -- HUMAN-POWERED 191
BICYCLE, SAFETY. LTE -- HUMAN-POWERED 191
 Bicycle, Side-by-side LTE -- HUMAN-POWERED
 use SOCIABLE
BICYCLE, STEAM LTE -- MOTORIZED 192
BICYCLE, TANDEM. LTE -- HUMAN-POWERED 191
BIDET. PLUMBING FIXTURE 21
BIGGIN CLOTHING -- HEADWEAR 26
 Bilboquet TOY
 use CUP & BALL
BILL DOCUMENTARY ARTIFACT 209
BILL ARMAMENT -- EDGED. 126
BILLBOARD. OTHER STRUCTURE. 7
BILLET MASONRY & STONEWORKING T&E 86
BILLHOOK AGRICULTURAL T&E 41
 rt HOOK, PRUNING
BILL-OF-SALE DOCUMENTARY ARTIFACT 209

- -

BILLY, SLUBBING. TEXTILEWORKING T&E 105
BIN, FOOD-STORAGE. FOOD PROCESSING T&E. 58
BIN, ORE MINING & MINERAL HARVESTING T&E. . 98
BIN,STORAGE. MERCHANDISING T&E. 156
BINDER CLOTHING -- UNDERWEAR. 32
BINDER, CORN AGRICULTURAL T&E 41
BINDER, GRAIN. AGRICULTURAL T&E 41
BINDER, OBSTETRICAL. MEDICAL & PSYCHOLOGICAL T&E. . . . 149
BINDER, RING WRITTEN COMMUNICATION T&E. 183
 Binder, Row AGRICULTURAL T&E
 use BINDER, CORN
 Binder, Twine AGRICULTURAL T&E
 use BINDER, GRAIN
 Binder, Wire. AGRICULTURAL T&E
 use BINDER, GRAIN
BINDING. TEXTILEWORKING T&E 105
BINGO rt . . . GAME 217
 LOTTO
BINOCULARS OPTICAL T&E. 159
BIOMETER MEDICAL & PSYCHOLOGICAL T&E. . . . 149
BIOSATELLITE AEROSPACE -- EQUIPMENT 187
 rt SATELLITE
BIOSCOPE MEDICAL & PSYCHOLOGICAL T&E. . . . 149
BIPOD. ARMAMENT -- ACCESSORY. 130
 Bird, Clay. ARMAMENT -- ACCESSORY
 use TARGET, SKEET
 Bird, Pie FOOD PROCESSING T&E
 use FUNNEL, PIE
 Bird, Sewing. TEXTILEWORKING T&E
 use CLAMP, SEWING
BIRDBATH SITE FEATURE 7
BIRDCAGE HOUSEHOLD ACCESSORY. 15
BIRDHOUSE. SITE FEATURE 7
BIRETTA. CLOTHING -- HEADWEAR 26
BISTOURY MEDICAL & PSYCHOLOGICAL T&E. . . . 149
BIT. ANIMAL HUSBANDRY T&E 52
BIT. WOODWORKING T&E. 112
BIT. MINING & MINERAL HARVESTING T&E. . 98
BIT. MASONRY & STONEWORKING T&E 86
BIT. LTE -- ACCESSORY 193
BIT, ANNULAR WOODWORKING T&E. 112
 rt SAW, CROWN
BIT, CENTER. WOODWORKING T&E. 112
BIT, CORE. MINING & MINERAL HARVESTING T&E. . 98
BIT, COUNTERSINK WOODWORKING T&E. 112
BIT, CUTTING METALWORKING T&E 88
BIT, FLAT. METALWORKING T&E 88
BIT, GIMLET. WOODWORKING T&E. 112
BIT, NOSE. WOODWORKING T&E. 112
BIT, SHELL WOODWORKING T&E. 112

```
- - - - - - - - - - - - - - - - - - - - - - - - - - - - - - - - - - -
BIT, SPOON . . . . . . . . . . . . . . . WOODWORKING T&E. . . . . . . . . . 112
BIT, STRAIGHT-FLUTED . . . . . . . . . WOODWORKING T&E. . . . . . . . . . 112
BIT, STRAIGHT-FLUTED . . . . . . . . . METALWORKING T&E . . . . . . . . .  88
BIT, TAPER . . . . . . . . . . . . . . WOODWORKING T&E. . . . . . . . . . 112
BIT, TWIST . . . . . . . . . . . . . . WOODWORKING T&E. . . . . . . . . . 112
BIT, TWIST . . . . . . . . . . . . . . METALWORKING T&E . . . . . . . . .  88
 Bitstock. . . . . . . . . . . . . . . WOODWORKING T&E
  use  BRACE
 Blackboard. . . . . . . . . . . . . . WRITTEN COMMUNICATION T&E
  use  CHALKBOARD
BLACKJACK. . . . . . . . . . . . . . . ARMAMENT -- BLUDGEON . . . . . . . 127
 Blade . . . . . . . . . . . . . . . . CONSTRUCTION T&E
  use  GRADER
BLADE, RAZOR . . . . . . . . . . . . . TOILET ARTICLE . . . . . . . . . .  38
BLANCHIMETER . . . . . . . . . . . . . CHEMICAL T&E . . . . . . . . . . . 138
BLANK, HORN. . . . . . . . . . . . . . LEATHER, HORN, SHELLWORKING T&E. .  82
BLANK, TORTOISE. . . . . . . . . . . . LEATHER, HORN, SHELLWORKING T&E. .  82
BLANKET. . . . . . . . . . . . . . . . BEDDING. . . . . . . . . . . . . .   9
BLANKET. . . . . . . . . . . . . . . . ANIMAL HUSBANDRY T&E . . . . . . .  52
BLANKET, CARRIAGE. . . . . . . . . . . LTE -- ACCESSORY . . . . . . . . . 194
BLANKET, OFFSET. . . . . . . . . . . . PRINTING T&E . . . . . . . . . . . 177
BLANKET, SADDLE. . . . . . . . . . . . LTE -- ACCESSORY . . . . . . . . . 194
BLANKET/SHEET. . . . . . . . . . . . . BEDDING. . . . . . . . . . . . . .   9
 Blaster . . . . . . . . . . . . . . . MINING & MINERAL HARVESTING T&E
  use  DETONATOR
 Bleacher. . . . . . . . . . . . . . . OTHER STRUCTURE
  use  GRANDSTAND
BLENDER. . . . . . . . . . . . . . . . FOOD PROCESSING T&E. . . . . . . .  58
 Blender, Bread. . . . . . . . . . . . FOOD PROCESSING T&E
  use  MIXER, DOUGH
BLENDER, FEEDER. . . . . . . . . . . . TEXTILEWORKING T&E . . . . . . . . 105
BLENDER, FLOUR . . . . . . . . . . . . FOOD PROCESSING T&E. . . . . . . .  58
BLENDER, PASTRY. . . . . . . . . . . . FOOD PROCESSING T&E. . . . . . . .  58
BLENDER, SANDWICH. . . . . . . . . . . TEXTILEWORKING T&E . . . . . . . . 105
BLENDER, STOCK . . . . . . . . . . . . PAPERMAKING T&E. . . . . . . . . . 103
 Blimp . . . . . . . . . . . . . . . . AEROSPACE -- EQUIPMENT
  use  AIRSHIP
BLIND, VENETIAN. . . . . . . . . . . . WINDOW OR DOOR COVERING. . . . . .  23
BLINDER. . . . . . . . . . . . . . . . LTE -- ACCESSORY . . . . . . . . . 194
BLOCK. . . . . . . . . . . . . . . . . TOY. . . . . . . . . . . . . . . . 223
BLOCK, ALPHABET. . . . . . . . . . . . TOY. . . . . . . . . . . . . . . . 223
BLOCK, BEVEL . . . . . . . . . . . . . WOODWORKING T&E. . . . . . . . . . 112
BLOCK, CHOPPING. . . . . . . . . . . . FOOD PROCESSING T&E. . . . . . . .  58
BLOCK, CLINCHING . . . . . . . . . . . ANIMAL HUSBANDRY T&E . . . . . . .  52
BLOCK, ENGRAVER'S. . . . . . . . . . . PRINTING T&E . . . . . . . . . . . 177
BLOCK, FABRIC. . . . . . . . . . . . . PRINTING T&E . . . . . . . . . . . 177
BLOCK, FIREMAKING. . . . . . . . . . . TEMPERATURE CONTROL DEVICE . . . .  22
BLOCK, FORMING . . . . . . . . . . . . GLASS, PLASTICS, CLAYWORKING T&E .  78
BLOCK, FRAMING . . . . . . . . . . . . WOODWORKING T&E. . . . . . . . . . 112
BLOCK, GAVEL . . . . . . . . . . . . . CEREMONIAL ARTIFACT. . . . . . . . 206
```

- -

BLOCK, GLASSBLOWER'S GLASS, PLASTICS, CLAYWORKING T&E . 79
BLOCK, HAT TEXTILEWORKING T&E 105
BLOCK, LINOLEUM. PRINTING T&E 177
BLOCK, MITER WOODWORKING T&E. 112
 Block, Miter-shooting WOODWORKING T&E
 use JACK, MITER
BLOCK, PARQUETRY TOY. 223
BLOCK, PICTURE TOY. 223
BLOCK, POLISHING MASONRY & STONEWORKING T&E 86
BLOCK, PRINTING. LEATHER, HORN, SHELLWORKING T&E. . 82
BLOCK, PRINTING. PRINTING T&E 177
BLOCK, QUILT TEXTILEWORKING T&E 105
 note use for materials intended for the finished quilt
BLOCK, SHAVING WOODWORKING T&E. 112
 rt HORSE, SHAVING
BLOCK, STARTING. SPORTS EQUIPMENT 220
BLOCK, TELESCOPIC. TOY. 223
BLOCK, WALLPAPER PRINTING T&E 177
BLOCK, WOOD. PRINTING T&E 177
 rt PLATE, ENGRAVING
BLOCKHOUSE BUILDING 1
BLOOMERS CLOTHING -- UNDERWEAR. 32
BLOTTER. WRITTEN COMMUNICATION T&E. 183
BLOUSE CLOTHING -- OUTERWEAR. 28
BLOWER, BLACKSMITH'S METALWORKING T&E 88
 rt BELLOWS, BLACKSMITH'S
BLOWER, ENSILAGE AGRICULTURAL T&E 41
 Blower, Forage. AGRICULTURAL T&E
 use BLOWER, ENSILAGE
 Blower, Impeller. AGRICULTURAL T&E
 use BLOWER, ENSILAGE
 Blower, Silage. AGRICULTURAL T&E
 use BLOWER, ENSILAGE
 Blower, Silo. AGRICULTURAL T&E
 use BLOWER, ENSILAGE
BLOWGUN. ARMAMENT -- EDGED. 126
 Blowiron. GLASS, PLASTICS, CLAYWORKING T&E
 use BLOWPIPE
BLOWPIPE GLASS, PLASTICS, CLAYWORKING T&E . 79
BLOWPIPE BIOLOGICAL T&E 136
 Blowtorch METALWORKING T&E
 use TORCH modified according to fuel
BLUEPRINT. DOCUMENTARY ARTIFACT 209
BLUNDERBUSS. ARMAMENT -- FIREARM. 124
BLUNGER. GLASS, PLASTICS, CLAYWORKING T&E . 79
BOA. CLOTHING -- ACCESSORY. 33
BOARD. BUILDING COMPONENT 4
BOARD, BINDING PRINTING T&E 177
 Board, Bread. FOOD PROCESSING T&E
 use BOARD, CUTTING

- -

```
BOARD, BUNK. . . . . . . . . . . . . . WATER TRANSPORTATION -- ACCESSORY.  201
BOARD, CIRCUIT . . . . . . . . . . . . ELECTRICAL & MAGNETIC T&E. . . . .  142
 Board, Control. . . . . . . . . . . . LIGHTING DEVICE
  use CONSOLE, LIGHTING
BOARD, CRIBBAGE. . . . . . . . . . . . GAME . . . . . . . . . . . . . . .  217
BOARD, CUT-DOWN. . . . . . . . . . . . GLASS, PLASTICS, CLAYWORKING T&E .   79
BOARD, CUTTING . . . . . . . . . . . . FOOD PROCESSING T&E. . . . . . . .   58
 Board, Dibble . . . . . . . . . . . . AGRICULTURAL T&E
  use DIBBLE
BOARD, DRAWING . . . . . . . . . . . . DRAFTING T&E . . . . . . . . . . .  170
BOARD, GAME. . . . . . . . . . . . . . GAME . . . . . . . . . . . . . . .  217
  note use for a board suitable for many games or if specific game cannot
       be identified
BOARD, GANGWAY . . . . . . . . . . . . WATER TRANSPORTATION -- ACCESSORY.  201
BOARD, GRAINING. . . . . . . . . . . . LEATHER, HORN, SHELLWORKING T&E. .   82
BOARD, HUNT. . . . . . . . . . . . . . FURNITURE. . . . . . . . . . . . .   10
 rt  SIDEBOARD
BOARD, IRONING . . . . . . . . . . . . MAINTENANCE T&E. . . . . . . . . .  145
BOARD, LEVELING. . . . . . . . . . . . CHEMICAL T&E . . . . . . . . . . .  138
BOARD, MEASURING . . . . . . . . . . . FISHING & TRAPPING T&E . . . . . .   56
BOARD, NAME. . . . . . . . . . . . . . WATER TRANSPORTATION -- ACCESSORY.  201
BOARD, NAVIGATOR'S . . . . . . . . . . SURVEYING & NAVIGATIONAL T&E . . .  161
 Board, Plug . . . . . . . . . . . . . DATA PROCESSING T&E
  use PATCH
BOARD, QUARTER . . . . . . . . . . . . WATER TRANSPORTATION -- ACCESSORY.  201
 Board, Raising. . . . . . . . . . . . LEATHER, HORN, SHELLWORKING T&E
  use BOARD, GRAINING
BOARD, SANDWICH. . . . . . . . . . . . ADVERTISING MEDIUM . . . . . . . .  204
BOARD, SCUTCHING . . . . . . . . . . . TEXTILEWORKING T&E . . . . . . . .  105
BOARD, SHOOTING. . . . . . . . . . . . WOODWORKING T&E. . . . . . . . . .  112
 Board, Sleeve . . . . . . . . . . . . MAINTENANCE T&E
  use BOARD, IRONING
 Board, Sounding . . . . . . . . . . . CEREMONIAL ARTIFACT
  use BLOCK, GAVEL
 Board, Spotting . . . . . . . . . . . AGRICULTURAL T&E
  use DIBBLE
BOARD, STOVE . . . . . . . . . . . . . TEMPERATURE CONTROL DEVICE . . . .   22
BOARD, TOOL. . . . . . . . . . . . . . GLASS, PLASTICS, CLAYWORKING T&E .   79
BOARD, TRAIL . . . . . . . . . . . . . WATER TRANSPORTATION -- ACCESSORY.  201
BOARD, WALKING . . . . . . . . . . . . RECREATIONAL DEVICE. . . . . . . .  219
 Boat, Albemarle Sound . . . . . . . . WATER TRANSPORTATION -- EQUIPMENT
  use BOAT, SEINE
BOAT, BEACH. . . . . . . . . . . . . . WATER TRANSPORTATION -- EQUIPMENT.  197
BOAT, BULL . . . . . . . . . . . . . . WATER TRANSPORTATION -- EQUIPMENT.  197
 rt  CORACLE
BOAT, BUOY . . . . . . . . . . . . . . WATER TRANSPORTATION -- EQUIPMENT.  197
BOAT, CANAL. . . . . . . . . . . . . . WATER TRANSPORTATION -- EQUIPMENT.  197
BOAT, DREDGE . . . . . . . . . . . . . WATER TRANSPORTATION -- EQUIPMENT.  197
 Boat, Feeding . . . . . . . . . . . . FOOD SERVICE T&E
  use FEEDER, INVALID
```

- -

Boat, Flying. AEROSPACE -- EQUIPMENT
 use AIRPLANE
Boat, Gravy FOOD SERVICE T&E
 use SAUCEBOAT
BOAT, HAMPTON. WATER TRANSPORTATION -- EQUIPMENT. 197
Boat, Incense CEREMONIAL ARTIFACT
 use NAVETTE
BOAT, INFLATABLE WATER TRANSPORTATION -- EQUIPMENT. 198
BOAT, LOBSTER. WATER TRANSPORTATION -- EQUIPMENT. 198
BOAT, PADDLE WATER TRANSPORTATION -- EQUIPMENT. 198
Boat, Pap FOOD SERVICE T&E
 use FEEDER, INVALID
BOAT, PATROL WATER TRANSPORTATION -- EQUIPMENT. 198
BOAT, PILOT. WATER TRANSPORTATION -- EQUIPMENT. 198
BOAT, RANGELY. WATER TRANSPORTATION -- EQUIPMENT. 198
BOAT, SEINE. WATER TRANSPORTATION -- EQUIPMENT. 198
Boat, Stone AGRICULTURAL T&E
 use STONEBOAT
BOAT, STRIKER. WATER TRANSPORTATION -- EQUIPMENT. 198
BOAT, TONGING. WATER TRANSPORTATION -- EQUIPMENT. 198
BOATER CLOTHING -- HEADWEAR 26
BOB, PLUMB CONSTRUCTION T&E 141
BOBBIN TEXTILEWORKING T&E 105
BOBBIN, LACE TEXTILEWORKING T&E 105
BOBECHE. LIGHTING DEVICE. 19
BOBSLED. LTE -- ANIMAL-POWERED. 188
BOBSLED. SPORTS EQUIPMENT 220
BOCKS BRILLE REGULATIVE & PROTECTIVE T&E. . . . 160
BODICE CLOTHING -- OUTERWEAR. 28
BODKIN ADORNMENT. 24
BODKIN BASKET, BROOM, BRUSH MAKING T&E. . 121
BODKIN TEXTILEWORKING T&E 105
 rt FID
BODKIN PRINTING T&E 177
BODYSTOCKING CLOTHING -- UNDERWEAR. 32
BOGIE. MINING & MINERAL HARVESTING T&E. . 98
BOILER MINING & MINERAL HARVESTING T&E. . 98
BOILER, DOUBLE FOOD PROCESSING T&E. 58
BOILER, FEED AGRICULTURAL T&E 41
BOILER, LAUNDRY. MAINTENANCE T&E. 145
BOILER, STEAM. ENERGY PRODUCTION T&E. 143
Boiler, Steam Wash. MAINTENANCE T&E
 use BOILER, LAUNDRY
Boiler, Wash. MAINTENANCE T&E
 use BOILER, LAUNDRY
BOLA ARMAMENT -- BLUDGEON 127
BOLERO CLOTHING -- OUTERWEAR. 28
BOLLARD. WATER TRANSPORTATION -- ACCESSORY. 201
BOLO ARMAMENT -- EDGED. 126
BOLOMETER. THERMAL T&E. 164

- -

```
BOLSTER. . . . . . . . . . . . . . . . . BEDDING. . . . . . . . . . . . .   9
BOLT . . . . . . . . . . . . . . . . . . BUILDING COMPONENT . . . . . . .   4
BOLT . . . . . . . . . . . . . . . . . . WOODWORKING T&E. . . . . . . . . 112
BOLT, CLOTH. . . . . . . . . . . . . . . TEXTILEWORKING T&E . . . . . . . 105
BOLT, DRAW . . . . . . . . . . . . . . . BUILDING COMPONENT . . . . . . .   4
BOLT, EYE. . . . . . . . . . . . . . . . METALWORKING T&E . . . . . . . .  88
BOLT, LEWIS. . . . . . . . . . . . . . . MINING & MINERAL HARVESTING T&E.  98
BOLT, RAG. . . . . . . . . . . . . . . . MINING & MINERAL HARVESTING T&E.  98
BOLT, ROOF . . . . . . . . . . . . . . . MINING & MINERAL HARVESTING T&E.  98
 Bolter, Cloth . . . . . . . . . . . . . FOOD PROCESSING T&E
   use  BOLTER, SIEVE
BOLTER, SIEVE. . . . . . . . . . . . . . FOOD PROCESSING T&E. . . . . . .  58
BOMB, AIR-TO-AIR . . . . . . . . . . . . ARMAMENT -- AMMUNITION . . . . . 128
BOMB, AIR-TO-SURFACE . . . . . . . . . . ARMAMENT -- AMMUNITION . . . . . 128
BOMB, AIR-TO-UNDERWATER. . . . . . . . . ARMAMENT -- AMMUNITION . . . . . 128
 Bomb, Antiaircraft. . . . . . . . . . . ARMAMENT -- AMMUNITION
   use  BOMB, AIR-TO-AIR
BOMBACHAS. . . . . . . . . . . . . . . . CLOTHING -- OUTERWEAR. . . . . .  28
 Bombardon . . . . . . . . . . . . . . . MUSICAL T&E
   use  TUBA
 Bonbonniere . . . . . . . . . . . . . . FOOD SERVICE T&E
   use  DISH, BONBON
BOND . . . . . . . . . . . . . . . . . . DOCUMENTARY ARTIFACT . . . . . . 209
BONE, WORKED . . . . . . . . . . . . . . ARTIFACT REMNANT . . . . . . . . 227
 Bones, Napiers' . . . . . . . . . . . . DATA PROCESSING T&E
   use  ROD, CALCULATING
 Boneshaker. . . . . . . . . . . . . . . LTE -- HUMAN-POWERED
   use  VELOCIPEDE
BONNET . . . . . . . . . . . . . . . . . CLOTHING -- HEADWEAR . . . . . .  26
BONNET, INDOOR . . . . . . . . . . . . . CLOTHING -- HEADWEAR . . . . . .  26
 Booby . . . . . . . . . . . . . . . . . LTE -- ANIMAL-POWERED
   use  SLEIGH
BOOK . . . . . . . . . . . . . . . . . . DOCUMENTARY ARTIFACT . . . . . . 209
BOOK . . . . . . . . . . . . . . . . . . TOY. . . . . . . . . . . . . . . 223
BOOK, ACCOUNT. . . . . . . . . . . . . . DOCUMENTARY ARTIFACT . . . . . . 210
BOOK, ADDRESS. . . . . . . . . . . . . . DOCUMENTARY ARTIFACT . . . . . . 210
BOOK, COMIC. . . . . . . . . . . . . . . DOCUMENTARY ARTIFACT . . . . . . 210
BOOK, COUPON . . . . . . . . . . . . . . EXCHANGE MEDIUM. . . . . . . . . 214
BOOK, INSTRUCTION. . . . . . . . . . . . DOCUMENTARY ARTIFACT . . . . . . 210
 Book, Match . . . . . . . . . . . . . . TEMPERATURE CONTROL DEVICE
   use  MATCHBOOK
BOOK, RATION . . . . . . . . . . . . . . EXCHANGE MEDIUM. . . . . . . . . 214
BOOKCASE . . . . . . . . . . . . . . . . FURNITURE. . . . . . . . . . . .  10
BOOKEND. . . . . . . . . . . . . . . . . HOUSEHOLD ACCESSORY. . . . . . .  16
BOOKLET. . . . . . . . . . . . . . . . . DOCUMENTARY ARTIFACT . . . . . . 210
BOOKLET. . . . . . . . . . . . . . . . . ADVERTISING MEDIUM . . . . . . . 204
BOOKLET, INSTRUCTION . . . . . . . . . . DOCUMENTARY ARTIFACT . . . . . . 210
BOOKMARK . . . . . . . . . . . . . . . . DOCUMENTARY ARTIFACT . . . . . . 210
BOOKMARK . . . . . . . . . . . . . . . . WRITTEN COMMUNICATION T&E. . . . 183
BOOKPLATE. . . . . . . . . . . . . . . . DOCUMENTARY ARTIFACT . . . . . . 210
```

- -

- -

BOTTLE, VACCINE. MEDICAL & PSYCHOLOGICAL T&E. . . . 149
 rt BOTTLE, SERUM
BOTTLE, VACUUM FOOD SERVICE T&E 70
 Bottlebrush MAINTENANCE T&E
 use BRUSH, BOTTLE
BOUGIE MEDICAL & PSYCHOLOGICAL T&E. . . . 149
 rt CATHETER
BOUNCER. LEATHER, HORN, SHELLWORKING T&E. . 82
BOUQUET, FLORAL. ART. 205
BOUQUET, WEDDING CEREMONIAL ARTIFACT. 206
 Boutonniere ADORNMENT
 use PIN, LAPEL
BOW. ADORNMENT. 24
BOW. CLOTHING -- ACCESSORY. 33
BOW. ARMAMENT -- EDGED. 126
BOW, FIRE. TEMPERATURE CONTROL DEVICE 22
 Bow, Horse. LTE -- ACCESSORY
 use YOKE, ANIMAL
BOW, SHOE. ADORNMENT. 24
BOW, SPRING. DRAFTING T&E 170
BOW, VIOLIN. MUSICAL T&E. 172
BOWL HOUSEHOLD ACCESSORY. 16
BOWL FOOD SERVICE T&E 70
BOWL, BAPTISMAL. CEREMONIAL ARTIFACT. 207
BOWL, BERRY. FOOD SERVICE T&E 70
BOWL, BLEEDING MEDICAL & PSYCHOLOGICAL T&E. . . . 149
BOWL, BOUILLON FOOD SERVICE T&E 70
BOWL, BRIDE'S. FOOD SERVICE T&E 70
BOWL, BULB HOUSEHOLD ACCESSORY. 16
BOWL, BUTTER-WORKING FOOD PROCESSING T&E. 58
BOWL, CEREAL FOOD SERVICE T&E 70
BOWL, CHOPPING FOOD PROCESSING T&E. 58
BOWL, DENTAL MIXING. MEDICAL & PSYCHOLOGICAL T&E. . . . 149
BOWL, DESSERT. FOOD SERVICE T&E 70
BOWL, FINGER FOOD SERVICE T&E 70
 Bowl, Fish. HOUSEHOLD ACCESSORY
 use FISHBOWL
BOWL, FLOWER HOUSEHOLD ACCESSORY. 16
BOWL, FRUIT. FOOD SERVICE T&E 70
BOWL, GATHERING. AGRICULTURAL T&E 41
 rt BASKET, GATHERING
BOWL, JELLY. FOOD SERVICE T&E 70
BOWL, LIBATION CEREMONIAL ARTIFACT. 207
 rt PHIALE
BOWL, MARRIAGE CEREMONIAL ARTIFACT. 207
BOWL, MIXING FOOD PROCESSING T&E. 58
BOWL, NUT. FOOD SERVICE T&E 70
BOWL, PET. ANIMAL HUSBANDRY T&E 52
BOWL, PUNCH. FOOD SERVICE T&E 70
BOWL, SALAD. FOOD SERVICE T&E 70

- -

BOWL, SCOURING TEXTILEWORKING T&E 105
BOWL, SERVING. FOOD SERVICE T&E 70
BOWL, SKIMMING FOOD PROCESSING T&E. 58
 Bowl, Slop. FOOD SERVICE T&E
 use BOWL, WASTE
BOWL, SOUP FOOD SERVICE T&E 70
BOWL, SUGAR. FOOD SERVICE T&E 70
BOWL, TEA. FOOD SERVICE T&E 70
BOWL, WASTE. FOOD SERVICE T&E 70
 Bowler. CLOTHING -- HEADWEAR
 use DERBY
BOX. MERCHANDISING T&E. 156
BOX. CONTAINER. 186
BOX, AMMUNITION. ARMAMENT -- ACCESSORY. 130
BOX, ARTIST'S. PAINTING T&E 102
BOX, BALLOT. REGULATIVE & PROTECTIVE T&E. 160
 Box, Band PERSONAL GEAR
 use BANDBOX
BOX, BEE ANIMAL HUSBANDRY T&E 52
BOX, BIBLE HOUSEHOLD ACCESSORY. 16
BOX, BOOTBLACKING. CLOTHING -- ACCESSORY. 33
 rt KIT, SHOESHINE
BOX, BREAD FOOD PROCESSING T&E. 58
 Box, Bride's. PERSONAL GEAR
 use BANDBOX
BOX, CANDLE. LIGHTING DEVICE. 19
BOX, CAP ARMAMENT -- ACCESSORY. 130
BOX, CARD. GAME 217
BOX, CARTRIDGE ARMAMENT -- ACCESSORY. 130
BOX, CHARGING. METALWORKING T&E 88
BOX, CHEESE. FOOD PROCESSING T&E. 58
BOX, CHEST GLASS, PLASTICS, CLAYWORKING T&E . 79
BOX, CHOPPING. FOOD PROCESSING T&E. 58
BOX, CIGARETTE HOUSEHOLD ACCESSORY. 16
BOX, COLLAR. PERSONAL GEAR. 35
BOX, CONTROL ELECTRICAL & MAGNETIC T&E. 142
 Box, Dealing. GAME
 use SHOE
BOX, DIP MINING & MINERAL HARVESTING T&E. . 98
BOX, DOCUMENT. DOCUMENTARY ARTIFACT 210
 Box, Dough. FOOD PROCESSING T&E
 use TROUGH, DOUGH
BOX, DRILL BIT METALWORKING T&E 88
BOX, FEED. ANIMAL HUSBANDRY T&E 52
BOX, FIELD AGRICULTURAL T&E 41
BOX, FILE. WRITTEN COMMUNICATION T&E. 183
BOX, FIRE-ALARM. REGULATIVE & PROTECTIVE T&E. 160
 Box, Flatware FOOD SERVICE T&E
 use TRAY, FLATWARE
BOX, FLEES'. MEDICAL & PSYCHOLOGICAL T&E. 149

- -

```
BOX, FOOD-STORAGE. . . . . . . . . . . FOOD PROCESSING T&E. . . . . . . .   58
BOX, GERMINATION . . . . . . . . . . . BIOLOGICAL T&E . . . . . . . . . .  136
BOX, GILL. . . . . . . . . . . . . . . TEXTILEWORKING T&E . . . . . . . .  105
BOX, GLOVE . . . . . . . . . . . . . . PERSONAL GEAR. . . . . . . . . . .   35
BOX, GRAIN . . . . . . . . . . . . . . AGRICULTURAL T&E . . . . . . . . .   41
BOX, HAIRPIN . . . . . . . . . . . . . TOILET ARTICLE . . . . . . . . . .   38
BOX, HANDKERCHIEF. . . . . . . . . . . PERSONAL GEAR. . . . . . . . . . .   35
BOX, JEWELRY . . . . . . . . . . . . . HOUSEHOLD ACCESSORY. . . . . . . .   16
BOX, JUNCTION. . . . . . . . . . . . . ELECTRICAL & MAGNETIC T&E. . . . .  142
  Box, Knife. . . . . . . . . . . . . . FOOD SERVICE T&E
   use  TRAY, FLATWARE
  Box, Knife and Fork . . . . . . . . . FOOD SERVICE T&E
   use  TRAY, FLATWARE
BOX, LETTER. . . . . . . . . . . . . . HOUSEHOLD ACCESSORY. . . . . . . .   16
BOX, LUNCH . . . . . . . . . . . . . . FOOD SERVICE T&E . . . . . . . . .   70
   rt  PAIL, DINNER
  Box, Match. . . . . . . . . . . . . . TEMPERATURE CONTROL DEVICE
   use  MATCHBOX
BOX, MITER . . . . . . . . . . . . . . WOODWORKING T&E. . . . . . . . . .  112
BOX, MOLDING . . . . . . . . . . . . . WOODWORKING T&E. . . . . . . . . .  112
BOX, MONEY . . . . . . . . . . . . . . MERCHANDISING T&E. . . . . . . . .  156
BOX, MUSIC . . . . . . . . . . . . . . SOUND COMMUNICATION T&E. . . . . .  180
BOX, NEEDLEWORK. . . . . . . . . . . . TEXTILEWORKING T&E . . . . . . . .  105
  Box, Offering . . . . . . . . . . . . CEREMONIAL ARTIFACT
   use  PLATE, OFFERING
BOX, PACKING . . . . . . . . . . . . . CONTAINER. . . . . . . . . . . . .  186
BOX, PATCH . . . . . . . . . . . . . . ARMAMENT -- ACCESSORY. . . . . . .  130
BOX, PERCUSSION CAP. . . . . . . . . . ARMAMENT -- ACCESSORY. . . . . . .  130
  Box, Picnic . . . . . . . . . . . . . FOOD SERVICE T&E
   use  HAMPER, PICNIC
  Box, Pill . . . . . . . . . . . . . . PERSONAL GEAR
   use  PILLBOX
BOX, PIN . . . . . . . . . . . . . . . TEXTILEWORKING T&E . . . . . . . .  105
BOX, PIPE. . . . . . . . . . . . . . . HOUSEHOLD ACCESSORY. . . . . . . .   16
BOX, POUNCE. . . . . . . . . . . . . . WRITTEN COMMUNICATION T&E. . . . .  183
  Box, Powder . . . . . . . . . . . . . TOILET ARTICLE
   use  BOX, PUFF
BOX, PUFF. . . . . . . . . . . . . . . TOILET ARTICLE . . . . . . . . . .   38
BOX, RESISTANCE. . . . . . . . . . . . ELECTRICAL & MAGNETIC T&E. . . . .  142
BOX, SALT. . . . . . . . . . . . . . . FOOD PROCESSING T&E. . . . . . . .   58
BOX, SARDINE . . . . . . . . . . . . . FOOD SERVICE T&E . . . . . . . . .   70
BOX, SHADOW. . . . . . . . . . . . . . ART. . . . . . . . . . . . . . . .  205
BOX, SHAVING . . . . . . . . . . . . . TOILET ARTICLE . . . . . . . . . .   38
BOX, SHIP'S LOG. . . . . . . . . . . . WATER TRANSPORTATION -- ACCESSORY. 201
BOX, SHIPWRIGHT'S CAULKING . . . . . . WOODWORKING T&E. . . . . . . . . .  113
BOX, SHIPWRIGHT'S OIL. . . . . . . . . WOODWORKING T&E. . . . . . . . . .  113
BOX, SHOEING . . . . . . . . . . . . . ANIMAL HUSBANDRY T&E . . . . . . .   52
BOX, SIGNET. . . . . . . . . . . . . . WRITTEN COMMUNICATION T&E. . . . .  183
BOX, SLUICE. . . . . . . . . . . . . . MINING & MINERAL HARVESTING T&E. .   98
BOX, SNEAK . . . . . . . . . . . . . . WATER TRANSPORTATION -- EQUIPMENT. 198
```

- -

```
  Box, Snuff. . . . . . . . . . . . . . PERSONAL GEAR
    use  SNUFFBOX
BOX, SPICE . . . . . . . . . . . . . . FOOD PROCESSING T&E. . . . . . . .  58
  Box, Spoon. . . . . . . . . . . . . . FOOD SERVICE T&E
    use  TRAY, FLATWARE
BOX, STAMP . . . . . . . . . . . . . . WRITTEN COMMUNICATION T&E. . . . . 183
BOX, STORAGE . . . . . . . . . . . . . CONTAINER. . . . . . . . . . . . . 186
  Box, Strong . . . . . . . . . . . . . HOUSEHOLD ACCESSORY
    use  STRONGBOX
BOX, STUFFER . . . . . . . . . . . . . TEXTILEWORKING T&E . . . . . . . . 105
BOX, STUFFING. . . . . . . . . . . . . MINING & MINERAL HARVESTING T&E. .  98
BOX, SUCTION . . . . . . . . . . . . . PAPERMAKING T&E. . . . . . . . . . 103
  Box, Surprise . . . . . . . . . . . . TOY
    use  JACK-IN-THE-BOX
BOX, TACK. . . . . . . . . . . . . . . LTE -- ACCESSORY . . . . . . . . . 194
BOX, TACKLE. . . . . . . . . . . . . . FISHING & TRAPPING T&E . . . . . .  56
BOX, TOBACCO . . . . . . . . . . . . . PERSONAL GEAR. . . . . . . . . . .  35
BOX, TOOL. . . . . . . . . . . . . . . WOODWORKING T&E. . . . . . . . . . 113
BOX, TOOL. . . . . . . . . . . . . . . MULTIPLE USE ARTIFACT. . . . . . . 227
BOX, TRINKET . . . . . . . . . . . . . HOUSEHOLD ACCESSORY. . . . . . . .  16
  Box, Turning. . . . . . . . . . . . . WOODWORKING T&E
    use  BOX, MOLDING
  Box, Voting . . . . . . . . . . . . . REGULATIVE & PROTECTIVE T&E
    use  BOX, BALLOT
BOX, WALL. . . . . . . . . . . . . . . HOUSEHOLD ACCESSORY. . . . . . . .  16
  Box, Wood . . . . . . . . . . . . . . TEMPERATURE CONTROL DEVICE
    use  WOODBIN
  Box, Writing. . . . . . . . . . . . . WRITTEN COMMUNICATION T&E
    use  DESK, PORTABLE
BOXCAR . . . . . . . . . . . . . . . . RAIL TRANSPORTATION -- EQUIPMENT . 196
BRACE. . . . . . . . . . . . . . . . . WOODWORKING T&E. . . . . . . . . . 113
BRACE. . . . . . . . . . . . . . . . . MULTIPLE USE ARTIFACT. . . . . . . 227
BRACE, ENGINEER'S RATCHET. . . . . . . WOODWORKING T&E. . . . . . . . . . 113
BRACE, EXTENSION . . . . . . . . . . . WOODWORKING T&E. . . . . . . . . . 113
BRACE, SPOFFORD. . . . . . . . . . . . WOODWORKING T&E. . . . . . . . . . 113
BRACE, WIMBLE. . . . . . . . . . . . . WOODWORKING T&E. . . . . . . . . . 113
BRACELET . . . . . . . . . . . . . . . ADORNMENT. . . . . . . . . . . . .  24
BRACKET. . . . . . . . . . . . . . . . HOUSEHOLD ACCESSORY. . . . . . . .  16
BRACKET. . . . . . . . . . . . . . . . BUILDING COMPONENT . . . . . . . .   4
BRACKET, FIRESET . . . . . . . . . . . TEMPERATURE CONTROL DEVICE . . . .  22
BRACKET, FLOWERPOT . . . . . . . . . . BUILDING COMPONENT . . . . . . . .   4
BRACKET, LAMP. . . . . . . . . . . . . BUILDING COMPONENT . . . . . . . .   4
BRACKET, PEDIMENT. . . . . . . . . . . BUILDING COMPONENT . . . . . . . .   4
  Bracket, Plant. . . . . . . . . . . . BUILDING COMPONENT
    use  BRACKET, FLOWERPOT
BRACKET, ROD . . . . . . . . . . . . . WINDOW OR DOOR COVERING. . . . . .  23
  Bracket, Shelf. . . . . . . . . . . . BUILDING COMPONENT
    use  BRACKET
  Bracket, Wall . . . . . . . . . . . . BUILDING COMPONENT
    use  BRACKET
```

- -

```
BRAD . . . . . . . . . . . . . . . . WOODWORKING T&E. . . . . . . . . 113
BRADAWL. . . . . . . . . . . . . . . WOODWORKING T&E. . . . . . . . . 113
 Braid . . . . . . . . . . . . . . . TEXTILEWORKING T&E
  use  TRIM
BRAIDER. . . . . . . . . . . . . . . TEXTILEWORKING T&E . . . . . . . 105
BRAKE. . . . . . . . . . . . . . . . METALWORKING T&E . . . . . . . .  88
  rt   MACHINE, FOLDING
BRAKE. . . . . . . . . . . . . . . . BASKET, BROOM, BRUSH MAKING T&E. . 121
 Brake . . . . . . . . . . . . . . . LTE -- ANIMAL-POWERED
  use  BREAK, SKELETON or BREAK, WAGONETTE
BRAKE, BAND. . . . . . . . . . . . . MECHANICAL T&E . . . . . . . . . 147
 Brake, Cleaving . . . . . . . . . . WOODWORKING T&E
  use  HORSE, FROE
BRAKE, MUZZLE. . . . . . . . . . . . ARMAMENT -- ACCESSORY. . . . . . 130
BRANDER, FREEZING. . . . . . . . . . ANIMAL HUSBANDRY T&E . . . . . .  52
BRANDER, HORN. . . . . . . . . . . . ANIMAL HUSBANDRY T&E . . . . . .  52
BRASSIERE. . . . . . . . . . . . . . CLOTHING -- UNDERWEAR. . . . . .  32
BRAYER . . . . . . . . . . . . . . . PRINTING T&E . . . . . . . . . . 177
BRAZIER. . . . . . . . . . . . . . . FOOD PROCESSING T&E. . . . . . .  58
BRAZIER. . . . . . . . . . . . . . . METALWORKING T&E . . . . . . . .  88
 Breadboard. . . . . . . . . . . . . FOOD PROCESSING T&E
  use  BOARD, CUTTING
 Break, Peg. . . . . . . . . . . . . LEATHER, HORN, SHELLWORKING T&E
  use  RASP, SHOEMAKER'S
BREAK, SKELETON. . . . . . . . . . . LTE -- ANIMAL-POWERED. . . . . . 188
BREAK, WAGONETTE . . . . . . . . . . LTE -- ANIMAL-POWERED. . . . . . 188
BREAKER, BALE. . . . . . . . . . . . TEXTILEWORKING T&E . . . . . . . 105
BREAKER, BUTTON. . . . . . . . . . . TEXTILEWORKING T&E . . . . . . . 105
BREAKER, CIRCUIT . . . . . . . . . . ELECTRICAL & MAGNETIC T&E. . . . 142
BREAKER, FLAX. . . . . . . . . . . . TEXTILEWORKING T&E . . . . . . . 105
 Breakfront. . . . . . . . . . . . . FURNITURE
  use   more specific term, e.g.: BOOKCASE; CABINET, CHINA
BREASTPLATE. . . . . . . . . . . . . WOODWORKING T&E. . . . . . . . . 113
BREASTPLATE. . . . . . . . . . . . . ARMAMENT -- BODY ARMOR . . . . . 129
 Breechcloth . . . . . . . . . . . . CLOTHING -- OUTERWEAR
  use  LOINCLOTH
BREECHES . . . . . . . . . . . . . . CLOTHING -- OUTERWEAR. . . . . .  29
 Breeches, Jodhpur . . . . . . . . . CLOTHING -- OUTERWEAR
  use  BREECHES, RIDING
BREECHES, RIDING . . . . . . . . . . CLOTHING -- OUTERWEAR. . . . . .  29
BREECHES, TRUNK. . . . . . . . . . . CLOTHING -- OUTERWEAR. . . . . .  29
BRELOQUE . . . . . . . . . . . . . . ADORNMENT. . . . . . . . . . . .  24
BRIC-A-BRAC. . . . . . . . . . . . . ART. . . . . . . . . . . . . . . 205
BRICK. . . . . . . . . . . . . . . . BUILDING COMPONENT . . . . . . .   4
 Brick, Kiln . . . . . . . . . . . . GLASS, PLASTICS, CLAYWORKING T&E
  use  FIREBRICK
BRICK, PAVING. . . . . . . . . . . . SITE FEATURE . . . . . . . . . .   7
BRIDGE . . . . . . . . . . . . . . . OTHER STRUCTURE. . . . . . . . .   7
  rt   TRESTLE
BRIDGE, BILLIARD . . . . . . . . . . SPORTS EQUIPMENT . . . . . . . . 220
```

- -

```
BRIDGE, COVERED. . . . . . . . . . . . . OTHER STRUCTURE. . . . . . . . .    7
BRIDGE, WHEATSTONE . . . . . . . . . . . ELECTRICAL & MAGNETIC T&E. . . . .  142
BRIDLE . . . . . . . . . . . . . . . . . LTE -- ACCESSORY . . . . . . . .   194
BRIDLE, NET. . . . . . . . . . . . . . . FISHING & TRAPPING T&E . . . . . .  56
BRIDLE, SINGLE . . . . . . . . . . . . . LTE -- ACCESSORY . . . . . . . .   194
BRIDLE, TEAM . . . . . . . . . . . . . . LTE -- ACCESSORY . . . . . . . .   194
BRIEFCASE. . . . . . . . . . . . . . . . PERSONAL GEAR. . . . . . . . . .    35
BRIEFS . . . . . . . . . . . . . . . . . CLOTHING -- UNDERWEAR. . . . . . .  32
BRIER. . . . . . . . . . . . . . . . . . FORESTRY T&E . . . . . . . . . .    77
BRISTLE, SEWING. . . . . . . . . . . . . LEATHER, HORN, SHELLWORKING T&E. .  82
BROACH . . . . . . . . . . . . . . . . . METALWORKING T&E . . . . . . . .    88
BROACH . . . . . . . . . . . . . . . . . WOODWORKING T&E. . . . . . . . .   113
   rt  REAMER
BROADAX. . . . . . . . . . . . . . . . . WOODWORKING T&E. . . . . . . . .   113
Broadcaster. . . . . . . . . . . . . . . AGRICULTURAL T&E . . . . . . . .    41
        or SEEDER, HAND SEEDBOX
  Broadcaster . . . . . . . . . . . . . . AGRICULTURAL T&E
  use  SEEDER, CENTRIFUGAL or SEEDER, HAND CENTRIFUGAL or SEEDER, SEEDBOX
  Broadside . . . . . . . . . . . . . . . ADVERTISING MEDIUM
  use  POSTER or HANDBILL
BROADSWORD . . . . . . . . . . . . . . . ARMAMENT -- EDGED. . . . . . . .   126
BROCHE . . . . . . . . . . . . . . . . . TEXTILEWORKING T&E . . . . . . .   105
  Brochure. . . . . . . . . . . . . . . . DOCUMENTARY ARTIFACT
  use  BOOKLET
BROILER. . . . . . . . . . . . . . . . . FOOD PROCESSING T&E. . . . . . .    58
BROOCH . . . . . . . . . . . . . . . . . ADORNMENT. . . . . . . . . . . .    24
   rt  PIN
BROODER, POULTRY . . . . . . . . . . . . ANIMAL HUSBANDRY T&E . . . . . .    52
BROOM. . . . . . . . . . . . . . . . . . MAINTENANCE T&E. . . . . . . . .   145
BROOM, CURLING . . . . . . . . . . . . . SPORTS EQUIPMENT . . . . . . . .   220
BROOM, ELECTRIC. . . . . . . . . . . . . MAINTENANCE T&E. . . . . . . . .   145
BROOM, FIREPLACE . . . . . . . . . . . . TEMPERATURE CONTROL DEVICE . . .    22
BROOM, PUSH. . . . . . . . . . . . . . . MAINTENANCE T&E. . . . . . . . .   145
BROOM, WHISK . . . . . . . . . . . . . . MAINTENANCE T&E. . . . . . . . .   145
BROUGHAM . . . . . . . . . . . . . . . . LTE -- ANIMAL-POWERED. . . . . .   188
   rt  BAROUCHE; CALECHE; CARRIAGE; PHAETON
BRUSH. . . . . . . . . . . . . . . . . . CLOTHING -- ACCESSORY. . . . . .    33
BRUSH. . . . . . . . . . . . . . . . . . MULTIPLE USE ARTIFACT. . . . . .   227
BRUSH, ANIMAL. . . . . . . . . . . . . . ANIMAL HUSBANDRY T&E . . . . . .    52
BRUSH, BORE. . . . . . . . . . . . . . . MUSICAL T&E. . . . . . . . . . .   172
BRUSH, BOTTLE. . . . . . . . . . . . . . MAINTENANCE T&E. . . . . . . . .   145
BRUSH, BURETTE . . . . . . . . . . . . . CHEMICAL T&E . . . . . . . . . .   138
BRUSH, CLOTHES . . . . . . . . . . . . . CLOTHING -- ACCESSORY. . . . . .    33
BRUSH, DUSTING . . . . . . . . . . . . . MAINTENANCE T&E. . . . . . . . .   145
BRUSH, FILE. . . . . . . . . . . . . . . METALWORKING T&E . . . . . . . .    88
BRUSH, FOOD. . . . . . . . . . . . . . . FOOD PROCESSING T&E. . . . . . .    58
BRUSH, GLAZING . . . . . . . . . . . . . GLASS, PLASTICS, CLAYWORKING T&E .  79
BRUSH, HAT . . . . . . . . . . . . . . . CLOTHING -- ACCESSORY. . . . . .    33
BRUSH, LETTERING . . . . . . . . . . . . PAINTING T&E . . . . . . . . . .   102
BRUSH, NAIL. . . . . . . . . . . . . . . TOILET ARTICLE . . . . . . . . .    38
```

- -

- -

```
BUGGY, MOUNTAIN. . . . . . . . . . . . LTE -- ANIMAL-POWERED. . . . . . . 189
BUGLE. . . . . . . . . . . . . . . . . MUSICAL T&E. . . . . . . . . . . . 172
BUGLE, KEY . . . . . . . . . . . . . . MUSICAL T&E. . . . . . . . . . . . 172
BUGLE, VALVE . . . . . . . . . . . . . MUSICAL T&E. . . . . . . . . . . . 172
  Building, Ceremonial. . . . . . . . . BUILDING
   use  more specific term, e.g.: CHURCH; MEETINGHOUSE; TEMPLE
  Building, Civic . . . . . . . . . . . BUILDING
   use  more specific term, e.g.: FIREHOUSE; STATION, POLICE; COURTHOUSE
  Building, Commercial. . . . . . . . . BUILDING
   use  more specific term, e.g.: RESTAURANT; SHOP, BARBER; STORE, DRUG
  Building, Cultural. . . . . . . . . . BUILDING
   use  more specific term, e.g.: MUSEUM; THEATER
  Building, Defense . . . . . . . . . . BUILDING
   use  more specific term, e.g.: ARMORY; BLOCKHOUSE; FORT
  Building, Educational . . . . . . . . BUILDING
   use  more specific term, e.g.: SCHOOL; LIBRARY; MUSEUM
  Building, Farm. . . . . . . . . . . . BUILDING
   use  more specific term, e.g.: BARN; COOP, CHICKEN
  Building, Health. . . . . . . . . . . BUILDING
   use  more specific term, e.g.: HOSPITAL
  Building, Industrial. . . . . . . . . BUILDING
   use  PLANT, INDUSTRIAL
BUILDING, OFFICE . . . . . . . . . . . BUILDING . . . . . . . . . . . . .   1
BUILDING, RECREATIONAL . . . . . . . . BUILDING . . . . . . . . . . . . .   1
  Building, Residential . . . . . . . . BUILDING
   use  HOUSE or another more specific term, e.g.: HOGAN; WICKIUP
BUILDING, STORAGE. . . . . . . . . . . BUILDING . . . . . . . . . . . . .   1
  Building, Transportation. . . . . . . BUILDING
   use  more specific term, e.g.: DEPOT; TERMINAL
BULB, ABSORPTION . . . . . . . . . . . CHEMICAL T&E . . . . . . . . . . . 138
BULB, CONNECTING . . . . . . . . . . . CHEMICAL T&E . . . . . . . . . . . 138
BULB, LIGHT. . . . . . . . . . . . . . LIGHTING DEVICE. . . . . . . . . .  19
BULKHEAD . . . . . . . . . . . . . . . BUILDING COMPONENT . . . . . . . .   4
BULLDOZER. . . . . . . . . . . . . . . CONSTRUCTION T&E . . . . . . . . . 141
BULLET . . . . . . . . . . . . . . . . ARMAMENT -- AMMUNITION . . . . . . 128
BULLET, ARMOR-PIERCING . . . . . . . . ARMAMENT -- AMMUNITION . . . . . . 128
BULLET, CONTROLLED-EXPANSION . . . . . ARMAMENT -- AMMUNITION . . . . . . 128
BULLET, EXPANDING. . . . . . . . . . . ARMAMENT -- AMMUNITION . . . . . . 128
BULLET, INCENDIARY . . . . . . . . . . ARMAMENT -- AMMUNITION . . . . . . 128
BULLET, MINIE. . . . . . . . . . . . . ARMAMENT -- AMMUNITION . . . . . . 128
BULLET, TRACER . . . . . . . . . . . . ARMAMENT -- AMMUNITION . . . . . . 128
BULLHORN . . . . . . . . . . . . . . . SOUND COMMUNICATION T&E. . . . . . 180
BULL-ROARER. . . . . . . . . . . . . . CEREMONIAL ARTIFACT. . . . . . . . 207
BUMPER . . . . . . . . . . . . . . . . BUILDING COMPONENT . . . . . . . .   4
  Bumper. . . . . . . . . . . . . . . . WATER TRANSPORTATION -- ACCESSORY
   use  FENDER
BUNDLE, MEDICINE . . . . . . . . . . . CEREMONIAL ARTIFACT. . . . . . . . 207
BUNG . . . . . . . . . . . . . . . . . WATER TRANSPORTATION -- ACCESSORY. 201
BUNGSTART. . . . . . . . . . . . . . . WOODWORKING T&E. . . . . . . . . . 113
BUNK, FEED . . . . . . . . . . . . . . ANIMAL HUSBANDRY T&E . . . . . . .  52
```

- -

- -

BUZZER SOUND COMMUNICATION T&E. 180
CAB. LTE -- ANIMAL-POWERED. 189
CAB, HANSOM. LTE -- ANIMAL-POWERED. 189
CABER. SPORTS EQUIPMENT 220
 Cabin BUILDING
 use HOUSE
CABINET. FURNITURE. 11
 rt CUPBOARD
CABINET, AUTOCLAVE MEDICAL & PSYCHOLOGICAL T&E. . . . 149
CABINET, CHINA FURNITURE. 11
CABINET, COIN. FURNITURE. 11
CABINET, CORNER. FURNITURE. 11
 Cabinet, Creamery FOOD PROCESSING T&E
 use SEPARATOR, CREAM
 Cabinet, Curio. FURNITURE
 use CABINET, DISPLAY
CABINET, DISPLAY FURNITURE. 11
CABINET, DISPLAY MERCHANDISING T&E. 156
CABINET, FILING. FURNITURE. 11
CABINET, FOOD-STORAGE. FOOD PROCESSING T&E. 59
CABINET, GUN FURNITURE. 11
CABINET, KITCHEN FURNITURE. 11
CABINET, LIQUOR. FURNITURE. 11
CABINET, MEDICINE. BUILDING COMPONENT 4
CABINET, MUSIC FURNITURE. 11
CABINET, PARLOR. FURNITURE. 11
CABINET, PHONOGRAPH. FURNITURE. 11
CABINET, RADIO FURNITURE. 11
CABINET, RECORD. FURNITURE. 11
 Cabinet, Sewing FURNITURE
 use TABLE, SEWING
CABINET, SPICE FOOD PROCESSING T&E. 59
CABINET, TRINKET HOUSEHOLD ACCESSORY. 16
CABLE. WATER TRANSPORTATION -- ACCESSORY. 201
CABLE. DATA PROCESSING T&E. 168
CABLE, SUBMARINE TELECOMMUNICATION T&E. 181
CABLE, TELEPHONE TELECOMMUNICATION T&E. 181
CABOOSE. RAIL TRANSPORTATION -- EQUIPMENT . 196
CABRIOLET. LTE -- ANIMAL-POWERED. 189
 rt CHAISE; VICTORIA
CACHEPOT HOUSEHOLD ACCESSORY. 16
CADDY. FOOD PROCESSING T&E. 59
CADDY, DRAWER. HOUSEHOLD ACCESSORY. 16
 Caddy, Tea. FOOD PROCESSING T&E
 use CADDY
CADGER MINING & MINERAL HARVESTING T&E. . 98
CADRAN, GEMOLOGIST'S LAPIDARY T&E 122
CAFTAN CLOTHING -- OUTERWEAR. 29
 rt ABA; TOGA
CAGE MINING & MINERAL HARVESTING T&E. . 98

- -

```
CAGE, ANIMAL . . . . . . . . . . . . . OTHER STRUCTURE. . . . . . . . . .     7
CAGE, ANIMAL . . . . . . . . . . . . . ANIMAL HUSBANDRY T&E . . . . . . .    52
CAGE, BIRD . . . . . . . . . . . . . . ANIMAL HUSBANDRY T&E . . . . . . .    52
CAGE, DRYING . . . . . . . . . . . . . LEATHER, HORN, SHELLWORKING T&E. .    82
CAGE, INSECT . . . . . . . . . . . . . ANIMAL HUSBANDRY T&E . . . . . . .    52
CAGE, MAN. . . . . . . . . . . . . . . MINING & MINERAL HARVESTING T&E. .    98
CAGE, SOUND. . . . . . . . . . . . . . ACOUSTICAL T&E . . . . . . . . . .   123
CAIRN. . . . . . . . . . . . . . . . . SURVEYING & NAVIGATIONAL T&E . . .   162
CAISSON. . . . . . . . . . . . . . . . LTE -- ANIMAL-POWERED. . . . . . .   189
CALCIMETER . . . . . . . . . . . . . . CHEMICAL T&E . . . . . . . . . . .   138
CALCULATOR, DESK . . . . . . . . . . . DATA PROCESSING T&E. . . . . . . .   168
CALCULATOR, POCKET . . . . . . . . . . DATA PROCESSING T&E. . . . . . . .   168
CALDRON. . . . . . . . . . . . . . . . FOOD PROCESSING T&E. . . . . . . .    59
  Caldron, Scalding . . . . . . . . . . FOOD PROCESSING T&E
   use  SCALDER, HOG
CALECHE. . . . . . . . . . . . . . . . LTE -- ANIMAL-POWERED. . . . . . .   189
   rt  BAROUCHE; CHAISE
CALENDAR . . . . . . . . . . . . . . . DOCUMENTARY ARTIFACT . . . . . . .   210
CALENDER . . . . . . . . . . . . . . . GLASS, PLASTICS, CLAYWORKING T&E .    79
   rt  MACHINE, COATING
CALENDER . . . . . . . . . . . . . . . PAPERMAKING T&E. . . . . . . . . .   103
CALENDER, EMBOSSING. . . . . . . . . . TEXTILEWORKING T&E . . . . . . . .   105
CALIPERS . . . . . . . . . . . . . . . GLASS, PLASTICS, CLAYWORKING T&E .    79
CALIPERS . . . . . . . . . . . . . . . WEIGHTS & MEASURES T&E . . . . . .   166
CALIPERS, DOUBLE . . . . . . . . . . . WEIGHTS & MEASURES T&E . . . . . .   166
CALIPERS, GUNNER'S . . . . . . . . . . ARMAMENT -- ACCESSORY. . . . . . .   131
CALIPERS, INSIDE . . . . . . . . . . . WEIGHTS & MEASURES T&E . . . . . .   166
CALIPERS, OUTSIDE. . . . . . . . . . . WEIGHTS & MEASURES T&E . . . . . .   166
CALIPERS, SHELL. . . . . . . . . . . . ARMAMENT -- ACCESSORY. . . . . . .   131
CALIPERS, TIMBER . . . . . . . . . . . FORESTRY T&E . . . . . . . . . . .    77
CALL, GAME . . . . . . . . . . . . . . ARMAMENT -- ACCESSORY. . . . . . .   131
CALLIOPE . . . . . . . . . . . . . . . MUSICAL T&E. . . . . . . . . . . .   172
CALORIMETER. . . . . . . . . . . . . . THERMAL T&E. . . . . . . . . . . .   164
  Calot . . . . . . . . . . . . . . . . CLOTHING -- HEADWEAR
   use  BEANIE
CALTROP. . . . . . . . . . . . . . . . ARMAMENT -- ACCESSORY. . . . . . .   131
CALUMET. . . . . . . . . . . . . . . . CEREMONIAL ARTIFACT. . . . . . . .   207
CAME . . . . . . . . . . . . . . . . . GLASS, PLASTICS, CLAYWORKING T&E .    79
  Cameo . . . . . . . . . . . . . . . . ADORNMENT
   use  more specific term, e.g.: BROOCH
CAMERA . . . . . . . . . . . . . . . . PHOTOGRAPHIC T&E . . . . . . . . .   176
CAMERA, BOX. . . . . . . . . . . . . . PHOTOGRAPHIC T&E . . . . . . . . .   176
CAMERA, FOLDING. . . . . . . . . . . . PHOTOGRAPHIC T&E . . . . . . . . .   176
CAMERA, MOTION-PICTURE . . . . . . . . PHOTOGRAPHIC T&E . . . . . . . . .   176
CAMERA, RANGEFINDER. . . . . . . . . . PHOTOGRAPHIC T&E . . . . . . . . .   176
CAMERA, SCHMIDT. . . . . . . . . . . . ASTRONOMICAL T&E . . . . . . . . .   135
   rt  TELESCOPE, REFLECTING
CAMERA, SINGLE LENS REFLEX . . . . . . PHOTOGRAPHIC T&E . . . . . . . . .   176
CAMERA, STEREO . . . . . . . . . . . . PHOTOGRAPHIC T&E . . . . . . . . .   176
CAMERA, TELEVISION . . . . . . . . . . TELECOMMUNICATION T&E. . . . . . .   181
```

- -

- -

CANTERBURY FURNITURE. 11
 rt RACK, MAGAZINE
CANTIR FOOD SERVICE T&E 70
CAP. CLOTHING -- HEADWEAR 26
CAP, BATHING CLOTHING -- HEADWEAR 26
CAP, BB. ARMAMENT -- AMMUNITION 128
CAP, BLASTING. MINING & MINERAL HARVESTING T&E. 98
CAP, BOTTLE. HOUSEHOLD ACCESSORY. 16
CAP, BOUDOIR CLOTHING -- HEADWEAR 26
 Cap, Day. CLOTHING -- HEADWEAR
 use BONNET, INDOOR
CAP, DUNCE REGULATIVE & PROTECTIVE T&E. . . 160
CAP, DUST. CLOTHING -- HEADWEAR 27
 Cap, Flat CLOTHING -- HEADWEAR
 use FLATCAP
CAP, FORAGE. CLOTHING -- HEADWEAR 27
CAP, GARRISON. CLOTHING -- HEADWEAR 27
CAP, GOB CLOTHING -- HEADWEAR 27
CAP, LENS. PHOTOGRAPHIC T&E 176
CAP, MINER'S CLOTHING -- HEADWEAR 27
CAP, MUSKET. ARMAMENT -- ACCESSORY. 131
CAP, MUZZLE. ARMAMENT -- ACCESSORY. 131
CAP, NURSE'S CLOTHING -- HEADWEAR 27
 Cap, Officer's. CLOTHING -- HEADWEAR
 use CAP, SERVICE
 Cap, Overseas : CLOTHING -- HEADWEAR
 use CAP, GARRISON
CAP, PERCUSSION. ARMAMENT -- ACCESSORY. 131
CAP, SAILOR. CLOTHING -- HEADWEAR 27
CAP, SERVICE CLOTHING -- HEADWEAR 27
CAP, SNAP. ARMAMENT -- ACCESSORY. 131
CAP, TIMBER. MINING & MINERAL HARVESTING T&E. 98
CAP, WATCH CLOTHING -- HEADWEAR 27
CAP, WINDOW. BUILDING COMPONENT 4
CAPACITOR. ELECTRICAL & MAGNETIC T&E. . . . 142
CAPACITOR, ELECTROLYTIC. ELECTRICAL & MAGNETIC T&E. . . . 142
CAPACITOR, VARIABLE. ELECTRICAL & MAGNETIC T&E. . . . 142
CAPARISON. LTE -- ACCESSORY 194
CAPE CLOTHING -- OUTERWEAR. 29
CAPOTE CLOTHING -- OUTERWEAR. 29
CAPPER, BOTTLE FOOD PROCESSING T&E. 59
 rt MACHINE, BOTTLING
CAPSTAN. WATER TRANSPORTATION -- ACCESSORY. 201
 rt WINDLASS
CAPSULE, TIME. DOCUMENTARY ARTIFACT 210
 Car LTE -- MOTORIZED
 use AUTOMOBILE
CAR, AMBULANCE MINING & MINERAL HARVESTING T&E. 98
CAR, ARMORED LTE -- MOTORIZED 192
CAR, BAGGAGE RAIL TRANSPORTATION -- EQUIPMENT . 196

- -

CAR, BUSINESS. RAIL TRANSPORTATION -- EQUIPMENT . 196
 note use for a car created for use by an executive or official
CAR, CABLE RAIL TRANSPORTATION -- EQUIPMENT . 196
 Car, Chair. RAIL TRANSPORTATION -- EQUIPMENT
 use COACH
 Car, Chair-lounge RAIL TRANSPORTATION -- EQUIPMENT
 use COACH
CAR, COAL. RAIL TRANSPORTATION -- EQUIPMENT . 196
 Car, Commuter RAIL TRANSPORTATION -- EQUIPMENT
 use COACH or CAR, SELF-PROPELLED
CAR, DYNAMOMETER SERVICE RAIL TRANSPORTATION -- EQUIPMENT . 196
 Car, Express. RAIL TRANSPORTATION -- EQUIPMENT
 use CAR, BAGGAGE
CAR, GONDOLA LTE -- MOTORIZED 192
CAR, HOPPER. RAIL TRANSPORTATION -- EQUIPMENT . 196
CAR, INSTRUCTIONAL SERVICE RAIL TRANSPORTATION -- EQUIPMENT . 196
CAR, LOUNGE. RAIL TRANSPORTATION -- EQUIPMENT . 196
CAR, MAN MINING & MINERAL HARVESTING T&E. . 98
CAR, MINE. MINING & MINERAL HARVESTING T&E. . 98
CAR, MONORAIL. RAIL TRANSPORTATION -- EQUIPMENT . 196
 Car, Ore. MINING & MINERAL HARVESTING T&E
 use CAR, MINE
CAR, PASSENGER RAIL TRANSPORTATION -- EQUIPMENT . 196
CAR, PEDAL TOY. 223
CAR, PIGGYBACK RAIL TRANSPORTATION -- EQUIPMENT . 196
 Car, Pullman. RAIL TRANSPORTATION -- EQUIPMENT
 use CAR, SLEEPING
CAR, RACING. LTE -- MOTORIZED 192
CAR, REFRIGERATOR. RAIL TRANSPORTATION -- EQUIPMENT . 196
CAR, SELF-PROPELLED. RAIL TRANSPORTATION -- EQUIPMENT . 196
CAR, SERVICE RAIL TRANSPORTATION -- EQUIPMENT . 196
CAR, SLAG. METALWORKING T&E 88
CAR, SLEEPING. RAIL TRANSPORTATION -- EQUIPMENT . 196
CAR, SLEEPING/LOUNGE RAIL TRANSPORTATION -- EQUIPMENT . 196
CAR, SNOWPLOW SERVICE. RAIL TRANSPORTATION -- EQUIPMENT . 196
CAR, STOCK RAIL TRANSPORTATION -- EQUIPMENT . 196
CAR, SUBWAY. RAIL TRANSPORTATION -- EQUIPMENT . 196
CAR, TANK. RAIL TRANSPORTATION -- EQUIPMENT . 196
CAR, VELOCIPEDE. RAIL TRANSPORTATION -- EQUIPMENT . 196
 rt HANDCAR
CARAFE FOOD SERVICE T&E 70
 rt DECANTER
CARBINE. ARMAMENT -- FIREARM. 124
 rt PETRONEL
CARBOLIMETER CHEMICAL T&E 138
CARBONOMETER CHEMICAL T&E 138
CARBOY MERCHANDISING T&E. 156
CARBUROMETER CHEMICAL T&E 138
CARCASS. ARMAMENT -- AMMUNITION 128
CAR-COUPLER. RAIL TRANSPORTATION -- ACCESSORY . 197

- -

```
CARD . . . . . . . . . . . . . . . . . LEATHER, HORN, SHELLWORKING T&E. .    82
CARD, ADMITTANCE . . . . . . . . . . . DOCUMENTARY ARTIFACT . . . . . . .   210
CARD, ALTAR. . . . . . . . . . . . . . CEREMONIAL ARTIFACT. . . . . . . .   207
CARD, AUTOGRAPH. . . . . . . . . . . . DOCUMENTARY ARTIFACT . . . . . . .   210
CARD, BASEBALL . . . . . . . . . . . . DOCUMENTARY ARTIFACT . . . . . . .   210
 Card, Business reply. . . . . . . . . WRITTEN COMMUNICATION T&E
  use  POSTCARD
CARD, CALLING. . . . . . . . . . . . . DOCUMENTARY ARTIFACT . . . . . . .   210
CARD, CIGARETTE. . . . . . . . . . . . ADVERTISING MEDIUM . . . . . . . .   204
CARD, COMMEMORATIVE. . . . . . . . . . DOCUMENTARY ARTIFACT . . . . . . .   210
CARD, COMPASS. . . . . . . . . . . . . SURVEYING & NAVIGATIONAL T&E . . .   162
CARD, CREDIT . . . . . . . . . . . . . EXCHANGE MEDIUM. . . . . . . . . .   214
CARD, DRAFT. . . . . . . . . . . . . . DOCUMENTARY ARTIFACT . . . . . . .   210
CARD, EDGE-NOTCH . . . . . . . . . . . DATA PROCESSING T&E. . . . . . . .   168
CARD, FLASH. . . . . . . . . . . . . . DOCUMENTARY ARTIFACT . . . . . . .   210
CARD, GREETING . . . . . . . . . . . . DOCUMENTARY ARTIFACT . . . . . . .   210
CARD, HAND . . . . . . . . . . . . . . TEXTILEWORKING T&E . . . . . . . .   105
CARD, IDENTIFICATION . . . . . . . . . DOCUMENTARY ARTIFACT . . . . . . .   210
CARD, INDEX. . . . . . . . . . . . . . WRITTEN COMMUNICATION T&E. . . . .   183
   note unused. If used, may be DOCUMENTARY ARTIFACT
CARD, INSPIRATIONAL. . . . . . . . . . DOCUMENTARY ARTIFACT . . . . . . .   210
CARD, JACQUARD . . . . . . . . . . . . TEXTILEWORKING T&E . . . . . . . .   105
CARD, MEMBERSHIP . . . . . . . . . . . DOCUMENTARY ARTIFACT . . . . . . .   210
CARD, MOURNING . . . . . . . . . . . . DOCUMENTARY ARTIFACT . . . . . . .   210
CARD, PICKER'S . . . . . . . . . . . . AGRICULTURAL T&E . . . . . . . . .    41
CARD, POLITICAL. . . . . . . . . . . . ADVERTISING MEDIUM . . . . . . . .   204
 Card, Post. . . . . . . . . . . . . . DOCUMENTARY ARTIFACT
  use  POSTCARD
CARD, PRAYER . . . . . . . . . . . . . CEREMONIAL ARTIFACT. . . . . . . .   207
CARD, PUNCH. . . . . . . . . . . . . . DATA PROCESSING T&E. . . . . . . .   168
CARD, REPORT . . . . . . . . . . . . . DOCUMENTARY ARTIFACT . . . . . . .   210
CARD, SEWING . . . . . . . . . . . . . TOY. . . . . . . . . . . . . . . .   223
CARD, SHOW . . . . . . . . . . . . . . ADVERTISING MEDIUM . . . . . . . .   204
CARD, SOUVENIR . . . . . . . . . . . . DOCUMENTARY ARTIFACT . . . . . . .   210
 Card, Stereoscope . . . . . . . . . . DOCUMENTARY ARTIFACT
  use  STEREOGRAPH
CARD, STORE. . . . . . . . . . . . . . EXCHANGE MEDIUM. . . . . . . . . .   214
   note a card exchanged for goods at a time of limited available currency
   rt  TOKEN, STORE
CARD, TRADE. . . . . . . . . . . . . . ADVERTISING MEDIUM . . . . . . . .   204
CARD, UNION. . . . . . . . . . . . . . DOCUMENTARY ARTIFACT . . . . . . .   210
CARDBOARD. . . . . . . . . . . . . . . MERCHANDISING T&E. . . . . . . . .   156
CARDIOGRAPH. . . . . . . . . . . . . . MEDICAL & PSYCHOLOGICAL T&E. . . .   149
CAROM. . . . . . . . . . . . . . . . . GAME . . . . . . . . . . . . . . .   217
CARPET . . . . . . . . . . . . . . . . FLOOR COVERING . . . . . . . . . .     9
 Carpetbag . . . . . . . . . . . . . . PERSONAL GEAR
  use  SUITCASE
CARRIAGE . . . . . . . . . . . . . . . LTE -- ANIMAL-POWERED. . . . . . .   189
   rt  BAROUCHE; BROUGHAM; CALECHE; PHAETON
CARRIAGE, BABY . . . . . . . . . . . . LTE -- HUMAN-POWERED . . . . . . .   191
```

- -

```
CARRIAGE, CANNON . . . . . . . . . . . . . LTE -- ANIMAL-POWERED. . . . . . .  189
CARRIAGE, DOLL . . . . . . . . . . . . . . TOY. . . . . . . . . . . . . . . .  223
CARRIAGE, POT-SETTING. . . . . . . . . GLASS, PLASTICS, CLAYWORKING T&E .   79
CARRIAGE, TUNNEL . . . . . . . . . . . MINING & MINERAL HARVESTING T&E. .   98
 Carrick . . . . . . . . . . . . . . . CLOTHING -- OUTERWEAR
   use  GREATCOAT
CARRIER, AIRCRAFT. . . . . . . . . . . WATER TRANSPORTATION -- EQUIPMENT.  198
CARRIER, AMALGAM . . . . . . . . . . . MEDICAL & PSYCHOLOGICAL T&E. . . .  149
CARRIER, AMMUNITION. . . . . . . . . . LTE -- MOTORIZED . . . . . . . . .  192
CARRIER, CHEESE. . . . . . . . . . . . FOOD PROCESSING T&E. . . . . . . .   59
CARRIER, EGG . . . . . . . . . . . . . FOOD PROCESSING T&E. . . . . . . .   59
CARRIER, FEED. . . . . . . . . . . . . ANIMAL HUSBANDRY T&E . . . . . . .   52
CARRIER, GAS MASK. . . . . . . . . . . REGULATIVE & PROTECTIVE T&E. . . .  160
CARRIER, GOLD-FOIL . . . . . . . . . . MEDICAL & PSYCHOLOGICAL T&E. . . .  149
CARRIER, LITTER. . . . . . . . . . . . ANIMAL HUSBANDRY T&E . . . . . . .   52
CARRIER, LOG . . . . . . . . . . . . . TEMPERATURE CONTROL DEVICE . . . .   22
CARRIER, LUGGAGE . . . . . . . . . . . LTE -- ACCESSORY . . . . . . . . .  194
CARRIER, LUGGAGE/SHAWL . . . . . . . . PERSONAL GEAR. . . . . . . . . . .   35
CARRIER, PERSONNEL . . . . . . . . . . LTE -- MOTORIZED . . . . . . . . .  192
 Carriole. . . . . . . . . . . . . . . LTE -- ANIMAL-POWERED
   use  SLEIGH
CARRONADE. . . . . . . . . . . . . . . ARMAMENT -- ARTILLERY. . . . . . .  127
CARROUSEL. . . . . . . . . . . . . . . RECREATIONAL DEVICE. . . . . . . .  219
CART . . . . . . . . . . . . . . . . . LTE -- ANIMAL-POWERED. . . . . . .  189
CART, BATCH. . . . . . . . . . . . . . GLASS, PLASTICS, CLAYWORKING T&E .   79
 Cart, Breaking. . . . . . . . . . . . LTE -- ANIMAL-POWERED
   use  BREAK, SKELETON
CART, DOG. . . . . . . . . . . . . . . LTE -- ANIMAL-POWERED. . . . . . .  189
 Cart, Doll. . . . . . . . . . . . . . TOY
   use  CARRIAGE, DOLL
CART, FIREHOSE . . . . . . . . . . . . LTE -- HUMAN-POWERED . . . . . . .  191
CART, GOLF . . . . . . . . . . . . . . SPORTS EQUIPMENT . . . . . . . . .  220
CART, GOVERNESS. . . . . . . . . . . . LTE -- ANIMAL-POWERED. . . . . . .  189
CART, IRISH JAUNTING . . . . . . . . . LTE -- ANIMAL-POWERED. . . . . . .  189
CART, LIFE-SAVING BEACH. . . . . . . . LTE -- ANIMAL-POWERED. . . . . . .  189
CART, LUMBER . . . . . . . . . . . . . LTE -- ANIMAL-POWERED. . . . . . .  189
CART, MAIL . . . . . . . . . . . . . . LTE -- ANIMAL-POWERED. . . . . . .  189
 Cart, Ox. . . . . . . . . . . . . . . LTE -- ANIMAL-POWERED
   use  OXCART
CART, TEA. . . . . . . . . . . . . . . FURNITURE. . . . . . . . . . . . .   11
   rt   TABLE, TEA
 Cart, Tractor grain . . . . . . . . . AGRICULTURAL T&E
   use  TRAILER, FARM
CARTE-DE-VISITE. . . . . . . . . . . . DOCUMENTARY ARTIFACT . . . . . . .  210
CARTON . . . . . . . . . . . . . . . . MERCHANDISING T&E. . . . . . . . .  156
CARTOON. . . . . . . . . . . . . . . . DOCUMENTARY ARTIFACT . . . . . . .  210
 Cartridge, Blank. . . . . . . . . . . ARMAMENT -- AMMUNITION
   use  CARTRIDGE, DUMMY
CARTRIDGE, CASELESS. . . . . . . . . . ARMAMENT -- AMMUNITION . . . . . .  128
CARTRIDGE, CENTER-FIRE . . . . . . . . ARMAMENT -- AMMUNITION . . . . . .  129
```

- -

- -

- -

```
Casket. . . . . . . . . . . . . . . . . . CEREMONIAL ARTIFACT
  use  COFFIN
CASSEROLE. . . . . . . . . . . . . . . . . FOOD PROCESSING T&E. . . . . . . .   59
CASSOCK. . . . . . . . . . . . . . . . . . CLOTHING -- OUTERWEAR. . . . . . .   29
CASTANETS. . . . . . . . . . . . . . . . . MUSICAL T&E. . . . . . . . . . . .  172
CASTER . . . . . . . . . . . . . . . . . . HOUSEHOLD ACCESSORY. . . . . . . .   16
CASTER . . . . . . . . . . . . . . . . . . FOOD SERVICE T&E . . . . . . . . .   70
CASTING. . . . . . . . . . . . . . . . . . ART. . . . . . . . . . . . . . . .  205
CASTLE . . . . . . . . . . . . . . . . . . BUILDING . . . . . . . . . . . . .    1
CAT. . . . . . . . . . . . . . . . . . . . ARMAMENT -- ACCESSORY. . . . . . .  131
CATAFALQUE . . . . . . . . . . . . . . . . CEREMONIAL ARTIFACT. . . . . . . .  207
CATALOG. . . . . . . . . . . . . . . . . . DOCUMENTARY ARTIFACT . . . . . . .  210
CATALOG. . . . . . . . . . . . . . . . . . ADVERTISING MEDIUM . . . . . . . .  204
CATALOG, TRADE . . . . . . . . . . . . . . ADVERTISING MEDIUM . . . . . . . .  204
CATAMARAN. . . . . . . . . . . . . . . . . WATER TRANSPORTATION -- EQUIPMENT.  198
  rt  SAILBOAT
CATAPULT . . . . . . . . . . . . . . . . . ARMAMENT -- ARTILLERY. . . . . . .  127
CATBOAT, EASTERN . . . . . . . . . . . . . WATER TRANSPORTATION -- EQUIPMENT.  198
CATCHER, FLY . . . . . . . . . . . . . . . HOUSEHOLD ACCESSORY. . . . . . . .   16
CATCHER, HOG . . . . . . . . . . . . . . . ANIMAL HUSBANDRY T&E . . . . . . .   52
CATCHER, POULTRY . . . . . . . . . . . . . ANIMAL HUSBANDRY T&E . . . . . . .   52
CATCHER, WATER . . . . . . . . . . . . . . HOUSEHOLD ACCESSORY. . . . . . . .   16
CATHETER . . . . . . . . . . . . . . . . . MEDICAL & PSYCHOLOGICAL T&E. . . .  149
CATHETOMETER . . . . . . . . . . . . . . . CHEMICAL T&E . . . . . . . . . . .  138
CATHETOMETER . . . . . . . . . . . . . . . SURVEYING & NAVIGATIONAL T&E . . .  162
  Cat-o-nine-tails. . . . . . . . . . . . . REGULATIVE & PROTECTIVE T&E
  use  WHIP
CATOPTER . . . . . . . . . . . . . . . . . OPTICAL T&E. . . . . . . . . . . .  159
CAUL . . . . . . . . . . . . . . . . . . . CLOTHING -- HEADWEAR . . . . . . .   27
  rt  HAIRNET
  Cauldron. . . . . . . . . . . . . . . . . FOOD PROCESSING T&E
  use  CALDRON
CAVIL. . . . . . . . . . . . . . . . . . . MASONRY & STONEWORKING T&E . . . .   86
CEILOMETER . . . . . . . . . . . . . . . . METEOROLOGICAL T&E . . . . . . . .  157
CELESTA. . . . . . . . . . . . . . . . . . MUSICAL T&E. . . . . . . . . . . .  172
CELL, BLEACHING. . . . . . . . . . . . . . PAPERMAKING T&E. . . . . . . . . .  103
CELL, FLOTATION. . . . . . . . . . . . . . MINING & MINERAL HARVESTING T&E. .   98
CELLAR, ROOT . . . . . . . . . . . . . . . SITE FEATURE . . . . . . . . . . .    7
CELLARETTE . . . . . . . . . . . . . . . . FURNITURE. . . . . . . . . . . . .   11
  Celt. . . . . . . . . . . . . . . . . . . WOODWORKING T&E
  use  AX or ADZ
CENSER . . . . . . . . . . . . . . . . . . CEREMONIAL ARTIFACT. . . . . . . .  207
  rt  THURIBLE
CENTERDRILL. . . . . . . . . . . . . . . . METALWORKING T&E . . . . . . . . .   88
CENTRIFUGE, CHEMICAL . . . . . . . . . . . CHEMICAL T&E . . . . . . . . . . .  138
CENTRIFUGE, CLINICAL . . . . . . . . . . . CHEMICAL T&E . . . . . . . . . . .  138
CENTRIFUGE, HUMAN. . . . . . . . . . . . . BIOLOGICAL T&E . . . . . . . . . .  136
CENTROLINEAD . . . . . . . . . . . . . . . DRAFTING T&E . . . . . . . . . . .  170
CEPHALOMETER . . . . . . . . . . . . . . . MEDICAL & PSYCHOLOGICAL T&E. . . .  149
CERTIFICATE, ACHIEVEMENT . . . . . . . . . DOCUMENTARY ARTIFACT . . . . . . .  210
```

- -

```
CERTIFICATE, ATTENDANCE. . . . . . . . DOCUMENTARY ARTIFACT . . . . . . . 210
 Certificate, Award. . . . . . . . . . DOCUMENTARY ARTIFACT
  use  CERTIFICATE, ACHIEVEMENT
CERTIFICATE, BAPTISMAL . . . . . . . . DOCUMENTARY ARTIFACT . . . . . . . 210
CERTIFICATE, BIRTH . . . . . . . . . . DOCUMENTARY ARTIFACT . . . . . . . 210
CERTIFICATE, CITIZENSHIP . . . . . . . DOCUMENTARY ARTIFACT . . . . . . 210
CERTIFICATE, COMMEMORATIVE . . . . . . DOCUMENTARY ARTIFACT . . . . . . . 210
 Certificate, Commendation . . . . . . DOCUMENTARY ARTIFACT
  use  CERTIFICATE, ACHIEVEMENT
CERTIFICATE, CONFIRMATION. . . . . . . DOCUMENTARY ARTIFACT . . . . . . . 210
CERTIFICATE, DEATH . . . . . . . . . . DOCUMENTARY ARTIFACT . . . . . . . 210
CERTIFICATE, DISCHARGE . . . . . . . . DOCUMENTARY ARTIFACT . . . . . . . 210
CERTIFICATE, GIFT. . . . . . . . . . . EXCHANGE MEDIUM. . . . . . . . . 214
CERTIFICATE, MARRIAGE. . . . . . . . . DOCUMENTARY ARTIFACT . . . . . . . 210
CERTIFICATE, MEMBERSHIP. . . . . . . . DOCUMENTARY ARTIFACT . . . . . . . 210
 Certificate, Merit. . . . . . . . . . DOCUMENTARY ARTIFACT
  use  REWARD OF MERIT
CERTIFICATE, REGISTRATION. . . . . . . DOCUMENTARY ARTIFACT . . . . . . . 211
CERTIFICATE, STOCK . . . . . . . . . . DOCUMENTARY ARTIFACT . . . . . . . 211
 Certificate, Testimonial. . . . . . . DOCUMENTARY ARTIFACT
  use  CERTIFICATE, ACHIEVEMENT
CHAD . . . . . . . . . . . . . . . . . DATA PROCESSING T&E. . . . . . . . 168
CHAIN. . . . . . . . . . . . . . . . . MULTIPLE USE ARTIFACT. . . . . . . 227
CHAIN, ANCHOR. . . . . . . . . . . . . WATER TRANSPORTATION -- ACCESSORY. 201
CHAIN, BICYCLE . . . . . . . . . . . . LTE -- ACCESSORY . . . . . . . . . 194
CHAIN, BRAKE . . . . . . . . . . . . . FORESTRY T&E . . . . . . . . . . . 77
CHAIN, CURB. . . . . . . . . . . . . . ANIMAL HUSBANDRY T&E . . . . . . . 52
CHAIN, ENGINEER'S. . . . . . . . . . . SURVEYING & NAVIGATIONAL T&E . . . 162
CHAIN, EYEGLASSES. . . . . . . . . . . PERSONAL GEAR. . . . . . . . . . . 36
 rt  CHAIN, LORGNETTE
CHAIN, KEY . . . . . . . . . . . . . . PERSONAL GEAR. . . . . . . . . . . 36
CHAIN, LOG . . . . . . . . . . . . . . FORESTRY T&E . . . . . . . . . . . 77
CHAIN, LORGNETTE . . . . . . . . . . . PERSONAL GEAR. . . . . . . . . . . 36
 rt  CHAIN, EYEGLASSES
CHAIN, OBSTETRICAL . . . . . . . . . . ANIMAL HUSBANDRY T&E . . . . . . . 52
CHAIN, RESTRAINING . . . . . . . . . . REGULATIVE & PROTECTIVE T&E. . . . 160
CHAIN, SURVEYOR'S. . . . . . . . . . . SURVEYING & NAVIGATIONAL T&E . . . 162
CHAIN, TIRE. . . . . . . . . . . . . . LTE -- ACCESSORY . . . . . . . . . 194
CHAIN, WATCH . . . . . . . . . . . . . PERSONAL GEAR. . . . . . . . . . . 36
CHAINS . . . . . . . . . . . . . . . . MUSICAL T&E. . . . . . . . . . . . 172
CHAIR. . . . . . . . . . . . . . . . . FURNITURE. . . . . . . . . . . . . 11
CHAIR, ALTAR . . . . . . . . . . . . . FURNITURE. . . . . . . . . . . . . 11
 Chair, Arm. . . . . . . . . . . . . . FURNITURE
  use  more specific term, e.g.: CHAIR, EASY; -,DINING
CHAIR, BALL-HOLDER'S . . . . . . . . . GLASS, PLASTICS, CLAYWORKING T&E . 79
CHAIR, BALLROOM. . . . . . . . . . . . FURNITURE. . . . . . . . . . . . . 11
CHAIR, BARBER'S. . . . . . . . . . . . FURNITURE. . . . . . . . . . . . . 11
CHAIR, BEACH . . . . . . . . . . . . . FURNITURE. . . . . . . . . . . . . 11
CHAIR, BED . . . . . . . . . . . . . . FURNITURE. . . . . . . . . . . . . 11
 Chair, Bent-wire. . . . . . . . . . . FURNITURE
  use  CHAIR, SODA FOUNTAIN
```

- -

CHAIR, BOATSWAIN'S WATER TRANSPORTATION -- ACCESSORY. 201
CHAIR, CAPTAIN'S FURNITURE. 11
CHAIR, CORNER. FURNITURE. 11
 Chair, Deck FURNITURE
 use CHAIR, FOLDING
CHAIR, DENTIST'S MEDICAL & PSYCHOLOGICAL T&E. . . . 149
CHAIR, DESK. FURNITURE. 11
CHAIR, DINING. FURNITURE. 11
CHAIR, EASY. FURNITURE. 11
CHAIR, ELECTRIC. REGULATIVE & PROTECTIVE T&E. . . . 160
CHAIR, EXAMINING MEDICAL & PSYCHOLOGICAL T&E. . . . 149
CHAIR, FIREPLACE FURNITURE. 11
CHAIR, FOLDING FURNITURE. 11
 Chair, Gaffer's GLASS, PLASTICS, CLAYWORKING T&E
 use BENCH, GLASSMAKER'S
CHAIR, GARDEN. FURNITURE. 11
 Chair, Gondola. FURNITURE
 use CHAIR, DINING
CHAIR, GREAT FURNITURE. 11
CHAIR, HALL. FURNITURE. 11
 Chair, High FURNITURE
 use HIGHCHAIR
CHAIR, INVALID FURNITURE. 11
 Chair, Morris FURNITURE
 use CHAIR, RECLINING
CHAIR, MUSIC FURNITURE. 11
CHAIR, PORTER'S. FURNITURE. 11
CHAIR, POTTY FURNITURE. 11
CHAIR, RECLINING FURNITURE. 12
CHAIR, ROCKING FURNITURE. 12
 Chair, Sedan. LTE -- HUMAN-POWERED
 use SEDAN
 Chair, Side FURNITURE
 use more specific term, e.g.: CHAIR, HALL; -,DINING
CHAIR, SLIPPER FURNITURE. 12
CHAIR, SODA FOUNTAIN FURNITURE. 12
 Chair, Spa. LTE -- HUMAN-POWERED
 use CHAIR, TOURING
CHAIR, STENOGRAPHER'S. FURNITURE. 12
CHAIR, STEP. FURNITURE. 12
 Chair, Swivel FURNITURE
 use more specific term, e.g.: CHAIR, STENOGRAPHER'S
CHAIR, TABLET-ARM. FURNITURE. 12
CHAIR, TOURING LTE -- HUMAN-POWERED 191
CHAIR, TREATMENT FURNITURE. 12
CHAIR, WING. FURNITURE. 12
CHAIR/TABLE. FURNITURE. 12
 rt TABLE, SETTLE
CHAISE LTE -- ANIMAL-POWERED. 189
 rt CABRIOLET; CALECHE

- -

```
CHAISE, POST . . . . . . . . . . . . . . LTE -- ANIMAL-POWERED. . . . . . .   189
 Chaise longue . . . . . . . . . . . . FURNITURE
  use  LOUNGE
 Chalet. . . . . . . . . . . . . . . . BUILDING
  use  HOUSE
CHALICE. . . . . . . . . . . . . . . . . CEREMONIAL ARTIFACT. . . . . . . .   207
CHALK. . . . . . . . . . . . . . . . . . WRITTEN COMMUNICATION T&E. . . . .   183
CHALK, LUMBER. . . . . . . . . . . . . . WOODWORKING T&E. . . . . . . . . .   113
CHALK, TAILOR'S. . . . . . . . . . . . . TEXTILEWORKING T&E . . . . . . . .   105
CHALKBOARD . . . . . . . . . . . . . . . WRITTEN COMMUNICATION T&E. . . . .   183
CHALUMEAU. . . . . . . . . . . . . . . . MUSICAL T&E. . . . . . . . . . . .   172
CHALWAR. . . . . . . . . . . . . . . . . CLOTHING -- OUTERWEAR. . . . . . .    29
CHAMBER, BUBBLE. . . . . . . . . . . . . NUCLEAR PHYSICS T&E. . . . . . . .   158
CHAMBER, CLOUD . . . . . . . . . . . . . METEOROLOGICAL T&E . . . . . . . .   157
CHAMBER, CLOUD . . . . . . . . . . . . . NUCLEAR PHYSICS T&E. . . . . . . .   158
CHAMBER, COUNTING. . . . . . . . . . . . MEDICAL & PSYCHOLOGICAL T&E. . . .   149
CHAMBER, HELIOTROPIC . . . . . . . . . . BIOLOGICAL T&E . . . . . . . . . .   136
CHAMBER, VACUUM. . . . . . . . . . . . . NUCLEAR PHYSICS T&E. . . . . . . .   158
CHANDELIER . . . . . . . . . . . . . . . LIGHTING DEVICE. . . . . . . . . .    19
    note may be modified according to fuel
CHANGKOL . . . . . . . . . . . . . . . . MINING & MINERAL HARVESTING T&E. .    98
CHANNELER. . . . . . . . . . . . . . . . MINING & MINERAL HARVESTING T&E. .    98
CHANNELER. . . . . . . . . . . . . . . . LEATHER, HORN, SHELLWORKING T&E. .    82
CHAPERON . . . . . . . . . . . . . . . . CLOTHING -- OUTERWEAR. . . . . . .    29
CHAPS. . . . . . . . . . . . . . . . . . CLOTHING -- OUTERWEAR. . . . . . .    29
 Charactron. . . . . . . . . . . . . . DATA PROCESSING T&E
  use  UNIT, VISUAL DISPLAY
CHARGE, DEPTH. . . . . . . . . . . . . . ARMAMENT -- AMMUNITION . . . . . .   129
CHARGER. . . . . . . . . . . . . . . . . FOOD SERVICE T&E . . . . . . . . .    70
CHARGER, FENCE . . . . . . . . . . . . . ANIMAL HUSBANDRY T&E . . . . . . .    52
CHARGER, NIPPLE. . . . . . . . . . . . . ARMAMENT -- ACCESSORY. . . . . . .   131
CHARIOT. . . . . . . . . . . . . . . . . LTE -- ANIMAL-POWERED. . . . . . .   189
CHARM. . . . . . . . . . . . . . . . . . ADORNMENT. . . . . . . . . . . . .    24
 Charm, Watch. . . . . . . . . . . . . ADORNMENT
  use  FOB
CHART, FLOW. . . . . . . . . . . . . . . DOCUMENTARY ARTIFACT . . . . . . .   211
CHART, NAVIGATIONAL. . . . . . . . . . . DOCUMENTARY ARTIFACT . . . . . . .   211
CHART, SEATING . . . . . . . . . . . . . DOCUMENTARY ARTIFACT . . . . . . .   211
CHART, VISUAL-ACUITY . . . . . . . . . . MEDICAL & PSYCHOLOGICAL T&E. . . .   149
CHARTOMETER. . . . . . . . . . . . . . . DRAFTING T&E . . . . . . . . . . .   170
CHASE. . . . . . . . . . . . . . . . . . PRINTING T&E . . . . . . . . . . .   177
CHASER, SUBMARINE. . . . . . . . . . . . WATER TRANSPORTATION -- EQUIPMENT.   198
CHASUBLE . . . . . . . . . . . . . . . . CLOTHING -- OUTERWEAR. . . . . . .    29
CHATELAINE . . . . . . . . . . . . . . . ADORNMENT. . . . . . . . . . . . .    24
CHECK, BANK. . . . . . . . . . . . . . . DOCUMENTARY ARTIFACT . . . . . . .   211
CHECKERS . . . . . . . . . . . . . . . . GAME . . . . . . . . . . . . . . .   217
CHECKERBOARD . . . . . . . . . . . . . . GAME . . . . . . . . . . . . . . .   217
CHECKERS, CHINESE. . . . . . . . . . . . GAME . . . . . . . . . . . . . . .   217
CHECKWRITER. . . . . . . . . . . . . . . PRINTING T&E . . . . . . . . . . .   177
CHEILVANGROSCOPE . . . . . . . . . . . . MEDICAL & PSYCHOLOGICAL T&E. . . .   149
```

- -

```
Chemise . . . . . . . . . . . . . . . CLOTHING -- OUTERWEAR
  use  DRESS
CHEMISE. . . . . . . . . . . . . . . . CLOTHING -- UNDERWEAR. . . . . . .    32
  Chemisette. . . . . . . . . . . . . . CLOTHING -- OUTERWEAR
  use  BLOUSE
CHESS. . . . . . . . . . . . . . . . . GAME . . . . . . . . . . . . . .   217
CHEST. . . . . . . . . . . . . . . . . FURNITURE. . . . . . . . . . . .    12
CHEST, AMMUNITION. . . . . . . . . . . ARMAMENT -- ACCESSORY. . . . . .   131
CHEST, APOTHECARY. . . . . . . . . . . FURNITURE. . . . . . . . . . . .    12
CHEST, BLANKET . . . . . . . . . . . . FURNITURE. . . . . . . . . . . .    12
CHEST, CAMPAIGN. . . . . . . . . . . . FURNITURE. . . . . . . . . . . .    12
CHEST, CHART . . . . . . . . . . . . . WATER TRANSPORTATION -- ACCESSORY. 201
CHEST, DOLL. . . . . . . . . . . . . . TOY. . . . . . . . . . . . . . .   223
  Chest, High . . . . . . . . . . . . FURNITURE
  use  CHEST OF DRAWERS
  Chest, Hope . . . . . . . . . . . . FURNITURE
  use  CHEST, BLANKET
CHEST, LIQUOR. . . . . . . . . . . . . PERSONAL GEAR. . . . . . . . . .    36
CHEST, MEDICINE. . . . . . . . . . . . HOUSEHOLD ACCESSORY. . . . . . .    16
CHEST, MEDICINE. . . . . . . . . . . . WATER TRANSPORTATION -- ACCESSORY. 201
CHEST, MEDICINE. . . . . . . . . . . . MEDICAL & PSYCHOLOGICAL T&E. . . .  149
CHEST, SEA . . . . . . . . . . . . . . PERSONAL GEAR. . . . . . . . . .    36
CHEST, SEWING. . . . . . . . . . . . . FURNITURE. . . . . . . . . . . .    12
CHEST, SILVER. . . . . . . . . . . . . HOUSEHOLD ACCESSORY. . . . . . .    16
CHEST, TOOL. . . . . . . . . . . . . . MULTIPLE USE ARTIFACT. . . . . .   227
CHEST, VETERINARY. . . . . . . . . . . ANIMAL HUSBANDRY T&E . . . . . .    52
CHEST OF DRAWERS . . . . . . . . . . . FURNITURE. . . . . . . . . . . .    12
  rt   CHIFFOROBE; CHEST ON FRAME
  Chest on chest. . . . . . . . . . . FURNITURE
  use  CHEST OF DRAWERS
CHEST ON FRAME . . . . . . . . . . . . FURNITURE. . . . . . . . . . . .    12
  rt   CHEST OF DRAWERS
CHEVAL-DE-FRISE. . . . . . . . . . . . ARMAMENT -- ACCESSORY. . . . . .   131
CHEVRON. . . . . . . . . . . . . . . . PERSONAL SYMBOL. . . . . . . . .   215
  Chiffonier. . . . . . . . . . . . . FURNITURE
  use  CHEST OF DRAWERS
CHIFFOROBE . . . . . . . . . . . . . . FURNITURE. . . . . . . . . . . .    12
  rt   CHEST OF DRAWERS; WARDROBE
CHIME. . . . . . . . . . . . . . . . . SOUND COMMUNICATION T&E. . . . .   180
  Chime, Wind . . . . . . . . . . . . ART
  use  WIND-BELL
CHIMES . . . . . . . . . . . . . . . . MUSICAL T&E. . . . . . . . . . .   172
CHIMES, DOOR . . . . . . . . . . . . . BUILDING COMPONENT . . . . . . .     4
  Chimney . . . . . . . . . . . . . . BUILDING COMPONENT
  use  more specific term, e.g.: FLUE
  Chimneypiece. . . . . . . . . . . . BUILDING COMPONENT
  use  OVERMANTEL
CHIP, POKER. . . . . . . . . . . . . . GAME . . . . . . . . . . . . . .   217
CHIPPER. . . . . . . . . . . . . . . . PAPERMAKING T&E. . . . . . . . .   103
CHISEL . . . . . . . . . . . . . . . . WOODWORKING T&E. . . . . . . . .   113
```

- -

```
CHISEL . . . . . . . . . . . . . . . . . . MASONRY & STONEWORKING T&E . . . .   86
CHISEL, BARKING. . . . . . . . . . . . . . FORESTRY T&E . . . . . . . . . . .   77
CHISEL, BENT . . . . . . . . . . . . . . . WOODWORKING T&E. . . . . . . . . .  113
CHISEL, BOATBUILDER'S. . . . . . . . . . . WOODWORKING T&E. . . . . . . . . .  113
CHISEL, BRICK. . . . . . . . . . . . . . . MASONRY & STONEWORKING T&E . . . .   86
 Chisel, Broad . . . . . . . . . . . . . . WOODWORKING T&E
  use  SLICK
 Chisel, Bruzz . . . . . . . . . . . . . . WOODWORKING T&E
  use  CHISEL, CORNER
 Chisel, Cant. . . . . . . . . . . . . . . WOODWORKING T&E
  use  CHISEL, FIRMER
CHISEL, CAPE . . . . . . . . . . . . . . . METALWORKING T&E . . . . . . . .     88
CHISEL, CARVING. . . . . . . . . . . . . . WOODWORKING T&E. . . . . . . . . .  113
CHISEL, CORNER . . . . . . . . . . . . . . WOODWORKING T&E. . . . . . . . . .  113
CHISEL, CUTTING. . . . . . . . . . . . . . MASONRY & STONEWORKING T&E . . . .   86
CHISEL, DENTAL . . . . . . . . . . . . . . MEDICAL & PSYCHOLOGICAL T&E. . . .  149
CHISEL, DIAMOND-POINT. . . . . . . . . . . METALWORKING T&E . . . . . . . . .   88
 Chisel, Filecutter's. . . . . . . . . . . METALWORKING T&E
  use  CHISEL, HOT
CHISEL, FIRMER . . . . . . . . . . . . . . WOODWORKING T&E. . . . . . . . . .  113
CHISEL, FLAT . . . . . . . . . . . . . . . METALWORKING T&E . . . . . . . . .   88
 Chisel, Forming . . . . . . . . . . . . . WOODWORKING T&E
  use  CHISEL, FIRMER
 Chisel, Framing . . . . . . . . . . . . . WOODWORKING T&E
  use  CHISEL, FIRMER
CHISEL, GOOSENECK. . . . . . . . . . . . . WOODWORKING T&E. . . . . . . . . .  113
CHISEL, GRAFTING . . . . . . . . . . . . . AGRICULTURAL T&E . . . . . . . . .   41
CHISEL, HALF-ROUND NOSE. . . . . . . . . . METALWORKING T&E . . . . . . . . .   88
CHISEL, HOOF . . . . . . . . . . . . . . . ANIMAL HUSBANDRY T&E . . . . . . .   52
CHISEL, HOT. . . . . . . . . . . . . . . . METALWORKING T&E . . . . . . . . .   89
 rt  CREASER, HOT
CHISEL, ICE. . . . . . . . . . . . . . . . MINING & MINERAL HARVESTING T&E. .   98
CHISEL, ICE. . . . . . . . . . . . . . . . FOOD PROCESSING T&E. . . . . . . .   59
CHISEL, MORTISE. . . . . . . . . . . . . . WOODWORKING T&E. . . . . . . . . .  113
CHISEL, OCTAGONAL. . . . . . . . . . . . . MASONRY & STONEWORKING T&E . . . .   86
CHISEL, PARING . . . . . . . . . . . . . . WOODWORKING T&E. . . . . . . . . .  113
CHISEL, PARTING. . . . . . . . . . . . . . WOODWORKING T&E. . . . . . . . . .  113
CHISEL, PITCHING . . . . . . . . . . . . . MASONRY & STONEWORKING T&E . . . .   86
CHISEL, PLUGGING . . . . . . . . . . . . . MASONRY & STONEWORKING T&E . . . .   86
CHISEL, PRUNING. . . . . . . . . . . . . . AGRICULTURAL T&E . . . . . . . . .   41
CHISEL, RIPPING. . . . . . . . . . . . . . WOODWORKING T&E. . . . . . . . . .  113
 rt  WEDGE
CHISEL, SKEW . . . . . . . . . . . . . . . WOODWORKING T&E. . . . . . . . . .  113
 Chisel, Slice . . . . . . . . . . . . . . WOODWORKING T&E
  use  SLICK
CHISEL, SOCKET . . . . . . . . . . . . . . WOODWORKING T&E. . . . . . . . . .  113
CHISEL, SPLITTING. . . . . . . . . . . . . MASONRY & STONEWORKING T&E . . . .   86
CHISEL, STRAIGHT . . . . . . . . . . . . . MASONRY & STONEWORKING T&E . . . .   86
CHISEL, SURGICAL . . . . . . . . . . . . . MEDICAL & PSYCHOLOGICAL T&E. . . .  149
CHISEL, THONGING . . . . . . . . . . . . . LEATHER, HORN, SHELLWORKING T&E. .   82
```

- -

```
CHISEL, TOOTH. . . . . . . . . . . . MASONRY & STONEWORKING T&E . . . .   86
CHISEL, TURNING. . . . . . . . . . . WOODWORKING T&E. . . . . . . . . .  113
CHLOROMETER. . . . . . . . . . . . . CHEMICAL T&E . . . . . . . . . . .  138
CHOCK. . . . . . . . . . . . . . . . WATER TRANSPORTATION -- ACCESSORY. 201
CHOCK. . . . . . . . . . . . . . . . MULTIPLE USE ARTIFACT. . . . . . .  227
 Choker. . . . . . . . . . . . . . . ADORNMENT
   use  NECKLACE
 Choli . . . . . . . . . . . . . . . CLOTHING -- OUTERWEAR
   use  BLOUSE
CHOPINE. . . . . . . . . . . . . . . CLOTHING -- FOOTWEAR . . . . . . .   25
 Chopper, Ensilage . . . . . . . . . AGRICULTURAL T&E
   use  CUTTER, ENSILAGE
CHOPPER, FEED. . . . . . . . . . . . AGRICULTURAL T&E . . . . . . . . .   41
   rt   CUTTER, ENSILAGE
 Chopper, Fodder . . . . . . . . . . AGRICULTURAL T&E
   use  CHOPPER, FEED
CHOPPER, FOOD. . . . . . . . . . . . FOOD PROCESSING T&E. . . . . . . .   59
 Chopper, Hay. . . . . . . . . . . . AGRICULTURAL T&E
   use  CHOPPER, FEED
 Chopper, Silage . . . . . . . . . . AGRICULTURAL T&E
   use  CUTTER, ENSILAGE
 Chopper, Stalk. . . . . . . . . . . AGRICULTURAL T&E
   use  CHOPPER, FEED
 Chopper, Stover . . . . . . . . . . AGRICULTURAL T&E
   use  CHOPPER, FEED
CHOPSTICK. . . . . . . . . . . . . . FOOD SERVICE T&E . . . . . . . . .   70
CHOROGRAPH . . . . . . . . . . . . . SURVEYING & NAVIGATIONAL T&E . . . 162
CHROMASCOPE. . . . . . . . . . . . . OPTICAL T&E. . . . . . . . . . . . 159
CHROMATOMETER. . . . . . . . . . . . OPTICAL T&E. . . . . . . . . . . . 159
CHROMATOSCOPE. . . . . . . . . . . . ASTRONOMICAL T&E . . . . . . . . . 135
CHROMATROPE. . . . . . . . . . . . . BIOLOGICAL T&E . . . . . . . . . . 136
CHRONOGRAPH. . . . . . . . . . . . . TIMEKEEPING T&E. . . . . . . . . . 165
CHRONOMETER. . . . . . . . . . . . . SURVEYING & NAVIGATIONAL T&E . . . 162
 Chronometer, Solar. . . . . . . . . TIMEKEEPING T&E
   use  SUNDIAL
CHRONOSCOPE. . . . . . . . . . . . . TIMEKEEPING T&E. . . . . . . . . . 165
CHRONOTHERMOMETER. . . . . . . . . . THERMAL T&E. . . . . . . . . . . . 164
CHUCK. . . . . . . . . . . . . . . . WOODWORKING T&E. . . . . . . . . . 113
CHUCK, BOW DRILL . . . . . . . . . . METALWORKING T&E . . . . . . . . .  89
CHUCK, DRILL . . . . . . . . . . . . METALWORKING T&E . . . . . . . . .  89
CHUCK, LATHE . . . . . . . . . . . . METALWORKING T&E . . . . . . . . .  89
CHUCK, TAP . . . . . . . . . . . . . METALWORKING T&E . . . . . . . . .  89
CHURCH . . . . . . . . . . . . . . . BUILDING . . . . . . . . . . . . .    1
CHURN. . . . . . . . . . . . . . . . FOOD PROCESSING T&E. . . . . . . .   59
CHURN, BUTTER. . . . . . . . . . . . FOOD PROCESSING T&E. . . . . . . .   59
 Churn, Sylabub. . . . . . . . . . . FOOD PROCESSING T&E
   use  WHIP, CREAM
CHUTE, GRAIN . . . . . . . . . . . . AGRICULTURAL T&E . . . . . . . . .   42
CHYOMETER. . . . . . . . . . . . . . CHEMICAL T&E . . . . . . . . . . . 138
CIBORIUM . . . . . . . . . . . . . . CEREMONIAL ARTIFACT. . . . . . . . 207
```

- -

- -

- -

CLIP, PRINT. PHOTOGRAPHIC T&E 176
 Clip, Shirt CLOTHING -- ACCESSORY
 use CLASP
CLIP, TIE. CLOTHING -- ACCESSORY. 33
CLIPBOARD. WRITTEN COMMUNICATION T&E. 183
CLIPPER, ANIMAL. ANIMAL HUSBANDRY T&E 52
 Clipper, Bolt METALWORKING T&E
 use CUTTER, BOLT
CLIPPERS, FLOWER AGRICULTURAL T&E 42
CLIPPERS, HAIR TOILET ARTICLE 38
CLIPPERS, NAIL TOILET ARTICLE 38
CLOAK. CLOTHING -- OUTERWEAR. 29
 rt BURNOUS
CLOCHE CLOTHING -- HEADWEAR 27
CLOCK. TIMEKEEPING T&E. 165
CLOCK, ALARM TIMEKEEPING T&E. 165
CLOCK, ASTRONOMICAL. ASTRONOMICAL T&E 135
CLOCK, CARRIAGE. TIMEKEEPING T&E. 165
CLOCK, CASE. TIMEKEEPING T&E. 165
 Clock, Grandfather. TIMEKEEPING T&E
 use CLOCK, TALL CASE
 Clock, Grandmother. TIMEKEEPING T&E
 use CLOCK, CASE
CLOCK, SHIP'S. TIMEKEEPING T&E. 165
CLOCK, SIDEREAL. ASTRONOMICAL T&E 135
CLOCK, TALL CASE TIMEKEEPING T&E. 165
CLOCK, TIME RECORDING. TIMEKEEPING T&E. 165
CLOCK, TRAVEL. TIMEKEEPING T&E. 165
CLOCK, TURRET. TIMEKEEPING T&E. 165
CLOCK, WALL. TIMEKEEPING T&E. 165
CLOCK, WATER TIMEKEEPING T&E. 165
CLOG CLOTHING -- FOOTWEAR 25
 Cloth, Altar. CEREMONIAL ARTIFACT
 use FRONTAL
 Cloth, Bread Basket FOOD SERVICE T&E
 use NAPKIN, BREAD BASKET
CLOTH, CLEANING. MAINTENANCE T&E. 145
 Cloth, Dish MAINTENANCE T&E
 use DISHCLOTH
CLOTH, EMERY WOODWORKING T&E. 114
CLOTH, EMERY METALWORKING T&E 89
CLOTH, GROUND. BEDDING. 9
 Cloth, Mantel HOUSEHOLD ACCESSORY
 use LAMBREQUIN
CLOTHES, DOLL. TOY. 223
CLOTHESLINE. MAINTENANCE T&E. 145
CLOTHESPIN MAINTENANCE T&E. 145
CLOTH FRAGMENT ARTIFACT REMNANT 227
 rt LACE FRAGMENT
CLUB ARMAMENT -- BLUDGEON 127

- -

```
Club, Billy . . . . . . . . . . . . . . REGULATIVE & PROTECTIVE T&E
  use  NIGHTSTICK
CLUB, FROE . . . . . . . . . . . . . . . WOODWORKING T&E. . . . . . . . . . 114
CLUB, GOLF . . . . . . . . . . . . . . . SPORTS EQUIPMENT . . . . . . . . . 220
CLUB, INDIAN . . . . . . . . . . . . . . SPORTS EQUIPMENT . . . . . . . . . 220
COACH. . . . . . . . . . . . . . . . . . LTE -- ANIMAL-POWERED. . . . . . . 189
COACH. . . . . . . . . . . . . . . . . . RAIL TRANSPORTATION -- EQUIPMENT . 196
COACH, BERLIN. . . . . . . . . . . . . . LTE -- ANIMAL-POWERED. . . . . . . 189
COACH, CONCORD . . . . . . . . . . . . . LTE -- ANIMAL-POWERED. . . . . . . 189
COACH, ROAD. . . . . . . . . . . . . . . LTE -- ANIMAL-POWERED. . . . . . . 189
  rt  STAGECOACH; DRAG, PARK
 Coach, Stage. . . . . . . . . . . . . . LTE -- ANIMAL-POWERED
  use  STAGECOACH
COACH, STATE . . . . . . . . . . . . . . LTE -- ANIMAL-POWERED. . . . . . . 189
 Coach-and-four. . . . . . . . . . . . . LTE -- ANIMAL-POWERED
  use  more specific term, e.g.: BREAK, WAGONETTE; COACH, ROAD
COAGULOMETER . . . . . . . . . . . . . . BIOLOGICAL T&E . . . . . . . . . . 136
COASTER. . . . . . . . . . . . . . . . . FOOD SERVICE T&E . . . . . . . . . 70
COASTER, ROLLER. . . . . . . . . . . . . RECREATIONAL DEVICE. . . . . . . . 219
COASTER, WINE. . . . . . . . . . . . . . FOOD SERVICE T&E . . . . . . . . . 70
COAT . . . . . . . . . . . . . . . . . . CLOTHING -- OUTERWEAR. . . . . . . 29
COAT, CUTAWAY. . . . . . . . . . . . . . CLOTHING -- OUTERWEAR. . . . . . . 29
COAT, EVENING. . . . . . . . . . . . . . CLOTHING -- OUTERWEAR. . . . . . . 29
COAT; FROCK. . . . . . . . . . . . . . . CLOTHING -- OUTERWEAR. . . . . . . 29
COAT, LABORATORY . . . . . . . . . . . . CLOTHING -- OUTERWEAR. . . . . . . 29
 Coat, Morning . . . . . . . . . . . . . CLOTHING -- OUTERWEAR
  use  COAT, CUTAWAY
COAT, SPORTS . . . . . . . . . . . . . . CLOTHING -- OUTERWEAR. . . . . . . 29
COATEE . . . . . . . . . . . . . . . . . CLOTHING -- OUTERWEAR. . . . . . . 29
COATHANGER . . . . . . . . . . . . . . . HOUSEHOLD ACCESSORY. . . . . . . . 16
 Coat of arms. . . . . . . . . . . . . . PERSONAL SYMBOL
  use  more specific term, e.g.: RING, PLAQUE, SHIELD
COATRACK . . . . . . . . . . . . . . . . FURNITURE. . . . . . . . . . . . . 12
  rt  RACK, HAT
COAT-TREE. . . . . . . . . . . . . . . . FURNITURE. . . . . . . . . . . . . 12
  rt  HALLSTAND
COCKCROFT WALTON . . . . . . . . . . . . NUCLEAR PHYSICS T&E. . . . . . . . 158
CODDLER. . . . . . . . . . . . . . . . . FOOD PROCESSING T&E. . . . . . . . 59
CODPIECE . . . . . . . . . . . . . . . . CLOTHING -- OUTERWEAR. . . . . . . 29
COFFEEPOT. . . . . . . . . . . . . . . . FOOD SERVICE T&E . . . . . . . . . 70
COFFIN . . . . . . . . . . . . . . . . . CEREMONIAL ARTIFACT. . . . . . . . 207
  rt  SARCOPHAGUS; CASE, MUMMY
COGGLE . . . . . . . . . . . . . . . . . GLASS, PLASTICS, CLAYWORKING T&E . 79
COIN . . . . . . . . . . . . . . . . . . EXCHANGE MEDIUM. . . . . . . . . . 214
COIN, COMMEMORATIVE. . . . . . . . . . . DOCUMENTARY ARTIFACT . . . . . . . 211
COLANDER . . . . . . . . . . . . . . . . FOOD PROCESSING T&E. . . . . . . . 59
COLLAGE. . . . . . . . . . . . . . . . . ART. . . . . . . . . . . . . . . . 205
COLLAR . . . . . . . . . . . . . . . . . CLOTHING -- ACCESSORY. . . . . . . 33
  rt  RUCHE; RUFF
 Collar. . . . . . . . . . . . . . . . . ARMAMENT -- BODY ARMOR
  use  GORGET
```

- -

```
COLLAR, BARK-TRAINING. . . . . . . . . ANIMAL HUSBANDRY T&E . . . . . . .    52
COLLAR, BELL . . . . . . . . . . . . . ANIMAL HUSBANDRY T&E . . . . . . .    52
COLLAR, BREAST . . . . . . . . . . . . LTE -- ACCESSORY . . . . . . . . .   194
COLLAR, CHOKE. . . . . . . . . . . . . ANIMAL HUSBANDRY T&E . . . . . . .    52
COLLAR, FLEA . . . . . . . . . . . . . ANIMAL HUSBANDRY T&E . . . . . . .    52
COLLAR, HORSE. . . . . . . . . . . . . LTE -- ACCESSORY . . . . . . . . .   194
COLLAR, PET. . . . . . . . . . . . . . ANIMAL HUSBANDRY T&E . . . . . . .    52
 Collarbone. . . . . . . . . . . . . . CLOTHING -- ACCESSORY
   use  STAY, COLLAR
COLLATOR . . . . . . . . . . . . . . . DATA PROCESSING T&E. . . . . . . .   168
COLLIMATOR . . . . . . . . . . . . . . OPTICAL T&E. . . . . . . . . . . .   159
COLLIMATOR . . . . . . . . . . . . . . NUCLEAR PHYSICS T&E. . . . . . . .   158
COLORIMETER. . . . . . . . . . . . . . OPTICAL T&E. . . . . . . . . . . .   159
 Colorimeter . . . . . . . . . . . . . CHEMICAL T&E
   use  COMPARATOR
COLUMN . . . . . . . . . . . . . . . . BUILDING COMPONENT . . . . . . . .     4
COMB . . . . . . . . . . . . . . . . . TOILET ARTICLE . . . . . . . . . .    38
COMB . . . . . . . . . . . . . . . . . ADORNMENT. . . . . . . . . . . . .    24
COMB . . . . . . . . . . . . . . . . . BASKET, BROOM, BRUSH MAKING T&E. .   122
COMB . . . . . . . . . . . . . . . . . TEXTILEWORKING T&E . . . . . . . .   105
COMB, ANIMAL . . . . . . . . . . . . . ANIMAL HUSBANDRY T&E . . . . . . .    52
 Comb, Curry . . . . . . . . . . . . . ANIMAL HUSBANDRY T&E
   use  CURRYCOMB
COMB, GRAINING . . . . . . . . . . . . PAINTING T&E . . . . . . . . . . .   102
COMB, HAND . . . . . . . . . . . . . . TEXTILEWORKING T&E . . . . . . . .   105
COMB, MUSTACHE . . . . . . . . . . . . TOILET ARTICLE . . . . . . . . . .    39
COMB, PUFF . . . . . . . . . . . . . . TOILET ARTICLE . . . . . . . . . .    39
COMB, SIDE . . . . . . . . . . . . . . TOILET ARTICLE . . . . . . . . . .    39
COMB, TUCK . . . . . . . . . . . . . . TOILET ARTICLE . . . . . . . . . .    39
COMBINATION. . . . . . . . . . . . . . CLOTHING -- UNDERWEAR. . . . . . .    32
   rt  SUIT, UNION
COMBINE. . . . . . . . . . . . . . . . AGRICULTURAL T&E . . . . . . . . .    42
 Combine, Corn-head. . . . . . . . . . AGRICULTURAL T&E
   use  COMBINE
 Combine, Corn picker/sheller. . . . . AGRICULTURAL T&E
   use  COMBINE
COMBINE, GREEN PEA . . . . . . . . . . AGRICULTURAL T&E . . . . . . . . .    42
COMBINE, PEANUT. . . . . . . . . . . . AGRICULTURAL T&E . . . . . . . . .    42
 Combine, Pull-type. . . . . . . . . . AGRICULTURAL T&E
   use  COMBINE
 Combine, Self-propelled . . . . . . . AGRICULTURAL T&E
   use  COMBINE
 Combine, Side-hill. . . . . . . . . . AGRICULTURAL T&E
   use  COMBINE
 Combinette. . . . . . . . . . . . . . TOILET ARTICLE
   use  POT, CHAMBER
COME-ALONG . . . . . . . . . . . . . . MECHANICAL T&E . . . . . . . . . .   147
   rt  JACK, PULLING
COMFORTER. . . . . . . . . . . . . . . BEDDING. . . . . . . . . . . . . .     9
 Commander . . . . . . . . . . . . . . WOODWORKING T&E
   use  BEETLE
```

- -

- -

CONCENTRATOR METALWORKING T&E 89
CONCENTRATOR MINING & MINERAL HARVESTING T&E. . 98
 note may be modified as are METALWORKING concentrators
CONCENTRATOR, CYCLONE. METALWORKING T&E 89
CONCENTRATOR, ELECTROMAGNETIC. METALWORKING T&E 89
CONCENTRATOR, FLOTATION. METALWORKING T&E 89
CONCENTRATOR, JIG. METALWORKING T&E 89
CONCENTRATOR, SHAKING-TABLE. METALWORKING T&E 89
CONCERTINA MUSICAL T&E. 172
CONCHOMETER. BIOLOGICAL T&E 136
CONDENSER. TEXTILEWORKING T&E 105
CONDENSER. OPTICAL T&E. 159
 Condenser ELECTRICAL & MAGNETIC T&E
 use CAPACITOR
CONDENSER, COTTON. TEXTILEWORKING T&E 105
CONDENSER, GOULDING. TEXTILEWORKING T&E 105
CONDENSER, MILK. FOOD PROCESSING T&E. 59
CONDENSER, ROTATING. NUCLEAR PHYSICS T&E. 158
CONDENSER, RUB-APRON TEXTILEWORKING T&E 105
CONDENSER, RUB-ROLL. TEXTILEWORKING T&E 106
CONDENSER, TAPE. TEXTILEWORKING T&E 106
CONDITIONER, AIR TEMPERATURE CONTROL DEVICE 22
CONDITIONER, GRAIN FOOD PROCESSING T&E. 59
CONDITIONER, HAY AGRICULTURAL T&E 42
 rt MOWER/CONDITIONER
CONDITIONER, WATER PLUMBING FIXTURE 21
 Conditioner, Wheat. FOOD PROCESSING T&E
 use CONDITIONER, GRAIN
CONDUIT. OTHER STRUCTURE. 7
CONE GLASS, PLASTICS, CLAYWORKING T&E . 79
CONE, ABRASIVE DENTAL. MEDICAL & PSYCHOLOGICAL T&E. . . . 150
CONE, ADJUSTING. MEDICAL & PSYCHOLOGICAL T&E. . . . 150
CONE, IMHOFF CHEMICAL T&E 138
CONE, NOSE AEROSPACE -- ACCESSORY 187
CONE, TUNING ACOUSTICAL T&E 123
CONFORMATEUR BIOLOGICAL T&E 136
CONOGRAPH. DRAFTING T&E 171
 rt ELLIPSOGRAPH
CONSOLE. DATA PROCESSING T&E. 168
CONSOLE, LIGHTING. LIGHTING DEVICE. 19
CONTRACT DOCUMENTARY ARTIFACT 211
CONTROL, ANTENNA SOUND COMMUNICATION T&E. 180
 Controller, Card. DATA PROCESSING T&E
 use PROCESSOR, CARD
CONVERTER. METALWORKING T&E 89
CONVERTER. DATA PROCESSING T&E. 168
CONVERTER, AC-DC ENERGY PRODUCTION T&E. 143
CONVERTER, ANALOG-TO-DIGITAL DATA PROCESSING T&E. 168
CONVERTER, CARD-TO-TAPE. DATA PROCESSING T&E. 168
CONVERTER, DIGITAL-TO-ANALOG DATA PROCESSING T&E. 168

- -

CONVERTER, PACIFIC TEXTILEWORKING T&E 106
CONVEYOR MECHANICAL T&E 147
CONVEYOR, BELT MECHANICAL T&E 147
CONVEYOR, BUCKET MECHANICAL T&E 147
 Cooker, Electric. FOOD PROCESSING T&E
 use a more specific term, i.e. OVEN, ELECTRIC
COOKER, FEED AGRICULTURAL T&E 42
COOKER, PRESSURE FOOD PROCESSING T&E. 59
COOLER, BEER FOOD SERVICE T&E 70
 Cooler, Brine FOOD PROCESSING T&E
 use COOLER, DAIRY
COOLER, DAIRY. FOOD PROCESSING T&E. 59
COOLER, HAND PERSONAL GEAR. 36
COOLER, LARD FOOD PROCESSING T&E. 59
 Cooler, Milk. FOOD PROCESSING T&E
 use COOLER, DAIRY
 Cooler, Tubular FOOD PROCESSING T&E
 use COOLER, DAIRY
 Cooler, Unit. FOOD PROCESSING T&E
 use COOLER, DAIRY
COOLER, WATER. FOOD SERVICE T&E 70
COOLER, WINE FOOD SERVICE T&E 70
COOP, CHICKEN. BUILDING 1
COOP, POULTRY-SHIPPING ANIMAL HUSBANDRY T&E 52
 Cope. CLOTHING -- OUTERWEAR
 use CLOAK
 Copper, Soldering METALWORKING T&E
 use IRON, SOLDERING
 Cor, Tenor. MUSICAL T&E
 use MELLOPHONE
CORACLE. WATER TRANSPORTATION -- EQUIPMENT. 198
 rt BOAT, BULL
 Cor anglais MUSICAL T&E
 use HORN, ENGLISH
CORER, FRUIT FOOD PROCESSING T&E. 59
 Cork. HOUSEHOLD ACCESSORY
 use STOPPER, BOTTLE
CORKER, BOTTLE FOOD PROCESSING T&E. 59
CORKSCREW. FOOD PROCESSING T&E. 59
CORNCRIB BUILDING 1
CORNERSTONE. BUILDING COMPONENT 4
CORNET CLOTHING -- HEADWEAR 27
CORNET MUSICAL T&E. 172
CORNET, VALVE. MUSICAL T&E. 172
CORNHUSKER, HAND AGRICULTURAL T&E 42
CORNICE. BUILDING COMPONENT 4
 Cornopean MUSICAL T&E
 use CORNET
CORONOGRAPH. ASTRONOMICAL T&E 135
CORPORAL CEREMONIAL ARTIFACT. 207

- -

- -

```
COVER, FOOD. . . . . . . . . . . . . . . FOOD PROCESSING T&E. . . . . . . .   59
COVER, HELMET. . . . . . . . . . . . . . ARMAMENT -- BODY ARMOR . . . . . .  129
COVER, LAMP. . . . . . . . . . . . . . . HOUSEHOLD ACCESSORY. . . . . . . .   16
COVER, MANHOLE . . . . . . . . . . . . . OTHER STRUCTURE. . . . . . . . . .    7
COVER, MATTRESS. . . . . . . . . . . . . BEDDING. . . . . . . . . . . . . .    9
COVER, PARASOL . . . . . . . . . . . . . PERSONAL GEAR. . . . . . . . . . .   36
 Cover, Piano. . . . . . . . . . . . . . HOUSEHOLD ACCESSORY
   use  THROW
COVER, PILLOW. . . . . . . . . . . . . . BEDDING. . . . . . . . . . . . . .    9
COVER, ROLLING PIN . . . . . . . . . . . FOOD PROCESSING T&E. . . . . . . .   59
COVER, SHOE. . . . . . . . . . . . . . . PERSONAL GEAR. . . . . . . . . . .   36
COVER, STAIR . . . . . . . . . . . . . . FLOOR COVERING . . . . . . . . . .    9
 Cover, Table. . . . . . . . . . . . . . HOUSEHOLD ACCESSORY
   use  THROW, TABLE
COVER, TELESCOPE . . . . . . . . . . . . OPTICAL T&E. . . . . . . . . . . .  159
COVER, VENT. . . . . . . . . . . . . . . ARMAMENT -- ACCESSORY. . . . . . .  131
COVERALLS. . . . . . . . . . . . . . . . CLOTHING -- OUTERWEAR. . . . . . .   29
 Coverlet. . . . . . . . . . . . . . . . BEDDING
   use  BEDSPREAD
COVERPLATE . . . . . . . . . . . . . . . BUILDING COMPONENT . . . . . . . .    4
COWBELL. . . . . . . . . . . . . . . . . ANIMAL HUSBANDRY T&E . . . . . . .   52
COWBELL. . . . . . . . . . . . . . . . . MUSICAL T&E. . . . . . . . . . . .  172
COZY . . . . . . . . . . . . . . . . . . FOOD SERVICE T&E . . . . . . . . .   71
CPU. . . . . . . . . . . . . . . . . . . DATA PROCESSING T&E. . . . . . . .  168
   note use for computer central processing unit
 Cracker . . . . . . . . . . . . . . . . TOY
   use  NOISEMAKER
CRADLE . . . . . . . . . . . . . . . . . FURNITURE. . . . . . . . . . . . .   12
 Cradle, Barley. . . . . . . . . . . . . AGRICULTURAL T&E
   use  SCYTHE, CRADLE
CRADLE, BASKET . . . . . . . . . . . . . LTE -- HUMAN-POWERED . . . . . . .  191
CRADLE, BOARD. . . . . . . . . . . . . . LTE -- HUMAN-POWERED . . . . . . .  191
CRADLE, BOAT . . . . . . . . . . . . . . WATER TRANSPORTATION -- ACCESSORY. 201
CRADLE, CANNON . . . . . . . . . . . . . ARMAMENT -- ACCESSORY. . . . . . .  131
CRADLE, DOLL . . . . . . . . . . . . . . TOY. . . . . . . . . . . . . . . .  223
 Cradle, Grain . . . . . . . . . . . . . AGRICULTURAL T&E
   use  SCYTHE, CRADLE
CRADLE, HUB. . . . . . . . . . . . . . . WOODWORKING T&E. . . . . . . . . .  114
 Cradle, Rounding. . . . . . . . . . . . WOODWORKING T&E
   use  BLOCK, BEVEL
CRADLE, SLAT . . . . . . . . . . . . . . LTE -- HUMAN-POWERED . . . . . . .  191
CRADLE/ROCKER. . . . . . . . . . . . . . FURNITURE. . . . . . . . . . . . .   12
CRADLE-WITH-SPIKES . . . . . . . . . . . REGULATIVE & PROTECTIVE T&E. . . .  160
CRAFT, LANDING . . . . . . . . . . . . . WATER TRANSPORTATION -- EQUIPMENT. 198
CRAKOW . . . . . . . . . . . . . . . . . CLOTHING -- FOOTWEAR . . . . . . .   25
 Cramp . . . . . . . . . . . . . . . . . WOODWORKING T&E
   use  CLAMP
CRANE. . . . . . . . . . . . . . . . . . MECHANICAL T&E . . . . . . . . . .  147
 Crane, Gooseneck. . . . . . . . . . . . LTE -- MOTORIZED
   use  PLATFORM, ELEVATING
```

- -

CRANE, MAIL. RAIL TRANSPORTATION -- ACCESSORY . 197
CRANIOMETER. BIOLOGICAL T&E 136
CRATE, HOG-BREEDING. ANIMAL HUSBANDRY T&E 52
CRATE, SHIPPING. CONTAINER. 186
CRAVAT CLOTHING -- ACCESSORY. 33
CRAYON PAINTING T&E 102
CRAYON, LITHOGRAPHIC PRINTING T&E 177
CRAYON, LUMBER WOODWORKING T&E. 114
CRAYON, MARKING. WRITTEN COMMUNICATION T&E. 183
 Creamer FOOD SERVICE T&E
 use PITCHER, CREAM
CREASER, EDGE. LEATHER, HORN, SHELLWORKING T&E. . 83
CREASER, HOT METALWORKING T&E 89
 rt CHISEL, HOT
CREASER, SCREW LEATHER, HORN, SHELLWORKING T&E. . 83
CREASER, SINGLE. LEATHER, HORN, SHELLWORKING T&E. . 83
CRECHE CEREMONIAL ARTIFACT. 207
 Credenza. FURNITURE
 use SIDEBOARD
CREEL. FISHING & TRAPPING T&E 56
CREEL. TEXTILEWORKING T&E 106
CRESSET. LIGHTING DEVICE. 19
CRESSET. WOODWORKING T&E. 114
CRIB FURNITURE. 12
 Crib, Corn. BUILDING
 use CORNCRIB
CRIB, CRIBBING MINING & MINERAL HARVESTING T&E. . 98
CRIB, TOOL BUILDING 2
CRIBBAGE GAME 217
CRIMPER. GLASS, PLASTICS, CLAYWORKING T&E . 79
 Crimper METALWORKING T&E
 use MACHINE, CRIMPING
CRIMPER. ARMAMENT -- ACCESSORY. 131
CRIMPER. LEATHER, HORN, SHELLWORKING T&E. . 83
CRIMPER, BLASTING CAP. MINING & MINERAL HARVESTING T&E. . 98
 Crimper, Pie. FOOD PROCESSING T&E
 use WHEEL, JAGGING
 Crinoline CLOTHING -- UNDERWEAR
 use PETTICOAT
CROCK. FOOD PROCESSING T&E. 59
CROCK. MERCHANDISING T&E. 156
CROCK. CONTAINER. 186
CROKINOLE. GAME 217
CROOK, HAY AGRICULTURAL T&E 42
CROOK, SHEPHERD'S. ANIMAL HUSBANDRY T&E 52
 Crook, Throw. AGRICULTURAL T&E
 use TIER, CORN SHOCK
CROP, RIDING LTE -- ACCESSORY 194
CROP, RIDING SPORTS EQUIPMENT 220
CROSIER. PERSONAL SYMBOL. 215

- -

Cross PERSONAL SYMBOL
 use PENDANT, RELIGIOUS
Cross CEREMONIAL ARTIFACT
 use PLAQUE, RELIGIOUS
CROSS, TEASLE TEXTILEWORKING T&E 106
 Crossbar MINING & MINERAL HARVESTING T&E
 use CAP, TIMBER
CROSSBOW ARMAMENT -- EDGED 126
CROSS-STAFF SURVEYING & NAVIGATIONAL T&E . . . 162
 rt GROMA
CROSSTIE RAIL TRANSPORTATION -- ACCESSORY . 197
CROWBAR WOODWORKING T&E 114
CROWBAR MULTIPLE USE ARTIFACT 227
CROWN PERSONAL SYMBOL 215
 Crown, Dutch FOOD PROCESSING T&E
 use HOOK, MEAT
CROZE WOODWORKING T&E 114
 rt PLANE
 Crucible GLASS, PLASTICS, CLAYWORKING T&E
 use POT
CRUCIBLE CHEMICAL T&E 138
 Crucifix PERSONAL SYMBOL
 use PENDANT, RELIGIOUS or PLAQUE, RELIGIOUS
 Crucifix CEREMONIAL ARTIFACT
 use STATUE, RELIGIOUS
CRUET FOOD SERVICE T&E 71
CRUISER, GUIDED MISSILE WATER TRANSPORTATION -- EQUIPMENT. 198
CRUISER, HEAVY WATER TRANSPORTATION -- EQUIPMENT. 198
CRUISER, LIGHT WATER TRANSPORTATION -- EQUIPMENT. 198
CRUMBER MAINTENANCE T&E 145
CRUMHORN MUSICAL T&E 172
CRUPPER LTE -- ACCESSORY 194
CRUSHER, BALL MINING & MINERAL HARVESTING T&E. . 98
 Crusher, Chilean MINING & MINERAL HARVESTING T&E
 use CRUSHER, ROLLER
 Crusher, Corn-and-cob AGRICULTURAL T&E
 use GRINDER, FEED
CRUSHER, GYRATORY MINING & MINERAL HARVESTING T&E. . 98
CRUSHER, HAMMER MINING & MINERAL HARVESTING T&E. . 99
CRUSHER, ICE FOOD PROCESSING T&E 60
CRUSHER, JAW MINING & MINERAL HARVESTING T&E. . 99
CRUSHER, ORE MINING & MINERAL HARVESTING T&E. . 99
CRUSHER, ROLLER MINING & MINERAL HARVESTING T&E. . 99
CRUSHER, SEED FOOD PROCESSING T&E 60
CRUSHER, STAMP MINING & MINERAL HARVESTING T&E. . 99
CRUTCH PERSONAL GEAR 36
CRUTCH, BOOM WATER TRANSPORTATION -- ACCESSORY. 201
CRWTH MUSICAL T&E 173
CRYOMETER THERMAL T&E 164
CRYOPHORUS THERMAL T&E 164

```
CUBER, HAY . . . . . . . . . . . . . . . AGRICULTURAL T&E . . . . . . . . .   42
  Cudgel. . . . . . . . . . . . . . . . WOODWORKING T&E
    use  CLUB, FROE
CUE, BILLIARD. . . . . . . . . . . . . . SPORTS EQUIPMENT . . . . . . . . .  220
CUE, SHUFFLEBOARD. . . . . . . . . . . . SPORTS EQUIPMENT . . . . . . . . .  220
CUFF . . . . . . . . . . . . . . . . . . CLOTHING -- ACCESSORY. . . . . . .   33
CUIRASS. . . . . . . . . . . . . . . . . MEDICAL & PSYCHOLOGICAL T&E. . . .  150
CULOTTES . . . . . . . . . . . . . . . . CLOTHING -- OUTERWEAR. . . . . . .   29
  Cultipacker . . . . . . . . . . . . . AGRICULTURAL T&E
    use  ROLLER, LAND
CULTIVATOR . . . . . . . . . . . . . . . AGRICULTURAL T&E . . . . . . . . .   42
    note use for a cultivator on which the operator rides
  Cultivator, Chisel. . . . . . . . . . AGRICULTURAL T&E
    use  CULTIVATOR, FIELD
CULTIVATOR, FIELD. . . . . . . . . . . . AGRICULTURAL T&E . . . . . . . . .   42
    note a machine used for field preparation rather than cultivation
CULTIVATOR, GARDEN . . . . . . . . . . . AGRICULTURAL T&E . . . . . . . . .   42
    note use for any cultivator pushed by hand
CULTIVATOR, HAND . . . . . . . . . . . . AGRICULTURAL T&E . . . . . . . . .   42
    note use for a hand tool employed in garden cultivation
CULTIVATOR, ROTARY . . . . . . . . . . . AGRICULTURAL T&E . . . . . . . . .   42
    note a machine used for weed control or shallow mulching
CULTIVATOR, ROW-CROP . . . . . . . . . . AGRICULTURAL T&E . . . . . . . . .   42
  Cultivator, Straddle-row. . . . . . . AGRICULTURAL T&E
    use  CULTIVATOR
CULTIVATOR, WALKING. . . . . . . . . . . AGRICULTURAL T&E . . . . . . . . .   42
    note use for an animal-drawn cultivator behind which the operator walks
  Cultivator, Wheel-hoe . . . . . . . . AGRICULTURAL T&E
    use  CULTIVATOR, GARDEN
CULVERIN . . . . . . . . . . . . . . . . ARMAMENT -- ARTILLERY. . . . . . .  127
  Cummerbund. . . . . . . . . . . . . . CLOTHING -- ACCESSORY
    use  SASH
CUP. . . . . . . . . . . . . . . . . . . FOOD SERVICE T&E . . . . . . . . .   71
CUP, AMALGAM . . . . . . . . . . . . . . MEDICAL & PSYCHOLOGICAL T&E. . . .  150
CUP, BAPTISMAL . . . . . . . . . . . . . CEREMONIAL ARTIFACT. . . . . . . .  207
CUP, BLEEDING. . . . . . . . . . . . . . MEDICAL & PSYCHOLOGICAL T&E. . . .  150
CUP, BRIDE'S . . . . . . . . . . . . . . CEREMONIAL ARTIFACT. . . . . . . .  207
  Cup, Candy. . . . . . . . . . . . . . FOOD SERVICE T&E
    use  CUP, FAVOR
CUP, CANTEEN . . . . . . . . . . . . . . FOOD SERVICE T&E . . . . . . . . .   71
CUP, CASTER. . . . . . . . . . . . . . . HOUSEHOLD ACCESSORY. . . . . . . .   16
CUP, CAUDLE. . . . . . . . . . . . . . . FOOD SERVICE T&E . . . . . . . . .   71
CUP, CHOCOLATE . . . . . . . . . . . . . FOOD SERVICE T&E . . . . . . . . .   71
CUP, COFFEE. . . . . . . . . . . . . . . FOOD SERVICE T&E . . . . . . . . .   71
CUP, COLLAPSIBLE . . . . . . . . . . . . FOOD SERVICE T&E . . . . . . . . .   71
CUP, COMMUNION . . . . . . . . . . . . . CEREMONIAL ARTIFACT. . . . . . . .  207
  Cup, Cupping. . . . . . . . . . . . . MEDICAL & PSYCHOLOGICAL T&E
    use  CUP, BLEEDING
  Cup, Custard. . . . . . . . . . . . . FOOD PROCESSING T&E
    use  RAMEKIN
```

- -

```
CUP, DEMITASSE . . . . . . . . . . . . . FOOD SERVICE T&E . . . . . . . . .   71
CUP, DENTAL WASTE. . . . . . . . . . . MEDICAL & PSYCHOLOGICAL T&E. . . .  150
CUP, DICE. . . . . . . . . . . . . . . GAME . . . . . . . . . . . . . . .  217
  Cup, Expectorating. . . . . . . . . MEDICAL & PSYCHOLOGICAL T&E
    use  SPITTOON, INVALID
CUP, FAVOR . . . . . . . . . . . . . . FOOD SERVICE T&E . . . . . . . . .   71
CUP, GREASE. . . . . . . . . . . . . . ENERGY PRODUCTION T&E. . . . . . .  143
CUP, GRINDER . . . . . . . . . . . . . METALWORKING T&E . . . . . . . . .   89
CUP, IMPRESSION. . . . . . . . . . . . MEDICAL & PSYCHOLOGICAL T&E. . . .  150
CUP, INVALID . . . . . . . . . . . . . FOOD SERVICE T&E . . . . . . . . .   71
CUP, LOVING. . . . . . . . . . . . . . PERSONAL SYMBOL. . . . . . . . . .  215
    rt  TROPHY
CUP, MEASURING . . . . . . . . . . . . FOOD PROCESSING T&E. . . . . . . .   60
CUP, MUSTACHE. . . . . . . . . . . . . FOOD SERVICE T&E . . . . . . . . .   71
  Cup, Mustard. . . . . . . . . . . . FOOD SERVICE T&E
    use  POT, MUSTARD
CUP, NURSING . . . . . . . . . . . . . FOOD SERVICE T&E . . . . . . . . .   71
    rt  BOTTLE, NURSING
  Cup, Nut. . . . . . . . . . . . . . FOOD SERVICE T&E
    use  CUP, FAVOR
CUP, OIL . . . . . . . . . . . . . . . METALWORKING T&E . . . . . . . . .   89
CUP, PALETTE . . . . . . . . . . . . . PAINTING T&E . . . . . . . . . . .  102
CUP, PUNCH . . . . . . . . . . . . . . FOOD SERVICE T&E . . . . . . . . .   71
CUP, SAKI. . . . . . . . . . . . . . . FOOD SERVICE T&E . . . . . . . . .   71
CUP, SLIP-TRAILING . . . . . . . . . . GLASS, PLASTICS, CLAYWORKING T&E .   79
CUP, SOUP. . . . . . . . . . . . . . . FOOD SERVICE T&E . . . . . . . . .   71
  Cup, Tea. . . . . . . . . . . . . . FOOD SERVICE T&E
    use  TEACUP
CUP, TRAVELING . . . . . . . . . . . . FOOD SERVICE T&E . . . . . . . . .   71
CUP, WAGER . . . . . . . . . . . . . . GAME . . . . . . . . . . . . . . .  217
CUP & BALL . . . . . . . . . . . . . . TOY. . . . . . . . . . . . . . . .  223
CUPBOARD . . . . . . . . . . . . . . . FURNITURE. . . . . . . . . . . . .   12
    rt  CABINET
CUPBOARD, CORNER . . . . . . . . . . . FURNITURE. . . . . . . . . . . . .   12
CUPBOARD, HANGING. . . . . . . . . . . FURNITURE. . . . . . . . . . . . .   12
CUPBOARD, PRESS. . . . . . . . . . . . FURNITURE. . . . . . . . . . . . .   12
CUPEL. . . . . . . . . . . . . . . . . METALWORKING T&E . . . . . . . . .   89
CUPOLA . . . . . . . . . . . . . . . . BUILDING COMPONENT . . . . . . . .    4
CUP & SAUCER . . . . . . . . . . . . . FOOD SERVICE T&E . . . . . . . . .   71
CURETTE. . . . . . . . . . . . . . . . MEDICAL & PSYCHOLOGICAL T&E. . . .  150
CURETTE, ADENOID . . . . . . . . . . . MEDICAL & PSYCHOLOGICAL T&E. . . .  150
CURETTE, ALVEOLAR. . . . . . . . . . . MEDICAL & PSYCHOLOGICAL T&E. . . .  150
CURETTE, BONE. . . . . . . . . . . . . MEDICAL & PSYCHOLOGICAL T&E. . . .  150
CURETTE, PERIODONTAL . . . . . . . . . MEDICAL & PSYCHOLOGICAL T&E. . . .  150
CURLER . . . . . . . . . . . . . . . . TOILET ARTICLE . . . . . . . . . .   39
CURLER, BUTTER . . . . . . . . . . . . FOOD PROCESSING T&E. . . . . . . .   60
CURRENCY . . . . . . . . . . . . . . . EXCHANGE MEDIUM. . . . . . . . . .  214
  note use for paper money not coins
CURRICLE . . . . . . . . . . . . . . . LTE -- ANIMAL-POWERED. . . . . . .  189
CURRYCOMB. . . . . . . . . . . . . . . ANIMAL HUSBANDRY T&E . . . . . . .   52
```

```
CURTAIN. . . . . . . . . . . . . . . . . . WINDOW OR DOOR COVERING. . . . . .    23
CURTAIN, DOOR. . . . . . . . . . . . . . . WINDOW OR DOOR COVERING. . . . . .    23
CURTAIN, FURNITURE . . . . . . . . . . . . WINDOW OR DOOR COVERING. . . . . .    23
CURTAIN, SHOWER. . . . . . . . . . . . . . HOUSEHOLD ACCESSORY. . . . . . . .    16
CURTAIN, STAGE . . . . . . . . . . . . . . PUBLIC ENTERTAINMENT DEVICE. . . .   218
CURTAIN, WINDOW. . . . . . . . . . . . . . WINDOW OR DOOR COVERING. . . . . .    23
CURTAL . . . . . . . . . . . . . . . . . . MUSICAL T&E. . . . . . . . . . .     173
CURVE. . . . . . . . . . . . . . . . . . . DRAFTING T&E . . . . . . . . . .     171
CURVE, BROOK'S . . . . . . . . . . . . . . DRAFTING T&E . . . . . . . . . .     171
CUSHION. . . . . . . . . . . . . . . . . . HOUSEHOLD ACCESSORY. . . . . . . .    16
CUSHION, AIR . . . . . . . . . . . . . . . PERSONAL GEAR. . . . . . . . . . .    36
CUSHION, EMERY . . . . . . . . . . . . . . TEXTILEWORKING T&E . . . . . . .     106
CUSHION, GILDER'S. . . . . . . . . . . . . PAINTING T&E . . . . . . . . . .     102
CUSHION, HELMET. . . . . . . . . . . . . . CLOTHING -- HEADWEAR . . . . . . .    27
CUSHION, LACEMAKER'S . . . . . . . . . . . TEXTILEWORKING T&E . . . . . . .     106
CUSHION, LEAD. . . . . . . . . . . . . . . METALWORKING T&E . . . . . . . .      89
 Cuspidor. . . . . . . . . . . . . . . . . HOUSEHOLD ACCESSORY
   use SPITTOON
CUTLASS. . . . . . . . . . . . . . . . . . ARMAMENT -- EDGED. . . . . . . .     126
CUTTER . . . . . . . . . . . . . . . . . . BASKET, BROOM, BRUSH MAKING T&E. .   122
CUTTER . . . . . . . . . . . . . . . . . . PAPERMAKING T&E. . . . . . . . .     103
CUTTER . . . . . . . . . . . . . . . . . . WATER TRANSPORTATION -- EQUIPMENT.  198
CUTTER . . . . . . . . . . . . . . . . . . LTE -- ANIMAL-POWERED. . . . . .     189
CUTTER, ALBANY . . . . . . . . . . . . . . LTE -- ANIMAL-POWERED. . . . . .     189
CUTTER, BAR. . . . . . . . . . . . . . . . METALWORKING T&E . . . . . . . .      89
CUTTER, BISCUIT. . . . . . . . . . . . . . FOOD PROCESSING T&E. . . . . . .      60
CUTTER, BOARD. . . . . . . . . . . . . . . PRINTING T&E . . . . . . . . . .     177
CUTTER, BOLT . . . . . . . . . . . . . . . METALWORKING T&E . . . . . . . .      89
CUTTER, BONE . . . . . . . . . . . . . . . FOOD PROCESSING T&E. . . . . . .      60
CUTTER, BUTTER . . . . . . . . . . . . . . FOOD PROCESSING T&E. . . . . . .      60
CUTTER, CABBAGE. . . . . . . . . . . . . . FOOD PROCESSING T&E. . . . . . .      60
CUTTER, CAKE . . . . . . . . . . . . . . . ARMAMENT -- ACCESSORY. . . . . .     131
CUTTER, CHANNEL BAR. . . . . . . . . . . . MINING & MINERAL HARVESTING T&E. .    99
CUTTER, CIDER CHEESE . . . . . . . . . . . FOOD PROCESSING T&E. . . . . . .      60
CUTTER, CIGAR. . . . . . . . . . . . . . . PERSONAL GEAR. . . . . . . . . . .    36
CUTTER, CLINCH . . . . . . . . . . . . . . LEATHER, HORN, SHELLWORKING T&E. .    83
CUTTER, CLINCH . . . . . . . . . . . . . . METALWORKING T&E . . . . . . . .      89
CUTTER, COAL . . . . . . . . . . . . . . . MINING & MINERAL HARVESTING T&E. .    99
CUTTER, COOKIE . . . . . . . . . . . . . . FOOD PROCESSING T&E. . . . . . .      60
CUTTER, COUNTRY. . . . . . . . . . . . . . LTE -- ANIMAL-POWERED. . . . . .     189
 Cutter, Curd. . . . . . . . . . . . . . . FOOD PROCESSING T&E
   use KNIFE, CURD
CUTTER, DOUGHNUT . . . . . . . . . . . . . FOOD PROCESSING T&E. . . . . . .      60
 Cutter, Dowel . . . . . . . . . . . . . . WOODWORKING T&E
   use CUTTER, PEG
CUTTER, EDGE . . . . . . . . . . . . . . . PAINTING T&E . . . . . . . . . .     102
CUTTER, EDGE . . . . . . . . . . . . . . . LEATHER, HORN, SHELLWORKING T&E. .    83
CUTTER, ENSILAGE . . . . . . . . . . . . . AGRICULTURAL T&E . . . . . . . .      42
   rt CHOPPER, FEED
 Cutter, Feed. . . . . . . . . . . . . . . AGRICULTURAL T&E
   use CHOPPER, FEED
```

- -

Cutter, Flail AGRICULTURAL T&E
 use SHREDDER, FLAIL
Cutter, Fodder. AGRICULTURAL T&E
 use CHOPPER, FEED
CUTTER, FUZE ARMAMENT -- ACCESSORY. 131
Cutter, Gear. METALWORKING T&E
 use MACHINE, GEAR-CUTTING
CUTTER, GLASS. GLASS, PLASTICS, CLAYWORKING T&E . 79
Cutter, Green bone. FOOD PROCESSING T&E
 use CUTTER, BONE
CUTTER, ICE. MINING & MINERAL HARVESTING T&E. . 99
Cutter, Kraut FOOD PROCESSING T&E
 use CUTTER, CABBAGE
Cutter, Lead. PRINTING T&E
 use CUTTER, SLUG
CUTTER, MAT. PAINTING T&E 102
CUTTER, MICROSCOPIC SECTION. BIOLOGICAL T&E 136
CUTTER, MOLAR. ANIMAL HUSBANDRY T&E 52
Cutter, Nail. ANIMAL HUSBANDRY T&E
 use NIPPERS, NAIL
Cutter, Nail. METALWORKING T&E
 use NIPPERS, NAIL
CUTTER, NOODLE FOOD PROCESSING T&E. 60
CUTTER, PAPER. WRITTEN COMMUNICATION T&E. 183
CUTTER, PAPER. PRINTING T&E 177
CUTTER, PEG. WOODWORKING T&E. 114
CUTTER, PIPE METALWORKING T&E 89
CUTTER, PORTLAND LTE -- ANIMAL-POWERED. 189
CUTTER, POTATO SEED. AGRICULTURAL T&E 43
CUTTER, QUILL. WRITTEN COMMUNICATION T&E. 183
CUTTER, REVOLVING-WHEEL. LEATHER, HORN, SHELLWORKING T&E. . 83
CUTTER, ROOT AGRICULTURAL T&E 43
CUTTER, SHINGLE. WOODWORKING T&E. 114
Cutter, Silage. AGRICULTURAL T&E
 use CUTTER, ENSILAGE
Cutter, Slaw. FOOD PROCESSING T&E
 use CUTTER, CABBAGE
CUTTER, SLUG PRINTING T&E 177
CUTTER, SNOUT. ANIMAL HUSBANDRY T&E 52
CUTTER, SPRUE. ARMAMENT -- ACCESSORY. 131
CUTTER, STALK. AGRICULTURAL T&E 43
Cutter, Stover. AGRICULTURAL T&E
 use CHOPPER, FEED
CUTTER, SUGAR. FOOD PROCESSING T&E. 60
Cutter, Thistle-and-dock. AGRICULTURAL T&E
 use SPUD, WEEDING
CUTTER, TOBACCO. AGRICULTURAL T&E 43
CUTTER, TOBACCO. MERCHANDISING T&E. 156
CUTTER, TOGGLE GLASS, PLASTICS, CLAYWORKING T&E . 79
Cutter, Vegetable AGRICULTURAL T&E
 use CUTTER, ROOT

- -

- -

```
Davenport . . . . . . . . . . . . . . . FURNITURE
   use  SOFA
DAVIT, ANCHOR. . . . . . . . . . . . . WATER TRANSPORTATION -- ACCESSORY.  201
DAVIT, BOAT. . . . . . . . . . . . . . WATER TRANSPORTATION -- ACCESSORY.  201
DAYBED . . . . . . . . . . . . . . . . FURNITURE. . . . . . . . . . . . .   12
DAYBOOK. . . . . . . . . . . . . . . . DOCUMENTARY ARTIFACT . . . . . . .  211
DEADEYE. . . . . . . . . . . . . . . . WATER TRANSPORTATION -- ACCESSORY.  201
DEBEAKER . . . . . . . . . . . . . . . ANIMAL HUSBANDRY T&E . . . . . . .   53
DECAL. . . . . . . . . . . . . . . . . PERSONAL SYMBOL. . . . . . . . . .  215
DECAL. . . . . . . . . . . . . . . . . DOCUMENTARY ARTIFACT . . . . . . .  211
DECANTER . . . . . . . . . . . . . . . FOOD SERVICE T&E . . . . . . . . .   71
   rt  CARAFE
DECANTER, BAR. . . . . . . . . . . . . FOOD SERVICE T&E . . . . . . . . .   71
DECAPPER/RECAPPER. . . . . . . . . . . ARMAMENT -- ACCESSORY. . . . . . .  131
DECK, CARD . . . . . . . . . . . . . . GAME . . . . . . . . . . . . . . .  217
   note use for standard playing cards such as bridge or pinochle decks
DECKLE . . . . . . . . . . . . . . . . PAPERMAKING T&E. . . . . . . . . .  103
DECLARATION, CUSTOMS . . . . . . . . . DOCUMENTARY ARTIFACT . . . . . . .  211
DECLINOMETER . . . . . . . . . . . . . ELECTRICAL & MAGNETIC T&E. . . . .  142
DECODER. . . . . . . . . . . . . . . . DATA PROCESSING T&E. . . . . . . .  168
DECOY. . . . . . . . . . . . . . . . . ARMAMENT -- ACCESSORY. . . . . . .  131
DEED . . . . . . . . . . . . . . . . . DOCUMENTARY ARTIFACT . . . . . . .  211
DEFLECTOR. . . . . . . . . . . . . . . NUCLEAR PHYSICS T&E. . . . . . . .  158
DEFLECTOR. . . . . . . . . . . . . . . SURVEYING & NAVIGATIONAL T&E . . .  162
DEHORNER . . . . . . . . . . . . . . . ANIMAL HUSBANDRY T&E . . . . . . .   53
DEHUMIDIFIER . . . . . . . . . . . . . TEMPERATURE CONTROL DEVICE . . . .   22
DEHYDRATOR, DENTAL . . . . . . . . . . MEDICAL & PSYCHOLOGICAL T&E. . . .  150
DEMI-CANNON. . . . . . . . . . . . . . ARMAMENT -- ARTILLERY. . . . . . .  127
DEMI-CULVERIN. . . . . . . . . . . . . ARMAMENT -- ARTILLERY. . . . . . .  127
DEMIJOHN . . . . . . . . . . . . . . . MERCHANDISING T&E. . . . . . . . .  156
   rt  BOTTLE
DENDROMETER. . . . . . . . . . . . . . FORESTRY T&E . . . . . . . . . . .   77
DENSIMETER . . . . . . . . . . . . . . MECHANICAL T&E . . . . . . . . . .  147
DENSITOMETER . . . . . . . . . . . . . PHOTOGRAPHIC T&E . . . . . . . . .  176
DENTIMETER . . . . . . . . . . . . . . MEDICAL & PSYCHOLOGICAL T&E. . . .  150
DENTURES . . . . . . . . . . . . . . . PERSONAL GEAR. . . . . . . . . . .   36
DEPOT. . . . . . . . . . . . . . . . . BUILDING . . . . . . . . . . . . .    2
   rt  TERMINAL
DEPOT, RAILROAD. . . . . . . . . . . . BUILDING . . . . . . . . . . . . .    2
DEPRESSOR, TONGUE. . . . . . . . . . . MEDICAL & PSYCHOLOGICAL T&E. . . .  150
DERBY. . . . . . . . . . . . . . . . . CLOTHING -- HEADWEAR . . . . . . .   27
DERRICK. . . . . . . . . . . . . . . . MINING & MINERAL HARVESTING T&E. .   99
 Derrick . . . . . . . . . . . . . . . MECHANICAL T&E
   use  CRANE
DERRICK, GRAIN-STACKING. . . . . . . . AGRICULTURAL T&E . . . . . . . . .   43
DERRINGER. . . . . . . . . . . . . . . ARMAMENT -- FIREARM. . . . . . . .  124
   rt  PISTOL
DESICCATOR, BALANCE. . . . . . . . . . NUCLEAR PHYSICS T&E. . . . . . . .  158
DESK . . . . . . . . . . . . . . . . . FURNITURE. . . . . . . . . . . . .   12
DESK, CAMPAIGN . . . . . . . . . . . . FURNITURE. . . . . . . . . . . . .   12
```

- -

DESK, DROP-FRONT FURNITURE. 12
 rt SECRETARY
Desk, Lap WRITTEN COMMUNICATION T&E
 use DESK, PORTABLE
DESK, PORTABLE WRITTEN COMMUNICATION T&E. 184
DESK, QUARTER-CYLINDER FURNITURE. 12
DESK, ROLLTOP. FURNITURE. 12
DESK, SCHOOL FURNITURE. 12
DESK, SLANT-TOP. FURNITURE. 12
DESK, TAMBOUR. FURNITURE. 12
DESSICATOR CHEMICAL T&E 139
DESTROYER. WATER TRANSPORTATION -- EQUIPMENT. 198
DESTROYER, TANK. ARMAMENT -- ARTILLERY. 128
 Detector, Firedamp. MINING & MINERAL HARVESTING T&E
 use DETECTOR, GAS
DETECTOR, GAS. MINING & MINERAL HARVESTING T&E. . 99
DETECTOR, HEATMOUNT. ANIMAL HUSBANDRY T&E 53
DETECTOR, MINE ARMAMENT -- ACCESSORY. 131
DETONATOR. MINING & MINERAL HARVESTING T&E. . 99
DEVELOPER. PHOTOGRAPHIC T&E 176
DEVELOPER, WRIST SPORTS EQUIPMENT 220
DEVICE, TEST-SCORING DATA PROCESSING T&E. 168
DHOW WATER TRANSPORTATION -- EQUIPMENT. 198
DIABOLO. TOY. 223
 rt TOP
DIADEM PERSONAL SYMBOL. 215
DIAL, MINER'S. MINING & MINERAL HARVESTING T&E. . 99
DIAPER CLOTHING -- UNDERWEAR. 32
DIAPHANOMETER. METEOROLOGICAL T&E 157
DIARY. DOCUMENTARY ARTIFACT 211
DIBBLE AGRICULTURAL T&E 43
 Dibble, Planting spud AGRICULTURAL T&E
 use DIBBLE
DICE GAME 217
DICHROSCOPE. OPTICAL T&E. 159
DICKEY CLOTHING -- ACCESSORY. 33
DIE. METALWORKING T&E 89
DIE. GAME 217
DIE, BINDER. PRINTING T&E 177
DIE, DENTURE MEDICAL & PSYCHOLOGICAL T&E. . . . 150
DIE, HORNWORKER'S. LEATHER, HORN, SHELLWORKING T&E. . 83
DIE, LOADING ARMAMENT -- ACCESSORY. 131
DIE, SCREW METALWORKING T&E 89
DIE, TOE-CALK WELDING. METALWORKING T&E 89
DIE, WIREDRAWING METALWORKING T&E 89
DIFFUSIOMETER. CHEMICAL T&E 139
DIGESTER PAPERMAKING T&E. 103
DIGGER, POST-HOLE. MULTIPLE USE ARTIFACT. 227
 rt AUGER, POST-HOLE
DIGGER, POTATO AGRICULTURAL T&E 43

- -

Digger, Thistle AGRICULTURAL T&E
 use SPUD, WEEDING
DILATOMETER. CHEMICAL T&E 139
DILATOR. MEDICAL & PSYCHOLOGICAL T&E. . . . 150
DILATOR, CERVICAL. MEDICAL & PSYCHOLOGICAL T&E. . . . 150
DILATOR, UTERINE MEDICAL & PSYCHOLOGICAL T&E. . . . 150
 Diligence LTE -- ANIMAL-POWERED
 use STAGECOACH
DIMMER LIGHTING DEVICE. 19
 Dingelstuck METALWORKING T&E
 use ANVIL, SCYTHE-SHARPENING or STONE, SCYTHE-SHARPENING
DINGHY WATER TRANSPORTATION -- EQUIPMENT. 198
 rt TENDER, YACHT; ROWBOAT
DINGHY, BAHAMA WATER TRANSPORTATION -- EQUIPMENT. 198
DINGHY, SAILING. WATER TRANSPORTATION -- EQUIPMENT. 198
 rt SAILBOAT
DIORAMA. DOCUMENTARY ARTIFACT 211
 rt ROOM, MINIATURE
DIORAMA, AUTOMATA. DOCUMENTARY ARTIFACT 211
 Dip WOODWORKING T&E
 use ROD, GAUGE
DIPLEIDOSCOPE. ASTRONOMICAL T&E 135
DIPLOMA. DOCUMENTARY ARTIFACT 211
DIPPER FOOD PROCESSING T&E. 60
DIPPER, TURPENTINE FORESTRY T&E 77
DIPPER, WHALE-OIL. FISHING & TRAPPING T&E 56
 Diptych CEREMONIAL ARTIFACT
 use ALTARPIECE
DIRECTORY, TELEPHONE DOCUMENTARY ARTIFACT 211
 Dirigible AEROSPACE -- EQUIPMENT
 use AIRSHIP
DIRK ARMAMENT -- EDGED. 126
DIRNDL CLOTHING -- OUTERWEAR. 29
DISC, MUSIC-BOX. SOUND COMMUNICATION T&E. 181
DISCUS SPORTS EQUIPMENT 220
DISH FOOD SERVICE T&E 71
DISH, BAKING FOOD PROCESSING T&E. 60
DISH, BERRY. FOOD SERVICE T&E 71
DISH, BONBON FOOD SERVICE T&E 71
DISH, BONE FOOD SERVICE T&E 71
DISH, BUTTER FOOD SERVICE T&E 71
DISH, CANDY. FOOD SERVICE T&E 71
DISH, CELERY FOOD SERVICE T&E 71
DISH, CHAFING. FOOD PROCESSING T&E. 60
DISH, CHEESE FOOD SERVICE T&E 71
DISH, COMB HOUSEHOLD ACCESSORY. 16
 Dish, Condiment FOOD SERVICE T&E
 use DISH, RELISH
DISH, CULTURE. BIOLOGICAL T&E 136
DISH, DESSERT. FOOD SERVICE T&E 71

- -

DISH, DISSOLVING CHEMICAL T&E 139
DISH, EVAPORATING. CHEMICAL T&E 139
DISH, HONEY. FOOD SERVICE T&E 71
DISH, JELLY. FOOD SERVICE T&E 71
DISH, NAIL LEATHER, HORN, SHELLWORKING T&E. . 83
DISH, NUT. FOOD SERVICE T&E 71
 Dish, Olive FOOD SERVICE T&E
 use DISH, RELISH
DISH, PET. ANIMAL HUSBANDRY T&E 53
DISH, PETRI. CHEMICAL T&E 139
DISH, PETRI. BIOLOGICAL T&E 136
 Dish, Pickle. FOOD SERVICE T&E
 use DISH, RELISH
DISH, PUDDING. FOOD SERVICE T&E 71
DISH, RELISH FOOD SERVICE T&E 71
DISH, RING HOUSEHOLD ACCESSORY. 16
DISH, SALT FOOD SERVICE T&E 71
DISH, SAUCE. FOOD SERVICE T&E 71
DISH, SERVING. FOOD SERVICE T&E 71
DISH, SHERBERT FOOD SERVICE T&E 71
DISH, SOAP TOILET ARTICLE 39
DISH, SOAP MAINTENANCE T&E. 145
DISH, SOUFFLE. FOOD PROCESSING T&E. 60
DISH, TEA BAG. FOOD SERVICE T&E 71
DISH, VEGETABLE. FOOD SERVICE T&E 71
DISH, WASTE. FOOD SERVICE T&E 72
DISHCLOTH. MAINTENANCE T&E. 145
DISHPAN. MAINTENANCE T&E. 145
DISHWASHER MAINTENANCE T&E. 145
DISK, ABRASIVE DENTAL. MEDICAL & PSYCHOLOGICAL T&E. . . . 150
DISK, MAGNETIC DATA PROCESSING T&E. 168
DISK, PI CEREMONIAL ARTIFACT. 207
DISK, SHUFFLEBOARD SPORTS EQUIPMENT 220
DISK, SIGHT. ARMAMENT -- ACCESSORY. 131
DISPENSER, BEVERAGE. FOOD SERVICE T&E 72
DISPENSER, CAP ARMAMENT -- ACCESSORY. 131
DISPENSER, DENTAL. MEDICAL & PSYCHOLOGICAL T&E. . . . 150
DISPENSER, POWDER. ANIMAL HUSBANDRY T&E 53
DISPENSER, SHOE-POWDER CLOTHING -- ACCESSORY. 33
DISPENSER, TAPE. MULTIPLE USE ARTIFACT. 227
DISPENSER, TOKEN PERSONAL GEAR. 36
 Disposal, Garbage PLUMBING FIXTURE
 use DISPOSER
DISPOSER PLUMBING FIXTURE 21
DISTAFF. TEXTILEWORKING T&E 106
DISTRIBUTOR, FERTILIZER. AGRICULTURAL T&E 43
 Divan FURNITURE
 use SOFA or SETTEE or SEAT, LOVE
DIVIDER, STITCH. LEATHER, HORN, SHELLWORKING T&E. . 83
DIVIDERS WOODWORKING T&E. 114

- -

- -

- -

DRAWKNIFE, HORNWORKER'S. LEATHER, HORN, SHELLWORKING T&E. . 83
DRAWKNIFE, WHEELWRIGHT'S WOODWORKING T&E. 114
DRAWSHAVE. WOODWORKING T&E. 114
 rt DRAWKNIFE; SPOKESHAVE
DRAY LTE -- ANIMAL-POWERED. 189
 Dreadnought WATER TRANSPORTATION -- EQUIPMENT
 use BATTLESHIP
DREDGE FISHING & TRAPPING T&E 56
DREDGE MINING & MINERAL HARVESTING T&E. . 99
DREDGE WATER TRANSPORTATION -- EQUIPMENT. 198
DREDGE, BUCKETLINE MINING & MINERAL HARVESTING T&E. . 99
DREDGE, SUCTION. MINING & MINERAL HARVESTING T&E. . 99
DREDGER. FOOD PROCESSING T&E. 60
DRENCHER ANIMAL HUSBANDRY T&E 53
DRESS. CLOTHING -- OUTERWEAR. 29
 rt GOWN
 Dress, Folk CLOTHING -- OUTERWEAR
 use more specific term
 Dresser FURNITURE
 use CHEST OF DRAWERS
DRESSER. TEXTILEWORKING T&E 106
DRESSER, GRINDING WHEEL. METALWORKING T&E 89
DRIFT. METALWORKING T&E 89
 note use for a cutting tool; do not use for PIN, DRIFT or PUNCH, DRIFT
DRIFT. WOODWORKING T&E. 114
DRIFTSIGHT SURVEYING & NAVIGATIONAL T&E . . . 162
DRILL. MASONRY & STONEWORKING T&E 86
DRILL. WOODWORKING T&E. 114
DRILL. MINING & MINERAL HARVESTING T&E. . 99
DRILL. MULTIPLE USE ARTIFACT. 227
DRILL. CONSTRUCTION T&E 141
 note see also MINING T&E
 Drill, Barrow AGRICULTURAL T&E
 use DRILL, SEED
DRILL, BOW METALWORKING T&E 89
DRILL, BOW WOODWORKING T&E. 114
 Drill, Calyx. MINING & MINERAL HARVESTING T&E
 use DRILL, SHOT
DRILL, CHURN MINING & MINERAL HARVESTING T&E. . 99
DRILL, CORE. MINING & MINERAL HARVESTING T&E. . 99
DRILL, DENTAL. MEDICAL & PSYCHOLOGICAL T&E. . . . 150
DRILL, DIAMOND MINING & MINERAL HARVESTING T&E. . 99
 Drill, Disk AGRICULTURAL T&E
 use DRILL, SEED
 Drill, Drifter. MINING & MINERAL HARVESTING T&E
 use DRILL, PERCUSSIVE
DRILL, ELECTRIC. METALWORKING T&E 89
 Drill, Fertilizer AGRICULTURAL T&E
 use DRILL, SEED
DRILL, FIREMAKING. TEMPERATURE CONTROL DEVICE 22

- -

DRILL, FLEXIBLE-SHAFT. GLASS, PLASTICS, CLAYWORKING T&E . 79
DRILL, GANG. MINING & MINERAL HARVESTING T&E. . 99
 Drill, Garden AGRICULTURAL T&E
 use DRILL, SEED
 Drill, Grain. AGRICULTURAL T&E
 use DRILL, SEED
 Drill, Hand AGRICULTURAL T&E
 use DRILL, SEED
DRILL, HAND. METALWORKING T&E 89
 Drill, Hoe. AGRICULTURAL T&E
 use DRILL, SEED
DRILL, JETTING MINING & MINERAL HARVESTING T&E. . 99
DRILL, OCTAGONAL MASONRY & STONEWORKING T&E 87
DRILL, PERCUSSIVE. MINING & MINERAL HARVESTING T&E. . 99
DRILL, PERCUSSIVE. CONSTRUCTION T&E 141
 Drill, Pole MINING & MINERAL HARVESTING T&E
 use DRILL, CHURN
 Drill, Press. AGRICULTURAL T&E
 use DRILL, SEED
DRILL, PUMP. WOODWORKING T&E. 114
DRILL, PUSH. WOODWORKING T&E. 114
DRILL, ROTARY. MINING & MINERAL HARVESTING T&E. . 99
DRILL, ROUND MASONRY & STONEWORKING T&E 87
DRILL, SEED. AGRICULTURAL T&E 43
 Drill, Shoe AGRICULTURAL T&E
 use DRILL, SEED
DRILL, SHOT. MINING & MINERAL HARVESTING T&E. . 99
DRILL, SINKER. MINING & MINERAL HARVESTING T&E. . 99
DRILL, STOPPER MINING & MINERAL HARVESTING T&E. . 99
DRILL, TURBO MINING & MINERAL HARVESTING T&E. . 99
 Drill, Walking. AGRICULTURAL T&E
 use DRILL, SEED
 Drill, Well MINING & MINERAL HARVESTING T&E
 use more specific term, e.g.: DRILL, CHURN; -,ROTARY
 Drill, Wheelbarrow. AGRICULTURAL T&E
 use DRILL, SEED
DRIVER, CALK ANIMAL HUSBANDRY T&E 53
DRIVER, HOOP WOODWORKING T&E. 114
DRIVER, PILE CONSTRUCTION T&E 141
 Drone AEROSPACE -- EQUIPMENT
 use AIRPLANE
DROP, FLAT PUBLIC ENTERTAINMENT DEVICE. . . . 218
DROP, ROLL PUBLIC ENTERTAINMENT DEVICE. . . . 218
DROP, SCRIM. PUBLIC ENTERTAINMENT DEVICE. . . . 218
DROSHSKY LTE -- ANIMAL-POWERED. 189
DROSOMETER METEOROLOGICAL T&E 157
 Drug. FORESTRY T&E
 use DOLLY, TIMBER
 Drugget FLOOR COVERING
 use RUG

- -

```
DRUM . . . . . . . . . . . . . . . . . MUSICAL T&E. . . . . . . . . . . . 173
DRUM, BASS . . . . . . . . . . . . . . MUSICAL T&E. . . . . . . . . . . . 173
DRUM, BONGO. . . . . . . . . . . . . . MUSICAL T&E. . . . . . . . . . . . 173
DRUM, MAGNETIC . . . . . . . . . . . . DATA PROCESSING T&E. . . . . . . . 168
DRUM, SAWDUST. . . . . . . . . . . . . LEATHER, HORN, SHELLWORKING T&E. .  83
DRUM, SIDE . . . . . . . . . . . . . . MUSICAL T&E. . . . . . . . . . . . 173
DRUM, SNARE. . . . . . . . . . . . . . MUSICAL T&E. . . . . . . . . . . . 173
DRUM, TENOR. . . . . . . . . . . . . . MUSICAL T&E. . . . . . . . . . . . 173
DRUMSTICK. . . . . . . . . . . . . . . MUSICAL T&E. . . . . . . . . . . . 173
DRY-DOCK, FLOATING . . . . . . . . . . WATER TRANSPORTATION -- EQUIPMENT. 198
DRYER. . . . . . . . . . . . . . . . . PAPERMAKING T&E. . . . . . . . . . 103
DRYER. . . . . . . . . . . . . . . . . TEXTILEWORKING T&E . . . . . . . . 106
DRYER. . . . . . . . . . . . . . . . . MAINTENANCE T&E. . . . . . . . . . 145
DRYER, CROP. . . . . . . . . . . . . . AGRICULTURAL T&E . . . . . . . . .  43
DRYER, FILM. . . . . . . . . . . . . . PHOTOGRAPHIC T&E . . . . . . . . . 176
DRYER, FRUIT . . . . . . . . . . . . . FOOD PROCESSING T&E. . . . . . . .  60
 Dryer, Grain. . . . . . . . . . . . . AGRICULTURAL T&E
   use  DRYER, CROP
DRYER, HAIR. . . . . . . . . . . . . . TOILET ARTICLE . . . . . . . . . .  39
DRYER, LOOP. . . . . . . . . . . . . . TEXTILEWORKING T&E . . . . . . . . 106
 Dryer, Milk . . . . . . . . . . . . . FOOD PROCESSING T&E
   use  EVAPORATOR, MILK
DRYER, PRINT . . . . . . . . . . . . . PHOTOGRAPHIC T&E . . . . . . . . . 176
DRYER, REEL. . . . . . . . . . . . . . TEXTILEWORKING T&E . . . . . . . . 106
DUCKER, DELAWARE . . . . . . . . . . . WATER TRANSPORTATION -- EQUIPMENT. 198
   rt  SKIFF, GUNNING
 Duckpin . . . . . . . . . . . . . . . SPORTS EQUIPMENT
   use  PIN, BOWLING
DUCTILEMETER . . . . . . . . . . . . . MECHANICAL T&E . . . . . . . . . . 147
DULANG . . . . . . . . . . . . . . . . MINING & MINERAL HARVESTING T&E. .  99
DULCIAN. . . . . . . . . . . . . . . . MUSICAL T&E. . . . . . . . . . . . 173
DULCIMER . . . . . . . . . . . . . . . MUSICAL T&E. . . . . . . . . . . . 173
DUMBBELL . . . . . . . . . . . . . . . SPORTS EQUIPMENT . . . . . . . . . 221
DUMBWAITER . . . . . . . . . . . . . . BUILDING COMPONENT . . . . . . . .   5
DUMMY. . . . . . . . . . . . . . . . . GLASS, PLASTICS, CLAYWORKING T&E .  79
DUMMY, BLOCKING. . . . . . . . . . . . SPORTS EQUIPMENT . . . . . . . . . 221
DUMMY, TACKLING. . . . . . . . . . . . SPORTS EQUIPMENT . . . . . . . . . 221
DUMMY, VENTRILOQUIST . . . . . . . . . PUBLIC ENTERTAINMENT DEVICE. . . . 218
DUPLEX . . . . . . . . . . . . . . . . BUILDING . . . . . . . . . . . . .   2
DUPLICATOR . . . . . . . . . . . . . . PRINTING T&E . . . . . . . . . . . 177
   rt  MIMEOGRAPH
 Dustcap . . . . . . . . . . . . . . . CLOTHING -- HEADWEAR
   use  CAP, DUST
 Dustcloth . . . . . . . . . . . . . . MAINTENANCE T&E
   use  CLOTH, CLEANING
 Duster. . . . . . . . . . . . . . . . CLOTHING -- OUTERWEAR
   use  HOUSECOAT
DUSTER . . . . . . . . . . . . . . . . TEXTILEWORKING T&E . . . . . . . . 106
DUSTER . . . . . . . . . . . . . . . . MAINTENANCE T&E. . . . . . . . . . 145
DUSTER, BRAN . . . . . . . . . . . . . FOOD PROCESSING T&E. . . . . . . .  60
```

- -

Duster, Cloth MAINTENANCE T&E
 use CLOTH, CLEANING
DUSTER, DRY-POWDER AGRICULTURAL T&E 43
Duster, Hand. AGRICULTURAL T&E
 use DUSTER, DRY-POWDER
Duster, Potato. AGRICULTURAL T&E
 use DUSTER, DRY-POWDER
Duster, Saddle-gun. AGRICULTURAL T&E
 use DUSTER, DRY-POWDER
Duster, Tobacco AGRICULTURAL T&E
 use DUSTER, DRY-POWDER
Dust jacket, Book DOCUMENTARY ARTIFACT
 use JACKET, BOOK
DUSTPAN. MAINTENANCE T&E. 145
DYNACTINOMETER OPTICAL T&E. 159
DYNAMETER. OPTICAL T&E. 159
Dynamo. ENERGY PRODUCTION T&E
 use GENERATOR
DYNAMOMETER. MECHANICAL T&E 147
EARMUFFS CLOTHING -- HEADWEAR 27
EARPHONE PERSONAL GEAR. 36
EARPHONE SOUND COMMUNICATION T&E. 181
EARPLUG. PERSONAL GEAR. 36
Earplug ADORNMENT
 use SPOOL, EAR
EARRING. ADORNMENT. : 24
EARTHWORK. OTHER STRUCTURE. 7
Ease, Stript. LEATHER, HORN, SHELLWORKING T&E
 use GAUGE, DRAW
EASEL. FURNITURE. 13
EASEL. PAINTING T&E 102
EASEL. PHOTOGRAPHIC T&E 176
EASEL, PICTURE HOUSEHOLD ACCESSORY. 17
EBULLIOSCOPE THERMAL T&E. 164
ECCENTROLINEAD DRAFTING T&E , 171
ECHOMETER. SURVEYING & NAVIGATIONAL T&E . . . 162
ECHOPPE. PRINTING T&E 177
ECHOSCOPE. MEDICAL & PSYCHOLOGICAL T&E. . . . 150
ECLIPSAREON. ASTRONOMICAL T&E 135
Edger, Lawn AGRICULTURAL T&E
 use EDGER, TURF
EDGER, TURF. AGRICULTURAL T&E 43
EELPOT FISHING & TRAPPING T&E 56
EFFIGY CEREMONIAL ARTIFACT. 207
EGG, DARNING TEXTILEWORKING T&E 106
EGGBEATER. FOOD PROCESSING T&E. 60
 rt WHIP, CREAM
EGGCUP FOOD SERVICE T&E 72
Eidograph DRAFTING T&E
 use PANTOGRAPH

- -

Eidoscope TOY
 use KALEIDOSCOPE
EIKONOMETER. OPTICAL T&E. 159
ELACOMETER CHEMICAL T&E 139
ELECTRIFIER, FLOUR-BLEACHING FOOD PROCESSING T&E. 60
ELECTRODE. ELECTRICAL & MAGNETIC T&E. . . . 142
ELECTROMETER ELECTRICAL & MAGNETIC T&E. . . . 142
ELEVATOR BUILDING COMPONENT 5
ELEVATOR MEDICAL & PSYCHOLOGICAL T&E. . . 150
ELEVATOR, AUGER. AGRICULTURAL T&E 43
ELEVATOR, BALE AGRICULTURAL T&E 43
ELEVATOR, DENTAL MEDICAL & PSYCHOLOGICAL T&E. . . 150
ELEVATOR, GRAIN. OTHER STRUCTURE. 8
ELEVATOR, MALAR. MEDICAL & PSYCHOLOGICAL T&E. . . 150
ELEVATOR, PERIOSTEAL MEDICAL & PSYCHOLOGICAL T&E. . . 150
ELEVATOR, ROOT MEDICAL & PSYCHOLOGICAL T&E. . . 150
ELIMINATOR, STATIC NUCLEAR PHYSICS T&E. 158
ELLIPSOGRAPH DRAFTING T&E 171
 rt CONOGRAPH
Elliptograph. DRAFTING T&E
 use ELLIPSOGRAPH
E-machine MINING & MINERAL HARVESTING T&E
 use MACHINE, BLOWING
EMASCULATOR. ANIMAL HUSBANDRY T&E 53
 Emblem. PERSONAL SYMBOL
 use more specific term, e.g.: PIN; PATCH; MEDAL
Emulsior, Milk. FOOD PROCESSING T&E
 use HOMOGENIZER, MILK
ENCODER. DATA PROCESSING T&E. 168
ENDOSCOPE. MEDICAL & PSYCHOLOGICAL T&E. . . 150
 Ends, Wax LEATHER, HORN, SHELLWORKING T&E
 use BRISTLE, SEWING
ENFRAMEMENT, DOOR. BUILDING COMPONENT 5
 note use for entire structure including case and frame and possibly
 other parts such as the door, fanlight, sidelight etc.
ENFRAMEMENT, FIREPLACE BUILDING COMPONENT 5
ENGINE ENERGY PRODUCTION T&E. 143
ENGINE AEROSPACE -- ACCESSORY 187
 Engine. RAIL TRANSPORTATION -- EQUIPMENT
 use LOCOMOTIVE
ENGINE, BLOWING. METALWORKING T&E 89
 Engine, Compression-ignition. ENERGY PRODUCTION T&E
 use ENGINE, DIESEL
ENGINE, DENTAL MEDICAL & PSYCHOLOGICAL T&E. . . 150
ENGINE, DIESEL ENERGY PRODUCTION T&E. 143
ENGINE, DIVIDING DRAFTING T&E 171
ENGINE, GAS. ENERGY PRODUCTION T&E. 143
ENGINE, GASOLINE ENERGY PRODUCTION T&E. 143
 rt ENGINE, LIQUID-FUEL
ENGINE, HOT-AIR. ENERGY PRODUCTION T&E. 143

- -

ENGINE, LIQUID-FUEL. ENERGY PRODUCTION T&E. 143
 rt ENGINE, GASOLINE
ENGINE, MAN. MINING & MINERAL HARVESTING T&E. . 99
ENGINE, MODEL. TOY. 223
ENGINE, OIL-TRACTION ENERGY PRODUCTION T&E. 143
ENGINE, RADIAL AEROSPACE -- ACCESSORY 187
ENGINE, RAMJET ENERGY PRODUCTION T&E. 143
ENGINE, RECIPROCATING. AEROSPACE -- ACCESSORY 187
ENGINE, RULING DRAFTING T&E 171
ENGINE, STEAM. ENERGY PRODUCTION T&E. 143
ENGINE, STEAM-GAS. ENERGY PRODUCTION T&E. 143
ENGINE, STEAM-TRACTION ENERGY PRODUCTION T&E. 143
ENGINE, TURBOJET AEROSPACE -- ACCESSORY 187
ENGINE, TURBOPROP. AEROSPACE -- ACCESSORY 187
 Engine, Winding MECHANICAL T&E
 use WINDLASS
 Engiscope OPTICAL T&E
 use MICROSCOPE
ENGRAVING. ART. 205
ENLARGER PHOTOGRAPHIC T&E 176
ENSEMBLE CLOTHING -- OUTERWEAR. 29
ENTABLATURE. BUILDING COMPONENT 5
ENVELOPE DOCUMENTARY ARTIFACT 211
ENVELOPE MERCHANDISING T&E. 156
ENVELOPE WRITTEN COMMUNICATION T&E. 184
 note unused. If used, may be DOCUMENTARY ARTIFACT
 Envelope, Seed. AGRICULTURAL T&E
 use PACKET, SEED
EPAULET. PERSONAL SYMBOL. 215
EPEE SPORTS EQUIPMENT 221
 rt SABER, FENCING
EPERGNE. FOOD SERVICE T&E 72
 Ephemera. DOCUMENTARY ARTIFACT
 use more specific term, e.g.: PROGRAM; INVITATION; LETTER
EQUINOCTIAL. MEDICAL & PSYCHOLOGICAL T&E. . . . 150
 Equipment, Exercise SPORTS EQUIPMENT
 use more specific term, e.g.: DUMBELL; BARBELL; MACHINE, ROWING
 Equipment, Magician's PUBLIC ENTERTAINMENT DEVICE
 use PROPERTIES, MAGICIAN'S
 Equipment, Peripheral DATA PROCESSING T&E
 use more specific term, e.g.: READER, CHARACTER
 Equipment, Playground RECREATIONAL DEVICE
 use more specific term, e.g.: CLIMBER; SEESAW
ERASER WRITTEN COMMUNICATION T&E. 184
ERIOMETER. WEIGHTS & MEASURES T&E 166
ESCAPE, FIRE BUILDING COMPONENT 5
ESCUTCHEON BUILDING COMPONENT 5
ESPADRILLE CLOTHING -- FOOTWEAR 25
ESTHESIOMETER. BIOLOGICAL T&E 137
ESTOQUE. SPORTS EQUIPMENT 221

- -

- -

- -

- -

FIREBACK TEMPERATURE CONTROL DEVICE 22
FIREBOARD. TEMPERATURE CONTROL DEVICE 22
FIREBOAT WATER TRANSPORTATION -- EQUIPMENT. 198
FIREBRICK. GLASS, PLASTICS, CLAYWORKING T&E . 79
 Firedog TEMPERATURE CONTROL DEVICE
 use ANDIRON
 Fireguard FURNITURE
 use FENDER
FIREHOUSE. BUILDING 2
FIREPIT. SITE FEATURE 7
FIREPLACE. BUILDING 2
 Fireplug. OTHER STRUCTURE
 use HYDRANT
FIREPOLE BUILDING COMPONENT 5
FIRESET. TEMPERATURE CONTROL DEVICE 22
FIRKIN FOOD PROCESSING T&E. 60
FISHBOWL HOUSEHOLD ACCESSORY. 17
FISHERMAN. WATER TRANSPORTATION -- EQUIPMENT. 198
FISHHOOK FISHING & TRAPPING T&E 56
FISHPLATE. MINING & MINERAL HARVESTING T&E. . 99
FITTING, OIL ENERGY PRODUCTION T&E. 143
FITTING, PIPE. BUILDING COMPONENT 5
FIXTURE, CEILING LIGHTING DEVICE. 20
FIXTURE, WALL. LIGHTING DEVICE. 20
FLABELLUM. CEREMONIAL ARTIFACT. 207
FLAG CEREMONIAL ARTIFACT. 207
FLAG, CODE VISUAL COMMUNICATION T&E 182
FLAG, SEMAPHORE. VISUAL COMMUNICATION T&E 182
FLAG, SIGNAL VISUAL COMMUNICATION T&E 182
FLAG, WIND ARMAMENT -- ACCESSORY. 131
FLAGEOLET. MUSICAL T&E. 173
FLAGEOLET, DOUBLE. MUSICAL T&E. 173
FLAGEOLET, TRIPLE. MUSICAL T&E. 173
FLAGON FOOD SERVICE T&E 72
FLAGPOLE SITE FEATURE 7
FLAIL. AGRICULTURAL T&E 44
 Flail, Threshing. AGRICULTURAL T&E
 use FLAIL
 Flamethrower. AGRICULTURAL T&E
 use WEEDER, FLAME
FLAMETHROWER ARMAMENT -- FIREARM. 124
FLANGE METALWORKING T&E 90
FLANGE GLASS, PLASTICS, CLAYWORKING T&E . 79
FLARE, DISTRESS. VISUAL COMMUNICATION T&E 182
FLASHLIGHT LIGHTING DEVICE. 20
FLASK. CHEMICAL T&E 139
 Flask FOOD SERVICE T&E
 use DECANTER
 Flask MERCHANDISING T&E
 use BOTTLE

- -

```
FLASK, BOILING . . . . . . . . . . . . CHEMICAL T&E . . . . . . . . . . . 139
FLASK, CULTURE . . . . . . . . . . . . CHEMICAL T&E . . . . . . . . . . . 139
FLASK, CULTURE . . . . . . . . . . . . BIOLOGICAL T&E . . . . . . . . . 137
FLASK, DENTURE CURING. . . . . . . . . MEDICAL & PSYCHOLOGICAL T&E. . . . 151
FLASK, DISTILLING. . . . . . . . . . . CHEMICAL T&E . . . . . . . . . . . 139
FLASK, ERLENMEYER. . . . . . . . . . . CHEMICAL T&E . . . . . . . . . . . 139
FLASK, FILTERING . . . . . . . . . . . CHEMICAL T&E . . . . . . . . . . . 139
FLASK, POCKET. . . . . . . . . . . . . PERSONAL GEAR. . . . . . . . . . . 36
FLASK, POWDER. . . . . . . . . . . . . ARMAMENT -- ACCESSORY. . . . . . . 131
FLASK, PRIMING . . . . . . . . . . . . ARMAMENT -- ACCESSORY. . . . . . . 131
FLASK, SHOT. . . . . . . . . . . . . . ARMAMENT -- ACCESSORY. . . . . . . 131
FLASK, SNAP. . . . . . . . . . . . . . GLASS, PLASTICS, CLAYWORKING T&E . 79
  Flask, Urinal . . . . . . . . . . . . TOILET ARTICLE
   use URINAL
  Flat. . . . . . . . . . . . . . . . . PUBLIC ENTERTAINMENT DEVICE
   use DROP, FLAT
FLATCAP. . . . . . . . . . . . . . . . CLOTHING -- HEADWEAR . . . . . . . 27
FLATCAR. . . . . . . . . . . . . . . . RAIL TRANSPORTATION -- EQUIPMENT . 196
FLATIRON . . . . . . . . . . . . . . . MAINTENANCE T&E. . . . . . . . . . 145
FLATTER. . . . . . . . . . . . . . . . METALWORKING T&E . . . . . . . . . 90
   rt  HAMMER, SET
  Flier . . . . . . . . . . . . . . . . ADVERTISING MEDIUM
   use HANDBILL or CATALOG
FLINT. . . . . . . . . . . . . . . . . TEMPERATURE CONTROL DEVICE . . . . 22
FLINT. . . . . . . . . . . . . . . . . ARMAMENT -- ACCESSORY. . . . . . . 131
FLIPPER-FLOPPER. . . . . . . . . . . . TOY. . . . . . . . . . . . . . . . 223
FLOAT. . . . . . . . . . . . . . . . . FISHING & TRAPPING T&E . . . . . . 56
FLOAT. . . . . . . . . . . . . . . . . MASONRY & STONEWORKING T&E . . . . 87
FLOAT. . . . . . . . . . . . . . . . . WOODWORKING T&E. . . . . . . . . . 114
   rt   RASP; FILE
FLOAT, DENTAL. . . . . . . . . . . . . ANIMAL HUSBANDRY T&E . . . . . . . 53
FLOAT, LIFE. . . . . . . . . . . . . . WATER TRANSPORTATION -- ACCESSORY. 202
FLOAT, LONG. . . . . . . . . . . . . . MASONRY & STONEWORKING T&E . . . . 87
  Flogger, Bung . . . . . . . . . . . . WOODWORKING T&E
   use BUNGSTART
FLOODGATE. . . . . . . . . . . . . . . OTHER STRUCTURE. . . . . . . . . . 8
FLOODLIGHT . . . . . . . . . . . . . . LIGHTING DEVICE. . . . . . . . . . 20
FLOORCLOTH . . . . . . . . . . . . . . FLOOR COVERING . . . . . . . . . . 10
  Flounce, Bed. . . . . . . . . . . . . BEDDING
   use RUFFLE, DUST
FLOWER, ARTIFICIAL . . . . . . . . . . ART. . . . . . . . . . . . . . . . 205
FLOWERPOT. . . . . . . . . . . . . . . HOUSEHOLD ACCESSORY. . . . . . . . 17
FLOWERPOT, HANGING . . . . . . . . . . HOUSEHOLD ACCESSORY. . . . . . . . 17
FLUE . . . . . . . . . . . . . . . . . BUILDING COMPONENT . . . . . . . . 5
  Flugelhorn. . . . . . . . . . . . . . MUSICAL T&E
   use BUGLE, VALVE
FLUME. . . . . . . . . . . . . . . . . OTHER STRUCTURE. . . . . . . . . . 8
   rt  SLUICE
FLUOROSCOPE. . . . . . . . . . . . . . MEDICAL & PSYCHOLOGICAL T&E. . . . 151
FLUTE. . . . . . . . . . . . . . . . . MUSICAL T&E. . . . . . . . . . . . 173
```

- -

```
FLUXMETER. . . . . . . . . . . . . . . . ELECTRICAL & MAGNETIC T&E. . . . .  142
 Flyer . . . . . . . . . . . . . . . . . DOCUMENTARY ARTIFACT
   use  HANDBILL
FLYPAPER . . . . . . . . . . . . . . . . HOUSEHOLD ACCESSORY. . . . . . . .   17
FLYTRAP. . . . . . . . . . . . . . . . . HOUSEHOLD ACCESSORY. . . . . . . .   17
FLYWHEEL . . . . . . . . . . . . . . . . MECHANICAL T&E . . . . . . . . . .  147
FLYWISK. . . . . . . . . . . . . . . . . HOUSEHOLD ACCESSORY. . . . . . . .   17
FOB. . . . . . . . . . . . . . . . . . . ADORNMENT. . . . . . . . . . . .     24
FOB, KEY . . . . . . . . . . . . . . . . ADORNMENT. . . . . . . . . . . .     24
FOCOMETER. . . . . . . . . . . . . . . . OPTICAL T&E. . . . . . . . . . .    159
FOGHORN. . . . . . . . . . . . . . . . . SOUND COMMUNICATION T&E. . . . .    181
FOIL . . . . . . . . . . . . . . . . . . SPORTS EQUIPMENT . . . . . . . .    221
   rt   SABER, FENCING
FOLDER, BONE . . . . . . . . . . . . . . PRINTING T&E . . . . . . . . . .    177
FOLDER, FILE . . . . . . . . . . . . . . WRITTEN COMMUNICATION T&E. . . .    184
FOLIO. . . . . . . . . . . . . . . . . . DOCUMENTARY ARTIFACT . . . . . .    211
FONT, BAPTISMAL. . . . . . . . . . . . . CEREMONIAL ARTIFACT. . . . . . .    207
FONT, HOLY WATER . . . . . . . . . . . . CEREMONIAL ARTIFACT. . . . . . .    207
FOOTBALL . . . . . . . . . . . . . . . . SPORTS EQUIPMENT . . . . . . . .    221
FOOTBATH . . . . . . . . . . . . . . . . PLUMBING FIXTURE . . . . . . . .     21
FOOTLIGHT. . . . . . . . . . . . . . . . LIGHTING DEVICE. . . . . . . . .     20
FOOTLOCKER . . . . . . . . . . . . . . . PERSONAL GEAR. . . . . . . . . .     36
FOOTSTICKS . . . . . . . . . . . . . . . GLASS, PLASTICS, CLAYWORKING T&E .   79
FOOTSTOOL. . . . . . . . . . . . . . . . FURNITURE. . . . . . . . . . . .     13
   rt   OTTOMAN; HASSOCK
FORCEPS. . . . . . . . . . . . . . . . . MEDICAL & PSYCHOLOGICAL T&E. . .    151
FORCEPS, CATCH . . . . . . . . . . . . . MEDICAL & PSYCHOLOGICAL T&E. . .    151
FORCEPS, DENTAL. . . . . . . . . . . . . MEDICAL & PSYCHOLOGICAL T&E. . .    151
FORCEPS, DISSECTING. . . . . . . . . . . BIOLOGICAL T&E . . . . . . . . .    137
FORCEPS, OBSTETRICAL . . . . . . . . . . MEDICAL & PSYCHOLOGICAL T&E. . .    151
FORCEPS, PILL. . . . . . . . . . . . . . ANIMAL HUSBANDRY T&E . . . . . .     53
   rt   AID, PILL
FORCEPS, TREPHINING. . . . . . . . . . . MEDICAL & PSYCHOLOGICAL T&E. . .    151
FORGE          N . . . . . . . . . . . . METALWORKING T&E . . . . . . . .     90
FORGE, BLACKSMITH'S. . . . . . . . . . . METALWORKING T&E . . . . . . . .     90
 Forge, Drop . . . . . . . . . . . . . . METALWORKING T&E
   use  HAMMER, DROP
FORK . . . . . . . . . . . . . . . . . . AGRICULTURAL T&E . . . . . . . .     44
FORK . . . . . . . . . . . . . . . . . . FOOD PROCESSING T&E. . . . . . .     60
FORK . . . . . . . . . . . . . . . . . . FOOD SERVICE T&E . . . . . . . .     72
FORK, ALFALFA. . . . . . . . . . . . . . AGRICULTURAL T&E . . . . . . . .     44
FORK, BAILING-PRESS. . . . . . . . . . . AGRICULTURAL T&E . . . . . . . .     44
FORK, BARLEY . . . . . . . . . . . . . . AGRICULTURAL T&E . . . . . . . .     44
FORK, BEET . . . . . . . . . . . . . . . AGRICULTURAL T&E . . . . . . . .     44
FORK, BENDING. . . . . . . . . . . . . . METALWORKING T&E . . . . . . . .     90
FORK, BERRY. . . . . . . . . . . . . . . FOOD SERVICE T&E . . . . . . . .     72
FORK, BLUBBER. . . . . . . . . . . . . . FISHING & TRAPPING T&E . . . . .     56
FORK, CABBAGE-HARVESTING . . . . . . . . AGRICULTURAL T&E . . . . . . . .     44
FORK, CARRYING-IN. . . . . . . . . . . . GLASS, PLASTICS, CLAYWORKING T&E .   79
FORK, CARVING. . . . . . . . . . . . . . FOOD SERVICE T&E . . . . . . . .     72
```

- -

```
Fork, Chaff . . . . . . . . . . . . . . AGRICULTURAL T&E
  use  FORK, HEADER
FORK, COLD-MEAT. . . . . . . . . . . . . FOOD SERVICE T&E . . . . . . . .   72
FORK, COTTONSEED . . . . . . . . . . . AGRICULTURAL T&E . . . . . . . .    44
FORK, CURD . . . . . . . . . . . . . . FOOD PROCESSING T&E. . . . . . . .  60
FORK, DESSERT. . . . . . . . . . . . . FOOD SERVICE T&E . . . . . . . .    72
Fork, Digging . . . . . . . . . . . . AGRICULTURAL T&E
  use  FORK, SPADING
FORK, DINNER . . . . . . . . . . . . . FOOD SERVICE T&E . . . . . . . .    72
FORK, ENSILAGE . . . . . . . . . . . . AGRICULTURAL T&E . . . . . . . .    44
FORK, FISH . . . . . . . . . . . . . . FOOD SERVICE T&E . . . . . . . .    72
FORK, FISH-SERVING . . . . . . . . . . FOOD SERVICE T&E . . . . . . . .    72
Fork, Garden. . . . . . . . . . . . . AGRICULTURAL T&E
  use  FORK, SPADING
Fork, Grain . . . . . . . . . . . . . AGRICULTURAL T&E
  use  FORK, HEADER
Fork, Grapple . . . . . . . . . . . . AGRICULTURAL T&E
  use  FORK, HAY-LIFTING
Fork, Harpoon . . . . . . . . . . . . AGRICULTURAL T&E
  use  FORK, HAY-LIFTING
Fork, Hay . . . . . . . . . . . . . . AGRICULTURAL T&E
  use  HAYFORK
FORK, HAY-LIFTING. . . . . . . . . . . AGRICULTURAL T&E . . . . . . . .    44
FORK, HEADER . . . . . . . . . . . . . AGRICULTURAL T&E . . . . . . . .    44
Fork, Horse hay . . . . . . . . . . . AGRICULTURAL T&E
  use  FORK, HAY-LIFTING
FORK, HOT-SHOT . . . . . . . . . . . . ARMAMENT -- ACCESSORY. . . . . . . 131
FORK, LAUNDRY. . . . . . . . . . . . . MAINTENANCE T&E. . . . . . . . .   145
FORK, LEMON. . . . . . . . . . . . . . FOOD SERVICE T&E . . . . . . . .    72
Fork, Lock-lever. . . . . . . . . . . AGRICULTURAL T&E
  use  FORK, HAY-LIFTING
FORK, LUNCHEON . . . . . . . . . . . . FOOD SERVICE T&E . . . . . . . .    72
FORK, MANURE . . . . . . . . . . . . . AGRICULTURAL T&E . . . . . . . .    44
FORK, OYSTER . . . . . . . . . . . . . FOOD SERVICE T&E . . . . . . . .    72
FORK, PICKLE . . . . . . . . . . . . . FOOD SERVICE T&E . . . . . . . .    72
Fork, Pitch . . . . . . . . . . . . . AGRICULTURAL T&E
  use  HAYFORK or FORK, MANURE
FORK, POTATO-DIGGING . . . . . . . . . AGRICULTURAL T&E . . . . . . . .    44
FORK, SALAD. . . . . . . . . . . . . . FOOD SERVICE T&E . . . . . . . .    72
FORK, SARDINE. . . . . . . . . . . . . FOOD SERVICE T&E . . . . . . . .    72
Fork, Silage. . . . . . . . . . . . . AGRICULTURAL T&E
  use  FORK, ENSILAGE
FORK, SLUICE . . . . . . . . . . . . . MINING & MINERAL HARVESTING T&E. .  99
FORK, SPADING. . . . . . . . . . . . . AGRICULTURAL T&E . . . . . . . .    44
Fork, Straw . . . . . . . . . . . . . AGRICULTURAL T&E
  use  FORK, BARLEY
Fork, Table . . . . . . . . . . . . . FOOD SERVICE T&E
  use  FORK, DINNER
FORK, TOASTING . . . . . . . . . . . . FOOD PROCESSING T&E. . . . . . . .  60
FORK, TUNING . . . . . . . . . . . . . ACOUSTICAL T&E . . . . . . . . .   123
```

- -

- -

```
FRIGATE. . . . . . . . . . . . . . . . . WATER TRANSPORTATION -- EQUIPMENT.  198
 Fringe. . . . . . . . . . . . . . . . . TEXTILEWORKING T&E
   use  TRIM
FRISBEE. . . . . . . . . . . . . . . . . SPORTS EQUIPMENT . . . . . . . . .  221
FRISKET. . . . . . . . . . . . . . . . . PRINTING T&E . . . . . . . . . . .  177
FROE . . . . . . . . . . . . . . . . . . WOODWORKING T&E. . . . . . . . . .  115
FROE, COOPER'S . . . . . . . . . . . . . WOODWORKING T&E. . . . . . . . . .  115
FROE, KNIFE. . . . . . . . . . . . . . . WOODWORKING T&E. . . . . . . . . .  115
FROE, LATHMAKER'S. . . . . . . . . . . . WOODWORKING T&E. . . . . . . . . .  115
FROG . . . . . . . . . . . . . . . . . . HOUSEHOLD ACCESSORY. . . . . . . .   17
FRONTAL. . . . . . . . . . . . . . . . . CEREMONIAL ARTIFACT. . . . . . . .  207
FRONTLET . . . . . . . . . . . . . . . . ADORNMENT. . . . . . . . . . . . .   24
FRONTLET . . . . . . . . . . . . . . . . CEREMONIAL ARTIFACT. . . . . . . .  207
 Frow. . . . . . . . . . . . . . . . . . WOODWORKING T&E
   use  FROE
FRUIT, ARTIFICIAL. . . . . . . . . . . . ART. . . . . . . . . . . . . . . .  205
FRYER, DEEP-FAT. . . . . . . . . . . . . FOOD PROCESSING T&E. . . . . . . .   61
FULLER . . . . . . . . . . . . . . . . . METALWORKING T&E . . . . . . . . .   90
FULLER, BOTTOM . . . . . . . . . . . . . METALWORKING T&E . . . . . . . . .   90
FULLER, TOP. . . . . . . . . . . . . . . METALWORKING T&E . . . . . . . . .   90
FUNNEL . . . . . . . . . . . . . . . . . FOOD PROCESSING T&E. . . . . . . .   61
FUNNEL . . . . . . . . . . . . . . . . . CHEMICAL T&E . . . . . . . . . . .  139
FUNNEL . . . . . . . . . . . . . . . . . MULTIPLE USE ARTIFACT. . . . . . .  227
FUNNEL, PIE. . . . . . . . . . . . . . . FOOD PROCESSING T&E. . . . . . . .   61
FUNNEL-HORN. . . . . . . . . . . . . . . ACOUSTICAL T&E . . . . . . . . . .  123
   rt  AMPLIFIER, AUDIO
FURNACE. . . . . . . . . . . . . . . . . TEMPERATURE CONTROL DEVICE . . . .   22
 Furnace, Agricultural . . . . . . . . . AGRICULTURAL T&E
   use  BOILER, FEED
FURNACE, ANNEALING . . . . . . . . . . . METALWORKING T&E . . . . . . . . .   90
FURNACE, BLAST . . . . . . . . . . . . . METALWORKING T&E . . . . . . . . .   90
FURNACE, CEMENT-TEST . . . . . . . . . . CHEMICAL T&E . . . . . . . . . . .  139
FURNACE, GLASS . . . . . . . . . . . . . GLASS, PLASTICS, CLAYWORKING T&E .   79
FURNACE, HEARTH. . . . . . . . . . . . . METALWORKING T&E . . . . . . . . .   90
FURNACE, MUFFLE. . . . . . . . . . . . . METALWORKING T&E . . . . . . . . .   90
FURNACE, REVERBERATORY . . . . . . . . . METALWORKING T&E . . . . . . . . .   90
FURNACE, SOLAR . . . . . . . . . . . . . ENERGY PRODUCTION T&E. . . . . . .  143
FURNITURE, KILN. . . . . . . . . . . . . GLASS, PLASTICS, CLAYWORKING T&E .   79
 Fuse. . . . . . . . . . . . . . . . . . ELECTRICAL & MAGNETIC T&E
   use  BREAKER, CIRCUIT
FUSE, DETONATING . . . . . . . . . . . . MINING & MINERAL HARVESTING T&E. .   99
FUSIL. . . . . . . . . . . . . . . . . . ARMAMENT -- FIREARM. . . . . . . .  124
   rt  MUSKET
FUZE . . . . . . . . . . . . . . . . . . ARMAMENT -- AMMUNITION . . . . . .  129
GAD. . . . . . . . . . . . . . . . . . . MINING & MINERAL HARVESTING T&E. .   99
   rt  MOIL
GADDER . . . . . . . . . . . . . . . . . MINING & MINERAL HARVESTING T&E. .   99
GAFF . . . . . . . . . . . . . . . . . . WATER TRANSPORTATION -- ACCESSORY. 202
GAFF, FISH . . . . . . . . . . . . . . . FISHING & TRAPPING T&E . . . . . .   56
 Gaff, Hay . . . . . . . . . . . . . . . AGRICULTURAL T&E
   use  CROOK, HAY
```

- -

GAFF, SEALING. FISHING & TRAPPING T&E 56
GAFFER PHOTOGRAPHIC T&E 176
GAG. REGULATIVE & PROTECTIVE T&E. . . . 160
GAG, CANINE. ANIMAL HUSBANDRY T&E 53
 Gage. METALWORKING T&E
 use GAUGE
GAITER CLOTHING -- FOOTWEAR 25
GALACTOMETER FOOD PROCESSING T&E. 61
GALLERY, SHOOTING. RECREATIONAL DEVICE. 219
GALLEY WATER TRANSPORTATION -- EQUIPMENT. 198
GALLIPOT MEDICAL & PSYCHOLOGICAL T&E. . . . 151
GALLOWS. REGULATIVE & PROTECTIVE T&E. . . . 161
GALOSH CLOTHING -- FOOTWEAR· 25
GALVANOMETER ELECTRICAL & MAGNETIC T&E. 142
GALVANOMETER, BLASTING MINING & MINERAL HARVESTING T&E. . 99
GALVANOSCOPE ELECTRICAL & MAGNETIC T&E. 142
GALVANOTHERMOMETER THERMAL T&E. 164
GAMBREL. FOOD PROCESSING T&E. 61
GAME GAME 217
 game names may be entered individually, e.g.: CRIBBAGE; DOMINOES
GAME GAME 217
 note use for non-mechanical games not played on boards. Non-proprietary
GAME, BOARD. GAME 217
 note use for a titled game played on a board. Non-proprietory names may
 be entered individually, e.g.: CHECKERS; CHESS
 GAME, CARD. GAME
 use for such games as Old Maid; Authors; Uno
GAME, MECHANICAL GAME 217
GANGPLANK. WATER TRANSPORTATION -- ACCESSORY. 202
GARAGE BUILDING 2
GARDEN, FLOWER TOY. 224
GARDEN, VEGETABLE. TOY. 224
GARGOYLE BUILDING COMPONENT 5
GARNITURE, CLOCK TIMEKEEPING T&E. 165
GARTER CLOTHING -- ACCESSORY. 33
GARVEY WATER TRANSPORTATION -- EQUIPMENT. 198
 Gasolier. LIGHTING DEVICE
 use CHANDELIER with an appropriate modifier
GATE SITE FEATURE 7
GATE, SWINGING RECREATIONAL DEVICE. 219
GATEHOUSE. BUILDING 2
GATEWAY. SITE FEATURE 7
 Gatherer, Fruit AGRICULTURAL T&E
 use PICKER, FRUIT
GAUGE. METALWORKING T&E 90
GAUGE. WOODWORKING T&E. 115
GAUGE. LEATHER, HORN, SHELLWORKING T&E. . 83
GAUGE. WEIGHTS & MEASURES T&E 166
GAUGE, AMMONIA CHEMICAL T&E 139
GAUGE, ARTILLERY ARMAMENT -- ACCESSORY. 131

- -

```
GAUGE, BEVEL . . . . . . . . . . . . . . WOODWORKING T&E. . . . . . . . . 115
GAUGE, BORING. . . . . . . . . . . . . . WOODWORKING T&E. . . . . . . . . 115
GAUGE, BULLET. . . . . . . . . . . . . . ARMAMENT -- ACCESSORY. . . . . . 131
 Gauge, Butt . . . . . . . . . . . . . . WOODWORKING T&E
  use GAUGE, MARKING
GAUGE, CANNONBALL. . . . . . . . . . . . ARMAMENT -- ACCESSORY. . . . . . 131
GAUGE, CENTER. . . . . . . . . . . . . . METALWORKING T&E . . . . . . . .  90
GAUGE, COMBINATION . . . . . . . . . . . WOODWORKING T&E. . . . . . . . . 115
GAUGE, COMPOSING STICK . . . . . . . . . PRINTING T&E . . . . . . . . . . 178
GAUGE, CROWN . . . . . . . . . . . . . . MEDICAL & PSYCHOLOGICAL T&E. . . 151
GAUGE, CUTTING . . . . . . . . . . . . . WOODWORKING T&E. . . . . . . . . 115
GAUGE, DEPTH . . . . . . . . . . . . . . SURVEYING & NAVIGATIONAL T&E . . 162
GAUGE, DOVETAIL. . . . . . . . . . . . . WOODWORKING T&E. . . . . . . . . 115
GAUGE, DRAW. . . . . . . . . . . . . . . LEATHER, HORN, SHELLWORKING T&E.  83
  rt GAUGE, PLOUGH
GAUGE, DRILL . . . . . . . . . . . . . . METALWORKING T&E . . . . . . . .  90
GAUGE, FRUIT . . . . . . . . . . . . . . AGRICULTURAL T&E . . . . . . . .  44
 Gauge, Grasshopper. . . . . . . . . . . WOODWORKING T&E
  use GAUGE, MONKEY
 Gauge, Handrail . . . . . . . . . . . . WOODWORKING T&E
  use GAUGE, MONKEY
GAUGE, KNITTING NEEDLE . . . . . . . . . TEXTILEWORKING T&E . . . . . . . 106
GAUGE, LINE. . . . . . . . . . . . . . . PRINTING T&E . . . . . . . . . . 178
GAUGE, MARKING . . . . . . . . . . . . . WOODWORKING T&E. . . . . . . . . 115
GAUGE, MONKEY. . . . . . . . . . . . . . WOODWORKING T&E. . . . . . . . . 115
 Gauge, Mortise. . . . . . . . . . . . . WOODWORKING T&E
  use GAUGE, MARKING
GAUGE, NET . . . . . . . . . . . . . . . TEXTILEWORKING T&E . . . . . . . 106
 Gauge, Panel. . . . . . . . . . . . . . WOODWORKING T&E
  use GAUGE, MARKING
 Gauge, Patternmaker's . . . . . . . . . WOODWORKING T&E
  use GAUGE, MONKEY
GAUGE, PLATE . . . . . . . . . . . . . . PRINTING T&E . . . . . . . . . . 178
GAUGE, PLOUGH. . . . . . . . . . . . . . LEATHER, HORN, SHELLWORKING T&E.  83
  rt GAUGE, DRAW
GAUGE, POWDER. . . . . . . . . . . . . . ARMAMENT -- ACCESSORY. . . . . . 131
GAUGE, PRECIPITATION . . . . . . . . . . METEOROLOGICAL T&E . . . . . . . 157
GAUGE, RABBET. . . . . . . . . . . . . . WOODWORKING T&E. . . . . . . . . 115
GAUGE, RAILWAY . . . . . . . . . . . . . WEIGHTS & MEASURES T&E . . . . . 166
GAUGE, RING. . . . . . . . . . . . . . . WEIGHTS & MEASURES T&E . . . . . 166
GAUGE, SAW . . . . . . . . . . . . . . . PRINTING T&E . . . . . . . . . . 178
GAUGE, SCREW-PITCH . . . . . . . . . . . METALWORKING T&E . . . . . . . .  90
 Gauge, Slitting . . . . . . . . . . . . WOODWORKING T&E
  use GAUGE, CUTTING
GAUGE, STAVE . . . . . . . . . . . . . . WOODWORKING T&E. . . . . . . . . 115
GAUGE, STEAM PRESSURE. . . . . . . . . . MECHANICAL T&E . . . . . . . . . 147
GAUGE, THREAD. . . . . . . . . . . . . . METALWORKING T&E . . . . . . . .  90
 Gauge, Thumb. . . . . . . . . . . . . . WOODWORKING T&E
  use GAUGE, MARKING
GAUGE, TIRE PRESSURE . . . . . . . . . . LTE -- ACCESSORY . . . . . . . . 194
```

- -

```
Gauge, Tiring . . . . . . . . . . . . . METALWORKING T&E
   use  TRAVELER
GAUGE, TURNER'S. . . . . . . . . . . . . WOODWORKING T&E. . . . . . . . . 115
GAUGE, TYPE HIGH . . . . . . . . . . . . PRINTING T&E . . . . . . . . . . 178
GAUGE, VACUUM. . . . . . . . . . . . . . ENERGY PRODUCTION T&E. . . . . . 144
GAUGE, VENT. . . . . . . . . . . . . . . ARMAMENT -- ACCESSORY. . . . . . 131
GAUGE, WATER . . . . . . . . . . . . . . WEIGHTS & MEASURES T&E . . . . . 166
GAUGE, WATER . . . . . . . . . . . . . . MECHANICAL T&E . . . . . . . . . 147
GAUGE, WHEELWRIGHT'S . . . . . . . . . . WOODWORKING T&E. . . . . . . . . 115
GAUGE, WIND. . . . . . . . . . . . . . . ARMAMENT -- ACCESSORY. . . . . . 131
GAUGE, WIRE. . . . . . . . . . . . . . . METALWORKING T&E . . . . . . . .  90
GAUNTLET . . . . . . . . . . . . . . . . ARMAMENT -- BODY ARMOR . . . . . 129
GAZEBO . . . . . . . . . . . . . . . . . BUILDING . . . . . . . . . . . .   2
Gear, Flight. . . . . . . . . . . . . . AEROSPACE -- ACCESSORY
   use  more specific term elsewhere in lexicon; see also CLOTHING
GEE-JOGGLE . . . . . . . . . . . . . . . RECREATIONAL DEVICE. . . . . . . 219
GENERATOR. . . . . . . . . . . . . . . . ENERGY PRODUCTION T&E. . . . . . 144
   note may be modified according to power source
GENERATOR, ELECTROSTATIC . . . . . . . NUCLEAR PHYSICS T&E. . . . . . . 158
GENERATOR, GASOLINE. . . . . . . . . . . ENERGY PRODUCTION T&E. . . . . . 144
GENERATOR, SOUND . . . . . . . . . . . . ACOUSTICAL T&E . . . . . . . . . 123
GENERATOR, STEAM . . . . . . . . . . . . ENERGY PRODUCTION T&E. . . . . . 144
GENERATOR, WATER . . . . . . . . . . . . ENERGY PRODUCTION T&E. . . . . . 144
GEODESCOPE . . . . . . . . . . . . . . . ASTRONOMICAL T&E . . . . . . . . 135
GEOPHONE . . . . . . . . . . . . . . . . MINING & MINERAL HARVESTING T&E.  99
GEOTHERMOMETER . . . . . . . . . . . . . THERMAL T&E. . . . . . . . . . . 164
GERMINATOR . . . . . . . . . . . . . . . AGRICULTURAL T&E . . . . . . . .  44
GETA . . . . . . . . . . . . . . . . . . CLOTHING -- FOOTWEAR . . . . . .  25
Giant, Hydraulic. . . . . . . . . . . . MINING & MINERAL HARVESTING T&E
   use  MONITOR, HYDRAULIC
Gibus . . . . . . . . . . . . . . . . . CLOTHING -- HEADWEAR
   use  HAT, TOP
GIG. . . . . . . . . . . . . . . . . . . FISHING & TRAPPING T&E . . . . .  56
Gig . . . . . . . . . . . . . . . . . . ARMAMENT -- EDGED
   use  SPEAR
GIG. . . . . . . . . . . . . . . . . . . LTE -- ANIMAL-POWERED. . . . . . 189
GIG, NAPPING . . . . . . . . . . . . . . TEXTILEWORKING T&E . . . . . . . 106
Gig, Teasel . . . . . . . . . . . . . . TEXTILEWORKING T&E
   use  GIG, NAPPING
GIMBAL, COMPASS. . . . . . . . . . . . . SURVEYING & NAVIGATIONAL T&E . . 162
GIMLET . . . . . . . . . . . . . . . . . WOODWORKING T&E. . . . . . . . . 115
GIMLET, FUZE . . . . . . . . . . . . . . ARMAMENT -- ACCESSORY. . . . . . 131
GIMLET, GUNNER'S . . . . . . . . . . . . ARMAMENT -- ACCESSORY. . . . . . 131
Gin . . . . . . . . . . . . . . . . . . MINING & MINERAL HARVESTING T&E
   use  HOIST, MINE
GIN, COTTON. . . . . . . . . . . . . . . TEXTILEWORKING T&E . . . . . . . 106
GIRANDOLE. . . . . . . . . . . . . . . . LIGHTING DEVICE. . . . . . . . .  20
GIRDLE . . . . . . . . . . . . . . . . . CLOTHING -- UNDERWEAR. . . . . .  32
GIRT . . . . . . . . . . . . . . . . . . MINING & MINERAL HARVESTING T&E.  99
GIRTH. . . . . . . . . . . . . . . . . . LTE -- ACCESSORY . . . . . . . . 194
```

- -

```
Glaive. . . . . . . . . . . . . . . . ARMAMENT -- EDGED
  use  BROADSWORD
GLARIMETER . . . . . . . . . . . . . . PAPERMAKING T&E. . . . . . . . . . 103
GLASS. . . . . . . . . . . . . . . . . FOOD SERVICE T&E . . . . . . . . .  72
 Glass, Ale. . . . . . . . . . . . . . FOOD SERVICE T&E
  use  GLASS, MALT-BEVERAGE
 Glass, Beer . . . . . . . . . . . . . FOOD SERVICE T&E
  use  GLASS, MALT-BEVERAGE
GLASS, CHAMPAGNE . . . . . . . . . . . FOOD SERVICE T&E . . . . . . . . .  72
GLASS, COCKTAIL. . . . . . . . . . . . FOOD SERVICE T&E . . . . . . . . .  72
GLASS, CORDIAL . . . . . . . . . . . . FOOD SERVICE T&E . . . . . . . . .  72
 Glass, Cupping. . . . . . . . . . . . MEDICAL & PSYCHOLOGICAL T&E
  use  CUP, BLEEDING
GLASS, DESSERT . . . . . . . . . . . . FOOD SERVICE T&E . . . . . . . . .  72
 Glass, Dressing . . . . . . . . . . . FURNITURE
  use  MIRROR, CHEVAL
 Glass, Flip . . . . . . . . . . . . . FOOD SERVICE T&E
  use  BEAKER
 Glass, Flute. . . . . . . . . . . . . FOOD SERVICE T&E
  use  GLASS, CHAMPAGNE
 Glass, Goblet . . . . . . . . . . . . FOOD SERVICE T&E
  use  GOBLET
 Glass, Hock . . . . . . . . . . . . . FOOD SERVICE T&E
  use  GLASS, WINE
 Glass, Jelly. . . . . . . . . . . . . FOOD PROCESSING T&E
  use  JAR, PRESERVING
GLASS, JUICE . . . . . . . . . . . . . FOOD SERVICE T&E . . . . . . . . .  72
GLASS, LEMONADE. . . . . . . . . . . . FOOD SERVICE T&E . . . . . . . . .  72
 Glass, Liqueur. . . . . . . . . . . . FOOD SERVICE T&E
  use  GLASS, CORDIAL
 Glass, Looking. . . . . . . . . . . . FURNITURE
  use  MIRROR, CHEVAL
GLASS, MAGNIFYING. . . . . . . . . . . OPTICAL T&E. . . . . . . . . . . . 159
GLASS, MALT-BEVERAGE . . . . . . . . . FOOD SERVICE T&E . . . . . . . . .  72
  rt  STEIN; TANKARD
GLASS, MEASURING . . . . . . . . . . . FOOD PROCESSING T&E. . . . . . . .  61
GLASS, REDUCING. . . . . . . . . . . . OPTICAL T&E. . . . . . . . . . . . 159
 Glass, Sherry . . . . . . . . . . . . FOOD SERVICE T&E
  use  GLASS, WINE
GLASS, SHOT. . . . . . . . . . . . . . FOOD SERVICE T&E . . . . . . . . .  72
  rt  JIGGER
GLASS, SODA FOUNTAIN . . . . . . . . . FOOD SERVICE T&E . . . . . . . . .  72
GLASS, SWEETMEAT . . . . . . . . . . . FOOD SERVICE T&E . . . . . . . . .  72
GLASS, TRICK . . . . . . . . . . . . . FOOD SERVICE T&E . . . . . . . . .  73
GLASS, WATCH . . . . . . . . . . . . . CHEMICAL T&E . . . . . . . . . . . 139
GLASS, WATER . . . . . . . . . . . . . FOOD SERVICE T&E . . . . . . . . .  73
GLASS, WINE. . . . . . . . . . . . . . FOOD SERVICE T&E . . . . . . . . .  73
 Glasses, Eye. . . . . . . . . . . . . PERSONAL GEAR
  use  EYEGLASSES
GLASSES, FIELD . . . . . . . . . . . . OPTICAL T&E. . . . . . . . . . . . 159
  rt  BINOCULARS
```

- -

- -

GOUGE, TURNING WOODWORKING T&E. 115
GOUGE, V LEATHER, HORN, SHELLWORKING T&E. . 83
GOUGE, WHEELWRIGHT'S WOODWORKING T&E. 115
GOVERNOR ENERGY PRODUCTION T&E. 144
GOVERNOR MINING & MINERAL HARVESTING T&E. . 100
GOWN CLOTHING -- OUTERWEAR. 29
 rt DRESS
GOWN, ACADEMIC PERSONAL SYMBOL. 215
GOWN, BAPTISMAL. CLOTHING -- OUTERWEAR. 29
GOWN, DRESSING CLOTHING -- OUTERWEAR. 30
GOWN, EVENING. CLOTHING -- OUTERWEAR. 30
 Gown, Night CLOTHING -- OUTERWEAR
 use NIGHTGOWN
GOWN, WEDDING. CLOTHING -- OUTERWEAR. 30
GRADER CONSTRUCTION T&E 141
 Grader, Bean. FOOD PROCESSING T&E
 use SORTER, BEAN
GRADER, EGG. FOOD PROCESSING T&E. 61
GRADER, FRUIT. FOOD PROCESSING T&E. 61
GRADIOMETER. SURVEYING & NAVIGATIONAL T&E . . . 162
GRADUATE CHEMICAL T&E 139
GRADUATE WEIGHTS & MEASURES T&E 166
GRADUATOR. DATA PROCESSING T&E. 169
GRAGER CEREMONIAL ARTIFACT. 207
GRAIL, HORNWORKER'S. LEATHER, HORN, SHELLWORKING T&E. . 83
 rt FILE
GRAIN. ARMAMENT -- EDGED. 126
 Grainer PAINTING T&E
 use COMB, GRAINING
GRANDSTAND OTHER STRUCTURE. 8
GRANOMETER BIOLOGICAL T&E 137
GRAPESHOT. ARMAMENT -- AMMUNITION 129
GRAPHOMETER. SURVEYING & NAVIGATIONAL T&E . . . 162
 rt CIRCUMFERENTOR; QUADRANT
GRAPHOSCOPE. VISUAL COMMUNICATION T&E 182
GRAPHOTYPE METALWORKING T&E 90
GRAPNEL. MINING & MINERAL HARVESTING T&E. . 100
GRAPPLE. MULTIPLE USE ARTIFACT. 227
GRATE, FIREPLACE TEMPERATURE CONTROL DEVICE . . . 22
GRATE, HOT SHOT. ARMAMENT -- ACCESSORY. 132
GRATE, REGISTER. BUILDING COMPONENT 5
GRATE, STOVE TEMPERATURE CONTROL DEVICE . . . 22
GRATER FOOD PROCESSING T&E. 61
GRATER, SOAP MAINTENANCE T&E. 145
GRATER, SPICE. FOOD PROCESSING T&E. 61
GRAVER MASONRY & STONEWORKING T&E . . . 87
 rt BURIN
GRAVER PRINTING T&E 178
 Gravestone. CEREMONIAL ARTIFACT
 use TOMBSTONE

- -

```
GRAVIMETER . . . . . . . . . . . . . MECHANICAL T&E . . . . . . . . . .  147
GREATCOAT. . . . . . . . . . . . . . CLOTHING -- OUTERWEAR. . . . . . .   30
GREENHOUSE . . . . . . . . . . . . . BUILDING . . . . . . . . . . . . .    2
GRENADE, ANTIPERSONNEL . . . . . . . ARMAMENT -- AMMUNITION . . . . . .  129
GRENADE, ANTITANK. . . . . . . . . . ARMAMENT -- AMMUNITION . . . . . .  129
GRENADE, INCENDIARY. . . . . . . . . ARMAMENT -- AMMUNITION . . . . . .  129
GRENADE, TEAR GAS. . . . . . . . . . REGULATIVE & PROTECTIVE T&E. . . .  161
GRIDDLE. . . . . . . . . . . . . . . FOOD PROCESSING T&E. . . . . . . .   61
GRIDIRON . . . . . . . . . . . . . . FOOD PROCESSING T&E. . . . . . . .   61
GRILL. . . . . . . . . . . . . . . . FOOD PROCESSING T&E. . . . . . . .   61
GRILL. . . . . . . . . . . . . . . . BUILDING COMPONENT . . . . . . . .    5
GRILL, VENTILATOR. . . . . . . . . . BUILDING COMPONENT . . . . . . . .    5
GRILL, WINDOW. . . . . . . . . . . . BUILDING COMPONENT . . . . . . . .    5
GRINDER. . . . . . . . . . . . . . . FOOD PROCESSING T&E. . . . . . . .   61
   rt  MILL
GRINDER. . . . . . . . . . . . . . . METALWORKING T&E . . . . . . . . .   90
   rt  GRINDSTONE
 Grinder . . . . . . . . . . . . . . PAPERMAKING T&E
   use CHIPPER
GRINDER, BONE. . . . . . . . . . . . FOOD PROCESSING T&E. . . . . . . .   61
GRINDER, BRAN. . . . . . . . . . . . FOOD PROCESSING T&E. . . . . . . .   61
GRINDER, CARD. . . . . . . . . . . . TEXTILEWORKING T&E . . . . . . . .  106
 Grinder, Coffee . . . . . . . . . . FOOD PROCESSING T&E
   use MILL, COFFEE
GRINDER, CYLINDRICAL . . . . . . . . METALWORKING T&E . . . . . . . . .   90
GRINDER, FEED. . . . . . . . . . . . AGRICULTURAL T&E . . . . . . . . .   44
GRINDER, MEAT. . . . . . . . . . . . FOOD PROCESSING T&E. . . . . . . .   61
 Grinder, Middlings. . . . . . . . . FOOD PROCESSING T&E
   use MILL, MIDDLINGS
GRINDER, MOWER-KNIFE . . . . . . . . METALWORKING T&E . . . . . . . . .   90
GRINDER, PLANER KNIFE. . . . . . . . METALWORKING T&E . . . . . . . . .   90
GRINDER, SOIL. . . . . . . . . . . . AGRICULTURAL T&E . . . . . . . . .   44
 Grinder, Spice. . . . . . . . . . . FOOD PROCESSING T&E
   use MILL, SPICE
GRINDER, SURFACE . . . . . . . . . . METALWORKING T&E . . . . . . . . .   90
GRINDER, TOOL. . . . . . . . . . . . METALWORKING T&E . . . . . . . . .   90
GRINDER, VALVE . . . . . . . . . . . METALWORKING T&E . . . . . . . . .   90
GRINDER/MIXER, FEED. . . . . . . . . AGRICULTURAL T&E . . . . . . . . .   44
GRINDSTONE . . . . . . . . . . . . . METALWORKING T&E . . . . . . . . .   90
   rt  GRINDER
GRIPPER. . . . . . . . . . . . . . . MULTIPLE USE ARTIFACT. . . . . . .  227
GRIZZLY. . . . . . . . . . . . . . . MINING & MINERAL HARVESTING T&E. .  100
GROMA. . . . . . . . . . . . . . . . SURVEYING & NAVIGATIONAL T&E . . .  162
   rt  CROSS-STAFF; SQUARE, OPTICAL
GROOVER, HAND. . . . . . . . . . . . METALWORKING T&E . . . . . . . . .   90
GROOVER, HOOF. . . . . . . . . . . . ANIMAL HUSBANDRY T&E . . . . . . .   53
GROOVER, STITCHING . . . . . . . . . LEATHER, HORN, SHELLWORKING T&E. .   83
 Grozer. . . . . . . . . . . . . . . GLASS, PLASTICS, CLAYWORKING T&E
   use PLIERS, GLASS
GUARD, ARM . . . . . . . . . . . . . ARMAMENT -- ACCESSORY. . . . . . .  132
```

- -

- -

GUN, GATLING ARMAMENT -- ARTILLERY. 128
Gun, Grease ARMAMENT -- FIREARM
 use GUN, SUBMACHINE
GUN, GREASE. LTE -- ACCESSORY 194
GUN, HARPOON ARMAMENT -- FIREARM. 124
Gun, Insect powder. AGRICULTURAL T&E
 use DUSTER, DRY-POWDER
GUN, LINE-THROWING WATER TRANSPORTATION -- ACCESSORY. 202
GUN, LYLE. WATER TRANSPORTATION -- ACCESSORY. 202
GUN, MACHINE ARMAMENT -- FIREARM. 124
GUN, MARKING ANIMAL HUSBANDRY T&E 53
GUN, PRESENTATION. PERSONAL SYMBOL. 215
GUN, RAILWAY ARMAMENT -- ARTILLERY. 128
GUN, RECOILESS ARMAMENT -- ARTILLERY. 128
GUN, SEA-COAST ARMAMENT -- ARTILLERY. 128
GUN, SEIGE ARMAMENT -- ARTILLERY. 128
GUN, SELF-PROPELLED. ARMAMENT -- ARTILLERY. 128
GUN, SPRAY PAINTING T&E 102
GUN, SPRAY GLASS, PLASTICS, CLAYWORKING T&E . 79
GUN, SUBMACHINE. ARMAMENT -- FIREARM. 124
GUN, SWIVEL. ARMAMENT -- ARTILLERY. 128
GUN, TATTOO. ANIMAL HUSBANDRY T&E 53
GUN, TRANQUILIZER. ARMAMENT -- FIREARM. 124
Gun, Whaling. ARMAMENT -- FIREARM
 use GUN, HARPOON
GUNBOAT, PATROL. WATER TRANSPORTATION -- EQUIPMENT. 199
GUN/HOWITZER ARMAMENT -- ARTILLERY. 128
Gym, Jungle RECREATIONAL DEVICE
 use CLIMBER
GYRO-COMPASS SURVEYING & NAVIGATIONAL T&E . . . 162
 rt COMPASS
GYRO-COMPASS AEROSPACE -- ACCESSORY 187
GYROJET. ARMAMENT -- ACCESSORY. 132
GYROSCOPE. MECHANICAL T&E 147
Gyrostat. MECHANICAL T&E
 use GYROSCOPE
HABIT, MONK'S. CLOTHING -- OUTERWEAR. 30
HABIT, NUN'S CLOTHING -- OUTERWEAR. 30
HABIT, RIDING. CLOTHING -- OUTERWEAR. 30
Hack. LTE -- ANIMAL-POWERED
 use CAB or CAB, HANSOM
HACK, TURPENTINE FORESTRY T&E 78
Hackle. TEXTILEWORKING T&E
 use HATCHEL
HACKSAW. METALWORKING T&E 90
Haemacytometer. MEDICAL & PSYCHOLOGICAL T&E
 use HEMOCYTOMETER
Haematometer. MEDICAL & PSYCHOLOGICAL T&E
 use HEMOCYTOMETER
Haemoscope. MEDICAL & PSYCHOLOGICAL T&E
 use HEMOSCOPE

- -

- -

```
HAMMER, FILE-CUTTING . . . . . . . . . METALWORKING T&E . . . . . . . . .   91
HAMMER, FITTING. . . . . . . . . . . . ANIMAL HUSBANDRY T&E . . . . . . .   53
  Hammer, Flooring. . . . . . . . . . . WOODWORKING T&E
    use HAMMER, CLENCH
HAMMER, FOOT-POWERED . . . . . . . . . METALWORKING T&E . . . . . . . . .   91
HAMMER, FORGING. . . . . . . . . . . . METALWORKING T&E . . . . . . . . .   91
HAMMER, FRAMING. . . . . . . . . . . . WOODWORKING T&E. . . . . . . . . .  115
HAMMER, HAND . . . . . . . . . . . . . MINING & MINERAL HARVESTING T&E. .  100
HAMMER, HEEL . . . . . . . . . . . . . LEATHER, HORN, SHELLWORKING T&E. .   83
HAMMER, HELVE. . . . . . . . . . . . . METALWORKING T&E . . . . . . . . .   91
HAMMER, IRONING. . . . . . . . . . . . METALWORKING T&E . . . . . . . . .   91
HAMMER, JOINER'S . . . . . . . . . . . WOODWORKING T&E. . . . . . . . . .  115
  Hammer, Killing . . . . . . . . . . . FOOD PROCESSING T&E
    use HAMMER, SLAUGHTERING
HAMMER, KNAPPING . . . . . . . . . . . MASONRY & STONEWORKING T&E . . . .   87
HAMMER, MARKING. . . . . . . . . . . . FORESTRY T&E . . . . . . . . . . .   78
HAMMER, MASON'S. . . . . . . . . . . . MASONRY & STONEWORKING T&E . . . .   87
  Hammer, Meat. . . . . . . . . . . . . FOOD PROCESSING T&E
    use MAUL, MEAT
HAMMER, PATENT . . . . . . . . . . . . MASONRY & STONEWORKING T&E . . . .   87
HAMMER, PATTERNMAKER'S . . . . . . . . WOODWORKING T&E. . . . . . . . . .  115
HAMMER, PLANISHING . . . . . . . . . . METALWORKING T&E . . . . . . . . .   91
HAMMER, PLOW . . . . . . . . . . . . . METALWORKING T&E . . . . . . . . .   91
  Hammer, Power . . . . . . . . . . . . METALWORKING T&E
    use  more specific term, e.g.: HAMMER, HELVE or TRIP-HAMMER
HAMMER, RAISING. . . . . . . . . . . . METALWORKING T&E . . . . . . . . .   91
HAMMER, RIVETING . . . . . . . . . . . METALWORKING T&E . . . . . . . . .   91
  Hammer, Roofing . . . . . . . . . . . WOODWORKING T&E
    use HAMMER, CLENCH
  Hammer, Rounding. . . . . . . . . . . METALWORKING T&E
    use HAMMER, TURNING
HAMMER, SADDLER'S. . . . . . . . . . . LEATHER, HORN, SHELLWORKING T&E. .   83
HAMMER, SET. . . . . . . . . . . . . . METALWORKING T&E . . . . . . . . .   91
  rt  FLATTER
HAMMER, SETTING. . . . . . . . . . . . METALWORKING T&E . . . . . . . . .   91
  rt  HAMMER, SWAGE
HAMMER, SHARPENING . . . . . . . . . . METALWORKING T&E . . . . . . . . .   91
  Hammer, Ship's maul . . . . . . . . . WOODWORKING T&E
    use HAMMER, TOP MAUL
  Hammer, Shoeing . . . . . . . . . . . ANIMAL HUSBANDRY T&E
    use HAMMER, DRIVING
HAMMER, SHOEMAKER'S. . . . . . . . . . LEATHER, HORN, SHELLWORKING T&E. .   83
  Hammer, Shoe-turning. . . . . . . . . METALWORKING T&E
    use HAMMER, TURNING
HAMMER, SLATER'S . . . . . . . . . . . MASONRY & STONEWORKING T&E . . . .   87
HAMMER, SLAUGHTERING . . . . . . . . . FOOD PROCESSING T&E. . . . . . . .   61
  Hammer, Sledge. . . . . . . . . . . . METALWORKING T&E
    use SLEDGE
HAMMER, SOUND. . . . . . . . . . . . . ACOUSTICAL T&E . . . . . . . . . .  123
  Hammer, Steak . . . . . . . . . . . . FOOD PROCESSING T&E
    use MAUL, MEAT
```

- -

```
HAMMER, STEAM. . . . . . . . . . . . . . METALWORKING T&E . . . . . . . . .  91
HAMMER, STONE. . . . . . . . . . . . . . CONSTRUCTION T&E . . . . . . . . . 141
HAMMER, STRAIGHT-PEEN. . . . . . . . . . METALWORKING T&E . . . . . . . .   91
 Hammer, Striking. . . . . . . . . . . . METALWORKING T&E
   use SLEDGE
HAMMER, SUGAR. . . . . . . . . . . . . . FOOD SERVICE T&E . . . . . . . . .  73
HAMMER, SWAGE. . . . . . . . . . . . . . METALWORKING T&E . . . . . . . .   91
   rt  HAMMER, SETTING
HAMMER, TACK . . . . . . . . . . . . . . WOODWORKING T&E. . . . . . . . .  115
 Hammer, Tilt. . . . . . . . . . . . . . METALWORKING T&E
   use HAMMER, HELVE
HAMMER, TOP MAUL . . . . . . . . . . . . WOODWORKING T&E. . . . . . . . .  115
HAMMER, TRIMMER'S. . . . . . . . . . . . WOODWORKING T&E. . . . . . . . .  116
 Hammer, Trip. . . . . . . . . . . . . . METALWORKING T&E
   use TRIP-HAMMER
HAMMER, TURNING. . . . . . . . . . . . . METALWORKING T&E . . . . . . . .   91
HAMMER, TURN-SHOE. . . . . . . . . . . . LEATHER, HORN, SHELLWORKING T&E. .  83
HAMMER, VENEER . . . . . . . . . . . . . WOODWORKING T&E. . . . . . . . .  116
HAMMER, WAR. . . . . . . . . . . . . . . ARMAMENT -- BLUDGEON . . . . . .  127
HAMMER, WELDING. . . . . . . . . . . . . METALWORKING T&E . . . . . . . .   91
HAMMERSTONE. . . . . . . . . . . . . . . MULTIPLE USE ARTIFACT. . . . . .  228
HAMMOCK. . . . . . . . . . . . . . . . . BEDDING. . . . . . . . . . . . .    9
HAMPER . . . . . . . . . . . . . . . . . MAINTENANCE T&E. . . . . . . . .  145
HAMPER, PICNIC . . . . . . . . . . . . . FOOD SERVICE T&E . . . . . . . .   73
HAND, SCOTCH . . . . . . . . . . . . . . FOOD PROCESSING T&E. . . . . . .   61
 Handbag . . . . . . . . . . . . . . . . PERSONAL GEAR
   use PURSE
HANDBALL . . . . . . . . . . . . . . . . SPORTS EQUIPMENT . . . . . . . .  221
HANDBILL . . . . . . . . . . . . . . . . DOCUMENTARY ARTIFACT . . . . . .  211
HANDBILL . . . . . . . . . . . . . . . . ADVERTISING MEDIUM . . . . . . .  204
   rt  POSTER
HANDBILL, POLITICAL. . . . . . . . . . . ADVERTISING MEDIUM . . . . . . .  204
HANDBILL, TRADE. . . . . . . . . . . . . ADVERTISING MEDIUM . . . . . . .  204
HANDCAR. . . . . . . . . . . . . . . . . RAIL TRANSPORTATION -- EQUIPMENT . 196
   rt  CAR, VELOCIPEDE
HANDCART . . . . . . . . . . . . . . . . LTE -- HUMAN-POWERED . . . . . .  191
HANDCUFFS. . . . . . . . . . . . . . . . REGULATIVE & PROTECTIVE T&E. . . . 161
 Handgun . . . . . . . . . . . . . . . . ARMAMENT -- FIREARM
   use  more specific term, e.g.: PISTOL; REVOLVER
HANDKERCHIEF . . . . . . . . . . . . . . PERSONAL GEAR. . . . . . . . . .   36
HANDLE, DENTAL . . . . . . . . . . . . . MEDICAL & PSYCHOLOGICAL T&E. . . . 151
HAND-PIECE, DENTAL . . . . . . . . . . . MEDICAL & PSYCHOLOGICAL T&E. . . . 151
HANDPRESS. . . . . . . . . . . . . . . . PRINTING T&E . . . . . . . . . .  178
 Hands, Butter . . . . . . . . . . . . . FOOD PROCESSING T&E
   use WORKER, BUTTER
 Handsaw . . . . . . . . . . . . . . . . WOODWORKING T&E
   use  more specific term, e.g.: SAW, CROSSCUT; RIPSAW
 Handsaw . . . . . . . . . . . . . . . . MASONRY & STONEWORKING T&E
   use SAW, MASON'S
HANDSPIKE. . . . . . . . . . . . . . . . ARMAMENT -- ACCESSORY. . . . . .  132
```

- -

```
HANDSPIKE. . . . . . . . . . . . . . . . WATER TRANSPORTATION -- ACCESSORY. 202
HANDSTEEL. . . . . . . . . . . . . . . . MINING & MINERAL HARVESTING T&E. .  100
   rt   DRILL
HANGER . . . . . . . . . . . . . . . . . GLASS, PLASTICS, CLAYWORKING T&E .   79
  Hanger, Clothes . . . . . . . . . . . HOUSEHOLD ACCESSORY
   use  COATHANGER
HANGER, PICTURE. . . . . . . . . . . . . HOUSEHOLD ACCESSORY. . . . . . . .   17
HANGER, SHAFT. . . . . . . . . . . . . . ENERGY PRODUCTION T&E. . . . . . .  144
HANGING. . . . . . . . . . . . . . . . . ART. . . . . . . . . . . . . . . .  205
     note use for macrame, needlework, weaving and other craft objects not
          otherwise named, e.g.: SAMPLER; TAPESTRY
HARDWARE, HARNESS. . . . . . . . . . . . LTE -- ACCESSORY . . . . . . . .    194
HARDY. . . . . . . . . . . . . . . . . . METALWORKING T&E . . . . . . . .     91
HARDY, SIDE-CUTTING. . . . . . . . . . . METALWORKING T&E . . . . . . . .     91
HARDY, STRAIGHT. . . . . . . . . . . . . METALWORKING T&E . . . . . . . .     91
HARMONICA. . . . . . . . . . . . . . . . MUSICAL T&E. . . . . . . . . . .    173
HARMONICA, GLASS . . . . . . . . . . . . MUSICAL T&E. . . . . . . . . . .    173
  Harmonium . . . . . . . . . . . . . . MUSICAL T&E
   use  ORGAN, REED
HARMONOMETER . . . . . . . . . . . . . . ACOUSTICAL T&E . . . . . . . . .    123
HARNESS. . . . . . . . . . . . . . . . . LTE -- ACCESSORY . . . . . . . .    194
HARNESS, BUGGY . . . . . . . . . . . . . LTE -- ACCESSORY . . . . . . . .    194
HARNESS, CASTING . . . . . . . . . . . . ANIMAL HUSBANDRY T&E . . . . . .     53
HARNESS, DOG . . . . . . . . . . . . . . LTE -- ACCESSORY . . . . . . . .    194
HARNESS, DONKEY. . . . . . . . . . . . . LTE -- ACCESSORY . . . . . . . .    194
HARNESS, EXPRESS . . . . . . . . . . . . LTE -- ACCESSORY . . . . . . . .    194
HARNESS, FARM. . . . . . . . . . . . . . LTE -- ACCESSORY . . . . . . . .    194
  Harness, Heavy truck. . . . . . . . . LTE -- ACCESSORY
   use  HARNESS, EXPRESS
HARNESS, PONY. . . . . . . . . . . . . . LTE -- ACCESSORY . . . . . . . .    194
HARNESS, RUNABOUT. . . . . . . . . . . . LTE -- ACCESSORY . . . . . . . .    194
  Harness, Team . . . . . . . . . . . . LTE -- ACCESSORY
   use  HARNESS, FARM
HARNESS, TRACK . . . . . . . . . . . . . LTE -- ACCESSORY . . . . . . . .    194
HARP . . . . . . . . . . . . . . . . . . MUSICAL T&E. . . . . . . . . . .    173
HARP, JEW'S. . . . . . . . . . . . . . . MUSICAL T&E. . . . . . . . . . .    173
HARPOON. . . . . . . . . . . . . . . . . FISHING & TRAPPING T&E . . . . .     56
HARPOON. . . . . . . . . . . . . . . . . ARMAMENT -- EDGED. . . . . . . .    126
HARPSICHORD. . . . . . . . . . . . . . . MUSICAL T&E. . . . . . . . . . .    173
HARQUEBUS. . . . . . . . . . . . . . . . ARMAMENT -- FIREARM. . . . . . .    125
HARROW, ACME . . . . . . . . . . . . . . AGRICULTURAL T&E . . . . . . . .     44
HARROW, DISK . . . . . . . . . . . . . . AGRICULTURAL T&E . . . . . . . .     44
  Harrow, Drag. . . . . . . . . . . . . AGRICULTURAL T&E
   use  HARROW, SPIKE-TOOTH
  Harrow, Spading . . . . . . . . . . . AGRICULTURAL T&E
   use  HOE, ROTARY
HARROW, SPIKE-TOOTH. . . . . . . . . . . AGRICULTURAL T&E . . . . . . . .     45
HARROW, SPRING-TOOTH . . . . . . . . . . AGRICULTURAL T&E . . . . . . . .     45
HARROW, TINE-TOOTH . . . . . . . . . . . AGRICULTURAL T&E . . . . . . . .     45
HARVESTER, BEAN. . . . . . . . . . . . . AGRICULTURAL T&E . . . . . . . .     45
```

- -

HARVESTER, CORN. AGRICULTURAL T&E 45
HARVESTER, FORAGE. AGRICULTURAL T&E 45
HARVESTER, ONION AGRICULTURAL T&E 45
HARVESTER, POTATO. AGRICULTURAL T&E 45
HARVESTER, SUGAR-BEET. AGRICULTURAL T&E 45
HARVESTER, SUGARCANE AGRICULTURAL T&E 45
HARVESTER, TOMATO. AGRICULTURAL T&E 45
 Harvester/thresher. AGRICULTURAL T&E
 use COMBINE
HASP BUILDING COMPONENT 5
HASSOCK. FURNITURE. 13
 rt OTTOMAN; FOOTSTOOL
HAT. CLOTHING -- HEADWEAR 27
HAT, COCKED. CLOTHING -- HEADWEAR 27
HAT, COWBOY. CLOTHING -- HEADWEAR 27
 rt SOMBRERO
Hat, Derby. CLOTHING -- HEADWEAR
 use DERBY
HAT, ECCLESIASTIC. PERSONAL SYMBOL. 215
HAT, FRATERNAL PERSONAL SYMBOL. 215
HAT, HARD. CLOTHING -- HEADWEAR 27
 Hat, Homberg. CLOTHING -- HEADWEAR
 use HOMBERG
HAT, KETTLE. ARMAMENT -- BODY ARMOR 129
HAT, PANAMA. CLOTHING -- HEADWEAR 27
HAT, PICTURE CLOTHING -- HEADWEAR 27
 Hat, Safety CLOTHING -- HEADWEAR
 use more specific term, e.g.: HAT, HARD
HAT, TOP CLOTHING -- HEADWEAR 27
HATBAND. CLOTHING -- HEADWEAR 27
HATBOX PERSONAL GEAR. 36
HATCHEL. BASKET, BROOM, BRUSH MAKING T&E. . 122
HATCHEL. WIGMAKING T&E. 122
HATCHEL. TEXTILEWORKING T&E 106
HATCHER, POULTRY ANIMAL HUSBANDRY T&E 53
HATCHET. WOODWORKING T&E. 116
 rt AX
HATCHET, CANDY FOOD PROCESSING T&E. 61
HATCHET, CLAW. WOODWORKING T&E. 116
HATCHET, DENTAL. MEDICAL & PSYCHOLOGICAL T&E. . . . 151
HATCHET, HEWING. WOODWORKING T&E. 116
HATCHET, LATHING WOODWORKING T&E. 116
HATCHET, SHINGLING WOODWORKING T&E. 116
HATPIN CLOTHING -- ACCESSORY. 33
HAUBERK. ARMAMENT -- BODY ARMOR 129
 Hautboy MUSICAL T&E
 use OBOE
HAVELOCK CLOTHING -- HEADWEAR 27
HAVERSACK. PERSONAL GEAR. 36
HAVERSACK, GUNNER'S. ARMAMENT -- ACCESSORY. 132

- -

HAWK MASONRY & STONEWORKING T&E 87
HAYFORK. AGRICULTURAL T&E 45
HAY-LOADER AGRICULTURAL T&E 45
HAY-LOADER, BALE AGRICULTURAL T&E 45
HEAD, DOLL TOY. 224
HEAD, TROPHY PERSONAL SYMBOL. 215
HEADBAND CLOTHING -- HEADWEAR 27
HEADBAND, TIGHTENING REGULATIVE & PROTECTIVE T&E. . . . 161
HEADDRESS. PERSONAL SYMBOL. 215
HEADER, GRAIN. AGRICULTURAL T&E 45
 Headkerchief. CLOTHING -- HEADWEAR
 use KERCHIEF
HEADREST BEDDING. 9
HEADREST PHOTOGRAPHIC T&E 176
HEADRING PERSONAL GEAR. 36
HEADSET, RADIO TELECOMMUNICATION T&E. 181
 Headstone CEREMONIAL ARTIFACT
 use TOMBSTONE
HEARSE LTE -- MOTORIZED 192
HEARSE LTE -- ANIMAL-POWERED. 189
HEATER TEMPERATURE CONTROL DEVICE 22
HEATER, BRANDING-IRON. METALWORKING T&E 91
HEATER, CALROD GLASS, PLASTICS, CLAYWORKING T&E . 79
HEATER, ELECTRIC TEMPERATURE CONTROL DEVICE . . . 22
HEATER, LAMP TEMPERATURE CONTROL DEVICE . . . 22
HEATER, MILK FOOD PROCESSING T&E. 61
HEATER, OIL. TEMPERATURE CONTROL DEVICE . . . 22
HEATER, STRIP. GLASS, PLASTICS, CLAYWORKING T&E . 79
HEATER, WATER. TEMPERATURE CONTROL DEVICE 22
HEATER, WATER. PLUMBING FIXTURE 21
 Heater, Wheat FOOD PROCESSING T&E
 use CONDITIONER, GRAIN
HEAUME ARMAMENT -- BODY ARMOR 130
 rt HELMET
HEAVER WATER TRANSPORTATION -- ACCESSORY. 202
 Heckle. TEXTILEWORKING T&E
 use HATCHEL
HECTOGRAPH PRINTING T&E 178
HELICOGRAPH. DRAFTING T&E 171
HELICOPTER AEROSPACE -- EQUIPMENT 187
HELIOGRAPH VISUAL COMMUNICATION T&E 182
HELIOMETER ASTRONOMICAL T&E 135
HELIOSCOPE ASTRONOMICAL T&E 135
 Heliostat SURVEYING & NAVIGATIONAL T&E
 use HELIOTROPE
HELIOTROPE SURVEYING & NAVIGATIONAL T&E . . . 162
HELM ARMAMENT -- BODY ARMOR 130
HELMET CLOTHING -- HEADWEAR 27
HELMET ARMAMENT -- BODY ARMOR 130
 rt HEAUME

- -

```
HELMET, CRASH. . . . . . . . . . . . . . CLOTHING -- HEADWEAR . . . . . . .    27
HELMET, DIVER'S. . . . . . . . . . . . . CLOTHING -- HEADWEAR . . . . . . .    27
HELMET, FOOTBALL . . . . . . . . . . . . SPORTS EQUIPMENT . . . . . . . . .   221
HELMET, LACROSSE . . . . . . . . . . . . SPORTS EQUIPMENT . . . . . . . . .   221
HELMET, PITH . . . . . . . . . . . . . . CLOTHING -- HEADWEAR . . . . . . .    27
HELMET, SOUND. . . . . . . . . . . . . . ACOUSTICAL T&E . . . . . . . . . .   123
HEMACYTOMETER. . . . . . . . . . . . . . BIOLOGICAL T&E . . . . . . . . . .   137
HEMAGLOBINOMETER . . . . . . . . . . . . BIOLOGICAL T&E . . . . . . . . . .   137
HEMOCYTOMETER. . . . . . . . . . . . . . MEDICAL & PSYCHOLOGICAL T&E. . . .   151
HEMOSCOPE. . . . . . . . . . . . . . . . MEDICAL & PSYCHOLOGICAL T&E. . . .   151
HEMOSTAT . . . . . . . . . . . . . . . . MEDICAL & PSYCHOLOGICAL T&E. . . .   151
HENNIN . . . . . . . . . . . . . . . . . CLOTHING -- HEADWEAR . . . . . . .    27
 Hetchel . . . . . . . . . . . . . . . . TEXTILEWORKING T&E
   use  HATCHEL
 Hibachi . . . . . . . . . . . . . . . . FOOD PROCESSING T&E
   use  GRILL
 Highboy . . . . . . . . . . . . . . . . FURNITURE
   use  CHEST OF DRAWERS
HIGHCHAIR. . . . . . . . . . . . . . . . FURNITURE. . . . . . . . . . . . .    13
 Highwheeler . . . . . . . . . . . . . . LTE -- HUMAN-POWERED
   use  BICYCLE, ORDINARY
 Hilac . . . . . . . . . . . . . . . . . NUCLEAR PHYSICS T&E
   use  ACCELERATOR, LINEAR
HINGE. . . . . . . . . . . . . . . . . . BUILDING COMPONENT . . . . . . . .     5
HOBBLE . . . . . . . . . . . . . . . . . ANIMAL HUSBANDRY T&E . . . . . . .    53
HOBBYHORSE . . . . . . . . . . . . . . . TOY. . . . . . . . . . . . . . . .   224
 Hobbyhorse. . . . . . . . . . . . . . . LTE -- HUMAN-POWERED
   use  DRAISINE
HOD. . . . . . . . . . . . . . . . . . . MASONRY & STONEWORKING T&E . . . .    87
HOD, COAL. . . . . . . . . . . . . . . . TEMPERATURE CONTROL DEVICE . . . .    22
 Hodometer . . . . . . . . . . . . . . . SURVEYING & NAVIGATIONAL T&E
   use  WHEEL, SURVEYOR'S
HOE. . . . . . . . . . . . . . . . . . . AGRICULTURAL T&E . . . . . . . . .    45
HOE, BEET-THINNING . . . . . . . . . . . AGRICULTURAL T&E . . . . . . . . .    45
 Hoe, Bog. . . . . . . . . . . . . . . . AGRICULTURAL T&E
   use  HOE, GRUB
 Hoe, Broad. . . . . . . . . . . . . . . AGRICULTURAL T&E
   use  HOE, GARDEN
 Hoe, Bunching . . . . . . . . . . . . . AGRICULTURAL T&E
   use  HOE, BEET-THINNING
HOE, CELERY. . . . . . . . . . . . . . . AGRICULTURAL T&E . . . . . . . . .    45
HOE, CLAMMING. . . . . . . . . . . . . . FISHING & TRAPPING T&E . . . . . .    56
HOE, CORN. . . . . . . . . . . . . . . . AGRICULTURAL T&E . . . . . . . . .    45
HOE, COTTON. . . . . . . . . . . . . . . AGRICULTURAL T&E . . . . . . . . .    45
 Hoe, Cultivator . . . . . . . . . . . . AGRICULTURAL T&E
   use  HOE, WEEDING
 Hoe, Dutch. . . . . . . . . . . . . . . AGRICULTURAL T&E
   use  HOE, SCUFFLE
HOE, GARDEN. . . . . . . . . . . . . . . AGRICULTURAL T&E . . . . . . . . .    45
HOE, GRAPE . . . . . . . . . . . . . . . AGRICULTURAL T&E . . . . . . . . .    45
```

- -

```
Hoe, Grass. . . . . . . . . . . . . . AGRICULTURAL T&E
   use  HOE, MEADOW
HOE, GRUB. . . . . . . . . . . . . . AGRICULTURAL T&E . . . . . . . .    45
HOE, HOP . . . . . . . . . . . . . . AGRICULTURAL T&E . . . . . . . .    45
Hoe, Horse. . . . . . . . . . . . . AGRICULTURAL T&E
   use  CULTIVATOR, ROW-CROP
HOE, MATTOCK . . . . . . . . . . . . AGRICULTURAL T&E . . . . . . . .    45
HOE, MEADOW. . . . . . . . . . . . . AGRICULTURAL T&E . . . . . . . .    45
Hoe, Narrow . . . . . . . . . . . . AGRICULTURAL T&E
   use  HOE, GRUB
HOE, NURSERY . . . . . . . . . . . . AGRICULTURAL T&E . . . . . . . .    45
HOE, PERIODONTAL . . . . . . . . . . MEDICAL & PSYCHOLOGICAL T&E. . . .  151
Hoe, Plantation . . . . . . . . . . AGRICULTURAL T&E
   use  HOE, COTTON
Hoe, Planter. . . . . . . . . . . . AGRICULTURAL T&E
   use  HOE, COTTON
HOE, ROTARY. . . . . . . . . . . . . AGRICULTURAL T&E . . . . . . . .    45
HOE, SCUFFLE . . . . . . . . . . . . AGRICULTURAL T&E . . . . . . . .    45
Hoe, Shuffle. . . . . . . . . . . . AGRICULTURAL T&E
   use  HOE, SCUFFLE
HOE, SUGAR BEET. . . . . . . . . . . AGRICULTURAL T&E . . . . . . . .    45
HOE, TOBACCO . . . . . . . . . . . . AGRICULTURAL T&E . . . . . . . .    45
HOE, TURNIP. . . . . . . . . . . . . AGRICULTURAL T&E . . . . . . . .    45
HOE, WARREN. . . . . . . . . . . . . AGRICULTURAL T&E . . . . . . . .    45
HOE, WEEDING . . . . . . . . . . . . AGRICULTURAL T&E . . . . . . . .    45
Hoe, Wheel. . . . . . . . . . . . . AGRICULTURAL T&E
   use  CULTIVATOR, GARDEN
HOGAN. . . . . . . . . . . . . . . . BUILDING . . . . . . . . . . . .     2
HOIST. . . . . . . . . . . . . . . . MECHANICAL T&E . . . . . . . . .   147
   note use for any lifting machine which operates with ropes and pulleys
HOIST, DRESSING. . . . . . . . . . . FOOD PROCESSING T&E. . . . . . .    61
HOIST, MINE. . . . . . . . . . . . . MINING & MINERAL HARVESTING T&E. .  100
HOIST, QUARRY. . . . . . . . . . . . MINING & MINERAL HARVESTING T&E. .  100
Holdback. . . . . . . . . . . . . . WINDOW OR DOOR COVERING
   use  LOOP, CURTAIN
HOLDER, AMPUL. . . . . . . . . . . . MEDICAL & PSYCHOLOGICAL T&E. . . .  151
HOLDER, BAG. . . . . . . . . . . . . FOOD PROCESSING T&E. . . . . . .    61
HOLDER, BOTTLE . . . . . . . . . . . HOUSEHOLD ACCESSORY. . . . . . .    17
HOLDER, BROACH . . . . . . . . . . . MEDICAL & PSYCHOLOGICAL T&E. . . .  151
HOLDER, BRUSH. . . . . . . . . . . . WRITTEN COMMUNICATION T&E. . . . .  184
Holder, Candle. . . . . . . . . . . LIGHTING DEVICE
   use  CANDELABRUM or CANDLESTICK or SCONCE
HOLDER, CARTRIDGE. . . . . . . . . . ARMAMENT -- ACCESSORY. . . . . . .  132
HOLDER, CASSEROLE. . . . . . . . . . FOOD SERVICE T&E . . . . . . . .    73
HOLDER, CIGAR. . . . . . . . . . . . PERSONAL GEAR. . . . . . . . . .    36
HOLDER, CIGARETTE. . . . . . . . . . PERSONAL GEAR. . . . . . . . . .    36
HOLDER, CLIP . . . . . . . . . . . . ARMAMENT -- ACCESSORY. . . . . .   132
HOLDER, CLOTHESPIN . . . . . . . . . MAINTENANCE T&E. . . . . . . . .   146
HOLDER, COIN . . . . . . . . . . . . PERSONAL GEAR. . . . . . . . . .    36
HOLDER, COW-TAIL . . . . . . . . . . ANIMAL HUSBANDRY T&E . . . . . .    53
```

- -

Holder, Cuff. CLOTHING -- ACCESSORY
 use CLASP
HOLDER, CUT-FILM PHOTOGRAPHIC T&E 176
HOLDER, DENTAL FILM. MEDICAL & PSYCHOLOGICAL T&E. . . 151
HOLDER, DENTAL FILM. PHOTOGRAPHIC T&E 176
HOLDER, DESK-BLOTTER WRITTEN COMMUNICATION T&E. . . . 184
HOLDER, DIE. METALWORKING T&E 91
HOLDER, FIRE EXTINGUISHER. REGULATIVE & PROTECTIVE T&E. . . 161
Holder, Fireplace Tool. TEMPERATURE CONTROL DEVICE
 use STAND, FIRESET
HOLDER, FLAG CEREMONIAL ARTIFACT. 207
HOLDER, FLAX TEXTILEWORKING T&E 106
Holder, Grain bag FOOD PROCESSING T&E
 use HOLDER, BAG
HOLDER, HATPIN CLOTHING -- ACCESSORY. 33
HOLDER, HOG. ANIMAL HUSBANDRY T&E 53
HOLDER, LAMP LIGHTING DEVICE. 20
HOLDER, MATCH. HOUSEHOLD ACCESSORY. 17
HOLDER, NAPKIN FOOD SERVICE T&E 73
HOLDER, NEEDLE TEXTILEWORKING T&E 106
HOLDER, NOSEGAY. PERSONAL GEAR. 36
HOLDER, PAPER CLIP WRITTEN COMMUNICATION T&E. . . . 184
HOLDER, PEN. WRITTEN COMMUNICATION T&E. . . . 184
HOLDER, PENCIL WRITTEN COMMUNICATION T&E. . . . 184
HOLDER, PIPE HOUSEHOLD ACCESSORY. 17
HOLDER, PLACECARD. FOOD SERVICE T&E 73
Holder, Plate PHOTOGRAPHIC T&E
 use PLATEHOLDER
HOLDER, RETORT CHEMICAL T&E 139
HOLDER, ROLL-FILM. PHOTOGRAPHIC T&E 176
HOLDER, RUBBER DAM MEDICAL & PSYCHOLOGICAL T&E. . . 151
HOLDER, RUSHLIGHT. LIGHTING DEVICE. 20
 rt HOLDER, TAPER
HOLDER, SCARF. HOUSEHOLD ACCESSORY. 17
HOLDER, SCYTHE-SHARPENER METALWORKING T&E 91
HOLDER, SHAVING PAPER. TOILET ARTICLE 39
HOLDER, SHELL. ARMAMENT -- ACCESSORY. 132
HOLDER, SHIP'S BELL. WATER TRANSPORTATION -- ACCESSORY. 202
HOLDER, SHOE PERSONAL GEAR. 36
HOLDER, SIGN MERCHANDISING T&E. 156
HOLDER, SPHERE ART. 205
HOLDER, SPILL. HOUSEHOLD ACCESSORY. 17
HOLDER, SPLINT LIGHTING DEVICE. 20
HOLDER, SPOOL. TEXTILEWORKING T&E 106
Holder, Spoon FOOD SERVICE T&E
 use SPOONER
HOLDER, STAMP. WRITTEN COMMUNICATION T&E. . . . 184
HOLDER, STRING MERCHANDISING T&E. 156
HOLDER, TAPE TEXTILEWORKING T&E 107
HOLDER, TAPER. LIGHTING DEVICE. 20
 rt HOLDER, RUSHLIGHT

- -

HOLDER, THIMBLE. TEXTILEWORKING T&E 107
HOLDER, THREAD TEXTILEWORKING T&E 107
HOLDER, TIRE-BOLT. METALWORKING T&E 91
HOLDER, TISSUE HOUSEHOLD ACCESSORY. 17
HOLDER, TOOTHBRUSH TOILET ARTICLE 39
HOLDER, TOOTHPICK. FOOD SERVICE T&E 73
HOLDER, TORCH. LIGHTING DEVICE. 20
HOLDER, TREE HOUSEHOLD ACCESSORY. 17
HOLDER, UMBRELLA HOUSEHOLD ACCESSORY. 17
HOLDER, WATCH. HOUSEHOLD ACCESSORY. 17
HOLDER, WHIP LTE -- ACCESSORY 194
HOLDER, WHISK BROOM. MAINTENANCE T&E. 146
HOLDFAST WOODWORKING T&E. 116
HOLOMETER. DATA PROCESSING T&E. 169
HOLOPHOTE. OPTICAL T&E. 159
HOLSTER. ARMAMENT -- ACCESSORY. 132
HOLYSTONE. WATER TRANSPORTATION -- ACCESSORY. 202
HOMBERG. CLOTHING -- HEADWEAR 27
HOMOGENIZER, MILK. FOOD PROCESSING T&E. 61
 Hone. METALWORKING T&E
 use WHETSTONE
HOOD CLOTHING -- HEADWEAR 28
HOOD, ACADEMIC PERSONAL SYMBOL. 215
HOOD, GALLOWS. REGULATIVE & PROTECTIVE T&E. . . . 161
HOOD, STOVE. TEMPERATURE CONTROL DEVICE 22
HOOD, SWEAT. ANIMAL HUSBANDRY T&E 53
HOOK HOUSEHOLD ACCESSORY. 17
HOOK GLASS, PLASTICS, CLAYWORKING T&E . 79
HOOK MULTIPLE USE ARTIFACT. 228
 Hook, Bagging AGRICULTURAL T&E
 use HOOK, REAPING
HOOK, BENCH. WOODWORKING T&E. 116
 Hook, Bill. AGRICULTURAL T&E
 use BILLHOOK
 Hook, Bill. ARMAMENT -- EDGED
 use BILL
HOOK, BLUBBER. FISHING & TRAPPING T&E 56
HOOK, BOAT WATER TRANSPORTATION -- ACCESSORY. 202
HOOK, BOOT CLOTHING -- ACCESSORY. 33
 Hook, Bramble AGRICULTURAL T&E
 use HOOK, BRUSH
HOOK, BRUSH. AGRICULTURAL T&E 46
 Hook, Bush. AGRICULTURAL T&E
 use HOOK, BRUSH
 Hook, Button. CLOTHING -- ACCESSORY
 use BUTTONHOOK
HOOK, CANT FORESTRY T&E 78
HOOK, CARCASS. ANIMAL HUSBANDRY T&E 53
HOOK, CEILING. BUILDING COMPONENT 5
HOOK, COAT HOUSEHOLD ACCESSORY. 17

- -

```
HOOK, CORN . . . . . . . . . . . . . . AGRICULTURAL T&E . . . . . . . . .  46
  rt  KNIFE, CORN
HOOK, CROCHET. . . . . . . . . . . . . TEXTILEWORKING T&E . . . . . . . . 107
HOOK, CURTAIN. . . . . . . . . . . . . HOUSEHOLD ACCESSORY. . . . . . . .  17
HOOK, DRILL. . . . . . . . . . . . . . AGRICULTURAL T&E . . . . . . . . .  46
 Hook, Fagging . . . . . . . . . . . . AGRICULTURAL T&E
  use HOOK, REAPING
 Hook, Garden. . . . . . . . . . . . . AGRICULTURAL T&E
  use HOOK, NURSERY
HOOK, GRAB . . . . . . . . . . . . . . MINING & MINERAL HARVESTING T&E. . 100
HOOK, GRAPPLING. . . . . . . . . . . . FORESTRY T&E . . . . . . . . . . .  78
HOOK, GRASS. . . . . . . . . . . . . . AGRICULTURAL T&E . . . . . . . . .  46
 Hook, Grub. . . . . . . . . . . . . . AGRICULTURAL T&E
  use HOOK, POTATO
 Hook, Hay . . . . . . . . . . . . . . AGRICULTURAL T&E
  use CROOK, HAY
HOOK, HEDGE. . . . . . . . . . . . . . AGRICULTURAL T&E . . . . . . . . .  46
 Hook, Husking . . . . . . . . . . . . AGRICULTURAL T&E
  use CORNHUSKER, HAND
HOOK, ICE. . . . . . . . . . . . . . . MINING & MINERAL HARVESTING T&E. . 100
HOOK, LAST . . . . . . . . . . . . . . LEATHER, HORN, SHELLWORKING T&E. .  83
HOOK, MANURE . . . . . . . . . . . . . AGRICULTURAL T&E . . . . . . . . .  46
HOOK, MEAT . . . . . . . . . . . . . . FOOD PROCESSING T&E. . . . . . . .  61
HOOK, NURSERY. . . . . . . . . . . . . AGRICULTURAL T&E . . . . . . . . .  46
HOOK, OX . . . . . . . . . . . . . . . ANIMAL HUSBANDRY T&E . . . . . . .  53
HOOK, PICTURE. . . . . . . . . . . . . HOUSEHOLD ACCESSORY. . . . . . . .  17
HOOK, POTATO . . . . . . . . . . . . . AGRICULTURAL T&E . . . . . . . . .  46
HOOK, PRUNING. . . . . . . . . . . . . AGRICULTURAL T&E . . . . . . . . .  46
  rt  BILLHOOK
HOOK, PULLMAN PORTER'S . . . . . . . . RAIL TRANSPORTATION -- ACCESSORY . 197
HOOK, RAFT . . . . . . . . . . . . . . FORESTRY T&E . . . . . . . . . . .  78
HOOK, REAPING. . . . . . . . . . . . . AGRICULTURAL T&E . . . . . . . . .  46
  rt  SICKLE
HOOK, RUG. . . . . . . . . . . . . . . TEXTILEWORKING T&E . . . . . . . . 107
HOOK, SHELL. . . . . . . . . . . . . . ARMAMENT -- ACCESSORY. . . . . . . 132
 Hook, Shrubbery . . . . . . . . . . . AGRICULTURAL T&E
  use HOOK, NURSERY
HOOK, SWAMP. . . . . . . . . . . . . . FORESTRY T&E . . . . . . . . . . .  78
HOOK, TAMBOUR. . . . . . . . . . . . . TEXTILEWORKING T&E . . . . . . . . 107
HOOK, TENDON . . . . . . . . . . . . . MEDICAL & PSYCHOLOGICAL T&E. . . . 151
 Hook, Vine. . . . . . . . . . . . . . AGRICULTURAL T&E
  use HOOK, NURSERY
HOOKAH . . . . . . . . . . . . . . . . PERSONAL GEAR. . . . . . . . . . .  36
HOOKAH . . . . . . . . . . . . . . . . MINING & MINERAL HARVESTING T&E. . 100
HOOP . . . . . . . . . . . . . . . . . TOY. . . . . . . . . . . . . . . . 224
HOOP, BASKETBALL . . . . . . . . . . . SPORTS EQUIPMENT . . . . . . . . . 221
HOOP, EMBROIDERY . . . . . . . . . . . TEXTILEWORKING T&E . . . . . . . . 107
HOOP, EXTRACTOR. . . . . . . . . . . . ARMAMENT -- ACCESSORY. . . . . . . 132
 Hoop, Hula. . . . . . . . . . . . . . TOY
  use HOOP
```

- -

```
Hoppit. . . . . . . . . . . . . . . . . . MINING & MINERAL HARVESTING T&E
   use  KIBBLE
HORIZON, ARTIFICIAL. . . . . . . . . . . SURVEYING & NAVIGATIONAL T&E . . .  162
HORN . . . . . . . . . . . . . . . . . . LTE -- ACCESSORY . . . . . . . . .  194
HORN . . . . . . . . . . . . . . . . . . MUSICAL T&E. . . . . . . . . . . .  173
HORN, ALTO . . . . . . . . . . . . . . . MUSICAL T&E. . . . . . . . . . . .  173
HORN, BARITONE . . . . . . . . . . . . . MUSICAL T&E. . . . . . . . . . . .  173
HORN, BASS . . . . . . . . . . . . . . . MUSICAL T&E. . . . . . . . . . . .  173
HORN, BASSET . . . . . . . . . . . . . . MUSICAL T&E. . . . . . . . . . . .  173
HORN, BUFFALO. . . . . . . . . . . . . . LEATHER, HORN, SHELLWORKING T&E. .   83
HORN, COACH. . . . . . . . . . . . . . . MUSICAL T&E. . . . . . . . . . . .  173
HORN, DINNER . . . . . . . . . . . . . . SOUND COMMUNICATION T&E. . . . . .  181
   rt    BELL, SERVICE
HORN, DRINKING . . . . . . . . . . . . . FOOD SERVICE T&E . . . . . . . . .   73
HORN, ENGLISH. . . . . . . . . . . . . . MUSICAL T&E. . . . . . . . . . . .  173
HORN, FRENCH . . . . . . . . . . . . . . MUSICAL T&E. . . . . . . . . . . .  173
HORN, HUNTING. . . . . . . . . . . . . . MUSICAL T&E. . . . . . . . . . . .  173
HORN, MINER'S. . . . . . . . . . . . . . MINING & MINERAL HARVESTING T&E. .  100
  Horn, Mower's . . . . . . . . . . . . . METALWORKING T&E
   use  HOLDER, SCYTHE-SHARPENER
HORN, POST . . . . . . . . . . . . . . . MUSICAL T&E. . . . . . . . . . . .  173
HORN, POWDER . . . . . . . . . . . . . . ARMAMENT -- ACCESSORY. . . . . . .  132
HORN, TENOR. . . . . . . . . . . . . . . MUSICAL T&E. . . . . . . . . . . .  173
HOROMETER. . . . . . . . . . . . . . . . TIMEKEEPING T&E. . . . . . . . . .  165
HORSE, ANVIL . . . . . . . . . . . . . . METALWORKING T&E . . . . . . . . .   91
HORSE, FROE. . . . . . . . . . . . . . . WOODWORKING T&E. . . . . . . . . .  116
   rt   HORSE, SHAVING
HORSE, HORNWORKER'S. . . . . . . . . . . LEATHER, HORN, SHELLWORKING T&E. .   83
HORSE, ROCKING . . . . . . . . . . . . . TOY. . . . . . . . . . . . . . . .  224
  Horse, Saw. . . . . . . . . . . . . . . WOODWORKING T&E
   use  SAWHORSE
HORSE, SAW-SHARPENING. . . . . . . . . . WOODWORKING T&E. . . . . . . . . .  116
HORSE, SHAVING . . . . . . . . . . . . . WOODWORKING T&E. . . . . . . . . .  116
   rt   BLOCK, SHAVING; HORSE, FROE
HORSE, SHEET . . . . . . . . . . . . . . WATER TRANSPORTATION -- ACCESSORY. 202
  Horse, Shingling. . . . . . . . . . . . WOODWORKING T&E
   use  HORSE, FROE
HORSE, SIDE. . . . . . . . . . . . . . . SPORTS EQUIPMENT . . . . . . . . .  221
  Horse, Stick. . . . . . . . . . . . . . TOY
   use  HOBBYHORSE
HORSE, VAULTING. . . . . . . . . . . . . SPORTS EQUIPMENT . . . . . . . . .  221
HORSESHOE. . . . . . . . . . . . . . . . ANIMAL HUSBANDRY T&E . . . . . . .   53
HORSESHOE. . . . . . . . . . . . . . . . SPORTS EQUIPMENT . . . . . . . . .  221
HOSE, FIRE . . . . . . . . . . . . . . . REGULATIVE & PROTECTIVE T&E. . . .  161
HOSE, IRRIGATION . . . . . . . . . . . . AGRICULTURAL T&E . . . . . . . . .   46
HOSPITAL . . . . . . . . . . . . . . . . BUILDING . . . . . . . . . . . . .    2
HOTEL. . . . . . . . . . . . . . . . . . BUILDING . . . . . . . . . . . . .    2
HOURGLASS. . . . . . . . . . . . . . . . TIMEKEEPING T&E. . . . . . . . . .  165
HOUSE. . . . . . . . . . . . . . . . . . BUILDING . . . . . . . . . . . . .    2
HOUSE, CHARNEL . . . . . . . . . . . . . BUILDING . . . . . . . . . . . . .    2
   rt   MAUSOLEUM
```

- -

```
House, Doll . . . . . . . . . . . . . . TOY
   use  DOLLHOUSE
HOUSE, FRUIT-DRYING. . . . . . . . . . . BUILDING . . . . . . . . . . . . .    2
HOUSE, HOG . . . . . . . . . . . . . . . BUILDING . . . . . . . . . . . . .    2
HOUSE, POWDER. . . . . . . . . . . . . . BUILDING . . . . . . . . . . . . .    2
House, Toll . . . . . . . . . . . . . . BUILDING
   use  TOLLHOUSE
HOUSECOAT. . . . . . . . . . . . . . . . CLOTHING -- OUTERWEAR. . . . . . .   30
Housewife . . . . . . . . . . . . . . . TEXTILEWORKING T&E
   use  KIT, NEEDLEWORK
HOUSING, CLUTCH. . . . . . . . . . . . . ENERGY PRODUCTION T&E. . . . . . .  144
HOVERCRAFT . . . . . . . . . . . . . . . WATER TRANSPORTATION -- EQUIPMENT. 199
HOWDAH . . . . . . . . . . . . . . . . . LTE -- ANIMAL-POWERED. . . . . . .  189
HOWITZER . . . . . . . . . . . . . . . . ARMAMENT -- ARTILLERY. . . . . . .  128
HUARACHE . . . . . . . . . . . . . . . . CLOTHING -- FOOTWEAR . . . . . . .   25
HULLER, NUT. . . . . . . . . . . . . . . FOOD PROCESSING T&E. . . . . . . .   61
Huller, Pea . . . . . . . . . . . . . . FOOD PROCESSING T&E
   use  HULLER, SEED
HULLER, SEED . . . . . . . . . . . . . . FOOD PROCESSING T&E. . . . . . . .   61
HUMIDIFIER . . . . . . . . . . . . . . . TEMPERATURE CONTROL DEVICE . . . .   22
HUMIDOR. . . . . . . . . . . . . . . . . HOUSEHOLD ACCESSORY. . . . . . . .   17
Hummeler. . . . . . . . . . . . . . . . AGRICULTURAL T&E
   use  BEARDER, BARLEY
HURDLE . . . . . . . . . . . . . . . . . SPORTS EQUIPMENT . . . . . . . . .  221
HURDY-GURDY. . . . . . . . . . . . . . . FISHING & TRAPPING T&E . . . . . .   56
HURDY-GURDY. . . . . . . . . . . . . . . MINING & MINERAL HARVESTING T&E. .  100
HURDY-GURDY. . . . . . . . . . . . . . . MUSICAL T&E. . . . . . . . . . . .  173
Husker, Corn. . . . . . . . . . . . . . AGRICULTURAL T&E
   use  CORNHUSKER, HAND or HUSKER/SHREDDER, CORN
HUSKER/SHREDDER, CORN. . . . . . . . . . AGRICULTURAL T&E . . . . . . . . .   46
HUSLA. . . . . . . . . . . . . . . . . . MUSICAL T&E. . . . . . . . . . . .  173
Hutch . . . . . . . . . . . . . . . . . FURNITURE
   use  more specific term, e.g.: CABINET, CORNER; CABINET, CHINA
HYALOGRAPH . . . . . . . . . . . . . . . DRAFTING T&E . . . . . . . . . . .  171
HYDRANT. . . . . . . . . . . . . . . . . OTHER STRUCTURE. . . . . . . . . .    8
HYDRIA . . . . . . . . . . . . . . . . . HOUSEHOLD ACCESSORY. . . . . . . .   17
   rt  JAR, WATER
HYDRODYNAMOMETER . . . . . . . . . . . . MECHANICAL T&E . . . . . . . . . .  147
HYDROFOIL. . . . . . . . . . . . . . . . WATER TRANSPORTATION -- EQUIPMENT. 199
HYDROMETER . . . . . . . . . . . . . . . MECHANICAL T&E . . . . . . . . . .  147
HYDROPHORE . . . . . . . . . . . . . . . CHEMICAL T&E . . . . . . . . . . .  139
HYDROPLANE . . . . . . . . . . . . . . . WATER TRANSPORTATION -- EQUIPMENT. 199
   rt  RUNABOUT
Hydropyrometer. . . . . . . . . . . . . THERMAL T&E
   use  PYROMETER
HYDROSCOPE . . . . . . . . . . . . . . . CHEMICAL T&E . . . . . . . . . . .  139
HYGROGRAPH . . . . . . . . . . . . . . . METEOROLOGICAL T&E . . . . . . . .  157
HYGROMETER . . . . . . . . . . . . . . . METEOROLOGICAL T&E . . . . . . . .  157
Hygrophant. . . . . . . . . . . . . . . METEOROLOGICAL T&E
   use  HYGROMETER
```

- -

- -

INSTRUMENT, AZIMUTH. ASTRONOMICAL T&E 135
 Instrument, Flight. AEROSPACE -- ACCESSORY
 use a term from SURVEYING & NAVIGATIONAL or TELECOMMUNICATION T&E
INSULATOR. ELECTRICAL & MAGNETIC T&E. 142
INSULATOR. ENERGY PRODUCTION T&E. 144
INTEGRATOR DATA PROCESSING T&E. 169
 rt PLANIMETER
INTERCOM SOUND COMMUNICATION T&E. 181
INTERFEROMETER OPTICAL T&E. 159
INTERFEROMETER, RADIO. ASTRONOMICAL T&E 135
INVENTIONSHORN MUSICAL T&E. 173
INVENTORY. DOCUMENTARY ARTIFACT 211
INVITATION DOCUMENTARY ARTIFACT 211
INVOICE. DOCUMENTARY ARTIFACT 211
IRON MAINTENANCE T&E. 146
IRON, BARKING. FORESTRY T&E 78
 Iron, Bick. METALWORKING T&E
 use BEAKIRON
IRON, BRANDING ANIMAL HUSBANDRY T&E 53
IRON, BRANDING REGULATIVE & PROTECTIVE T&E. . . . 161
IRON, BUCKING. MINING & MINERAL HARVESTING T&E. . 100
IRON, CAULKING WOODWORKING T&E. 116
IRON, CAUTERIZING. ANIMAL HUSBANDRY T&E 53
IRON, CHINCING WOODWORKING T&E. 116
IRON, COOPER'S BURNING WOODWORKING T&E. 116
IRON, CREASING WOODWORKING T&E. 116
IRON, CURLING. TOILET ARTICLE 39
IRON, FLAGGING WOODWORKING T&E. 116
 Iron, Flat. MAINTENANCE T&E
 use FLATIRON
IRON, FLUTING. MAINTENANCE T&E. 146
IRON, GATHERING. GLASS, PLASTICS, CLAYWORKING T&E . 79
 Iron, Glazing LEATHER, HORN, SHELLWORKING T&E
 use SLICKER
 Iron, Goffering MAINTENANCE T&E
 use IRON, FLUTING
IRON, GRAFTING AGRICULTURAL T&E 46
IRON, HORSING. WOODWORKING T&E. 116
IRON, KNOCKING-DOWN. PRINTING T&E 178
 Iron, Knocking-up WOODWORKING T&E
 use JUMPER
 Iron, Leg REGULATIVE & PROTECTIVE T&E
 use SHACKLE, LEG
IRON, LILY FISHING & TRAPPING T&E 56
IRON, MARKING. WOODWORKING T&E. 116
 Iron, Pinching. TOILET ARTICLE
 use IRON, STRAIGHTENING
IRON, PINKING. LEATHER, HORN, SHELLWORKING T&E. . 84
 Iron, Polishing MAINTENANCE T&E
 use SADIRON

- -

```
IRON, RAISING. . . . . . . . . . . . WOODWORKING T&E. . . . . . . . . 116
  rt   JUMPER
IRON, ROSETTE. . . . . . . . . . . . FOOD PROCESSING T&E. . . . . . .  61
IRON, SEAT . . . . . . . . . . . . . LEATHER, HORN, SHELLWORKING T&E. .  84
IRON, SHIPWRIGHT'S CAULKING. . . . . WOODWORKING T&E. . . . . . . . . 116
IRON, SHIPWRIGHT'S MEAKING . . . . . WOODWORKING T&E. . . . . . . . . 116
IRON, SHOEMAKER'S. . . . . . . . . . LEATHER, HORN, SHELLWORKING T&E. .  84
IRON, SNARLING . . . . . . . . . . . METALWORKING T&E . . . . . . . .  91
IRON, SOLDERING. . . . . . . . . . . METALWORKING T&E . . . . . . . .  91
IRON, STRAIGHTENING. . . . . . . . . TOILET ARTICLE . . . . . . . . .  39
IRON, SWITCH . . . . . . . . . . . . RAIL TRANSPORTATION -- ACCESSORY . 197
IRON, TACKING. . . . . . . . . . . . PHOTOGRAPHIC T&E . . . . . . . . 176
IRON, WAFER. . . . . . . . . . . . . FOOD PROCESSING T&E. . . . . . .  61
IRON, WAFFLE . . . . . . . . . . . . FOOD PROCESSING T&E. . . . . . .  61
IRON, WHEELWRIGHT'S BURNING. . . . . WOODWORKING T&E. . . . . . . . . 116
IRRIGATOR. . . . . . . . . . . . . . MEDICAL & PSYCHOLOGICAL T&E. . . 151
ISOCHRONOUS. . . . . . . . . . . . . NUCLEAR PHYSICS T&E. . . . . . . 158
ISOGRAPH . . . . . . . . . . . . . . DRAFTING T&E . . . . . . . . . . 171
ITA. . . . . . . . . . . . . . . . . MINING & MINERAL HARVESTING T&E. . 100
JABOT. . . . . . . . . . . . . . . . CLOTHING -- ACCESSORY. . . . . .  33
JACK . . . . . . . . . . . . . . . . GLASS, PLASTICS, CLAYWORKING T&E .  79
JACK . . . . . . . . . . . . . . . . LTE -- ACCESSORY . . . . . . . . 194
  Jack, Bell. . . . . . . . . . . . . FOOD PROCESSING T&E
  use  JACK, BOTTLE
JACK, BOTTLE . . . . . . . . . . . . FOOD PROCESSING T&E. . . . . . .  62
  Jack, Clock . . . . . . . . . . . . FOOD PROCESSING T&E
  use  JACK, ROASTING
JACK, FENCE. . . . . . . . . . . . . MULTIPLE USE ARTIFACT. . . . . . 228
JACK, GLAZING. . . . . . . . . . . . LEATHER, HORN, SHELLWORKING T&E. .  84
JACK, HOISTING . . . . . . . . . . . MECHANICAL T&E . . . . . . . . . 147
JACK, JUMPING. . . . . . . . . . . . TOY. . . . . . . . . . . . . . . 224
JACK, LAST . . . . . . . . . . . . . LEATHER, HORN, SHELLWORKING T&E. .  84
JACK, LIFTING. . . . . . . . . . . . MECHANICAL T&E . . . . . . . . . 147
JACK, MITER. . . . . . . . . . . . . WOODWORKING T&E. . . . . . . . . 116
JACK, PULLING. . . . . . . . . . . . MECHANICAL T&E . . . . . . . . . 147
  rt   COME-ALONG
JACK, ROASTING . . . . . . . . . . . FOOD PROCESSING T&E. . . . . . .  62
  Jack, Single. . . . . . . . . . . . MINING & MINERAL HARVESTING T&E
  use  HAMMER, HAND
JACK, SPINNING . . . . . . . . . . . TEXTILEWORKING T&E . . . . . . . 107
JACK, STAGECOACH . . . . . . . . . . LTE -- ACCESSORY . . . . . . . . 194
JACK, WAGON. . . . . . . . . . . . . LTE -- ACCESSORY . . . . . . . . 194
  Jack, Wax . . . . . . . . . . . . . LIGHTING DEVICE
  use  HOLDER, TAPER
JACKBOOT . . . . . . . . . . . . . . CLOTHING -- FOOTWEAR . . . . . .  25
JACKET . . . . . . . . . . . . . . . CLOTHING -- OUTERWEAR. . . . . .  30
JACKET, BED. . . . . . . . . . . . . CLOTHING -- OUTERWEAR. . . . . .  30
JACKET, BOOK . . . . . . . . . . . . DOCUMENTARY ARTIFACT . . . . . . 211
JACKET, BUSH . . . . . . . . . . . . CLOTHING -- OUTERWEAR. . . . . .  30
  Jacket, Combing . . . . . . . . . . CLOTHING -- OUTERWEAR
  use  JACKET, BED
```

- -

```
Jacket, Dinner. . . . . . . . . . . . CLOTHING -- OUTERWEAR
  use  TUXEDO
JACKET, LIFE . . . . . . . . . . . . WATER TRANSPORTATION -- ACCESSORY.  202
JACKET, MESS . . . . . . . . . . . . CLOTHING -- OUTERWEAR. . . . . . .   30
JACKET, PEA. . . . . . . . . . . . . CLOTHING -- OUTERWEAR. . . . . . .   30
JACKET, SMOKING. . . . . . . . . . . CLOTHING -- OUTERWEAR. . . . . . .   30
JACKET, TARGET SHOOTER'S . . . . . . ARMAMENT -- ACCESSORY. . . . . . .  132
  Jackhammer. . . . . . . . . . . . . MINING & MINERAL HARVESTING T&E
  use  DRILL, PERCUSSIVE
  Jackhammer. . . . . . . . . . . . . CONSTRUCTION T&E
  use  DRILL, PERCUSSIVE
JACK-IN-THE-BOX. . . . . . . . . . . TOY. . . . . . . . . . . . . . . .  224
  Jackknife . . . . . . . . . . . . . PERSONAL GEAR
  use  KNIFE, POCKET
  Jackleg . . . . . . . . . . . . . . MINING & MINERAL HARVESTING T&E
  use  LEG, AIR
JACKS. . . . . . . . . . . . . . . . GAME . . . . . . . . . . . . . . .  217
JACKSHAFT. . . . . . . . . . . . . . ENERGY PRODUCTION T&E. . . . . . .  144
JACKSTRAWS . . . . . . . . . . . . . GAME . . . . . . . . . . . . . . .  217
JAG. . . . . . . . . . . . . . . . . ARMAMENT -- ACCESSORY. . . . . . .  132
JAIL . . . . . . . . . . . . . . . . BUILDING . . . . . . . . . . . . .    2
JAR. . . . . . . . . . . . . . . . . CONTAINER. . . . . . . . . . . . .  186
JAR. . . . . . . . . . . . . . . . . MERCHANDISING T&E. . . . . . . . .  156
JAR, BATTERY . . . . . . . . . . . . ELECTRICAL & MAGNETIC T&E. . . . .  142
JAR, BELL. . . . . . . . . . . . . . HOUSEHOLD ACCESSORY. . . . . . . .   17
JAR, CANOPIC . . . . . . . . . . . . CEREMONIAL ARTIFACT. . . . . . . .  207
JAR, CONDIMENT . . . . . . . . . . . FOOD SERVICE T&E . . . . . . . . .   73
JAR, CONFECTIONARY . . . . . . . . . MERCHANDISING T&E. . . . . . . . .  156
JAR, COOKIE. . . . . . . . . . . . . FOOD PROCESSING T&E. . . . . . . .   62
JAR, COSMETIC. . . . . . . . . . . . TOILET ARTICLE . . . . . . . . . .   39
JAR, FOOD-STORAGE. . . . . . . . . . FOOD PROCESSING T&E. . . . . . . .   62
JAR, GINGER. . . . . . . . . . . . . FOOD SERVICE T&E . . . . . . . . .   73
JAR, HONEY . . . . . . . . . . . . . FOOD SERVICE T&E . . . . . . . . .   73
  Jar, Mortuary . . . . . . . . . . . CEREMONIAL ARTIFACT
  use  URN
  Jar, Mustard. . . . . . . . . . . . FOOD SERVICE T&E
  use  POT, MUSTARD
JAR, PICKLE. . . . . . . . . . . . . FOOD SERVICE T&E . . . . . . . . .   73
JAR, POTPOURRI . . . . . . . . . . . HOUSEHOLD ACCESSORY. . . . . . . .   17
JAR, PRESERVING. . . . . . . . . . . FOOD PROCESSING T&E. . . . . . . .   62
JAR, SEED. . . . . . . . . . . . . . AGRICULTURAL T&E . . . . . . . . .   46
JAR, SLOP. . . . . . . . . . . . . . HOUSEHOLD ACCESSORY. . . . . . . .   17
JAR, SNUFF . . . . . . . . . . . . . HOUSEHOLD ACCESSORY. . . . . . . .   17
JAR, SPECIMEN. . . . . . . . . . . . MEDICAL & PSYCHOLOGICAL T&E. . . .  151
JAR, SYRINGE . . . . . . . . . . . . MEDICAL & PSYCHOLOGICAL T&E. . . .  151
  Jar, Tobacco. . . . . . . . . . . . HOUSEHOLD ACCESSORY
  use  HUMIDOR
JAR, VACUUM. . . . . . . . . . . . . MECHANICAL T&E . . . . . . . . . .  147
JAR, WATCH . . . . . . . . . . . . . HOUSEHOLD ACCESSORY. . . . . . . .   17
JAR, WATER . . . . . . . . . . . . . HOUSEHOLD ACCESSORY. . . . . . . .   17
  rt  HYDRIA
```

- -

```
JARDINIERE . . . . . . . . . . . . . . HOUSEHOLD ACCESSORY. . . . . . .   17
  rt  PLANTER
JAVELIN. . . . . . . . . . . . . . . . SPORTS EQUIPMENT . . . . . . . .  221
JEEP . . . . . . . . . . . . . . . . . LTE -- MOTORIZED . . . . . . . .  192
JENNY, SPINNING. . . . . . . . . . . . TEXTILEWORKING T&E . . . . . . .  107
JERKIN . . . . . . . . . . . . . . . . CLOTHING -- OUTERWEAR. . . . . .   30
JIB. . . . . . . . . . . . . . . . . . WATER TRANSPORTATION -- ACCESSORY. 202
JIG. . . . . . . . . . . . . . . . . . FISHING & TRAPPING T&E . . . . .   56
JIG. . . . . . . . . . . . . . . . . . METALWORKING T&E . . . . . . . .   91
JIGGER . . . . . . . . . . . . . . . . FOOD SERVICE T&E . . . . . . . .   73
  rt  GLASS, SHOT
JIGGER . . . . . . . . . . . . . . . . WOODWORKING T&E. . . . . . . . .  116
  rt  DRAWKNIFE
 Jigger, Pastry. . . . . . . . . . . . FOOD PROCESSING T&E
  use  WHEEL, JAGGING
JIGSAW . . . . . . . . . . . . . . . . WOODWORKING T&E. . . . . . . . .  116
JINGLES. . . . . . . . . . . . . . . . MUSICAL T&E. . . . . . . . . . .  173
 Jodphur . . . . . . . . . . . . . . . CLOTHING -- OUTERWEAR
  use  BREECHES, RIDING
JOINT, MORTISE . . . . . . . . . . . . BUILDING . . . . . . . . . . . .    2
JOINTER. . . . . . . . . . . . . . . . WOODWORKING T&E. . . . . . . . .  116
JOINTER. . . . . . . . . . . . . . . . MASONRY & STONEWORKING T&E . . .   87
JOINTER-PLANER . . . . . . . . . . . . WOODWORKING T&E. . . . . . . . .  116
JOIST, FLOOR . . . . . . . . . . . . . BUILDING . . . . . . . . . . . .    2
JOURNAL. . . . . . . . . . . . . . . . DOCUMENTARY ARTIFACT . . . . . .  211
JUG. . . . . . . . . . . . . . . . . . FOOD PROCESSING T&E. . . . . . .   62
 Jug . . . . . . . . . . . . . . . . . FOOD SERVICE T&E
  use  PITCHER
JUG. . . . . . . . . . . . . . . . . . MERCHANDISING T&E. . . . . . . .  156
JUG. . . . . . . . . . . . . . . . . . CONTAINER. . . . . . . . . . . .  186
JUG, MILK. . . . . . . . . . . . . . . FOOD PROCESSING T&E. . . . . . .   62
JUG, SYRUP . . . . . . . . . . . . . . FOOD PROCESSING T&E. . . . . . .   62
JUG, WHISKEY . . . . . . . . . . . . . FOOD PROCESSING T&E. . . . . . .   62
 Juicer. . . . . . . . . . . . . . . . FOOD PROCESSING T&E
  use  REAMER, JUICE
JUKEBOX. . . . . . . . . . . . . . . . SOUND COMMUNICATION T&E. . . . .  181
  rt  NICKELODEON
JUMBO. . . . . . . . . . . . . . . . . MINING & MINERAL HARVESTING T&E. .  100
JUMPER . . . . . . . . . . . . . . . . CLOTHING -- OUTERWEAR. . . . . .   30
 Jumper. . . . . . . . . . . . . . . . MASONRY & STONEWORKING T&E
  use  DRILL
JUMPER . . . . . . . . . . . . . . . . WOODWORKING T&E. . . . . . . . .  116
  rt  IRON, RAISING
JUNK . . . . . . . . . . . . . . . . . WATER TRANSPORTATION -- EQUIPMENT. 199
KACHINA. . . . . . . . . . . . . . . . CEREMONIAL ARTIFACT. . . . . . .  207
KALEIDOSCOPE . . . . . . . . . . . . . TOY. . . . . . . . . . . . . . .  224
 Kanzashi. . . . . . . . . . . . . . . ADORNMENT
  use  ORNAMENT, HAIR
 Kas . . . . . . . . . . . . . . . . . FURNITURE
  use  WARDROBE
```

- -

KAYAK. WATER TRANSPORTATION -- EQUIPMENT. 199
 rt UMIAK
KAZOO. MUSICAL T&E. 173
KEEPER, SLING. ARMAMENT -- ACCESSORY. 132
 Keeve METALWORKING T&E
 use CONCENTRATOR
KEG. FOOD PROCESSING T&E. 62
KEG. MERCHANDISING T&E. 156
KEG. CONTAINER. 186
KEG, PAINT PAINTING T&E 102
KEG, POWDER. ARMAMENT -- ACCESSORY. 132
KELLEY MINING & MINERAL HARVESTING T&E. . 100
KENNEL BUILDING 2
 Kepi. CLOTHING -- HEADWEAR
 use CAP, FORAGE
KERATOME MEDICAL & PSYCHOLOGICAL T&E. . . . 151
KERATOMETER. MEDICAL & PSYCHOLOGICAL T&E. . . . 151
KERCHIEF CLOTHING -- HEADWEAR 28
KETTLE FOOD PROCESSING T&E. 62
KETTLE, DYEING TEXTILEWORKING T&E 107
KETTLE, HORNWORKER'S LEATHER, HORN, SHELLWORKING T&E. . 84
KETTLE, LARD-RENDERING FOOD PROCESSING T&E. 62
 Kettle, Lard-settling FOOD PROCESSING T&E
 use TANK, LARD-SETTLING
KETTLE, PRESERVING FOOD PROCESSING T&E. 62
 Kettle, Tea FOOD PROCESSING T&E
 use TEAKETTLE
 Kettledrum. MUSICAL T&E
 use TIMPANUM
KEY. HOUSEHOLD ACCESSORY. 17
KEY, CLOCK TIMEKEEPING T&E. 165
KEY, COMMEMORATIVE DOCUMENTARY ARTIFACT 211
 Key, Cotter METALWORKING T&E
 use PIN, COTTER
KEY, HANDCUFFS REGULATIVE & PROTECTIVE T&E. . . . 161
KEY, IGNITION. LTE -- ACCESSORY 194
KEY, JAIL. REGULATIVE & PROTECTIVE T&E. . . . 161
 Key, Nipple ARMAMENT -- ACCESSORY
 use WRENCH, NIPPLE
KEY, SEWING. PRINTING T&E 178
KEY, TELEGRAPH TELECOMMUNICATION T&E. 182
 Key, tooth. MEDICAL & PSYCHOLOGICAL T&E
 use EXTRACTOR, TOOTH
KEY, WATCH TIMEKEEPING T&E. 165
KEYBOARD DATA PROCESSING T&E. 169
 Keypunch. DATA PROCESSING T&E
 use PUNCH, KEYBOARD
KIBBLE MINING & MINERAL HARVESTING T&E. . 100
KICKER LEATHER, HORN, SHELLWORKING T&E. . 84
KICK-STOP. ANIMAL HUSBANDRY T&E 53

- -

```
KIDDIE-CAR . . . . . . . . . . . . . . . . TOY . . . . . . . . . . . . . . . 224
KIDNEY . . . . . . . . . . . . . . . . . . GLASS, PLASTICS, CLAYWORKING T&E .  79
  Killer, Poultry . . . . . . . . . . . . FOOD PROCESSING T&E
    use  KNIFE, POULTRY-KILLING
KILLICK . . . . . . . . . . . . . . . . . WATER TRANSPORTATION -- ACCESSORY.  202
  rt   ANCHOR
KILN . . . . . . . . . . . . . . . . . . . GLASS, PLASTICS, CLAYWORKING T&E .  80
KILN, BRICK . . . . . . . . . . . . . . . MASONRY & STONEWORKING T&E . . . .   87
KILN, LIME . . . . . . . . . . . . . . . . MASONRY & STONEWORKING T&E . . . .   87
KILN, MOLD . . . . . . . . . . . . . . . . GLASS, PLASTICS, CLAYWORKING T&E .  80
KILN, POT . . . . . . . . . . . . . . . . GLASS, PLASTICS, CLAYWORKING T&E .  80
KILT . . . . . . . . . . . . . . . . . . . CLOTHING -- OUTERWEAR . . . . . .   30
KIMONO . . . . . . . . . . . . . . . . . . CLOTHING -- OUTERWEAR . . . . . .   30
KINEGRAPH . . . . . . . . . . . . . . . . MECHANICAL T&E . . . . . . . . .   147
KINETOSCOPE . . . . . . . . . . . . . . . VISUAL COMMUNICATION T&E . . . . . 182
KIT . . . . . . . . . . . . . . . . . . . MUSICAL T&E . . . . . . . . . . .  173
  rt   VIOLIN
KIT, BICYCLE TOOL . . . . . . . . . . . . LTE -- ACCESSORY . . . . . . . .  194
KIT, CUPPING . . . . . . . . . . . . . . . MEDICAL & PSYCHOLOGICAL T&E . . .  151
KIT, DENTAL FILLING . . . . . . . . . . . MEDICAL & PSYCHOLOGICAL T&E . . .  151
KIT, DISSECTING . . . . . . . . . . . . . BIOLOGICAL T&E . . . . . . . . .   137
  Kit, Dop . . . . . . . . . . . . . . . . TOILET ARTICLE
    use  KIT, TOILET
KIT, FIRST AID . . . . . . . . . . . . . . MEDICAL & PSYCHOLOGICAL T&E . . .  151
KIT, GUN-CLEANING . . . . . . . . . . . . ARMAMENT -- ACCESSORY . . . . . .  132
KIT, INSEMINATION . . . . . . . . . . . . ANIMAL HUSBANDRY T&E . . . . . .    53
KIT, MEDICINE . . . . . . . . . . . . . . MEDICAL & PSYCHOLOGICAL T&E . . .  151
KIT, MESS . . . . . . . . . . . . . . . . FOOD SERVICE T&E . . . . . . . .    73
KIT, MODEL . . . . . . . . . . . . . . . . TOY . . . . . . . . . . . . . . . 224
KIT, NEEDLEWORK . . . . . . . . . . . . . TEXTILEWORKING T&E . . . . . . .   107
KIT, SALES-SAMPLE . . . . . . . . . . . . MERCHANDISING T&E . . . . . . . .  156
  Kit, Sewing . . . . . . . . . . . . . . TEXTILEWORKING T&E
    use  KIT, NEEDLEWORK
KIT, SHAVING . . . . . . . . . . . . . . . TOILET ARTICLE . . . . . . . . .    39
KIT, SHOESHINE . . . . . . . . . . . . . . CLOTHING -- ACCESSORY . . . . . .   33
  rt   BOX, BOOTBLACKING
KIT, SOIL-TESTING . . . . . . . . . . . . AGRICULTURAL T&E . . . . . . . .    46
KIT, SURGICAL . . . . . . . . . . . . . . MEDICAL & PSYCHOLOGICAL T&E . . .  151
KIT, THERMO-CAUTERY . . . . . . . . . . . MEDICAL & PSYCHOLOGICAL T&E . . .  151
KIT, TOILET . . . . . . . . . . . . . . . TOILET ARTICLE . . . . . . . . .    39
KIT, TOOL . . . . . . . . . . . . . . . . MULTIPLE USE ARTIFACT . . . . . .  228
KIT, TOOL . . . . . . . . . . . . . . . . LTE -- ACCESSORY . . . . . . . .  194
KITE . . . . . . . . . . . . . . . . . . . AEROSPACE -- EQUIPMENT . . . . .  187
  note use for a heavier-than-air aircraft propelled by a towline
KITE . . . . . . . . . . . . . . . . . . . TOY . . . . . . . . . . . . . . . 224
KIVA . . . . . . . . . . . . . . . . . . . BUILDING . . . . . . . . . . . . .  2
  Klismos . . . . . . . . . . . . . . . . FURNITURE
    use  CHAIR, DINING
  Klomp . . . . . . . . . . . . . . . . . CLOTHING -- FOOTWEAR
    use  SABOT
```

- -

KLYSTRON NUCLEAR PHYSICS T&E. 158
KNAPSACK PERSONAL GEAR. 37
 rt BACKPACK
KNEECAP, HORSE LTE -- ACCESSORY 194
KNICKERS CLOTHING -- OUTERWEAR. 30
 Knick-knack ART
 use BRIC-A-BRAC
KNIFE. PERSONAL GEAR. 37
KNIFE. FOOD SERVICE T&E 73
KNIFE. ARMAMENT -- EDGED. 126
KNIFE, AMPUTATING. MEDICAL & PSYCHOLOGICAL T&E. . . . 151
KNIFE, BAND-CUTTER AGRICULTURAL T&E 46
KNIFE, BEAMING LEATHER, HORN, SHELLWORKING T&E. . 84
KNIFE, BEET-TOPPING. AGRICULTURAL T&E 46
 Knife, Bench. WOODWORKING T&E
 use KNIFE, BLOCK
KNIFE, BLOCK WOODWORKING T&E. 116
KNIFE, BOARDING. FISHING & TRAPPING T&E 56
KNIFE, BONING. FOOD PROCESSING T&E. 62
KNIFE, BOWIE ARMAMENT -- EDGED. 126
KNIFE, BREAD FOOD PROCESSING T&E. 62
KNIFE, BREAD FOOD SERVICE T&E 73
 Knife, Budding. AGRICULTURAL T&E
 use KNIFE, GRAFTING
KNIFE, BUTCHER FOOD PROCESSING T&E. 62
KNIFE, BUTTER. FOOD SERVICE T&E 73
KNIFE, CAKE. FOOD SERVICE T&E 73
KNIFE, CARVING FOOD SERVICE T&E 73
KNIFE, CARVING WOODWORKING T&E. 116
KNIFE, CASTRATING. ANIMAL HUSBANDRY T&E 53
 Knife, Chamfer. WOODWORKING T&E
 use DRAWKNIFE, CHAMFERING
KNIFE, CHEESE. FOOD PROCESSING T&E. 62
KNIFE, CHEF'S. FOOD PROCESSING T&E. 62
KNIFE, CHEST GLASS, PLASTICS, CLAYWORKING T&E . 80
KNIFE, CHOPPING. FOOD PROCESSING T&E. 62
KNIFE, CORN. AGRICULTURAL T&E 46
 rt HOOK, CORN
KNIFE, CORN. TOILET ARTICLE 39
KNIFE, CURD. FOOD PROCESSING T&E. 62
KNIFE, CUTICLE TOILET ARTICLE 39
 Knife, Dehorning. ANIMAL HUSBANDRY T&E
 use DEHORNER
KNIFE, DESSERT FOOD SERVICE T&E 73
KNIFE, DINNER. FOOD SERVICE T&E 73
KNIFE, DRAW. LEATHER, HORN, SHELLWORKING T&E. . 84
KNIFE, ETCHING PRINTING T&E 178
 Knife, Farrier's. ANIMAL HUSBANDRY T&E
 use more specific term, e.g.: KNIFE, HOOF; KNIFE, TOE
KNIFE, FETTLING. GLASS, PLASTICS, CLAYWORKING T&E 80

- -

- -

```
KNIFE, SKINNING. . . . . . . . . . . . . FOOD PROCESSING T&E. . . . . . .   62
KNIFE, SKIVING . . . . . . . . . . . . . LEATHER, HORN, SHELLWORKING T&E. .  84
KNIFE, SKIVING . . . . . . . . . . . . . PRINTING T&E . . . . . . . . . .   178
KNIFE, SLATE-TRIMMING. . . . . . . . . . MASONRY & STONEWORKING T&E . . . .  87
 Knife, Slaughtering . . . . . . . . . . FOOD PROCESSING T&E
  use  KNIFE, STICKING
KNIFE, SOLE. . . . . . . . . . . . . . . ANIMAL HUSBANDRY T&E . . . . . . .  54
KNIFE, STEAK . . . . . . . . . . . . . . FOOD SERVICE T&E . . . . . . . . .  73
KNIFE, STICKING. . . . . . . . . . . . . FOOD PROCESSING T&E. . . . . . .    62
KNIFE, STOPPING. . . . . . . . . . . . . GLASS, PLASTICS, CLAYWORKING T&E .  80
KNIFE, STRETCHING. . . . . . . . . . . . LEATHER, HORN, SHELLWORKING T&E. .  84
KNIFE, STROUP. . . . . . . . . . . . . . LEATHER, HORN, SHELLWORKING T&E. .  84
KNIFE, SUGARCANE . . . . . . . . . . . . AGRICULTURAL T&E . . . . . . . .    46
  rt  MACHETE
 Knife, Swingling. . . . . . . . . . . . TEXTILEWORKING T&E
  use  KNIFE, SCUTCHING
KNIFE, SWITCHBLADE . . . . . . . . . . ARMAMENT -- EDGED. . . . . . . .    126
KNIFE, TAB-CUTTER. . . . . . . . . . . PRINTING T&E . . . . . . . . . .    178
 Knife, Table. . . . . . . . . . . . . . FOOD SERVICE T&E
  use  KNIFE, DINNER
KNIFE, TEAT. . . . . . . . . . . . . . . ANIMAL HUSBANDRY T&E . . . . . .    54
KNIFE, THROWING. . . . . . . . . . . . . ARMAMENT -- EDGED. . . . . . . .   126
KNIFE, TOBACCO . . . . . . . . . . . . . AGRICULTURAL T&E . . . . . . . .    46
KNIFE, TOE . . . . . . . . . . . . . . . ANIMAL HUSBANDRY T&E . . . . . .    54
KNIFE, TRENCH. . . . . . . . . . . . . . ARMAMENT -- EDGED. . . . . . . .   126
KNIFE, TRIMMER . . . . . . . . . . . . . PRINTING T&E . . . . . . . . . .   178
KNIFE, UNHAIRING . . . . . . . . . . . . LEATHER, HORN, SHELLWORKING T&E. .  84
KNIFE, UTILITY . . . . . . . . . . . . . MULTIPLE USE ARTIFACT. . . . . .   228
KNIFE, WALLPAPER . . . . . . . . . . . . PAINTING T&E . . . . . . . . . .   103
KNIFE, WILLOW. . . . . . . . . . . . . . BASKET, BROOM, BRUSH MAKING T&E. . 122
 Knife, X-acto . . . . . . . . . . . . . MULTIPLE USE ARTIFACT
  use  KNIFE, UTILITY
KNIFEBOARD . . . . . . . . . . . . . . . FOOD PROCESSING T&E. . . . . . .    62
KNIFE & SHEATH . . . . . . . . . . . . . SPORTS EQUIPMENT . . . . . . . .   221
KNOCKER. . . . . . . . . . . . . . . . . BUILDING COMPONENT . . . . . . .     5
KNOCKER, SNOW. . . . . . . . . . . . . . MAINTENANCE T&E. . . . . . . . .   146
KNOT, ORNAMENTAL . . . . . . . . . . . . ART. . . . . . . . . . . . . . .   205
KNOT, SHOULDER . . . . . . . . . . . . . PERSONAL SYMBOL. . . . . . . . .   215
KNOT, SWORD. . . . . . . . . . . . . . . PERSONAL SYMBOL. . . . . . . . .   215
KNOTTER. . . . . . . . . . . . . . . . . TEXTILEWORKING T&E . . . . . . .   107
KNUCKLES, BRASS. . . . . . . . . . . . . ARMAMENT -- BLUDGEON . . . . . .   127
 Kogai . . . . . . . . . . . . . . . . . ADORNMENT
  use  ORNAMENT, HAIR
KONISCOPE. . . . . . . . . . . . . . . . METEOROLOGICAL T&E . . . . . . .   157
KRIS . . . . . . . . . . . . . . . . . . ARMAMENT -- EDGED. . . . . . . .   126
KUA. . . . . . . . . . . . . . . . . . . MINING & MINERAL HARVESTING T&E. . 100
KYMOSCOPE. . . . . . . . . . . . . . . . ACOUSTICAL T&E . . . . . . . . .   123
LABEL. . . . . . . . . . . . . . . . . . DOCUMENTARY ARTIFACT . . . . . .   211
LABEL, ADDRESS . . . . . . . . . . . . . WRITTEN COMMUNICATION T&E. . . .   184
  note blank. If non-blank, may be DOCUMENTARY ARTIFACT
```

- -

```
LABRET . . . . . . . . . . . . . . . . ADORNMENT. . . . . . . . . . . .    24
 Lace, Boot. . . . . . . . . . . . . . CLOTHING -- FOOTWEAR
   use  SHOELACE
LACE FRAGMENT. . . . . . . . . . . . . ARTIFACT REMNANT . . . . . . . .   227
LACTOBUTYROMETER . . . . . . . . . . . FOOD PROCESSING T&E. . . . . . .    62
LACTOMETER . . . . . . . . . . . . . . FOOD PROCESSING T&E. . . . . . .    62
LACTORIUM. . . . . . . . . . . . . . . BUILDING COMPONENT . . . . . . .     5
LADDER . . . . . . . . . . . . . . . . HOUSEHOLD ACCESSORY. . . . . . .    17
LADDER, FRUIT-PICKING. . . . . . . . . AGRICULTURAL T&E . . . . . . . .    46
LADDER, HORIZONTAL . . . . . . . . . . RECREATIONAL DEVICE. . . . . . .   219
 Ladder, Jacob's . . . . . . . . . . . TOY
   use  FLIPPER-FLOPPER
LADDER, JACOB'S. . . . . . . . . . . . WATER TRANSPORTATION -- ACCESSORY.  202
LADDER, ROPE . . . . . . . . . . . . . RECREATIONAL DEVICE. . . . . . .   219
LADDER, SHIP'S . . . . . . . . . . . . WATER TRANSPORTATION -- ACCESSORY.  202
 Ladder, Step. . . . . . . . . . . . . HOUSEHOLD ACCESSORY
   use  STEPLADDER
LADLE. . . . . . . . . . . . . . . . . FOOD PROCESSING T&E. . . . . . .    62
LADLE. . . . . . . . . . . . . . . . . FOOD SERVICE T&E . . . . . . . .    73
LADLE. . . . . . . . . . . . . . . . . GLASS, PLASTICS, CLAYWORKING T&E .  80
LADLE, CINDER. . . . . . . . . . . . . METALWORKING T&E . . . . . . . .    92
LADLE, HOT-METAL . . . . . . . . . . . METALWORKING T&E . . . . . . . .    92
LADLE, PUNCH . . . . . . . . . . . . . FOOD SERVICE T&E . . . . . . . .    73
LADLE, SAUCE . . . . . . . . . . . . . FOOD SERVICE T&E . . . . . . . .    73
LADLE, SHIPWRIGHT'S CAULKING . . . . . WOODWORKING T&E. . . . . . . . .   116
LADLE, SLAG. . . . . . . . . . . . . . METALWORKING T&E . . . . . . . .    92
LADLE, SOUP. . . . . . . . . . . . . . FOOD SERVICE T&E . . . . . . . .    73
LADLE, WAX . . . . . . . . . . . . . . GLASS, PLASTICS, CLAYWORKING T&E .  80
LAGGING. . . . . . . . . . . . . . . . MINING & MINERAL HARVESTING T&E. . 100
LAMBREQUIN . . . . . . . . . . . . . . HOUSEHOLD ACCESSORY. . . . . . .    17
LAMELLA. . . . . . . . . . . . . . . . ACOUSTICAL T&E . . . . . . . . .   123
LAMP . . . . . . . . . . . . . . . . . LIGHTING DEVICE. . . . . . . . .    20
   note usually modified according to fuel
LAMP, ALCOHOL. . . . . . . . . . . . . LIGHTING DEVICE. . . . . . . . .    20
LAMP, ALDIS. . . . . . . . . . . . . . VISUAL COMMUNICATION T&E . . . .   182
 Lamp, Argand. . . . . . . . . . . . . LIGHTING DEVICE
   use  LAMP, OIL
 Lamp, Astral. . . . . . . . . . . . . LIGHTING DEVICE
   use  LAMP, OIL
LAMP, BATTERY OPERATED . . . . . . . . LIGHTING DEVICE. . . . . . . . .    20
 Lamp, Betty . . . . . . . . . . . . . LIGHTING DEVICE
   use  LAMP, SEMILIQUID
LAMP, BICYCLE. . . . . . . . . . . . . LTE -- ACCESSORY . . . . . . . .   195
LAMP, BINNACLE . . . . . . . . . . . . WATER TRANSPORTATION -- ACCESSORY.  202
LAMP, BURNING-FLUID. . . . . . . . . . LIGHTING DEVICE. . . . . . . . .    20
LAMP, CAMPHENE . . . . . . . . . . . . LIGHTING DEVICE. . . . . . . . .    20
LAMP, CANDLE . . . . . . . . . . . . . LIGHTING DEVICE. . . . . . . . .    20
LAMP, CARBIDE. . . . . . . . . . . . . LIGHTING DEVICE. . . . . . . . .    20
 Lamp, Carcel. . . . . . . . . . . . . LIGHTING DEVICE
   use  LAMP, OIL
```

- -

```
LAMP, CARRIAGE . . . . . . . . . . . . . LTE -- ACCESSORY . . . . . . . . .  195
 Lamp, Crusie. . . . . . . . . . . . . . LIGHTING DEVICE
   use  LAMP, SEMILIQUID
LAMP, ELECTRIC . . . . . . . . . . . . . LIGHTING DEVICE. . . . . . . . .     20
 Lamp, Fairy . . . . . . . . . . . . . . LIGHTING DEVICE
   use  LAMP, CANDLE
LAMP, GAS. . . . . . . . . . . . . . . . LIGHTING DEVICE. . . . . . . . .     20
LAMP, GASOLINE . . . . . . . . . . . . . LIGHTING DEVICE. . . . . . . . .     20
 Lamp, Hitchcock . . . . . . . . . . . . LIGHTING DEVICE
   use  LAMP, OIL
 Lamp, Jewelers. . . . . . . . . . . . . METALWORKING T&E
   use  TORCH, ALCOHOL
LAMP, KEROSINE . . . . . . . . . . . . . LIGHTING DEVICE. . . . . . . . .     20
 Lamp, Mantel. . . . . . . . . . . . . . LIGHTING DEVICE
   use  more specific term, e.g.: LAMP, KEROSINE; -,OIL
 Lamp, Moderator . . . . . . . . . . . . LIGHTING DEVICE
   use  LAMP, OIL
LAMP, MOSQUE . . . . . . . . . . . . . . CEREMONIAL ARTIFACT. . . . . . . .  207
LAMP, OIL. . . . . . . . . . . . . . . . LIGHTING DEVICE. . . . . . . . . .   20
   note use for a lamp designed to burn whale-, seal-, colza- or rosin oil
LAMP, OPIUM. . . . . . . . . . . . . . . PERSONAL GEAR. . . . . . . . . .     37
LAMP, RAILROAD . . . . . . . . . . . . . VISUAL COMMUNICATION T&E . . . . .  182
 Lamp, Rumford . . . . . . . . . . . . . LIGHTING DEVICE
   use  LAMP, OIL
LAMP, SEMILIQUID . . . . . . . . . . . . LIGHTING DEVICE. . . . . . . . .     20
   note use for any lamp designed to burn lard, tallow, grease
 Lamp, Solid-fuel. . . . . . . . . . . . LIGHTING DEVICE
   use  more specific term, e.g.: CANDLE; RUSHLIGHT; SPLINT
LAMP, SPIRIT . . . . . . . . . . . . . . CHEMICAL T&E . . . . . . . . . .    139
 Lamp, Wanzer. . . . . . . . . . . . . . LIGHTING DEVICE
   use  LAMP, OIL
LAMPPOST . . . . . . . . . . . . . . . . SITE FEATURE . . . . . . . . . . .    7
LANCE. . . . . . . . . . . . . . . . . . ARMAMENT -- EDGED. . . . . . . . .  126
LANCE, WHALE . . . . . . . . . . . . . . ARMAMENT -- EDGED. . . . . . . . .  126
LANCET . . . . . . . . . . . . . . . . . MEDICAL & PSYCHOLOGICAL T&E. . . .  151
LANCET, BLOOD. . . . . . . . . . . . . . MEDICAL & PSYCHOLOGICAL T&E. . . .  152
LANCET, VACCINE. . . . . . . . . . . . . MEDICAL & PSYCHOLOGICAL T&E. . . .  152
LANDAU . . . . . . . . . . . . . . . . . LTE -- ANIMAL-POWERED. . . . . . .  189
LANDAULET. . . . . . . . . . . . . . . . LTE -- ANIMAL-POWERED. . . . . . .  189
LANTERN. . . . . . . . . . . . . . . . . LIGHTING DEVICE. . . . . . . . .     20
   note usually modified according to fuel; e.g., LANTERN, KEROSINE
LANTERN, BATTLE. . . . . . . . . . . . . VISUAL COMMUNICATION T&E . . . . .  182
LANTERN, CANDLE. . . . . . . . . . . . . LIGHTING DEVICE. . . . . . . . .     20
LANTERN, GASOLINE. . . . . . . . . . . . LIGHTING DEVICE. . . . . . . . .     20
LANTERN, KEROSINE. . . . . . . . . . . . LIGHTING DEVICE. . . . . . . . .     20
LANTERN, MAGIC . . . . . . . . . . . . . TOY. . . . . . . . . . . . . . . .  224
 Lantern, Magic. . . . . . . . . . . . . VISUAL COMMUNICATION T&E
   use  PROJECTOR, LANTERN-SLIDE
LANTERN, PAPER . . . . . . . . . . . . . HOUSEHOLD ACCESSORY. . . . . . . .   17
LANTERN, RAILROAD. . . . . . . . . . . . VISUAL COMMUNICATION T&E . . . . .  182
```

- -

```
LANYARD. . . . . . . . . . . . . . . . . PERSONAL GEAR. . . . . . . . . . .  37
LANYARD. . . . . . . . . . . . . . . . . ARMAMENT -- ACCESSORY. . . . . . . 132
LAPBOARD . . . . . . . . . . . . . . . . BASKET, BROOM, BRUSH MAKING T&E. . 122
LAPBOARD . . . . . . . . . . . . . . . . WRITTEN COMMUNICATION T&E. . . . . 184
LAPPET . . . . . . . . . . . . . . . . . CLOTHING -- HEADWEAR . . . . . . .  28
LARIAT . . . . . . . . . . . . . . . . . ANIMAL HUSBANDRY T&E . . . . . . .  54
LARIAT . . . . . . . . . . . . . . . . . LTE -- ACCESSORY . . . . . . . . . 195
LARYNGOSCOPE . . . . . . . . . . . . . . MEDICAL & PSYCHOLOGICAL T&E. . . . 152
LAST . . . . . . . . . . . . . . . . . . LEATHER, HORN, SHELLWORKING T&E. .  84
LAST, BOOT . . . . . . . . . . . . . . . LEATHER, HORN, SHELLWORKING T&E. .  84
LAST, SHOE . . . . . . . . . . . . . . . LEATHER, HORN, SHELLWORKING T&E. .  84
  Latch . . . . . . . . . . . . . . . . BUILDING COMPONENT
  use ASSEMBLY, LATCH
LATH . . . . . . . . . . . . . . . . . . BUILDING COMPONENT . . . . . . . .   5
LATHE. . . . . . . . . . . . . . . . . . WOODWORKING T&E. . . . . . . . . . 116
LATHE. . . . . . . . . . . . . . . . . . GLASS, PLASTICS, CLAYWORKING T&E .  80
LATHE. . . . . . . . . . . . . . . . . . METALWORKING T&E . . . . . . . . .  92
LATHE, BORING. . . . . . . . . . . . . . WOODWORKING T&E. . . . . . . . . . 116
LATHE, DENTAL. . . . . . . . . . . . . . MEDICAL & PSYCHOLOGICAL T&E. . . . 152
LATHE, DUPLICATING . . . . . . . . . . . WOODWORKING T&E. . . . . . . . . . 116
LATHE, ENGINE. . . . . . . . . . . . . . METALWORKING T&E . . . . . . . . .  92
  note use for a lathe with a slide rest and a power feed on the carriage
LATHE, FOOT. . . . . . . . . . . . . . . METALWORKING T&E . . . . . . . . .  92
  note use for a lathe operated by a treadle
LATHE, HAND. . . . . . . . . . . . . . . METALWORKING T&E . . . . . . . . .  92
  note use for a lathe in which the lathe tool is hand-held
LATHE, SPOKE . . . . . . . . . . . . . . WOODWORKING T&E. . . . . . . . . . 116
LATHE, TURRET. . . . . . . . . . . . . . METALWORKING T&E . . . . . . . . .  92
  note use for a multi-tooled lathe
LAUNCH, GASOLINE . . . . . . . . . . . . WATER TRANSPORTATION -- EQUIPMENT. 199
  rt  RUNABOUT
LAUNCH, NAPTHA . . . . . . . . . . . . . WATER TRANSPORTATION -- EQUIPMENT. 199
LAUNCH, STEAM. . . . . . . . . . . . . . WATER TRANSPORTATION -- EQUIPMENT. 199
LAUNCHER, GRENADE. . . . . . . . . . . . ARMAMENT -- FIREARM. . . . . . . . 125
LAVABO . . . . . . . . . . . . . . . . . CEREMONIAL ARTIFACT. . . . . . . . 207
LAVALIERE. . . . . . . . . . . . . . . . ADORNMENT. . . . . . . . . . . . .  24
  Lavatory. . . . . . . . . . . . . . . PLUMBING FIXTURE
  use   more specific term, e.g.: TOILET; SINK
LAWN . . . . . . . . . . . . . . . . . . GLASS, PLASTICS, CLAYWORKING T&E .  80
LAYETTE. . . . . . . . . . . . . . . . . CLOTHING -- OUTERWEAR. . . . . . .  30
LAYOUT . . . . . . . . . . . . . . . . . DOCUMENTARY ARTIFACT . . . . . . . 211
LEAD, SOUNDING . . . . . . . . . . . . . SURVEYING & NAVIGATIONAL T&E . . . 163
LEAD, SOUNDING . . . . . . . . . . . . . WATER TRANSPORTATION -- ACCESSORY. 202
  Leader, Cattle. . . . . . . . . . . . ANIMAL HUSBANDRY T&E
  use  LEADER, LIVESTOCK
LEADER, LIVESTOCK. . . . . . . . . . . . ANIMAL HUSBANDRY T&E . . . . . . .  54
  Leader, Ribbon. . . . . . . . . . . . TEXTILEWORKING T&E
  use  BODKIN
  Leaflet . . . . . . . . . . . . . . . DOCUMENTARY ARTIFACT
  use  HANDBILL
```

- -

Leaflet ADVERTISING MEDIUM
 use HANDBILL
LEAN-TO. BUILDING 2
LEASH. ANIMAL HUSBANDRY T&E 54
LEATHER FRAGMENT ARTIFACT REMNANT 227
LECTURN. FURNITURE. 13
Lecture DOCUMENTARY ARTIFACT
 use SPEECH
Lederhosen. CLOTHING -- OUTERWEAR
 use SHORTS
LEDGER DOCUMENTARY ARTIFACT 211
LEG, AIR MINING & MINERAL HARVESTING T&E. . 100
Leg, Artificial PERSONAL GEAR
 use PROSTHESIS
LEGGING. CLOTHING -- OUTERWEAR. 30
LEG-HARNESS. ARMAMENT -- BODY ARMOR 130
LENCOSCOPE MEDICAL & PSYCHOLOGICAL T&E. . . . 152
LENS OPTICAL T&E. 159
LENS PHOTOGRAPHIC T&E 176
LENS, ANASTIGMATIC OPTICAL T&E. 159
LENS, CONTACT. PERSONAL GEAR. 37
LENS, STENOPAIC. MEDICAL & PSYCHOLOGICAL T&E. . . . 152
LENS, WATER. OPTICAL T&E. 159
Leotard CLOTHING -- UNDERWEAR
 use BODYSTOCKING
LETTER DOCUMENTARY ARTIFACT 211
LETTERPRESS. PRINTING T&E 178
Levando METALWORKING T&E
 use CONCENTRATOR
LEVEL. WOODWORKING T&E. 117
LEVEL, GUNNER'S. ARMAMENT -- ACCESSORY. 132
LEVEL, MASON'S MASONRY & STONEWORKING T&E 87
LEVEL, PLUMB WOODWORKING T&E. 117
Level, Spirit WOODWORKING T&E
 use LEVEL
LEVEL, SURVEYOR'S. SURVEYING & NAVIGATIONAL T&E . . . 163
LEVELER, HOOF. ANIMAL HUSBANDRY T&E 54
LEVELER, LAND. AGRICULTURAL T&E 46
LEVER. MECHANICAL T&E 147
LEVIGATOR. PRINTING T&E 178
LEWIS. MASONRY & STONEWORKING T&E 87
LIBRARY. BUILDING 2
LICENSE. DOCUMENTARY ARTIFACT 211
LICENSE, ANIMAL.·) . DOCUMENTARY ARTIFACT 211
License, Fishing. DOCUMENTARY ARTIFACT
 use LICENSE, SPORTING
License, Hunting. DOCUMENTARY ARTIFACT
 use LICENSE, SPORTING
LICENSE, OCCUPATIONAL. DOCUMENTARY ARTIFACT 212
LICENSE, SPORTING. DOCUMENTARY ARTIFACT 212

- -

```
LICENSE, TRANSPORTATION. . . . . . . . . DOCUMENTARY ARTIFACT . . . . . . . 212
        transportation devices
LICENSE, TRANSPORTATION. . . . . . . . . DOCUMENTARY ARTIFACT . . . . . . . 212
   note use for a license issued to operators or officers of
LIFEBOAT, RESCUE . . . . . . . . . . . WATER TRANSPORTATION -- EQUIPMENT. 199
   rt  SURFBOAT; LIFECAR
LIFEBOAT, SHIP'S . . . . . . . . . . . WATER TRANSPORTATION -- EQUIPMENT. 199
LIFECAR. . . . . . . . . . . . . . . . WATER TRANSPORTATION -- EQUIPMENT. 199
   rt  LIFEBOAT, RESCUE; SURFBOAT
LIFT, CHAIR. . . . . . . . . . . . . . AEROSPACE -- EQUIPMENT . . . . . . 187
LIFT, COW. . . . . . . . . . . . . . . ANIMAL HUSBANDRY T&E . . . . . . .  54
LIFT, DRAWING. . . . . . . . . . . . . MINING & MINERAL HARVESTING T&E. . 100
LIFT, HYDRAULIC. . . . . . . . . . . . MECHANICAL T&E . . . . . . . . . . 147
LIFTER, JAR. . . . . . . . . . . . . . FOOD PROCESSING T&E. . . . . . . .  62
LIFTER, PIE. . . . . . . . . . . . . . FOOD PROCESSING T&E. . . . . . . .  62
LIFTER, POT. . . . . . . . . . . . . . FOOD PROCESSING T&E. . . . . . . .  62
LIFTER, SKIRT. . . . . . . . . . . . . CLOTHING -- ACCESSORY. . . . . . .  33
LIFTER, SOD. . . . . . . . . . . . . . AGRICULTURAL T&E . . . . . . . . .  46
LIFTER, STOVE. . . . . . . . . . . . . FOOD PROCESSING T&E. . . . . . . .  62
 Lifter, Stump . . . . . . . . . . . . AGRICULTURAL T&E
   use  PULLER, STUMP
LIFTER, TODDY. . . . . . . . . . . . . FOOD SERVICE T&E . . . . . . . . .  73
LIGATURE . . . . . . . . . . . . . . . MEDICAL & PSYCHOLOGICAL T&E. . . . 152
LIGHT, AIRCRAFT. . . . . . . . . . . . AEROSPACE -- ACCESSORY . . . . . . 188
LIGHT, ANCHOR. . . . . . . . . . . . . WATER TRANSPORTATION -- ACCESSORY. 202
LIGHT, CHANNEL . . . . . . . . . . . . WATER TRANSPORTATION -- ACCESSORY. 202
 Light, Christmas Tree . . . . . . . . ART
   use  ORNAMENT, CHRISTMAS TREE
LIGHT, MASTHEAD. . . . . . . . . . . . WATER TRANSPORTATION -- ACCESSORY. 202
LIGHT, NAVIGATION. . . . . . . . . . . WATER TRANSPORTATION -- ACCESSORY. 202
LIGHT, RUNNING . . . . . . . . . . . . WATER TRANSPORTATION -- ACCESSORY. 202
LIGHT, SIGNAL. . . . . . . . . . . . . VISUAL COMMUNICATION T&E . . . . . 182
LIGHT, STERN . . . . . . . . . . . . . WATER TRANSPORTATION -- ACCESSORY. 202
 Light, Strobe . . . . . . . . . . . . PHOTOGRAPHIC T&E
   use  ATTACHMENT, FLASH
 Light, Traffic. . . . . . . . . . . . VISUAL COMMUNICATION T&E
   use  SIGNAL, TRAFFIC
LIGHTER. . . . . . . . . . . . . . . . PERSONAL GEAR. . . . . . . . . . .  37
LIGHTHOUSE . . . . . . . . . . . . . . BUILDING . . . . . . . . . . . . .   2
LIGHTSHIP. . . . . . . . . . . . . . . WATER TRANSPORTATION -- EQUIPMENT. 199
 Linac . . . . . . . . . . . . . . . . NUCLEAR PHYSICS T&E
   use  ACCELERATOR, LINEAR
LINE . . . . . . . . . . . . . . . . . AEROSPACE -- ACCESSORY . . . . . . 188
LINE, CHALK. . . . . . . . . . . . . . WOODWORKING T&E. . . . . . . . . . 117
   rt  REEL, CHALK
LINE, CONTROL. . . . . . . . . . . . . AEROSPACE -- ACCESSORY . . . . . . 188
LINE, MAIN MOORING . . . . . . . . . . AEROSPACE -- ACCESSORY . . . . . . 188
LINE, MAST YAW . . . . . . . . . . . . AEROSPACE -- ACCESSORY . . . . . . 188
LINE, SPINNING . . . . . . . . . . . . MINING & MINERAL HARVESTING T&E. . 100
 Linen, Stair. . . . . . . . . . . . . FLOOR COVERING
   use  COVER, STAIR
```

- -

- -

LOGOMETER. CHEMICAL T&E 139
LOINCLOTH. CLOTHING -- OUTERWEAR. 30
LONGBOAT WATER TRANSPORTATION -- EQUIPMENT. 199
LONGLINE FISHING & TRAPPING T&E 56
LOOM TEXTILEWORKING T&E 107
LOOM, BACKSTRAP. TEXTILEWORKING T&E 107
LOOM, BEAD TEXTILEWORKING T&E 107
LOOM, BELT TEXTILEWORKING T&E 107
LOOM, BROAD. TEXTILEWORKING T&E 107
 note use for any loom designed to weave a fabric 54" or more in width
LOOM, CAM. TEXTILEWORKING T&E 107
LOOM, CARPET TEXTILEWORKING T&E 107
LOOM, COUNTER-BALANCE. TEXTILEWORKING T&E 107
LOOM, COUNTER-MARCH. TEXTILEWORKING T&E 107
LOOM, DOBBY. TEXTILEWORKING T&E 107
 Loom, Doup. TEXTILEWORKING T&E
 use LOOM, LENO
LOOM, DRAW TEXTILEWORKING T&E 107
LOOM, HAND TEXTILEWORKING T&E 107
LOOM, JACK TEXTILEWORKING T&E 107
LOOM, JACQUARD TEXTILEWORKING T&E 107
LOOM, LACE TEXTILEWORKING T&E 107
LOOM, LENO TEXTILEWORKING T&E 107
LOOM, NEEDLE POINT TEXTILEWORKING T&E 107
LOOM, PILE FABRIC. TEXTILEWORKING T&E 107
LOOM, RAPIER TEXTILEWORKING T&E 107
LOOM, RIGID HEDDLE TEXTILEWORKING T&E 107
LOOM, SHUTTLELESS. TEXTILEWORKING T&E 107
LOOM, SWIVEL TEXTILEWORKING T&E 107
LOOM, TABLET TEXTILEWORKING T&E 107
LOOM, TAPE TEXTILEWORKING T&E 107
LOOM, WARP WEIGHTED. TEXTILEWORKING T&E 107
LOOM, WATER-JET. TEXTILEWORKING T&E 107
LOOP, CURTAIN. WINDOW OR DOOR COVERING. 23
LOOP, SHOULDER PERSONAL SYMBOL. 215
LORGNETTE. PERSONAL GEAR. 37
LOTTO. GAME 217
 rt BINGO
LOUNGE FURNITURE. 13
 Lowboy. FURNITURE
 use CHEST OF DRAWERS
LUBRICATOR, PRESSURE MECHANICAL T&E 147
LUBRICATOR-SIZER ARMAMENT -- ACCESSORY. 132
LUCET. TEXTILEWORKING T&E 107
 Lucimeter OPTICAL T&E
 use PHOTOMETER
LUGE SPORTS EQUIPMENT 221
LUNG, IRON MEDICAL & PSYCHOLOGICAL T&E. . . . 152
LURE FISHING & TRAPPING T&E 56
LUSTER ART. 205

- -

LUTE MUSICAL T&E. 174
 rt THEOROBO
LYRE MUSICAL T&E. 174
LYRE-GUITAR. MUSICAL T&E. 174
LYSIMETER. BIOLOGICAL T&E 137
MACE ARMAMENT -- BLUDGEON 127
MACE PERSONAL SYMBOL. 215
MACE-HEAD. PRINTING T&E 178
MACHETE. AGRICULTURAL T&E 47
 rt KNIFE, SUGARCANE
Machine, Accounting DATA PROCESSING T&E
 use MACHINE, BOOKKEEPING
MACHINE, ADDING. DATA PROCESSING T&E. 169
MACHINE, ADDRESSING. PRINTING T&E 178
MACHINE, ARCADE. RECREATIONAL DEVICE. 219
 note use for any machine not identified by another general term: e.g.,
 MACHINE, PINBALL
MACHINE, BACKFILLING TEXTILEWORKING T&E 107
MACHINE, BACKSTRIPPING PRINTING T&E 178
MACHINE, BAG-CLOSING FOOD PROCESSING T&E. 62
MACHINE, BAG-FORMING PAPERMAKING T&E. 104
Machine, Bag-sewing FOOD PROCESSING T&E
 use MACHINE, BAG-CLOSING
MACHINE, BAG-TYING FOOD PROCESSING T&E. 62
MACHINE, BANDING PRINTING T&E 178
MACHINE, BATCHER/JOGGER. PRINTING T&E 178
MACHINE, BATT-MAKING TEXTILEWORKING T&E 108
MACHINE, BEADING METALWORKING T&E 92
MACHINE, BEAMING LEATHER, HORN, SHELLWORKING T&E. . 84
MACHINE, BEATING LEATHER, HORN, SHELLWORKING T&E. . 84
MACHINE, BEDDING WOODWORKING T&E. 117
MACHINE, BINDING PRINTING T&E 178
MACHINE, BLEACHING TEXTILEWORKING T&E 108
MACHINE, BLOWING MINING & MINERAL HARVESTING T&E. . 100
MACHINE, BOLT-CLIPPER. METALWORKING T&E 92
MACHINE, BOLT-HEADING. METALWORKING T&E 92
MACHINE, BONDING TEXTILEWORKING T&E 108
MACHINE, BOOKKEEPING DATA PROCESSING T&E. 169
MACHINE, BOOK-SEWING PRINTING T&E 178
MACHINE, BOOK-SMASHING PRINTING T&E 178
MACHINE, BOOK-TRIMMING PRINTING T&E 178
MACHINE, BORING. WOODWORKING T&E. 117
MACHINE, BORING. METALWORKING T&E 92
MACHINE, BOTTLING. FOOD PROCESSING T&E. 63
 rt CAPPER, BOTTLE
MACHINE, BRADING METALWORKING T&E 92
MACHINE, BREECHING METALWORKING T&E 92
MACHINE, BRICK MASONRY & STONEWORKING T&E . . . 87
MACHINE, BROACHING METALWORKING T&E 92
MACHINE, BROOM BASKET, BROOM, BRUSH MAKING T&E. . 122

- -

MACHINE, BRUSH FOOD PROCESSING T&E. 63
MACHINE, BRUSHING. TEXTILEWORKING T&E 108
MACHINE, BRUSHING. LEATHER, HORN, SHELLWORKING T&E. . 84
MACHINE, BUFFING LEATHER, HORN, SHELLWORKING T&E. . 84
MACHINE, BUFFING METALWORKING T&E 92
MACHINE, BULKING TEXTILEWORKING T&E 108
MACHINE, BURLING TEXTILEWORKING T&E 108
MACHINE, BURRING METALWORKING T&E 92
MACHINE, CAN-CAPPING FOOD PROCESSING T&E. 63
MACHINE, CARD CLOTHING TEXTILEWORKING T&E 108
MACHINE, CARDING TEXTILEWORKING T&E 108
MACHINE, CARDING LEATHER, HORN, SHELLWORKING T&E. . 84
MACHINE, CARD-PUNCHING TEXTILEWORKING T&E 108
 Machine, Cartoning. FOOD PROCESSING T&E
 use MACHINE, PACKAGING
MACHINE, CASEMAKING. PRINTING T&E 178
MACHINE, CASING-IN PRINTING T&E 178
MACHINE, CHARGING. METALWORKING T&E 92
MACHINE, CHINCHILLA. TEXTILEWORKING T&E 108
MACHINE, COATING PAPERMAKING T&E. 104
MACHINE, COATING TEXTILEWORKING T&E 108
MACHINE, COATING GLASS, PLASTICS, CLAYWORKING T&E . 80
 rt CALENDER
MACHINE, COLLATING PRINTING T&E 178
 Machine, Composing. PRINTING T&E
 use TYPESETTER
MACHINE, CONCRETE-FINISHING. MASONRY & STONEWORKING T&E 87
MACHINE, CONE. METALWORKING T&E 92
MACHINE, CRABBING. TEXTILEWORKING T&E 108
MACHINE, CREASING. METALWORKING T&E 92
MACHINE, CRIMPING. METALWORKING T&E 92
MACHINE, CRIMPING. TEXTILEWORKING T&E 108
MACHINE, CROCHETING. TEXTILEWORKING T&E 108
MACHINE, CUTTING MINING & MINERAL HARVESTING T&E. . 100
 Machine, Cylinder PAPERMAKING T&E
 use MACHINE, PAPER
 Machine, Data-processing. DATA PROCESSING T&E
 use more specific term, e.g.: COMPUTER, ANALOG
MACHINE, DE-BURRING. LEATHER, HORN, SHELLWORKING T&E. . 84
MACHINE, DECATING. TEXTILEWORKING T&E 108
MACHINE, DEHAIRING LEATHER, HORN, SHELLWORKING T&E. . 84
MACHINE, DIBBLING. AGRICULTURAL T&E 47
MACHINE, DICTATING SOUND COMMUNICATION T&E. 181
MACHINE, DIE-CUTTING LEATHER, HORN, SHELLWORKING T&E. . 84
MACHINE, DIE-CUTTING METALWORKING T&E 92
 Machine, Ditching CONSTRUCTION T&E
 use MACHINE, TRENCHING
MACHINE, DOUBLE-SEAMING. METALWORKING T&E 92
MACHINE, DOVE-TAILING. WOODWORKING T&E. 117
MACHINE, DRAFTING. DRAFTING T&E 171

- -

```
MACHINE, DRAWING-IN. . . . . . . . . . TEXTILEWORKING T&E . . . . . . . . 108
MACHINE, DRYING. . . . . . . . . . . . LEATHER, HORN, SHELLWORKING T&E. .  84
MACHINE, DYEING. . . . . . . . . . . . TEXTILEWORKING T&E . . . . . . . . 108
MACHINE, ELECTROTHERAPY. . . . . . . . MEDICAL & PSYCHOLOGICAL T&E. . . . 152
MACHINE, EMBROIDERY. . . . . . . . . . TEXTILEWORKING T&E . . . . . . . . 108
MACHINE, ENGRAVING . . . . . . . . . . GLASS, PLASTICS, CLAYWORKING T&E .  80
MACHINE, FALL. . . . . . . . . . . . . MECHANICAL T&E . . . . . . . . . . 147
MACHINE, FELTING . . . . . . . . . . . TEXTILEWORKING T&E . . . . . . . . 108
MACHINE, FILAMENT-WINDING. . . . . . . GLASS, PLASTICS, CLAYWORKING T&E .  80
 Machine, Finishing. . . . . . . . . . TEXTILEWORKING T&E
  use  more specific term, e.g.: MACHINE, DECATING; CALENDER, EMBOSSING
MACHINE, FLESHING. . . . . . . . . . . LEATHER, HORN, SHELLWORKING T&E. .  84
MACHINE, FLOAT-CUTTING . . . . . . . . TEXTILEWORKING T&E . . . . . . . . 108
MACHINE, FLOCKING. . . . . . . . . . . TEXTILEWORKING T&E . . . . . . . . 108
MACHINE, FOAM. . . . . . . . . . . . . GLASS, PLASTICS, CLAYWORKING T&E .  80
MACHINE, FOAM-CUTTING. . . . . . . . . GLASS, PLASTICS, CLAYWORKING T&E .  80
MACHINE, FOLDING . . . . . . . . . . . METALWORKING T&E . . . . . . . . .  92
  rt   BRAKE
MACHINE, FOLDING . . . . . . . . . . . TEXTILEWORKING T&E . . . . . . . . 108
MACHINE, FOLDING . . . . . . . . . . . PRINTING T&E . . . . . . . . . . . 178
MACHINE, FORMING . . . . . . . . . . . METALWORKING T&E . . . . . . . . .  92
MACHINE, FORMING . . . . . . . . . . . GLASS, PLASTICS, CLAYWORKING T&E .  80
 Machine, Fourdrinier. . . . . . . . . PAPERMAKING T&E
  use  MACHINE, PAPER
MACHINE, FULLING . . . . . . . . . . . TEXTILEWORKING T&E . . . . . . . . 108
MACHINE, GARNETT . . . . . . . . . . . TEXTILEWORKING T&E . . . . . . . . 108
MACHINE, GEAR-CUTTING. . . . . . . . . METALWORKING T&E . . . . . . . . .  92
MACHINE, GIGGING . . . . . . . . . . . TEXTILEWORKING T&E . . . . . . . . 108
MACHINE, GLUING. . . . . . . . . . . . PRINTING T&E . . . . . . . . . . . 178
MACHINE, GROOVING. . . . . . . . . . . METALWORKING T&E . . . . . . . . .  92
 Machine, Grout. . . . . . . . . . . . MINING & MINERAL HARVESTING T&E
  use  INJECTOR, CEMENT
MACHINE, GUNNITE . . . . . . . . . . . CONSTRUCTION T&E . . . . . . . . . 141
MACHINE, HEAT-SETTING. . . . . . . . . TEXTILEWORKING T&E . . . . . . . . 108
MACHINE, HORNWORKER'S. . . . . . . . . LEATHER, HORN, SHELLWORKING T&E. .  84
 Machine, Husking. . . . . . . . . . . AGRICULTURAL T&E
  use  HUSKER/SHREDDER, CORN
MACHINE, IRONING . . . . . . . . . . . LEATHER, HORN, SHELLWORKING T&E. .  84
MACHINE, KNIT/SEW. . . . . . . . . . . TEXTILEWORKING T&E . . . . . . . . 108
MACHINE, KNITTING. . . . . . . . . . . TEXTILEWORKING T&E . . . . . . . . 108
MACHINE, LOADING . . . . . . . . . . . MINING & MINERAL HARVESTING T&E. . 100
MACHINE, LOOPING . . . . . . . . . . . TEXTILEWORKING T&E . . . . . . . . 108
MACHINE, MAILING . . . . . . . . . . . WRITTEN COMMUNICATION T&E. . . . . 184
MACHINE, MERCERIZING . . . . . . . . . TEXTILEWORKING T&E . . . . . . . . 108
MACHINE, METAL-CASTING . . . . . . . . MEDICAL & PSYCHOLOGICAL T&E. . . . 152
MACHINE, METERING. . . . . . . . . . . GLASS, PLASTICS, CLAYWORKING T&E .  80
MACHINE, MILKING . . . . . . . . . . . FOOD PROCESSING T&E. . . . . . . .  63
MACHINE, MILLING . . . . . . . . . . . METALWORKING T&E . . . . . . . . .  92
MACHINE, MITERING. . . . . . . . . . . PRINTING T&E . . . . . . . . . . . 178
MACHINE, MOLDING . . . . . . . . . . . GLASS, PLASTICS, CLAYWORKING T&E .  80
```

- -

```
MACHINE, MORTISING . . . . . . . . . . WOODWORKING T&E. . . . . . . . . . 117
 Machine, Mowing . . . . . . . . . . AGRICULTURAL T&E
  use  MOWER
 Machine, Mucking. . . . . . . . . . MINING & MINERAL HARVESTING T&E
  use  LOADER
MACHINE, NAIL-CUTTING. . . . . . . . METALWORKING T&E . . . . . . . . .  92
MACHINE, NUMBERING . . . . . . . . . PRINTING T&E . . . . . . . . . . . 178
MACHINE, OFFSET-PLATE PROCESSING . . . PRINTING T&E . . . . . . . . . . 178
MACHINE, OXYGEN. . . . . . . . . . . MEDICAL & PSYCHOLOGICAL T&E. . . . 152
MACHINE, PACKAGE-CHANGING. . . . . . TEXTILEWORKING T&E . . . . . . . . 108
     note see also SPOOLER; WINDER; REEL
MACHINE, PACKAGING . . . . . . . . . FOOD PROCESSING T&E. . . . . . . .  63
MACHINE, PACKING . . . . . . . . . . FOOD PROCESSING T&E. . . . . . . .  63
MACHINE, PACKING . . . . . . . . . . PAPERMAKING T&E. . . . . . . . . . 104
MACHINE, PAD . . . . . . . . . . . . TEXTILEWORKING T&E . . . . . . . . 108
MACHINE, PAPER . . . . . . . . . . . PAPERMAKING T&E. . . . . . . . . . 104
 Machine, Paper-making . . . . . . . PAPERMAKING T&E
  use  MACHINE, PAPER
MACHINE, PEEP-SHOW . . . . . . . . . RECREATIONAL DEVICE. . . . . . . . 219
  rt   MUTASCOPE
MACHINE, PERLOCK . . . . . . . . . . TEXTILEWORKING T&E . . . . . . . . 108
 Machine, Photocomposing . . . . . . PRINTING T&E
  use  PHOTOTYPESETTER
MACHINE, PILL. . . . . . . . . . . . MEDICAL & PSYCHOLOGICAL T&E. . . . 152
MACHINE, PINBALL . . . . . . . . . . RECREATIONAL DEVICE. . . . . . . . 219
MACHINE, PINBOARD. . . . . . . . . . DATA PROCESSING T&E. . . . . . . . 169
MACHINE, PINKING . . . . . . . . . . TEXTILEWORKING T&E . . . . . . . . 108
MACHINE, PLEATING. . . . . . . . . . TEXTILEWORKING T&E . . . . . . . . 108
MACHINE, POLISHING . . . . . . . . . METALWORKING T&E . . . . . . . . .  92
 Machine, Posting. . . . . . . . . . DATA PROCESSING T&E
  use  MACHINE, BOOKKEEPING
MACHINE, PREFORM . . . . . . . . . . GLASS, PLASTICS, CLAYWORKING T&E .  80
MACHINE, PRESSING. . . . . . . . . . MINING & MINERAL HARVESTING T&E. . 100
MACHINE, PROFILING . . . . . . . . . WOODWORKING T&E. . . . . . . . . . 117
MACHINE, PULLING . . . . . . . . . . LEATHER, HORN, SHELLWORKING T&E. .  84
MACHINE, PUMPING . . . . . . . . . . GLASS, PLASTICS, CLAYWORKING T&E .  80
MACHINE, QUARRYING . . . . . . . . . MINING & MINERAL HARVESTING T&E. . 100
  rt   DRILL, GANG; CUTTER, CHANNEL BAR; CUTTER, JET-PIERCING
MACHINE, QUILTING. . . . . . . . . . TEXTILEWORKING T&E . . . . . . . . 108
MACHINE, RIFLING . . . . . . . . . . METALWORKING T&E . . . . . . . . .  92
MACHINE, RIVETING. . . . . . . . . . LEATHER, HORN, SHELLWORKING T&E. .  84
MACHINE, RIVET-MAKING. . . . . . . . METALWORKING T&E . . . . . . . . .  92
MACHINE, ROCKET-DRIVING. . . . . . . ARMAMENT -- ACCESSORY. . . . . . . 132
MACHINE, ROLLING . . . . . . . . . . PRINTING T&E . . . . . . . . . . . 178
MACHINE, ROPE-MAKING . . . . . . . . TEXTILEWORKING T&E . . . . . . . . 108
MACHINE, ROUND-BACKING . . . . . . . PRINTING T&E . . . . . . . . . . . 178
MACHINE, ROUND-CORNERING . . . . . . PRINTING T&E . . . . . . . . . . . 178
MACHINE, ROWING. . . . . . . . . . . SPORTS EQUIPMENT . . . . . . . . . 221
MACHINE, RULING. . . . . . . . . . . PRINTING T&E . . . . . . . . . . . 178
MACHINE, SCORING . . . . . . . . . . PAPERMAKING T&E. . . . . . . . . . 104
```

- -

- -

- -

MALLET, FUZE ARMAMENT -- ACCESSORY. 132
MALLET, GONG SOUND COMMUNICATION T&E. 181
MALLET, GRAFTING AGRICULTURAL T&E 47
MALLET, MASON'S. MASONRY & STONEWORKING T&E 87
MALLET, ORAL SURGERY MEDICAL & PSYCHOLOGICAL T&E. . . . 152
MALLET, SERVING. TEXTILEWORKING T&E 109
MALLET, SHIPWRIGHT'S WOODWORKING T&E. 117
MALLET, STONECARVER'S. MASONRY & STONEWORKING T&E 87
 Manacle REGULATIVE & PROTECTIVE T&E
 use SHACKLE
 Manchette CLOTHING -- ACCESSORY
 use SLEEVE
MANDOCELLO MUSICAL T&E. 174
MANDOLIN MUSICAL T&E. 174
 rt MANDORE
MANDORE. MUSICAL T&E. 174
 rt MANDOLIN
MANDREL. METALWORKING T&E 93
MANDREL, DENTAL. MEDICAL & PSYCHOLOGICAL T&E. . . . 152
MANDREL, HORNWORKER'S. LEATHER, HORN, SHELLWORKING T&E. . 84
MANGLE MAINTENANCE T&E. 146
MANGONEL ARMAMENT -- ARTILLERY. 128
MANIKIN. MERCHANDISING T&E. 156
MANIPLE. CLOTHING -- OUTERWEAR. 30
MANO FOOD PROCESSING T&E. 63
MAN-OF-WAR WATER TRANSPORTATION -- EQUIPMENT. 199
 note use only for a full-rigged ship of the line
MANOMETER. CHEMICAL T&E 139
MANOPTOSCOPE MEDICAL & PSYCHOLOGICAL T&E. . . . 152
MANTEL BUILDING COMPONENT 5
 Mantelet. CLOTHING -- OUTERWEAR
 use CAPE
 Mantelshelf BUILDING COMPONENT
 use MANTEL
 Mantilla. CLOTHING -- HEADWEAR
 use SCARF
 Mantle. CLOTHING -- OUTERWEAR
 use CAPE
 Manual. DOCUMENTARY ARTIFACT
 use BOOK or BOOKLET
MANUSCRIPT DOCUMENTARY ARTIFACT 212
MAP. DOCUMENTARY ARTIFACT 212
MARACAS. MUSICAL T&E. 174
MARBLE GAME 217
MARIMBA. MUSICAL T&E. 174
MARIONETTE TOY. 224
 rt DOLL; PUPPET, HAND
MARIONETTE PUBLIC ENTERTAINMENT DEVICE. . . . 218
 rt PUPPET, HAND
 Mark, Bench SURVEYING & NAVIGATIONAL T&E
 use more specific term, e.g.: CAIRN; STAKE; MARKER, CONCRETE

- -

MEASURE, SPRING. WEIGHTS & MEASURES T&E 166
MEASURE, TAPE. WEIGHTS & MEASURES T&E 166
 rt RULE, RETRACTABLE
MEASURER, SOUND. ACOUSTICAL T&E 123
 note use for a sound generator with scales
 Meat-ax FOOD PROCESSING T&E
 use CLEAVER
 Meatoscope. MEDICAL & PSYCHOLOGICAL T&E
 use SPECULUM
MEDAL, COMMEMORATIVE DOCUMENTARY ARTIFACT 212
MEDAL, POLITICAL PERSONAL SYMBOL. 215
 Medallion PERSONAL SYMBOL
 use MEDAL
 Medallion DOCUMENTARY ARTIFACT
 use MEDAL, COMMEMORATIVE
MEETINGHOUSE BUILDING 2
 Megalith. CEREMONIAL ARTIFACT
 use DOLMEN or MENHIR
MEGALITHOSCOPE VISUAL COMMUNICATION T&E 182
MEGAPHONE. SOUND COMMUNICATION T&E. 181
 Megascope VISUAL COMMUNICATION T&E
 use PROJECTOR, LANTERN-SLIDE
MELANOSCOPE. CHEMICAL T&E 139
MELLOPHONE MUSICAL T&E. 174
 Melodeon. MUSICAL T&E
 use ORGAN, REED
MEMORANDUM DOCUMENTARY ARTIFACT 212
 Memorial
 use more specific term, e.g.: ALTAR; MONUMENT
 Menat PERSONAL SYMBOL
 use AMULET
MENHIR CEREMONIAL ARTIFACT. 208
MENORAH. CEREMONIAL ARTIFACT. 208
MENU DOCUMENTARY ARTIFACT 212
 Meridienne. FURNITURE
 use LOUNGE
 Merit badge PERSONAL SYMBOL
 use PATCH, MERIT-BADGE
 Merry-go-round. RECREATIONAL DEVICE
 use CARROUSEL
METAL FRAGMENT ARTIFACT REMNANT 227
METATE FOOD PROCESSING T&E. 63
METEOROGRAPH METEOROLOGICAL T&E 157
METEOROMETER METEOROLOGICAL T&E 157
METEOROSCOPE ASTRONOMICAL T&E 135
METER, AIR METEOROLOGICAL T&E 157
METER, ANGLE SURVEYING & NAVIGATIONAL T&E . . . 163
METER, LIGHT PHOTOGRAPHIC T&E 176
METER, PARKING REGULATIVE & PROTECTIVE T&E. . . . 161
METER, POSTAGE WRITTEN COMMUNICATION T&E. 184

- -

- -

```
MILL, NUT. . . . . . . . . . . . . . . FOOD PROCESSING T&E. . . . . . . .   63
MILL, PEPPER . . . . . . . . . . . . . FOOD SERVICE T&E . . . . . . . . .   73
MILL, PUG. . . . . . . . . . . . . . . GLASS, PLASTICS, CLAYWORKING T&E .   80
 Mill, Quartz. . . . . . . . . . . . . MINING & MINERAL HARVESTING T&E
   use  MILL, STAMP
MILL, RAIL . . . . . . . . . . . . . . METALWORKING T&E . . . . . . . . .   93
MILL, ROLLER . . . . . . . . . . . . . FOOD PROCESSING T&E. . . . . . . .   63
MILL, ROLLER . . . . . . . . . . . . . PAINTING T&E . . . . . . . . . . .  103
MILL, ROLLING. . . . . . . . . . . . . METALWORKING T&E . . . . . . . . .   93
MILL, SAMPLING . . . . . . . . . . . . METALWORKING T&E . . . . . . . . .   93
MILL, SLITTING . . . . . . . . . . . . METALWORKING T&E . . . . . . . . .   93
MILL, SPICE. . . . . . . . . . . . . . FOOD PROCESSING T&E. . . . . . . .   63
MILL, STAMP. . . . . . . . . . . . . . MINING & MINERAL HARVESTING T&E. .  100
MILL, STAMPING . . . . . . . . . . . . METALWORKING T&E . . . . . . . . .   93
 Mill, Steel . . . . . . . . . . . . . MINING & MINERAL HARVESTING T&E
   use  MILL, FLINT
 Mill, Stone . . . . . . . . . . . . . FOOD PROCESSING T&E
   use  MILL, BUHR
MILL, TUBE . . . . . . . . . . . . . . METALWORKING T&E . . . . . . . . .   93
 Mill, Winnowing . . . . . . . . . . . AGRICULTURAL T&E
   use  MILL, FANNING
MILL, WIRE . . . . . . . . . . . . . . METALWORKING T&E . . . . . . . . .   93
MILLBRACE. . . . . . . . . . . . . . . MINING & MINERAL HARVESTING T&E. .  100
 Mimeograph. . . . . . . . . . . . . . PRINTING T&E
   use  DUPLICATOR
MINE . . . . . . . . . . . . . . . . . OTHER STRUCTURE. . . . . . . . . .    8
MINELAYER. . . . . . . . . . . . . . . WATER TRANSPORTATION -- EQUIPMENT.  199
MINER, CONTINUOUS. . . . . . . . . . . MINING & MINERAL HARVESTING T&E. .  100
 Miner, Mechanical . . . . . . . . . . MINING & MINERAL HARVESTING T&E
   use  MINER, CONTINUOUS
MINESWEEPER. . . . . . . . . . . . . . WATER TRANSPORTATION -- EQUIPMENT.  199
MINICOMPUTER . . . . . . . . . . . . . DATA PROCESSING T&E. . . . . . . .  169
 Minieball . . . . . . . . . . . . . . ARMAMENT -- AMMUNITION
   use  BULLET, MINIE
MINION . . . . . . . . . . . . . . . . ARMAMENT -- ARTILLERY. . . . . . .  128
MIRROR . . . . . . . . . . . . . . . . FURNITURE. . . . . . . . . . . . .   13
MIRROR . . . . . . . . . . . . . . . . ASTRONOMICAL T&E . . . . . . . . .  135
MIRROR, CHEVAL . . . . . . . . . . . . FURNITURE. . . . . . . . . . . . .   13
MIRROR, CLOUD. . . . . . . . . . . . . METEOROLOGICAL T&E . . . . . . . .  157
MIRROR, DRESSER. . . . . . . . . . . . FURNITURE. . . . . . . . . . . . .   13
MIRROR, EYE-OBSERVATION. . . . . . . . MEDICAL & PSYCHOLOGICAL T&E. . . .  152
 Mirror, Girandole . . . . . . . . . . FURNITURE
   use  MIRROR, WALL
MIRROR, HAND . . . . . . . . . . . . . TOILET ARTICLE . . . . . . . . . .   39
 Mirror, Mantel. . . . . . . . . . . . FURNITURE
   use  MIRROR, WALL
MIRROR, ORAL-EXAMINING . . . . . . . . MEDICAL & PSYCHOLOGICAL T&E. . . .  152
 Mirror, Tabernacle. . . . . . . . . . FURNITURE
   use  MIRROR, WALL
MIRROR, WALL . . . . . . . . . . . . . FURNITURE. . . . . . . . . . . . .   13
```

- -

- -

Mold, Border FOOD PROCESSING T&E
 use MOLD, RING
MOLD, BRICK MASONRY & STONEWORKING T&E 87
MOLD, BULLET ARMAMENT -- ACCESSORY 132
MOLD, BUTTER FOOD PROCESSING T&E 63
MOLD, CAKE FOOD PROCESSING T&E 63
MOLD, CANDLE GLASS, PLASTICS, CLAYWORKING T&E . 80
MOLD, CANDY FOOD PROCESSING T&E 63
MOLD, CASTING METALWORKING T&E 93
MOLD, CHEESE FOOD PROCESSING T&E 63
Mold, Chocolate FOOD PROCESSING T&E
 use MOLD, CANDY
MOLD, CIGAR CIGAR MAKING T&E 122
MOLD, COOKIE FOOD PROCESSING T&E 63
MOLD, DENTAL-CASTING MEDICAL & PSYCHOLOGICAL T&E 152
MOLD, DOLL GLASS, PLASTICS, CLAYWORKING T&E . 80
MOLD, DOLL HEAD GLASS, PLASTICS, CLAYWORKING T&E . 80
MOLD, FUZE ARMAMENT -- ACCESSORY 132
MOLD, GELATIN FOOD PROCESSING T&E 63
MOLD, GLASS GLASS, PLASTICS, CLAYWORKING T&E . 80
MOLD, HAT TEXTILEWORKING T&E 109
MOLD, ICE-CREAM FOOD PROCESSING T&E 63
MOLD, JELLY FOOD PROCESSING T&E 63
MOLD, PAPERMAKING PAPERMAKING T&E 104
MOLD, PIECE GLASS, PLASTICS, CLAYWORKING T&E . 80
MOLD, PLATE GLASS, PLASTICS, CLAYWORKING T&E . 80
MOLD, PORTFIRE ARMAMENT -- ACCESSORY 132
MOLD, PUDDING FOOD PROCESSING T&E 63
MOLD, RING FOOD PROCESSING T&E 64
MOLD, ROCKET ARMAMENT -- ACCESSORY 132
Mold, Springerle FOOD PROCESSING T&E
 use MOLD, COOKIE
MOLD, SUPPOSITORY MEDICAL & PSYCHOLOGICAL T&E 152
MOLD, TOY GLASS, PLASTICS, CLAYWORKING T&E . 80
MOLD, WAD ARMAMENT -- ACCESSORY 132
Money, Paper EXCHANGE MEDIUM
 use CURRENCY
MONEYCHANGER MERCHANDISING T&E 156
MONITOR, HYDRAULIC MINING & MINERAL HARVESTING T&E . . 101
MONOCLE PERSONAL GEAR 37
MONOGRAM CLOTHING -- ACCESSORY 34
MONOGRAPH DOCUMENTARY ARTIFACT 212
MONSTRANCE CEREMONIAL ARTIFACT 208
MONTAGE ART 205
MONTERA CLOTHING -- HEADWEAR 28
MONUMENT BUILDING 2
 rt SHRINE
MONUMENT CEREMONIAL ARTIFACT 208
MOP . MAINTENANCE T&E 146
MORION ARMAMENT -- BODY ARMOR 130

- -

MORTAR FOOD PROCESSING T&E. 64
MORTAR CHEMICAL T&E 139
MORTAR ARMAMENT -- ARTILLERY. 128
MORTAR MEDICAL & PSYCHOLOGICAL T&E. . . . 152
 Mortar, Samp. FOOD PROCESSING T&E
 use MORTAR, STAMP
MORTAR, STAMP. FOOD PROCESSING T&E. 64
MORTARBOARD. PERSONAL SYMBOL. 216
MORTAR & PESTLE. FOOD PROCESSING T&E. 64
MORTAR & PESTLE. CHEMICAL T&E 139
MORTGAGE DOCUMENTARY ARTIFACT 212
MORTISER WOODWORKING T&E. 117
MOSAIC BUILDING COMPONENT 5
 Motor MINING & MINERAL HARVESTING T&E
 use LOCOMOTIVE, MINE
MOTOR, ELECTRIC. ENERGY PRODUCTION T&E. 144
MOTOR, ELECTRIC. TOY. 224
MOTOR, OUTBOARD. WATER TRANSPORTATION -- ACCESSORY. 202
 Motorbike LTE -- MOTORIZED
 use BICYCLE, GASOLINE
MOTORCYCLE LTE -- MOTORIZED 192
 Mould
 use MOLD
MOULDER. WOODWORKING T&E. 117
MOUND. OTHER STRUCTURE. 8
MOUNT, SIGHT ARMAMENT -- ACCESSORY. 132
MOUNT, SPECIMEN. BIOLOGICAL T&E 137
MOUSE. DATA PROCESSING T&E. 169
MOUSETRAP. HOUSEHOLD ACCESSORY. 17
MOUTHPIECE MUSICAL T&E. 174
MOUTHPIECE, SALIVA-EJECTOR MEDICAL & PSYCHOLOGICAL T&E. . . . 152
MOWER. AGRICULTURAL T&E 47
MOWER, GANG-REEL AGRICULTURAL T&E 47
MOWER, HORSE-DRAWN AGRICULTURAL T&E 47
MOWER, LAWN. AGRICULTURAL T&E 47
 Mower, Semimounted. AGRICULTURAL T&E
 use MOWER
 Mower, Tractor-drawn. AGRICULTURAL T&E
 use MOWER or MOWER, GANG-REEL
 Mower, Tractor-mounted. AGRICULTURAL T&E
 use MOWER
MOWER/CONDITIONER. AGRICULTURAL T&E 47
 rt CONDITIONER, HAY
MUFF CLOTHING -- ACCESSORY. 34
 Muffineer FOOD SERVICE T&E
 use SHAKER, SUGAR
MUFFLER. CLOTHING -- ACCESSORY. 34
 rt SCARF, NECK
MUG. FOOD SERVICE T&E 73
MUG. HOUSEHOLD ACCESSORY. 17

- -

- -

- -

```
NEWSPAPER. . . . . . . . . . . . . . . . DOCUMENTARY ARTIFACT . . . . . . .   212
NICKELODEON. . . . . . . . . . . . . . . SOUND COMMUNICATION T&E. . . . . .   181
  rt  JUKEBOX
NIDDY NODDY. . . . . . . . . . . . . . . TEXTILEWORKING T&E . . . . . . . .   109
NIGHTCAP . . . . . . . . . . . . . . . . CLOTHING -- HEADWEAR . . . . . .      28
NIGHTGOWN. . . . . . . . . . . . . . . . CLOTHING -- OUTERWEAR. . . . . . .    30
  Nightshirt. . . . . . . . . . . . . . CLOTHING -- OUTERWEAR
  use  NIGHTGOWN
  Nightstand. . . . . . . . . . . . . . FURNITURE
  use  TABLE, NIGHT
NIGHTSTICK . . . . . . . . . . . . . . . REGULATIVE & PROTECTIVE T&E. . . .   161
NINEPINS . . . . . . . . . . . . . . . . GAME . . . . . . . . . . . . . . .   218
NIPPERS. . . . . . . . . . . . . . . . . LEATHER, HORN, SHELLWORKING T&E. .    84
NIPPERS, BAND. . . . . . . . . . . . . . PRINTING T&E . . . . . . . . . . .   179
  Nippers, Hoof . . . . . . . . . . . . ANIMAL HUSBANDRY T&E
  use  PARER, HOOF
NIPPERS, NAIL. . . . . . . . . . . . . . ANIMAL HUSBANDRY T&E . . . . . . .    54
  note use for tool to cut the toe nails of small animals
NIPPERS, NAIL. . . . . . . . . . . . . . METALWORKING T&E . . . . . . . . .    93
NIPPERS, PULLING . . . . . . . . . . . . METALWORKING T&E . . . . . . . . .    93
NIPPERS, SHEET . . . . . . . . . . . . . METALWORKING T&E . . . . . . . . .    93
  Nippers, Sugar. . . . . . . . . . . . FOOD PROCESSING T&E
  use  CUTTER, SUGAR
NIPPERS, TILE. . . . . . . . . . . . . . MASONRY & STONEWORKING T&E . . . .    87
NIPPLE, NURSING. . . . . . . . . . . . . ANIMAL HUSBANDRY T&E . . . . . . .    54
NITROMETER . . . . . . . . . . . . . . . CHEMICAL T&E . . . . . . . . . . .   139
  Nocturnal . . . . . . . . . . . . . . SURVEYING & NAVIGATIONAL T&E
  use  ASTROLABE, MARINER'S
NOISEMAKER . . . . . . . . . . . . . . . TOY. . . . . . . . . . . . . . . .   224
NOOSE, HANGMAN'S . . . . . . . . . . . . REGULATIVE & PROTECTIVE T&E. . . .   161
  Nosebag . . . . . . . . . . . . . . . ANIMAL HUSBANDRY T&E
  use  FEEDBAG
NOTCHER, EAR . . . . . . . . . . . . . . ANIMAL HUSBANDRY T&E . . . . . . .    54
NOTEBOOK . . . . . . . . . . . . . . . . DOCUMENTARY ARTIFACT . . . . . . .   212
NOTEBOOK . . . . . . . . . . . . . . . . WRITTEN COMMUNICATION T&E. . . . .   184
  note unused. If used, may be DOCUMENTARY ARTIFACT
NOTECARD . . . . . . . . . . . . . . . . DOCUMENTARY ARTIFACT . . . . . . .   212
  Notice. . . . . . . . . . . . . . . . DOCUMENTARY ARTIFACT
  use  ANNOUNCEMENT
NOVELTY. . . . . . . . . . . . . . . . . ADVERTISING MEDIUM . . . . . . . .   204
NUT. . . . . . . . . . . . . . . . . . . METALWORKING T&E . . . . . . . . .    93
NUT. . . . . . . . . . . . . . . . . . . WOODWORKING T&E. . . . . . . . . .   117
NUTCRACKER . . . . . . . . . . . . . . . FOOD PROCESSING T&E. . . . . . . .    64
NUTCRACKER . . . . . . . . . . . . . . . FOOD SERVICE T&E . . . . . . . . .    73
NUTPICK. . . . . . . . . . . . . . . . . FOOD SERVICE T&E . . . . . . . . .    73
  Nylon . . . . . . . . . . . . . . . . CLOTHING -- FOOTWEAR
  use  STOCKING
OAR. . . . . . . . . . . . . . . . . . . WATER TRANSPORTATION -- ACCESSORY.  202
  rt  SWEEP
OAR, SCULLING. . . . . . . . . . . . . . WATER TRANSPORTATION -- ACCESSORY.  202
  rt  YULOH
```

- -

```
OAR, STEERING. . . . . . . . . . . . . . . WATER TRANSPORTATION -- ACCESSORY.  202
OARLOCK. . . . . . . . . . . . . . . . . . WATER TRANSPORTATION -- ACCESSORY.  202
  Obelisk . . . . . . . . . . . . . . . . . CEREMONIAL ARTIFACT
    use  MONUMENT
  Obi . . . . . . . . . . . . . . . . . . . CLOTHING -- ACCESSORY
    use  SASH
OBOE . . . . . . . . . . . . . . . . . . . MUSICAL T&E. . . . . . . . . . . .  174
OBOE D'AMORE . . . . . . . . . . . . . . . MUSICAL T&E. . . . . . . . . . . .  174
OBSERVATORY, ORBITING SOLAR. . . . . . AEROSPACE -- EQUIPMENT . . . . . .  187
    rt  SATELLITE
OCARINA. . . . . . . . . . . . . . . . . . MUSICAL T&E. . . . . . . . . . . .  174
OCTANT . . . . . . . . . . . . . . . . . . SURVEYING & NAVIGATIONAL T&E . . .  163
    rt  CIRCUMFERENTOR; SEXTANT
OCTAVIN. . . . . . . . . . . . . . . . . . MUSICAL T&E. . . . . . . . . . . .  174
  Odometer. . . . . . . . . . . . . . . . . SURVEYING & NAVIGATIONAL T&E
    use  WHEEL, SURVEYOR'S
ODONTOGRAPH. . . . . . . . . . . . . . . . DRAFTING T&E . . . . . . . . . .  171
OENOMETER. . . . . . . . . . . . . . . . . FOOD PROCESSING T&E. . . . . . . .  64
OFFICE, POST . . . . . . . . . . . . . . . BUILDING . . . . . . . . . . . . .  2
OILCAN . . . . . . . . . . . . . . . . . . METALWORKING T&E . . . . . . . . .  93
OILSKIN. . . . . . . . . . . . . . . . . . CLOTHING -- OUTERWEAR. . . . . . .  30
    rt  RAINCOAT; SLICKER
  Oilstone. . . . . . . . . . . . . . . . . METALWORKING T&E
    use  WHETSTONE
OJIME. . . . . . . . . . . . . . . . . . . PERSONAL GEAR. . . . . . . . . . .  37
  Okimono . . . . . . . . . . . . . . . . . ART
    use  FIGURINE
  Oleometer . . . . . . . . . . . . . . . . MECHANICAL T&E
    use  HYDROMETER
  Olla. . . . . . . . . . . . . . . . . . . FOOD PROCESSING T&E
    use  JAR, FOOD-STORAGE
OMBROMETER . . . . . . . . . . . . . . . . METEOROLOGICAL T&E . . . . . . . .  157
OMNIBUS. . . . . . . . . . . . . . . . . . LTE -- ANIMAL-POWERED. . . . . . .  190
  Omnimeter . . . . . . . . . . . . . . . . SURVEYING & NAVIGATIONAL T&E
    use  THEODOLITE
ONCOMETER. . . . . . . . . . . . . . . . . MEDICAL & PSYCHOLOGICAL T&E. . . .  152
  Oomiak. . . . . . . . . . . . . . . . . . WATER TRANSPORTATION -- EQUIPMENT
    use  UMIAK
OPACIMETER . . . . . . . . . . . . . . . . PAPERMAKING T&E. . . . . . . . . .  104
OPEIDOSCOPE. . . . . . . . . . . . . . . . ACOUSTICAL T&E . . . . . . . . . .  123
OPENER, BOTTLE . . . . . . . . . . . . . . FOOD PROCESSING T&E. . . . . . . .  64
OPENER, CAN. . . . . . . . . . . . . . . . FOOD PROCESSING T&E. . . . . . . .  64
OPENER, FID-LEAD . . . . . . . . . . . . . GLASS, PLASTICS, CLAYWORKING T&E .  80
OPENER, JAR. . . . . . . . . . . . . . . . FOOD PROCESSING T&E. . . . . . . .  64
  Opener, Letter. . . . . . . . . . . . . . WRITTEN COMMUNICATION T&E
    use  KNIFE, PAPER
  Opener-picker . . . . . . . . . . . . . . TEXTILEWORKING T&E
    use  PICKER
OPERAMETER . . . . . . . . . . . . . . . . MECHANICAL T&E . . . . . . . . . .  147
OPHICLEIDE . . . . . . . . . . . . . . . . MUSICAL T&E. . . . . . . . . . . .  174
```

- -

```
OPHTHALMOMETER . . . . . . . . . . . . MEDICAL & PSYCHOLOGICAL T&E. . . . 152
OPHTHALMOSCOPE . . . . . . . . . . . . MEDICAL & PSYCHOLOGICAL T&E. . . . 152
OPISOMETER . . . . . . . . . . . . . . SURVEYING & NAVIGATIONAL T&E . . . 163
  Opsiometer. . . . . . . . . . . . . . MEDICAL & PSYCHOLOGICAL T&E
   use  OPTOMETER
OPTOMETER. . . . . . . . . . . . . . . MEDICAL & PSYCHOLOGICAL T&E. . . . 152
ORB. . . . . . . . . . . . . . . . . . PERSONAL SYMBOL. . . . . . . . . . 216
ORCHESTRION. . . . . . . . . . . . . . MUSICAL T&E. . . . . . . . . . . . 174
ORDER, MONEY . . . . . . . . . . . . . EXCHANGE MEDIUM. . . . . . . . . . 214
ORDERS, MILITARY . . . . . . . . . . . DOCUMENTARY ARTIFACT . . . . . . . 212
  Ordinary. . . . . . . . . . . . . . . LTE -- HUMAN-POWERED
   use  BICYCLE, ORDINARY
ORGAN, ELECTRONIC. . . . . . . . . . . MUSICAL T&E. . . . . . . . . . . . 174
ORGAN, LABORATORY. . . . . . . . . . . ACOUSTICAL T&E . . . . . . . . . . 123
ORGAN, PIPE. . . . . . . . . . . . . . MUSICAL T&E. . . . . . . . . . . . 174
ORGAN, REED. . . . . . . . . . . . . . MUSICAL T&E. . . . . . . . . . . . 174
ORGANETTE. . . . . . . . . . . . . . . MUSICAL T&E. . . . . . . . . . . . 174
ORIENTATOR . . . . . . . . . . . . . . SURVEYING & NAVIGATIONAL T&E . . . 163
ORLE . . . . . . . . . . . . . . . . . CLOTHING -- HEADWEAR . . . . . . . 28
ORNAMENT, BRIDLE . . . . . . . . . . . LTE -- ACCESSORY . . . . . . . . . 195
ORNAMENT, CEILING. . . . . . . . . . . BUILDING COMPONENT . . . . . . . . 5
ORNAMENT, CHRISTMAS TREE . . . . . . . ART. . . . . . . . . . . . . . . . 205
ORNAMENT, GARDEN . . . . . . . . . . . ART. . . . . . . . . . . . . . . . 205
ORNAMENT, HAIR . . . . . . . . . . . . ADORNMENT. . . . . . . . . . . . . 24
ORNAMENT, MASTHEAD . . . . . . . . . . WATER TRANSPORTATION -- ACCESSORY. 202
  Ornament, Package . . . . . . . . . . CEREMONIAL ARTIFACT
   use  WRAP, GIFT
ORNAMENT, PILOT-HOUSE. . . . . . . . . WATER TRANSPORTATION -- ACCESSORY. 202
ORNAMENT, SHOE . . . . . . . . . . . . CLOTHING -- ACCESSORY. . . . . . . 34
ORNAMENT, YACHT. . . . . . . . . . . . WATER TRANSPORTATION -- ACCESSORY. 202
ORNITHOPTER. . . . . . . . . . . . . . AEROSPACE -- EQUIPMENT . . . . . . 187
OROGRAPH . . . . . . . . . . . . . . . SURVEYING & NAVIGATIONAL T&E . . . 163
ORRERY . . . . . . . . . . . . . . . . ASTRONOMICAL T&E . . . . . . . . . 135
ORTHOSCANNER . . . . . . . . . . . . . DATA PROCESSING T&E. . . . . . . . 169
   rt  READER, CHARACTER
ORTHOSCOPE . . . . . . . . . . . . . . MEDICAL & PSYCHOLOGICAL T&E. . . . 152
OSCILLATOR . . . . . . . . . . . . . . ELECTRICAL & MAGNETIC T&E. . . . . 142
OSCILLOGRAPH . . . . . . . . . . . . . ELECTRICAL & MAGNETIC T&E. . . . . 142
OSCILLOMETER . . . . . . . . . . . . . SURVEYING & NAVIGATIONAL T&E . . . 163
OSCILLOSCOPE . . . . . . . . . . . . . ELECTRICAL & MAGNETIC T&E. . . . . 142
OSMOMETER. . . . . . . . . . . . . . . CHEMICAL T&E . . . . . . . . . . . 139
OSMOSCOPE. . . . . . . . . . . . . . . BIOLOGICAL T&E . . . . . . . . . . 137
OSTEOPHONE . . . . . . . . . . . . . . MEDICAL & PSYCHOLOGICAL T&E. . . . 152
OTACOUSTIC . . . . . . . . . . . . . . MEDICAL & PSYCHOLOGICAL T&E. . . . 153
OTHEOSCOPE . . . . . . . . . . . . . . OPTICAL T&E. . . . . . . . . . . . 159
OTOSCOPE . . . . . . . . . . . . . . . MEDICAL & PSYCHOLOGICAL T&E. . . . 153
OTTOMAN. . . . . . . . . . . . . . . . FURNITURE. . . . . . . . . . . . . 13
   rt  HASSOCK; FOOTSTOOL
OUTHOUSE . . . . . . . . . . . . . . . BUILDING . . . . . . . . . . . . . 2
OVEN, BEEHIVE. . . . . . . . . . . . . SITE FEATURE . . . . . . . . . . . 7
```

```
- - - - - - - - - - - - - - - - - - - - - - - - - - - - - - - - - - - - - -
OVEN, COKE . . . . . . . . . . . . . . METALWORKING T&E . . . . . . . . .  93
OVEN, CURING . . . . . . . . . . . . . GLASS, PLASTICS, CLAYWORKING T&E .  80
 Oven, Dutch . . . . . . . . . . . . . FOOD PROCESSING T&E
   use  PAN, ROASTING
OVEN, ELECTRIC . . . . . . . . . . . . FOOD PROCESSING T&E. . . . . . . .  64
OVEN, MICROWAVE. . . . . . . . . . . . FOOD PROCESSING T&E. . . . . . . .  64
OVEN, REFLECTOR. . . . . . . . . . . . FOOD PROCESSING T&E. . . . . . . .  64
OVEN, WARMING. . . . . . . . . . . . . FOOD PROCESSING T&E. . . . . . . .  64
OVERCOAT . . . . . . . . . . . . . . . CLOTHING -- OUTERWEAR. . . . . . .  30
OVERDRESS. . . . . . . . . . . . . . . CLOTHING -- OUTERWEAR. . . . . . .  30
OVERMANTEL . . . . . . . . . . . . . . BUILDING COMPONENT . . . . . . . .   5
 Overshoe. . . . . . . . . . . . . . . CLOTHING -- FOOTWEAR
   use  BOOT or GALOSH or RUBBER
OVERSKIRT. . . . . . . . . . . . . . . CLOTHING -- OUTERWEAR. . . . . . .  30
 Oversleeve. . . . . . . . . . . . . . CLOTHING -- ACCESSORY
   use  SLEEVE
 Oxbow . . . . . . . . . . . . . . . . LTE -- ACCESSORY
   use  YOKE, ANIMAL
OXCART . . . . . . . . . . . . . . . . LTE -- ANIMAL-POWERED. . . . . . . 190
OXSHOE . . . . . . . . . . . . . . . . ANIMAL HUSBANDRY T&E . . . . . . .  54
OZONOMETER . . . . . . . . . . . . . . METEOROLOGICAL T&E . . . . . . . . 157
PAC. . . . . . . . . . . . . . . . . . CLOTHING -- FOOTWEAR . . . . . . .  26
PACEMAKER. . . . . . . . . . . . . . . MEDICAL & PSYCHOLOGICAL T&E. . . . 153
PACHISI. . . . . . . . . . . . . . . . GAME . . . . . . . . . . . . . . . 218
PACHYMETER . . . . . . . . . . . . . . WEIGHTS & MEASURES T&E . . . . . . 166
PACIFIER . . . . . . . . . . . . . . . PERSONAL GEAR. . . . . . . . . . .  37
PACIFIER . . . . . . . . . . . . . . . TOY. . . . . . . . . . . . . . . . 224
PACK . . . . . . . . . . . . . . . . . MERCHANDISING T&E. . . . . . . . . 156
PACKER, BARREL . . . . . . . . . . . . FOOD PROCESSING T&E. . . . . . . .  64
 Packer, Bran. . . . . . . . . . . . . FOOD PROCESSING T&E
   use  PACKER, BARREL
PACKER, BUTTER . . . . . . . . . . . . FOOD PROCESSING T&E. . . . . . . .  64
 Packer, Feed. . . . . . . . . . . . . FOOD PROCESSING T&E
   use  PACKER, BARREL
 Packer, Flour . . . . . . . . . . . . FOOD PROCESSING T&E
   use  PACKER, BARREL
 Packer, Surface . . . . . . . . . . . AGRICULTURAL T&E
   use  ROLLER, LAND
PACKET . . . . . . . . . . . . . . . . MERCHANDISING T&E. . . . . . . . . 156
PACKET . . . . . . . . . . . . . . . . WATER TRANSPORTATION -- EQUIPMENT. 199
PACKET, SEED . . . . . . . . . . . . . AGRICULTURAL T&E . . . . . . . . .  47
PAD. . . . . . . . . . . . . . . . . . WRITTEN COMMUNICATION T&E. . . . . 184
PAD, BUCKLE. . . . . . . . . . . . . . LTE -- ACCESSORY . . . . . . . . . 195
PAD, CARPET. . . . . . . . . . . . . . FLOOR COVERING . . . . . . . . . .  10
PAD, COLLAR. . . . . . . . . . . . . . LTE -- ACCESSORY . . . . . . . . . 195
PAD, HORSESHOE . . . . . . . . . . . . ANIMAL HUSBANDRY T&E . . . . . . .  54
PAD, HOT . . . . . . . . . . . . . . . FOOD SERVICE T&E . . . . . . . . .  74
PAD, LEGAL . . . . . . . . . . . . . . WRITTEN COMMUNICATION T&E. . . . . 184
PAD, SADDLE. . . . . . . . . . . . . . LTE -- ACCESSORY . . . . . . . . . 195
PAD, SKETCH. . . . . . . . . . . . . . PAINTING T&E . . . . . . . . . . . 103
```

- -

```
PAD, STOVE . . . . . . . . . . . . . . . FOOD PROCESSING T&E. . . . . . . .   64
PAD, TABLE . . . . . . . . . . . . . . . FOOD SERVICE T&E . . . . . . . . .   74
PAD, WRITING . . . . . . . . . . . . . . WRITTEN COMMUNICATION T&E. . . . .  184
PADDLE . . . . . . . . . . . . . . . . . GLASS, PLASTICS, CLAYWORKING T&E .   80
PADDLE . . . . . . . . . . . . . . . . . FOOD PROCESSING T&E. . . . . . . .   64
PADDLE . . . . . . . . . . . . . . . . . REGULATIVE & PROTECTIVE T&E. . . .  161
PADDLE . . . . . . . . . . . . . . . . . WATER TRANSPORTATION -- ACCESSORY. 202
PADDLE, APPLE BUTTER . . . . . . . . . . FOOD PROCESSING T&E. . . . . . . .   64
  Paddle, Butter. . . . . . . . . . . . . FOOD PROCESSING T&E
    use  SPADE, BUTTER-WORKING
PADDLE, CANOE. . . . . . . . . . . . . . WATER TRANSPORTATION -- ACCESSORY. 202
PADDLE, CROUPIER'S . . . . . . . . . . . GAME . . . . . . . . . . . . . . .  218
PADDLE, DOUBLE-BLADED. . . . . . . . . . WATER TRANSPORTATION -- ACCESSORY. 202
PADDLE, FRATERNAL. . . . . . . . . . . . PERSONAL SYMBOL. . . . . . . . . .  216
  Paddle, Ping pong . . . . . . . . . . . SPORTS EQUIPMENT
    use  PADDLE, TABLE TENNIS
PADDLE, TABLE TENNIS . . . . . . . . . . SPORTS EQUIPMENT . . . . . . . . .  221
PADDLE, TENNIS . . . . . . . . . . . . . SPORTS EQUIPMENT . . . . . . . . .  221
PADDOCK. . . . . . . . . . . . . . . . . SITE FEATURE . . . . . . . . . . .    7
PADLOCK. . . . . . . . . . . . . . . . . HOUSEHOLD ACCESSORY. . . . . . . .   17
PADLOCK. . . . . . . . . . . . . . . . . REGULATIVE & PROTECTIVE T&E. . . .  161
PADS, HIP. . . . . . . . . . . . . . . . SPORTS EQUIPMENT . . . . . . . . .  221
PADS, SHOULDER . . . . . . . . . . . . . SPORTS EQUIPMENT . . . . . . . . .  221
  Pagoda. . . . . . . . . . . . . . . . . BUILDING
    use  TEMPLE
PAGOSCOPE. . . . . . . . . . . . . . . . METEOROLOGICAL T&E . . . . . . . .  157
PAIL . . . . . . . . . . . . . . . . . . MAINTENANCE T&E. . . . . . . . . .  146
PAIL, DINNER . . . . . . . . . . . . . . FOOD SERVICE T&E . . . . . . . . .   74
  rt   BOX, LUNCH
PAIL, MILKING. . . . . . . . . . . . . . FOOD PROCESSING T&E. . . . . . . .   64
PAIL & WRINGER . . . . . . . . . . . . . MAINTENANCE T&E. . . . . . . . . .  146
PAINT. . . . . . . . . . . . . . . . . . PAINTING T&E . . . . . . . . . . .  103
PAINTING . . . . . . . . . . . . . . . . ART. . . . . . . . . . . . . . . .  205
PAJAMAS. . . . . . . . . . . . . . . . . CLOTHING -- OUTERWEAR. . . . . . .   30
PALANQUIN. . . . . . . . . . . . . . . . LTE -- HUMAN-POWERED . . . . . . .  191
PALETTE. . . . . . . . . . . . . . . . . PAINTING T&E . . . . . . . . . . .  103
PALINURUS. . . . . . . . . . . . . . . . SURVEYING & NAVIGATIONAL T&E . . .  163
PALISADE . . . . . . . . . . . . . . . . OTHER STRUCTURE. . . . . . . . . .    8
PALL . . . . . . . . . . . . . . . . . . CEREMONIAL ARTIFACT. . . . . . . .  208
PALLET . . . . . . . . . . . . . . . . . PRINTING T&E . . . . . . . . . . .  179
PALM . . . . . . . . . . . . . . . . . . LEATHER, HORN, SHELLWORKING T&E. .   85
PALM, SAILMAKER'S. . . . . . . . . . . . TEXTILEWORKING T&E . . . . . . . .  109
  Paltock . . . . . . . . . . . . . . . . CLOTHING -- OUTERWEAR
    use  TUNIC
  Pamphlet. . . . . . . . . . . . . . . . DOCUMENTARY ARTIFACT
    use  BOOKLET
  Pan . . . . . . . . . . . . . . . . . . FOOD PROCESSING T&E
    use  SAUCEPAN
PAN, AMALGAMATING. . . . . . . . . . . . METALWORKING T&E . . . . . . . . .   93
PAN, BAKING. . . . . . . . . . . . . . . FOOD PROCESSING T&E. . . . . . . .   64
```

- -

```
PAN, BLOCKING. . . . . . . . . . . . . GLASS, PLASTICS, CLAYWORKING T&E .   80
PAN, BREAD . . . . . . . . . . . . . . FOOD PROCESSING T&E. . . . . . .      64
PAN, BREADSTICK. . . . . . . . . . . . FOOD PROCESSING T&E. . . . . . .      64
PAN, CAKE. . . . . . . . . . . . . . . FOOD PROCESSING T&E. . . . . . .      64
 Pan, Cornstick. . . . . . . . . . . . FOOD PROCESSING T&E
   use  PAN, BREADSTICK
PAN, CREPE . . . . . . . . . . . . . . FOOD PROCESSING T&E. . . . . . .      64
PAN, DOUCHE. . . . . . . . . . . . . . TOILET ARTICLE . . . . . . . . .      39
PAN, DRIP. . . . . . . . . . . . . . . GLASS, PLASTICS, CLAYWORKING T&E .   80
PAN, FRYING. . . . . . . . . . . . . . FOOD PROCESSING T&E. . . . . . .      64
   rt   SPIDER
 Pan, Gem. . . . . . . . . . . . . . . FOOD PROCESSING T&E
   use  PAN, MUFFIN
PAN, JELLY ROLL. . . . . . . . . . . . FOOD PROCESSING T&E. . . . . . .      64
PAN, MILK. . . . . . . . . . . . . . . FOOD PROCESSING T&E. . . . . . .      64
PAN, MINER'S . . . . . . . . . . . . . MINING & MINERAL HARVESTING T&E. .  101
PAN, MUFFIN. . . . . . . . . . . . . . FOOD PROCESSING T&E. . . . . . .      64
PAN, OMELET. . . . . . . . . . . . . . FOOD PROCESSING T&E. . . . . . .      64
PAN, PIE . . . . . . . . . . . . . . . FOOD PROCESSING T&E. . . . . . .      64
 Pan, Popover. . . . . . . . . . . . . FOOD PROCESSING T&E
   use  PAN, MUFFIN
PAN, PUDDING . . . . . . . . . . . . . FOOD PROCESSING T&E. . . . . . .      64
PAN, ROASTING. . . . . . . . . . . . . FOOD PROCESSING T&E. . . . . . .      64
 Pan, Roll . . . . . . . . . . . . . . FOOD PROCESSING T&E
   use  PAN, MUFFIN
PAN, SPRING-FORM . . . . . . . . . . . FOOD PROCESSING T&E. . . . . . .      64
PAN, STEW. . . . . . . . . . . . . . . FOOD PROCESSING T&E. . . . . . .      64
PAN, TUBE. . . . . . . . . . . . . . . FOOD PROCESSING T&E. . . . . . .      65
PANEL, SOLAR . . . . . . . . . . . . . ENERGY PRODUCTION T&E. . . . . .     144
PANNIER. . . . . . . . . . . . . . . . CLOTHING -- UNDERWEAR. . . . . .      32
PANNIER. . . . . . . . . . . . . . . . CLOTHING -- OUTERWEAR. . . . . .      30
PANNIER. . . . . . . . . . . . . . . . LTE -- ACCESSORY . . . . . . . .     195
PANORAMA . . . . . . . . . . . . . . . TOY. . . . . . . . . . . . . . .     224
PANPIPE. . . . . . . . . . . . . . . . MUSICAL T&E. . . . . . . . . . .     174
PANTALETTES. . . . . . . . . . . . . . CLOTHING -- UNDERWEAR. . . . . .      32
PANTALOONS . . . . . . . . . . . . . . CLOTHING -- UNDERWEAR. . . . . .      32
 Pantaloons. . . . . . . . . . . . . . CLOTHING -- OUTERWEAR
   use  PANTS
PANTIES. . . . . . . . . . . . . . . . CLOTHING -- UNDERWEAR. . . . . .      32
PANTILE. . . . . . . . . . . . . . . . BUILDING COMPONENT . . . . . . .       5
PANTOGRAPH . . . . . . . . . . . . . . DRAFTING T&E . . . . . . . . . .     171
PANTOMETER . . . . . . . . . . . . . . SURVEYING & NAVIGATIONAL T&E . . .   163
PANTS. . . . . . . . . . . . . . . . . CLOTHING -- OUTERWEAR. . . . . .      30
PANTS, BAZOOKA . . . . . . . . . . . . ARMAMENT -- ACCESSORY. . . . . .     132
PANTSUIT . . . . . . . . . . . . . . . CLOTHING -- OUTERWEAR. . . . . .      30
PANTYHOSE. . . . . . . . . . . . . . . CLOTHING -- UNDERWEAR. . . . . .      32
PANYOCHROMETER . . . . . . . . . . . . WEIGHTS & MEASURES T&E . . . . .     166
PAPER. . . . . . . . . . . . . . . . . WRITTEN COMMUNICATION T&E. . . .     184
PAPER, CONSTRUCTION. . . . . . . . . . TOY. . . . . . . . . . . . . . .     224
PAPER, FILTER. . . . . . . . . . . . . BIOLOGICAL T&E . . . . . . . . .     137
```

- -

```
Paper, Fly. . . . . . . . . . . . . . . HOUSEHOLD ACCESSORY
 use  FLYPAPER
PAPER, LETTERHEAD. . . . . . . . . . . WRITTEN COMMUNICATION T&E. . . . .  184
PAPER, LITMUS. . . . . . . . . . . . . CHEMICAL T&E . . . . . . . . . .   139
Paper, Music. . . . . . . . . . . . . . WRITTEN COMMUNICATION T&E
 use  PAPER, STAFF
PAPER, ORIGAMI . . . . . . . . . . . . TOY. . . . . . . . . . . . . . .   224
PAPER, PHOTOGRAPHIC. . . . . . . . . . PHOTOGRAPHIC T&E . . . . . . . .   176
PAPER, SHELF . . . . . . . . . . . . . MAINTENANCE T&E. . . . . . . . .   146
PAPER, STAFF . . . . . . . . . . . . . WRITTEN COMMUNICATION T&E. . . . .  184
 note use for paper ruled to accommodate the writing of music
PAPER, TYPING. . . . . . . . . . . . . WRITTEN COMMUNICATION T&E. . . . .  184
PAPER, WRAPPING. . . . . . . . . . . . MERCHANDISING T&E. . . . . . . .   156
 rt  WRAP, GIFT (CEREMONIAL ARTIFACT)
PAPER, WRITING . . . . . . . . . . . . WRITTEN COMMUNICATION T&E. . . . .  184
PAPERWEIGHT. . . . . . . . . . . . . . WRITTEN COMMUNICATION T&E. . . . .  184
PARACHUTE. . . . . . . . . . . . . . . AEROSPACE -- ACCESSORY . . . . .   188
PARACHUTE, CARGO . . . . . . . . . . . AEROSPACE -- ACCESSORY . . . . .   188
PARACHUTE, DROGUE. . . . . . . . . . . AEROSPACE -- ACCESSORY . . . . .   188
PARACHUTE, PERSONNEL . . . . . . . . . AEROSPACE -- ACCESSORY . . . . .   188
PARASOL. . . . . . . . . . . . . . . . PERSONAL GEAR. . . . . . . . . .    37
PARBUCKLE. . . . . . . . . . . . . . . FORESTRY T&E . . . . . . . . . .    78
PARDON . . . . . . . . . . . . . . . . DOCUMENTARY ARTIFACT . . . . . .   212
PARER, HOOF. . . . . . . . . . . . . . ANIMAL HUSBANDRY T&E . . . . . .    54
PARKA. . . . . . . . . . . . . . . . . CLOTHING -- OUTERWEAR. . . . . .    30
PARLOR, MILKING. . . . . . . . . . . . BUILDING . . . . . . . . . . . .     2
PARTISAN . . . . . . . . . . . . . . . ARMAMENT -- EDGED. . . . . . . .   126
PASS . . . . . . . . . . . . . . . . . EXCHANGE MEDIUM. . . . . . . . .   214
PASS . . . . . . . . . . . . . . . . . DOCUMENTARY ARTIFACT . . . . . .   212
 Passglas. . . . . . . . . . . . . . . FOOD SERVICE T&E
 use  BEAKER
 Passometer. . . . . . . . . . . . . . SPORTS EQUIPMENT
 use  PEDOMETER
PASSPORT . . . . . . . . . . . . . . . DOCUMENTARY ARTIFACT . . . . . .   212
PASTEURIZER, MILK. . . . . . . . . . . FOOD PROCESSING T&E. . . . . . .    65
PATCH. . . . . . . . . . . . . . . . . DATA PROCESSING T&E. . . . . . .   169
PATCH. . . . . . . . . . . . . . . . . PERSONAL SYMBOL. . . . . . . . .   216
PATCH, EYE . . . . . . . . . . . . . . MEDICAL & PSYCHOLOGICAL T&E. . . . 153
PATCH, FRATERNAL . . . . . . . . . . . PERSONAL SYMBOL. . . . . . . . .   216
PATCH, MERIT-BADGE . . . . . . . . . . PERSONAL SYMBOL. . . . . . . . .   216
PATCH, MILITARY. . . . . . . . . . . . PERSONAL SYMBOL. . . . . . . . .   216
PATEN. . . . . . . . . . . . . . . . . CEREMONIAL ARTIFACT. . . . . . .   208
PATENT . . . . . . . . . . . . . . . . DOCUMENTARY ARTIFACT . . . . . .   212
 Patten. . . . . . . . . . . . . . . . CLOTHING -- FOOTWEAR
 use  CLOG
PATTERN. . . . . . . . . . . . . . . . WOODWORKING T&E. . . . . . . . .   117
 rt  TEMPLATE
PATTERN. . . . . . . . . . . . . . . . TEXTILEWORKING T&E . . . . . . .   109
PATTERN, CASTING . . . . . . . . . . . METALWORKING T&E . . . . . . . .    93
PATTERN, EAR . . . . . . . . . . . . . ANIMAL HUSBANDRY T&E . . . . . .    54
```

- -

- -

```
PENCIL, STYPTIC. . . . . . . . . . . . TOILET ARTICLE . . . . . . . . . .    39
PENDANT. . . . . . . . . . . . . . . . ADORNMENT. . . . . . . . . . . .      24
PENDANT. . . . . . . . . . . . . . . . PERSONAL SYMBOL. . . . . . . . .     216
PENDANT,FRATERNAL. . . . . . . . . . . PERSONAL SYMBOL. . . . . . . . .     216
PENDANT, RELIGIOUS . . . . . . . . . . PERSONAL SYMBOL. . . . . . . . .     216
PENDULUM . . . . . . . . . . . . . . . MECHANICAL T&E . . . . . . . . .     147
PENDULUM, BALLISTIC. . . . . . . . . . ARMAMENT -- ACCESSORY. . . . . .     132
PENDULUM, SOUND. . . . . . . . . . . . ACOUSTICAL T&E . . . . . . . . .     123
PENETROMETER . . . . . . . . . . . . . CHEMICAL T&E . . . . . . . . . .     139
 Penknife. . . . . . . . . . . . . . . PERSONAL GEAR
   use  KNIFE, POCKET
PENNANT. . . . . . . . . . . . . . . . DOCUMENTARY ARTIFACT . . . . . .     212
PENNANT. . . . . . . . . . . . . . . . CEREMONIAL ARTIFACT. . . . . . .     208
 Pen Nib . . . . . . . . . . . . . . . WRITTEN COMMUNICATION T&E
   use  PEN
PENSTOCK . . . . . . . . . . . . . . . OTHER STRUCTURE. . . . . . . . .       8
 Pepperbox . . . . . . . . . . . . . . FOOD PROCESSING T&E
   use  SHAKER, PEPPER
PEPPERBOX. . . . . . . . . . . . . . . ARMAMENT -- FIREARM. . . . . . .     125
 Perambulator. . . . . . . . . . . . . SURVEYING & NAVIGATIONAL T&E
   use  WHEEL, SURVEYOR'S
 Perambulator. . . . . . . . . . . . . LTE -- HUMAN-POWERED
   use  CARRIAGE, BABY
 Perambulator, Doll. . . . . . . . . . TOY
   use  CARRIAGE, DOLL
 Percolator. . . . . . . . . . . . . . FOOD PROCESSING T&E
   use  MAKER, COFFEE
PERCOLATOR . . . . . . . . . . . . . . CHEMICAL T&E . . . . . . . . . .     139
PERFORATOR . . . . . . . . . . . . . . MEDICAL & PSYCHOLOGICAL T&E. . . .   153
PERFORATOR . . . . . . . . . . . . . . DATA PROCESSING T&E. . . . . . . .   169
PERFORATOR . . . . . . . . . . . . . . PRINTING T&E . . . . . . . . . .     179
PERGOLA. . . . . . . . . . . . . . . . BUILDING . . . . . . . . . . . .       2
PERIMETER. . . . . . . . . . . . . . . MEDICAL & PSYCHOLOGICAL T&E. . . .   153
PERIMETER, SOUND . . . . . . . . . . . ACOUSTICAL T&E . . . . . . . . .     123
PERISCOPE. . . . . . . . . . . . . . . OPTICAL T&E. . . . . . . . . . .     159
 Periwig . . . . . . . . . . . . . . . ADORNMENT
   use  WIG
PERMIT . . . . . . . . . . . . . . . . DOCUMENTARY ARTIFACT . . . . . .     212
PERRIER. . . . . . . . . . . . . . . . ARMAMENT -- ARTILLERY. . . . . .     128
PERSPECTOGRAPH . . . . . . . . . . . . DRAFTING T&E . . . . . . . . . .     171
PERSPECTOSCOPE . . . . . . . . . . . . MEDICAL & PSYCHOLOGICAL T&E. . . .   153
 Peruke. . . . . . . . . . . . . . . . ADORNMENT
   use  WIG
PESSARY. . . . . . . . . . . . . . . . MEDICAL & PSYCHOLOGICAL T&E. . . .   153
PESTLE . . . . . . . . . . . . . . . . FOOD PROCESSING T&E. . . . . . .      65
PESTLE . . . . . . . . . . . . . . . . CHEMICAL T&E . . . . . . . . . .     139
PESTLE . . . . . . . . . . . . . . . . MEDICAL & PSYCHOLOGICAL T&E. . . .   153
PESTLE, PAINT. . . . . . . . . . . . . PAINTING T&E . . . . . . . . . .     103
PETARD . . . . . . . . . . . . . . . . ARMAMENT -- AMMUNITION . . . . .     129
PETITION . . . . . . . . . . . . . . . DOCUMENTARY ARTIFACT . . . . . .     212
```

- -

PETRONEL ARMAMENT -- FIREARM. 125
 rt CARBINE
PETTICOAT. CLOTHING -- UNDERWEAR. 32
PEW. FURNITURE. 13
PHAETON. LTE -- ANIMAL-POWERED. 190
 rt BAROUCHE; BROUGHAM; CALECHE; CARRIAGE
PHANAROGRISONMETER MINING & MINERAL HARVESTING T&E. . 101
 Phantoscope TOY
 use KALEIDOSCOPE
PHENAKISTOSCOPE. MEDICAL & PSYCHOLOGICAL T&E. . . . 153
 Phial CONTAINER
 use VIAL
PHIALE CEREMONIAL ARTIFACT. 208
 rt BOWL, LIBATION
 Phone, Data DATA PROCESSING T&E
 use COUPLER
PHONEIDOSCOPE. OPTICAL T&E. 159
PHONELESCOPE ACOUSTICAL T&E 123
PHONODEIK. ACOUSTICAL T&E 123
PHONOGRAPH SOUND COMMUNICATION T&E. 181
PHONOMETER ACOUSTICAL T&E 123
PHONO-PROJECTOSCOPE. ACOUSTICAL T&E 123
PHONORGANON. ACOUSTICAL T&E 123
PHONOSCOPE ACOUSTICAL T&E 123
PHOSPHOROSCOPE CHEMICAL T&E 139
PHOTOCLINOMETER. MINING & MINERAL HARVESTING T&E. . 101
PHOTOCOPIER. PRINTING T&E 179
PHOTODROME OPTICAL T&E. 159
Photograph DOCUMENTARY ARTIFACT 212
 DAGUERREOTYPE; CARTE-DE-VISITE; PHOTOGRAPH, CABINET
 Photograph. DOCUMENTARY ARTIFACT
 use more specific term; e.g., PRINT, PHOTOGRAPHIC; TINTYPE;
PHOTOGRAPH, CABINET. DOCUMENTARY ARTIFACT 212
PHOTOHELIOGRAPH. ASTRONOMICAL T&E 135
PHOTOMETER OPTICAL T&E. 159
PHOTOMETER, PHOTOELECTRIC. ASTRONOMICAL T&E 135
PHOTOMETER, POLARIZING OPTICAL T&E. 159
PHOTOPHONE ACOUSTICAL T&E 123
PHOTOSYNTHOMETER BIOLOGICAL T&E 137
PHOTOTYPESETTER. PRINTING T&E 179
PHRENOGRAPH. MEDICAL & PSYCHOLOGICAL T&E. . . . 153
PIANO. MUSICAL T&E. 174
PIANO, BABY GRAND. MUSICAL T&E. 174
PIANO, BARREL. MUSICAL T&E. 174
PIANO, GRAND MUSICAL T&E. 174
PIANO, PLAYER. MUSICAL T&E. 174
 Piano, Reproducing. MUSICAL T&E
 use PIANO, PLAYER
PIANO, SQUARE. MUSICAL T&E. 174
PIANO, UPRIGHT MUSICAL T&E. 174

- -

```
PICCOLO. . . . . . . . . . . . . . . . . MUSICAL T&E. . . . . . . . . . . . 174
PICK . . . . . . . . . . . . . . . . . . MASONRY & STONEWORKING T&E . . . .  87
PICK . . . . . . . . . . . . . . . . . . MINING & MINERAL HARVESTING T&E. . 101
PICK . . . . . . . . . . . . . . . . . . MULTIPLE USE ARTIFACT. . . . . . . 228
PICK, COAL . . . . . . . . . . . . . . . TEMPERATURE CONTROL DEVICE . . . .  22
PICK, DOUBLE-POINTED . . . . . . . . . . MINING & MINERAL HARVESTING T&E. . 101
PICK, DRIFTING . . . . . . . . . . . . . MINING & MINERAL HARVESTING T&E. . 101
PICK, FLINTING . . . . . . . . . . . . . MASONRY & STONEWORKING T&E . . . .  87
 Pick, Holing. . . . . . . . . . . . . . MINING & MINERAL HARVESTING T&E
  use  PICK, UNDERCUTTING
PICK, HOOF . . . . . . . . . . . . . . . ANIMAL HUSBANDRY T&E . . . . . . .  54
PICK, ICE. . . . . . . . . . . . . . . . FOOD PROCESSING T&E. . . . . . . .  65
PICK, MASON'S. . . . . . . . . . . . . . MASONRY & STONEWORKING T&E . . . .  87
PICK, MILL . . . . . . . . . . . . . . . MASONRY & STONEWORKING T&E . . . .  87
PICK, PALEONTOLOGIST'S . . . . . . . . . GEOLOGICAL T&E . . . . . . . . . . 144
PICK, POLL . . . . . . . . . . . . . . . MINING & MINERAL HARVESTING T&E. . 101
PICK, UNDERCUTTING . . . . . . . . . . . MINING & MINERAL HARVESTING T&E. . 101
PICKAROON. . . . . . . . . . . . . . . . FORESTRY T&E . . . . . . . . . . .  78
PICKER . . . . . . . . . . . . . . . . . MINING & MINERAL HARVESTING T&E. . 101
PICKER . . . . . . . . . . . . . . . . . TEXTILEWORKING T&E . . . . . . . . 109
PICKER, CORN . . . . . . . . . . . . . . AGRICULTURAL T&E . . . . . . . . .  47
PICKER, COTTON . . . . . . . . . . . . . AGRICULTURAL T&E . . . . . . . . .  47
PICKER, FRUIT. . . . . . . . . . . . . . AGRICULTURAL T&E . . . . . . . . .  47
PICKER/HUSKER, CORN. . . . . . . . . . . AGRICULTURAL T&E . . . . . . . . .  47
PICKER/SHELLER, CORN . . . . . . . . . . AGRICULTURAL T&E . . . . . . . . .  47
 Pickup. . . . . . . . . . . . . . . . . LTE -- MOTORIZED
  use  TRUCK, PICKUP
 Pick up sticks. . . . . . . . . . . . . GAME
  use  JACKSTRAWS
PICTURE. . . . . . . . . . . . . . . . . ART. . . . . . . . . . . . . . . . 205
PICTURE, CUT-PAPER . . . . . . . . . . . ART. . . . . . . . . . . . . . . . 205
 Picture, Embroidery . . . . . . . . . . ART
  use  PICTURE, NEEDLEWORK
PICTURE, FLORA . . . . . . . . . . . . . ART. . . . . . . . . . . . . . . . 205
PICTURE, FRETWORK. . . . . . . . . . . . ART. . . . . . . . . . . . . . . . 206
PICTURE, HAIR. . . . . . . . . . . . . . ART. . . . . . . . . . . . . . . . 206
PICTURE, NEEDLEWORK. . . . . . . . . . . ART. . . . . . . . . . . . . . . . 206
PICTURE, SCRIMSHAW . . . . . . . . . . . ART. . . . . . . . . . . . . . . . 206
 Picture, Seed . . . . . . . . . . . . . ART
  use  PICTURE, FLORA
PICTURE, SHELL . . . . . . . . . . . . . ART. . . . . . . . . . . . . . . . 206
PICTURE, WOVEN . . . . . . . . . . . . . ART. . . . . . . . . . . . . . . . 206
PIECE, DISPLAY . . . . . . . . . . . . . ADVERTISING MEDIUM . . . . . . . . 204
PIECE, GAME. . . . . . . . . . . . . . . GAME . . . . . . . . . . . . . . . 218
   note use for a piece suitable for multiple games or if specific game is
        unidentified
PIER . . . . . . . . . . . . . . . . . . OTHER STRUCTURE. . . . . . . . . .   8
PIEZOMETER . . . . . . . . . . . . . . . MECHANICAL T&E . . . . . . . . . . 147
PIG. . . . . . . . . . . . . . . . . . . GLASS, PLASTICS, CLAYWORKING T&E .  80
 Piggin, Milking . . . . . . . . . . . . FOOD PROCESSING T&E
  use  PAIL, MILKING
```

- -

- -

PIN, STRAIGHT. TEXTILEWORKING T&E 109
PIN, TRUSS WATER TRANSPORTATION -- ACCESSORY. 202
PIN, WATCH PERSONAL GEAR. 37
PINAFORE CLOTHING -- OUTERWEAR. 31
PINBOARD DATA PROCESSING T&E. 169
 Pince-nez PERSONAL GEAR
 use EYEGLASSES
PINCERS. GLASS, PLASTICS, CLAYWORKING T&E . 80
PINCERS. WOODWORKING T&E. 117
PINCERS, FARRIER'S ANIMAL HUSBANDRY T&E 54
PINCERS, GUNNER'S. ARMAMENT -- ACCESSORY. 132
PINCERS, LASTING LEATHER, HORN, SHELLWORKING T&E. . 85
PINCERS, WIRE. METALWORKING T&E 93
PINCHBAR MULTIPLE USE ARTIFACT. 228
PINCUSHION TEXTILEWORKING T&E 109
PINK WATER TRANSPORTATION -- EQUIPMENT. 199
PINWHEEL TOY. 224
PIOSCOPE FOOD PROCESSING T&E. 65
PIPE PERSONAL GEAR. 37
PIPE BUILDING COMPONENT 5
 Pipe. MUSICAL T&E
 use BAGPIPE or FIFE or PANPIPE
PIPE, BOATSWAIN'S. SOUND COMMUNICATION T&E. 181
 Pipe, Bosun's SOUND COMMUNICATION T&E
 use PIPE, BOATSWAIN'S
PIPE, BUBBLE TOY. 224
PIPE, COUPLING METALWORKING T&E 93
PIPE, DRAUGHT. CHEMICAL T&E 139
 note use for funnel collecting gases over experiment table
PIPE, IRRIGATION AGRICULTURAL T&E 47
PIPE, OPIUM. PERSONAL GEAR. 37
 Pipe, Peace CEREMONIAL ARTIFACT
 use CALUMET
PIPE, PITCH. MUSICAL T&E. 174
PIPE, TABOR. MUSICAL T&E. 174
PIPE, WATER. BUILDING COMPONENT 5
PIPE, WHISTLE. TOY. 224
PIPETTE. CHEMICAL T&E 139
PIPETTE, ABSORPTION. CHEMICAL T&E 139
PIPETTE, INTRAUTERINE. ANIMAL HUSBANDRY T&E 54
PIPETTE, VOLUMETRIC. CHEMICAL T&E 140
 Pirogue WATER TRANSPORTATION -- EQUIPMENT
 use CANOE, DUGOUT
PISTOL ARMAMENT -- FIREARM. 125
 rt REVOLVER; DERRINGER
PISTOL, AUTOMATIC. ARMAMENT -- FIREARM. 125
PISTOL, BLANK. ARMAMENT -- FIREARM. 125
PISTOL, CAP. TOY. 224
PISTOL, DUELLING ARMAMENT -- FIREARM. 125
PISTOL, FIRE CRACKER TOY. 224

- -

```
Pistol, Machine . . . . . . . . . . ARMAMENT -- FIREARM
   use  GUN, SUBMACHINE
Pistol, Paint-pellet. . . . . . . . ANIMAL HUSBANDRY T&E
   use  GUN, MARKING
PISTOL, POCKET . . . . . . . . . . . ARMAMENT -- FIREARM. . . . . . . . 125
PISTOL, SEMI-AUTOMATIC . . . . . . . ARMAMENT -- FIREARM. . . . . . . . 125
PISTOL, SIGNAL . . . . . . . . . . . VISUAL COMMUNICATION T&E . . . . . 182
PISTOL, TARGET . . . . . . . . . . . ARMAMENT -- FIREARM. . . . . . . . 125
Pistol, Tinder. . . . . . . . . . . TEMPERATURE CONTROL DEVICE
   use  TINDERPISTOL
Pistol, Very. . . . . . . . . . . . VISUAL COMMUNICATION T&E
   use  PISTOL, SIGNAL
PISTOL, WATER. . . . . . . . . . . . TOY. . . . . . . . . . . . . . . . 224
PISTOL/AX. . . . . . . . . . . . . . ARMAMENT -- FIREARM. . . . . . . . 125
PISTOL/CARBINE . . . . . . . . . . . ARMAMENT -- FIREARM. . . . . . . . 125
PISTOL/CUTLASS . . . . . . . . . . . ARMAMENT -- FIREARM. . . . . . . . 125
PISTOL/KNIFE . . . . . . . . . . . . ARMAMENT -- FIREARM. . . . . . . . 125
PISTOL/SWORD . . . . . . . . . . . . ARMAMENT -- FIREARM. . . . . . . . 125
PITCHER. . . . . . . . . . . . . . . TOILET ARTICLE . . . . . . . . . . 39
PITCHER. . . . . . . . . . . . . . . FOOD SERVICE T&E . . . . . . . . . 74
PITCHER, BATTER. . . . . . . . . . . FOOD PROCESSING T&E. . . . . . . . 65
PITCHER, BEER. . . . . . . . . . . . FOOD SERVICE T&E . . . . . . . . . 74
PITCHER, COMMUNION . . . . . . . . . CEREMONIAL ARTIFACT. . . . . . . . 208
PITCHER, CREAM . . . . . . . . . . . FOOD SERVICE T&E . . . . . . . . . 74
PITCHER, DRY . . . . . . . . . . . . FOOD PROCESSING T&E. . . . . . . . 65
PITCHER, HOT WATER . . . . . . . . . FOOD SERVICE T&E . . . . . . . . . 74
PITCHER, ICE WATER . . . . . . . . . FOOD SERVICE T&E . . . . . . . . . 74
PITCHER,MEASURING. . . . . . . . . . FOOD PROCESSING T&E. . . . . . . . 65
PITCHER, MILK. . . . . . . . . . . . FOOD SERVICE T&E . . . . . . . . . 74
PITCHER, SYRUP . . . . . . . . . . . FOOD SERVICE T&E . . . . . . . . . 74
PITCHER, WATER . . . . . . . . . . . FOOD SERVICE T&E . . . . . . . . . 74
Pitchfork . . . . . . . . . . . . . AGRICULTURAL T&E
   use  HAYFORK or FORK, MANURE
PITON. . . . . . . . . . . . . . . . SPORTS EQUIPMENT . . . . . . . . . 221
PITTER, FRUIT. . . . . . . . . . . . FOOD PROCESSING T&E. . . . . . . . 65
Placard . . . . . . . . . . . . . . ADVERTISING MEDIUM
   use  POSTER
PLACECARD. . . . . . . . . . . . . . DOCUMENTARY ARTIFACT . . . . . . . 213
Plagiograph . . . . . . . . . . . . DRAFTING T&E
   use  PANTOGRAPH
PLANE. . . . . . . . . . . . . . . . WOODWORKING T&E. . . . . . . . . . 117
PLANE, ASTRAGAL. . . . . . . . . . . WOODWORKING T&E. . . . . . . . . . 117
Plane, Badger . . . . . . . . . . . WOODWORKING T&E
   use  PLANE, RABBET
PLANE, BANDING . . . . . . . . . . . WOODWORKING T&E. . . . . . . . . . 117
Plane, Beading. . . . . . . . . . . WOODWORKING T&E
   use  PLANE, ASTRAGAL
Plane, Bead Molding . . . . . . . . WOODWORKING T&E
   use  PLANE, ASTRAGAL
PLANE, BLOCK . . . . . . . . . . . . WOODWORKING T&E. . . . . . . . . . 117
```

- -

PLANE, BULLNOSE. WOODWORKING T&E. 117
 Plane, Center-Bead. WOODWORKING T&E
 use PLANE, CENTERBOARD
PLANE, CENTERBOARD WOODWORKING T&E. 117
 Plane, Chisel WOODWORKING T&E
 use PLANE, EDGE
 Plane, Chiv WOODWORKING T&E
 use PLANE, HOWELL
 Plane, Cluster-Bead WOODWORKING T&E
 use PLANE, MOLDING
PLANE, COACH WOODWORKING T&E. 117
PLANE, COMBINATION WOODWORKING T&E. 117
PLANE, COMPASS WOODWORKING T&E. 118
PLANE, COOPER'S STOUP. WOODWORKING T&E. 118
PLANE, CORNICE WOODWORKING T&E. 118
 Plane, Crown. WOODWORKING T&E
 use PLANE, CORNICE
 Plane, Croze. WOODWORKING T&E
 use CROZE
PLANE, DADO. WOODWORKING T&E. 118
 rt PLANE, GROOVING
PLANE, DRAWER. WOODWORKING T&E. 118
PLANE, EDGE. WOODWORKING T&E. 118
PLANE, FILLISTER WOODWORKING T&E. 118
PLANE, FLOOR WOODWORKING T&E. 118
 Plane, Fore WOODWORKING T&E
 use PLANE, JACK
PLANE, GROOVING. WOODWORKING T&E. 118
 rt PLANE, PLOW; PLANE, DADO
PLANE, GUTTERING WOODWORKING T&E. 118
 rt ADZ, GUTTERING
 Plane, Handrail WOODWORKING T&E
 use PLANE, STAIRBUILDER'S
PLANE, HOLLOW. WOODWORKING T&E. 118
 rt PLANE, ROUND
PLANE, HOWELL. WOODWORKING T&E. 118
PLANE, INCLINED. MECHANICAL T&E 147
PLANE, JACK. WOODWORKING T&E. 118
PLANE, JOINTER WOODWORKING T&E. 118
 rt PLANE, TRYING
 Plane, Leveling WOODWORKING T&E
 use PLANE, SUN
PLANE, MITER WOODWORKING T&E. 118
PLANE, MODELING. WOODWORKING T&E. 118
PLANE, MOLDING WOODWORKING T&E. 118
 Plane, Old woman's tooth. WOODWORKING T&E
 use PLANE, ROUTER
PLANE, PANEL WOODWORKING T&E. 118
 Plane, Panel-fielding WOODWORKING T&E
 use PLANE, RAISING

- -

PLANE, PLOW. WOODWORKING T&E. 118
 rt PLANE, GROOVING
 Plane, Pull WOODWORKING T&E
 use PLANE, JOINTER
PLANE, RABBET. WOODWORKING T&E. 118
PLANE, RAISING WOODWORKING T&E. 118
 Plane, Rebate WOODWORKING T&E
 use PLANE, RABBET
PLANE, ROUGHING. WOODWORKING T&E. 118
PLANE, ROUND WOODWORKING T&E. 118
 rt PLANE, HOLLOW
PLANE, ROUNDER WOODWORKING T&E. 118
PLANE, ROUTER. WOODWORKING T&E. 118
 rt ROUTER
PLANE, SASH. WOODWORKING T&E. 118
 Plane, Scaleboard WOODWORKING T&E
 use PLANE, SPLINT
PLANE, SCOOPMAKER. WOODWORKING T&E. 118
PLANE, SHOULDER. WOODWORKING T&E. 118
PLANE, SIDE RABBET WOODWORKING T&E. 118
 Plane, Skew WOODWORKING T&E
 use PLANE, RABBET
PLANE, SMOOTHING WOODWORKING T&E. 118
PLANE, SPLINT. WOODWORKING T&E. 118
PLANE, SPOKE WOODWORKING T&E. 118
PLANE, STAIRBUILDER'S. WOODWORKING T&E. 118
PLANE, SUN WOODWORKING T&E. 118
PLANE, TONGUE-AND-GROOVE WOODWORKING T&E. 118
PLANE, TONGUING. WOODWORKING T&E. 118
PLANE, TOOTHING. WOODWORKING T&E. 118
 Plane, Topping. WOODWORKING T&E
 use PLANE, SUN
PLANE, TRYING. WOODWORKING T&E. 119
 rt PLANE, JOINTER
PLANE, VIOLINMAKER'S WOODWORKING T&E. 119
 Plane, Witchet. WOODWORKING T&E
 use PLANE, ROUNDER
PLANER METALWORKING T&E 93
 rt SHAPER
PLANER WOODWORKING T&E. 119
PLANER PRINTING T&E 179
PLANER, DRIFT. METALWORKING T&E 93
PLANETARIUM. BUILDING 3
PLANETARIUM. ASTRONOMICAL T&E 135
 Planigraph. DRAFTING T&E
 use PANTOGRAPH
PLANIMETER DATA PROCESSING T&E. 169
 rt INTEGRATOR
PLANIMETER SURVEYING & NAVIGATIONAL T&E . . 163
PLANISPHERE. ASTRONOMICAL T&E 135

- -

PLANSIFTER FOOD PROCESSING T&E. 65
PLANT, BATCH CONSTRUCTION T&E 141
PLANT, INDUSTRIAL. BUILDING 3
PLANTER. AGRICULTURAL T&E 47
 note use for a horse- or machine-drawn planter
PLANTER. HOUSEHOLD ACCESSORY. 18
 rt JARDINIERE
 Planter, Bed. AGRICULTURAL T&E
 use PLANTER or PLANTER, WALKING
 Planter, Drill. AGRICULTURAL T&E
 use PLANTER or PLANTER, WALKING or PLANTER, GARDEN
PLANTER, GARDEN. AGRICULTURAL T&E 47
 note use for a planter pushed by hand
PLANTER, GARDEN. SITE FEATURE 7
PLANTER, HAND. AGRICULTURAL T&E 47
 note use for a planter carried by hand
 Planter, Lister AGRICULTURAL T&E
 use PLANTER or PLANTER, WALKING
PLANTER, POTATO. AGRICULTURAL T&E 47
 Planter, Precision. AGRICULTURAL T&E
 use PLANTER
 Planter, Riding AGRICULTURAL T&E
 use PLANTER
PLANTER, WALKING AGRICULTURAL T&E 48
 note use for an animal-drawn planter behind which the operator walks
 Planter, Walking-stick. AGRICULTURAL T&E
 use PLANTER, HAND
 Planter, Wheel. AGRICULTURAL T&E
 use PLANTER, GARDEN
PLAQUE PERSONAL SYMBOL. 216
PLAQUE CEREMONIAL ARTIFACT. 208
PLAQUE, DATE BUILDING COMPONENT 5
PLAQUE, RELIGIOUS. PERSONAL SYMBOL. 216
PLAQUE, RELIGIOUS. CEREMONIAL ARTIFACT. 208
PLASTER, COUGH MEDICAL & PSYCHOLOGICAL T&E. . . . 153
 Plastograph MEDICAL & PSYCHOLOGICAL T&E
 use ANAGLYPH
PLASTRON SPORTS EQUIPMENT 221
PLATE. FOOD SERVICE T&E 74
PLATE. ARMAMENT -- BODY ARMOR 130
 Plate, Amalgam. METALWORKING T&E
 use TABLE, AMALGAMATING
PLATE, BENCH METALWORKING T&E 93
PLATE, BUTTER. FOOD SERVICE T&E 74
PLATE, CAKE. FOOD SERVICE T&E 74
PLATE, COFFIN. CEREMONIAL ARTIFACT. 208
 Plate, Collection CEREMONIAL ARTIFACT
 use PLATE, OFFERING
PLATE, COMMEMORATIVE DOCUMENTARY ARTIFACT 213
PLATE, CUP FOOD SERVICE T&E 74

- -

```
PLATE, CUT-OFF . . . . . . . . . . . . . GLASS, PLASTICS, CLAYWORKING T&E .  80
PLATE, DESSERT . . . . . . . . . . . . . FOOD SERVICE T&E . . . . . . . .    74
PLATE, DINNER. . . . . . . . . . . . . . FOOD SERVICE T&E . . . . . . . .    74
 Plate, Doorknob . . . . . . . . . . . . BUILDING COMPONENT
   use  ESCUTCHEON
 Plate, Dowel. . . . . . . . . . . . . . WOODWORKING T&E
   use  CUTTER, PEG
PLATE, DRY . . . . . . . . . . . . . . . PHOTOGRAPHIC T&E . . . . . . . .   176
PLATE, ENGRAVING . . . . . . . . . . . . PRINTING T&E . . . . . . . . . .   179
   rt   BLOCK, WOOD
PLATE, FERROTYPE . . . . . . . . . . . . PHOTOGRAPHIC T&E . . . . . . . .   176
PLATE, FRUIT . . . . . . . . . . . . . . FOOD SERVICE T&E . . . . . . . .    74
PLATE, GLUE. . . . . . . . . . . . . . . WOODWORKING T&E. . . . . . . . .   119
PLATE, HEEL. . . . . . . . . . . . . . . CLOTHING -- ACCESSORY. . . . . .    34
PLATE, HOT . . . . . . . . . . . . . . . FOOD PROCESSING T&E. . . . . . .    65
PLATE, JAMB. . . . . . . . . . . . . . . METALWORKING T&E . . . . . . . .    93
 Plate, Kettle . . . . . . . . . . . . . GLASS, PLASTICS, CLAYWORKING T&E
   use  PLATE, CUT-OFF
PLATE, LICENSE . . . . . . . . . . . . . LTE -- ACCESSORY . . . . . . . .   195
PLATE, LITHOGRAPH. . . . . . . . . . . . PRINTING T&E . . . . . . . . . .   179
PLATE, LUNCHEON. . . . . . . . . . . . . FOOD SERVICE T&E . . . . . . . .    74
 Plate, Name . . . . . . . . . . . . . . DOCUMENTARY ARTIFACT
   use  NAMEPLATE
PLATE, OFFERING. . . . . . . . . . . . . CEREMONIAL ARTIFACT. . . . . . .   208
PLATE, OFFSET. . . . . . . . . . . . . . PRINTING T&E . . . . . . . . . .   179
PLATE, OYSTER. . . . . . . . . . . . . . FOOD SERVICE T&E . . . . . . . .    74
 Plate, Pie. . . . . . . . . . . . . . . FOOD PROCESSING T&E
   use  PAN, PIE
PLATE, PLACE . . . . . . . . . . . . . . FOOD SERVICE T&E . . . . . . . .    74
PLATE, SALAD . . . . . . . . . . . . . . FOOD SERVICE T&E . . . . . . . .    74
PLATE, SAUCEBOAT . . . . . . . . . . . . FOOD SERVICE T&E . . . . . . . .    74
PLATE, SCREW . . . . . . . . . . . . . . METALWORKING T&E . . . . . . . .    93
PLATE, SERVING . . . . . . . . . . . . . FOOD SERVICE T&E . . . . . . . .    74
PLATE, SNATCH. . . . . . . . . . . . . . MINING & MINERAL HARVESTING T&E. . 101
PLATE, SOUP. . . . . . . . . . . . . . . FOOD SERVICE T&E . . . . . . . .    74
PLATE, STEREOTYPE. . . . . . . . . . . . PRINTING T&E . . . . . . . . . .   179
PLATE, STRIKE. . . . . . . . . . . . . . BUILDING COMPONENT . . . . . . .     6
PLATE, TEA . . . . . . . . . . . . . . . FOOD SERVICE T&E . . . . . . . .    74
PLATE, VEGETABLE . . . . . . . . . . . . FOOD SERVICE T&E . . . . . . . .    74
 Plate, Wiredrawing. . . . . . . . . . . METALWORKING T&E
   use  DIE, WIREDRAWING
PLATEAU. . . . . . . . . . . . . . . . . FOOD SERVICE T&E . . . . . . . .    74
PLATEHOLDER. . . . . . . . . . . . . . . PHOTOGRAPHIC T&E . . . . . . . .   176
PLATFORM . . . . . . . . . . . . . . . . SITE FEATURE . . . . . . . . . .     7
PLATFORM, ELEVATING. . . . . . . . . . . LTE -- MOTORIZED . . . . . . . .   192
 Platform, Telescoping . . . . . . . . . LTE -- MOTORIZED
   use  PLATFORM, ELEVATING
PLATOMETER . . . . . . . . . . . . . . . SURVEYING & NAVIGATIONAL T&E . . . 163
PLATTER. . . . . . . . . . . . . . . . . FOOD SERVICE T&E . . . . . . . .    74
PLATYMETER . . . . . . . . . . . . . . . ELECTRICAL & MAGNETIC T&E. . . . . 142
```

- -

Playbill. DOCUMENTARY ARTIFACT
 use PROGRAM, THEATER
Player, Record. SOUND COMMUNICATION T&E
 use PHONOGRAPH
PLAYPEN. FURNITURE. 13
PLETHYSMOGRAPH MEDICAL & PSYCHOLOGICAL T&E. . . . 153
PLIERS MULTIPLE USE ARTIFACT. 228
Pliers, Band Soldering. MEDICAL & PSYCHOLOGICAL T&E
 use TWEEZERS, SOLDERING
PLIERS, COMBINATION. MULTIPLE USE ARTIFACT. 228
PLIERS, CONTOURING MEDICAL & PSYCHOLOGICAL T&E. . . . 153
PLIERS, DRESSING MEDICAL & PSYCHOLOGICAL T&E. . . . 153
PLIERS, ELECTRICIAN'S. ELECTRICAL & MAGNETIC T&E. 142
PLIERS, GLASS. GLASS, PLASTICS, CLAYWORKING T&E . 80
PLIERS, LACING LEATHER, HORN, SHELLWORKING T&E. . 85
PLIERS, LINOTYPE PRINTING T&E 179
PLIERS, NEEDLENOSE ELECTRICAL & MAGNETIC T&E. 142
PLIERS, PAD SCREW. LEATHER, HORN, SHELLWORKING T&E. . 85
PLIERS, STRETCHING PAINTING T&E 103
PLOTTER. DATA PROCESSING T&E. 169
PLOUGH PRINTING T&E 179
PLOW, BOG-CUTTER AGRICULTURAL T&E 48
PLOW, BREAKING AGRICULTURAL T&E 48
Plow, Chisel. AGRICULTURAL T&E
 use PLOW, SUBSOIL
PLOW, DISK AGRICULTURAL T&E 48
PLOW, GANG AGRICULTURAL T&E 48
PLOW, GARDEN AGRICULTURAL T&E 48
Plow, Lister. AGRICULTURAL T&E
 use MIDDLEBUSTER
Plow, Middlebuster. AGRICULTURAL T&E
 use MIDDLEBUSTER
PLOW, MOLDBOARD. AGRICULTURAL T&E 48
Plow, One-way wheatland AGRICULTURAL T&E
 use PLOW, DISK
Plow, Peat. AGRICULTURAL T&E
 use PLOW, BOG-CUTTER
PLOW, SHOVEL AGRICULTURAL T&E 48
PLOW, SNOW LTE -- ANIMAL-POWERED. 190
PLOW, SNOW LTE -- MOTORIZED 192
PLOW, STUBBLE. AGRICULTURAL T&E 48
PLOW, SUBSOIL. AGRICULTURAL T&E 48
PLUG MASONRY & STONEWORKING T&E 87
PLUG, DRAIN. HOUSEHOLD ACCESSORY. 18
PLUG, NOSE ADORNMENT. 25
PLUG, NOSE PERSONAL GEAR. 37
PLUG, RECEPTACLE ELECTRICAL & MAGNETIC T&E. 142
PLUG, SOCKET ELECTRICAL & MAGNETIC T&E. 142
PLUME. ADORNMENT. 25
PLUME. PERSONAL SYMBOL. 216

- -

- -

Poleax. FOOD PROCESSING T&E
 use AX, SLAUGHTERING
POLEAX ARMAMENT -- EDGED. 127
POLEMOSCOPE. VISUAL COMMUNICATION T&E 182
POLISHER, DENTAL MEDICAL & PSYCHOLOGICAL T&E. . . . 153
POLISHER, FLOOR. MAINTENANCE T&E. 146
POLISHER, PORTE. MEDICAL & PSYCHOLOGICAL T&E. . . . 153
Polygonoscope TOY
 use KALEIDOSCOPE
POLYGRAPH. MEDICAL & PSYCHOLOGICAL T&E. . . . 153
POLYTROPE. MECHANICAL T&E 147
POMANDER TOILET ARTICLE 39
Pommel. LEATHER, HORN, SHELLWORKING T&E
 use BOARD, GRAINING
PONCHO CLOTHING -- OUTERWEAR. 31
PONIARD. ARMAMENT -- EDGED. 127
 rt DAGGER; STILETTO
PONTIL GLASS, PLASTICS, CLAYWORKING T&E . 80
PONTOON. WATER TRANSPORTATION -- EQUIPMENT. 199
PONY, LACING LEATHER, HORN, SHELLWORKING T&E. . 85
POOL OTHER STRUCTURE. 8
POOL, SWIMMING OTHER STRUCTURE. 8
POOL, WADING RECREATIONAL DEVICE. 219
POPGUN TOY. 224
POPPER, CORN FOOD PROCESSING T&E. 65
PORCH. BUILDING 3
PORRINGER. FOOD SERVICE T&E 74
PORRO. FOOD SERVICE T&E 74
Porte, Screw. MEDICAL & PSYCHOLOGICAL T&E
 use EXTRACTOR, ROOT
PORTFOLIO. WRITTEN COMMUNICATION T&E. 185
PORTICO. BUILDING 3
Portiere. WINDOW OR DOOR COVERING
 use CURTAIN, DOOR
Portmanteau PERSONAL GEAR
 use SUITCASE
POST, AIMING ARMAMENT -- ACCESSORY. 132
POST, FENCE. SITE FEATURE 7
POST, HITCHING SITE FEATURE 7
POSTCARD WRITTEN COMMUNICATION T&E. 185
 note unused. If used, may be DOCUMENTARY ARTIFACT
POSTCARD DOCUMENTARY ARTIFACT 213
POSTER ADVERTISING MEDIUM 204
POSTER, POLITICAL. ADVERTISING MEDIUM 204
POSTER, THEATER. ADVERTISING MEDIUM 204
POSTUROMETER BIOLOGICAL T&E 137
Pot FOOD PROCESSING T&E
 use SAUCEPAN
POT. GLASS, PLASTICS, CLAYWORKING T&E . 80
Pot, Bean FOOD PROCESSING T&E
 use POT, CROCK

- -

```
POT, CHAMBER . . . . . . . . . . . . . TOILET ARTICLE . . . . . . . . . .    39
POT, CHIMNEY . . . . . . . . . . . . . BUILDING COMPONENT . . . . . . . .     6
POT, CHOCOLATE . . . . . . . . . . . . FOOD SERVICE T&E . . . . . . . . .    74
 Pot, Coffee . . . . . . . . . . . . . FOOD SERVICE T&E
  use  COFFEEPOT
POT, CRAB. . . . . . . . . . . . . . . FISHING & TRAPPING T&E . . . . . .    57
POT, CROCK . . . . . . . . . . . . . . FOOD PROCESSING T&E. . . . . . . .    65
 Pot, Eel. . . . . . . . . . . . . . . FISHING & TRAPPING T&E
  use  EELPOT
POT, FISH. . . . . . . . . . . . . . . FISHING & TRAPPING T&E . . . . . .    57
  rt  TRAP, FISH
 Pot, Flower . . . . . . . . . . . . . HOUSEHOLD ACCESSORY
  use  FLOWERPOT
POT, GLUE. . . . . . . . . . . . . . . PRINTING T&E . . . . . . . . . . .   179
POT, HOT-WATER . . . . . . . . . . . . FOOD SERVICE T&E . . . . . . . . .    74
POT, LOBSTER . . . . . . . . . . . . . FISHING & TRAPPING T&E . . . . . .    57
POT, MUSTARD . . . . . . . . . . . . . FOOD SERVICE T&E . . . . . . . . .    74
POT, PASTE . . . . . . . . . . . . . . HOUSEHOLD ACCESSORY. . . . . . . .    18
 Pot, Pepper . . . . . . . . . . . . . FOOD PROCESSING T&E
  use  SHAKER, PEPPER
POT, POSSET. . . . . . . . . . . . . . FOOD SERVICE T&E . . . . . . . . .    74
POT, SMUDGE. . . . . . . . . . . . . . AGRICULTURAL T&E . . . . . . . . .    48
POT, SMUDGE. . . . . . . . . . . . . . VISUAL COMMUNICATION T&E . . . . .   182
POT, STOCK . . . . . . . . . . . . . . FOOD PROCESSING T&E. . . . . . . .    65
 Pot, Tea. . . . . . . . . . . . . . . FOOD SERVICE T&E
  use  TEAPOT
POT, TRY . . . . . . . . . . . . . . . FISHING & TRAPPING T&E . . . . . .    57
POTENTIOMETER. . . . . . . . . . . . . ELECTRICAL & MAGNETIC T&E. . . . .   142
POTHOLDER. . . . . . . . . . . . . . . FOOD PROCESSING T&E. . . . . . . .    65
POTOMETER. . . . . . . . . . . . . . . BIOLOGICAL T&E . . . . . . . . . .   137
 Potty . . . . . . . . . . . . . . . . TOILET ARTICLE
  use  POT, CHAMBER or COMMODE
POUCH. . . . . . . . . . . . . . . . . PERSONAL GEAR. . . . . . . . . . .    37
POUCH. . . . . . . . . . . . . . . . . CONTAINER. . . . . . . . . . . . .   186
POUCH, CAP . . . . . . . . . . . . . . ARMAMENT -- ACCESSORY. . . . . . .   132
POUCH, CARTRIDGE . . . . . . . . . . . ARMAMENT -- ACCESSORY. . . . . . .   132
POUCH, GUNNER'S. . . . . . . . . . . . ARMAMENT -- ACCESSORY. . . . . . .   133
POUCH, NAIL. . . . . . . . . . . . . . WOODWORKING T&E. . . . . . . . . .   119
POUCH, PRIMER. . . . . . . . . . . . . ARMAMENT -- ACCESSORY. . . . . . .   133
POUCH, SHOT. . . . . . . . . . . . . . ARMAMENT -- ACCESSORY. . . . . . .   133
POUCH, TOBACCO . . . . . . . . . . . . PERSONAL GEAR. . . . . . . . . . .    37
 Poulaine. . . . . . . . . . . . . . . CLOTHING -- FOOTWEAR
  use  CRAKOW
 Pounder, Meat . . . . . . . . . . . . FOOD PROCESSING T&E
  use  MAUL, MEAT
POWDER, DEVELOPING . . . . . . . . . . PHOTOGRAPHIC T&E . . . . . . . . .   176
POWDER, INK. . . . . . . . . . . . . . WRITTEN COMMUNICATION T&E. . . . .   185
POWER-PLANT, NUCLEAR . . . . . . . . . ENERGY PRODUCTION T&E. . . . . . .   144
PRAM . . . . . . . . . . . . . . . . . WATER TRANSPORTATION -- EQUIPMENT.   199
  rt  SAILBOAT
```

- -

```
Pram, Doll. . . . . . . . . . . . . . TOY
   use CARRIAGE, DOLL
PRAM, SAILING. . . . . . . . . . . . . WATER TRANSPORTATION -- EQUIPMENT.  199
PRAXINOSCOPE . . . . . . . . . . . . . TOY. . . . . . . . . . . . . . .   224
PREMIUM. . . . . . . . . . . . . . . . ADVERTISING MEDIUM . . . . . . .   204
   note may be modified to indicate its original product package
PREMIUM, CIGARETTE . . . . . . . . . . ADVERTISING MEDIUM . . . . . . .   204
   Press, Arming . . . . . . . . . . . PRINTING T&E
   use PRESS, BLOCKING
PRESS, BLINDER . . . . . . . . . . . . LEATHER, HORN, SHELLWORKING T&E. .  85
PRESS, BLOCKING. . . . . . . . . . . . PRINTING T&E . . . . . . . . . .   179
PRESS, BOOK. . . . . . . . . . . . . . PRINTING T&E . . . . . . . . . .   179
PRESS, BUTTER. . . . . . . . . . . . . FOOD PROCESSING T&E. . . . . . .    65
PRESS, CARTRIDGE-CASE. . . . . . . . . ARMAMENT -- ACCESSORY. . . . . .   133
PRESS, CHEESE. . . . . . . . . . . . . FOOD PROCESSING T&E. . . . . . .    65
PRESS, CLOTH . . . . . . . . . . . . . TEXTILEWORKING T&E . . . . . . .   109
PRESS, CORK. . . . . . . . . . . . . . WOODWORKING T&E. . . . . . . . .   119
PRESS, CUTTING . . . . . . . . . . . . PRINTING T&E . . . . . . . . . .   179
PRESS, CYLINDER. . . . . . . . . . . . PRINTING T&E . . . . . . . . . .   179
PRESS, DRILL . . . . . . . . . . . . . METALWORKING T&E . . . . . . . .    93
PRESS, DRY-MOUNTING. . . . . . . . . . PHOTOGRAPHIC T&E . . . . . . . .   176
PRESS, EMBOSSING . . . . . . . . . . . PRINTING T&E . . . . . . . . . .   179
PRESS, ETCHING . . . . . . . . . . . . PRINTING T&E . . . . . . . . . .   179
   Press, Fly. . . . . . . . . . . . . PRINTING T&E
   use PRESS, EMBOSSING
PRESS, FRUIT . . . . . . . . . . . . . FOOD PROCESSING T&E. . . . . . .    65
   Press, Hand . . . . . . . . . . . . PRINTING T&E
   use HANDPRESS
   Press, Hay-baling . . . . . . . . . AGRICULTURAL T&E
   use BALER, HAY
PRESS, HORNWORKER'S. . . . . . . . . . LEATHER, HORN, SHELLWORKING T&E. .  85
PRESS, HOT-HEAD. . . . . . . . . . . . TEXTILEWORKING T&E . . . . . . .   109
   Press, Job. . . . . . . . . . . . . PRINTING T&E
   use more specific term, e.g.: LETTERPRESS
PRESS, LARD. . . . . . . . . . . . . . FOOD PROCESSING T&E. . . . . . .    65
   Press, Letter . . . . . . . . . . . PRINTING T&E
   use LETTERPRESS
   Press, Linen. . . . . . . . . . . . FURNITURE
   use CUPBOARD, PRESS
PRESS, LINEN . . . . . . . . . . . . . MAINTENANCE T&E. . . . . . . . .   146
PRESS, LYING . . . . . . . . . . . . . PRINTING T&E . . . . . . . . . .   179
PRESS, MOLD. . . . . . . . . . . . . . GLASS, PLASTICS, CLAYWORKING T&E .  80
PRESS, NEWSPAPER . . . . . . . . . . . PRINTING T&E . . . . . . . . . .   179
PRESS, NIPPING . . . . . . . . . . . . PRINTING T&E . . . . . . . . . .   179
PRESS, OFFSET. . . . . . . . . . . . . PRINTING T&E . . . . . . . . . .   179
PRESS, PLATEN. . . . . . . . . . . . . PRINTING T&E . . . . . . . . . .   179
PRESS, PRIMING . . . . . . . . . . . . ARMAMENT -- ACCESSORY. . . . . .   133
PRESS, PUNCH . . . . . . . . . . . . . METALWORKING T&E . . . . . . . .    93
PRESS, SMOOTHING . . . . . . . . . . . PAPERMAKING T&E. . . . . . . . .   104
PRESS, STAMPING. . . . . . . . . . . . METALWORKING T&E . . . . . . . .    93
```

- -

- -

PROJECTOR, LANTERN-SLIDE VISUAL COMMUNICATION T&E 183
PROJECTOR, MOTION-PICTURE. VISUAL COMMUNICATION T&E 183
PROJECTOR, OPAQUE. VISUAL COMMUNICATION T&E 183
PROJECTOR, SLIDE VISUAL COMMUNICATION T&E 183
 Projector, Sound. SOUND COMMUNICATION T&E
 use BULLHORN or AMPLIFIER, AUDIO
PROOF, PRINTING. DOCUMENTARY ARTIFACT 213
PROP, SAWYER'S WOODWORKING T&E. 119
 rt SAWBUCK; SAWHORSE; TACKLE, SAWING
PROPELLER. AEROSPACE -- ACCESSORY 188
PROPELLER. WATER TRANSPORTATION -- ACCESSORY. 202
PROPELLER, ADJUSTABLE-PITCH. AEROSPACE -- ACCESSORY 188
PROPELLER, FIXED-PITCH AEROSPACE -- ACCESSORY 188
PROPERTIES PUBLIC ENTERTAINMENT DEVICE. . . . 218
 note use for an object that provides a realistic effect in a production
PROPERTIES, MAGICIAN'S PUBLIC ENTERTAINMENT DEVICE. . . . 218
 Props PUBLIC ENTERTAINMENT DEVICE
 use PROPERTIES
PROSPECTUS DOCUMENTARY ARTIFACT 213
PROSTHESIS PERSONAL GEAR. 37
PROTECTOR, BODY. SPORTS EQUIPMENT 222
PROTECTOR, CHECK WRITTEN COMMUNICATION T&E. 185
PROTECTOR, THROAT. ARMAMENT -- ACCESSORY. 133
PROTONSYNCHROTRON. NUCLEAR PHYSICS T&E. 158
 rt ACCELERATOR; BETATRON
PROTRACTOR DRAFTING T&E 171
PROTRACTOR, HOOF ANIMAL HUSBANDRY T&E 54
PROVER, LINEN. TEXTILEWORKING T&E 109
PRUNER, TREE AGRICULTURAL T&E 48
PSCHENT. PERSONAL SYMBOL. 216
PSEUDOPHONE. ACOUSTICAL T&E 123
PSEUDOSCOPE. OPTICAL T&E. 160
PSEUDOSCOPE, LENTICULAR. MEDICAL & PSYCHOLOGICAL T&E. . . . 153
 rt STEREOSCOPE
 Psychrometer. MECHANICAL T&E
 use HYDROMETER
 Pucellas. GLASS, PLASTICS, CLAYWORKING T&E
 use JACK
PUCK, HOCKEY SPORTS EQUIPMENT 222
PUEBLO BUILDING 3
PUFF, POWDER TOILET ARTICLE 39
 Pull-a-way. RECREATIONAL DEVICE
 use WHIRL
PULLER, BULLET ARMAMENT -- ACCESSORY. 133
PULLER, CALF ANIMAL HUSBANDRY T&E 54
PULLER, NAIL WOODWORKING T&E. 119
PULLER, STAPLE WOODWORKING T&E. 119
PULLER, STUMP. AGRICULTURAL T&E 48
PULLER, TACK WOODWORKING T&E. 119
 Pullers, Shoe ANIMAL HUSBANDRY T&E
 use PINCERS, FARRIER'S

- -

- -

```
PUNCH, HOLLOW. . . . . . . . . . . . . . METALWORKING T&E . . . . . . . . .  93
PUNCH, KEYBOARD. . . . . . . . . . . . . DATA PROCESSING T&E. . . . . . . . 169
PUNCH, LINE. . . . . . . . . . . . . . . LEATHER, HORN, SHELLWORKING T&E. .  85
PUNCH, MARKING . . . . . . . . . . . . . WOODWORKING T&E. . . . . . . . . . 119
PUNCH, NAIL. . . . . . . . . . . . . . . WOODWORKING T&E. . . . . . . . . . 119
PUNCH, OBLONG. . . . . . . . . . . . . . LEATHER, HORN, SHELLWORKING T&E. .  85
PUNCH, OBLONG. . . . . . . . . . . . . . METALWORKING T&E . . . . . . . . .  93
PUNCH, OVAL. . . . . . . . . . . . . . . METALWORKING T&E . . . . . . . . .  94
PUNCH, PAPER . . . . . . . . . . . . . . WRITTEN COMMUNICATION T&E. . . . . 185
PUNCH, PIERCING. . . . . . . . . . . . . LEATHER, HORN, SHELLWORKING T&E. .  85
   Punch, Pin. . . . . . . . . . . . . . METALWORKING T&E
     use  PUNCH, BACKING-OUT
PUNCH, POULTRY . . . . . . . . . . . . . ANIMAL HUSBANDRY T&E . . . . . . .  54
PUNCH, PRICK . . . . . . . . . . . . . . METALWORKING T&E . . . . . . . . .  94
PUNCH, REVOLVING . . . . . . . . . . . . LEATHER, HORN, SHELLWORKING T&E. .  85
   Punch, Rivet. . . . . . . . . . . . . WOODWORKING T&E
     use  PUNCH, STARTING
PUNCH, ROUND . . . . . . . . . . . . . . METALWORKING T&E . . . . . . . . .  94
PUNCH, RUBBER DAM. . . . . . . . . . . . MEDICAL & PSYCHOLOGICAL T&E. . . . 153
PUNCH, SADDLER'S . . . . . . . . . . . . LEATHER, HORN, SHELLWORKING T&E. .  85
PUNCH, SAILMAKER'S . . . . . . . . . . . TEXTILEWORKING T&E . . . . . . . . 109
PUNCH, SCALLOPING. . . . . . . . . . . . LEATHER, HORN, SHELLWORKING T&E. .  85
PUNCH, SHINGLE . . . . . . . . . . . . . WOODWORKING T&E. . . . . . . . . . 119
PUNCH, SPOT. . . . . . . . . . . . . . . DATA PROCESSING T&E. . . . . . . . 169
PUNCH, SQUARE. . . . . . . . . . . . . . METALWORKING T&E . . . . . . . . .  94
PUNCH, STARTING. . . . . . . . . . . . . WOODWORKING T&E. . . . . . . . . . 119
PUNCH, STRAP-END . . . . . . . . . . . . LEATHER, HORN, SHELLWORKING T&E. .  85
PUNCH, SUMMARY . . . . . . . . . . . . . DATA PROCESSING T&E. . . . . . . . 169
PUNCH, VENEER. . . . . . . . . . . . . . WOODWORKING T&E. . . . . . . . . . 119
PUNCH, VENT. . . . . . . . . . . . . . . ARMAMENT -- ACCESSORY. . . . . . . 133
PUNCH, WOOD. . . . . . . . . . . . . . . WOODWORKING T&E. . . . . . . . . . 119
PUNCHBOARD . . . . . . . . . . . . . . . DATA PROCESSING T&E. . . . . . . . 169
   Pung. . . . . . . . . . . . . . . . . LTE -- ANIMAL-POWERED
     use  SLEIGH
PUNT . . . . . . . . . . . . . . . . . . WATER TRANSPORTATION -- EQUIPMENT. 199
   Punty . . . . . . . . . . . . . . . . GLASS, PLASTICS, CLAYWORKING T&E
     use  PONTIL
PUPILOMETER. . . . . . . . . . . . . . . MEDICAL & PSYCHOLOGICAL T&E. . . . 153
PUPPET, HAND . . . . . . . . . . . . . . TOY. . . . . . . . . . . . . . . . 224
   rt  DOLL; MARIONETTE
PUPPET, HAND . . . . . . . . . . . . . . PUBLIC ENTERTAINMENT DEVICE. . . . 218
   rt  MARIONETTE
PUPPET, SHADOW . . . . . . . . . . . . . PUBLIC ENTERTAINMENT DEVICE. . . . 218
PURIFICATOR. . . . . . . . . . . . . . . CEREMONIAL ARTIFACT. . . . . . . . 208
PURIFIER, MIDDLINGS. . . . . . . . . . . FOOD PROCESSING T&E. . . . . . . .  65
PURSE. . . . . . . . . . . . . . . . . . PERSONAL GEAR. . . . . . . . . . .  37
PURSE, CHANGE. . . . . . . . . . . . . . PERSONAL GEAR. . . . . . . . . . .  37
PURSE, COSMETIC. . . . . . . . . . . . . TOILET ARTICLE . . . . . . . . . .  39
   Purse, Hairpin. . . . . . . . . . . . TOILET ARTICLE
     use  CASE, HAIRPIN
```

- -

Pushcart. LTE -- HUMAN-POWERED
 use BARROW
PUSHPIN. WRITTEN COMMUNICATION T&E. 185
PUSHPLATE, DOOR. BUILDING COMPONENT 6
PUTTEE CLOTHING -- OUTERWEAR. 31
PUZZLE TOY. 224
 Puzzle, Chinese TOY
 use BLOCK, PARQUETRY
PYCNOMETER MECHANICAL T&E 147
 Pyjamas CLOTHING -- OUTERWEAR
 use PAJAMAS
PYRAMID, DESSERT FOOD SERVICE T&E 74
PYRHELIOMETER. ASTRONOMICAL T&E 135
PYROMETER. THERMAL T&E. 165
 rt THERMOMETER
PYX. CEREMONIAL ARTIFACT. 208
QUADRANT SURVEYING & NAVIGATIONAL T&E . . . 163
 rt CIRCUMFERENTOR; GRAPHOMETER
QUADRANT, ASTRONOMICAL ASTRONOMICAL T&E 135
QUADRANT, GUNNER'S ARMAMENT -- ACCESSORY. 133
QUADRICYCLE. LTE -- HUMAN-POWERED 191
 Quadruple LTE -- MOTORIZED
 use more specific term, e.g.: TRUCK, PUMPER/LADDER
QUANT. WATER TRANSPORTATION -- ACCESSORY. 202
QUARNET, HORNWORKER'S. LEATHER, HORN, SHELLWORKING T&E. . 85
QUARRY OTHER STRUCTURE. 8
QUERN. FOOD PROCESSING T&E. 65
QUID ARTIFACT REMNANT 227
QUILLER. TEXTILEWORKING T&E 109
QUILT. BEDDING. 9
QUIRT. LTE -- ACCESSORY 195
 rt WHIP
QUIVER ARMAMENT -- ACCESSORY. 133
QUOIN. ARMAMENT -- ACCESSORY. 133
QUOIN. PRINTING T&E 179
QUOITS SPORTS EQUIPMENT 222
RABBLE METALWORKING T&E 94
 Race. OTHER STRUCTURE
 use FLUME
RACK FURNITURE. 13
RACK HOUSEHOLD ACCESSORY. 18
RACK, ARMS ARMAMENT -- ACCESSORY. 133
RACK, BLOWPIPE GLASS, PLASTICS, CLAYWORKING T&E . 81
RACK, BOMB ARMAMENT -- ACCESSORY. 133
RACK, BOOK HOUSEHOLD ACCESSORY. 18
RACK, BOOT FURNITURE. 13
RACK, BOTTLE FOOD SERVICE T&E 74
RACK, BOTTLE FOOD PROCESSING T&E. 65
RACK, BROOM. HOUSEHOLD ACCESSORY. 18
RACK, BUCKET WATER TRANSPORTATION -- ACCESSORY. 202

- -

```
RACK, CANNING. . . . . . . . . . . . . . FOOD PROCESSING T&E. . . . . . . .   65
RACK, COOLING. . . . . . . . . . . . . . FOOD PROCESSING T&E. . . . . . . .   65
RACK, CUE. . . . . . . . . . . . . . . . SPORTS EQUIPMENT . . . . . . . .    222
RACK, DISPLAY. . . . . . . . . . . . . . MERCHANDISING T&E. . . . . . . .    156
RACK, DRYING . . . . . . . . . . . . . . MAINTENANCE T&E. . . . . . . . .    146
RACK, GUN. . . . . . . . . . . . . . . . FURNITURE. . . . . . . . . . . .     13
RACK, HAT. . . . . . . . . . . . . . . . FURNITURE. . . . . . . . . . . .     13
  rt  COATRACK
RACK, HORSE-SHOEING. . . . . . . . . . . ANIMAL HUSBANDRY T&E . . . . . . .   54
RACK, HOSE . . . . . . . . . . . . . . . WATER TRANSPORTATION -- ACCESSORY. 202
RACK, LETTER . . . . . . . . . . . . . . WRITTEN COMMUNICATION T&E. . . . . 185
RACK, LIFE RING. . . . . . . . . . . . . WATER TRANSPORTATION -- ACCESSORY. 202
RACK, LUGGAGE. . . . . . . . . . . . . . FURNITURE. . . . . . . . . . . .     13
RACK, MAGAZINE . . . . . . . . . . . . . FURNITURE. . . . . . . . . . . .     13
  rt  CANTERBURY
RACK, MEAT . . . . . . . . . . . . . . . FOOD PROCESSING T&E. . . . . . . .   65
RACK, MUSIC. . . . . . . . . . . . . . . HOUSEHOLD ACCESSORY. . . . . . . .   18
RACK, NEEDLEWORK . . . . . . . . . . . . TEXTILEWORKING T&E . . . . . . .    109
RACK, NEWSPAPER. . . . . . . . . . . . . HOUSEHOLD ACCESSORY. . . . . . . .   18
RACK, PIPE . . . . . . . . . . . . . . . HOUSEHOLD ACCESSORY. . . . . . . .   18
RACK, PLANT. . . . . . . . . . . . . . . FURNITURE. . . . . . . . . . . .     13
RACK, PLATE. . . . . . . . . . . . . . . HOUSEHOLD ACCESSORY. . . . . . . .   18
RACK, POKER CHIP . . . . . . . . . . . . GAME . . . . . . . . . . . . . .    218
RACK, RECORD . . . . . . . . . . . . . . HOUSEHOLD ACCESSORY. . . . . . . .   18
RACK, SAFETY PIN . . . . . . . . . . . . TEXTILEWORKING T&E . . . . . . .    109
RACK, SAUCEPAN . . . . . . . . . . . . . FOOD PROCESSING T&E. . . . . . . .   65
RACK, SIGNAL FLAG. . . . . . . . . . . . WATER TRANSPORTATION -- ACCESSORY. 203
RACK, SPICE. . . . . . . . . . . . . . . FOOD PROCESSING T&E. . . . . . . .   65
RACK, SPOOL. . . . . . . . . . . . . . . TEXTILEWORKING T&E . . . . . . .    109
RACK, SPOON. . . . . . . . . . . . . . . HOUSEHOLD ACCESSORY. . . . . . . .   18
RACK, TEST TUBE. . . . . . . . . . . . . CHEMICAL T&E . . . . . . . . . .    140
RACK, TOAST. . . . . . . . . . . . . . . FOOD SERVICE T&E . . . . . . . .     74
RACK, TOOL . . . . . . . . . . . . . . . MULTIPLE USE ARTIFACT. . . . . .    228
RACK, TOWEL. . . . . . . . . . . . . . . FURNITURE. . . . . . . . . . . .     13
RACK, TOWEL. . . . . . . . . . . . . . . HOUSEHOLD ACCESSORY. . . . . . . .   18
 Rack, Umbrella. . . . . . . . . . . . . HOUSEHOLD ACCESSORY
  use  HOLDER, UMBRELLA
RACK, UTENSIL. . . . . . . . . . . . . . FOOD PROCESSING T&E. . . . . . . .   65
RACK, WINE . . . . . . . . . . . . . . . FOOD PROCESSING T&E. . . . . . . .   65
RACKET . . . . . . . . . . . . . . . . . MUSICAL T&E. . . . . . . . . . .    174
RACKET, BADMINTON. . . . . . . . . . . . SPORTS EQUIPMENT . . . . . . . .    222
RACKET, SQUASH . . . . . . . . . . . . . SPORTS EQUIPMENT . . . . . . . .    222
RACKET, TENNIS . . . . . . . . . . . . . SPORTS EQUIPMENT . . . . . . . .    222
RADIATOR . . . . . . . . . . . . . . . . TEMPERATURE CONTROL DEVICE . . . .   22
RADIO. . . . . . . . . . . . . . . . . . TELECOMMUNICATION T&E. . . . . .    182
 note use for instruments used for the reception of audio messages only
 Radio, Cb . . . . . . . . . . . . . . . TELECOMMUNICATION T&E
  use  TRANSCEIVER
RADIOGRAM. . . . . . . . . . . . . . . . DOCUMENTARY ARTIFACT . . . . . .    213
RADIOMETER . . . . . . . . . . . . . . . ELECTRICAL & MAGNETIC T&E. . . .    142
```

- -

RADIOPHONE ACOUSTICAL T&E 123
RADIOPHONE TELECOMMUNICATION T&E. 182
RADIOSONDE METEOROLOGICAL T&E 157
 Radiotelephone. TELECOMMUNICATION T&E
 use RADIOPHONE
RAFT WATER TRANSPORTATION -- EQUIPMENT. 199
RAIL, BAR. BUILDING COMPONENT 6
RAIL, FIFE WATER TRANSPORTATION -- ACCESSORY. 203
RAILWAY, CENTRIFUGAL MECHANICAL T&E 147
RAINCOAT CLOTHING -- OUTERWEAR. 31
 rt SLICKER; OILSKIN
RAKE AGRICULTURAL T&E 48
RAKE GLASS, PLASTICS, CLAYWORKING T&E . 81
RAKE, BLACKSMITH'S METALWORKING T&E 94
 Rake, Buck. AGRICULTURAL T&E
 use RAKE, HAY-BUNCHING
 Rake, Bull. AGRICULTURAL T&E
 use RAKE, HAND HAY
RAKE, CLOVER AGRICULTURAL T&E 48
RAKE, COMMON HAY AGRICULTURAL T&E 48
RAKE, CRANBERRY. AGRICULTURAL T&E 48
RAKE, CURD FOOD PROCESSING T&E. 65
RAKE, DUMP HAY AGRICULTURAL T&E 48
 Rake, Flip-flop AGRICULTURAL T&E
 use RAKE, REVOLVING HAY
 Rake, Floral. AGRICULTURAL T&E
 use RAKE, GARDEN
RAKE, GARDEN AGRICULTURAL T&E 48
RAKE, GRADING. CONSTRUCTION T&E 141
 Rake, Grain AGRICULTURAL T&E
 use RAKE, HAND HAY
RAKE, GRAIN-BINDER'S AGRICULTURAL T&E 48
RAKE, HAND HAY AGRICULTURAL T&E 48
RAKE, HAY-BUNCHING AGRICULTURAL T&E 48
RAKE, HERRING. FISHING & TRAPPING T&E 57
RAKE, HOT-SHOT ARMAMENT -- ACCESSORY. 133
RAKE, LAWN AGRICULTURAL T&E 48
 Rake, Man AGRICULTURAL T&E
 use RAKE, HAND HAY
RAKE, ONION. AGRICULTURAL T&E 48
RAKE, POMACE FOOD PROCESSING T&E. 65
RAKE, REAPER-PLATFORM. AGRICULTURAL T&E 48
 Rake, Reel-type hay AGRICULTURAL T&E
 use RAKE, SIDE-DELIVERY HAY
RAKE, REVOLVING HAY. AGRICULTURAL T&E 48
RAKE, SHELLFISH. FISHING & TRAPPING T&E 57
RAKE, SIDE-DELIVERY HAY. AGRICULTURAL T&E 48
 Rake, Spring-tooth hay. AGRICULTURAL T&E
 use RAKE, DUMP HAY
 Rake, Sweep AGRICULTURAL T&E
 use RAKE, HAY-BUNCHING

- -

RAKER. MASONRY & STONEWORKING T&E 87
RAM, BATTERING ARMAMENT -- ARTILLERY. 128
RAM, HYDRAULIC MECHANICAL T&E 147
RAMEKIN. FOOD PROCESSING T&E. 66
RAMMER, PAVER'S. CONSTRUCTION T&E 141
RAPIER ARMAMENT -- EDGED. 127
RASP WOODWORKING T&E. 119
 rt FILE; FLOAT
RASP, HOOF ANIMAL HUSBANDRY T&E 54
RASP, SHOEMAKER'S. LEATHER, HORN, SHELLWORKING T&E. . 85
 Rasp, Tooth ANIMAL HUSBANDRY T&E
 use FLOAT, DENTAL
RATCHET. MUSICAL T&E. 174
RATCHET. METALWORKING T&E 94
RATTLE MUSICAL T&E. 174
RATTLE CEREMONIAL ARTIFACT. 208
RATTLE TOY. 224
RATTLE, BABY TOY. 225
RATTLE, COMBINATION. TOY. 225
RATTLE, GAS. SOUND COMMUNICATION T&E. 181
RATTRAP. HOUSEHOLD ACCESSORY. 18
RAZOR. TOILET ARTICLE 39
RAZOR, ELECTRIC. TOILET ARTICLE 39
READER, CARD DATA PROCESSING T&E. 169
READER, CHARACTER. DATA PROCESSING T&E. 169
 rt ORTHOSCANNER
READER, MICROFICHE VISUAL COMMUNICATION T&E 183
READER, MICROFILM. VISUAL COMMUNICATION T&E 183
READER, TAPE DATA PROCESSING T&E. 169
REAMER GLASS, PLASTICS, CLAYWORKING T&E . 81
REAMER METALWORKING T&E 94
REAMER WOODWORKING T&E. 119
 rt AUGER; BIT; BROACH
REAMER, CHAMBER. ARMAMENT -- ACCESSORY. 133
REAMER, FUZE-PLUG. ARMAMENT -- ACCESSORY. 133
REAMER, HORNWORKER'S LEATHER, HORN, SHELLWORKING T&E. . 85
REAMER, JUICE. FOOD PROCESSING T&E. 66
REAPER AGRICULTURAL T&E 49
 Reaper, Hand-rake AGRICULTURAL T&E
 use REAPER
 Reaper, Self-rake AGRICULTURAL T&E
 use REAPER
 Reaper/mower. AGRICULTURAL T&E
 use REAPER
REBEC. MUSICAL T&E. 174
 rt VIOLIN
 Recamier. FURNITURE
 use LOUNGE
RECEIPT. DOCUMENTARY ARTIFACT 213
RECEIVER CHEMICAL T&E 140
 rt APPARATUS, DISTILLING

- -

```
RECEIVER . . . . . . . . . . . . . . . . . . SURVEYING & NAVIGATIONAL T&E . . . 163
RECEIVER, BEACON . . . . . . . . . . . . . . SURVEYING & NAVIGATIONAL T&E . . . 163
RECEIVER, CARD . . . . . . . . . . . . . . . HOUSEHOLD ACCESSORY. . . . . . . .  18
RECEIVER, HAIR . . . . . . . . . . . . . . . TOILET ARTICLE . . . . . . . . . .  39
RECEIVER, HAIRPIN. . . . . . . . . . . . . . TOILET ARTICLE . . . . . . . . . .  39
RECEIVER, LONG-WAVE BEACON . . . . . . . . . SURVEYING & NAVIGATIONAL T&E . . . 163
RECEIVER, SOUND. . . . . . . . . . . . . . . ACOUSTICAL T&E . . . . . . . . . . 123
RECEIVER/DISPLAY, LORAN. . . . . . . . . . . SURVEYING & NAVIGATIONAL T&E . . . 163
RECEIVER/DISPLAY, RADAR. . . . . . . . . . . SURVEYING & NAVIGATIONAL T&E . . . 163
RECEPTACLE . . . . . . . . . . . . . . . . . ELECTRICAL & MAGNETIC T&E. . . . . 142
RECIPE . . . . . . . . . . . . . . . . . . . DOCUMENTARY ARTIFACT . . . . . . . 213
RECORD, PHONOGRAPH . . . . . . . . . . . . . SOUND COMMUNICATION T&E. . . . . . 181
RECORDER . . . . . . . . . . . . . . . . . . MUSICAL T&E. . . . . . . . . . . . 174
RECORDER, FILM . . . . . . . . . . . . . . . DATA PROCESSING T&E. . . . . . . . 169
RECORDER, FLIGHT . . . . . . . . . . . . . . AEROSPACE -- ACCESSORY . . . . . . 188
RECORDER, SCEPTRE. . . . . . . . . . . . . . SURVEYING & NAVIGATIONAL T&E . . . 163
RECORDER, SOUND. . . . . . . . . . . . . . . ACOUSTICAL T&E . . . . . . . . . . 123
RECORDER, SUNSHINE . . . . . . . . . . . . . METEOROLOGICAL T&E . . . . . . . . 157
RECORDER, TAPE . . . . . . . . . . . . . . . SOUND COMMUNICATION T&E. . . . . . 181
   Reducer, Tubing . . . . . . . . . . . . . CHEMICAL T&E
    use  TUBING, ADAPTER
REED . . . . . . . . . . . . . . . . . . . . TEXTILEWORKING T&E . . . . . . . . 109
REEL . . . . . . . . . . . . . . . . . . . . TEXTILEWORKING T&E . . . . . . . . 109
REEL . . . . . . . . . . . . . . . . . . . . MULTIPLE USE ARTIFACT. . . . . . . 228
REEL, CANDLE-DIPPING . . . . . . . . . . . . GLASS, PLASTICS, CLAYWORKING T&E .  81
REEL, CHALK. . . . . . . . . . . . . . . . . WOODWORKING T&E. . . . . . . . . . 119
    rt  LINE, CHALK
REEL, CLOCK. . . . . . . . . . . . . . . . . TEXTILEWORKING T&E . . . . . . . . 109
    rt  WINDER
REEL, FISHING. . . . . . . . . . . . . . . . FISHING & TRAPPING T&E . . . . . .  57
REEL, HOSE . . . . . . . . . . . . . . . . . LTE -- ANIMAL-POWERED. . . . . . . 190
    rt  WAGON, HOSE
REEL, LOG. . . . . . . . . . . . . . . . . . SURVEYING & NAVIGATIONAL T&E . . . 163
REEL, WARPING. . . . . . . . . . . . . . . . TEXTILEWORKING T&E . . . . . . . . 109
   Reel, Yarn. . . . . . . . . . . . . . . . TEXTILEWORKING T&E
    use  REEL
REFLECTOR, SOLAR . . . . . . . . . . . . . . ENERGY PRODUCTION T&E. . . . . . . 144
REFRACTOMETER. . . . . . . . . . . . . . . . OPTICAL T&E. . . . . . . . . . . . 160
REFRIGERATOR . . . . . . . . . . . . . . . . FOOD PROCESSING T&E. . . . . . . .  66
   Refrigerator, Dairy . . . . . . . . . . . FOOD PROCESSING T&E
    use  COOLER, DAIRY
REGISTER, CASH . . . . . . . . . . . . . . . MERCHANDISING T&E. . . . . . . . . 156
REGISTER, TAFFRAIL LOG . . . . . . . . . . . WATER TRANSPORTATION -- ACCESSORY. 203
REGULATOR, SCUBA . . . . . . . . . . . . . . SPORTS EQUIPMENT . . . . . . . . . 222
REGULATOR, VOLTAGE . . . . . . . . . . . . . ELECTRICAL & MAGNETIC T&E. . . . . 142
REINS, CHECK . . . . . . . . . . . . . . . . LTE -- ACCESSORY . . . . . . . . . 195
REINS, DRIVING . . . . . . . . . . . . . . . LTE -- ACCESSORY . . . . . . . . . 195
REJON. . . . . . . . . . . . . . . . . . . . SPORTS EQUIPMENT . . . . . . . . . 222
RELAY. . . . . . . . . . . . . . . . . . . . ELECTRICAL & MAGNETIC T&E. . . . . 142
RELEASE, BOMB. . . . . . . . . . . . . . . . ARMAMENT -- ACCESSORY. . . . . . . 133
```

- -

- -

- -

- -

```
ROD, TUNGSTEN. . . . . . . . . . . . . . . GLASS, PLASTICS, CLAYWORKING T&E .   81
ROD, WANTAGE . . . . . . . . . . . . . . . WEIGHTS & MEASURES T&E . . . . . .  166
RODE, ANCHOR . . . . . . . . . . . . . . . WATER TRANSPORTATION -- ACCESSORY.  203
   rt   ROPE
Roemer. . . . . . . . . . . . . . . . . . . FOOD SERVICE T&E
   use  GOBLET
Roll, Cornish . . . . . . . . . . . . . . . MINING & MINERAL HARVESTING T&E
   use  CRUSHER, ROLLER
ROLL, DANDY. . . . . . . . . . . . . . . . PAPERMAKING T&E. . . . . . . . . .  104
ROLL, LARD . . . . . . . . . . . . . . . . FOOD PROCESSING T&E. . . . . . . .   66
ROLL, MUSTER . . . . . . . . . . . . . . . DOCUMENTARY ARTIFACT . . . . . . .  213
ROLL, PLAYER PIANO . . . . . . . . . . . . SOUND COMMUNICATION T&E. . . . . .  181
ROLLER . . . . . . . . . . . . . . . . . . PAINTING T&E . . . . . . . . . . .  103
ROLLER . . . . . . . . . . . . . . . . . . CONSTRUCTION T&E . . . . . . . . .  141
ROLLER . . . . . . . . . . . . . . . . . . METALWORKING T&E . . . . . . . . .   94
ROLLER, CIGARETTE. . . . . . . . . . . . . CIGAR MAKING T&E . . . . . . . . .  122
   Roller, Corrugated. . . . . . . . . . . AGRICULTURAL T&E
   use  ROLLER, LAND
ROLLER, GARDEN . . . . . . . . . . . . . . AGRICULTURAL T&E . . . . . . . . .   49
ROLLER, GOLD-FINISHING . . . . . . . . . . MEDICAL & PSYCHOLOGICAL T&E. . . .  153
ROLLER, GRAINING . . . . . . . . . . . . . PAINTING T&E . . . . . . . . . . .  103
ROLLER, IMPREGNATING . . . . . . . . . . . GLASS, PLASTICS, CLAYWORKING T&E .   81
ROLLER, LAND . . . . . . . . . . . . . . . AGRICULTURAL T&E . . . . . . . . .   49
   Roller, Lawn. . . . . . . . . . . . . . AGRICULTURAL T&E
   use  ROLLER, GARDEN
   Roller, Linen . . . . . . . . . . . . . FOOD SERVICE T&E
   use  CASE, NAPKIN
ROLLER, POTTER'S . . . . . . . . . . . . . GLASS, PLASTICS, CLAYWORKING T&E .   81
ROLLER, PRINT. . . . . . . . . . . . . . . PHOTOGRAPHIC T&E . . . . . . . . .  177
ROLLER, SNOW . . . . . . . . . . . . . . . LTE -- ANIMAL-POWERED. . . . . . .  190
ROLLER, TOBACCO. . . . . . . . . . . . . . CIGAR MAKING T&E . . . . . . . . .  122
ROLLER, TOWEL. . . . . . . . . . . . . . . HOUSEHOLD ACCESSORY. . . . . . . .   18
ROLLY-DOLL . . . . . . . . . . . . . . . . TOY. . . . . . . . . . . . . . . .  225
ROMPER . . . . . . . . . . . . . . . . . . CLOTHING -- OUTERWEAR. . . . . . .   31
ROMPER . . . . . . . . . . . . . . . . . . TOY. . . . . . . . . . . . . . . .  225
ROOM, MINIATURE. . . . . . . . . . . . . . DOCUMENTARY ARTIFACT . . . . . . .  213
   rt   DIORAMA
ROPE . . . . . . . . . . . . . . . . . . . WATER TRANSPORTATION -- ACCESSORY.  203
   rt   SHEET; RODE, ANCHOR
ROPE . . . . . . . . . . . . . . . . . . . MULTIPLE USE ARTIFACT. . . . . . .  228
ROPE, CLIMBING . . . . . . . . . . . . . . SPORTS EQUIPMENT . . . . . . . . .  222
ROPE, JUMP . . . . . . . . . . . . . . . . TOY. . . . . . . . . . . . . . . .  225
   Rope, Skipping. . . . . . . . . . . . . TOY
   use  ROPE, JUMP
ROPE, SWINGING . . . . . . . . . . . . . . SPORTS EQUIPMENT . . . . . . . . .  222
ROSETTE. . . . . . . . . . . . . . . . . . BUILDING COMPONENT . . . . . . . .    6
   Rosette, Bridle . . . . . . . . . . . . LTE -- ACCESSORY
   use  ORNAMENT, BRIDLE
ROSIN. . . . . . . . . . . . . . . . . . . MUSICAL T&E. . . . . . . . . . . .  174
ROSTER . . . . . . . . . . . . . . . . . . DOCUMENTARY ARTIFACT . . . . . . .  213
```

- -

- -

```
RUNNER, TABLE. . . . . . . . . . . . . . . HOUSEHOLD ACCESSORY. . . . . . .   18
RUSHLIGHT. . . . . . . . . . . . . . . . . LIGHTING DEVICE. . . . . . . . .   21
SABER. . . . . . . . . . . . . . . . . . . ARMAMENT -- EDGED. . . . . . . .  127
SABRE, FENCING . . . . . . . . . . . . . . SPORTS EQUIPMENT . . . . . . . .  222
   rt   EPEE; FOIL
SABER, SHORT . . . . . . . . . . . . . . . ARMAMENT -- EDGED. . . . . . . .  127
SABOT. . . . . . . . . . . . . . . . . . . CLOTHING -- FOOTWEAR . . . . . .   26
SABOTON. . . . . . . . . . . . . . . . . . ARMAMENT -- BODY ARMOR . . . . .  130
SACCHARIMETER. . . . . . . . . . . . . . . CHEMICAL T&E . . . . . . . . . .  140
SACHET . . . . . . . . . . . . . . . . . . CLOTHING -- ACCESSORY. . . . . .   34
SACK,. . . . . . . . . . . . . . . . . . . CLOTHING -- OUTERWEAR. . . . . .   31
  Sack. . . . . . . . . . . . . . . . . . . MERCHANDISING T&E
   use  BAG
  Sackbut . . . . . . . . . . . . . . . . . MUSICAL T&E
   use  TROMBONE
  Sacque. . . . . . . . . . . . . . . . . . CLOTHING -- OUTERWEAR
   use  SACK
SADDLE . . . . . . . . . . . . . . . . . . LTE -- ACCESSORY . . . . . . . .  195
SADDLE, PACK . . . . . . . . . . . . . . . LTE -- ACCESSORY . . . . . . . .  195
SADDLE, RACING . . . . . . . . . . . . . . LTE -- ACCESSORY . . . . . . . .  195
SADDLE, RIDING . . . . . . . . . . . . . . LTE -- ACCESSORY . . . . . . . .  195
SADDLE, STOCK. . . . . . . . . . . . . . . LTE -- ACCESSORY . . . . . . . .  195
SADDLEBAG. . . . . . . . . . . . . . . . . LTE -- ACCESSORY . . . . . . . .  195
SADIRON. . . . . . . . . . . . . . . . . . MAINTENANCE T&E. . . . . . . . .  146
SAFE . . . . . . . . . . . . . . . . . . . FURNITURE. . . . . . . . . . . .   13
SAFE, CANDLE . . . . . . . . . . . . . . . LIGHTING DEVICE. . . . . . . . .   21
  Safe, Food. . . . . . . . . . . . . . . . FOOD PROCESSING T&E
   use  CABINET, FOOD-STORAGE
SAFE, MATCH. . . . . . . . . . . . . . . . HOUSEHOLD ACCESSORY. . . . . . .   18
SAFE, MATCH. . . . . . . . . . . . . . . . PERSONAL GEAR. . . . . . . . . .   37
  Safe, Pie . . . . . . . . . . . . . . . . FOOD PROCESSING T&E
   use  CABINET, FOOD-STORAGE
SAFELIGHT. . . . . . . . . . . . . . . . . PHOTOGRAPHIC T&E . . . . . . . .  177
SAFETY, GRIP . . . . . . . . . . . . . . . ARMAMENT -- ACCESSORY. . . . . .  133
SAGGER . . . . . . . . . . . . . . . . . . GLASS, PLASTICS, CLAYWORKING T&E .  81
SAIL . . . . . . . . . . . . . . . . . . . WATER TRANSPORTATION -- ACCESSORY. 203
SAILBOAT . . . . . . . . . . . . . . . . . WATER TRANSPORTATION -- EQUIPMENT. 199
   rt   PRAM; DINGHY, SAILING; CATAMARAN
SAILBOAT, COMET. . . . . . . . . . . . . . WATER TRANSPORTATION -- EQUIPMENT. 199
SAILBOAT, PENGUIN. . . . . . . . . . . . . WATER TRANSPORTATION -- EQUIPMENT. 199
  Sailplane . . . . . . . . . . . . . . . . AEROSPACE -- EQUIPMENT
   use  GLIDER
SAKER. . . . . . . . . . . . . . . . . . . ARMAMENT -- ARTILLERY. . . . . .  128
SALES-SAMPLE . . . . . . . . . . . . . . . MERCHANDISING T&E. . . . . . . .  156
SALIMETER. . . . . . . . . . . . . . . . . CHEMICAL T&E . . . . . . . . . .  140
  Salinometer . . . . . . . . . . . . . . . CHEMICAL T&E
   use  SALIMETER
SALLET . . . . . . . . . . . . . . . . . . ARMAMENT -- BODY ARMOR . . . . .  130
SALOON . . . . . . . . . . . . . . . . . . BUILDING . . . . . . . . . . . .    3
SALTCELLAR . . . . . . . . . . . . . . . . FOOD SERVICE T&E . . . . . . . .   75
```

- -

SALTSHAKER FOOD PROCESSING T&E. 66
SALTSHAKER FOOD SERVICE T&E 75
SALVER FOOD SERVICE T&E 75
 Salver, Cake. FOOD SERVICE T&E
 use STAND, CAKE
 Samovar FOOD SERVICE T&E
 use URN, COFFEE
SAMPAN WATER TRANSPORTATION -- EQUIPMENT. 199
SAMPLER. ART. 206
SAMPLER, EFFLUENT. CHEMICAL T&E 140
SAMPLER, MILK. FOOD PROCESSING T&E. 66
SAMPLER, SIDEWALL. MINING & MINERAL HARVESTING T&E. . 101
SANDAL CLOTHING -- FOOTWEAR 26
SANDBAG. REGULATIVE & PROTECTIVE T&E. . . . 161
SANDBAGGER, HUDSON RIVER WATER TRANSPORTATION -- EQUIPMENT. 199
 Sandbox WRITTEN COMMUNICATION T&E
 use BOX, POUNCE
SANDBOX. RECREATIONAL DEVICE. 219
SANDER WOODWORKING T&E. 119
SANDER, BELT WOODWORKING T&E. 119
SANDER, DISK WOODWORKING T&E. 119
SANDPAPER. WOODWORKING T&E. 119
SANDPAPER. MULTIPLE USE ARTIFACT. 228
SARCOPHAGUS. CEREMONIAL ARTIFACT. 208
 rt COFFIN; CASE, MUMMY
SARI CLOTHING -- OUTERWEAR. 31
SARONG CLOTHING -- OUTERWEAR. 31
SARRUSOPHONE MUSICAL T&E. 174
SASH CLOTHING -- ACCESSORY. 34
 Sash. PERSONAL SYMBOL
 use BANDOLIER
SASH, WINDOW BUILDING COMPONENT 6
 rt FANLIGHT; SIDELIGHT; SKYLIGHT
SATCHEL. PERSONAL GEAR. 37
SATELLITE. AEROSPACE -- EQUIPMENT 187
 rt BIOSATELLITE; OBSERVATORY, ORBITING SOLAR
SATELLITE, COMMUNICATIONS. AEROSPACE -- EQUIPMENT 187
SATELLITE, DATASPHERE. AEROSPACE -- EQUIPMENT 187
SATELLITE, METEOROLOGICAL. AEROSPACE -- EQUIPMENT 187
SAUCEBOAT. FOOD SERVICE T&E 75
SAUCEPAN FOOD PROCESSING T&E. 66
SAUCER FOOD SERVICE T&E 75
SAUCER, BERRY. FOOD SERVICE T&E 75
SAUCER, DEMITASSE. FOOD SERVICE T&E 75
SAUCER, FLOWERPOT. HOUSEHOLD ACCESSORY. 18
SAUCER, NEST PAINTING T&E 103
 Sautoir ADORNMENT
 use PENDANT
SAVE-ALL PAPERMAKING T&E. 104
SAVER, SOAP. MAINTENANCE T&E. 146

- -

```
SAW. . . . . . . . . . . . . . . . . . . WOODWORKING T&E. . . . . . . . . . 119
SAW. . . . . . . . . . . . . . . . . . . METALWORKING T&E . . . . . . . . .  94
SAW. . . . . . . . . . . . . . . . . . . MULTIPLE USE ARTIFACT. . . . . . . 228
SAW, ANGLE . . . . . . . . . . . . . . . WOODWORKING T&E. . . . . . . . . . 119
SAW, BACK. . . . . . . . . . . . . . . . WOODWORKING T&E. . . . . . . . . . 119
SAW, BAND. . . . . . . . . . . . . . . . WOODWORKING T&E. . . . . . . . . . 119
SAW, BEAD. . . . . . . . . . . . . . . . WOODWORKING T&E. . . . . . . . . . 119
SAW, BENCH . . . . . . . . . . . . . . . WOODWORKING T&E. . . . . . . . . . 119
 Saw, Board. . . . . . . . . . . . . . . WOODWORKING T&E
   use  SAW, PIT
SAW, BOW . . . . . . . . . . . . . . . . WOODWORKING T&E. . . . . . . . . . 119
 Saw, Bracket. . . . . . . . . . . . . . WOODWORKING T&E
   use` FRETSAW
SAW, BRICK . . . . . . . . . . . . . . . MASONRY & STONEWORKING T&E . . . .  87
 Saw, Buck . . . . . . . . . . . . . . . FORESTRY T&E
   use  BUCKSAW
 Saw, Buhl . . . . . . . . . . . . . . . WOODWORKING T&E
   use  FRETSAW
SAW, CARCASS . . . . . . . . . . . . . . WOODWORKING T&E. . . . . . . . . . 120
SAW, CHAIN . . . . . . . . . . . . . . . FORESTRY T&E . . . . . . . . . . .  78
 Saw, Chairmaker's . . . . . . . . . . . WOODWORKING T&E
   use  SAW, FELLOE
SAW, CHEESE. . . . . . . . . . . . . . . FOOD PROCESSING T&E. . . . . . . .  66
 Saw, Circular . . . . . . . . . . . . . WOODWORKING T&E
   use  SAW, BENCH or SAW, RADIAL-ARM or SAW, ELECTRIC-PORTABLE
SAW, COMPASS . . . . . . . . . . . . . . WOODWORKING T&E. . . . . . . . . . 120
   rt  SAW, KEYHOLE
SAW, CONCRETE. . . . . . . . . . . . . . CONSTRUCTION T&E . . . . . . . . . 141
SAW, COPING. . . . . . . . . . . . . . . WOODWORKING T&E. . . . . . . . . . 120
   rt  FRETSAW
SAW, CROSSCUT. . . . . . . . . . . . . . WOODWORKING T&E. . . . . . . . . . 120
SAW, CROWN . . . . . . . . . . . . . . . WOODWORKING T&E. . . . . . . . . . 120
   rt  BIT, ANNULAR
 Saw, Dehorning. . . . . . . . . . . . . ANIMAL HUSBANDRY T&E
   use  DEHORNER
SAW, DENTAL. . . . . . . . . . . . . . . MEDICAL & PSYCHOLOGICAL T&E. . . . 153
SAW, DOVETAIL. . . . . . . . . . . . . . WOODWORKING T&E. . . . . . . . . . 120
SAW, ELECTRIC-PORTABLE . . . . . . . . . WOODWORKING T&E. . . . . . . . . . 120
SAW, FELLOE. . . . . . . . . . . . . . . WOODWORKING T&E. . . . . . . . . . 120
SAW, FRAME . . . . . . . . . . . . . . . WOODWORKING T&E. . . . . . . . . . 120
SAW, FRAMED VENEER . . . . . . . . . . . WOODWORKING T&E. . . . . . . . . . 120
   rt  SAW, VENEER
 Saw, Fret . . . . . . . . . . . . . . . WOODWORKING T&E
   use  FRETSAW
 Saw, Fretwork . . . . . . . . . . . . . WOODWORKING T&E
   use  FRETSAW
SAW, FUZE. . . . . . . . . . . . . . . . ARMAMENT -- ACCESSORY. . . . . . . 133
 Saw, Hack . . . . . . . . . . . . . . . METALWORKING T&E
   use  HACKSAW
SAW, HAND. . . . . . . . . . . . . . . . WOODWORKING T&E. . . . . . . . . . 120
```

- -

```
SAW, HEADING . . . . . . . . . . . . . WOODWORKING T&E. . . . . . . . .  120
SAW, ICE . . . . . . . . . . . . . . . MINING & MINERAL HARVESTING T&E. .  101
 Saw, Jig. . . . . . . . . . . . . . . WOODWORKING T&E
  use JIGSAW
SAW, KEYHOLE . . . . . . . . . . . . . WOODWORKING T&E. . . . . . . . . .  120
  rt  SAW, COMPASS
 Saw, Lock . . . . . . . . . . . . . . WOODWORKING T&E
  use SAW, KEYHOLE
 Saw, Long . . . . . . . . . . . . . . WOODWORKING T&E
  use SAW, CROSSCUT
SAW, MASON'S . . . . . . . . . . . . . MASONRY & STONEWORKING T&E . . . .   87
SAW, MEAT. . . . . . . . . . . . . . . FOOD PROCESSING T&E. . . . . . . .   66
SAW, MITER-BOX . . . . . . . . . . . . WOODWORKING T&E. . . . . . . . . .  120
SAW, MUSICAL . . . . . . . . . . . . . MUSICAL T&E. . . . . . . . . . . .  174
SAW, PATTERNMAKER'S. . . . . . . . . . WOODWORKING T&E. . . . . . . . . .  120
SAW, PIT . . . . . . . . . . . . . . . WOODWORKING T&E. . . . . . . . . .  120
SAW, PRUNING . . . . . . . . . . . . . AGRICULTURAL T&E . . . . . . . . .   49
SAW, RABBET. . . . . . . . . . . . . . WOODWORKING T&E. . . . . . . . . .  120
  rt  PLANE, RABBET
SAW, RADIAL-ARM. . . . . . . . . . . . WOODWORKING T&E. . . . . . . . . .  120
 Saw, Rip. . . . . . . . . . . . . . . WOODWORKING T&E
  use RIPSAW
SAW, SABRE . . . . . . . . . . . . . . WOODWORKING T&E. . . . . . . . . .  120
 Saw, Scroll . . . . . . . . . . . . . WOODWORKING T&E
  use FRETSAW
 Saw, Skill. . . . . . . . . . . . . . WOODWORKING T&E
  use SAW, ELECTRIC PORTABLE
SAW, STAIRBUILDER'S. . . . . . . . . . WOODWORKING T&E. . . . . . . . . .  120
 Saw, Stone. . . . . . . . . . . . . . MASONRY & STONEWORKING T&E
  use SAW, MASON'S
SAW, SURGICAL. . . . . . . . . . . . . MEDICAL & PSYCHOLOGICAL T&E. . . .  153
SAW, TENON . . . . . . . . . . . . . . WOODWORKING T&E. . . . . . . . . .  120
 Saw, Thwart . . . . . . . . . . . . . WOODWORKING T&E
  use SAW, CROSSCUT
SAW, TWO-HANDED CROSSCUT . . . . . . . FORESTRY T&E . . . . . . . . . . .   78
SAW, VELLUM. . . . . . . . . . . . . . WOODWORKING T&E. . . . . . . . . .  120
SAW, VENEER. . . . . . . . . . . . . . WOODWORKING T&E. . . . . . . . . .  120
 Saw, Woodcutter's . . . . . . . . . . FORESTRY T&E
  use BUCKSAW
SAWBUCK. . . . . . . . . . . . . . . . WOODWORKING T&E. . . . . . . . . .  120
  rt  PROP, SAWYER'S; SAWHORSE; TACKLE, SAWING
SAWHORSE . . . . . . . . . . . . . . . WOODWORKING T&E. . . . . . . . . .  120
  rt  SAWBUCK; PROP, SAWYER'S; TACKLE, SAWING
SAWMILL, BAND. . . . . . . . . . . . . WOODWORKING T&E. . . . . . . . . .  120
SAWMILL, CIRCULAR. . . . . . . . . . . WOODWORKING T&E. . . . . . . . . .  120
SAWMILL, GANG. . . . . . . . . . . . . WOODWORKING T&E. . . . . . . . . .  120
SAWMILL, GATE-TYPE . . . . . . . . . . WOODWORKING T&E. . . . . . . . . .  120
SAWMILL, MULEY . . . . . . . . . . . . WOODWORKING T&E. . . . . . . . . .  120
SAWMILL, UP-AND-DOWN . . . . . . . . . WOODWORKING T&E. . . . . . . . . .  120
SAW-SET. . . . . . . . . . . . . . . . WOODWORKING T&E. . . . . . . . . .  120
  rt  WREST, SAW
```

- -

- -

```
Scarf, Washstand. . . . . . . . . . HOUSEHOLD ACCESSORY
   use  SCARF, BUREAU
SCARIFICATOR . . . . . . . . . . . . MEDICAL & PSYCHOLOGICAL T&E. . . . 153
SCARIFIER. . . . . . . . . . . . . . CONSTRUCTION T&E . . . . . . . . . 141
SCEPTER. . . . . . . . . . . . . . . PERSONAL SYMBOL. . . . . . . . . . 216
SCHOOL . . . . . . . . . . . . . . . BUILDING . . . . . . . . . . . . .   3
SCHOONER, PRAIRIE. . . . . . . . . . LTE -- ANIMAL-POWERED. . . . . . . 190
   rt  WAGON, CONESTOGA
SCIOPTICON . . . . . . . . . . . . . PUBLIC ENTERTAINMENT DEVICE. . . . 218
SCISSORS . . . . . . . . . . . . . . TOILET ARTICLE . . . . . . . . . .  39
SCISSORS . . . . . . . . . . . . . . TEXTILEWORKING T&E . . . . . . . . 109
   rt  SHEARS
SCISSORS . . . . . . . . . . . . . . MULTIPLE USE ARTIFACT. . . . . . . 228
SCISSORS, BANDAGE. . . . . . . . . . MEDICAL & PSYCHOLOGICAL T&E. . . . 153
SCISSORS, DENTAL . . . . . . . . . . MEDICAL & PSYCHOLOGICAL T&E. . . . 153
SCISSORS, DISSECTING . . . . . . . . BIOLOGICAL T&E . . . . . . . . . . 137
SCISSORS, MANICURE . . . . . . . . . TOILET ARTICLE . . . . . . . . . .  39
Scissors, Pineapple . . . . . . . . FOOD PROCESSING T&E
   use  SNIPS, PINEAPPLE
Scissors, Poultry . . . . . . . . . FOOD PROCESSING T&E
   use  SHEARS, POULTRY
SCISSORS, SURGICAL . . . . . . . . . MEDICAL & PSYCHOLOGICAL T&E. . . . 154
SCISSORS, VINE . . . . . . . . . . . AGRICULTURAL T&E . . . . . . . . .  49
SCLEROMETER. . . . . . . . . . . . . MECHANICAL T&E . . . . . . . . . . 147
SCONCE . . . . . . . . . . . . . . . LIGHTING DEVICE. . . . . . . . . .  21
   rt  CANDELABRUM; CANDLESTICK
SCOOP. . . . . . . . . . . . . . . . FOOD PROCESSING T&E . . . . . . .   66
SCOOP. . . . . . . . . . . . . . . . MULTIPLE USE ARTIFACT. . . . . . . 228
SCOOP, BUTTER. . . . . . . . . . . . FOOD PROCESSING T&E . . . . . . .   66
SCOOP, CHEESE. . . . . . . . . . . . FOOD SERVICE T&E . . . . . . . . .  75
SCOOP, CRANBERRY . . . . . . . . . . FOOD PROCESSING T&E . . . . . . .   66
SCOOP, CURD. . . . . . . . . . . . . FOOD PROCESSING T&E . . . . . . .   66
SCOOP, FEED. . . . . . . . . . . . . AGRICULTURAL T&E . . . . . . . . .  49
Scoop, Grain. . . . . . . . . . . . AGRICULTURAL T&E
   use  SHOVEL, GRAIN
SCOOP, ICE-CREAM . . . . . . . . . . FOOD PROCESSING T&E . . . . . . .   66
SCOOP, MARROW. . . . . . . . . . . . FOOD PROCESSING T&E . . . . . . .   66
SCOOP, NUT . . . . . . . . . . . . . FOOD SERVICE T&E . . . . . . . . .  75
Scoop, Potato . . . . . . . . . . . AGRICULTURAL T&E
   use  FORK, VEGETABLE SCOOP
SCOOP, SCALE . . . . . . . . . . . . WEIGHTS & MEASURES T&E . . . . . . 166
SCOOP, TURTLE. . . . . . . . . . . . FISHING & TRAPPING T&E . . . . . .  57
Scoop, Winnowing. . . . . . . . . . AGRICULTURAL T&E
   use  BASKET, WINNOWING
SCOOTER. . . . . . . . . . . . . . . TOY. . . . . . . . . . . . . . . . 225
SCOOTER, MOTOR . . . . . . . . . . . LTE -- MOTORIZED . . . . . . . . . 192
Scope, Rangefinder. . . . . . . . . ARMAMENT -- ACCESSORY
   use  SIGHT, TELESCOPE
Scope, Sniper's . . . . . . . . . . ARMAMENT -- ACCESSORY
   use  SIGHT, TELESCOPE
```

- -

Scope, Target ARMAMENT -- ACCESSORY
 use SIGHT, TELESCOPE
SCORECARD. DOCUMENTARY ARTIFACT 213
SCORPER, CLOSED. WOODWORKING T&E. 120
 rt DRAWKNIFE
SCORPER, OPEN. WOODWORKING T&E. 121
 rt DRAWKNIFE
SCOTOSCOPE OPTICAL T&E. 160
SCOURER, GRAIN FOOD PROCESSING T&E. 66
 Scourer, Wheat. FOOD PROCESSING T&E
 use SCOURER, GRAIN
SCOW WATER TRANSPORTATION -- EQUIPMENT. 199
SCRAP. ART. 206
SCRAPBOOK. DOCUMENTARY ARTIFACT 213
SCRAPER. LEATHER, HORN, SHELLWORKING T&E. . 85
SCRAPER. GLASS, PLASTICS, CLAYWORKING T&E . 81
SCRAPER. METALWORKING T&E 94
SCRAPER. WOODWORKING T&E. 121
SCRAPER. PRINTING T&E 179
SCRAPER. CONSTRUCTION T&E 141
SCRAPER, ASH TEMPERATURE CONTROL DEVICE 22
SCRAPER, BAND. ARMAMENT -- ACCESSORY. 133
SCRAPER, BARREL. ARMAMENT -- ACCESSORY. 133
SCRAPER, BOOT. HOUSEHOLD ACCESSORY. 18
SCRAPER, BOOT. MAINTENANCE T&E. 146
SCRAPER, CASING. FOOD PROCESSING T&E. 66
SCRAPER, CORN. FOOD PROCESSING T&E. 66
SCRAPER, COTTON. AGRICULTURAL T&E 49
SCRAPER, DENTAL. MEDICAL & PSYCHOLOGICAL T&E. . . . 154
SCRAPER, DOUGH FOOD PROCESSING T&E. 66
SCRAPER, FLAT. METALWORKING T&E 94
SCRAPER, HALF-ROUND. METALWORKING T&E 94
SCRAPER, HOE MINING & MINERAL HARVESTING T&E. . 101
SCRAPER, HOG FOOD PROCESSING T&E. 66
SCRAPER, HOOK. METALWORKING T&E 94
SCRAPER, MORTAR. ARMAMENT -- ACCESSORY. 133
SCRAPER, SHELL ARMAMENT -- ACCESSORY. 133
SCRAPER, STOVE TEMPERATURE CONTROL DEVICE 22
SCRAPER, SWEAT ANIMAL HUSBANDRY T&E 55
SCRAPER, THREE-CORNERED. METALWORKING T&E 94
SCRAPER, TONGUE. TOILET ARTICLE 39
SCRAPER, TONGUE. MEDICAL & PSYCHOLOGICAL T&E. . . . 154
SCRAPER, TREE. FORESTRY T&E 78
SCRAPER, TURPENTINE. FORESTRY T&E 78
SCRAPER, WALL. PAINTING T&E 103
SCRATCHER, BACK. TOILET ARTICLE 40
SCREED MASONRY & STONEWORKING T&E 87
SCREEN FURNITURE. 13
SCREEN METALWORKING T&E 94
SCREEN VISUAL COMMUNICATION T&E 183

- -

SCREEN, FIRE TEMPERATURE CONTROL DEVICE 22
 Screen, Food. FOOD PROCESSING T&E
 use COVER, FOOD
SCREEN, POLE FURNITURE. 14
 Screen, Revolving FOOD PROCESSING T&E
 use SCREEN, ROLLING
SCREEN, ROLLING. FOOD PROCESSING T&E. 66
 Screen, Silk. PRINTING T&E
 use STENCIL
SCREEN, TABLE. HOUSEHOLD ACCESSORY. 18
SCREEN, TROMMEL. MINING & MINERAL HARVESTING T&E. . 101
SCREEN, WINDOW BUILDING COMPONENT 6
SCREW. METALWORKING T&E 94
SCREW. WOODWORKING T&E. 121
SCREW, ARCHIMEDIAN MECHANICAL T&E 148
SCREW, MACHINE METALWORKING T&E 94
SCREW, RIGGERS METALWORKING T&E 94
SCREW, SHEET METAL METALWORKING T&E 94
SCREWDRIVER. MULTIPLE USE ARTIFACT. 228
SCRIBE, TIMBER FORESTRY T&E 78
SCRIBER. WOODWORKING T&E. 121
 rt AWL, MARKING
 Scrip EXCHANGE MEDIUM
 use CURRENCY
SCRIPT DOCUMENTARY ARTIFACT 213
SCROLLER GLASS, PLASTICS, CLAYWORKING T&E . 81
SCRUBBER MAINTENANCE T&E. 146
 Scuff CLOTHING -- FOOTWEAR
 use SLIPPER
 Scull WATER TRANSPORTATION -- EQUIPMENT
 use SHELL, SINGLE SCULL
SCULPTURE. ART. 206
 Scutcheon BUILDING COMPONENT
 use ESCUTCHEON
 Scutcher, Flax. TEXTILEWORKING T&E
 use KNIFE, SCUTCHING
SCUTTLE, COAL. TEMPERATURE CONTROL DEVICE 22
SCYTHE AGRICULTURAL T&E 49
 Scythe, Brush AGRICULTURAL T&E
 use SCYTHE
SCYTHE, CRADLE AGRICULTURAL T&E 49
SCYTHE, FLEMISH. AGRICULTURAL T&E 49
 Scythe, Grass AGRICULTURAL T&E
 use SCYTHE
 Scythe, Hainault. AGRICULTURAL T&E
 use SCYTHE, FLEMISH
 Scythe, Weed. AGRICULTURAL T&E
 use SCYTHE
SEAL PERSONAL SYMBOL. 216
 rt RING, SIGNET

- -

SEAL, JAR LID. FOOD PROCESSING T&E. 66
SEALER, TREE AGRICULTURAL T&E 49
 Seaplane. AEROSPACE -- EQUIPMENT
 use AIRPLANE
SEARCHER, VENT ARMAMENT -- ACCESSORY. 133
SEARCHLIGHT. LIGHTING DEVICE. 21
SEAT, FOLDING. LTE -- ACCESSORY 195
SEAT, GARDEN FURNITURE. 14
SEAT, LOVE FURNITURE. 14
 rt SOFA, CONVERSATIONAL
SEAT, WINDOW BUILDING COMPONENT 6
SEATER, BULLET ARMAMENT -- ACCESSORY. 133
SECRETARY. FURNITURE. 14
 rt DESK, DROP-FRONT
SECTOGRAPH DRAFTING T&E 171
SECTOR DRAFTING T&E 171
SEDAN. LTE -- HUMAN-POWERED 191
SEED, MELON. WATER TRANSPORTATION -- EQUIPMENT. 199
 rt SKIFF, GUNNING
 Seeder, Broadcast AGRICULTURAL T&E
 use SEEDER, CENTRIFUGAL; SEEDER, HAND CENTRIFUGAL; SEEDER SEEDBOX; or
 SEEDER, HAND SEEDBOX
SEEDER, CENTRIFUGAL. AGRICULTURAL T&E 49
 note use for an animal- or machine-powered centrifugal seeder
 Seeder, Endgate AGRICULTURAL T&E
 use SEEDER, CENTRIFUGAL
SEEDER, HAND CENTRIFUGAL AGRICULTURAL T&E 49
 note use for a hand-powered centrifugal seeder
SEEDER, HAND SEEDBOX AGRICULTURAL T&E 49
 note use for a hand-carried or -pushed seedbox seeder
 Seeder, Rotary. AGRICULTURAL T&E
 use SEEDER, CENTRIFUGAL or SEEDER, HAND CENTRIFUGAL
SEEDER, SEEDBOX. AGRICULTURAL T&E 49
 note use for an animal- or machine-powered seedbox seeder
 Seeder, Wheelbarrow AGRICULTURAL T&E
 use SEEDER, HAND SEEDBOX
SEESAW RECREATIONAL DEVICE. 219
SEESAW, COILED-SPRING. RECREATIONAL DEVICE. 219
 Seine FISHING & TRAPPING T&E
 use NET, SEINE or NET, PURSE
SEISMOGRAPH. METEOROLOGICAL T&E 157
SEISMOPHONE. METEOROLOGICAL T&E 158
SELENOTROPE. ASTRONOMICAL T&E 135
SEMAPHORE, RAILROAD. VISUAL COMMUNICATION T&E 183
 rt SIGNAL, RAILROAD
SEMICIRCLE SURVEYING & NAVIGATIONAL T&E . . . 163
SEMICIRCUMFERENTOR SURVEYING & NAVIGATIONAL T&E . . . 163
SEMITRAILER. LTE -- MOTORIZED 192
 rt TRAILER
 Separator AGRICULTURAL T&E
 use THRESHER/SEPARATOR

- -

Separator. METALWORKING T&E 94
 note see Mining T&E for separators for metals
SEPARATOR. MINING & MINERAL HARVESTING T&E. . 101
SEPARATOR, BEAM. NUCLEAR PHYSICS T&E. 158
SEPARATOR, CRADLE. MINING & MINERAL HARVESTING T&E. . 101
SEPARATOR, CREAM FOOD PROCESSING T&E. 66
SEPARATOR, DISK. FOOD PROCESSING T&E. 66
SEPARATOR, EGG FOOD PROCESSING T&E. 66
SEPARATOR, ELECTROMAGNETIC MINING & MINERAL HARVESTING T&E. . 101
SEPARATOR, ELECTROSTATIC MINING & MINERAL HARVESTING T&E. . 101
SEPARATOR, FRAME MINING & MINERAL HARVESTING T&E. . 101
SEPARATOR, GRADING FOOD PROCESSING T&E. 66
SEPARATOR, JIGGING-MACHINE MINING & MINERAL HARVESTING T&E. . 101
SEPARATOR, MILLING FOOD PROCESSING T&E. 66
SEPARATOR, RECEIVING FOOD PROCESSING T&E. 66
SEPARATOR, TEETH MEDICAL & PSYCHOLOGICAL T&E. . . . 154
 Separator, Warehouse. FOOD PROCESSING T&E
 use SEPARATOR, RECEIVING
SEPARATOR, WASHER. MINING & MINERAL HARVESTING T&E. . 101
 Serape. CLOTHING -- OUTERWEAR
 use PONCHO
SERPENT. MUSICAL T&E. 175
SERPENT, HIDDEN. TOY. 225
 Server. FURNITURE
 use TABLE, SERVING
SERVER, CAKE FOOD SERVICE T&E 75
SERVER, CHEESE FOOD SERVICE T&E 75
SERVER, ICE-CREAM. FOOD SERVICE T&E 75
SERVER, LEMON. FOOD SERVICE T&E 75
SERVER, PIE. FOOD SERVICE T&E 75
SERVER, SALAD. FOOD SERVICE T&E 75
SERVER, TOMATO FOOD SERVICE T&E 75
SERVICE, DESSERT FOOD SERVICE T&E 75
SERVICE, TEA FOOD SERVICE T&E 75
 Serviette FOOD SERVICE T&E
 use NAPKIN
SET, ARCHWIRE SPLINT MEDICAL & PSYCHOLOGICAL T&E. . . . 154
SET, BEVERAGE. FOOD SERVICE T&E 75
 note use for a set comprising a pitcher and matching glasses
SET, BLEEDING. MEDICAL & PSYCHOLOGICAL T&E. . . . 154
SET, BLOOD COLLECTING. MEDICAL & PSYCHOLOGICAL T&E. . . . 154
 Set, Bridge FOOD SERVICE T&E
 use SET, LUNCHEON
SET, CARVING FOOD SERVICE T&E 75
SET, COLLAR & CUFF CLOTHING -- ACCESSORY. 34
SET, COLLAR & MUFF CLOTHING -- ACCESSORY. 34
SET, COLLAR & SLEEVE CLOTHING -- ACCESSORY. 34
SET, COMB & HAIRBRUSH. TOILET ARTICLE 40
SET, COMMUNION CEREMONIAL ARTIFACT. 208
SET, CONDIMENT FOOD SERVICE T&E 75
 note use for a set comprising a mustard jar, saltshaker, pepperbox, etc

- -

```
SET, CONSTRUCTION. . . . . . . . . . . . TOY. . . . . . . . . . . . . . . .  225
SET, CROQUET . . . . . . . . . . . . . . SPORTS EQUIPMENT . . . . . . . . .  222
SET, DESK. . . . . . . . . . . . . . . . WRITTEN COMMUNICATION T&E. . . . .  185
  Set, Dish . . . . . . . . . . . . . . . FOOD SERVICE T&E
    use  SET, TABLEWARE
SET, DISSECTING. . . . . . . . . . . . . BIOLOGICAL T&E . . . . . . . . . .  137
SET, DISSECTING. . . . . . . . . . . . . MEDICAL & PSYCHOLOGICAL T&E. . . .  154
SET, DRAFTING. . . . . . . . . . . . . . DRAFTING T&E . . . . . . . . . . .  171
SET, DRESSER . . . . . . . . . . . . . . TOILET ARTICLE . . . . . . . . . .   40
  Set, Erector. . . . . . . . . . . . . . TOY
    use  SET, CONSTRUCTION
  Set, Ewer & Basin . . . . . . . . . . . TOILET ARTICLE
    use  SET, TOILET
SET, FLATWARE. . . . . . . . . . . . . . FOOD SERVICE T&E . . . . . . . .    75
SET, GAME. . . . . . . . . . . . . . . . GAME . . . . . . . . . . . . . . .  218
    note use for a set of games or if specific game is unidentified
SET, GOLF. . . . . . . . . . . . . . . . SPORTS EQUIPMENT . . . . . . . . .  222
SET, INOCULATING . . . . . . . . . . . . MEDICAL & PSYCHOLOGICAL T&E. . . .  154
SET, IV. . . . . . . . . . . . . . . . . MEDICAL & PSYCHOLOGICAL T&E. . . .  154
SET, JEWELRY . . . . . . . . . . . . . . ADORNMENT. . . . . . . . . . . . .   25
SET, LAST & JACK . . . . . . . . . . . . LEATHER, HORN, SHELLWORKING T&E. .   85
  Set, Lemonade . . . . . . . . . . . . . FOOD SERVICE T&E
    use  SET, BEVERAGE
SET, LENS. . . . . . . . . . . . . . . . MEDICAL & PSYCHOLOGICAL T&E. . . .  154
SET, LUNCHEON. . . . . . . . . . . . . . FOOD SERVICE T&E . . . . . . . . .   75
      or for a relatively small tablecloth and matching napkins
SET, LUNCHEON. . . . . . . . . . . . . . FOOD SERVICE T&E . . . . . . . . .   75
    note use for a matching set of place mats, coasters, centerpiece, etc.,
SET, LUNCHEON. . . . . . . . . . . . . . FOOD SERVICE T&E . . . . . . . . .   75
    rt   SET, TABLECLOTH
SET, MANICURE. . . . . . . . . . . . . . TOILET ARTICLE . . . . . . . . . .   40
SET, OUIJA . . . . . . . . . . . . . . . GAME . . . . . . . . . . . . . . .  218
  Set, Pitcher & Cordial. . . . . . . . . FOOD SERVICE T&E
    use  SET, BEVERAGE
SET, RAWIN . . . . . . . . . . . . . . . METEOROLOGICAL T&E . . . . . . . .  158
SET, SALT & PEPPER . . . . . . . . . . . FOOD SERVICE T&E . . . . . . . . .   75
SET, SCRIBE. . . . . . . . . . . . . . . PERSONAL GEAR. . . . . . . . . . .   37
SET, SHAVING . . . . . . . . . . . . . . TOILET ARTICLE . . . . . . . . . .   40
SET, SHUFFLEBOARD. . . . . . . . . . . . SPORTS EQUIPMENT . . . . . . . . .  222
SET, SPOON & SALT. . . . . . . . . . . . FOOD SERVICE T&E . . . . . . . . .   75
  Set, Surgical instrument. . . . . . . . MEDICAL & PSYCHOLOGICAL T&E
    use  KIT, SURGICAL
SET, TABLECLOTH. . . . . . . . . . . . . FOOD SERVICE T&E . . . . . . . . .   75
    rt   SET, LUNCHEON
SET, TABLECLOTH. . . . . . . . . . . . . FOOD SERVICE T&E . . . . . . . . .   75
    note use for a matching set of napkins and tablecloth
SET, TABLE CROQUET . . . . . . . . . . . SPORTS EQUIPMENT . . . . . . . . .  222
SET, TABLE TENNIS. . . . . . . . . . . . SPORTS EQUIPMENT . . . . . . . . .  222
SET, TABLEWARE . . . . . . . . . . . . . FOOD SERVICE T&E . . . . . . . . .   75
    note use for any matched set of cups, saucers, plates, etc.
```

- -

- -

SHAKO. CLOTHING -- HEADWEAR 28
SHAM, BOLSTER. BEDDING. 9
SHAM, PILLOW BEDDING. 9
SHAPER METALWORKING T&E 94
 rt PLANER
SHAPER WOODWORKING T&E. 121
 Sharpener, Knife. METALWORKING T&E
 use STEEL or WHETSTONE
SHARPENER, NEEDLE. TEXTILEWORKING T&E 109
SHARPENER, PENCIL. WRITTEN COMMUNICATION T&E. 185
 Sharpener, Scissors METALWORKING T&E
 use STEEL or WHETSTONE
 Sharpener, Scythe METALWORKING T&E
 use ANVIL, SCYTHE-SHARPENING or STONE, SCYTHE-SHARPENING
 Sharpener, Sickle-bar METALWORKING T&E
 use GRINDER, MOWER-KNIFE
SHARPIE. WATER TRANSPORTATION -- EQUIPMENT. 199
SHARPIE, NEW HAVEN WATER TRANSPORTATION -- EQUIPMENT. 199
 Shave WOODWORKING T&E
 use DRAWSHAVE or SPOKESHAVE
SHAVE, BASKET. BASKET, BROOM, BRUSH MAKING T&E. . 122
SHAVE, EDGE. LEATHER, HORN, SHELLWORKING T&E. . 85
SHAVE, HEEL. LEATHER, HORN, SHELLWORKING T&E. . 85
SHAVE, ICE FOOD PROCESSING T&E. 67
 Shave, Round. WOODWORKING T&E
 use SCORPER, CLOSED or SCORPER, OPEN
SHAVE, UPRIGHT BASKET, BROOM, BRUSH MAKING T&E. . 122
SHAVER, DICTATING MACHINE. SOUND COMMUNICATION T&E. 181
SHAWABTI CEREMONIAL ARTIFACT. 208
SHAWL. CLOTHING -- OUTERWEAR. 31
SHAWM. MUSICAL T&E. 175
 Shay. LTE -- ANIMAL-POWERED
 use CHAISE
SHEARS GLASS, PLASTICS, CLAYWORKING T&E . 81
SHEARS TEXTILEWORKING T&E 109
 rt SCISSORS
SHEARS BASKET, BROOM, BRUSH MAKING T&E. . 122
SHEARS, BAND-CUTTER. AGRICULTURAL T&E 49
SHEARS, BENCH. METALWORKING T&E 94
SHEARS, BENCH. PRINTING T&E 180
SHEARS, CIRCLE METALWORKING T&E 94
SHEARS, DENTAL ANIMAL HUSBANDRY T&E 55
SHEARS, DRESSMAKER'S TEXTILEWORKING T&E 109
SHEARS, FETLOCK. ANIMAL HUSBANDRY T&E 55
SHEARS, FULLER'S TEXTILEWORKING T&E 109
 Shears, Garden. AGRICULTURAL T&E
 use SHEARS, HEDGE
SHEARS, GRAPE. FOOD SERVICE T&E 75
SHEARS, GRASS. AGRICULTURAL T&E 49
SHEARS, HEDGE. AGRICULTURAL T&E 49

- -

SHEARS, HORSE. ANIMAL HUSBANDRY T&E 55
SHEARS, LAWN AGRICULTURAL T&E 49
SHEARS, LEATHER. LEATHER, HORN, SHELLWORKING T&E. . 85
SHEARS, LEVER. METALWORKING T&E 94
 Shears, Mule. ANIMAL HUSBANDRY T&E
 use SHEARS, HORSE
SHEARS, PINKING. TEXTILEWORKING T&E 109
SHEARS, PORTFIRE ARMAMENT -- ACCESSORY. 133
SHEARS, POULTRY. FOOD PROCESSING T&E. 67
 Shears, Pruning AGRICULTURAL T&E
 use PRUNER, TREE
SHEARS, SHEEP. ANIMAL HUSBANDRY T&E 55
SHEARS, SQUARING METALWORKING T&E 94
SHEARS, THINNING TOILET ARTICLE 40
SHEATH ARMAMENT -- ACCESSORY. 133
SHEATH, AXE. WOODWORKING T&E. 121
SHEATH, MARLINESPIKE WATER TRANSPORTATION -- ACCESSORY. 203
SHEAVE, WINDING. MINING & MINERAL HARVESTING T&E. . 101
SHED BUILDING 3
SHED, CATTLE BUILDING 3
SHED, SHEEP. BUILDING 3
SHEET. BEDDING. 9
SHEET. WATER TRANSPORTATION -- ACCESSORY. 203
 rt ROPE
SHEET, COOKIE. FOOD PROCESSING T&E. 67
 Sheet, Order. DOCUMENTARY ARTIFACT
 use FORM, ORDER
SHEET, PLATE-BACKING PRINTING T&E 180
 Sheet/Blanket BEDDING
 use BLANKET/SHEET
SHELF. BUILDING COMPONENT 6
SHELL. WATER TRANSPORTATION -- EQUIPMENT. 199
SHELL, ARTILLERY ARMAMENT -- AMMUNITION 129
SHELL, BAND. BUILDING 3
SHELL, EIGHT-OARED WATER TRANSPORTATION -- EQUIPMENT. 199
SHELL, FOUR-OARED. WATER TRANSPORTATION -- EQUIPMENT. 199
SHELL, PAIR-OARED. WATER TRANSPORTATION -- EQUIPMENT. 200
SHELL, PRACTICE WHERRY WATER TRANSPORTATION -- EQUIPMENT. 200
SHELL, SHOTGUN ARMAMENT -- AMMUNITION 129
SHELL, SINGLE SCULL. WATER TRANSPORTATION -- EQUIPMENT. 200
 Shell, Sugar. FOOD SERVICE T&E
 use SPOON, SUGAR
SHELLER, BEAN. AGRICULTURAL T&E 50
SHELLER, CORN. AGRICULTURAL T&E 50
SHELTER, BOMB. OTHER STRUCTURE. 8
SHERD. ARTIFACT REMNANT 227
SHIELD MINING & MINERAL HARVESTING T&E. . 101
SHIELD ARMAMENT -- ACCESSORY. 133
SHIELD, HEAT AEROSPACE -- ACCESSORY 188
SHIELD, MAGNETIC ELECTRICAL & MAGNETIC T&E. 142

- -

SHIELD, SOLAR. ENERGY PRODUCTION T&E. 144
SHIFT. CLOTHING -- UNDERWEAR. 32
SHILLELAGH ARMAMENT -- BLUDGEON 127
SHINGLE. BUILDING COMPONENT 6
SHIP WATER TRANSPORTATION -- EQUIPMENT. 200
 note for sailing ships, use only with modifier indicating rigging,
 e.g.: SHIP, CLIPPER
SHIP, LANDING. WATER TRANSPORTATION -- EQUIPMENT. 200
SHIP-IN-A-BOTTLE ART. 206
SHIRT. CLOTHING -- OUTERWEAR. 31
SHIRT, DRESS CLOTHING -- OUTERWEAR. 31
SHIRT, POLO. CLOTHING -- OUTERWEAR. 31
 Shirt, T. CLOTHING -- OUTERWEAR
 use T-SHIRT
 Shiv. ARMAMENT -- EDGED
 use KNIFE
SHOCKER, CORN. AGRICULTURAL T&E 50
SHOE CLOTHING -- FOOTWEAR 26
SHOE GAME 218
SHOE, DECK CLOTHING -- FOOTWEAR 26
SHOE, TENNIS CLOTHING -- FOOTWEAR 26
SHOE, TOE. CLOTHING -- FOOTWEAR 26
SHOE, TRACK. CLOTHING -- FOOTWEAR 26
SHOE, TRIGGER. ARMAMENT -- ACCESSORY. 133
SHOEHORN CLOTHING -- ACCESSORY. 34
SHOELACE CLOTHING -- FOOTWEAR 26
SHOFAR CEREMONIAL ARTIFACT. 208
SHOP BUILDING 3
 note usually modified to indicate service or product provided
SHORTS CLOTHING -- UNDERWEAR. 32
SHORTS CLOTHING -- OUTERWEAR. 31
SHOT, BAR. ARMAMENT -- AMMUNITION 129
SHOT, CASE ARMAMENT -- AMMUNITION 129
SHOT, CHAIN. ARMAMENT -- AMMUNITION 129
SHOTGUN. ARMAMENT -- FIREARM. 125
SHOTGUN, DOUBLE-BARREL ARMAMENT -- FIREARM. 125
SHOTGUN, MULTI-BARREL. ARMAMENT -- FIREARM. 125
SHOTGUN, REPEATING ARMAMENT -- FIREARM. 125
SHOTGUN, SINGLE-BARREL ARMAMENT -- FIREARM. 125
SHOTGUN, SKEET ARMAMENT -- FIREARM. 125
SHOTGUN, TRAP. ARMAMENT -- FIREARM. 125
SHOTPUT. SPORTS EQUIPMENT 222
SHOVEL MULTIPLE USE ARTIFACT. 228
SHOVEL, BLACKSMITH'S METALWORKING T&E 94
SHOVEL, CARRYING-IN. GLASS, PLASTICS, CLAYWORKING T&E . 81
SHOVEL, COAL TEMPERATURE CONTROL DEVICE 22
SHOVEL, FIREPLACE. TEMPERATURE CONTROL DEVICE 22
SHOVEL, GRAIN. AGRICULTURAL T&E 50
 Shovel, Potato. AGRICULTURAL T&E
 use FORK, VEGETABLE SCOOP

- -

```
SHOVEL, POWER. . . . . . . . . . . . . . CONSTRUCTION T&E . . . . . . . . .  141
SHOVEL, STOVE. . . . . . . . . . . . . . TEMPERATURE CONTROL DEVICE . . . .   23
SHOWER . . . . . . . . . . . . . . . . . PLUMBING FIXTURE . . . . . . . . .   21
  Shrank. . . . . . . . . . . . . . . . . FURNITURE
  use WARDROBE
SHREDDER, FLAIL. . . . . . . . . . . . . AGRICULTURAL T&E . . . . . . . . .   50
  Shredder, Stalk . . . . . . . . . . . AGRICULTURAL T&E
  use CUTTER, STALK
SHRINE . . . . . . . . . . . . . . . . . BUILDING . . . . . . . . . . . . .    3
  rt MONUMENT
SHRINE . . . . . . . . . . . . . . . . . CEREMONIAL ARTIFACT. . . . . . .    208
  rt RELIQUARY
SHRINE, RELIGIOUS. . . . . . . . . . . . CEREMONIAL ARTIFACT. . . . . . .    208
  Shrinker, Tire. . . . . . . . . . . . . METALWORKING T&E
  use UPSETTER, TIRE
SHROUD . . . . . . . . . . . . . . . . . CEREMONIAL ARTIFACT. . . . . . .    208
SHUTTER. . . . . . . . . . . . . . . . . WINDOW OR DOOR COVERING. . . . .     23
SHUTTER. . . . . . . . . . . . . . . . . BUILDING COMPONENT . . . . . . .      6
SHUTTER. . . . . . . . . . . . . . . . . PHOTOGRAPHIC T&E . . . . . . . .    177
SHUTTLE. . . . . . . . . . . . . . . . . TEXTILEWORKING T&E . . . . . . .    110
SHUTTLE, NETTING . . . . . . . . . . . . TEXTILEWORKING T&E . . . . . . .    110
SHUTTLE, TATTING . . . . . . . . . . . . TEXTILEWORKING T&E . . . . . . .    110
SHUTTLECOCK. . . . . . . . . . . . . . . SPORTS EQUIPMENT . . . . . . . .    222
SICKLE . . . . . . . . . . . . . . . . . AGRICULTURAL T&E . . . . . . . .     50
  rt HOOK, REAPING
  Sickle, Grass . . . . . . . . . . . . AGRICULTURAL T&E
  use HOOK, GRASS
SIDEBOARD. . . . . . . . . . . . . . . . FURNITURE. . . . . . . . . . . .     14
  rt BOARD, HUNT
SIDECAR, MOTORCYCLE. . . . . . . . . . . LTE -- MOTORIZED . . . . . . . .    192
SIDELIGHT. . . . . . . . . . . . . . . . BUILDING COMPONENT . . . . . . .      6
  rt SASH, WINDOW
SIDEROSCOPE. . . . . . . . . . . . . . . ELECTRICAL & MAGNETIC T&E. . . .    142
SIDEROSTAT . . . . . . . . . . . . . . . ASTRONOMICAL T&E . . . . . . . .    135
SIDESADDLE . . . . . . . . . . . . . . . LTE -- ACCESSORY . . . . . . . .    195
SIEVE. . . . . . . . . . . . . . . . . . FOOD PROCESSING T&E. . . . . . .     67
  rt SIFTER
  Sieve, Grain. . . . . . . . . . . . . AGRICULTURAL T&E
  use RIDDLE, GRAIN
  Sieve, Winnowing. . . . . . . . . . . AGRICULTURAL T&E
  use RIDDLE, GRAIN
SIFTER . . . . . . . . . . . . . . . . . FOOD PROCESSING T&E. . . . . . .     67
  rt SIEVE
SIFTER, ASH. . . . . . . . . . . . . . . MAINTENANCE T&E. . . . . . . . .    146
SIFTER, FLOUR. . . . . . . . . . . . . . FOOD PROCESSING T&E. . . . . . .     67
SIGHT. . . . . . . . . . . . . . . . . . ARMAMENT -- ACCESSORY. . . . . .    133
SIGHT, GLOBE . . . . . . . . . . . . . . ARMAMENT -- ACCESSORY. . . . . .    133
SIGHT, MICROMETER. . . . . . . . . . . . ARMAMENT -- ACCESSORY. . . . . .    134
SIGHT, MILITARY. . . . . . . . . . . . . ARMAMENT -- ACCESSORY. . . . . .    134
SIGHT, TANG. . . . . . . . . . . . . . . ARMAMENT -- ACCESSORY. . . . . .    134
```

- -

- -

- -

```
SLEDGE, STRAIGHT-PEEN. . . . . . . . . METALWORKING T&E . . . . . . . . .  95
  Sledgehammer. . . . . . . . . . . . . METALWORKING T&E
   use  SLEDGE
SLEEVE . . . . . . . . . . . . . . . . CLOTHING -- ACCESSORY. . . . . . .  34
SLEEVE, GUNNER'S . . . . . . . . . . . ARMAMENT -- ACCESSORY. . . . . . . 134
SLEIGH . . . . . . . . . . . . . . . . LTE -- ANIMAL-POWERED. . . . . . . 190
SLEIGH, RUNABOUT . . . . . . . . . . . LTE -- ANIMAL-POWERED. . . . . . . 190
SLEIGH, SURREY . . . . . . . . . . . . LTE -- ANIMAL-POWERED. . . . . . . 190
SLICER, CHEESE . . . . . . . . . . . . FOOD PROCESSING T&E. . . . . . . .  67
SLICER, EAR-CORN . . . . . . . . . . . AGRICULTURAL T&E . . . . . . . . .  50
SLICER, FRUIT. . . . . . . . . . . . . FOOD PROCESSING T&E. . . . . . . .  67
SLICER, MEAT . . . . . . . . . . . . . FOOD PROCESSING T&E. . . . . . . .  67
SLICER, VEGETABLE. . . . . . . . . . . FOOD PROCESSING T&E. . . . . . . .  67
SLICK. . . . . . . . . . . . . . . . . WOODWORKING T&E. . . . . . . . . . 121
   rt  CHISEL
SLICKER. . . . . . . . . . . . . . . . CLOTHING -- OUTERWEAR. . . . . . .  31
   rt  RAINCOAT; OILSKIN
SLICKER. . . . . . . . . . . . . . . . LEATHER, HORN, SHELLWORKING T&E. .  85
SLIDE. . . . . . . . . . . . . . . . . OPTICAL T&E. . . . . . . . . . . . 160
  Slide . . . . . . . . . . . . . . . . DOCUMENTARY ARTIFACT
   use  TRANSPARENCY, LANTERN-SLIDE or TRANSPARENCY, SLIDE
SLIDE. . . . . . . . . . . . . . . . . RECREATIONAL DEVICE. . . . . . . . 219
SLIDE, FRICTION. . . . . . . . . . . . MECHANICAL T&E . . . . . . . . . . 148
  Slide, Lantern. . . . . . . . . . . . DOCUMENTARY ARTIFACT
   use  TRANSPARENCY, LANTERN-SLIDE
SLIDE, MICROSCOPE. . . . . . . . . . . BIOLOGICAL T&E . . . . . . . . . . 137
SLIDE, SCARF . . . . . . . . . . . . . CLOTHING -- ACCESSORY. . . . . . .  34
SLING. . . . . . . . . . . . . . . . . ARMAMENT -- ACCESSORY. . . . . . . 134
  Sling, Grain. . . . . . . . . . . . . AGRICULTURAL T&E
   use  SLING, HAY
SLING, HAY . . . . . . . . . . . . . . AGRICULTURAL T&E . . . . . . . . .  50
SLINGSHOT. . . . . . . . . . . . . . . ARMAMENT -- BLUDGEON . . . . . . . 127
SLINKY . . . . . . . . . . . . . . . . TOY. . . . . . . . . . . . . . . . 225
SLIP . . . . . . . . . . . . . . . . . CLOTHING -- UNDERWEAR. . . . . . .  32
  Slip, Half. . . . . . . . . . . . . . CLOTHING -- UNDERWEAR
   use  PETTICOAT
  Slip, Pillow. . . . . . . . . . . . . BEDDING
   use  PILLOWCASE
SLIPCASE, BOOK . . . . . . . . . . . . DOCUMENTARY ARTIFACT . . . . . . . 213
SLIPCOVER. . . . . . . . . . . . . . . HOUSEHOLD ACCESSORY. . . . . . . .  18
SLIPPER. . . . . . . . . . . . . . . . CLOTHING -- FOOTWEAR . . . . . . .  26
SLIPPER, BALLET. . . . . . . . . . . . CLOTHING -- FOOTWEAR . . . . . . .  26
SLIPPER, BATHING . . . . . . . . . . . CLOTHING -- FOOTWEAR . . . . . . .  26
SLITTER. . . . . . . . . . . . . . . . PAPERMAKING T&E. . . . . . . . . . 104
SLITTER, TEAT. . . . . . . . . . . . . ANIMAL HUSBANDRY T&E . . . . . . .  55
SLOOP, FRIENDSHIP. . . . . . . . . . . WATER TRANSPORTATION -- EQUIPMENT. 200
SLOOP, NOANK . . . . . . . . . . . . . WATER TRANSPORTATION -- EQUIPMENT. 200
SLOT, MAIL . . . . . . . . . . . . . . BUILDING COMPONENT . . . . . . . .   6
SLUBBER. . . . . . . . . . . . . . . . TEXTILEWORKING T&E . . . . . . . . 110
SLUG . . . . . . . . . . . . . . . . . PRINTING T&E . . . . . . . . . . . 180
```

- -

SLUICE OTHER STRUCTURE. 8
 rt FLUME
SLUSHER. MINING & MINERAL HARVESTING T&E. . 101
SMOCK. CLOTHING -- OUTERWEAR. 31
SMOKEHOUSE BUILDING 3
 Smokejack FOOD PROCESSING T&E
 use JACK, BOTTLE
SMOKER, BEE. ANIMAL HUSBANDRY T&E 55
 Smokestack. BUILDING COMPONENT
 use FLUE
SMOOTHER LEATHER, HORN, SHELLWORKING T&E. . 85
SMUTTER. FOOD PROCESSING T&E. 67
SNAPDRAGON GLASS, PLASTICS, CLAYWORKING T&E . 81
 Snapper, Corn AGRICULTURAL T&E
 use PICKER, CORN
SNAPSETTER TEXTILEWORKING T&E 110
 Snapshot. DOCUMENTARY ARTIFACT
 use PRINT, PHOTOGRAPHIC
SNARE. FISHING & TRAPPING T&E 57
 Sneaker CLOTHING -- FOOTWEAR
 use SHOE with suitable modifier, e.g.: SHOE, TENNIS
SNIFTER. FOOD SERVICE T&E 76
SNIPS, PINEAPPLE FOOD SERVICE T&E 76
SNIPS, PINEAPPLE FOOD PROCESSING T&E. 67
SNIPS, SHEET METALWORKER'S METALWORKING T&E 95
 Snood CLOTHING -- HEADWEAR
 use HAIRNET
SNORE. MINING & MINERAL HARVESTING T&E. . 101
SNORKEL. SPORTS EQUIPMENT 222
 Snorkel LTE -- MOTORIZED
 use PLATFORM, ELEVATING
SNOWMOBILE LTE -- MOTORIZED 192
SNOWSHED BUILDING 3
SNOWSHOE LTE -- HUMAN-POWERED 191
SNUFFBOX PERSONAL GEAR. 37
 Snuffer, Candle LIGHTING DEVICE
 use CANDLESNUFFER
SOAP TOILET ARTICLE 40
SOAP MAINTENANCE T&E. 146
SOCIABLE LTE -- HUMAN-POWERED 191
SOCIABLE LTE -- ANIMAL-POWERED. 190
SOCK CLOTHING -- FOOTWEAR 26
SOCK, WIND AEROSPACE -- ACCESSORY 188
SOCKET METALWORKING T&E 95
SOCKET, TUBE ELECTRICAL & MAGNETIC T&E. 143
SOFA FURNITURE. 14
 rt SETTEE
SOFA, CONVERSATIONAL FURNITURE. 14
 rt SEAT, LOVE

- -

SOFA, CONVERSATIONAL FURNITURE. 14
 note use for a sofa seating two persons facing in opposite directions
SOFTBALL SPORTS EQUIPMENT 222
SOLANDER WRITTEN COMMUNICATION T&E. 185
 Soldier TOY
 use FIGURE
 Solenoid. ELECTRICAL & MAGNETIC T&E
 use SWITCH, SOLENOID
SOLOPHONE. MUSICAL T&E. 175
SOMBRERO CLOTHING -- HEADWEAR 28
 rt HAT, COWBOY
SONDOGRAPH SURVEYING & NAVIGATIONAL T&E . . . 164
SONOMETER. ACOUSTICAL T&E 123
SORTER, BEAN FOOD PROCESSING T&E. 67
SORTER, CARD DATA PROCESSING T&E. 170
 Sorter, Pea FOOD PROCESSING T&E
 use SORTER, BEAN
SORTER, POTATO FOOD PROCESSING T&E. 67
SOUND. MEDICAL & PSYCHOLOGICAL T&E. . . . 154
 Sousaphone. MUSICAL T&E
 use TUBA
 Sower, Broadcast. AGRICULTURAL T&E
 use SEEDER, CENTRIFUGAL or SEEDER, SEEDBOX
 Sower, Seedbox. AGRICULTURAL T&E
 use SEEDER, SEEDBOX
SPACECRAFT AEROSPACE -- EQUIPMENT 187
SPACECRAFT, MANNED COMMAND-MODULE. . . AEROSPACE -- EQUIPMENT 187
SPACECRAFT, MANNED LUNAR-MODULE. . . . AEROSPACE -- EQUIPMENT 187
SPACECRAFT, MANNED ORBITAL-WORKSHOP. . AEROSPACE -- EQUIPMENT 187
 Spacecraft, Unmanned. AEROSPACE -- EQUIPMENT
 use SPACEPROBE
SPACEPROBE AEROSPACE -- EQUIPMENT 187
SPADE, BLUBBER FISHING & TRAPPING T&E 57
SPADE, BONE. FISHING & TRAPPING T&E 57
SPADE, BUTTER-WORKING. FOOD PROCESSING T&E. 67
SPADE, DITCHING. AGRICULTURAL T&E 50
SPADE, DRAIN-TILE. AGRICULTURAL T&E 50
SPADE, GARDEN. AGRICULTURAL T&E 50
SPADE, GRAFTING. MINING & MINERAL HARVESTING T&E. . 101
SPADE, HAY AGRICULTURAL T&E 50
 rt KNIFE, HAY
SPADE, PEAT. AGRICULTURAL T&E 50
 Spade, Turf AGRICULTURAL T&E
 use LIFTER, SOD
SPANKER. WATER TRANSPORTATION -- ACCESSORY. 203
SPAT CLOTHING -- FOOTWEAR 26
SPATULA. GLASS, PLASTICS, CLAYWORKING T&E . 81
SPATULA. FOOD PROCESSING T&E. 67
SPATULA. MEDICAL & PSYCHOLOGICAL T&E. . . . 154
SPATULA. PAINTING T&E 103

- -

```
SPATULA, DENTAL. . . . . . . . . . . . . MEDICAL & PSYCHOLOGICAL T&E. . . . 154
SPATULA, SURGICAL. . . . . . . . . . . . MEDICAL & PSYCHOLOGICAL T&E. . . . 154
SPAUDLER . . . . . . . . . . . . . . . . ARMAMENT -- BODY ARMOR . . . . . . 130
SPEAKER. . . . . . . . . . . . . . . . . SOUND COMMUNICATION T&E. . . . . . 181
SPEAR. . . . . . . . . . . . . . . . . . ARMAMENT -- EDGED. . . . . . . . . 127
SPEAR, EEL . . . . . . . . . . . . . . . ARMAMENT -- EDGED. . . . . . . . . 127
SPEAR, FISH. . . . . . . . . . . . . . . ARMAMENT -- EDGED. . . . . . . . . 127
SPEAR, SQUID . . . . . . . . . . . . . . ARMAMENT -- EDGED. . . . . . . . . 127
SPECTROGRAM, SOUND . . . . . . . . . . . ACOUSTICAL T&E . . . . . . . . . . 123
SPECTROGRAPH . . . . . . . . . . . . . . OPTICAL T&E. . . . . . . . . . . . 160
SPECTROGRAPH, MASS . . . . . . . . . . . NUCLEAR PHYSICS T&E. . . . . . . . 158
SPECTROGRAPH, SOUND. . . . . . . . . . . ACOUSTICAL T&E . . . . . . . . . . 124
SPECTROHELIOGRAPH. . . . . . . . . . . . ASTRONOMICAL T&E . . . . . . . . . 135
SPECTROMETER . . . . . . . . . . . . . . OPTICAL T&E. . . . . . . . . . . . 160
SPECTROMETER, MASS . . . . . . . . . . . NUCLEAR PHYSICS T&E. . . . . . . . 158
SPECTROPHOTOMETER. . . . . . . . . . . . OPTICAL T&E. . . . . . . . . . . . 160
SPECTROSCOPE . . . . . . . . . . . . . . OPTICAL T&E. . . . . . . . . . . . 160
 Speculum. . . . . . . . . . . . . . . . ASTRONOMICAL T&E
  use  MIRROR
SPECULUM . . . . . . . . . . . . . . . . MEDICAL & PSYCHOLOGICAL T&E. . . . 154
SPECULUM, ANIMAL . . . . . . . . . . . . ANIMAL HUSBANDRY T&E . . . . . . . 55
SPEECH . . . . . . . . . . . . . . . . . DOCUMENTARY ARTIFACT . . . . . . . 213
SPEEDBALL. . . . . . . . . . . . . . . . SPORTS EQUIPMENT . . . . . . . . . 222
 Speedboat . . . . . . . . . . . . . . . WATER TRANSPORTATION -- EQUIPMENT
  use  RUNABOUT
SPHERE . . . . . . . . . . . . . . . . . ART. . . . . . . . . . . . . . . . 206
SPHERE, ARMILLARY. . . . . . . . . . . . ASTRONOMICAL T&E . . . . . . . . . 136
SPHEROGRAPH. . . . . . . . . . . . . . . SURVEYING & NAVIGATIONAL T&E . . . 164
SPHEROMETER. . . . . . . . . . . . . . . DATA PROCESSING T&E. . . . . . . . 170
SPHEROSCOPE. . . . . . . . . . . . . . . ASTRONOMICAL T&E . . . . . . . . . 136
SPHYGMOMANOMETER . . . . . . . . . . . . MEDICAL & PSYCHOLOGICAL T&E. . . . 154
SPIDER . . . . . . . . . . . . . . . . . FOOD PROCESSING T&E. . . . . . . . 67
  rt  PAN, FRYING
SPIDER, BURNER . . . . . . . . . . . . . CHEMICAL T&E . . . . . . . . . . . 140
SPIGOT . . . . . . . . . . . . . . . . . FOOD PROCESSING T&E. . . . . . . . 67
SPIGOT . . . . . . . . . . . . . . . . . MULTIPLE USE ARTIFACT. . . . . . . 228
SPIKE. . . . . . . . . . . . . . . . . . BUILDING COMPONENT . . . . . . . . 6
SPIKE. . . . . . . . . . . . . . . . . . WOODWORKING T&E. . . . . . . . . . 121
SPIKE. . . . . . . . . . . . . . . . . . RAIL TRANSPORTATION -- ACCESSORY . 197
 Spike, Bill . . . . . . . . . . . . . . WRITTEN COMMUNICATION T&E
  use  SPINDLE
SPIKE, CANNON. . . . . . . . . . . . . . ARMAMENT -- ACCESSORY. . . . . . . 134
 Spile . . . . . . . . . . . . . . . . . FORESTRY T&E
  use  SPOUT, SAP
 Spillikins. . . . . . . . . . . . . . . GAME
  use  JACKSTRAWS
SPILLWAY . . . . . . . . . . . . . . . . OTHER STRUCTURE. . . . . . . . . . 8
SPINDLE. . . . . . . . . . . . . . . . . WRITTEN COMMUNICATION T&E. . . . . 185
SPINDLE. . . . . . . . . . . . . . . . . TEXTILEWORKING T&E . . . . . . . . 110
SPINDLE, ROPEMAKING. . . . . . . . . . . TEXTILEWORKING T&E . . . . . . . . 110
```

- -

- -

SPOON, LEMONADE SIPPER FOOD SERVICE T&E 76
SPOON, MEASURING FOOD PROCESSING T&E. 67
SPOON, MEDICAL MEDICAL & PSYCHOLOGICAL T&E. . . . 154
SPOON, MUD MASONRY & STONEWORKING T&E 87
SPOON, MUSTARD FOOD SERVICE T&E 76
SPOON, OLIVE FOOD SERVICE T&E 76
SPOON, ORANGE. FOOD SERVICE T&E 76
SPOON, SALT. FOOD SERVICE T&E 76
SPOON, SERVING FOOD SERVICE T&E 76
SPOON, SHERBET FOOD SERVICE T&E 76
SPOON, SODA. FOOD SERVICE T&E 76
SPOON, SOUP. FOOD SERVICE T&E 76
SPOON, SUGAR FOOD SERVICE T&E 76
 Spoon, Table. FOOD SERVICE T&E
 use TABLESPOON
 Spoon, Tea. FOOD SERVICE T&E
 use TEASPOON
SPOONER. FOOD SERVICE T&E 76
SPOTLIGHT. LIGHTING DEVICE. 21
SPOUT, DRAIN BUILDING COMPONENT 6
SPOUT, EAR MEDICAL & PSYCHOLOGICAL T&E. . . . 154
SPOUT, SAP FORESTRY T&E 78
 Sprayer, Bucket AGRICULTURAL T&E
 use SPRAYER, HAND
 Sprayer, Flame. AGRICULTURAL T&E
 use WEEDER, FLAME
SPRAYER, HAND. AGRICULTURAL T&E 50
 Sprayer, Knapsack AGRICULTURAL T&E
 use SPRAYER, HAND
SPRAYER, POWER AGRICULTURAL T&E 50
 Sprayer, Wheelbarrow. AGRICULTURAL T&E
 use SPRAYER, HAND
SPREADER, ASPHALT. CONSTRUCTION T&E 141
SPREADER, COLLAR CLOTHING -- ACCESSORY. 34
 Spreader, Garden manure AGRICULTURAL T&E
 use SPREADER, WHEELBARROW
SPREADER, JAW. MEDICAL & PSYCHOLOGICAL T&E. . . . 154
SPREADER, MANURE AGRICULTURAL T&E 50
 note use for an animal- or machine-drawn spreader
 Spreader, Shoe. ANIMAL HUSBANDRY T&E
 use TONGS, SHOE-SPREADING
SPREADER, TIRE LTE -- ACCESSORY 195
SPREADER, WHEELBARROW. AGRICULTURAL T&E 50
 note use for a hand-pushed spreader
SPRING, INDICATOR. MECHANICAL T&E 148
SPRING, PRESSURE MECHANICAL T&E 148
SPRING, SPIRAL MECHANICAL T&E 148
 Springdom, Animal RECREATIONAL DEVICE
 use RIDER, COILED-SPRING
SPRINGHOUSE. BUILDING 3

- -

```
Springs, Box. . . . . . . . . . . . BEDDING
  use  BEDSPRINGS
SPRINKLER. . . . . . . . . . . . . . MAINTENANCE T&E. . . . . . . . . . .  146
SPRINKLER, BLACKSMITH'S. . . . . . . METALWORKING T&E . . . . . . . . . .   95
  Sprinkler, Holy water . . . . . . . CEREMONIAL ARTIFACT
  use  ASPERGILLUM
SPRINKLER, IRRIGATION. . . . . . . . AGRICULTURAL T&E . . . . . . . . .   50
  Sprinkler, Knapsack . . . . . . . . AGRICULTURAL T&E
  use  SPRAYER, HAND
  Sprinkler, Lawn . . . . . . . . . . AGRICULTURAL T&E
  use  SPRINKLER, IRRIGATION
SPUD . . . . . . . . . . . . . . . . MINING & MINERAL HARVESTING T&E. .  102
SPUD, BARKING. . . . . . . . . . . . FORESTRY T&E . . . . . . . . . . .   78
  Spud, Dandelion . . . . . . . . . . AGRICULTURAL T&E
  use  SPUD, WEEDING
SPUD, WEEDING. . . . . . . . . . . . AGRICULTURAL T&E . . . . . . . . .   50
SPUR . . . . . . . . . . . . . . . . LTE -- ACCESSORY . . . . . . . . .  195
  Squails . . . . . . . . . . . . . . GAME
  use  TIDDLYWINKS
SQUARE . . . . . . . . . . . . . . . WOODWORKING T&E. . . . . . . . . .  121
SQUARE, BEVEL. . . . . . . . . . . . WOODWORKING T&E. . . . . . . . . .  121
SQUARE, CARPENTER'S. . . . . . . . . WOODWORKING T&E. . . . . . . . . .  121
SQUARE, DRILL POINT. . . . . . . . . WOODWORKING T&E. . . . . . . . . .  121
SQUARE, MASON'S. . . . . . . . . . . MASONRY & STONEWORKING T&E . . . .   88
SQUARE, MITER. . . . . . . . . . . . WOODWORKING T&E. . . . . . . . . .  121
SQUARE, OPTICAL. . . . . . . . . . . SURVEYING & NAVIGATIONAL T&E . . .  164
  rt  GROMA
SQUARE, SET. . . . . . . . . . . . . WOODWORKING T&E. . . . . . . . . .  121
SQUARE, SLIDING. . . . . . . . . . . WOODWORKING T&E. . . . . . . . . .  121
SQUARE, TRY. . . . . . . . . . . . . WOODWORKING T&E. . . . . . . . . .  121
SQUEAKER . . . . . . . . . . . . . . TOY. . . . . . . . . . . . . . . .  225
SQUEEGEE . . . . . . . . . . . . . . PRINTING T&E . . . . . . . . . . .  180
SQUEEZER, CURD . . . . . . . . . . . FOOD PROCESSING T&E. . . . . . . .   67
SQUEEZER, FRUIT. . . . . . . . . . . FOOD PROCESSING T&E. . . . . . . .   67
STABILIZER . . . . . . . . . . . . . ARMAMENT -- ACCESSORY. . . . . . .  134
STABLE . . . . . . . . . . . . . . . BUILDING . . . . . . . . . . . . .    3
STABLE, LIVERY . . . . . . . . . . . BUILDING . . . . . . . . . . . . .    3
  Stacker, Cable. . . . . . . . . . . AGRICULTURAL T&E
  use  STACKER, HAY
  Stacker, Derrick. . . . . . . . . . AGRICULTURAL T&E
  use  STACKER, HAY
STACKER, HAY . . . . . . . . . . . . AGRICULTURAL T&E . . . . . . . . .   50
  Stacker, Overshot . . . . . . . . . AGRICULTURAL T&E
  use  STACKER, HAY
  Stacker, Swinging . . . . . . . . . AGRICULTURAL T&E
  use  STACKER, HAY
  Stacker, Tripod . . . . . . . . . . AGRICULTURAL T&E
  use  STACKER, HAY
STADIMETER . . . . . . . . . . . . . SURVEYING & NAVIGATIONAL T&E . . .  164
STADIUM. . . . . . . . . . . . . . . OTHER STRUCTURE. . . . . . . . . .    8
```

- -

```
STAFF, STATION . . . . . . . . . . . . . SURVEYING & NAVIGATIONAL T&E . . . 164
STAGE. . . . . . . . . . . . . . . . . . BUILDING COMPONENT . . . . . . . .   6
STAGE, PUPPET. . . . . . . . . . . . . . PUBLIC ENTERTAINMENT DEVICE. . . . 218
STAGECOACH . . . . . . . . . . . . . . . LTE -- ANIMAL-POWERED. . . . . . . 190
   rt  COACH, ROAD
STAIRCASE. . . . . . . . . . . . . . . . BUILDING . . . . . . . . . . . . .   3
STAKE. . . . . . . . . . . . . . . . . . METALWORKING T&E . . . . . . . . .  95
STAKE. . . . . . . . . . . . . . . . . . SURVEYING & NAVIGATIONAL T&E . . . 164
STAKE, BLOWHORN. . . . . . . . . . . . . METALWORKING T&E . . . . . . . . .  95
STAKE, CANDLEMOLD. . . . . . . . . . . . METALWORKING T&E . . . . . . . . .  95
STAKE, CREASING. . . . . . . . . . . . . METALWORKING T&E . . . . . . . . .  95
STAKE, DOUBLE-CREASING . . . . . . . . . METALWORKING T&E . . . . . . . . .  95
STAKE, HATCHET . . . . . . . . . . . . . METALWORKING T&E . . . . . . . . .  95
STAKE, HOLLOW-MANDREL. . . . . . . . . . METALWORKING T&E . . . . . . . . .  95
STAKE, NEEDLE CASE . . . . . . . . . . . METALWORKING T&E . . . . . . . . .  95
STAKE, PLANISHING. . . . . . . . . . . . METALWORKING T&E . . . . . . . . .  95
STAKE, SQUARE. . . . . . . . . . . . . . METALWORKING T&E . . . . . . . . .  95
STALAGMOMETER. . . . . . . . . . . . . . MEDICAL & PSYCHOLOGICAL T&E. . . . 154
STALL. . . . . . . . . . . . . . . . . . BUILDING . . . . . . . . . . . . .   3
STALL, SHOWER. . . . . . . . . . . . . . PLUMBING FIXTURE . . . . . . . . .  21
STAMP. . . . . . . . . . . . . . . . . . METALWORKING T&E . . . . . . . . .  95
STAMP. . . . . . . . . . . . . . . . . . WRITTEN COMMUNICATION T&E. . . . . 185
STAMP, BAG . . . . . . . . . . . . . . . PRINTING T&E . . . . . . . . . . . 180
STAMP, DATE. . . . . . . . . . . . . . . WRITTEN COMMUNICATION T&E. . . . . 185
STAMP, EMBROIDERY. . . . . . . . . . . . PRINTING T&E . . . . . . . . . . . 180
STAMP, MARKING . . . . . . . . . . . . . WRITTEN COMMUNICATION T&E. . . . . 185
STAMP, NOTARY. . . . . . . . . . . . . . WRITTEN COMMUNICATION T&E. . . . . 185
STAMP, POSTAGE . . . . . . . . . . . . . EXCHANGE MEDIUM. . . . . . . . . . 214
STAMP, RATION. . . . . . . . . . . . . . EXCHANGE MEDIUM. . . . . . . . . . 214
STAMP, TAX . . . . . . . . . . . . . . . EXCHANGE MEDIUM. . . . . . . . . . 214
STAMP, TRADING . . . . . . . . . . . . . EXCHANGE MEDIUM. . . . . . . . . . 214
 Stamper . . . . . . . . . . . . . . . . PAPERMAKING T&E
   use  PULPER
STANCHION. . . . . . . . . . . . . . . . BUILDING . . . . . . . . . . . . .   3
STAND, ANIMAL. . . . . . . . . . . . . . PUBLIC ENTERTAINMENT DEVICE. . . . 218
STAND, AWL . . . . . . . . . . . . . . . LEATHER, HORN, SHELLWORKING T&E. .  85
 Stand, Basket . . . . . . . . . . . . . FURNITURE
   use  TABLE, KNITTING
STAND, BLACKSMITH'S. . . . . . . . . . . METALWORKING T&E . . . . . . . . .  95
STAND, BOOK. . . . . . . . . . . . . . . HOUSEHOLD ACCESSORY. . . . . . . .  18
STAND, CAKE. . . . . . . . . . . . . . . FOOD SERVICE T&E . . . . . . . . .  76
STAND, CAKE. . . . . . . . . . . . . . . FOOD PROCESSING T&E. . . . . . . .  67
 Stand, Candle . . . . . . . . . . . . . FURNITURE
   use  CANDLESTAND
STAND, CASK. . . . . . . . . . . . . . . FOOD SERVICE T&E . . . . . . . . .  76
 Stand, Christmas tree . . . . . . . . . HOUSEHOLD ACCESSORY
   use  HOLDER, TREE
STAND, CRUET . . . . . . . . . . . . . . FOOD SERVICE T&E . . . . . . . . .  76
STAND, CURLING IRON. . . . . . . . . . . TOILET ARTICLE . . . . . . . . . .  40
STAND, DISPLAY . . . . . . . . . . . . . MERCHANDISING T&E. . . . . . . . . 156
```

- -

- -

STEAMER. FOOD PROCESSING T&E. 67
 Steamer, Wheat. FOOD PROCESSING T&E
 use CONDITIONER, GRAIN
 Steamroller CONSTRUCTION T&E
 use ROLLER
STEEL. METALWORKING T&E 95
 rt WHETSTONE
STEEL. TEMPERATURE CONTROL DEVICE 23
STEEL, CARVING FOOD PROCESSING T&E. 67
STEEL, FINGER. LEATHER, HORN, SHELLWORKING T&E. . 85
STEEL, TURNING LEATHER, HORN, SHELLWORKING T&E. . 85
STEIN. FOOD SERVICE T&E 76
 rt GLASS, MALT-BEVERAGE; TANKARD
STEMMER, TAMPING-BAR MINING & MINERAL HARVESTING T&E. . 102
STENCIL. METALWORKING T&E 95
STENCIL. LEATHER, HORN, SHELLWORKING T&E. . 86
STENCIL. PRINTING T&E 180
STENCIL. WRITTEN COMMUNICATION T&E. 185
STEPLADDER HOUSEHOLD ACCESSORY. 18
STEPS, BED FURNITURE. 14
STEPS, LIBRARY FURNITURE. 14
STEREOGRAM MEDICAL & PSYCHOLOGICAL T&E. . . . 154
STEREOGRAPH. MEDICAL & PSYCHOLOGICAL T&E. . . . 154
STEREOGRAPH. DOCUMENTARY ARTIFACT 213
 note use for the pictorial object viewed in a stereoscope
STEREOMETER. MECHANICAL T&E 148
 Stereopticon. VISUAL COMMUNICATION T&E
 use PROJECTOR, LANTERN-SLIDE
STEREOSCOPE. MEDICAL & PSYCHOLOGICAL T&E. . . . 154
 rt PSEUDOSCOPE, LENTICULAR
STEREOSCOPE. VISUAL COMMUNICATION T&E 183
STEREOSCOPE/PSEUDOSCOPE. MEDICAL & PSYCHOLOGICAL T&E. . . . 154
STEREOVIEW DOCUMENTARY ARTIFACT 213
 note use for the pictorial object viewed in a modern stereoviewer
STEREOVIEWER VISUAL COMMUNICATION T&E 183
 note use only for a "modern" stereoviewer
 Sterilizer. MEDICAL & PSYCHOLOGICAL T&E
 use AUTOCLAVE
STERILIZER, BOTTLE FOOD PROCESSING T&E. 67
STETHOGONIOMETER BIOLOGICAL T&E 137
STETHOMETER. MEDICAL & PSYCHOLOGICAL T&E. . . . 154
STETHOSCOPE. MEDICAL & PSYCHOLOGICAL T&E. . . . 154
 Stevengraph ART
 use PICTURE, WOVEN
STICK, CLAPPER GLASS, PLASTICS, CLAYWORKING T&E . 81
STICK, COMPOSING PRINTING T&E 180
STICK, CUTICLE TOILET ARTICLE 40
STICK, HOCKEY. SPORTS EQUIPMENT 222
 Stick, Job. PRINTING T&E
 use STICK, COMPOSING

- -

STICK, LACROSSE. SPORTS EQUIPMENT 222
STICK, MIXING. FOOD PROCESSING T&E. 67
 Stick, Planting AGRICULTURAL T&E
 use DIBBLE
STICK, POGO. TOY. 225
STICK, POLO. SPORTS EQUIPMENT 222
STICK, PRAYER. CEREMONIAL ARTIFACT. 208
STICK, SHOOTING. PERSONAL GEAR. 37
STICK, SHOOTING. PRINTING T&E 180
STICK, SHOW. ANIMAL HUSBANDRY T&E 55
STICK, SIZE. LEATHER, HORN, SHELLWORKING T&E. . 86
 Stick, Skiddle. SPORTS EQUIPMENT
 use PIN, BOWLING
STICK, STEAM GLASS, PLASTICS, CLAYWORKING T&E . 81
STICK, SWAGGER PERSONAL GEAR. 37
STICK, SWIZZLE FOOD SERVICE T&E 76
 Stick, Toddy. FOOD SERVICE T&E
 use STICK, SWIZZLE
 Stick, Walking. PERSONAL GEAR
 use CANE
STICKER. ADVERTISING MEDIUM 204
STICKER. DOCUMENTARY ARTIFACT 213
STICKER, BUMPER. DOCUMENTARY ARTIFACT 213
STICKER, BUMPER. ADVERTISING MEDIUM 204
STICKPIN CLOTHING -- ACCESSORY. 34
STILE. OTHER STRUCTURE. 8
STILETTO ARMAMENT -- EDGED. 127
 rt DAGGER; PONIARD
STILETTO TEXTILEWORKING T&E 110
STILL. FOOD PROCESSING T&E. 67
STILL, SOLAR FOOD PROCESSING T&E. 67
STILT. GLASS, PLASTICS, CLAYWORKING T&E . 81
STILT. TOY. 225
STILT, PRUNING AGRICULTURAL T&E 51
STIMULATOR, SOUND. ACOUSTICAL T&E 124
STIRRER. FOOD PROCESSING T&E. 68
STIRRER. CHEMICAL T&E 140
STIRRER, APPLE BUTTER. FOOD PROCESSING T&E. 68
STIRRER, CURD. FOOD PROCESSING T&E. 68
STIRRER, LARD. FOOD PROCESSING T&E. 68
STIRRER, MILK. FOOD PROCESSING T&E. 68
STIRRER, SCRAPPLE. FOOD PROCESSING T&E. 68
STIRRUP. LTE -- ACCESSORY 195
STITCH-HEAVER, RIGGER'S. TEXTILEWORKING T&E 110
 Stock CLOTHING -- ACCESSORY
 use CRAVAT
 Stock, Drill. WOODWORKING T&E
 use DRILL
STOCK, PORTFIRE. ARMAMENT -- ACCESSORY. 134
STOCKING CLOTHING -- FOOTWEAR 26

- -

STOCKING, CHRISTMAS. CEREMONIAL ARTIFACT. 208
STOCKS REGULATIVE & PROTECTIVE T&E. . . . 161
STOLE. CLOTHING -- OUTERWEAR. 31
STOMATOSCOPE MEDICAL & PSYCHOLOGICAL T&E. . . . 154
 Stomper, Kraut. FOOD PROCESSING T&E
 use MASHER, KRAUT
STONE, BALLAST WATER TRANSPORTATION -- ACCESSORY. 203
STONE, BUILDING. BUILDING 3
STONE, CURLING SPORTS EQUIPMENT 222
STONE, DATE. BUILDING COMPONENT 6
STONE, IMPOSING. PRINTING T&E 180
STONE, LITHOGRAPH. PRINTING T&E 180
STONE, PAINT PAINTING T&E 103
STONE, SCYTHE-SHARPENING METALWORKING T&E 95
STONE, WORKED. ARTIFACT REMNANT 227
STONEBOAT. AGRICULTURAL T&E 51
STOOL. FURNITURE. 14
 Stool, Bar. FURNITURE
 use BARSTOOL
 Stool, Camp FURNITURE
 use STOOL, FOLDING
STOOL, CAULKER'S WATER TRANSPORTATION -- ACCESSORY. 203
STOOL, DUCKING REGULATIVE & PROTECTIVE T&E. . . . 161
STOOL, FOLDING FURNITURE. 14
STOOL, GOUT. FURNITURE. 14
STOOL, KITCHEN FURNITURE. 14
STOOL, MILKING FURNITURE. 14
STOOL, PIANO MUSICAL T&E. 175
STOOL, STEP. FURNITURE. 14
STOOP. BUILDING COMPONENT 6
STOP, BENCH. WOODWORKING T&E. 121
STOPCOCK CHEMICAL T&E 140
STOPPER. FOOD PROCESSING T&E. 68
STOPPER, BOTTLE. HOUSEHOLD ACCESSORY. 18
STOPWATCH. TIMEKEEPING T&E. 165
STORE. BUILDING 3
 note usually modified to indicate service or product provided
 Store, Retail BUILDING
 use more specific term, e.g.: STORE, GROCERY
STOVE. TEMPERATURE CONTROL DEVICE 23
 note usually modified according to fuel used
STOVE. FOOD PROCESSING T&E. 68
STOVE, ALCOHOL FOOD PROCESSING T&E. 68
STOVE, ELECTRIC. FOOD PROCESSING T&E. 68
STOVE, FINISHING PRINTING T&E 180
STOVE, GAS FOOD PROCESSING T&E. 68
STOVE, LAUNDRY MAINTENANCE T&E. 146
STOVE, WOOD. FOOD PROCESSING T&E. 68
STOVEPIPE. TEMPERATURE CONTROL DEVICE 23
STRABISMOMETER MEDICAL & PSYCHOLOGICAL T&E. . . . 154

- -

- -

STUD CLOTHING -- ACCESSORY. 34
STUD, FRATERNAL. PERSONAL SYMBOL. 216
STUFFER, SAUSAGE FOOD PROCESSING T&E. 68
STULL. MINING & MINERAL HARVESTING T&E. . 102
STUMP. PAINTING T&E 103
STYLOGRAPH PAINTING T&E 103
STYLUS GLASS, PLASTICS, CLAYWORKING T&E . 81
STYLUS DRAFTING T&E 171
STYLUS, LIGHT. DATA PROCESSING T&E. 170
SUBMARINE. WATER TRANSPORTATION -- EQUIPMENT. 200
SUBMARINE, ATTACK. WATER TRANSPORTATION -- EQUIPMENT. 200
SUBMARINE, BALLISTIC MISSILE WATER TRANSPORTATION -- EQUIPMENT. 200
SUBMARINE, COMMERCIAL. WATER TRANSPORTATION -- EQUIPMENT. 200
SUBMARINE, RESEARCH. WATER TRANSPORTATION -- EQUIPMENT. 200
 rt VESSEL, RESEARCH
 Subsoiler AGRICULTURAL T&E
 use PLOW, SUBSOIL
SUGAR & CREAMER. FOOD SERVICE T&E 76
SUIT CLOTHING -- OUTERWEAR. 31
SUIT, BATHING. CLOTHING -- OUTERWEAR. 31
SUIT, DIVER'S. CLOTHING -- OUTERWEAR. 31
SUIT, EXPOSURE CLOTHING -- OUTERWEAR. 31
SUIT, FLIER'S. CLOTHING -- OUTERWEAR. 31
SUIT, JUMP CLOTHING -- OUTERWEAR. 31
 Suit, Pants CLOTHING -- OUTERWEAR
 use PANTSUIT
SUIT, SPACE. CLOTHING -- OUTERWEAR. 31
SUIT, UNION. CLOTHING -- UNDERWEAR. 32
 rt COMBINATION
SUITCASE PERSONAL GEAR. 37
SUITE, BEDROOM FURNITURE. 14
SUITE, DINING. FURNITURE. 14
SUITE, GARDEN. FURNITURE. 14
SUITE, HALL. FURNITURE. 14
SUITE, LIBRARY FURNITURE. 14
 Suite, Living Room. FURNITURE
 use SUITE, PARLOR
SUITE, NURSERY FURNITURE. 14
SUITE, PARLOR. FURNITURE. 14
SULKY. LTE -- ANIMAL-POWERED. 190
SUMMONS. DOCUMENTARY ARTIFACT 213
SUNBONNET. CLOTHING -- HEADWEAR 28
SUNDIAL. TIMEKEEPING T&E. 165
SUNGLASSES PERSONAL GEAR. 37
SUNSUIT. CLOTHING -- OUTERWEAR. 31
SUPERCALENDER. PAPERMAKING T&E. 104
SUPPLEMENT, NEWSPAPER. DOCUMENTARY ARTIFACT 213
SUPPORT, IMHOFF CONE CHEMICAL T&E 140
SUPPORT, STOVE HOUSEHOLD ACCESSORY. 18
SUPPORTER. CLOTHING -- UNDERWEAR. 32

- -

SUPPORTER, MOUTH MEDICAL & PSYCHOLOGICAL T&E. . . . 154
SUPPORTS, POWERED. MINING & MINERAL HARVESTING T&E. . 102
SUPPRESSOR, FLASH. ARMAMENT -- ACCESSORY. 134
 Surcingle LTE -- ACCESSORY
 use GIRTH
SURFACER, SLUG PRINTING T&E 180
SURFBOARD. SPORTS EQUIPMENT 222
SURFBOAT WATER TRANSPORTATION -- EQUIPMENT. 200
 rt LIFEBOAT, RESCUE; LIFECAR
SURPLICE CLOTHING -- OUTERWEAR. 31
SURREY LTE -- ANIMAL-POWERED. 190
SURVEYOR, DENTURE ROD. MEDICAL & PSYCHOLOGICAL T&E. . . . 154
SUSPENDERS CLOTHING -- ACCESSORY. 34
SUTURE MEDICAL & PSYCHOLOGICAL T&E. . . . 154
SWAG WINDOW OR DOOR COVERING. 23
SWAGE. METALWORKING T&E 95
SWAGE, ANVIL METALWORKING T&E 95
SWAGE, BOLT-HEADING. METALWORKING T&E 95
SWAGE, BOTTOM. METALWORKING T&E 95
SWAGE, CREASING. METALWORKING T&E 95
SWAGE, DENTAL. MEDICAL & PSYCHOLOGICAL T&E. . . . 154
SWAGE, FORMING METALWORKING T&E 95
SWAGE, HALF-ROUND TOP. METALWORKING T&E 95
SWAGE, HATCHET METALWORKING T&E 95
SWAGE, MANDREL METALWORKING T&E 95
SWAGE, NECKING METALWORKING T&E 95
SWAGE, NUT METALWORKING T&E 95
SWAGE, SPRING. METALWORKING T&E 95
SWAGE, TOP METALWORKING T&E 95
SWAGE, V-SHAPED. METALWORKING T&E 95
SWATTER, FLY HOUSEHOLD ACCESSORY. 18
SWEATBAND. CLOTHING -- HEADWEAR 28
SWEATER. CLOTHING -- OUTERWEAR. 31
 Swedge. METALWORKING T&E
 use SWAGE
SWEEP. WATER TRANSPORTATION -- ACCESSORY. 203
 rt OAR
SWEEP, ANIMAL-POWERED. ENERGY PRODUCTION T&E. 144
SWEEP, HUMAN-POWERED ENERGY PRODUCTION T&E. 144
SWEEP, WELL. SITE FEATURE 7
SWEEPER, CARPET. MAINTENANCE T&E. 146
SWEEPER, STREET. LTE -- MOTORIZED 192
SWIFT. TEXTILEWORKING T&E 110
SWING. RECREATIONAL DEVICE. 219
SWING, CIRCLE. RECREATIONAL DEVICE. 219
 Swingle, Flax TEXTILEWORKING T&E
 use KNIFE, SCUTCHING
SWITCH ELECTRICAL & MAGNETIC T&E. 143
SWITCH MUSICAL T&E. 175
SWITCH, FLY. ANIMAL HUSBANDRY T&E 55

- -

SWITCH, SOLENOID ELECTRICAL & MAGNETIC T&E. 143
SWITCH, TIME ELECTRICAL & MAGNETIC T&E. 143
SWITCHBOARD. TELECOMMUNICATION T&E. 182
SWIVEL ANIMAL HUSBANDRY T&E 55
 note for Lariat
SWORD. ARMAMENT -- EDGED. 127
SWORD, ARTILLERY ARMAMENT -- EDGED. 127
 Sword, Court. PERSONAL SYMBOL
 use SWORD, PRESENTATION
SWORD, HANGER. ARMAMENT -- EDGED. 127
SWORD, HUNTING ARMAMENT -- EDGED. 127
SWORD, PRESENTATION. PERSONAL SYMBOL. 216
SYMBOL, TRADE. ADVERTISING MEDIUM 205
 note use for an object which by custom is considered a visual symbol
 of a product or service, e.g.: a barber pole, a cigar store figure
 Sympiesometer METEOROLOGICAL T&E
 use BAROMETER
SYNAGOGUE. BUILDING 3
SYNCHROCYCLOTRON NUCLEAR PHYSICS T&E. 158
SYNCHROTRON. NUCLEAR PHYSICS T&E. 158
SYNCHROTRON, ALTERNATING-GRADIENT. . . . NUCLEAR PHYSICS T&E. 158
SYNCHROTRON, CONSTANT-GRADIENT NUCLEAR PHYSICS T&E. 158
SYNCHROTRON, ZERO-GRADIENT NUCLEAR PHYSICS T&E. 159
SYNTHESIZER. MUSICAL T&E. 175
SYRINGE. GLASS, PLASTICS, CLAYWORKING T&E . 81
SYRINGE. MEDICAL & PSYCHOLOGICAL T&E. . . . 154
SYRINGE. MULTIPLE USE ARTIFACT. 228
SYRINGE, DOSE. ANIMAL HUSBANDRY T&E 55
SYSTEM, FIRE-ALARM REGULATIVE & PROTECTIVE T&E. . . . 161
TABARD CLOTHING -- OUTERWEAR. 31
TABERNACLE CEREMONIAL ARTIFACT. 208
TABI CLOTHING -- FOOTWEAR 26
TABLE. FURNITURE. 14
 Table, Air. METALWORKING T&E
 use CONCENTRATOR
TABLE, AMALGAMATING. METALWORKING T&E 95
TABLE, ANIMAL-POWERED. ENERGY PRODUCTION T&E. 144
 Table, Banquet. FURNITURE
 use TABLE, DINING
TABLE, BILLIARD. SPORTS EQUIPMENT 222
TABLE, BINDERY PRINTING T&E 180
TABLE, BREAKFAST FURNITURE. 14
TABLE, CALLING CARD. FURNITURE. 14
TABLE, CARD. FURNITURE. 14
 Table, Chair. FURNITURE
 use CHAIR/TABLE
TABLE, CHART FURNITURE. 14
TABLE, COFFEE. FURNITURE. 14
TABLE, DENTAL INSTRUMENT MEDICAL & PSYCHOLOGICAL T&E. . . . 154
TABLE, DINING. FURNITURE. 14

- -

- -

```
TABOR. . . . . . . . . . . . . . . . . . MUSICAL T&E. . . . . . . . . . . . . 175
TABORET. . . . . . . . . . . . . . . . . FURNITURE. . . . . . . . . . . . . .  15
TABS, FINGER . . . . . . . . . . . . . . SPORTS EQUIPMENT . . . . . . . . . . 222
TACHISTOSCOPE. . . . . . . . . . . . . . OPTICAL T&E. . . . . . . . . . . . . 160
TACHOMETER . . . . . . . . . . . . . . . AEROSPACE -- ACCESSORY . . . . . . . 188
TACHOMETER . . . . . . . . . . . . . . . MECHANICAL T&E . . . . . . . . . . . 148
  Tachymeter. . . . . . . . . . . . . . . SURVEYING & NAVIGATIONAL T&E
    use   THEODOLITE or ALIDADE or TRANSIT
TACK . . . . . . . . . . . . . . . . . . MULTIPLE USE ARTIFACT. . . . . . . . 228
  Tack, Bulletin Board. . . . . . . . . . WRITTEN COMMUNICATION T&E
    use   PUSHPIN
TACK, TIE. . . . . . . . . . . . . . . . CLOTHING -- ACCESSORY. . . . . . . .  34
TACKER, CARPET . . . . . . . . . . . . . MAINTENANCE T&E. . . . . . . . . . . 146
  Tackle. . . . . . . . . . . . . . . . . MECHANICAL T&E
    use   HOIST
TACKLE, BREAKING . . . . . . . . . . . . ANIMAL HUSBANDRY T&E . . . . . . . .  55
TACKLE, SAWING . . . . . . . . . . . . . WOODWORKING T&E. . . . . . . . . . . 121
    rt    PROP, SAWYER'S; SAWBUCK; SAWHORSE
TAG, ANIMAL. . . . . . . . . . . . . . . ANIMAL HUSBANDRY T&E . . . . . . . .  55
  Tag, Dog. . . . . . . . . . . . . . . . DOCUMENTARY ARTIFACT
    use   TAG, IDENTIFICATION
TAG, GIFT. . . . . . . . . . . . . . . . DOCUMENTARY ARTIFACT . . . . . . . . 213
TAG, IDENTIFICATION. . . . . . . . . . . DOCUMENTARY ARTIFACT . . . . . . . . 213
TAG, MERCHANDISE . . . . . . . . . . . . DOCUMENTARY ARTIFACT . . . . . . . . 213
TAILRACE . . . . . . . . . . . . . . . . OTHER STRUCTURE. . . . . . . . . . .   8
TAJ. . . . . . . . . . . . . . . . . . . CLOTHING -- HEADWEAR . . . . . . . .  28
TALISMAN . . . . . . . . . . . . . . . . PERSONAL SYMBOL. . . . . . . . . . . 216
TALLITH. . . . . . . . . . . . . . . . . PERSONAL SYMBOL. . . . . . . . . . . 216
  Tally-ho. . . . . . . . . . . . . . . . LTE -- ANIMAL-POWERED
    use   COACH, ROAD
  Tambour . . . . . . . . . . . . . . . . TEXTILEWORKING T&E
    use   HOOP, EMBROIDERY
TAMBOURINE . . . . . . . . . . . . . . . MUSICAL T&E. . . . . . . . . . . . . 175
  Tamer, Hog. . . . . . . . . . . . . . . ANIMAL HUSBANDRY T&E
    use   CUTTER, SNOUT
TAM-O-SHANTER. . . . . . . . . . . . . . CLOTHING -- HEADWEAR . . . . . . . .  28
    rt    BERET
TAMPER . . . . . . . . . . . . . . . . . FOOD PROCESSING T&E. . . . . . . . .  68
TAMPER . . . . . . . . . . . . . . . . . GLASS, PLASTICS, CLAYWORKING T&E .  81
TAMPER . . . . . . . . . . . . . . . . . CONSTRUCTION T&E . . . . . . . . . . 141
  Tamper, Kraut . . . . . . . . . . . . . FOOD PROCESSING T&E
    use   MASHER, KRAUT
  Tam-tam . . . . . . . . . . . . . . . . MUSICAL T&E
    use   TOM-TOM or GONG
TANK . . . . . . . . . . . . . . . . . . LTE -- MOTORIZED . . . . . . . . . . 192
TANK, COOLING. . . . . . . . . . . . . . FOOD PROCESSING T&E. . . . . . . . .  68
  Tank, Diver's . . . . . . . . . . . . . SPORTS EQUIPMENT
    use   TANK, SCUBA
TANK, FILM-PROCESSING. . . . . . . . . . PHOTOGRAPHIC T&E . . . . . . . . . . 177
TANK, OIL. . . . . . . . . . . . . . . . TEMPERATURE CONTROL DEVICE . . . .  23
```

- -

TANK, PROCESSING FOOD PROCESSING T&E. 68
TANK, SCUBA. SPORTS EQUIPMENT 222
TANK, STORAGE. FOOD PROCESSING T&E. 68
TANKARD. FOOD SERVICE T&E 76
 rt GLASS, MALT-BEVERAGE; STEIN
TANTALUS FOOD SERVICE T&E 76
TAP. METALWORKING T&E 95
TAP, BEER. FOOD SERVICE T&E 76
TAP, BOTTOM. METALWORKING T&E 95
TAP, FUZE. ARMAMENT -- ACCESSORY. 134
TAP, PLUG. METALWORKING T&E 95
TAP, SCREW WOODWORKING T&E. 121
TAP, TAPER METALWORKING T&E 95
TAPE SOUND COMMUNICATION T&E. 181
TAPE, ADHESIVE MEDICAL & PSYCHOLOGICAL T&E. . . . 154
TAPE, MAGNETIC DATA PROCESSING T&E. 170
TAPE, PAPER. DATA PROCESSING T&E. 170
 Tape, Steel WEIGHTS & MEASURES T&E
 use MEASURE, TAPE or RULE, RETRACTABLE
TAPE, TICKER DATA PROCESSING T&E. 170
TAPE, UMBILICAL. MEDICAL & PSYCHOLOGICAL T&E. . . . 154
TAPER. LIGHTING DEVICE. 21
TAPESTRY ART. 206
TARGET ARMAMENT -- ACCESSORY. 134
TARGET, ARCHERY. ARMAMENT -- ACCESSORY. 134
TARGET, GALLERY. RECREATIONAL DEVICE. 219
TARGET, SKEET. ARMAMENT -- ACCESSORY. 134
TAROGATO MUSICAL T&E. 175
TARPAULIN. MULTIPLE USE ARTIFACT. 228
TARPOT LTE -- ACCESSORY 195
TASEOMETER BIOLOGICAL T&E 137
TASIMETER. METEOROLOGICAL T&E 158
TAVERN BUILDING 3
TAXIMETER. LTE -- ACCESSORY 195
TAZZA. FOOD SERVICE T&E 76
TEACUP FOOD SERVICE T&E 76
TEAKETTLE. FOOD PROCESSING T&E. 68
TEAPOT FOOD SERVICE T&E 76
 Teapoy. FURNITURE
 use TABLE, TEA
TEASPOON FOOD SERVICE T&E 76
TECHNICON. MUSICAL T&E. 175
TEDDER AGRICULTURAL T&E 51
 Teddy CLOTHING -- UNDERWEAR
 use COMBINATION
 Teeter-totter RECREATIONAL DEVICE
 use SEESAW
 Teeth, False. PERSONAL GEAR
 use DENTURES
TEINOSCOPE OPTICAL T&E. 160

- -

TELEGRAM DOCUMENTARY ARTIFACT 213
TELEGRAPH, ENGINE ROOM WATER TRANSPORTATION -- ACCESSORY. 203
TELENGISCOPE ASTRONOMICAL T&E 136
TELEPHONE. TELECOMMUNICATION T&E. 182
TELEPOLARISCOPE. ASTRONOMICAL T&E 136
TELEPRINTER. DATA PROCESSING T&E. 170
TELESCOPE. SURVEYING & NAVIGATIONAL T&E . . . 164
TELESCOPE. OPTICAL T&E. 160
TELESCOPE. ASTRONOMICAL T&E 136
TELESCOPE, ACHROMATIC. ASTRONOMICAL T&E 136
 rt TELESCOPE, GALILEAN; TELESCOPE, REFRACTING
TELESCOPE, CASSEGRAIN. ASTRONOMICAL T&E 136
 rt TELESCOPE, REFLECTING
TELESCOPE, EQUATORIAL. ASTRONOMICAL T&E 136
TELESCOPE, GALILEAN. ASTRONOMICAL T&E 136
TELESCOPE, ORBITING. ASTRONOMICAL T&E 136
TELESCOPE, QUADRANT. SURVEYING & NAVIGATIONAL T&E . . . 164
TELESCOPE, RADIO ASTRONOMICAL T&E 136
TELESCOPE, REFLECTING. ASTRONOMICAL T&E 136
 rt TELESCOPE, CASSEGRAIN
TELESCOPE, REFRACTING. ASTRONOMICAL T&E 136
 rt TELESCOPE, ACHROMATIC; TELESCOPE, GALILEAN
 Telescope, Schmidt. ASTRONOMICAL T&E
 use CAMERA, SCHMIDT
TELESCOPE, SEXTANT SURVEYING & NAVIGATIONAL T&E . . . 164
TELESCOPE, SOLAR ASTRONOMICAL T&E 136
TELESCOPE, SPOTTING. ARMAMENT -- ACCESSORY. 134
TELESPECTROSCOPE ASTRONOMICAL T&E 136
 Telethermometer THERMAL T&E
 use PYROMETER
TELLTALE WATER TRANSPORTATION -- ACCESSORY. 203
TELPHER. LTE -- MOTORIZED 192
TEMPLATE METALWORKING T&E 95
TEMPLATE WOODWORKING T&E. 121
 rt PATTERN
TEMPLATE, DENTAL MEDICAL & PSYCHOLOGICAL T&E. . . . 155
TEMPLATE, DRAFTING DRAFTING T&E 171
TEMPLE BUILDING 3
TEMPLE TEXTILEWORKING T&E 110
TENACULUM. MEDICAL & PSYCHOLOGICAL T&E. . . . 155
TENDER RAIL TRANSPORTATION -- EQUIPMENT . 197
TENDER, BUOY WATER TRANSPORTATION -- EQUIPMENT. 200
TENDER, SUBMARINE. WATER TRANSPORTATION -- EQUIPMENT. 200
TENDER, YACHT. WATER TRANSPORTATION -- EQUIPMENT. 200
 rt DINGHY; ROWBOAT
 Tenderer, Meat. FOOD PROCESSING T&E
 use MAUL, MEAT
TENOROON MUSICAL T&E. 175
 Tenpin. SPORTS EQUIPMENT
 use PIN, BOWLING

- -

TENSIMETER MECHANICAL T&E 148
TENSIOMETER. MECHANICAL T&E 148
TENT BUILDING 3
TEPEE. BUILDING 3
 Tepoy FURNITURE
 use TABLE, TEA
TERMINAL BUILDING 3
 rt DEPOT
TERMINAL DATA PROCESSING T&E. 170
TERMINAL, CRT. DATA PROCESSING T&E. 170
TERMINAL, MAGNETIC-TAPE. DATA PROCESSING T&E. 170
TERMINAL, TYPEWRITER DATA PROCESSING T&E. 170
TEST, COLOR-PERCEPTION MEDICAL & PSYCHOLOGICAL T&E. . . . 155
TEST, OVEN GLASS, PLASTICS, CLAYWORKING T&E . 81
TESTER TEXTILEWORKING T&E 110
TESTER, ACIDITY. FOOD PROCESSING T&E. 68
TESTER, BURST. TEXTILEWORKING T&E 110
TESTER, CHEESE FOOD PROCESSING T&E. 68
TESTER, CIRCUIT. ELECTRICAL & MAGNETIC T&E. 143
TESTER, COLOR-SENSE. MEDICAL & PSYCHOLOGICAL T&E. . . . 155
TESTER, CRIMP. TEXTILEWORKING T&E 110
TESTER, FINENESS TEXTILEWORKING T&E 110
TESTER, FINENESS CHEMICAL T&E 140
TESTER, FIRE-RESISTANCE. TEXTILEWORKING T&E 110
TESTER, HOOF ANIMAL HUSBANDRY T&E 55
TESTER, MAGNETO & COIL ELECTRICAL & MAGNETIC T&E. 143
TESTER, MILK FOOD PROCESSING T&E. 68
TESTER, MULLEN PAPERMAKING T&E. 104
TESTER, NEP. TEXTILEWORKING T&E 110
TESTER, OVERRUN. FOOD PROCESSING T&E. 68
TESTER, POWDER ARMAMENT -- ACCESSORY. 134
TESTER, SCHOPPER PAPERMAKING T&E. 104
TESTER, SCORCH TEXTILEWORKING T&E 110
TESTER, SEDIMENT FOOD PROCESSING T&E. 68
TESTER, SHRINKAGE. TEXTILEWORKING T&E 110
TESTER, SLIVER TEXTILEWORKING T&E 110
TESTER, SOUNDNESS. CHEMICAL T&E 140
TESTER, TEAR TEXTILEWORKING T&E 110
TESTER, TUBE ELECTRICAL & MAGNETIC T&E. 143
TESTER, TWIST. TEXTILEWORKING T&E 110
TESTER, WASHFASTNESS TEXTILEWORKING T&E 110
 Test-scoring Device DATA PROCESSING T&E
 use DEVICE, TEST-SCORING
TESTUDO. ARMAMENT -- ACCESSORY. 134
TETANOMETER. MEDICAL & PSYCHOLOGICAL T&E. . . . 155
 Tete-a-tete FURNITURE
 use SOFA, CONVERSATIONAL
TETHERBALL SPORTS EQUIPMENT 222
 Tetrahedron ARMAMENT -- ACCESSORY
 use CALTROP

- -

```
THUMBSTALL . . . . . . . . . . . . . . ARMAMENT -- ACCESSORY. . . . . . .  134
THURIBLE . . . . . . . . . . . . . . . CEREMONIAL ARTIFACT. . . . . . .   208
   rt  CENSER
TIARA. . . . . . . . . . . . . . . . . ADORNMENT. . . . . . . . . . .      25
   Tick. . . . . . . . . . . . . . . . BEDDING
     use  COVER, MATTRESS
TICKER, STOCK. . . . . . . . . . . . . TELECOMMUNICATION T&E. . . . . .   182
TICKET . . . . . . . . . . . . . . . . EXCHANGE MEDIUM. . . . . . . . .   214
TIDDLYWINKS. . . . . . . . . . . . . . GAME . . . . . . . . . . . . . .   218
   Tidy. . . . . . . . . . . . . . . . HOUSEHOLD ACCESSORY
     use  ANTIMACASSAR
TIE, BOW . . . . . . . . . . . . . . . CLOTHING -- ACCESSORY. . . . . .    34
TIE, CATTLE. . . . . . . . . . . . . . ANIMAL HUSBANDRY T&E . . . . . .    55
   Tie, Neck . . . . . . . . . . . . . CLOTHING -- ACCESSORY
     use  NECKTIE
TIE, SLEEPERS. . . . . . . . . . . . . MINING & MINERAL HARVESTING T&E.   102
TIE, STRING. . . . . . . . . . . . . . CLOTHING -- ACCESSORY. . . . . .    34
TIEBACK. . . . . . . . . . . . . . . . BUILDING COMPONENT . . . . . . .     6
   Tiepin. . . . . . . . . . . . . . . CLOTHING -- ACCESSORY
     use  STICKPIN
   Tier, Corn. . . . . . . . . . . . . AGRICULTURAL T&E
     use  TIER, CORN-SHOCK
   Tier, Corn-fodder . . . . . . . . . AGRICULTURAL T&E
     use  TIER, CORN-SHOCK
TIER, CORN-SHOCK . . . . . . . . . . . AGRICULTURAL T&E . . . . . . . .    51
TIGHTENER, CHAIN . . . . . . . . . . . LTE -- ACCESSORY . . . . . . . .   195
TIGHTS . . . . . . . . . . . . . . . . CLOTHING -- OUTERWEAR: . . . . .    31
TIKI . . . . . . . . . . . . . . . . . CEREMONIAL ARTIFACT. . . . . . .   208
TILBURY. . . . . . . . . . . . . . . . LTE -- ANIMAL-POWERED. . . . . .   190
TILE . . . . . . . . . . . . . . . . . BUILDING COMPONENT . . . . . . .     6
TILE, DRAIN. . . . . . . . . . . . . . BUILDING COMPONENT . . . . . . .     6
TILE, FIREPLACE. . . . . . . . . . . . BUILDING COMPONENT . . . . . . .     6
TILE, ROOF . . . . . . . . . . . . . . BUILDING COMPONENT . . . . . . .     6
   Till. . . . . . . . . . . . . . . . MERCHANDISING T&E
     use  BOX, MONEY
TILLER . . . . . . . . . . . . . . . . MINING & MINERAL HARVESTING T&E.   102
TILLER . . . . . . . . . . . . . . . . WATER TRANSPORTATION -- ACCESSORY. 203
TILLER, GARDEN ROTARY. . . . . . . . . AGRICULTURAL T&E . . . . . . . .    51
TILLER, ROTARY . . . . . . . . . . . . AGRICULTURAL T&E . . . . . . . .    51
TILTER, POT. . . . . . . . . . . . . . FOOD SERVICE T&E . . . . . . . .    76
TIMBER . . . . . . . . . . . . . . . . MINING & MINERAL HARVESTING T&E.   102
TIMER, DARKROOM. . . . . . . . . . . . PHOTOGRAPHIC T&E . . . . . . . .   177
TIMER, KITCHEN . . . . . . . . . . . . FOOD PROCESSING T&E. . . . . . .    68
TIMER, PILL. . . . . . . . . . . . . . MEDICAL & PSYCHOLOGICAL T&E. . .   155
TIMETABLE. . . . . . . . . . . . . . . DOCUMENTARY ARTIFACT . . . . . .   213
TIMPANUM . . . . . . . . . . . . . . . MUSICAL T&E. . . . . . . . . . .   175
TIN. . . . . . . . . . . . . . . . . . MERCHANDISING T&E. . . . . . . .   157
TIN, IMPRESSION. . . . . . . . . . . . MEDICAL & PSYCHOLOGICAL T&E. . .   155
   Tin, Kitchen. . . . . . . . . . . . FOOD PROCESSING T&E
     use  OVEN, REFLECTOR
```

- -

TINDERBOX. TEMPERATURE CONTROL DEVICE 23
TINDERBOX. ARMAMENT -- ACCESSORY. 134
TINDERBOX, POCKET. ARMAMENT -- ACCESSORY. 134
TINDERPISTOL TEMPERATURE CONTROL DEVICE 23
TINTOMETER TEXTILEWORKING T&E 110
TINTYPE. DOCUMENTARY ARTIFACT 214
TIP, GILDER'S. PAINTING T&E 103
TIRE LTE -- ACCESSORY 195
TISSUE TOILET ARTICLE 40
TISSUE, DRY-MOUNTING PHOTOGRAPHIC T&E 177
TITHONOMETER CHEMICAL T&E 140
TITRATOR CHEMICAL T&E 140
TITROMETER CHEMICAL T&E 140
TIVOLI GAME 218
TOASTER. FOOD PROCESSING T&E. 68
TOBACCO. PERSONAL GEAR. 38
TOBACCO, CHEWING PERSONAL GEAR. 38
TOBOGGAN SPORTS EQUIPMENT 222
TOGA CLOTHING -- OUTERWEAR. 31
 rt ABA; CAFTAN
TOILET PLUMBING FIXTURE 21
TOKEN. ADVERTISING MEDIUM 205
TOKEN. EXCHANGE MEDIUM. 214
TOKEN, COMMEMORATIVE DOCUMENTARY ARTIFACT 214
TOKEN, RATION. EXCHANGE MEDIUM. 214
TOKEN, STORE EXCHANGE MEDIUM. 214
 rt CARD, STORE
TOKEN, TAX EXCHANGE MEDIUM. 214
TOKEN, TRANSPORTATION. EXCHANGE MEDIUM. 214
TOLLGATE SITE FEATURE 7
TOLLHOUSE. BUILDING 3
 Tom, Long MINING & MINERAL HARVESTING T&E
 use SEPARATOR
TOMAHAWK ARMAMENT -- EDGED. 127
TOMBSTONE. CEREMONIAL ARTIFACT. 208
TOM-TOM. MUSICAL T&E. 175
 Tong, Curling TOILET ARTICLE
 use IRON, CURLING
TONGS. FOOD PROCESSING T&E. 68
TONGS. CHEMICAL T&E 140
 Tongs, Anvil. METALWORKING T&E
 use TONGS, PICKUP
TONGS, ASPARAGUS FOOD SERVICE T&E 76
TONGS, BEAKER. CHEMICAL T&E 140
TONGS, BENDING METALWORKING T&E 95
TONGS, BOLT. METALWORKING T&E 96
 rt TONGS, HOLLOW-BIT; TONGS, ROUND-LIP
TONGS, BOX METALWORKING T&E 96
 rt TONGS, DOUBLE BOX
TONGS, BRAZING METALWORKING T&E 96

- -

TONGS, CHAIN METALWORKING T&E 96
TONGS, CLAM. FISHING & TRAPPING T&E 57
TONGS, CLINCHING ANIMAL HUSBANDRY T&E 55
TONGS, CLIP. METALWORKING T&E 96
TONGS, CROOK-BIT METALWORKING T&E 96
 rt TONGS, SIDE
TONGS, DENTAL. MEDICAL & PSYCHOLOGICAL T&E. . . . 155
TONGS, DIPPING GLASS, PLASTICS, CLAYWORKING T&E . 81
TONGS, DOUBLE BOX. METALWORKING T&E 96
 rt TONGS, BOX
TONGS, DRAWING METALWORKING T&E 96
 Tongs, Eye. METALWORKING T&E
 use TONGS, HAMMER
 Tongs, Farrier's. ANIMAL HUSBANDRY T&E
 use more specific term, e.g.: TONGS, CLINCHING; TONGS, SHOE-SPREADING
TONGS, FIREPLACE TEMPERATURE CONTROL DEVICE 23
TONGS, FLASK CHEMICAL T&E 140
TONGS, FLAT. METALWORKING T&E 96
TONGS, GAD METALWORKING T&E 96
TONGS, HALF-ROUND. METALWORKING T&E 96
TONGS, HAMMER. METALWORKING T&E 96
TONGS, HOLLOW-BIT. METALWORKING T&E 96
 rt TONGS, BOLT; TONGS, ROUND-LIP
TONGS, HOOP. METALWORKING T&E 96
TONGS, HORNWORKER'S. LEATHER, HORN, SHELLWORKING T&E. . 86
TONGS, ICE MINING & MINERAL HARVESTING T&E. . 102
TONGS, ICE FOOD SERVICE T&E 77
TONGS, LAUNDRY MAINTENANCE T&E. 146
TONGS, LINK. METALWORKING T&E 96
TONGS, LOADING ARMAMENT -- ACCESSORY. 134
TONGS, MERCURY CHEMICAL T&E 140
TONGS, NAIL. METALWORKING T&E 96
TONGS, OYSTER. FISHING & TRAPPING T&E 57
TONGS, PICKUP. METALWORKING T&E 96
TONGS, PINCER. METALWORKING T&E 96
TONGS, PIPE. PERSONAL GEAR. 38
TONGS, PLOW. METALWORKING T&E 96
TONGS, RAKU. GLASS, PLASTICS, CLAYWORKING T&E . 81
 Tongs, Right-angle bit. METALWORKING T&E
 use TONGS, SIDE
TONGS, ROCKET. ARMAMENT -- ACCESSORY. 134
TONGS, ROOFING METALWORKING T&E 96
TONGS, ROUND-LIP METALWORKING T&E 96
 rt TONGS, BOLT; TONGS, HOLLOW-BIT
TONGS, SANDWICH. FOOD SERVICE T&E 77
TONGS, SHELF MERCHANDISING T&E. 157
TONGS, SHOE. METALWORKING T&E 96
TONGS, SHOE-SPREADING. ANIMAL HUSBANDRY T&E 55
TONGS, SIDE. METALWORKING T&E 96
 rt TONGS, CROOK-BIT

- -

```
TONGS, SKIDDING. . . . . . . . . . . . FORESTRY T&E . . . . . . . . . . .   78
TONGS, SLIDING . . . . . . . . . . . . METALWORKING T&E . . . . . . . . .   96
 Tongs, Straight-lip . . . . . . . . . METALWORKING T&E
  use  TONGS, FLAT
TONGS, SUGAR . . . . . . . . . . . . . FOOD SERVICE T&E . . . . . . . . .   77
TONGS, SWIVEL JAW. . . . . . . . . . . METALWORKING T&E . . . . . . . . .   96
TONGS, TIRE. . . . . . . . . . . . . . METALWORKING T&E . . . . . . . . .   96
TONGS, TIRE-PULLING. . . . . . . . . . METALWORKING T&E . . . . . . . . .   96
 Tongs, V-lip. . . . . . . . . . . . . METALWORKING T&E
  use  TONGS, HOLLOW-BIT
TONOMETER. . . . . . . . . . . . . . . MEDICAL & PSYCHOLOGICAL T&E. . . .  155
TONOMETER. . . . . . . . . . . . . . . MECHANICAL T&E . . . . . . . . . .  148
TONOMETER. . . . . . . . . . . . . . . ACOUSTICAL T&E . . . . . . . . . .  124
TONOSCOPE. . . . . . . . . . . . . . . ACOUSTICAL T&E . . . . . . . . . .  124
TONSILLOTOME . . . . . . . . . . . . . MEDICAL & PSYCHOLOGICAL T&E. . . .  155
TOOL, ANGLE-BENDING. . . . . . . . . . METALWORKING T&E . . . . . . . . .   96
TOOL, BORING . . . . . . . . . . . . . METALWORKING T&E . . . . . . . . .   96
TOOL, COMBINATION. . . . . . . . . . . MULTIPLE USE ARTIFACT. . . . . . .  228
TOOL, FINISHING. . . . . . . . . . . . GLASS, PLASTICS, CLAYWORKING T&E .   81
TOOL, FISHING. . . . . . . . . . . . . MINING & MINERAL HARVESTING T&E. .  102
TOOL, FLARING. . . . . . . . . . . . . GLASS, PLASTICS, CLAYWORKING T&E .   81
TOOL, FLENSING . . . . . . . . . . . . FISHING & TRAPPING T&E . . . . . .   57
TOOL, FOAM-CUTTING . . . . . . . . . . GLASS, PLASTICS, CLAYWORKING T&E .   81
TOOL, FORMING. . . . . . . . . . . . . GLASS, PLASTICS, CLAYWORKING T&E .   81
TOOL, HEADING. . . . . . . . . . . . . METALWORKING T&E . . . . . . . . .   96
TOOL, INCISING . . . . . . . . . . . . GLASS, PLASTICS, CLAYWORKING T&E .   81
TOOL, KNURLING . . . . . . . . . . . . METALWORKING T&E . . . . . . . . .   96
TOOL, LOOP . . . . . . . . . . . . . . GLASS, PLASTICS, CLAYWORKING T&E .   81
 Tool, Modeling. . . . . . . . . . . . GLASS, PLASTICS, CLAYWORKING T&E
  use  more specific term, e.g.: TOOL, LOOP; TOOL, RIB
TOOL, NEEDLE . . . . . . . . . . . . . GLASS, PLASTICS, CLAYWORKING T&E .   81
TOOL, POT-SETTING. . . . . . . . . . . GLASS, PLASTICS, CLAYWORKING T&E .   81
TOOL, RIB. . . . . . . . . . . . . . . GLASS, PLASTICS, CLAYWORKING T&E .   81
TOOL, TINT . . . . . . . . . . . . . . PRINTING T&E . . . . . . . . . . .  180
TOOL, TONG . . . . . . . . . . . . . . ARMAMENT -- ACCESSORY. . . . . . .  134
TOOL, TURNING. . . . . . . . . . . . . GLASS, PLASTICS, CLAYWORKING T&E .   81
 Tools, Fireplace. . . . . . . . . . . TEMPERATURE CONTROL DEVICE
  use  FIRESET
TOOTHBRUSH . . . . . . . . . . . . . . TOILET ARTICLE . . . . . . . . . .   40
TOOTHPICK. . . . . . . . . . . . . . . TOILET ARTICLE . . . . . . . . . .   40
TOP. . . . . . . . . . . . . . . . . . TOY. . . . . . . . . . . . . . . .  225
   rt  DIABOLO
TOP, BOWSTRING . . . . . . . . . . . . TOY. . . . . . . . . . . . . . . .  225
TOP, GYROSCOPE . . . . . . . . . . . . TOY. . . . . . . . . . . . . . . .  225
TOP, INERTIA . . . . . . . . . . . . . MECHANICAL T&E . . . . . . . . . .  148
TOP, MAGNETIC. . . . . . . . . . . . . TOY. . . . . . . . . . . . . . . .  225
TOP, PEG . . . . . . . . . . . . . . . TOY. . . . . . . . . . . . . . . .  225
TOP, WHIP. . . . . . . . . . . . . . . TOY. . . . . . . . . . . . . . . .  225
 Topcoat . . . . . . . . . . . . . . . CLOTHING -- OUTERWEAR
  use  OVERCOAT
```

- -

```
    Topee . . . . . . . . . . . . . . . CLOTHING -- HEADWEAR
      use  HELMET, PITH
    TOPOPHONE. . . . . . . . . . . . . . ACOUSTICAL T&E . . . . . . . . . .  124
    TOPPER, BARREL . . . . . . . . . . . WOODWORKING T&E. . . . . . . . . .  121
    TOPPER, EGG. . . . . . . . . . . . . FOOD PROCESSING T&E. . . . . . . .   68
    TOPPER, HORNWORKER'S . . . . . . . . LEATHER, HORN, SHELLWORKING T&E. .   86
    TOQUE. . . . . . . . . . . . . . . . CLOTHING -- HEADWEAR . . . . . . .   28
    TORAH, SEPHER. . . . . . . . . . . . CEREMONIAL ARTIFACT. . . . . . . .  208
    TORCH. . . . . . . . . . . . . . . . LIGHTING DEVICE. . . . . . . . . .   21
    TORCH. . . . . . . . . . . . . . . . METALWORKING T&E . . . . . . . . .   96
    TORCH, ACETYLENE . . . . . . . . . . METALWORKING T&E . . . . . . . . .   96
    TORCH, ALCOHOL . . . . . . . . . . . METALWORKING T&E . . . . . . . . .   96
    TORCH, GASOLINE. . . . . . . . . . . METALWORKING T&E . . . . . . . . .   96
    TORCH, KEROSENE. . . . . . . . . . . METALWORKING T&E . . . . . . . . .   96
    TORCH, OXYACETYLENE. . . . . . . . . METALWORKING T&E . . . . . . . . .   96
    TORCH, OXYHYDROGEN . . . . . . . . . METALWORKING T&E . . . . . . . . .   96
    Torchere . . . . . . . . . . . . . . FURNITURE
      use  CANDLESTAND
    TORPEDO. . . . . . . . . . . . . . . MINING & MINERAL HARVESTING T&E. .  102
    TORPEDO. . . . . . . . . . . . . . . ARMAMENT -- AMMUNITION . . . . . .  129
    TORPEDO, AERIAL. . . . . . . . . . . ARMAMENT -- AMMUNITION . . . . . .  129
    TOTEM. . . . . . . . . . . . . . . . CEREMONIAL ARTIFACT. . . . . . . .  208
    Toupee . . . . . . . . . . . . . . . ADORNMENT
      use  HAIRPIECE
    TOURNIQUET . . . . . . . . . . . . . MEDICAL & PSYCHOLOGICAL T&E. . . .  155
    TOWEL, BATH. . . . . . . . . . . . . TOILET ARTICLE . . . . . . . . . .   40
    TOWEL, BEACH . . . . . . . . . . . . TOILET ARTICLE . . . . . . . . . .   40
    TOWEL, DISH. . . . . . . . . . . . . MAINTENANCE T&E. . . . . . . . . .  146
    TOWEL, FACE. . . . . . . . . . . . . TOILET ARTICLE . . . . . . . . . .   40
    TOWEL, FINGERTIP . . . . . . . . . . TOILET ARTICLE . . . . . . . . . .   40
    TOWEL, HAND. . . . . . . . . . . . . TOILET ARTICLE . . . . . . . . . .   40
    TOWEL, SHOW. . . . . . . . . . . . . HOUSEHOLD ACCESSORY. . . . . . . .   19
    TOWER. . . . . . . . . . . . . . . . BUILDING . . . . . . . . . . . . .    3
    TOWER. . . . . . . . . . . . . . . . OTHER STRUCTURE. . . . . . . . . .    8
    TOWER, BELL. . . . . . . . . . . . . BUILDING . . . . . . . . . . . . .    3
    TOWER, CONTROL . . . . . . . . . . . BUILDING . . . . . . . . . . . . .    3
    TOWER, OBSERVATION . . . . . . . . . OTHER STRUCTURE. . . . . . . . . .    8
    TOWER, TRANSMITTING. . . . . . . . . OTHER STRUCTURE. . . . . . . . . .    8
    TOWER, WATER . . . . . . . . . . . . OTHER STRUCTURE. . . . . . . . . .    8
    TOWER, WATER . . . . . . . . . . . . LTE -- MOTORIZED . . . . . . . . .  192
    TOY, BELL. . . . . . . . . . . . . . TOY. . . . . . . . . . . . . . . .  225
    Toy, Optic . . . . . . . . . . . . . TOY
      use  more specific term, e.g.: KALEIDOSCOPE; THAUMATROPE; ZOETROPE
    Toy, Paper . . . . . . . . . . . . . TOY
      use  more specific term
    Toy, Penny . . . . . . . . . . . . . TOY
      use  more specific term
    TOY, POUNDING. . . . . . . . . . . . TOY. . . . . . . . . . . . . . . .  225
    TOY, PULL. . . . . . . . . . . . . . TOY. . . . . . . . . . . . . . . .  225
    Toy, Push . . . . . . . . . . . . . TOY
      use  TOY, TRUNDLE
```

- -

Toy, Rocking. TOY
 use TUMBLER
TOY, SAND. TOY. 225
TOY, SCISSOR TOY. 225
Toy, Spring TOY
 use more specific term
Toy, Stuffed. TOY
 use more specific term
TOY, TRUNDLE TOY. 225
Toy, Tumbling TOY
 use TUMBLER
TOY, WASHING TOY. 225
Toys, Tinker. TOY
 use SET, CONSTRUCTION
TRACER GLASS, PLASTICS, CLAYWORKING T&E . 81
TRACER, CURVE. DRAFTING T&E 171
TRACK SECTION. RAIL TRANSPORTATION -- ACCESSORY . 197
TRACTOR. CONSTRUCTION T&E 141
TRACTOR, ARTILLERY LTE -- MOTORIZED 193
TRACTOR, FARM. AGRICULTURAL T&E 51
TRACTOR, GARDEN. AGRICULTURAL T&E 51
TRACTOR, TRUCK LTE -- MOTORIZED 193
TRAILER. LTE -- MOTORIZED 193
 rt SEMITRAILER
TRAILER, BOAT. LTE -- MOTORIZED 193
TRAILER, FARM. AGRICULTURAL T&E 51
TRAILER, HOUSE LTE -- MOTORIZED 193
Trailer, Slip GLASS, PLASTICS, CLAYWORKING T&E
 use CUP, SLIP-TRAILING
Trailer, Tractor-drawn. AGRICULTURAL T&E
 use TRAILER, FARM
TRAIN. CLOTHING -- OUTERWEAR. 31
TRAIN. RAIL TRANSPORTATION -- EQUIPMENT . 197
 note use only when cataloging a complete unit of locomotive(s) and cars
TRAIN. TOY. 225
 note use for a complete set. See also RAIL TRANSPORTATION
TRAIN, FREIGHT RAIL TRANSPORTATION -- EQUIPMENT . 197
TRAIN, PASSENGER RAIL TRANSPORTATION -- EQUIPMENT . 197
TRAIN, SCOURING. TEXTILEWORKING T&E 110
TRAM MINING & MINERAL HARVESTING T&E. . 102
Tram. RAIL TRANSPORTATION -- EQUIPMENT
 use STREETCAR
TRAMMEL. FOOD PROCESSING T&E. 68
TRAMPOLINE SPORTS EQUIPMENT 222
TRANSCEIVER. TELECOMMUNICATION T&E. 182
 of audio messages
TRANSCEIVER. TELECOMMUNICATION T&E. 182
 note use for any instrument that permits transmission and reception
TRANSCRIPT DOCUMENTARY ARTIFACT 214
TRANSFORMER. ENERGY PRODUCTION T&E. 144

- -

TRANSFORMER. ELECTRICAL & MAGNETIC T&E. 143
TRANSFORMER, IMPEDENCE ELECTRICAL & MAGNETIC T&E. 143
TRANSILLUMINATOR MEDICAL & PSYCHOLOGICAL T&E. . . . 155
TRANSISTOR ELECTRICAL & MAGNETIC T&E. 143
TRANSIT. SURVEYING & NAVIGATIONAL T&E . . . 164
 rt THEODOLITE
TRANSMITTER. TELECOMMUNICATION T&E. 182
TRANSMITTER, RADIO TELECOMMUNICATION T&E. 182
TRANSMITTER, SOUND ACOUSTICAL T&E 124
TRANSMITTER, TELEVISION. TELECOMMUNICATION T&E. 182
TRANSPARENCY, LANTERN-SLIDE. DOCUMENTARY ARTIFACT 214
TRANSPARENCY, MAGIC LANTERN. TOY. 225
TRANSPARENCY, ROLL-FILM. DOCUMENTARY ARTIFACT 214
TRANSPARENCY, SLIDE. DOCUMENTARY ARTIFACT 214
TRANSPLANTER, HAND AGRICULTURAL T&E 51
TRANSPORT. WATER TRANSPORTATION -- EQUIPMENT. 200
TRAP FISHING & TRAPPING T&E 57
TRAP LTE -- ANIMAL-POWERED. 190
TRAP ARMAMENT -- ACCESSORY. 134
TRAP, BEAR FISHING & TRAPPING T&E 57
TRAP, BEAVER FISHING & TRAPPING T&E 57
TRAP, BULLET ARMAMENT -- ACCESSORY. 134
 Trap, Cartridge ARMAMENT -- ACCESSORY
 use TRAP, BULLET
TRAP, FISH FISHING & TRAPPING T&E 57
 rt NET, POUND; POT, FISH
 Trap, Fly HOUSEHOLD ACCESSORY
 use FLYTRAP
TRAP, HAND ARMAMENT -- ACCESSORY. 134
 Trap, Lobster FISHING & TRAPPING T&E
 use POT, LOBSTER
 Trap, Mouse HOUSEHOLD ACCESSORY
 use MOUSETRAP
 Trap, Rat HOUSEHOLD ACCESSORY
 use RATTRAP
TRAP, ROACH. HOUSEHOLD ACCESSORY. 19
 Trapeze PUBLIC ENTERTAINMENT DEVICE
 use RIGGING, AERIAL
TRAPEZE. RECREATIONAL DEVICE. 219
TRAVELER METALWORKING T&E 96
TRAVOIS. LTE -- ANIMAL-POWERED. 190
 rt LITTER
 Trawl FISHING & TRAPPING T&E
 use LONGLINE or NET, TRAWL
 Trawler WATER TRANSPORTATION -- EQUIPMENT
 use FISHERMAN
TRAY HOUSEHOLD ACCESSORY. 19
TRAY MERCHANDISING T&E. 157
TRAY, BALL ARMAMENT -- ACCESSORY. 134
TRAY, BED. FOOD SERVICE T&E 77

- -

TRAY, BREAD. FOOD SERVICE T&E 77
TRAY, BUTTER FOOD SERVICE T&E 77
 Tray, Calling card. HOUSEHOLD ACCESSORY
 use RECEIVER, CARD
TRAY, CEREMONIAL CEREMONIAL ARTIFACT. 209
TRAY, CHOPPING FOOD PROCESSING T&E. 68
 Tray, Cutlery FOOD SERVICE T&E
 use TRAY, FLATWARE
TRAY, CUT-OFF. GLASS, PLASTICS, CLAYWORKING T&E . 81
TRAY, DENTAL ACCESSORY MEDICAL & PSYCHOLOGICAL T&E. . . . 155
TRAY, DESK WRITTEN COMMUNICATION T&E. 185
TRAY, DRESSER. TOILET ARTICLE 40
TRAY, DRYING FOOD PROCESSING T&E. 68
TRAY, FLATWARE FOOD SERVICE T&E 77
TRAY, GAMBLING GAME 218
TRAY, ICE CUBE FOOD PROCESSING T&E. 68
TRAY, IMPRESSION MEDICAL & PSYCHOLOGICAL T&E. . . . 155
TRAY, MONEY. EXCHANGE MEDIUM. 214
TRAY, ORE. MINING & MINERAL HARVESTING T&E. . 102
TRAY, PEG. LEATHER, HORN, SHELLWORKING T&E. . 86
TRAY, PEN. WRITTEN COMMUNICATION T&E. 185
TRAY, PIN. TEXTILEWORKING T&E 110
TRAY, PRINT-PROCESSING PHOTOGRAPHIC T&E 177
TRAY, RELISH FOOD SERVICE T&E 77
TRAY, SAUCEBOAT. FOOD SERVICE T&E 77
TRAY, SERVING. FOOD SERVICE T&E 77
TRAY, WINNOWING. AGRICULTURAL T&E 51
TREAD, ANIMAL-POWERED. ENERGY PRODUCTION T&E. 144
TREAD, HUMAN-POWERED ENERGY PRODUCTION T&E. 144
TREAD, STAIR FLOOR COVERING 10
 Treadmill ENERGY PRODUCTION T&E
 use TREAD, ANIMAL-POWERED or TREAD, HUMAN-POWERED
TREBUCKET. ARMAMENT -- ARTILLERY. 128
 Trechometer SURVEYING & NAVIGATIONAL T&E
 use WHEEL, SURVEYOR'S
TREE, SADDLE LTE -- ACCESSORY 195
TREE, SHOE CLOTHING -- ACCESSORY. 34
TREENAIL WOODWORKING T&E. 121
 rt PEG; DOWEL
TRELLIS. SITE FEATURE 7
TRELLIS, PLANT HOUSEHOLD ACCESSORY. 19
 Trencher. FOOD SERVICE T&E
 use PLATTER
TREPHINE MEDICAL & PSYCHOLOGICAL T&E. . . . 155
TRESTLE. OTHER STRUCTURE. 8
 rt BRIDGE
TRIANGLE DRAFTING T&E 171
TRIANGLE MUSICAL T&E. 175
TRIBOMETER MECHANICAL T&E 148
TRICORN. CLOTHING -- HEADWEAR 28

- -

TRICYCLE LTE -- HUMAN-POWERED 192
TRICYCLE TOY. 225
TRICYCLE, GASOLINE LTE -- MOTORIZED 193
 Tricycle, Side-by-side. LTE -- HUMAN-POWERED
 use SOCIABLE
TRICYCLE, STEAM. LTE -- MOTORIZED 193
TRICYCLE, TANDEM LTE -- HUMAN-POWERED 192
TRICYCLE, TWO-TRACK. LTE -- HUMAN-POWERED 192
 Trier, Butter FOOD PROCESSING T&E
 use TRIER, CHEESE
TRIER, CHEESE. FOOD PROCESSING T&E. 69
TRIM TEXTILEWORKING T&E 110
TRIM ARTIFACT REMNANT 227
TRIMARAN WATER TRANSPORTATION -- EQUIPMENT. 200
TRIMMER. PAPERMAKING T&E. 104
TRIMMER, BRACKET PAPERMAKING T&E. 104
TRIMMER, EAR ANIMAL HUSBANDRY T&E 55
TRIMMER, EDGE. LEATHER, HORN, SHELLWORKING T&E. . 86
TRIMMER, GINGIVAL. MEDICAL & PSYCHOLOGICAL T&E. . . . 155
TRIMMER, HOOF. ANIMAL HUSBANDRY T&E 55
TRIMMER, PHOTOGRAPH. PHOTOGRAPHIC T&E 177
TRIMMER, WELT. LEATHER, HORN, SHELLWORKING T&E. . 86
TRIMMER, WICK. LIGHTING DEVICE. 21
TRINKET. HOUSEHOLD ACCESSORY. 19
TRIP-HAMMER. METALWORKING T&E 96
TRIP-HAMMER. PAPERMAKING T&E. 104
 Triple. LTE -- MOTORIZED
 use more specific term, e.g.: TRUCK, PUMPER/LADDER
TRIPLETREE LTE -- ACCESSORY 195
TRIPOD MINING & MINERAL HARVESTING T&E. . 102
TRIPOD PHOTOGRAPHIC T&E 177
TRIPOD ARMAMENT -- ACCESSORY. 134
TRIPOD CHEMICAL T&E 140
TRIPOD SURVEYING & NAVIGATIONAL T&E . . . 164
TRIPOD MULTIPLE USE ARTIFACT. 228
 Triptych. CEREMONIAL ARTIFACT
 use ALTARPIECE
TRIVET FOOD SERVICE T&E 77
TRIVET MAINTENANCE T&E. 146
TROCAR MEDICAL & PSYCHOLOGICAL T&E. . . . 155
 Trolley RAIL TRANSPORTATION -- EQUIPMENT
 use STREETCAR, ELECTRIC
 Trolley, Trackless. LTE -- ANIMAL-POWERED
 use OMNIBUS
TROMBONE MUSICAL T&E. 175
TROMBONE, VALVE. MUSICAL T&E. 175
TROMOMETER METEOROLOGICAL T&E 158
TROPHY PERSONAL SYMBOL. 216
 rt CUP, LOVING
TROPOSTEREOSCOPE MEDICAL & PSYCHOLOGICAL T&E. . . . 155

- -

```
TROUGH, DOUGH. . . . . . . . . . . . . . FOOD PROCESSING T&E. . . . . . . .    69
 Trough, Feed. . . . . . . . . . . . . ANIMAL HUSBANDRY T&E
  use  FEEDER, LIVESTOCK
TROUGH, MEAT-SALTING . . . . . . . . . . FOOD PROCESSING T&E. . . . . . . .    69
TROUGH, MIXING . . . . . . . . . . . . . MASONRY & STONEWORKING T&E . . . .    88
TROUGH, PNEUMATIC. . . . . . . . . . . . CHEMICAL T&E . . . . . . . . . .     140
 Trough, Poultry water . . . . . . . . ANIMAL HUSBANDRY T&E
  use  WATERER, POULTRY
 Trough, Scalding. . . . . . . . . . . FOOD PROCESSING T&E
  use  SCALDER, HOG
 Trough, Watering. . . . . . . . . . . ANIMAL HUSBANDRY T&E
  use  WATERER, LIVESTOCK
 Trousers. . . . . . . . . . . . . . . CLOTHING -- OUTERWEAR
  use  PANTS
TROWEL . . . . . . . . . . . . . . . . . MASONRY & STONEWORKING T&E . . . .    88
TROWEL, FRATERNAL. . . . . . . . . . . . PERSONAL SYMBOL. . . . . . . . .    216
TROWEL, GARDEN . . . . . . . . . . . . . AGRICULTURAL T&E . . . . . . . .     51
TROWEL, GROUTING . . . . . . . . . . . . MASONRY & STONEWORKING T&E . . . .    88
 Trowel, Nursery . . . . . . . . . . . AGRICULTURAL T&E
  use  TROWEL, GARDEN
TROWEL, POINTING . . . . . . . . . . . . MASONRY & STONEWORKING T&E . . . .    88
TROWEL, SMOOTHING. . . . . . . . . . . . MASONRY & STONEWORKING T&E . . . .    88
TRUCK. . . . . . . . . . . . . . . . . . LTE -- MOTORIZED . . . . . . . .    193
TRUCK, AERIAL LADDER . . . . . . . . . . LTE -- MOTORIZED . . . . . . . .    193
 Truck, Bag-holder . . . . . . . . . . FOOD PROCESSING T&E
  use  HOLDER, BAG
TRUCK, CRASH . . . . . . . . . . . . . . LTE -- MOTORIZED . . . . . . . .    193
 rt  AMBULANCE
 Truck, Delivery . . . . . . . . . . . LTE -- MOTORIZED
  use  specific body type: e.g., TRUCK, DUMP; -,PANEL; -,TANK
TRUCK, DUMP. . . . . . . . . . . . . . . LTE -- MOTORIZED . . . . . . . .    193
TRUCK, FLATBED . . . . . . . . . . . . . LTE -- MOTORIZED . . . . . . . .    193
TRUCK, HOOK & LADDER . . . . . . . . . . LTE -- MOTORIZED . . . . . . . .    193
 Truck, Ladder . . . . . . . . . . . . LTE -- MOTORIZED
  use  TRUCK, HOOK & LADDER
TRUCK, LIGHTING. . . . . . . . . . . . . LTE -- MOTORIZED . . . . . . . .    193
TRUCK, LUMBER. . . . . . . . . . . . . . LTE -- MOTORIZED . . . . . . . .    193
TRUCK, MAIL. . . . . . . . . . . . . . . LTE -- MOTORIZED . . . . . . . .    193
TRUCK, MILK. . . . . . . . . . . . . . . LTE -- MOTORIZED . . . . . . . .    193
TRUCK, ORDNANCE WORKSHOP . . . . . . . . LTE -- MOTORIZED . . . . . . . .    193
TRUCK, PANEL . . . . . . . . . . . . . . LTE -- MOTORIZED . . . . . . . .    193
TRUCK, PICKUP. . . . . . . . . . . . . . LTE -- MOTORIZED . . . . . . . .    193
TRUCK, PUMPER. . . . . . . . . . . . . . LTE -- MOTORIZED . . . . . . . .    193
 rt  APPARATUS, FIRE
TRUCK, PUMPER/AERIAL LADDER. . . . . . . LTE -- MOTORIZED . . . . . . . .    193
TRUCK, PUMPER/LADDER . . . . . . . . . . LTE -- MOTORIZED . . . . . . . .    193
 rt  APPARATUS, FIRE
TRUCK, SMOKE EJECTOR . . . . . . . . . . LTE -- MOTORIZED . . . . . . . .    193
TRUCK, STAKE . . . . . . . . . . . . . . LTE -- MOTORIZED . . . . . . . .    193
TRUCK, TANK. . . . . . . . . . . . . . . LTE -- MOTORIZED . . . . . . . .    193
```

- -

TUBE, PERCUSSION ARMAMENT -- ACCESSORY. 134
TUBE, QUINCKE'S. ACOUSTICAL T&E 124
TUBE, SOUNDING SURVEYING & NAVIGATIONAL T&E . . . 164
TUBE, SPEAKING SOUND COMMUNICATION T&E. 181
TUBE, STOMACH. MEDICAL & PSYCHOLOGICAL T&E. . . . 155
 Tube, Teat. FOOD PROCESSING T&E
 use TUBE, MILK
TUBE, TEST CHEMICAL T&E 140
TUBE, TRACHEOTOMY. ANIMAL HUSBANDRY T&E 55
TUBE, VACUUM ELECTRICAL & MAGNETIC T&E. 143
TUBING, ADAPTER. CHEMICAL T&E 140
 Tubing, Reducer CHEMICAL T&E
 use TUBING, ADAPTER
TUG-TOWBOAT. WATER TRANSPORTATION -- EQUIPMENT. 200
TUMBLER. FOOD SERVICE T&E 77
TUMBLER. TOY. 225
TUMPLINE LTE -- ACCESSORY 195
TUNIC. CLOTHING -- OUTERWEAR. 31
TUNNEL RECREATIONAL DEVICE. 219
TUNNEL, RAILROAD OTHER STRUCTURE. 8
TUNNEL, WIND MECHANICAL T&E 148
TUQUE. CLOTHING -- HEADWEAR 28
TURBAN CLOTHING -- HEADWEAR 28
TURBIDIMETER MECHANICAL T&E 148
TURBINE, HYDRAULIC ENERGY PRODUCTION T&E. 144
TURBINE, IMPULSE ENERGY PRODUCTION T&E. 144
TURBINE, INTERNAL-COMBUSTION ENERGY PRODUCTION T&E. 144
TURBINE, STEAM ENERGY PRODUCTION T&E. 144
 Turbine, Tub. ENERGY PRODUCTION T&E
 use WATERWHEEL, TUB
TUREEN FOOD SERVICE T&E 77
TUREEN, SAUCE. FOOD SERVICE T&E 77
TURNBUCKLE MECHANICAL T&E 148
TURNER, CAKE FOOD PROCESSING T&E. 69
TURNER, SEAM LEATHER, HORN, SHELLWORKING T&E. . 86
TURNSTILE. MERCHANDISING T&E. 157
TURNTABLE. SOUND COMMUNICATION T&E. 181
TURRET BUILDING 3
TURRET, MACHINE GUN. ARMAMENT -- ACCESSORY. 134
 Tus PERSONAL GEAR
 use CANTEEN
 Tutu. CLOTHING -- OUTERWEAR
 use COSTUME, DANCE
TUXEDO CLOTHING -- OUTERWEAR. 31
TWEEZERS TOILET ARTICLE 40
TWEEZERS GLASS, PLASTICS, CLAYWORKING T&E . 81
TWEEZERS MEDICAL & PSYCHOLOGICAL T&E. . . . 155
TWEEZERS MULTIPLE USE ARTIFACT. 228
TWEEZERS, SOLDERING. MEDICAL & PSYCHOLOGICAL T&E. . . . 155
TWEEZERS, STEAM INDICATOR. SURVEYING & NAVIGATIONAL T&E . . . 164

- -

- -

```
UNIT, TAPE . . . . . . . . . . . . . . DATA PROCESSING T&E. . . . . . . .  170
UNIT, VISUAL DISPLAY . . . . . . . . . DATA PROCESSING T&E. . . . . . . .  170
UPSETTER, TIRE . . . . . . . . . . . . METALWORKING T&E . . . . . . . . .   96
UREOMETER. . . . . . . . . . . . . . . MEDICAL & PSYCHOLOGICAL T&E. . . .  155
URETHROSCOPE . . . . . . . . . . . . . MEDICAL & PSYCHOLOGICAL T&E. . . .  155
URETHROTOME. . . . . . . . . . . . . . MEDICAL & PSYCHOLOGICAL T&E. . . .  155
URICOMETER . . . . . . . . . . . . . . MEDICAL & PSYCHOLOGICAL T&E. . . .  155
URINAL . . . . . . . . . . . . . . . . TOILET ARTICLE . . . . . . . . . .   40
   note a vessel for use by a bedfast patient
   rt  BEDPAN
URINOMETER . . . . . . . . . . . . . . MEDICAL & PSYCHOLOGICAL T&E. . . .  155
URINO-PYCNOMETER . . . . . . . . . . . MEDICAL & PSYCHOLOGICAL T&E. . . .  155
URN. . . . . . . . . . . . . . . . . . HOUSEHOLD ACCESSORY. . . . . . . .   19
URN. . . . . . . . . . . . . . . . . . CEREMONIAL ARTIFACT. . . . . . . .  209
URN, COFFEE. . . . . . . . . . . . . . FOOD SERVICE T&E . . . . . . . . .   77
URN, GARDEN. . . . . . . . . . . . . . SITE FEATURE . . . . . . . . . . .    7
URN, TEA . . . . . . . . . . . . . . . FOOD SERVICE T&E . . . . . . . . .   77
VALANCE. . . . . . . . . . . . . . . . WINDOW OR DOOR COVERING. . . . . .   23
  Valance, Shelf. . . . . . . . . . . HOUSEHOLD ACCESSORY
   use LAMBREQUIN
  Valentine, Sailor's . . . . . . . . ART
   use PICTURE, SHELL
VALET. . . . . . . . . . . . . . . . . FURNITURE. . . . . . . . . . . . .   15
  Valise. . . . . . . . . . . . . . . PERSONAL GEAR
   use SUITCASE
VALVE, PIPE. . . . . . . . . . . . . . BUILDING COMPONENT . . . . . . . .    6
VALVE, STEAM . . . . . . . . . . . . . ENERGY PRODUCTION T&E. . . . . . .  144
VAMBRACE . . . . . . . . . . . . . . . ARMAMENT -- BODY ARMOR . . . . . .  130
  Van . . . . . . . . . . . . . . . . RAIL TRANSPORTATION -- EQUIPMENT
   use CABOOSE
VAN. . . . . . . . . . . . . . . . . . LTE -- MOTORIZED . . . . . . . . .  193
VAN, GYPSY . . . . . . . . . . . . . . LTE -- ANIMAL-POWERED. . . . . . .  190
  Van De Graaff . . . . . . . . . . . NUCLEAR PHYSICS T&E
   use GENERATOR, ELECTROSTATIC
  Vanity. . . . . . . . . . . . . . . FURNITURE
   use TABLE, DRESSING
  Vanner. . . . . . . . . . . . . . . MINING & MINERAL HARVESTING T&E
   use SEPARATOR
VAPORIMETER. . . . . . . . . . . . . . CHEMICAL T&E . . . . . . . . . . .  140
VAPORIZER. . . . . . . . . . . . . . . MEDICAL & PSYCHOLOGICAL T&E. . . .  155
VARIATOR, STERN. . . . . . . . . . . . ACOUSTICAL T&E . . . . . . . . . .  124
VARIOPLEX. . . . . . . . . . . . . . . DATA PROCESSING T&E. . . . . . . .  170
   rt  MULTIPLEXOR
VASCULUM . . . . . . . . . . . . . . . BIOLOGICAL T&E . . . . . . . . . .  137
VASE . . . . . . . . . . . . . . . . . HOUSEHOLD ACCESSORY. . . . . . . .   19
VASE, AUTOMOBILE . . . . . . . . . . . LTE -- ACCESSORY . . . . . . . . .  195
VASE, BUD. . . . . . . . . . . . . . . HOUSEHOLD ACCESSORY. . . . . . . .   19
VASE, CELERY . . . . . . . . . . . . . FOOD SERVICE T&E . . . . . . . . .   77
VASE, CEREMONIAL . . . . . . . . . . . CEREMONIAL ARTIFACT. . . . . . . .  209
VASE, FLOWER . . . . . . . . . . . . . HOUSEHOLD ACCESSORY. . . . . . . .   19
```

- -

VASE, TEMPLE CEREMONIAL ARTIFACT. 209
VASE, WALL HOUSEHOLD ACCESSORY. 19
VAT. TEXTILEWORKING T&E 110
VAT. LEATHER, HORN, SHELLWORKING T&E. . 86
VAT. PAPERMAKING T&E. 104
VAT, BLEACHING LEATHER, HORN, SHELLWORKING T&E. . 86
VAT, CHEESE. FOOD PROCESSING T&E. 69
VAT, COOLING FOOD PROCESSING T&E. 69
 Vat, Cream. FOOD PROCESSING T&E
 use VAT, CHEESE
VAT, CYANIDATION MINING & MINERAL HARVESTING T&E. . 102
VAT, DYEING. LEATHER, HORN, SHELLWORKING T&E. . 86
VAT, PICKLING. LEATHER, HORN, SHELLWORKING T&E. . 86
VAT, PROCESSING. FOOD PROCESSING T&E. 69
VAT, STORAGE FOOD PROCESSING T&E. 69
V-BLOCK. GLASS, PLASTICS, CLAYWORKING T&E . 81
VEHICLE, LUNAR LTE -- MOTORIZED 193
VEIL CLOTHING -- HEADWEAR 28
VEIL, CHALICE. CEREMONIAL ARTIFACT. 209
VEIL, TABERNACLE CEREMONIAL ARTIFACT. 209
VEILLEUSE. HOUSEHOLD ACCESSORY. 19
VELOCIMETER. MECHANICAL T&E 148
 Velocipede. LTE -- MOTORIZED
 use BICYCLE, STEAM
VELOCIPEDE LTE -- HUMAN-POWERED 192
VENTILATOR BUILDING COMPONENT 6
VENTILATOR, WINDOW BUILDING COMPONENT 6
VERIFIER DATA PROCESSING T&E. 170
VERTIMETER SURVEYING & NAVIGATIONAL T&E . . 164
VESSEL, CARGO. WATER TRANSPORTATION -- EQUIPMENT. 200
VESSEL, EXCURSION. WATER TRANSPORTATION -- EQUIPMENT. 200
VESSEL, PASSENGER. WATER TRANSPORTATION -- EQUIPMENT. 200
VESSEL, PETROLEUM-SERVICE. WATER TRANSPORTATION -- EQUIPMENT. 200
 note use for offshore station tender
VESSEL, REFRIGERATOR WATER TRANSPORTATION -- EQUIPMENT. 200
VESSEL, RESEARCH WATER TRANSPORTATION -- EQUIPMENT. 200
 rt SUBMARINE, RESEARCH
 Vessel, Shari CEREMONIAL ARTIFACT
 use RELIQUARY
VESSEL, SURVEY WATER TRANSPORTATION -- EQUIPMENT. 200
 Vest. CLOTHING -- UNDERWEAR
 use UNDERSHIRT
VEST CLOTHING -- OUTERWEAR. 32
VEST, BULLETPROOF. ARMAMENT -- BODY ARMOR 130
VEST, FLAK ARMAMENT -- BODY ARMOR 130
VIAL MERCHANDISING T&E. 157
VIAL MEDICAL & PSYCHOLOGICAL T&E. . . 155
VIAL CONTAINER. 186
VIBRAPHONE MUSICAL T&E. 175
VIBRATOR, DENTAL MEDICAL & PSYCHOLOGICAL T&E. . . 155

- -

```
VIBROSCOPE . . . . . . . . . . . . . . . ACOUSTICAL T&E . . . . . . . . . 124
VICTORIA . . . . . . . . . . . . . . . . LTE -- ANIMAL-POWERED. . . . . . 190
   rt  CABRIOLET
VILLAGE. . . . . . . . . . . . . . . . . TOY. . . . . . . . . . . . . . . 225
  Vinaigrette . . . . . . . . . . . . . . PERSONAL GEAR
  use  BOTTLE, SMELLING
VINER, PEA . . . . . . . . . . . . . . . AGRICULTURAL T&E . . . . . . . .  51
VIOL . . . . . . . . . . . . . . . . . . MUSICAL T&E. . . . . . . . . . . 175
VIOL, BASS . . . . . . . . . . . . . . . MUSICAL T&E. . . . . . . . . . . 175
   rt  BARYTON
VIOL, CITHER . . . . . . . . . . . . . . MUSICAL T&E. . . . . . . . . . . 175
VIOL, LYRA . . . . . . . . . . . . . . . MUSICAL T&E. . . . . . . . . . . 175
VIOLA. . . . . . . . . . . . . . . . . . MUSICAL T&E. . . . . . . . . . . 175
   rt  LIRA
VIOLA D'AMORE. . . . . . . . . . . . . . MUSICAL T&E. . . . . . . . . . . 175
VIOLIN . . . . . . . . . . . . . . . . . MUSICAL T&E. . . . . . . . . . . 175
   rt  KIT; REBEC
VIOLONCELLO. . . . . . . . . . . . . . . MUSICAL T&E. . . . . . . . . . . 175
VIRGINAL . . . . . . . . . . . . . . . . MUSICAL T&E. . . . . . . . . . . 175
VIS-A-VIS. . . . . . . . . . . . . . . . LTE -- ANIMAL-POWERED. . . . . . 190
  Viscometer. . . . . . . . . . . . . . . MECHANICAL T&E
  use  VISCOSIMETER
VISCOSIMETER . . . . . . . . . . . . . . MECHANICAL T&E . . . . . . . . . 148
VISE . . . . . . . . . . . . . . . . . . METALWORKING T&E . . . . . . . .  96
VISE . . . . . . . . . . . . . . . . . . WOODWORKING T&E. . . . . . . . . 121
VISE . . . . . . . . . . . . . . . . . . BASKET, BROOM, BRUSH MAKING T&E. 122
VISE . . . . . . . . . . . . . . . . . . MULTIPLE USE ARTIFACT. . . . . . 228
VISE, BENCH. . . . . . . . . . . . . . . METALWORKING T&E . . . . . . . .  97
VISE, BLACKSMITH'S . . . . . . . . . . . METALWORKING T&E . . . . . . . .  97
VISE, BREECHING. . . . . . . . . . . . . ARMAMENT -- ACCESSORY. . . . . . 134
VISE, HAMMER SPRING. . . . . . . . . . . ARMAMENT -- ACCESSORY. . . . . . 134
VISE, HARNESSMAKER'S . . . . . . . . . . LEATHER, HORN, SHELLWORKING T&E.  86
VISE, LEG. . . . . . . . . . . . . . . . METALWORKING T&E . . . . . . . .  97
VISE, LOCK-SPRING. . . . . . . . . . . . ARMAMENT -- ACCESSORY. . . . . . 134
VISE, MACHINE. . . . . . . . . . . . . . METALWORKING T&E . . . . . . . .  97
VISIOMETER . . . . . . . . . . . . . . . MEDICAL & PSYCHOLOGICAL T&E. . . 155
  Visor . . . . . . . . . . . . . . . . . CLOTHING -- HEADWEAR
  use  EYESHADE
VITRINE. . . . . . . . . . . . . . . . . HOUSEHOLD ACCESSORY. . . . . . .  19
  Vitrine . . . . . . . . . . . . . . . . FURNITURE
  use  CABINET, DISPLAY
  Vivascope . . . . . . . . . . . . . . . OPTICAL T&E
  use  TELESCOPE
  Vizard. . . . . . . . . . . . . . . . . PUBLIC ENTERTAINMENT DEVICE
  use  MASK
VOLLEYBALL . . . . . . . . . . . . . . . SPORTS EQUIPMENT . . . . . . . . 222
VOLTMETER. . . . . . . . . . . . . . . . ELECTRICAL & MAGNETIC T&E. . . . 143
VOLUMINOMETER. . . . . . . . . . . . . . MECHANICAL T&E . . . . . . . . . 148
WAGON. . . . . . . . . . . . . . . . . . LTE -- ANIMAL-POWERED. . . . . . 190
WAGON. . . . . . . . . . . . . . . . . . TOY. . . . . . . . . . . . . . . 226
```

- -

```
WAGON, BATTERY . . . . . . . . . . . . . LTE -- ANIMAL-POWERED. . . . . . .  190
WAGON, CHEMICAL. . . . . . . . . . . . . LTE -- ANIMAL-POWERED. . . . . . .  190
WAGON, CIRCUS PARADE . . . . . . . . . . LTE -- ANIMAL-POWERED. . . . . . .  190
WAGON, CONESTOGA . . . . . . . . . . . . LTE -- ANIMAL-POWERED. . . . . . .  190
   rt  PRAIRIE SCHOONER
WAGON, DELIVERY. . . . . . . . . . . . . LTE -- ANIMAL-POWERED. . . . . . .  190
WAGON, FARM. . . . . . . . . . . . . . . LTE -- ANIMAL-POWERED. . . . . . .  190
WAGON, HOOK & LADDER . . . . . . . . . . LTE -- ANIMAL-POWERED. . . . . . .  190
   rt  APPARATUS, FIRE
WAGON, HOSE. . . . . . . . . . . . . . . LTE -- ANIMAL-POWERED. . . . . . .  190
   rt  REEL, HOSE
WAGON, HOUNDBAND . . . . . . . . . . . . LTE -- ANIMAL-POWERED. . . . . . .  190
WAGON, LOG . . . . . . . . . . . . . . . LTE -- ANIMAL-POWERED. . . . . . .  190
WAGON, MARKET. . . . . . . . . . . . . . LTE -- ANIMAL-POWERED. . . . . . .  190
WAGON, MORTAR. . . . . . . . . . . . . . LTE -- ANIMAL-POWERED. . . . . . .  190
WAGON, MOUNTAIN. . . . . . . . . . . . . LTE -- ANIMAL-POWERED. . . . . . .  190
 Wagon, Paddy. . . . . . . . . . . . . . LTE -- ANIMAL-POWERED
   use  WAGON, POLICE PATROL
WAGON, PEDDLER'S . . . . . . . . . . . . LTE -- ANIMAL-POWERED. . . . . . .  191
WAGON, POLICE PATROL . . . . . . . . . . LTE -- ANIMAL-POWERED. . . . . . .  191
 Wagon, Tea. . . . . . . . . . . . . . . FURNITURE
   use  CART, TEA
WAGON, THOROUGHBRACE . . . . . . . . . . LTE -- ANIMAL-POWERED. . . . . . .  191
 Wagon, Tractor-drawn. . . . . . . . . . AGRICULTURAL T&E
   use  TRAILER, FARM
WAGON, TRAY. . . . . . . . . . . . . . . LTE -- ANIMAL-POWERED. . . . . . .  191
WAIST. . . . . . . . . . . . . . . . . . CLOTHING -- OUTERWEAR. . . . . . .   32
WAISTCOAT. . . . . . . . . . . . . . . . CLOTHING -- OUTERWEAR. . . . . . .   32
WALKER . . . . . . . . . . . . . . . . . PERSONAL GEAR. . . . . . . . . . .   38
WALLET . . . . . . . . . . . . . . . . . PERSONAL GEAR. . . . . . . . . . .   38
WALLPAPER. . . . . . . . . . . . . . . . BUILDING COMPONENT . . . . . . . .    6
WANAGAN. . . . . . . . . . . . . . . . . FORESTRY T&E . . . . . . . . . . .   78
WARDROBE . . . . . . . . . . . . . . . . FURNITURE. . . . . . . . . . . . .   15
   rt  CHIFFOROBE
 Warehouse . . . . . . . . . . . . . . . BUILDING
   use  BUILDING, STORAGE
WARMER, BED. . . . . . . . . . . . . . . HOUSEHOLD ACCESSORY. . . . . . . .   19
WARMER, BOTTLE . . . . . . . . . . . . . FOOD PROCESSING T&E. . . . . . . .   69
WARMER, BRANDY . . . . . . . . . . . . . FOOD PROCESSING T&E. . . . . . . .   69
WARMER, FOOT . . . . . . . . . . . . . . HOUSEHOLD ACCESSORY. . . . . . . .   19
WARMER, HAND . . . . . . . . . . . . . . PERSONAL GEAR. . . . . . . . . . .   38
WARMER, PLATE. . . . . . . . . . . . . . FOOD PROCESSING T&E. . . . . . . .   69
 Washbasin . . . . . . . . . . . . . . . TOILET ARTICLE
   use  BASIN
WASHBOARD. . . . . . . . . . . . . . . . MAINTENANCE T&E. . . . . . . . . .  146
WASHCLOTH. . . . . . . . . . . . . . . . TOILET ARTICLE . . . . . . . . . .   40
WASHER . . . . . . . . . . . . . . . . . MINING & MINERAL HARVESTING T&E. .  102
WASHER . . . . . . . . . . . . . . . . . WOODWORKING T&E. . . . . . . . . .  121
WASHER . . . . . . . . . . . . . . . . . MULTIPLE USE -ARTIFACT. . . . . . .  228
WASHER, DRY. . . . . . . . . . . . . . . MINING & MINERAL HARVESTING T&E. .  102
```

- -

```
WASHER, EGG. . . . . . . . . . . . . . . FOOD PROCESSING T&E. . . . . . . .  69
WASHER, FILM . . . . . . . . . . . . . . PHOTOGRAPHIC T&E . . . . . . . . . 177
WASHER, GLASSWARE. . . . . . . . . . . . CHEMICAL T&E . . . . . . . . . . . 140
WASHER, GRAIN. . . . . . . . . . . . . . FOOD PROCESSING T&E. . . . . . . .  69
WASHER, MILK-BOTTLE. . . . . . . . . . . FOOD PROCESSING T&E. . . . . . . .  69
WASHER, MILK-CAN . . . . . . . . . . . . FOOD PROCESSING T&E. . . . . . . .  69
WASHER, PRINT. . . . . . . . . . . . . . PHOTOGRAPHIC T&E . . . . . . . . . 177
  Washer, Wheat . . . . . . . . . . . . . FOOD PROCESSING T&E
    use  WASHER, GRAIN
WASH-POUNDER . . . . . . . . . . . . . . MAINTENANCE T&E. . . . . . . . . . 146
WASHSTAND. . . . . . . . . . . . . . . . FURNITURE. . . . . . . . . . . . .  15
WASHTUB. . . . . . . . . . . . . . . . . MAINTENANCE T&E. . . . . . . . . . 146
WASTEBASKET. . . . . . . . . . . . . . . HOUSEHOLD ACCESSORY. . . . . . . .  19
  Waster. . . . . . . . . . . . . . . . . FOOD SERVICE T&E
    use  DISH, WASTE
WATCH, PENDANT . . . . . . . . . . . . . TIMEKEEPING T&E. . . . . . . . . . 165
WATCH, POCKET. . . . . . . . . . . . . . TIMEKEEPING T&E. . . . . . . . . . 165
WATERER, LIVESTOCK . . . . . . . . . . . ANIMAL HUSBANDRY T&E . . . . . . .  55
WATERER, POULTRY . . . . . . . . . . . . ANIMAL HUSBANDRY T&E . . . . . . .  55
WATERWHEEL, BREAST . . . . . . . . . . . ENERGY PRODUCTION T&E. . . . . . . 144
WATERWHEEL, OVERSHOT . . . . . . . . . . ENERGY PRODUCTION T&E. . . . . . . 144
WATERWHEEL, TUB. . . . . . . . . . . . . ENERGY PRODUCTION T&E. . . . . . . 144
WATERWHEEL, UNDERSHOT. . . . . . . . . . ENERGY PRODUCTION T&E. . . . . . . 144
WAVEMETER. . . . . . . . . . . . . . . . WEIGHTS & MEASURES T&E . . . . . . 167
WAX, DENTAL. . . . . . . . . . . . . . . MEDICAL & PSYCHOLOGICAL T&E. . . . 155
WAX, SEALING . . . . . . . . . . . . . . WRITTEN COMMUNICATION T&E. . . . . 185
WAX, SHOE. . . . . . . . . . . . . . . . CLOTHING -- ACCESSORY. . . . . . .  34
WAY-BILL . . . . . . . . . . . . . . . . DOCUMENTARY ARTIFACT . . . . . . . 214
  Waywiser. . . . . . . . . . . . . . . . SURVEYING & NAVIGATIONAL T&E
    use  WHEEL, SURVEYOR'S
WEANER, CALF . . . . . . . . . . . . . . ANIMAL HUSBANDRY T&E . . . . . . .  55
  Weapon, Automatic . . . . . . . . . . . ARMAMENT -- FIREARM
    use  GUN, MACHINE or GUN, SUBMACHINE
WEATHERVANE. . . . . . . . . . . . . . . METEOROLOGICAL T&E . . . . . . . . 158
WEDGE. . . . . . . . . . . . . . . . . . FORESTRY T&E . . . . . . . . . . .  78
WEDGE. . . . . . . . . . . . . . . . . . WOODWORKING T&E. . . . . . . . . . 121
  rt  CHISEL, RIPPING
WEDGE. . . . . . . . . . . . . . . . . . MECHANICAL T&E . . . . . . . . . . 148
WEDGE, DEFLECTION. . . . . . . . . . . . MINING & MINERAL HARVESTING T&E. . 102
WEEDER . . . . . . . . . . . . . . . . . AGRICULTURAL T&E . . . . . . . . .  51
WEEDER, FLAME. . . . . . . . . . . . . . AGRICULTURAL T&E . . . . . . . . .  51
WEEDER, ROD. . . . . `. . . . . . . . . . AGRICULTURAL T&E . . . . . . . . .  51
WEEDER, SPRING-TOOTH . . . . . . . . . . AGRICULTURAL T&E . . . . . . . . .  51
WEIGHT, BALANCE. . . . . . . . . . . . . WEIGHTS & MEASURES T&E . . . . . . 167
  Weight, Barrel. . . . . . . . . . . . . ARMAMENT -- ACCESSORY
    use  STABILIZER
  Weight, Counter . . . . . . . . . . . . BUILDING COMPONENT
    use  COUNTERWEIGHT
WEIGHT, CURTAIN. . . . . . . . . . . . . WINDOW OR DOOR COVERING. . . . . .  23
WEIGHT, HEAVING LINE . . . . . . . . . . WATER TRANSPORTATION -- ACCESSORY. 203
```

- -

WEIGHT, HORN ANIMAL HUSBANDRY T&E 56
WEIGHT, NET. FISHING & TRAPPING T&E 57
 rt SINKER
WEIGHT, RUBBER DAM MEDICAL & PSYCHOLOGICAL T&E. . . . 155
WEIGHT, SAFETY BLOW-OFF. ENERGY PRODUCTION T&E 144
WEIGHT, TOE. ANIMAL HUSBANDRY T&E 56
WEIGHT, WINDMILL ENERGY PRODUCTION T&E. 144
WEIGHTBELT CLOTHING -- ACCESSORY. 34
WEIR FISHING & TRAPPING T&E 57
 Welder, Arc METALWORKING T&E
 use WELDER, ELECTRIC
WELDER, ELECTRIC METALWORKING T&E 97
 Welder, Gas METALWORKING T&E
 use TORCH modified according to fuel
WHALEBOAT. WATER TRANSPORTATION -- EQUIPMENT. 200
WHALER WATER TRANSPORTATION -- EQUIPMENT. 200
WHALER, TANCOOK. WATER TRANSPORTATION -- EQUIPMENT. 200
WHARF. OTHER STRUCTURE. 8
WHATNOT. FURNITURE. 15
 rt ETAGERE
WHEEL. LTE -- ACCESSORY 195
WHEEL. MULTIPLE USE ARTIFACT. 228
WHEEL. ARTIFACT REMNANT 227
WHEEL, BANDING GLASS, PLASTICS, CLAYWORKING T&E . 81
WHEEL, BENCH GLASS, PLASTICS, CLAYWORKING T&E . 81
WHEEL, CUTTING GLASS, PLASTICS, CLAYWORKING T&E . 81
WHEEL, EMBOSSING LEATHER, HORN, SHELLWORKING T&E. . 86
WHEEL, FERRIS. RECREATIONAL DEVICE. 219
WHEEL, FINISHING LEATHER, HORN, SHELLWORKING T&E. . 86
WHEEL, FISH. FISHING & TRAPPING T&E 57
 Wheel, Godet. TEXTILEWORKING T&E
 use WHEEL, STRETCHING
WHEEL, GRINDING. GLASS, PLASTICS, CLAYWORKING T&E . 82
 rt WHEEL, LAPPING
WHEEL, HAND. TEXTILEWORKING T&E 110
WHEEL, JAGGING FOOD PROCESSING T&E. 69
WHEEL, JURY. REGULATIVE & PROTECTIVE T&E. . . . 161
WHEEL, KICK. GLASS, PLASTICS, CLAYWORKING T&E . 82
WHEEL, LAPPING GLASS, PLASTICS, CLAYWORKING T&E . 82
 rt WHEEL, GRINDING
WHEEL, LEATHERWORKING. LEATHER, HORN, SHELLWORKING T&E. . 86
 Wheel, Pelton ENERGY PRODUCTION T&E
 use TURBINE, IMPULSE
WHEEL, POLISHING GLASS, PLASTICS, CLAYWORKING T&E . 82
WHEEL, POLISHING/SANDING LEATHER, HORN, SHELLWORKING T&E. . 86
 Wheel, Potter's GLASS, PLASTICS, CLAYWORKING T&E
 use more specific term, e.g.: WHEEL, BENCH; WHEEL, KICK
WHEEL, PRAYER. CEREMONIAL ARTIFACT. 209
WHEEL, PRICKING. LEATHER, HORN, SHELLWORKING T&E. . 86
WHEEL, QUILLING. TEXTILEWORKING T&E 110

- -

WHEEL, ROULETTE. GAME 218
WHEEL, SAVART. ACOUSTICAL T&E 124
WHEEL, SPINNING. TEXTILEWORKING T&E 111
WHEEL, STEERING. WATER TRANSPORTATION -- ACCESSORY. 203
WHEEL, STRETCHING. TEXTILEWORKING T&E 111
WHEEL, SURVEYOR'S. SURVEYING & NAVIGATIONAL T&E . . . 164
WHEEL, TABLESTAND. GLASS, PLASTICS, CLAYWORKING T&E . 82
 Wheel, Tire-measuring METALWORKING T&E
 use TRAVELER
WHEEL, TOW TEXTILEWORKING T&E 111
WHEEL, TRACING TEXTILEWORKING T&E 111
WHEEL, WELL. SITE FEATURE 7
WHEELBARROW. LTE -- HUMAN-POWERED 192
WHEELCHAIR PERSONAL GEAR. 38
 Wheel of life TOY
 use ZOETROPE
WHEELS, LOG. FORESTRY T&E 78
WHERRY, SALMON WATER TRANSPORTATION -- EQUIPMENT. 200
WHETSTONE. METALWORKING T&E 97
 rt STEEL
WHIMSEY. ART. 206
WHIP LTE -- ACCESSORY 195
 rt QUIRT
WHIP MUSICAL T&E. 175
WHIP REGULATIVE & PROTECTIVE T&E. . . . 161
 Whip, Brush AGRICULTURAL T&E
 use CUTTER, WEED
WHIP, BUGGY. LTE -- ACCESSORY 195
WHIP, COACH. LTE -- ACCESSORY 195
WHIP, CREAM. FOOD PROCESSING T&E. 69
 rt EGGBEATER
 Whip, Egg FOOD PROCESSING T&E
 use WHISK
WHIP, RIDING LTE -- ACCESSORY 195
 Whipstock MINING & MINERAL HARVESTING T&E
 use WEDGE, DEFLECTION
WHIRL. RECREATIONAL DEVICE. 220
WHIRLIGIG. TOY. 226
WHIRLIGIG. ART. 206
WHISK. FOOD PROCESSING T&E. 69
WHISKY LTE -- ANIMAL-POWERED. 191
WHIST. GAME 218
WHISTLE. SOUND COMMUNICATION T&E. 181
WHISTLE. MUSICAL T&E. 175
WHISTLE, GALTON. ACOUSTICAL T&E 124
WHISTLE, STEAM WATER TRANSPORTATION -- ACCESSORY. 203
WHITEHALL. WATER TRANSPORTATION -- EQUIPMENT. 200
WICK LIGHTING DEVICE. 21
WICKET, CROQUET. SPORTS EQUIPMENT 222
WICKIUP. BUILDING 4

- -

Widowmaker. MINING & MINERAL HARVESTING T&E
 use DRILL
WIG. ADORNMENT. 25
 rt HAIRPIECE
WIG, BARRISTER'S PERSONAL SYMBOL. 216
WIGWAM BUILDING 4
WIMPLE CLOTHING -- HEADWEAR 28
 Winch MECHANICAL T&E
 use HOIST or WINDLASS
WIND-BELL. ART. 206
WINDER TEXTILEWORKING T&E 111
 rt REEL, CLOCK
WINDER, BOBBIN TEXTILEWORKING T&E 111
WINDER, CONE TEXTILEWORKING T&E 111
WINDER, SPOOL. TEXTILEWORKING T&E 111
WINDER, SPRING METALWORKING T&E 97
WINDLASS MECHANICAL T&E 148
 rt HOIST
WINDLASS WATER TRANSPORTATION -- ACCESSORY. 203
 rt CAPSTAN
WINDLASS, HAND WATER TRANSPORTATION -- ACCESSORY. 203
 Windlass, Slaughtering. FOOD PROCESSING T&E
 use HOIST, DRESSING
WINDMILL ENERGY PRODUCTION T&E. 144
 Window, Stained glass BUILDING COMPONENT
 use WINDOWPANE, LEADED
WINDOWPANE BUILDING COMPONENT 6
WINDOWPANE, LEADED BUILDING COMPONENT 6
WINDROWER. AGRICULTURAL T&E 51
WINGS, WATER SPORTS EQUIPMENT 223
 Winnower. AGRICULTURAL T&E
 use BASKET, WINNOWING or MILL, FANNING
WIPER, PEN WRITTEN COMMUNICATION T&E. 185
WIRE AEROSPACE -- ACCESSORY 188
WIRE ELECTRICAL & MAGNETIC T&E. 143
WIRE ENERGY PRODUCTION T&E. 144
WIRE, ANTIDRAG AEROSPACE -- ACCESSORY 188
WIRE, ANTIFLUTTER. AEROSPACE -- ACCESSORY 188
WIRE, FAIRING. AEROSPACE -- ACCESSORY 188
 Wire, High. PUBLIC ENTERTAINMENT DEVICE
 use RIGGING, AERIAL
WIRE, PRIMING. ARMAMENT -- ACCESSORY. 134
WIRE, STAGGER. AEROSPACE -- ACCESSORY 188
WOK. FOOD PROCESSING T&E. 69
WOOD, WORKED ARTIFACT REMNANT 227
WOODBIN. TEMPERATURE CONTROL DEVICE 23
WOODBLOCK. MUSICAL T&E. 175
 Woodcut PRINTING T&E
 use BLOCK, WOOD
WOODSHED BUILDING 4

- -

Workbasket. TEXTILEWORKING T&E
 use BASKET, NEEDLEWORK
WORKBENCH. MULTIPLE USE ARTIFACT. 228
WORKER, BUTTER FOOD PROCESSING T&E. 69
WORKSHEET, ENGINE CALCULATIONS DOCUMENTARY ARTIFACT 214
WORM ARMAMENT -- ACCESSORY. 134
WORM, SPIRAL MINING & MINERAL HARVESTING T&E. . 102
WRAP, GIFT CEREMONIAL ARTIFACT. 209
 rt PAPER, WRAPPING (MERCHANDISING T&E)
 Wrapper CLOTHING -- OUTERWEAR
 use GOWN, DRESSING
WRAPPER. MERCHANDISING T&E. 157
WREATH ART. 206
WREATH CEREMONIAL ARTIFACT. 209
 Wreath, Hair. ART
 use PICTURE, HAIR
WREATH, WEDDING. CLOTHING -- HEADWEAR 28
WRENCH METALWORKING T&E 97
 Wrench, Adjustable-end. METALWORKING T&E
 use WRENCH, CRESCENT
WRENCH, ALLEN. METALWORKING T&E 97
WRENCH, ALLIGATOR. METALWORKING T&E 97
WRENCH, AXLE CAP METALWORKING T&E 97
WRENCH, BOX. METALWORKING T&E 97
WRENCH, BOX-END. METALWORKING T&E 97
WRENCH, BREECHING: ARMAMENT -- ACCESSORY. 134
WRENCH, CARRIAGE NUT METALWORKING T&E 97
WRENCH, CLOSED END METALWORKING T&E 97
WRENCH, COCK ARMAMENT -- ACCESSORY. 134
WRENCH, COCK-AND-HAMMER. ARMAMENT -- ACCESSORY. 134
WRENCH, COMBINATION. METALWORKING T&E 97
WRENCH, CRESCENT METALWORKING T&E 97
WRENCH, FIRE PLUG. REGULATIVE & PROTECTIVE T&E. . . . 161
WRENCH, FRONT-SIGHT. ARMAMENT -- ACCESSORY. 134
WRENCH, FUZE ARMAMENT -- ACCESSORY. 135
WRENCH, GUN-CARRIAGE ARMAMENT -- ACCESSORY. 135
WRENCH, KEY. METALWORKING T&E 97
WRENCH, LUG. METALWORKING T&E 97
WRENCH, LUG. LTE -- ACCESSORY 195
WRENCH, MONKEY METALWORKING T&E 97
WRENCH, MUZZLE ARMAMENT -- ACCESSORY. 135
WRENCH, NIPPLE ARMAMENT -- ACCESSORY. 135
WRENCH, OPEN-END METALWORKING T&E 97
WRENCH, PIN. ARMAMENT -- ACCESSORY. 135
WRENCH, PIPE METALWORKING T&E 97
 Wrench, Rope bed. HOUSEHOLD ACCESSORY
 use BEDKEY
WRENCH, SOCKET METALWORKING T&E 97
WRENCH, T. METALWORKING T&E 97
WRENCH, TAP. METALWORKING T&E 97

- -

WRENCH, WAGON. METALWORKING T&E 97
WRENCH, WAGON. LTE -- ACCESSORY 195
WREST, SAW METALWORKING T&E 97
WREST,SAW. WOODWORKING T&E. 121
 rt SAW-SET
WRINGER. LEATHER, HORN, SHELLWORKING T&E. . 86
WRINGER, CLOTHES MAINTENANCE T&E. 146
WRINGER, MOP MAINTENANCE T&E. 146
WRISTLET CLOTHING -- ACCESSORY. 34
WRISTWATCH TIMEKEEPING T&E. 165
XYLOPHONE. MUSICAL T&E. 175
YACHT. WATER TRANSPORTATION -- EQUIPMENT. 201
YARDSTICK. WEIGHTS & MEASURES T&E 167
 Yarmulke. CLOTHING -- HEADWEAR
 use SKULLCAP
YARN TEXTILEWORKING T&E 111
 Yashmak CLOTHING -- HEADWEAR
 use VEIL
 Yatate. PERSONAL GEAR
 use SET, SCRIBE
YAWL-BOAT. WATER TRANSPORTATION -- EQUIPMENT. 201
YEARBOOK DOCUMENTARY ARTIFACT 214
YOKE LTE -- HUMAN-POWERED 192
YOKE, ANIMAL LTE -- ACCESSORY 196
YOKE, NECK LTE -- ACCESSORY 196
YO-YO. TOY. 226
YULOH. WATER TRANSPORTATION -- ACCESSORY. 203
 rt OAR, SCULLING
ZAX. MASONRY & STONEWORKING T&E 88
ZENOMETER. SURVEYING & NAVIGATIONAL T&E . . . 164
ZIPPER TEXTILEWORKING T&E 111
ZISCHAGGE. ARMAMENT -- BODY ARMOR 130
ZITHER MUSICAL T&E. 176
ZOETROPE TOY. 226
ZOO. TOY. 226
ZOOPRAXINOSCOPE. OPTICAL T&E. 160
ZYMOSISMETER FOOD PROCESSING T&E. 69

CHAPTER SIX
SELECTED BIBLIOGRAPHY

Adams, Ramon F. *The Language of the Railroader. Norman:* University of Oklahoma Press, 1977.

Alexander, Helene. *Fans.* London: B.T. Batsford, 1984.

Allen, Alistair, and Hoverstadt, Joan. *The History of Printed Scraps.* London: New Cavendish Books, 1983.

Allen, Edward M. *Harper's Dictionary of the Graphic Arts.* New York: Harper & Row, 1963.

Alth, Max. *All About Locks and Locksmithing.* New York: Hawthorne Books, 1972.

Amber, John T. *Cartridges of the World.* DBI Books, Inc., 1976.

American Fabrics and Fashions Magazine, Editors of. *Encyclopedia of Textiles.* Englewood Cliffs, N.J.: Prentice-Hall, 1980.

American Institute of Maintenance. *Selection and Care of Cleaning Equipment.* Glendale, Calif.: American Institute of Maintenance, 1982.

Applied Technical Dictionary: Acoustics. Collet.

Arbor, Marilyn. *Tools and Trades of America's Past: The Mercer Collection.* Doylestown, Pa.: The Bucks County Historical Society, 1981.

Ardrey, Robert L. *American Agricultural Implements.* 1894. Reprint. New York: Arno Press, 1972.

Art Journal. *Illustrated Catalogue of the International Exhibition, 1862.* London and New York: Virtue & Co., 1863.

Association of American Railroads. *Car and Locomotive Cyclopedia of American Practice.* 3rd. ed. New York: Simmons-Boardman, 1974.

Auer, Michel. *The Illustrated History of the Camera from 1839 to the Present.* Boston: New York Graphic Society, 1975.

Ayres, William S. *The Warner Collector's Guide to American Toys.* New York: Warner Books, 1981.

Bailey, Chris H. *Two Hundred Years of American Clocks and Watches.* Englewood Cliffs, N.J.: Prentice-Hall, 1975.

Baines, Anthony. *European and American Musical Instruments.* London: B.T. Batsford, 1966.

Baines, Patricia. *Spinning Wheels: Spinners & Spinning.* New York: Charles Scribners Sons, 1977.

Baker, T. Lindsay. *A Field Guide to American Windmills.* Norman, Okla.: University of Oklahoma Press, 1985. Bannerman, Francis, & Son. *Bannerman Catalogue of Military Goods.* 1927. Northfield, Ill.: DBI Books, 1980.

Barnes, Frank C. *Cartridges of the World.* Northbrook, Ill.: DBI Books, 1985.

Barry, Kit. *The Advertising Trade Card.* Brattleboro, Vt.: privately published, 1981.

Bateman, James A. *Animal Traps and Trapping.* Harrisburg, Pa.: Stackpole Books, 1971.

Bates, William. *The Computer Cookbook.* Garden City, N.Y.: Doubleday, 1984.

Baughman, Harold E. *Aviation Dictionary and Reference Guide.* 2nd ed. Glendale, Calif.: Aero Publishers, 1942.

Bedini, Silvio. *Thinkers and Tinkers: Early American Men of Science.* New York: Charles Scribners Sons, 1975.

Benjamin, Park. *A History of Electricity.* New York: Arno Press, 1975.

Bennett, Alva Herschel. *Glossary of Terms Frequently Used in Optics and Spectroscopy.* New York: American Institute of Physics, 1962.

Bennion, Elizabeth. *Antique Medical Instruments.* London: Sotheby Parke Bernet, and Berkley: University of California, 1979.

Berkebile, Don H. *Carriage Terminology: An Historical Dictionary.* Washington, D.C.: Smithsonian Institution Press, 1978.

Berlye, M. K. *Encyclopedia of Working with Glass.* New York: Everest House, 1983.

Binstead, Harry E. *The Fully Illustrated Book of Decorative Details from Major Architectural Styles.* 1894. Reprint. Alberquerque, N.M.: The Foundation for Classical Reprints, 1984.

Bivins, J., Jr. *The Moravian Potters in North Carolina.* Winston-Salem: Published for Old Salem, Inc. by the University of North Carolina Press, Chapel Hill, 1972.

Blackmore, Howard L. *Guns and Rifles of the World.* London: B.T. Batsford, 1968.

Blair, Carvel Hall, and Ansel, Willits Dyer. *A Guide to Fishing Boats and Their Gear.* Cambridge, Md.: Cornell Maritime Press, 1968.

Blair, Claude. *European Armour: Circa 1066 to Circa 1700.* Woodstock, N.Y.: Beekman Publishing, 1979.

——— . *Pistols of the World.* London: B.T. Batsford, 1968.

Blandford, Percy W. *Country Craft Tools.* London: David & Charles, 1974.

Blum, Andre. *On the Origin of Paper.* New York: R. R. Bowker, 1934.

——— . *The Origins of Printing and Engraving.* New York: Charles Scribners Sons, 1940.

Blumenson, John J.-G. *Identifying American Architec-*

ture: *A Pictorial Guide to Styles and Terms, 1600-1945*. Nashville: American Association for State and Local History, 1977.

Bonanni, Filippo. *Antique Musical Instruments and Their Players*. 1723. Reprint. New York: Dover Publications, 1964.

Bones, R. *Concise Encyclopaedic Dictionary of Telecommunications*. New York: Elsevier Science Publishing, 1970.

Booth, Larry, and Weinstein, Robert A. *Collection, Use, and Care of Historical Photographs*. Nashville: American Association for State and Local History, 1977.

Botham, Mary, and Sharrad, L. *Manual of Wigmaking*. 1972. Reprint. London: W. Heinemann, 1982.

Bowers, Q. David. *Encyclopedia of Automatic Musical Instruments*. Vestal, N.Y.: Vestal Press, 1972.

Brightman, Anna. *Window Treatments for Historic Houses, 1700-1850*. Washington, D.C.: National Trust for Historic Preservation, 1968.

Britten, Frederick James. *Britten's Old Clocks and Watches and Their Makers*. New York: Dutton, 1973.

Brooks, Hugh. *Encyclopedia of Building and Construction Terms*. Englewood Cliffs, N.J.: Prentice-Hall, 1983.

Brooks, Jerome E. *The Mighty Leaf: Tobacco Through the Centuries*. Boston: Little and Brown, 1952.

Broudy, Eric. *The Book of Looms: A History of the Handloom from Ancient Times to the Present*. New York: Van Nostrand Reinhold, 1979.

Bruce, Alfred W. *The Steam Locomotive in America*. New York: Bonanza Books, 1952.

Buck, Anne. *Victorian Costume and Costume Accessories*. 2nd ed. Carleton, Bedford: Ruth Bean, 1984.

Bucksch, Herbert. *Dictionary of Civil Engineering and Construction Machinery and Equipment*. New York: French & European Publications, 1976.

Bucksch, H. *Dictionary of Mechanisms*. New York: French & European Publications, 1976.

Burness, Tad. *American Truck Spotter's Guide, 1920-1970*. Osceola, Wis.: Motorbooks International, 1978.

Burnham, Harold, and Burnham, Dorothy. *"Keep Me Warm One Night": Early Handweaving in Eastern Canada*. Toronto: University of Toronto Press, 1972.

Burnham, Dorothy K. *Warp and Weft: A Textile Terminology*. Toronto: Royal Ontario Museum, 1980.

Buschsbaum, Ann. *Practical Guide to Print Collecting*. New York: Van Nostrand Reinhold, 1975.

Butler, Frank O. *The Story of Paper-Making: An Account of Paper-Making From Its Earliest Known Record Down to the Present Time*. Chicago: J.W. Butler Paper Co., 1901.

Butler, Joseph T. *Field Guide to American Antique Furniture*. New York: H. Holt, 1986.

Butterworth, Benjamin. *The Growth of Industrial Art* (Reprinted as *Rural America a Century Ago*). 1892. Reprint. St. Joseph, Mich.: American Society of Agricultural Engineers, 1976.

Calif, Ruth. *The World of Wheels: An Illustrated History of the Bicycle and Its Relatives*. East Brunswick, N.J.: Cornwall Books, 1981.

Calvert, Henry Reginald. *Astronomy: Globes, Orreries and Other Models*. London: Her Majesty's Stationery Office, 1971.

Campbell, Burt L. *Marine Badges and Insignia of the World*. London: Blandford Press, 1983.

Carman, W. Y. *A Dictionary of Military Uniform*. New York: Charles Scribners Sons, 1977.

Celehar, Jane H. *Kitchens and Gadgets: 1920-1950*. Des Moines, Iowa: Wallace-Homestead Books Co., 1982.

Child, Ernest. *The Tools of the Chemist: Their Ancestry and American Evolution*. New York: Van Nostrand Reinhold, 1940.

Christensen, Erwin C. *Early American Wood Carving*. New York: Dover Publications, 1973.

CIT Agency. *Construction Industry Thesaurus*. London: Property Services Agency (12 Marsham St., S.W. 1), 1976.

Clark, Fiona. *Hats*. New York: Drama Book Publishers, 1982.

Clay, Reginald Stanley, and Court, Thomas H. *The History of the Microscope*. London: C. Griffin, 1932.

The Coach Painter. 1880. Reprint. Stony Brook, N.Y.: The Museums at Stony Brook, 1981.

Coleman, Dorothy, et al. *The Collector's Encyclopedia of Dolls*. New York: Crown Publishers, 1968.

Colle, Doriece. *Collars, Stocks, Cravats: A History and Costume Dating Guide to Civilian Men's Neckpieces, 1655-1900*. Emmaus, Pa.: Rodale Press, 1972.

Condit, Carl W. *American Building: Materials and Techniques from the First Colonial Settlements to the Present*. Chicago: University of Chicago Press, 1982.

Considine, Douglas M., and Considine, Glenn D. *Foods and Food Production Encyclopedia*. New York: Van Nostrand Reinhold, 1982.

Construction Industry Research and Information. *Construction Industry Thesaurus*. London, 1976.

Corbeil, Jean-Claude, ed. *The Facts on File Visual Dictionary*. New York: Facts on File, 1986.

Cuddon, J. A. *The International Dictionary of Sports and Games*. New York: Schocken, 1979.

Cumming, Valerie. *Gloves*. London: B.T. Batsford, 1982.

Cunnington, C. Willett, and Cunnington, Phillis.

The History of Underclothes. London: Boston: Faber & Faber, 1981.

D'Allemagne, Henry Rene. *Decorative Antique Ironwork: A Pictorial Treasury.* New York: Dover Publications, 1968.

Dammann, Gordon. *Encyclopedia of Civil War Medical Instruments and Equipment.* Missoula, Mont.: Pictorial Histories Publishing Co., 1983.

Daniel, Dorothy. *Cut and Engraved Glass, 1771-1905.* New York: M. Barrows, 1950.

Darbee, Herbert C. *"A Glossary of Old Lamps and Lighting Devices."* American Association for State and Local History Technical Leaflet 30, *History News* 20:8 (August 1965).

Data Communication Buyers' Guide. New York: McGraw-Hill, 1979.

Davenport, Millia. *The Book of Costume.* 1948. Reprint. New York: Crown Publishers, 1979.

Davis, Audrey B. *Medicine and Its Technology: An Introduction to the History of Medical Instruments.* Westport, Conn.: Greenwood, 1981.

DeCarle, Donald. *Watch and Clock Encyclopedia.* New York: Bonanza Books, 1975.

Dewar, Michael. *Internal Security Weapons and Equipment of the World.* England: Ian Allan, 1981.

Diagram Group. *Handtools of Arts and Crafts: The Encyclopedia of the Fine, Decorative, and Applied Arts.* New York: St. Martin's Press, 1981.

———. *Musical Instruments of the World.* New York: Facts on File, 1976.

———. *Weapons: An International Encyclopedia from 5000 BC to 2000 AD.* New York: St. Martin's Press, 1980.

Dibner, Bern. *Early Electrical Machines: The Experiments and Apparatus of Two Enquiring Centuries (1600 to 1800) that Led to the Triumphs of the Electrical Age.* Norwalk, Conn.: Burndy Library, 1957.

Dickinson, Henry W. "A Brief History of Draughtsmen's Instruments." Newcomen Society, *Transactions,* 27 (1949-1951): 73-84.

Ditchfield, Peter H. *Old English Sports, Pastimes and Customs.* 1891. Reprint. Boston: Charles River Books, 1977.

Ditzel, Paul. *Fire Engines, Firefighters: The Men, Equipment, and Machines, from Colonial Days to the Present.* New York: Crown Publishers, 1976.

Dolan, Maryanne. *Vintage Clothing, 1880-1960: Identification and Value Guide.* Florence, Ala.: Books Americana, 1984.

Dover Stamping Company. *Dover Stamping Co., 1869: Tinware, Tin Toys, Tinned Iron Wares, Tinners Material, Enameled Stove Hollow Ware, Tinners' Tools and Machines.* Princeton, N.J.: Pyne Press, 1971.

Duckett, Kenneth W. *Modern Manuscripts: A Practical Manual for Their Management, Care, and Use.* Nashville: American Association for State and Local History, 1975.

Dunhill, Alfred. *The Pipe Book.* London: A.&C. Black, Ltd., 1924.

Duval, Francis Y., and Rigby, Ivan. *Early American Gravestone Art in Photographs.* New York: Dover Publications, 1978.

Eaches, Albert R. *"Scales and Weighing Devices: An Aid to Identification."* American Association for State and Local History Technical Leaflet 59. *History News* 27:3 (March 1972).

Emerson, William K. *Chevrons: Illustrated History and Catalog of U.S. Army Insignia.* Washington, D.C.: Smithsonian Institution Press, 1983.

Evan-Thomas, Owen. *Domestic Utensils of Wood, 16th to 19th Century.* London: Author, 1932.

Fairbanks, Jonathan L., and Bidwell, Elizabeth. *American Furniture, 1620 to the Present.* New York: Richard Marek Publishers, 1981.

Fairholt, F. W. *Costume in England: A History of Dress to the End of the 18th Century.* Detroit, Mich.: Singing Tree Press, 1968.

Favretti, Rudy J., and Favretti, Joy Putnam. *Landscapes and Gardens for Historic Buildings: A Handbook for Reproducing and Creating Authentic Landscape Settings.* Nashville: American Association for State and Local History, 1978.

Feirer, John L. *General Metals.* 6th ed. New York: McGraw-Hill, 1986.

Fisher Scientific Catalogs. Springfield, N.J.: Fisher Scientific, published annually.

Fitchen, John. *Building Construction Before Mechanization.* Cambridge, Mass.: MIT Press, 1986.

Flayderman, Norm, ed. *Flayderman's Guide to Antique American Firearms—and Their Values.* Northfield, Ill.: DBI Books, 1987.

Fleming, John; Honour, Hugh; and Pevsner, Nikolaus. *The Penguin Dictionary of Architecture.* New York: Penguin, 1982.

Forney, Matthias N. *The Railroad Car Builder's Pictorial Dictionary.* 1889. Reprint. New York: Dover Publications, 1974.

Foster, Vanda. *Bags & Purses.* The Costume Accessories Series. London: B.T. Batsford, 1982.

Fournier, Robert. *Illustrated Dictionary of Practical Pottery.* New York: Van Nostrand Reinhold, 1977.

Fraf, Rudolph F., et. al. *How It Works: Illustrated Everyday Devices and Mechanisms.* New York: Van Nostrand Reinhold, 1979.

Franklin, Linda. *300 Years of Kitchen Collectibles.* 2nd ed. Florence, Ala.: Books Americana, Inc., 1984.

French, Thomas E., and Vierck, Charles J. *Engineering Drawing and Graphic Technology*. New York: McGraw-Hill, 1972.

Fussell, George Edwin. *The Farmer's Tools: The History of British Farm Implements, Tools, and Machinery, AD 1500-1900*. London: Bloomsbury Books, 1985.

Garvan, Anthony N. B., and Wojtowicz, Carol A. *Catalogue of The Green Tree Collection*. Philadelphia, Pa.: The Mutual Assurance Company, 1977.

Gernsheim, Helmut, and Gernsheim, Alison. *The History of Photography*. New York: McGraw-Hill, 1969.

Gerstell, Richard. *The Steel Trap in North America*. Harrisburg, Pa.: Stackpole Books, 1985.

Gluckman, Arcadi. *Identifying Old U.S. Muskets, Rifles and Carbines*. Harris, Pa.: Stackpole Books, 1965.

Gorsline, Douglas W. *What People Wore: A Visual History of Dress from Ancient Times to Twentieth Century America*. New York: Bonanza Books, 1974.

Gould, Mary Earle. *Early American Woodenware and Other Kitchen Utensils*. Rutland, Vt.: Charles E. Tuttle Co., 1962.

Graham, Irvin. *Encyclopedia of Advertising*. New York: Fairchild, 1969.

Green, Harvey. *Fit for America*. New York: Viking, 1986.

Greenaway, Frank. *Chemistry*. London: Her Majesty's Stationery Office, 1966.

Gregor, Arthur S. *Amulets, Talismans and Fetishes*. New York: Charles Scribners Sons, 1975.

Gregorietti, Guido. *Jewelry Through the Ages*. New York: American Heritage, 1969.

Greysmith, Brenda. *Wallpaper*. New York: Macmillan, 1976.

Groves, Sylvia. *The History of Needlework Tools and Accessories*. New York: Arco Publishing Co., 1973.

Guthrie, Douglas. *A History of Medicine*. London, 1945.

Haggar, Reginald. *A Dictionary of Art Terms: Painting, Sculpture, Architecture, Engraving, etc.* New York: Hawthorn, 1962.

Hall, Henry. *The Ice Industry of the United States*. 1880. Reprint. Albany, N.Y.: The Early American Industries Assocation, 1974.

Halsted, Byron D., ed. *Barns, Sheds, and Outbuildings*. 1881. Reprint. Brattleboro, Vt.: Stephen Greene Press, 1977.

Hamilton, David. *The Thames and Hudson Manual of Pottery and Ceramics*. London: Thames and Hudson, Ltd., 1982.

Harris, H. G. *Handbook of Watch and Clock Repairs*. New York: Barnes and Noble, 1972.

Harris, John, and Lever, Jill. *Illustrated Glossary of Architecture, 850-1830*. London: Faber and Faber, 1966.

Hart, Harold H. *Weapons and Armor: A Pictorial Archive of Woodcuts & Engravings with over 1,400 Copyright-free Illustrations for Artists and Designers*. 1978. Reprint. New York: Dover Publications, 1982.

Harter, Jim, ed. *Transportation: A Pictorial Archive from 19th Century Sources*. New York: Dover Publications, 1983.

Hayward, Arthur H. *Colonial Lighting*. New York: Dover Publications, 1962.

Heffner, Hubert C. *Modern Theater Practice: A Handbook for Play Production*. Englewood Cliffs, N.J.: Prentice-Hall, 1973.

Hiscox, Gardner D. *Curious Mechanical Movements*. 1904. Reprint. Bradley, Ill.: Lindsay Publications, 1986.

Hobson, Burton, and Reinfeld, Fred. *Illustrated Encyclopedia of World Coins*. Garden City, N.Y.: Doubleday, 1970.

Holmstrom, John Gustaf, and Holford, Henry. *American Blacksmithing and Twentieth Century Toolsmith and Steelworker*. 1977. Reprint. New York: Greenwich House, 1982.

Hornung, Clarence P., and Johnson, Fridolf. *200 Years of American Graphic Art*. New York: Braziller, 1976.

Hough, Walter. *Collection of Heating and Lighting Utensils in the United States National Museum*. Talcottville, Conn.: Rushlight Club, 1981.

Houart, Victor. *Sewing Accessories: An Illustrated History*. London: Souvenir Press, 1984.

Hummel, Charles F. *With Hammer in Hand: The Dominy Craftsman of East Hampton, N.Y.* Charlottesville, University Press of Virginia, 1968.

Hunter, Dard. *Papermaking: The History and Technique of an Ancient Craft*. 1947. Reprint. New York: Dover Publications, 1978.

Huschke, Ralph E., ed. *Glossary of Meteorology*. Boston: American Meteorological Society, 1959.

Ingram, Arthur. *Horse Drawn Vehicles Since 1760*. England: Blandford Press, 1977.

Jane's Fighting Ships. Annual editions.

Jenkins, J. Geraint. *Traditional Country Craftsmen*. London: Boston: Routledge and Kegan Paul, 1978.

Johnson, Arthur W. *The Thames and Hudson Manual of Bookbinding*. London: Thames and Hudson, Ltd., 1978.

Kauffman, Henry J. *The American Fireplace: Chimneys, Mantlepieces, Fireplaces & Accessories*. Nashville: Thomas Nelson, Inc., 1972.

Kauffman, Henry J., and Bowers, Quentin H. *Early American Andirons and Other Fireplace Accessories*.

Nashville: Thomas Nelson, Inc., 1974.

Kebabian, Paul B., and Whitney, Dudley. *American Woodworking Tools*. Boston: New York Graphic Society, 1978.

Kemp, Peter, ed. *The Oxford Companion to Ships and the Sea*. London: Oxford University Press, 1976.

Ketchum, William C. *Chests, Cupboards, Desks & Other Pieces*. The Knopf Collectors' Guides to American Furniture. New York: Alfred A. Knopf, 1982.

——— . *Pottery & Porcelain*. New York: Alfred A. Knopf, 1983.

Ketchum, William C., Jr. *A Treasury of American Bottles*. New York: Bobbs-Merrill, 1975.

Kiely, Edmond R. *Surveying Instruments: Their History*. 1947. Reprint. Columbus, Ohio: CARBEN Survey, 1979.

King, Constance Eileen. *The Encyclopedia of Toys*. Secaucus, N.J.: Chartwell, 1984.

Kisch, Bruno. *Scales and Weights, A Historical Outline*. 1966. Reprint. New Haven, Conn.: Yale University Press, 1977.

Kohler, Karl. *History of Costume*. New York: Dover Publications, 1963.

Kulasiewicz, Frank. *Glassblowing*. New York: Watson-Guptill, 1974.

Landreau, Anthony N. *America Underfoot: A History of Floor Coverings from Colonial Times to the Present*. Washington, D.C.: Smithsonian Institution, 1976.

Lantz, Louise K. *Old American Kitchenware, 1725-1925*. Camden, N.J.: Thomas Nelson, Inc., 1970.

Lee, Ruth Webb. *Ruth Webb Lee's Handbook of Early American Pressed Glass Patterns*. Framingham, Mass.: R. W. Lee, 1936.

Lifshey, Earl. *The Housewares Story*. Chicago: National Housewares Mfg. Assoc., 1973.

Little, Nina Fletcher. *Floor Coverings in New England Before 1850*. Sturbridge, Mass.: Old Sturbridge Village, 1967.

Littleton, Harvey K. *Glassblowing: A Search for Form*. 1971. Reprint. New York: Van Nostrand Reinhold, 1980.

Logan, Herschel C. *Cartridges: A Pictorial Digest of Small Arms Ammunition*. Harrisburg, Pa.: Stackpole Books, 1959.

Long, Frank W. *Creative Lapidary: Materials, Tools, Techniques, Design*. New York: Van Nostrand Reinhold, 1976.

Lord & Taylor. *Clothing and Furnishings: Illustrated Catalog and Historical Introduction, 1881*. Princeton, N.J.: Pyne Press, 1971.

Loubat, Joseph F. *Medallic History of the U.S.A.* 1878. Reprint. New Milford, Conn.: Flayderman, 1967.

Lyman, James D. *Nuclear Terms: A Brief Glossary*. Oak Ridge, Tenn.: U.S. Atomic Energy Commission, 1964.

Mace (L. H.) & Company. *L. M. Mace & Co., 1883: Woodenware, Meat Safes, Toys, Refrigerators, Children's Carriages, and House Furnishing Goods; Illustrated Catalog and Historical Introduction*. Princeton, N.J.: Pyne Press, 1971.

Maddex, Diane, ed. *Built in the U.S.A.: American Buildings from Airports to Zoos*. Washington, D.C.: Preservation Press, 1985.

Manly, Harold Phillips. *Drake's Cyclopedia of Radio and Electronics*. Chicago: F.J. Drake & Co., 1942.

Marcus, Mordecai. *Talismans*. Lafayette, Ind.: Sparrow Press, 1981.

Marks, Robert W., ed. *The New Dictionary and Handbook of Aerospace.* New York: Praeger, 1969.

Marzio, Peter. *The Democratic Art, Chromolithography, 1840-1900*. Boston: David R. Godine, 1979.

Mason, Anita. *An Illustrated Dictionary of Jewelry*. New York: Harper & Row, 1974.

Mayer, Ralph. *A Dictionary of Art Terms and Techniques*. New York: Barnes and Noble, 1981.

McClellan, Mary Elizabeth. *Felt, Silk and Straw Handmade Hats—Tools and Processes*. Doylestown, Pa.: The Bucks County Historical Society, 1977.

McClintock, Inez, and McClintock, Marshall. *Toys in America*. Washington, D.C.: Public Affairs Press, 1961.

McClinton, Katherine M. *Antiques of American Childhood*. New York: C.N. Potter (distributed by Crown Publishers), 1970.

McCosker, M. J. *The Historical Collection of the Insurance Company of North America*. Philadelphia, Pa.: INA, 1967.

McGraw-Hill Encyclopedia of Chemistry. New York: McGraw-Hill, 1983.

McGraw-Hill Encyclopedia of Earth Sciences. New York: McGraw-Hill, 1984.

McGraw-Hill Encyclopedia of Electrical and Electronic Engineering. New York: McGraw-Hill, 1985.

McGraw-Hill Encyclopedia of Physics. New York: McGraw-Hill, 1983.

McKearin, Helen, and Wilson, Kenneth. *American Bottles and Flasks and Their Ancestry*. New York: Crown Publishers, 1978.

McKee, Harley J. *Introduction to Early American Masonry, Stone, Brick, Mortar and Plaster*. Washington, D.C.: The National Trust for Historic Preservation, 1973.

McNerny, Kathryn. *Antique Tools: Our American Heritage*. Paducah, Ky.: Collector Books, 1979.

——— . *Primitives: Our American Heritage*. Paducah, Ky.: Collector Books, 1979.

Meriden Britannia Company. *The Meriden Britannia*

Silver-Plate Treasury: The Complete Catalog of 1886-7 with 3,200 Illustrations. New York: Dover Publications, 1982.

Meyer, Herbert W. *A History of Electricity and Magnetism.* Norwalk, Conn.: Burndy Library, 1972.

Middleton, W. E. Knowles. *The History of the Barometer.* Baltimore: Johns Hopkins Press, 1964.

——— . *Invention of the Meteorological Instruments.* Baltimore: Johns Hopkins Press, 1969.

Miles, Charles. *Indian and Eskimo Artifacts of North America.* New York: Bonanza Books, 1963.

Miller, Dennis. *The Illustrated Encyclopedia of Trucks and Buses.* New York: W.H. Smith, 1982.

Miller, Robert W. *Pictorial Guide to Early American Tools and Implements.* Des Moines, Iowa: Wallace-Homestead, 1980.

Montgomery Ward and Co. *Catalogue and Buyers' Guide, No. 57, Spring and Summer, 1895.* New York: Dover Publications, 1969.

Moran, James. *Printing Presses: History and Development from the 15th Century to Modern Times.* Berkeley: University of California Press, 1973.

Moseman (C. M.) and Brother. *Moseman's Illustrated Guide for Purchasers of Horse Furnishing Goods: Novelties and Stable Appointments, Imported and Domestic.* 1892. Reprint. 5th ed. New York: Arco, 1976.

Moss, Roger. *Century of Color: Exterior Decoration for American Buildings, 1820-1920.* Watkins Glen, N.Y.: American Life Foundation, 1981.

Munsey, Cecil. *The Illustrated Guide to Collecting Bottles.* New York: Hawthorne, 1970.

Murphy, Jim. *Two Hundred Years of Bicycles.* New York: Harper & Row, 1983.

National Workshop on Equipment and Supplies for Athletics, Physical Education, and Recreation (1959: Michigan State University). *Equipment and Supplies for Athletics, Physical Education, and Recreation, by Participants in National Conference.* Chicago: Athletic Institute, 1960.

Nayler, J. N. *Concise Encyclopaedic Dictionary of Astronautics.* New York: Elsevier Science Publishing, 1964.

Neumann, George C., and Kravic, Frank J. *Collector's Illustrated Encyclopedia of the American Revolution.* Harrisburg, Pa.: Stackpole Books, 1975.

Norbeck, Jack. *Encyclopedia of American Steam Traction on Engines.* Sarasota, Fla.: Crestline, 1976.

Norwak, Mary. *Kitchen Antiques.* New York: Praeger Publishers, 1975.

Oliver, Smith H. *Catalog of the Cycle Collection of the Division of Engineering, United States National Museum.* Washington, D.C.: Smithsonian Institution, 1953.

Oliver, Smith H., and Berkebile, Donald H. *The Smithsonian Collection of Automobiles and Motorcycles.* Washington, D.C.: Smithsonian Institution, 1968.

——— . *Wheels and Wheeling: The Smithsonian Cycle Collection.* Washington, D.C.: Smithsonian Institution Press, 1974.

Ord-Hume, Arthur W. J. G. *Clockwork Music: An Illustrated History of Mechanical Musical Instruments.* New York: Crown Publishers, 1973.

Ormond, Leonee. *Writing.* London: Her Majesty's Stationery Office, 1981.

Osborne, Harold, ed. *The Oxford Companion to Art.* Oxford: Clarendon Press, 1970.

Page, Victor Wilfred. *Handbook of Early Motorcycles: Construction, Operation, Service.* Arcadia, Calif.: Post Motor Books, 1971.

Pallisser, Fanny M. *Historic Devices, Badges, and War Cries.* 1870. Reprint. Detroit, Mich.: Gale Research, 1971.

Papermaking: Art and Craft: An Account Derived from the Exhibition Presented in the Library of Congress, Washington, D.C., and Opened on April 21, 1968. Washington, D.C.: Library of Congress, 1968.

Parker, John H. *A Concise Glossary of Terms Used in Grecian, Roman, Italian and Gothic Architecture.* 1896. Reprint. Dover, N.H.: Longwood Publishing Group, 1980.

Partridge, Michael. *Farm Tools through the Ages.* Boston: New York Graphic Society, 1973.

Peck and Snyder. *Sporting Goods, 1886 Illustrated Catalog.* Princeton, N.J.: Pyne Press, n.d.

Peek, Hedley, and Aflalo, F. G. *Encyclopedia of Sport.* 1897. Reprint. Detroit, Mich.: Gale Research, 1976.

Pegler, Martin. *The Dictionary of Interior Design.* Rev. ed. New York: Fairchild, 1983.

Pevsner, Nikolaus. *A History of Building Types.* Princeton, N.J.: Princeton University Press, 1979.

Picken, Mary Brooks. *The Fashion Dictionary: Fabric, Sewing, and Apparel as Expressed in the Language of Fashion.* Funk & Wagnalls, 1978.

Pike, Benjamin. *Pike's Illustrated Catalogue of Scientific and Medical Instruments.* 1856. Reprint. San Francisco: The Antiquarian Scientist, 1984.

Pinto, Edward. *Treen and Other Wooden Bygones: An Encyclopedia and Social History.* 1969. Reprint. London: Bell and Hyman, 1979.

Potter, Carole A. *Knock on Wood: An Encyclopedia of Talismans, Charms, Superstitions, and Symbols.* New York: Beaufort Books, 1983.

Quick, John. *Dictionary of Weapons and Military Terms.* New York: McGraw-Hill, 1973.

Rand McNally and Co., ed. *The Rand McNally Encyclopedia of Transportation.* Chicago: Rand McNally,

1976.

Reilly, James M. *Care and Identification of 19th Century Photographic Prints.* Rochester, N.Y.: Kodak, 1986.

Reynolds, John. *Windmills and Watermills.* New York: Praeger Publishers, 1970.

Reynolds, Reginald. *Cleanliness and Godliness: or, the Further Metamorphosis: A Discussion of the Problems of Sanitation Raised by Sir John Harrington* New York: Harcourt, Brace & Jovanovitch, 1976.

Richardson, Lillian, and Richardson, Charles. *The Pill Rollers: Apothecary Antiques and Drug Store Collectibles.* Fort Washington, Md.: Old Fort Press, 1976.

Richardson, M. T., ed. *Practical Blacksmithing.* 1889-91. Reprint. New York: Weathervane Books, 1978.

Richter, Gunter. *Dictionary of Optics, Photography, and Photogrammetry.* New York: Elsevier Publishing Co., 1966.

Ridpath, Ian, ed. *The Illustrated Encyclopedia of Astronomy and Space.* New York: Thomas Y. Crowell, 1979.

Ring, Betty. *Needlework: An Historical Survey.* Pittstown, N.J.: Main Street Press, 1984.

Roberts, Matt T., and Etherington, Don. *Bookbinding and the Conservation of Books: A Dictionary of Descriptive Terminology.* Washington, D.C.: Library of Congress, 1982.

Rogers, Gay Ann. *An Illustrated History of Needlework Tools.* London: John Murray, 1983.

Rolt, L. T. C. *A Short History of Machine Tools.* Cambridge, Mass.: MIT Press, 1965.

Ross, David, and Chartaud, R. *Cataloging Military Uniforms.* St. John, New Brunswick: New Brunswick Museum, 1977.

Rushlight Club. *Early Lighting: A Pictorial Guide.* Talcottville, Conn.: Rushlight Club, 1979.

Russel and Erwin Manufacturing Co. *Illustrated Catalogue of American Hardware of the Russel and Erwin Manufacturing Co.* 1869. Reprint. Ottawa: Association of Preservation Technology, 1980.

Russell, Carl P. *Firearms, Traps, and Tools of the Mountain Men.* New York: Alfred A. Knopf, 1967.

Safford, Carleton L., and Bishop, Richard. *America's Quilts and Coverlets.* New York: Bonanza Books, 1980.

Salaman, R. A. *Dictionary of Leather-Working Tools, c. 1700-1950, and the Tools of Allied Trades.* New York: MacMillan, 1986.

——— . *Dictionary of Tools Used in the Woodworking and Allied Trades c. 1700-1970.* 1975. Reprint. New York: Macmillan, 1986.

Sambrook, Pamela. *Laundry Bygones.* Aylesbury, England: Shire Publications, 1983.

Savage, George, and Newman, Harold. *An Illustrated Dictionary of Ceramics: Defining 3,054 Terms Relating to Wares, Materials, Processes, Styles, Patterns and Shapes from Antiquity to the Present Day.* New York: Van Nostrand Reinhold, 1974.

Scarisbrick, Diana. *Jewelry.* New York: Drama Book Publishers, 1984.

Schapsmeier, Frederick H., and Edward L. *Encyclopedia of American Agricultural History.* Westport, Conn.: Greenwood Press, 1975.

Schilke, Oscar G., and Soloman, Raphael E. *America's Foreign Coins.* New York: Coin and Currency Institute, 1964.

Schroeder, Joseph J., comp. *The Wonderful World of Toys, Games and Dolls, 1860-1930.* 1971. Reprint. Northfield, Ill.: Digest, 1971.

Schwartz, Marvin D. *Chairs, Tables, Sofas and Beds.* New York: Alfred A. Knopf, 1982.

Scott, Peter. *The Thames and Hudson Manual of Metalworking.* London: Thames and Hudson, 1978.

Sharlin, Harold. *Making of the Electrical Age: From the Telegraph to Automation.* 1963. Reprint. New York: Abelard-Schuman, 1963.

Sippl, Charles J. *Dictionary of Data Communications.* New York: Wiley, 1985.

Sloane, Eric. *An Age of Barns.* New York: Ballantine (Published by arrangement with Funk and Wagnalls), 1967.

——— . *American Barns and Covered Bridges.* New York: Funk and Wagnalls, 1954.

——— . *Our Vanishing Landscape.* New York: Ballantine, 1974.

Smith, H. R. Bradley. *Blacksmiths' and Farriers' Tools at Shelburne Museum: A History of Their Development From Forge to Factory.* Shelburne, Vt.: Shelburne Museum, 1966.

Smith, Joseph. *Explanation or Key to the Various Manufactories of Sheffield.* 1816. Reprint. South Burlington, Vt.: The Early American Industries Association, 1975.

Spillman, Jane Shadel. *Glass, Bottles, Lamps and Other Objects.* New York: Alfred A. Knopf, 1983.

——— . *Glass Tableware, Bowls, and Vases.* New York: Alfred A. Knopf, 1982.

Spivey, Towana, ed. *A Historical Guide to Wagon Hardware and Blacksmith Supplies.* Lawton, Ok.: Museum of the Great Plains, 1979.

Staniforth, Arthur. *Straw and Straw Craftsmen.* Aylesbury, England: Shire Publications, 1981.

Steeds, W. *A History of Machine Tools 1700-1910.* Oxford: Clarendon Press, 1969.

Stein, J. Stewart. *Construction Glossary: An Encyclopedic Reference Manual.* New York: Wiley, 1980.

Stella, Jacques. *Games & Pastimes of Childhood.* New

York: Dover Publications, 1969.

Stone, George Cameron. *A Glossary of the Construction, Decoration and Use of Arms and Armor in All Countries and in All Times, Together with Closely Related Subjects*. New York: Jack Brussel, 1961.

Strung, Norman. *An Encyclopedia of Knives*. Philadelphia: Lippincott, 1976.

Struve, Otto, and Zebergs, Velta. *Astronomy of the 20th Century*. New York: MacMillan, 1962.

Sullivan, Edmund B. *American Political Campaign Badges and Medalets, 1789-1892*. Lawrence, Mass.: Quarterman, 1981.

Svenson, Sam, ed. *The Lore of Sail*. New York: Facts on File, 1982.

Swan, Susan Burrows. *A Winterthur Guide to American Needlework*. New York: Crown Publishers, 1976.

Swann, June. *Shoes*. New York: Drama Book Publishers, 1982.

Switzer, Ronald R. *The Bertrand Bottles: Study of 19th Century Glass and Ceramic Containers*. Washington, D.C.: National Park Service, 1974.

Talocci, Mauro. *Guide to the Flags of the World*. New York: William Morrow and Co., 1982.

Tarassuk, Leonid, & Blair, Claude. *The Complete Encyclopedia of Arms and Weapons: The Most Comprehensive Reference Work Ever Published on Arms and Armor*. New York: Bonanza Books, 1986.

Tarrant, Naomi. *Collecting Costume: Care and Display of Clothes and Accessories*. London: Boston: Allen and Unwin, 1983.

Taubes, Frederic. *Painter's Dictionary of Materials and Methods*. New York: Watson-Guptil, 1979.

The Coach Painter, 1880. Reprint. Stony Brook, N.Y.: The Museums at Stony Brook, 1981.

Thomas Scientific Catalog. Springfield, N.J.: Thomas Scientific, published annually.

Thrush, Paul W. *Dictionary of Mining, Minerals and Related Terms*. Washington, D.C.: U.S. Bureau of Mines, 1968. For sale by the Superintendent of Documents, U.S. Government Printing Office.

Timmons, R., & Sons. *Tools for the Trades and Crafts: An Eighteenth Century Pattern Book, R. Timmons & Sons, Birmingham*. Fitzwilliam, N.H.: K. Roberts Publishing Co., 1976.

Tuma, Ing J. *The Pictorial Encyclopedia of Transport*. New York: Hamlyn, 1979.

United States Patent Office. *Rural America a Century Ago*. Ed. by S. H. Rosenberg. 1892. Reprint. St. Joseph, Mich.: American Society of Agricultural Engineers, 1976.

Uzes, Francois D. *Illustrated Price Guide to Antique Surveying Instruments & Books*. Cardova, Calif.: Landmark Enterprises, 1980.

Van Cleve, John V., ed. *Gallaudet Encyclopedia of Deaf People and Deafness*. New York: McGraw-Hill, 1987.

Van Duren, Peter. *Orders of Knighthood, Awards and the Holy See*. Buckinghamshire, England: Van Duren Publishers, 1984.

Vince, John. *Old Farms: An Illustrated Guide*. New York: Bramhall House, 1986.

Von Boehn, Max. *Ornaments: Lace, Fans, Gloves, Walking Sticks, Parasols, Jewelry, and Trinkets*. New York: B. Blom, 1970.

Von Rosenstiel, Helene. *American Rugs and Carpets from the Seventeenth Century to Modern Times*. New York: William Morrow & Co., 1978.

Warren, William L. *Bed Rugs, 1722-1833*. Hartford, Conn.: Wadsworth Athenaeum, 1972.

Waugh, Norah. *Corsets and Crinolines*. London: B.T. Batsford, 1954.

Weaver, Robert B. *Amusements and Sports in American Life*. 1939. Reprint. Westport, Conn.: Greenwood Press, 1968.

Wendell, Charles H. *Encyclopedia of American Farm Tractors*. Sarasota, Fla.: Crestline, 1979.

Werlich, Robert. *Orders & Decorations of All Nations*. Washington, D.C.: Quaker Press, 1974.

Whalley, Joyce Irene. *Writing Implements and Accessories: From the Roman Stylus to the Typewriter*. Devon, England: David & Charles, 1975.

Wheatland, David. *The Apparatus of Science at Harvard, 1765-1800*. Cambridge, Mass.: Harvard University Press, 1968.

Wheeling, Kenneth E. *Horse-Drawn Vehicles at the Shelburne Museum*. Shelburne, Vt.: Shelburne Museum, 1974.

Whiffen, Marcus. *American Architecture Since 1780: Guide to the Styles*. Cambridge, Mass.: MIT Press, 1969.

Whiting, Gertrude. *Tools and Toys of Stitchery*. New York: Columbia University Press, 1928.

The Wigmaker in Eighteenth Century Williamsburg: An Account of His Barbering, Hairdreffing, and Perukemaking Services, and Some Remarks on Wigs of Various Styles. Williasmburg, Va.: Colonial Williamsburg, 1971.

Wilbur, C. Keith. *Antique Medical Instruments*. West Chester, Pa.: Schiffer Pub., 1987.

———. *Revolutionary Medicine: 1700-1800*. Chester, Conn.: The Globe Pequot Press, 1980.

Wilcox, Ruth T. *The Dictionary of Costume*. New York: MacMillan, 1986.

Wilcox, R. Turner. *The Mode in Hats and Headdress*. New York: Charles Scribners Sons, 1959.

Wildung, Frank H. *Woodworking Tools at Shelburne Museum*. Shelburne, Vt.: Shelburne Museum, 1957.

Williams, L. N., and Williams, M. *Fundamentals of Philately*. State College, Pa.: American Philatelic Society, 1971.

Winburne, John N., ed. *A Dictionary of Agricultural and Allied Terminology*. East Lansing, Mich.: Michigan State University Press, 1962.

Woodbury, Robert S. *Studies in the History of Machine Tools*. Cambridge, Mass.: MIT Press, 1972.

Wright, Lawrence. *Home Fires Burning: The History of Domestic Heating and Cooking*. Boston: Routledge & Kegan Paul, 1964.

Wright, Thomas. *The Romance of the Shoe: Being a History of Shoemaking in All Ages, and Especially in England and Scotland*. Detroit: Singing Tree Press, 1968.

Wyke, John. *A Catalog of Tools for Watch and Clock Makers*. Charlottesville: Published for the Henry Francis du Pont Winterthur Museum by the University Press of Virginia, 1978.

Zupko, Ronald Edward. *A Dictionary of English Weights and Measures: From Anglo-Saxon Times to the Nineteenth Century*. Madison: University of Wisconsin Press, 1968.

———. *Italian Weights and Measures from the Middle Ages to the Nineteenth Century*. Philadelphia, Pa.: American Philosophical Society, 1981.

Zweng, Charles A., ed. *The Zweng Aviation Dictionary*. N. Hollywood, Calif.: Pan American Navigation Service, 1944.

AM (SPEREF)
139
·C493
1988